# BAUHAUS

# STAATLICHES BAUHAUS →

Edited by

Jeannine Fiedler and
Peter Feierabend

# BAUHAUS

With contributions from:
Ute Ackermann, Olaf Arndt, Christoph Asendorf, Eva Badura-Triska,
Anja Baumhoff, Paul Betts, Bazon Brock, Ute Brüning, Cornelia von Buol, Nicole Colin,
Michael Erlhoff, Martin Faass, Ulrich Giersch, Andrea Gleininger, Andrea Haus,
Ulrike Herrmann, Karsten Hintz, Britta Kaiser-Schuster, Martin Kieren, Kay Kirchmann,
Friederike Kitschen, Karl Kühn, Frauke Mankartz, Christoph Metzger, Norbert M. Schmitz,
Eva von Seckendorff, Erik Spiekermann, Sabine Thümmler, Justus H. Ulbricht,
Katherine C. Ware, Arnd Wesemann, Karin Wilhelm

KÖNEMANN

Notes:

Unless otherwise stated, the measurements given for the illustrated objects refer to
height x width or height x width x depth. Where no location is given, the objects in
question are either privately owned or part of unidentified collections.

Original quotations have been typographically standardized for the sake of legibility.

The illustrations for this volume were selected and provided with captions by
Jeannine Fiedler, Ute Brüning, Martin Kieren and Norbert M. Schmitz.

Abbreviations:

| | |
|---|---|
| BHA | Bauhaus-Archiv Berlin |
| BUW | Bauhaus Universität, Weimar |
| HfG | Hochschule für Gestaltung (College of Design) |
| KW | Kunstsammlungen zu Weimar (Art Collections in Weimar) |
| MMA | The Metropolitan Museum of Art |
| MOMA, NYC | Museum of Modern Art, New York City |
| SBD | Stiftung Bauhaus Dessau (Bauhaus Foundation Dessau) |
| SMBPK | Staatliche Museen Berlin – Preußischer Kulturbesitz |
| | (State Museums in Berlin – Prussian Cultural Property) |

Frontispiece design using a preliminary design by Herbert Bayer for a route sign poster.
1923, Indian ink and bodycolor, 30.5 x 8.9 cm. Loaned by the Busch-Reisinger Museum,
Harvard University Art Museums, Gift of Herbert Bayer.

© Copyright 1999 Könemann Verlagsgesellschaft mbH
Bonner Straße 126, D-50968 Cologne

Design: Peter Feierabend (Art Dir.), Anne-Claire Martin, Philine Rath
Project Management: Birgit Gropp
Assistant: Ulrike Kraus
Picture editors: Jeannine Fiedler, Ute Brüning, Monika Bergmann
Production: Mark Voges
Reproduction: CDN Pressing, Verona

© Copyright 2000 for the English edition
Könemann Verlagsgesellschaft mbH

Translation and editing from German: Translate-A-Book, Oxford
Typesetting: Organ Graphic, Abingdon
Project coordination: Kristin Zeier
Production: Ursula Schümer
Printing and binding: MOHN Media – Mohndruck GmbH, Gütersloh
Printed in Germany

ISBN: 3-8290-2593-9

10 9 8 7 6 5 4 3 2 1

# Contents

# Foreword

What was probably the most successful and far-reaching school of design began with a vision: the idea of creating a "New Man" from the disaster of World War I. This was to be a creature who, endowed with all the senses and trained by the best artists and architects of the age, would be able to invent the present and the future of a modern century. In 1919 Walter Gropius gave his vision the programmatic title of "Bauhaus." He could scarcely have made a more adroit choice of name. For is not "house" synonymous with wealth of ideas, painstaking execution and the ability to adapt to the builder's new methods? A house provides a meaningful location for the communal development of ideas about the shape to be given to life and the outside world, and itself stimulates constant reflection regarding its own extension and rebuilding. The act of building a house, of making it into a home, is sustained by the defining elements of space and time and parallels the process of life itself. Gropius and the members of the Bauhaus wanted to change the face of their society, to erect a spectacular modern building which would be free of the decorative clutter of the imperial era and which would above all point in a new direction.

For a brief period of just 14 years the Bauhaus shared this desire for renewal with the young German republic. While the former was civilizing man and the various spheres of his life in the intellectual powerhouses of studios and workshops, politicians were attempting to democratize the edifice of state and society. We know that democratization was suspended in order to usher in a millennium. Likewise the National Socialists after 1933 brought an uncompromising end to the aesthetic and intellectual civilizing of Germany. Elsewhere, in exile, above all in the United States and Palestine, the Bauhaus idea of a social utopia was later taken further with the same energy as at its sites in Weimar, Dessau and Berlin. The

**Student on a balcony of the Prellerhaus.** About 1929, Bauhaus studio house, Dessau, photograph by Marianne Brandt, BHA. • Prophet or visionary? The Bauhaus student in a contemplative mood.

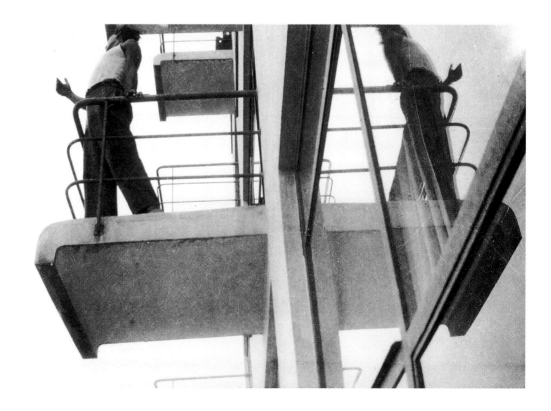

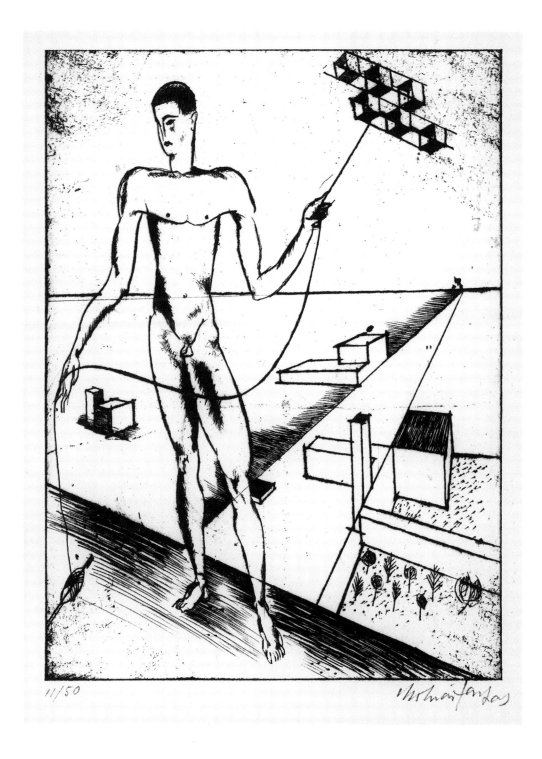

11/50

last Bauhaus director, Ludwig Mies van der Rohe, retrospectively expressed the matter with his characteristic precision: "Only an idea has the power to spread so widely."

The design philosophy embodied in this idea brought together its adherents regardless of national frontiers. Something takes shape (Gestalt). The idea of process inherent in the word "design" (Gestaltung) – how an artefact comes into existence and how it is constituted – is as old as the medieval concept of the "Bauhütten" (church masons' guilds), those centers

for the guilds and the cathedral builders to which Gropius was primarily alluding in the name "Bauhaus." And the words "Gestalt" and "Gestaltung" are so heavily laden with meaning that, being untranslatable, they have found their way into the vocabulary of English. That is why the youthful genius T. Lux Feininger, the photographic chronicler of the vibrant life of the Bauhaus, expressed the suspicion in his reflections on the school that "a feeling for the close proximity of pure thought and concrete substance [is] typically German."

After the Storm and Stress of the Weimar period, the founding years of the new beginning between Jugendstil and Expressionism, between craft and technology, the school had finally established itself in Dessau as a design laboratory by around 1925–1926. The new glass and steel teaching building, built to Gropius's plans, now housed the production workshops, for what was tested and developed at the Bauhaus had to be economically profitable. The future of handicrafts lay in creative design work for industrial production. From

**Unheimliche Strasse I (Sinister Street I).** 1928, photograph by Umbo (Otto Umbehr), BHA. • The utopian potential of the century caught in a silhouette on the asphalt: man in his urban setting.

the initial exploratory stage there had emerged fixed concepts such as norm, type and synthesis which in the combination of art and craft elements pointed the way forward to new forms of industrial design. A prospectus by Hannes Meyer contained the words: "Young people – come to the Bauhaus." They came from many countries and took the Bauhaus vision out into the world.

Following numerous publications on the subject of the Bauhaus, both the interested reader and specialists in the field will approach a present-day compendium with high expectations. This book is not intended to replace either monographs or specialized presentations such as have been compiled in the form of catalogues of the great collections – the Bauhaus Archive in Berlin, the Bauhaus Foundation in Dessau, the Bauhaus Museum in Weimar, the Getty Research Center in Los Angeles and the Misawa Homes' Bauhaus Collection in Tokyo. We would like to express our most sincere thanks to all these institutions and their staff for help in locating pictures. With their help it has been possible to compile an unprecedentedly comprehensive selection of pictures relating to the Bauhaus. This selection not only provides illustrations for the wide range of essays but also constitutes, with the aid of our own brief commentaries, a dramatic iconography which makes the Bauhaus phenomenon accessible on a purely visual level too.

The book is conceived in terms of three elements: themes, works and documentation. The thematic contributions offer insights into the historical, political and educational background to the Bauhaus, down to the present day. They make it easier to understand this germ cell of modernism, the roots of which, however, go back far into the nineteenth century. The history of the Bauhaus's reception is examined from aesthetic and philosophical points of view and in terms of its close connection with the history of the Weimar Republic along with the recognition of how it was conscripted to serve the social and political aims of the National Socialists and the East German dictatorship.

The school's specific achievements, from – at the very top of the list – the famous preliminary course and its didactic concept proposing a close interlocking of craft work and theoretical teaching, to the challenges of a curriculum that related study to practice – these achievements not only determined the educational legacy of the Bauhaus to its successor institutions, which recruited their staff in part from Bauhaus masters and pupils, they also continue to exert their influence down to the present day in modern colleges and academies.

These essays are followed by a group in which investigation of the everyday life of the members of the Bauhaus sheds light on its subtle internal mechanics. The Bauhaus as a focal point for the radical modernization of everyday life became in the 1920s the catalyst of a new self-awareness. Its achievement lay in bringing together a cluster of anti-academic attitudes and establishing them, in an unconventional manner, in an actual school. New styles in fashion and new forms of living together, modern concepts of the body, esoteric theories and techniques such as Mazdaznan, experiments in free love, the emancipation of women, and the Bauhaus parties as seismographs for the spirit of the age and its delight in experimentation – these were the life-enhancing recipes for the élan of the Bauhaus and for an undiminished vitality which the school itself continues to radiate even 80 years. For the first time, this copiously illustrated group of contributions lends power to the convergence of humanity and the educational institution.

The Bauhaus personalities provide the introduction to the "works" section, most notably the directors, who are presented in relation to the particular creative periods of the Bauhaus with their successes and their failures resulting from political turmoil. This is followed by a monographic selection of outstanding masters and young masters. Personalities such as Georg Muche, Lothar Schreyer, Hinnerk Scheper, Joost Schmidt, Mart Stam, Lucia Moholy or Lilly Reich are assessed in relation to their products or workshops, with basic information on how they shaped the character

and syllabus of the Bauhaus. This is developed by drawing attention to aspects of the artists' work which go beyond their activities at the Bauhaus and illustrate, among other things, their involvement in the avant-garde movements of the century. This section is also concerned with preparatory teaching at the Bauhaus. Here the specific differences are analyzed between the educational models of Itten, Moholy-Nagy and Albers through to the classes given by Kandinsky and Klee.

This is followed by an introduction to the formal spectrum of the workshops, with an account of the various stages of development from craft-based production in Weimar, via design work for a modern industrial society in Dessau, down to the curriculum in the late phase of the school with its academic slant. Here too, extended discussions with new specific starting points provide a more complex understanding of the workshops. The section on theory approaches the phenomenon of the Bauhaus and twentieth-century modernism in the form of a small forum for both retrospective and forward-looking considerations.

The final section is broken down into two parts: documentation and a merchandising appendix. The second part presents the Bauhaus designs that are most frequently produced today. In order to encourage collectors and connoisseurs, it lists the firms which sell Bauhaus artefacts, furniture and textiles.

The popular conception of the "Bauhaus style" was shaped by a small number of early writings on modern design. The material presented for scrutiny in this book shows, in contrast, an open, dynamic corpus of formal and functional rules which is intended, so to speak, to take the usual approach of looking at a single striking individual object and to extend and multiply it. Elevated by those who came under its influence to a classic among avant-garde movements, the Bauhaus remains, even beyond the century that is now coming to an end, a touchstone for a second or third era of modernism in design and architecture.

Jeannine Fiedler

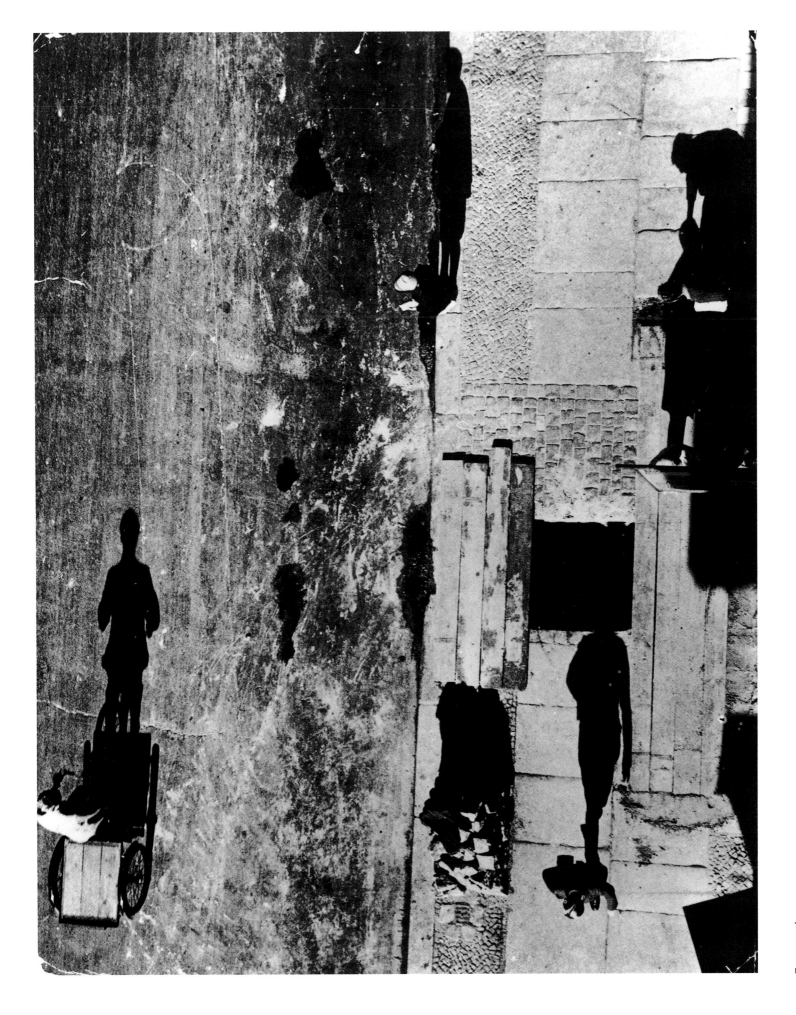

# THEMES

# Foundations and Consequences

# Bauhaus: History

Andreas Haus

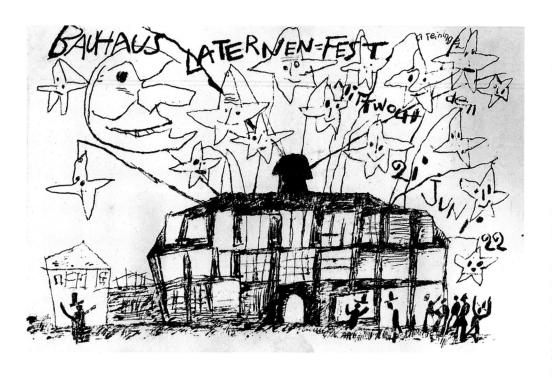

**Lyonel Feininger, Postcard of Lantern Party.** Wednesday June 21, 1922, lithograph on yellowish card, print 9.0 x 13.9 cm, postcard 9.6 x 14.5 cm, BHA. • In the in-house printworks the personal art of teachers and pupils alike flourished; multiple copies were made as postcards advertising parties and other events. Feininger's card shows the building, in functionalized Jugendstil style, which Henry van de Velde built for the art school between 1904 and 1911. From 1919 it served as a studio-cum-administrative building for the State Bauhaus in Weimar.

The Bauhaus was the child of an age that felt itself to be revolutionary. For many Germans who had lived through World War I and the collapse of the Empire, Nietzsche's "re-evaluation of all values" had become a reality. Not a few of them took the view that the old bourgeois world of industrialism and militarism with its aristocratic elite had destroyed itself, along with its own inner contradictions, in a hybrid war between nation-states. Everywhere, the ideas of the Russian October Revolution kindled visions of the renewal of society. The end of the "old" and the creation of the "new" now seemed possible, and there were many who felt that they were called to be leaders in the construction of a better future.

The intellectual basis for these reflections on the future had in fact been in the making for decades. Along with the social-democratic and trade union movements which came into being in response to Bismarck's antisocialist laws, it was above all the arts that since the final decades of the nineteenth century had nurtured new hopes of happiness and visions of human freedom. Since the turn of the century, an aesthetic movement had encompassed philosophy, educational theory and innumerable varieties of *Lebensreform* movements in support of a better lifestyle. Jugendstil and Art Nouveau laid the basis for all branches of modernism. The historicism of the older generation, the masculine cult of the ego in the "founding years" of economic growth following Germany's unification in 1871, the moral constraints of respectable society and the rationalism of positivistic philosophy – these had been followed in the realm of art, long before World War I, by a generation that took up the causes of pure feeling, authenticity, experience, expression and – as a substitute for religion – a more universal symbolic way of thinking and feeling.

Looking back, it may be said that the political hopes of renewal after World War I had been preceded by the artistic and aesthetic blueprints of an entire generation. These blueprints had in common the fundamental notion of a union of art and life. This idea generated a variety of projects for the reform of artistic production and art teaching. In particular, the academic distinction between high art and applied art came increasingly to be regarded as outdated and gave rise to plans – entirely in the spirit of Jugendstil, which from the beginning had jettisoned the separation of art and craft – to abolish the old academies or to amalgamate them with craft schools. This seemed an obvious thing to do since by then the craft schools that had been established in the 1870s and 1880s had rapidly overtaken the traditional academies in terms of modernity and international orientation and even before the turn of the century were quite often preferred by really gifted art students. Numerous leading modernist masters were former craft school pupils, both in Germany and abroad. France and England were regarded as models, and private ("free") art schools also acted as forerunners by virtue of their study programs, which more and more frequently gave space to the abstract decorative tendencies of modern craft work.

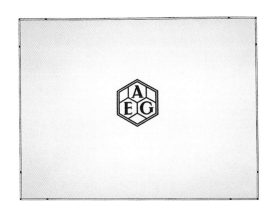

**Peter Behrens, AEG logo.** 1908, frontispiece for "AEG (the German General Electric Company) 1883–1908. Festschrift zum 25jährigen Bestehen" (Festschrift to mark the 25th anniversary), SMBPK, Art Library. • With Peter Behrens, in whose office the young Walter Gropius worked from 1908 to 1910, the attempt to imbue industry with art led at one stage to standardization of design, which he saw as a prerequisite for machine-manufactured forms. The geometric symbol was also intended, as part of the image of the AEG, to indicate standardization while at the same time constituting the "essence" of the good taste of earlier periods.

The industrial revolution made it clear at the beginning of the nineteenth century that along with the development of an economic principle driven by individual egoism, the hope for a harmonious society was ultimately crushed. The artists responded by retreating into their circles and the bohemian cult. The notion, reaching back to the Romantic era, that the real artist was an outsider on the edge of society remained fixed as a cliché well into the twentieth century. As so often, these avant-gardes were the vanguard of a large-scale subliminal movement which faced up to the rapid changes in the social and aesthetic parameters of the industrial revolution. The replacement of manual work by modern machine technology, and the consequent end of individual craftsmanship with its roots in society and culture, became symptoms of growing social contradictions. The rise of the industrial proletariat as an anonymous mass phenomenon in the big cities did indeed inevitably pose a threat to the individual citizen's desire for affluence. Romantic notions of social reform, which were to create a better society by way of artistic and cultural renewal through arts and crafts, had been advanced back in the mid-nineteenth century by John Ruskin

with his almost religious sermonizing on art and his critique of industry. They led to the Arts and Crafts movement of the entrepreneur William Morris and, as an alternative aesthetic orientation, exerted a decisive influence on the arts and crafts reforms of Jugendstil (the German version of Art Nouveau).

By upgrading the artistic component in craft work, the nineteenth-century Arts and Crafts movement attempted to preserve an ideal of the original unity of art and life, and to uphold the dignity of individual human labor within the limited sphere of domestic and lifestyle culture. It was a typical middle-class theory: through the artistic enhancement of productive labor a cultural and thus ultimately social community might be preserved in public life. The enormous state subsidies for art and craft museums and schools bear witness to the social and political importance attached to this movement. In Germany, however, struggling for markets for its goods, this was soon followed by an alliance between the aesthetic reformers and industry. The establishment of the German Werkbund (Art and Craft League) in 1907 brought together architects, artists, art historians, industrialists and political economists in a program

**The Bauhaus conquered by De Stijl.** Postcard from Theo van Doesburg to Antony Kok, September 12, 1921 (view of the school building built by Henry van de Velde), Haags Gemeendemuseum, The Hague. • In 1921 a victory in van Doesburg's struggle to win over the Bauhaus was not as yet in sight. At that time only a few people were enthusiastic about his lectures, which were later to have a subversive effect outside the Bauhaus. Most members of the Bauhaus were only just beginning to follow van de Velde's example and go out into the marketplace with craft products.

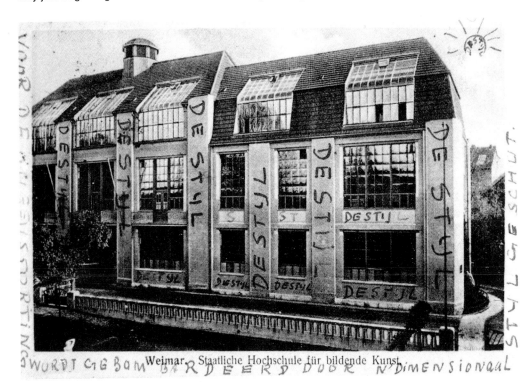

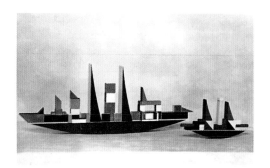

**Alma Buscher, Bauspiel: Ein Schiff (Building Game: A Ship).** 1923, photograph by Lucia Moholy, BHA. • A Bauhaus principle for organizing material: the attraction of the abstract is turned into an educational process. The idea of arranging stereometric blocks independently into the shape of ships or other forms encouraged an individual interpretation of geometry. Decoration was provided by the color.

whose goals were not only cultural but in fact primarily economic: "The aim of the Bund is to ennoble craft work by combining arts, industry and crafts through education, propaganda and a united front on the issues involved" (*German Werkbund Yearbook*, 1912).

Old-fashioned though the name Werkbund was, its goals were modern in a number of ways: a move away from the backward-looking ideology of the Arts and Crafts movement, the acknowledgment of industry, and the positively radical replacement of the concept of "art and life" by "art and economics." What was meant was economics at the most modern contemporary level, that is to say the export economy within the global market system of competing imperialistic nation-states. Hence the Werkbund was to a considerable extent oriented toward outward power, and no longer only toward inward culture. Until the outbreak of World War I there was a tendency in all the aesthetic discussions and aspirations of the Werkbund to glorify monumental large-scale technological forms. In the advertising section of the *Werkbund Yearbook*, power transmission machines with many hundreds of horsepower could be seen side by side with "middle-class pieces of furniture ... in the spirit of the modern age ... designed throughout with a view to functionality and utility, beautiful in themselves through the effect of the wood and the delicate balance of their proportions ...." (*German Werkbund Yearbook*, 1912).

"Good form" was adopted as the Werkbund's slogan. Its characteristics were defined as "quality" and "functionalism" – i.e. the functional conception of the item in question was completely subsumed in its perfection of construction free of superfluous ornament. This identity of form and content led the style of the Werkbund to become an early kind of functionalism. The object, the specific commodity, was to acquire a "necessary" validity for itself and, with its total functionality, to constitute a seamless unity with all the other shapes and forms of its surroundings "from sofa cushion to urban construction." In 1914 there were discussions within the Werkbund over including furniture production in the move away from individual artistic design in favor of machine-produced "type furniture," in line with the technological manufacture of goods. In accordance with the criterion of "good form," any individual ornamentation of particular items, any creative license or playful extravagance such as was on offer from international Art Nouveau, particularly from French arts and crafts, which occupied a leading position throughout the world and which to some extent were still working with rococo forms, came under suspicion of luxury and bad taste. In the German Werkbund there emerged for the first time an aesthetic of material objects which took its bearings from the standards of industrial technology and which made functional efficiency the decisive factor in determining both economic and aesthetic value. It was not by chance that the *Werkbund Yearbook* for 1914, which was devoted to transport issues, included a model contribution from a corvette captain who discussed the modern warship in order to emphasize the "strict adaptation of both technical construction and artistic form to the essence and purpose of the instrument of war, by evolving an organic entity that is true and faithful to that essence." This text, appearing on the eve of World War I, was not unique. High-speed railroads, the "architecture" of motor vehicles and aircraft and the forms of industrial buildings in general were deemed stylistic models. However, in order to ward off accusations of subscribing to a purely utilitarian aesthetic, this functional stylization was tagged with the slogan "the intellectualization of German labor" (*German Werkbund Yearbook*, 1912). The question of form became a question of culture and – not without a backward glance at German classicism – an issue of intellectual leadership.

The young Berlin architect Walter Gropius, whose great-uncle Martin Gropius had been a significant architect and pupil of Schinkel, belonged to the Werkbund from 1911 and occupied an important position as the compiler of its yearbooks. In 1914 Gropius began his article on "The value of industrial building forms as stylistic influences" with the words: "The art of the past few decades had no moral focal point and thus lacked the vital prerequisite for fruitful development. In that age, which only in material respects paved the way for the present, there was no intellectual ideal of such general validity as would have enabled the creative artist to transcend egocentric notions and derive from it a generally intelligible conception ... there was no longer any awareness of the fundamental problem of form. This crass materialism had its

exact counterpart in the excessive importance attached to purpose and materials in a work of art." Gropius, in contrast, pleaded for an "intellectual concept for the age" to be devised, and saw the beginnings of it in the organizational management of modern international transport: "More and more the solution of this global task is becoming the ethical center of the present age, and thus art is provided once again with intellectual subject matter to be symbolically represented in its works." According to Gropius it was railroad stations, factories and motor vehicles that confronted the visual artist with the real challenges of the age: "If he recognizes their necessity, if they become an inner experience for him, then he will not only seek their meaning on all sides but will in so doing fill his forms with poetic exaggeration, so that any observer will be able to see the basic idea of the whole thing." Gropius thus pleaded unequivocally for artistic, indeed "poetic" elaboration of technological forms, and indeed of such a kind that the model would be provided not by the bare bones of structure but by a new formal totality: "All inessential details are subordinated to a great, simple representational form which finally, when its definitive shape has been found, must constitute the symbolic expression of the inner meaning of the modern artefact ... automobile and railroad, steamship and sailing yacht, airship and aircraft have, through form, become symbols of speed. Their

lucid appearance can be taken in at a glance and no longer in any way suggests the complexity of the technological organism. In them, technological form and artistic form have become a close organic unity."

An interesting text by the 31-year-old writer, perhaps already tinged with Futurism and revealing an independent individual artistic personality. Yet one senses that, for all its modernity, the task of creating artistic form is still conceived here, in the spirit of Art Nouveau, as the symbolic formal expression of an organic natural dynamism. This monumental, utilitarian and at the same time organic quality is the hallmark of the "good form" of things in the German Werkbund: functionalism and formal physical presence coexisting almost like a law of nature and thus indisputably valid.

The use of materials and technology in the battles of World War I utterly shattered this optimistic cultural conception of the value of industrial forms as stylistic influences. It was no longer possible to have faith in "functionalism" or the value of "form." Rather, the misery of the people, their existential fear of destruction, positively cried out for a humane renewal of the society. Expressionism – which before the war had been more of a bohemian movement – underwent a spiritual change of heart and became an expression of the self-awareness of the war and postwar generation. In 1918 the Arbeitsrat für Kunst (Working Council for Art)

was set up under the impact of the November Revolution and following the example of the workers' and soldiers' councils. Gropius was one of its leaders and published an appeal in the *German Revolutionary Almanach* for 1919 with the title "Architecture in the Free People's State." In it he wrote: "The old state ruled autocratically over art. The new state must first serve it in order to acquire the lofty epithet 'free.'"
Gropius now no longer called for style and form, but for the "spiritual community which is necessary to create the natural rhythm of the whole .... Great, all-embracing art presupposes the spiritual unity of its age, it requires the closest connection with the environment, with living human beings ... the present generation must make a completely fresh start, must rejuvenate itself and first create a new humanity, a new form of life for the people. Then art will come ... then the people will once again take part in the building of the great art works of their age. The arts will find their way back from their lonely isolation into the bosom of all-embracing architecture ...."
This was the intellectual atmosphere in which the Bauhaus came into existence. The Großherzogliche Kunstgewerbeschule (the Grand Ducal School of Arts and Crafts in Weimar) had been closed down in 1915, the first year of the war, following the resignation of its director Henry van de Velde, who was now an undesirable foreigner. Since then Gropius, who had

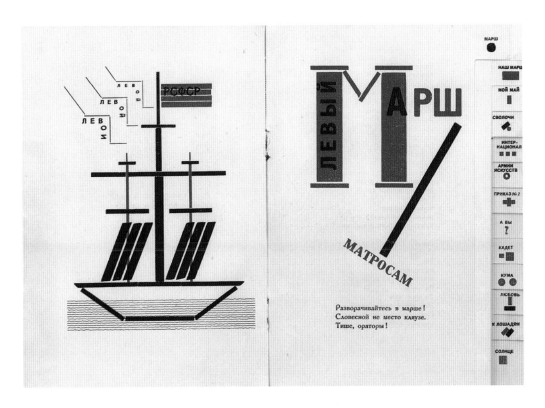

**El Lissitzky, Double page from Vladimir Mayakovski's volume of poetry "Dlja Golosa" (For the Voice).** Printed book, each page 19.0 x 13.5 cm, 1923, BHA. • A Constructivist principle for organizing material: the reversion to elementary straight lines helped the person reciting the poems to visualize the process of construction and the course steered by the good ship *USSR*. This was intended to lend the recitation a supra-individual quality. A thumb index with titles and geometric symbols served to locate poems quickly. Color was used to classify the various elements clearly.

been recommended by van de Velde as his successor, had campaigned in a number of ways for the reform of art education in Weimar. When he was finally appointed to the Hochschule für Bildende Kunst in Weimar at the beginning of 1919, this constituted a de facto acknowledgment of a new kind of school, in which, as also occurred later in Berlin, the educational institutions for fine arts and applied arts were merged. The name for the new school, proposed by Gropius on March 20, 1919, was a programmatic one: "Staatliches Bauhaus in Weimar (Vereininigte ehem. Großherzogliche Hochschule für bildende Kunst und ehem. Großherzogliche Kunstgewerbeschule)" (State Bauhaus in Weimar, combining the former Grand Ducal School of Fine Art and the former Grand Ducal School of Arts and Crafts). Whereas the Werkbund had continued, in the spirit of the German guild tradition, to emphasize the "work," i.e. the products and commodities to be created, the term "Bauhaus" referred back to an even earlier period, that is the medieval "Bauhütten" (church masons' guilds), and emphasized not so much the products to be created as the social and spiritual community of the creators. The guiding idea behind the Bauhaus was a thoroughgoing Romantic yearning for unity and harmony in autonomous shared work dedicated solely to art and faith. Thus the early Bauhaus, in comparison with the predominant intellectual movements in Germany at the time, embarked on a particular course of its own. The young German intellectuals of the world war generation were for the most part followers of Nietzsche with a critical attitude toward culture

**Constructivist and Dadaist Congress in Weimar.** September, 1922, photographer unknown, BHA. • Here a "classical" souvenir photograph was staged by Theo van Doesburg and a group of friends. In contrast to an initial serious version this photo symbolizes the abolition of rules. Top row, Lucia and László Moholy-Nagy, who did not join the Bauhaus until 1923, in the middle Alfréd Kemény; second row from back, Lotte Burchartz, El Lissitzky, Cornelis van Eesteren, Sturtzkopf; third row from back, Max Burchartz (plus child), Harry Scheibe, Theo van Doesburg, Vogel, Peter Röhl; front row standing, Alexa Röhl, Nelly van Doesburg, Tristan Tzara, Nini Smit, Hans Arp; front left, Werner Graeff; lying down, Hans Richter.

and a propensity for heroic individualism. For many, the devastating effects of the war intensified the Nietzschean critique of culture to the point of total nihilism, as for example in the case of Ernst Jünger. Dadaists such as Raoul Hausmann or Kurt Schwitters were also nihilists in this sense, remaining skeptical, often cynical loners – a stance which left its mark even on the New Functionalism of the 1920s. The Bauhaus, by contrast, was one of those progressive movements, hopeful, youthful and utopian, which wished to replace the dominance of the old order (which had been nihilistically destroyed) with fresh energies. The legacy of *Lebensreform* ideas awoke once more, a Romantic idealism of the heart which pinned its hopes on human community. Even after the famous change of course in 1923, when Gropius shifted the creative basis of the Bauhaus from craft work to technology with the slogan "art and technology – a new unity," the Bauhaus still remained a center of communal artistic and intellectual culture, in contrast to the neo-functionalist enthusiasm for technology which was emerging and the Americanism that was becoming fashionable by then, even if the outward guise of its creative principles had been changed and modernized in the direction of technology. The "light mysticism" of someone like Moholy-Nagy, for instance, Gropius's philosophies of space, Schlemmer's solemn idealism, or the poetry of nature in Klee's playful Romanticism – these are thematic constants which were more substantial than the formal change, typical of the period, from the jaggedness of woodcuts to the smooth surfaces of steel furniture. The change of direction was only an absolute one in terms of purely formal stylistic categories. But, intellectually speaking, the Bauhaus, at least in the Gropius era until 1927, was broadly a continuation of the older *Lebensreform*. Its fundamental features reveal a pronounced pedagogic tendency, with its aim of educating the senses, but it continuously adapted to external social and political changes, which included responding to criticism from outside, for example from the direction of De Stijl or the Esprit Nouveau.

The early Bauhaus is often called "Expressionist" in order to make a distinction between its beginnings and the orientation toward technology which began in 1923. It would be equally correct to speak of the "Romantic" Bauhaus.

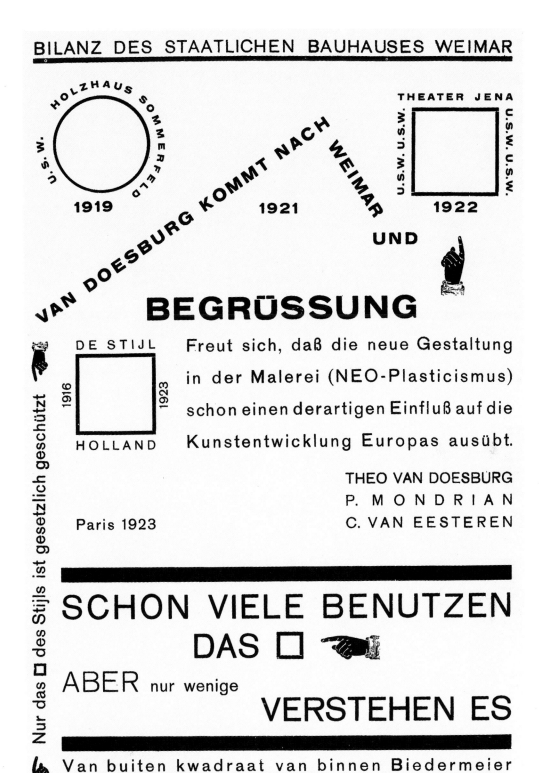

**I.K. Bonset (= Theo van Doesburg), Salut für das Quadrat (Salute to the Square).** 1923, page from "M-É-C-A-N-O," No. 4/5, BHA.

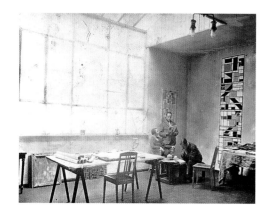

**Theo and Nelly van Doesburg and the French author Harry Scheibe in a Weimar studio.** February, 1922, photographer unknown, BHA. • On the right are sketches for "Large Pastorak," stained glass window in the agricultural college in Drachten, 1921. Was this a synthesis of art, technology and life? Was Doesburg not already announcing the direction to be taken by the later Bauhaus? The school did not in fact become a De Stijl creation, but a focal point for a variety of avant-garde ideas.

**Herbert Bayer, Isometric drawing of Walter Gropius's study in the Weimar Bauhaus.** 1923, illustration from *Staatliches Bauhaus Weimar, 1919–1923*, BHA. • The wall-painting apprentice Herbert Bayer translated Gropius's organization of space, with its debt to De Stijl, into the surface geometry of a hexagon, a parallel perspective which reinterpreted De Stijl notions of a spatial continuum and infinity as self-contained form. Bayer's presentation may well catch precisely Gropius's combination of the geometry of Behrens and De Stijl.

Gropius's words in the inaugural manifesto of 1919, "We must all return to craft work" and the motif of the cathedral as a "crystalline symbol of a coming new faith" are reminiscent of ideas from the period following the German wars of liberation of 1813–1814, of the religious craft ethos of the Nazarenes (a group of early nineteenth-century German artists with a strong religious orientation) and Karl Friedrich Schinkel's dreamy designs for Gothic cathedrals, which even at the time were intended as national monuments to the boom in commerce and a new handicraft ethos. Likewise, the French author Victor Hugo wrote a little later that the cathedral was the image of a people at work (*d'un peuple en travail*).

Historically speaking, the beginnings of the Bauhaus appear to hark back to the age of Romantic hopes of national unity. In 1918–1919 the return to handicrafts did indeed appear imminent as never before. The world war and the demands by the victorious powers for reparations had devastated German industry so completely that it was thought that Germany's economy would be reduced to pre-industrial conditions for many decades to come. Postwar economic privation strengthened the political and ideological position of lower middle-class crafts, which in earlier days had faced a massive threat from industry. This was the concrete political background to Gropius's first Bauhaus appeal. The fact that the reactionary craft associations turned against the Weimar Bauhaus was certainly not expected. At first the situation in 1919 made it seem perfectly possible for artists to become a creative force within the people. This aspect linked the aspirations of the early Bauhaus with other avant-garde movements as well, the most extreme positions being taken by the De Stijl movement in Holland and the Russian Constructivists. These movements also wanted to abolish the lone individual artist

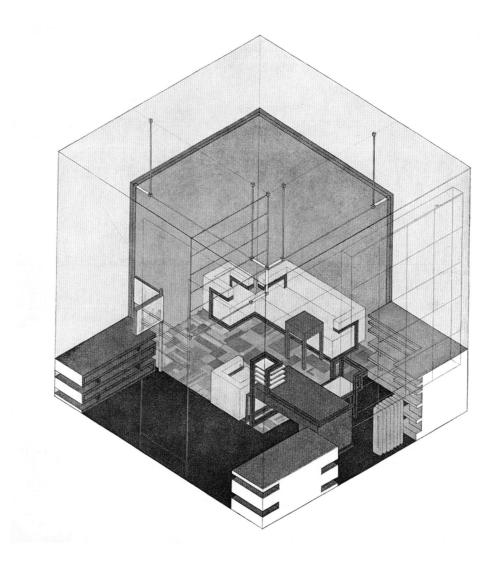

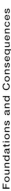

# ein bauhaus-film

fünf jahre lang

**autor:**
**das leben, das seine rechte fordert**
**operateur:**
**marcel breuer, der diese rechte anerkennt**

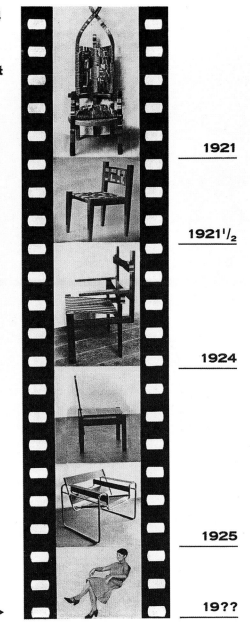

1921

1921¹/₂

1924

1925

19??

es geht mit jedem jahr besser und besser. am ende sitzt man auf einer elastischen luftsäule ➜

and go beyond pure elite and salon art and easel painting in the direction of a collective shaping of life. The means used were, however, entirely different. De Stijl still basically maintained the aesthetic stance of Art Nouveau, seeking a unified formal stylistic solution that combined the simplest formal elements. The Constructivists, on the other hand, with their consistently materialistic program, rejected all questions of form and aspired to "organize" the world and society themselves from the materials of the present. Both De Stijl and the Constructivists accepted modern engineering technology to the fullest possible extent as the basis of artistic creation: De Stijl preferred – for predominantly aesthetic reasons – the elementary geometric rationality and regularity of machine-produced parts, whereas the Russian Constructivists looked, with Futuristic rhetoric, to the intensified dynamic experience provided by the technology of large-scale industrial manufacture.

By comparison with the old industrial aesthetics of the Werkbund, both movements also shared a desire to leave the functional notion of "good form" completely behind them in favor of larger, coherent structural conceptions. There was also a link with the Bauhaus here, with Gropius emphasizing that the new creative task was not the object but had as its ultimate aim the

"creative shaping of the processes of life." Not objects but functional systems became the goal of creative activity. Within such systems, the importance of individual objects was scarcely more than that of integrated component parts without any beginning or end of their own. The entire creative enterprise was to be geared primarily to human movements in space. At this point the object as a self-sufficient entity, and with it the Werkbund's notion of "good form," began to disappear. There was an increasing critical realization that the perfectly formed individual object can become a fetish and that it does not release men from their

dependence on objects but rather creates such dependence. In 1928 Naum Gabo, writing in the periodical *bauhaus*, spoke of the "danger ... of turning the object into an idol;" Breuer created the stowable folding armchair, and developed the vision of sitting on a column of air rather than a chair.

If today Bauhaus furniture has a place in the spectrum of contemporary interior décor by virtue of specific classic pieces, this may be said to bypass the original creative intentions, and to show that our attitude has actually reverted to the ideology of "good form" which preceded the Bauhaus's visions of unity.

# Bauhaus Philosophy – Cultural Critique and Social Utopia

Nicole Colin

"We have left dry land to go by ship! We have demolished the bridges behind us, more than that, we have demolished the land behind us" (Friedrich Nietzsche, *Die fröhliche Wissenschaft* [The Gay Science], 1882).

The voices of cultural critiques in the 1910s and 1920s sound like an echo of this statement of Nietzsche's position. Whether philosophical or artistic in intention, most of the visions of how the world and life ought to be, with which Europe was inundated during the war and postwar years, were the product of a far-reaching critique of the disastrous prevailing circumstances backed by a resolute desire to make positive changes to the catastrophic mood of the age as the necessary prerequisite of a new beginning. Seen in the light of this dichotomy, the Bauhaus, as an artistic utopia, was entirely a child of its time. As Gropius retrospectively put it in 1963, the original idea developed essentially from a "blend of profound depression resulting from the lost war with its breakdown of intellectual and economic life, and the ardent hope and desire to build up something new from these ruins" (letter to Tomás Maldonado in *Ulm, Zeitschrift der Hochschule für Gestaltung* [Journal for the School of Design], November 10, 1964).

This sense of a world in crisis is admirably revealed in Oswald Spengler's monumental apocalyptic work, *The Decline of the West* (1918–1922). Spengler's verdict is final: the decadent "Faustian" culture is moving inexorably toward its final form, that is to say its imminent demise. His argument indiscriminately links phenomena such as "technology," "democracy," "cosmopolitan urban art, sport, titillation" and the "cult of science," along with "futile, vacuous architecture and ornamentation" as symptoms of this decline. Spengler was loudly applauded by his contemporaries for his gloomy prognosis with its radical hostility toward civilization. For the conservative middle class above all the concept of "civilization," as distinct from the notion of

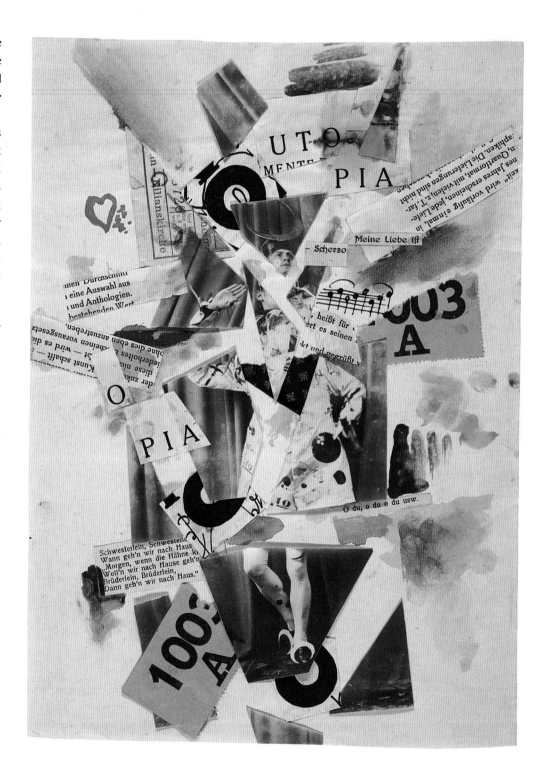

**Rudolf Lutz, "Utopia. Dokumente der Wirklichkeit" (Documents of Reality).** 1921–1922, collage of a cut-up photograph of Rudolf Lutz in Dadaist costume with lines from *Utopia. Dokumente der Wirklichkeit*, admission tickets, newspaper cuttings, black Indian ink, watercolor, 29.1 x 21.1 cm, BHA. • Only fragments of the Bauhaus publication *Utopia* are extant; they present a fragmented image of the artist. Itten's utopian concept of the whole man is now no more than a quotation.

"culture," became increasingly synonymous with leveling down and decline.

Spengler's euphoric pessimism about culture of course had its antecedents. Doubts had already begun to creep in during the nineteenth century over the positivistic faith in progress. In his *Über Wahrheit und Lüge im außermoralischen Sinne* (On Truth and Lies in the Non-Moral Sense), Friedrich Nietzsche describes how human beings, those "clever animals," dishonestly introduce the categories of reason into the world in order not to be crushed by the actual meaninglessness of all existence. Nihilism seeks to put a final end to this self-deception: there is nothing, nihil, in the Platonic-Christian interpretations of the meaning of life and history, nor in the positivistic categories of progress and development. However, in the dialectic of destruction and renewal the nihilist, unlike Spengler, sees himself as standing not at the end of history, but at its new beginning: a re-evaluation of all values brought about by the "will."

Not least as a result of the popularization of Nietzsche on a vast scale around the turn of the century, Zarathustra's "midday hour" became the leitmotif of the most disparate artistic and intellectual utopias. These visions, which in fact on closer examination often had very little to do with Nietzsche, generally speaking took on the task of transcending the hypertrophied materialism of the nineteenth century and resolving the inner turmoil of human beings who had become alienated from themselves, albeit with widely varying notions of how to set up this new unity.

One of the most significant attempts to bring about a universal change of thinking was the anthroposophy of Rudolf Steiner. Steiner had also studied Nietzsche, in whom he thought he had discovered a distorted caricature of his own ideas. However, in contrast to the rhetoric of decline in nihilism, anthroposophy saw itself as rooted in the fundamentally positive intention of uniting theory and practice, science and religion, the sensory and the extrasensory world. Steiner, a scientist with clairvoyant gifts and a Catholic believer, drew powerful initial inspiration from the Theosophical Society that had been founded in 1875 by the Russian medium H.P. Blavatsky. This was a fashionable movement which, like

Steiner himself, had an important influence on the "spiritual" contingent of the Bauhaus, especially on Kandinsky, Klee and Itten. But whereas theosophy, which should more properly be called the "study of spirits," remained trapped in mediumistic mysticism, Steiner, an epistemological optimist, strove to provide a scientific foundation for religious belief. He defined his goal of an "epistemological pathway" as early as 1894 in *Philosophie der Freiheit* (Philosophy of Freedom), which was directed above all against Immanuel Kant's epoch-making refutation of the ontological proof of the existence of God. It is, however, a fundamentally epigonal work, and was met to a large extent with incomprehension by professional philosophers.

Less occult than anthroposophy and more convincing in its content is the philosophy of Henri Bergson which has become known as vitalism. What is particularly interesting in his theory is the concept of "intuition," a phenomenon which played a particularly dominant role in Johannes Itten's educational program. Guided by similar motives to Steiner, Bergson wanted to take philosophy out of the speculative and into the spiritual sphere, in order to provide it with a new basis distinct from that of science. In *Creative Evolution*, published in German in 1912, Bergson proclaims the inadequacy of the intellect to provide knowledge of life, the fluidity and uniqueness of which cannot be grasped by scientific methods. The mind, he declared, is adequate only for the investigation of lifeless matter, of disparate, countable and calculable things. Only intuition – to be understood here not as mystical inspiration but rather as "metaphysical experience" – can grasp the whole, the spirit, life, and penetrate to the "inner essence of things."

In Bergson's negative assessment of the rational workings of the mind we come full circle to the cultural pessimism of Spengler, who considered empirical scientific methodology to be inappropriate as a means of grasping the meaning of history and who preferred instead to work with the concepts of "feeling" and "sensing." This swing of the pendulum to irrationalism was entirely typical of the thinking of the age and not by any means restricted to the conservative camp. It is also to be seen to the same extent in avant-garde and

Johannes Itten, Draft title page of "Utopia. Dokumente der Wirklichkeit." 1921, Indian ink on paper, 33.0 x 24.0 cm, Weimar, Itten Archive, Zürich. • Itten in particular showed how far-reaching Bauhaus utopias could be. His goal of harmonizing polar opposites in both art and life was oriented toward God. The *Documents of Reality* also comply with the word of God from A(lpha) to O(mega); these two letters, central and prominent in the design, seem to be singing a hymn of praise to His greatness.

Expressionist views of the world. Thus in 1996 Beat Wyss wrote in *Der Wille zur Kunst* (The Will to Art): "In terms of the history of culture, the modern age is the product of a mythology which speaks of earthly redemption."

People also had high hopes of earthly redemption from technological developments, which with increasing automation had more and more become the central issue in the critical discussion of culture. In 1927 the engineer and biophysicist Friedrich Dessauer noted in *Philosophie der Technik* (Philosophy of Technology): "These powerful and subtle artifacts with which the factories are filled have their own aura of solemnity, as does a plowed field or a forest. Of course, anyone who hears only economics and sees only money in their rhythm will have no conception of the great metaphysics of the machine. He will remain sad and unredeemed.... Anyone who immerses himself in them will come to feel reverence for the machines because he will sense their divine element."

In contrast to extreme positions such as this, the Bauhaus proclaimed not the apotheosis of technology but rather its humanization. Moholy-Nagy noted: "We need the machine. Without any Romanticism." But this apparently matter-of-fact vision of a restructuring of the world on a technological basis is actually still dependent on an interpretation of history which emphasizes God's saving acts (heilsgeschichte). Thus the Constructivists' enthusiasm for the universal potential of industrial manufacture came not least from the utopian notion that with the aid of technology the ultimate solution to all social problems would be found in the foreseeable future. This utopia, where capitalist and communist theories of civilization intersect, finds its most succinct expression in Henry Ford's autobiography *My Life and Work*, which appeared in Germany in 1923 and quickly became a bestseller. Ford's classic liberal philosophy of business and society, which he derived from his own success and which soon became the prime basis for modern technology theory, is, as far as its optimistic assessment of the social effects of technology is concerned, astonishingly close to communist ideas. Thus Marx's "perfected humanism," which demanded the restoration of wholeness to a human existence that had forfeited its real substance through the alienation of labor, was directed against capitalistic methods of production but not against technology itself.

However, in its utopian orientation the economic interpretation of technology remained indebted to eschatological hopes, hopes which could easily be broadened to encompass the whole of human existence. Thus for example Moholy-Nagy, in *Von Material zu Architektur* (From Material to Architecture) (1929), took up Marx's idea of the "whole man" and described

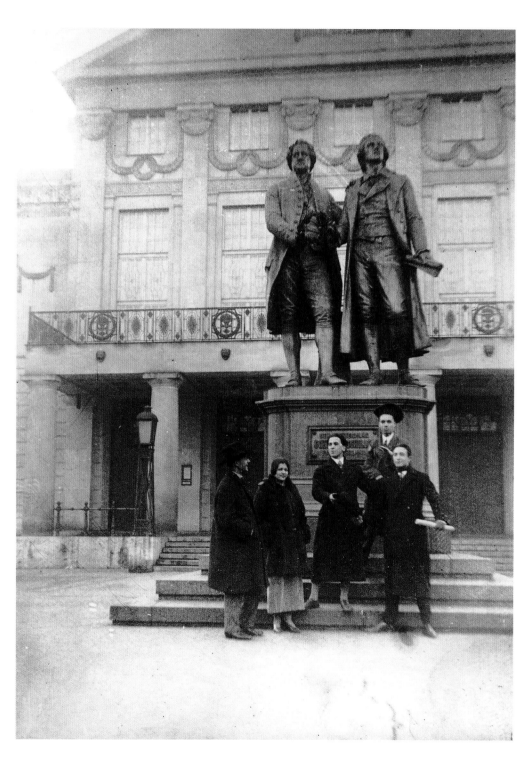

**Members of the Bauhaus at the Goethe-Schiller monument in front of the National Theater in Weimar.** About 1924–1925, from the left, Paul Citroën, Ellen Hauschild, Xanti Schawinsky, Walter Menzel, Kapelner (?), photographer unknown, BHA. • Students clowning: having their photograph taken in front of the classic writers – but the joke may well have reflected their awareness that with their work at the Bauhaus they were contributing to substantial social changes.

technology as the "most indispensable aid" to achieving "a standard of living which would enable blatant discrepancies to be removed," thus making it possible for man to become "free." This conclusion, while lacking absolute objectivity, leads us back to the above-mentioned ideas of "earthly redemption." The inconsistent blend of objective arguments and irrational belief in divine purpose does not have to be seen as a deficiency.

In the confused struggle to create a myth of man's spiritual and material unity, the Bauhaus ultimately created a space where the most disparate views could coexist in a state of fruitful tension, a coexistence which, however, remained fundamentally paradoxical. These views ranged from conceptions of art and the world inspired by Expressionism, vitalism or theosophy from masters such as Itten, Kandinsky, Klee, Feininger and Schlemmer, to the technological-functionalist visions of a trouble-free totally organized planned society in the case of Moholy-Nagy and Hannes Meyer.

This synthesis of revolutionary social philosophy and eschatological preaching is also reminiscent of Ernst Bloch's *Geist der Utopie* (Spirit of Utopia), published in 1918. While by no means aspiring to develop a systematic philosophy in either style or content, Bloch outlines the vitalistic creed of the Expressionist generation. The task of avant-garde art, he argues, is to provide visions of alternative worlds, to develop models of a new and better life using artistic means. The parallel between artistic and intellectual visions of the world is impressively visible here. Almost at the same time as the establishment of the Bauhaus in 1919, that Romantic new beginning invoked by Gropius which aimed to create "the new being in a new environment and release creative spontaneity in everybody" (letter to Tomás Moldonado), Bloch declared the utopian principle to be the indispensable subject of all visual art. His rhetorical "intention" reads like a poetic description of Lyonel Feininger's *Cathedral of Socialism*: "Now we have to begin. Life is given into our hands .... To find what is right, for the sake of which it is fitting that we should live ..., for this we set out ... build at random, into the blue, build ourselves into the blue and seek there the true, the real – incipit vita nova."

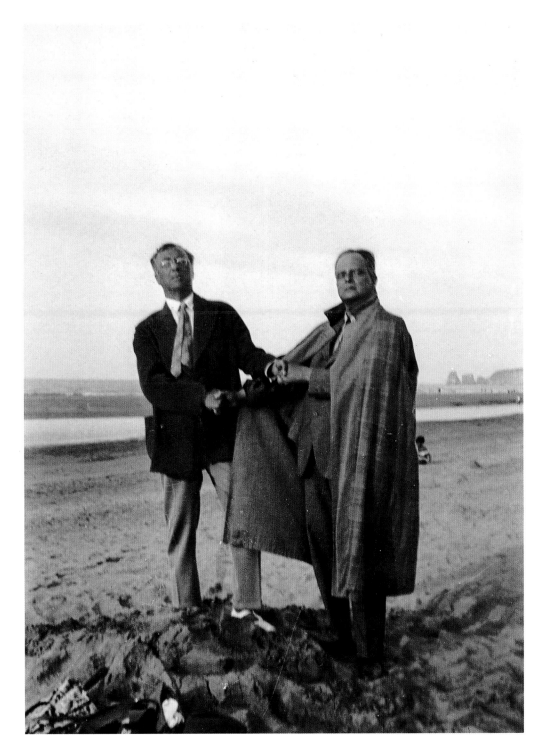

**Wassily Kandinsky and Paul Klee on the beach at Hendaye.** 1929, photograph by Lily Klee, Musée National d'Art Moderne, Centre Georges Pompidou, Paris. • In the pose of the Goethe-Schiller monument in Weimar the successful friends seem already to embody the concept of "classical modernism." However, it was only in the early Bauhaus that there was any correspondence between Goethe's attempt to bring science and art together again, after their separation by the Enlightenment, and the aim of promoting objective understanding and an aptitude for subjective experience.

# The Bauhaus and the Weimar Republic – Struggles for Political and Cultural Hegemony

Justus H. Ulbricht

**Onlookers outside the National Theater in Weimar for the first session of the National Assembly.** February 11, 1919, photographer unknown, Ullstein picture service. • From February 6 to the end of August, 1919, coinciding with the early days of the Bauhaus, 423 elected members worked to formulate the Weimar constitution.

Utopian yearnings and political enthusiasm in the beginning, chastened resignation and social disappointment at the end – these are the sentiments which mark the history of both the Bauhaus and the Republic which, like the art school, was founded in Weimar in 1919 and carried to its grave in Berlin in 1933. The fate of what was at the time Germany's most renowned school of artists and architects was, however, not merely chronologically but also causally connected with that of the first German democracy. The slow political decline of the Bauhaus – which did not of course preclude some fine aesthetic achievements – ran parallel to the political failure of the Weimar Republic, the cultural history of which has been constantly reinterpreted all the way down to the present day. In the early days after the foundation of the Federal Republic people liked to speak of the "Golden Twenties" and to refer to the legacy of that "better Germany" which was seen as being embodied in equal measure in the cultural life of the Berlin metropolis, the voices of exiled Germans, and the resistance of the "men of July 20," which soon came to be seen in heroic

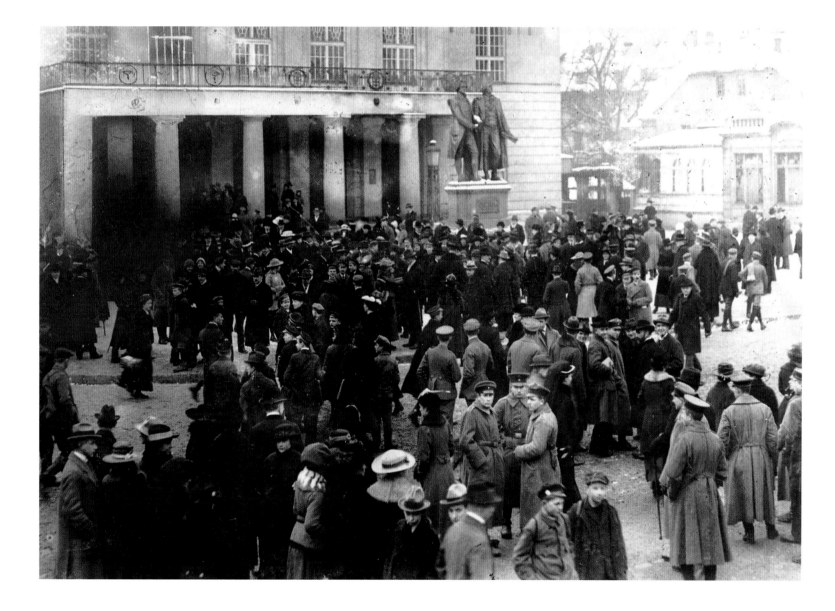

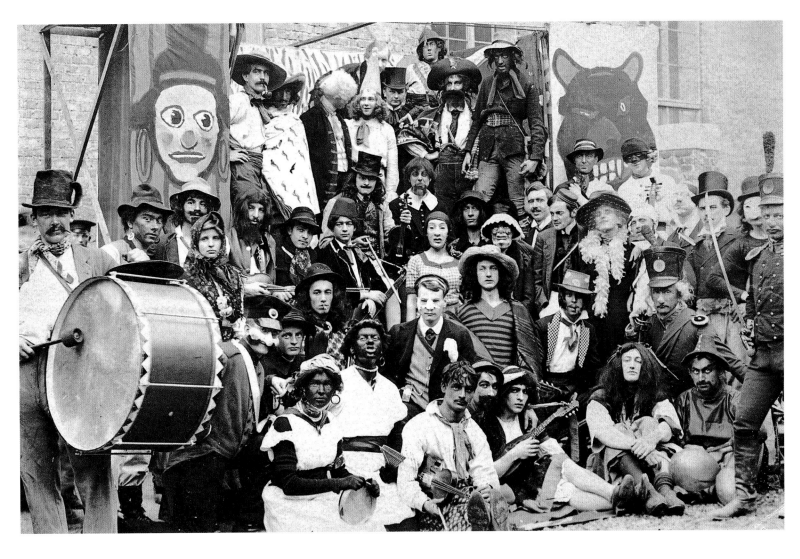

**Robbers' party at the Grand Ducal School of Fine Art in Weimar during the 1912 carnival.** Photographer unknown, BHA. • From time to time the legendary carnival processions and extravagant fancy dress parties of the art school students brought a whiff of unbridled exoticism to the town of Weimar, whose dignitaries regarded themselves as the Knights of the Grail standing guard over German classicism.

terms. Since the 1970s, others have seen the period between the November revolution, the founding of the Bauhaus and the Weimar national assembly, and the dark years of economic crisis and "seizure of power" under the National Socialists as the era of classic modernism. Interpretations and historical images of this kind always also encounter contradiction and correction. These have added necessary nuances to the myth of the first German democracy, and equally to that of the Bauhaus. Our task is to show up particular inconsistencies in the excessively sanitized image of an era, an era which was, however, more aware of its own inner conflicts than later generations for the most part have been. The present-day sense of being at the end of the "century of extremes" (in the words of the historian Eric Hobsbawm) leads to questions being asked as to the possible congenital defects of European modernism, the utopian potential of which led in not a few cases in the direction of totalitarianism.

Behind Walter Gropius's idea of recovering, through the unity of artistic and craft education, a unified aesthetic expression of culture, lay not only dissatisfaction with the contemporary training of artists and architects but also the hope of a renewal of society through the reintegration of all the arts in a typical national style. The repeated standard assertion by Gropius and other Bauhaus teachers, even during the fiercest political debates of the early '20s, that their concerns were basically "unpolitical" and that they must not allow themselves to be drawn into the dispute between the political camps, was to some extent merely an aspect of the unpolitical

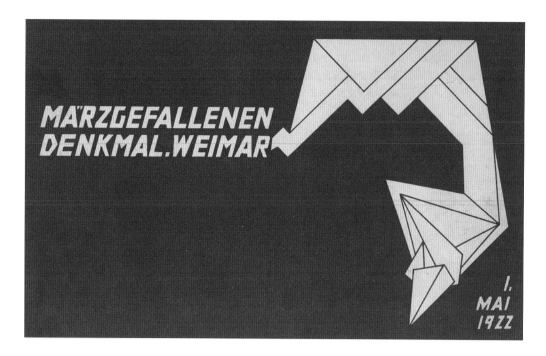

**Title page of the brochure for the unveiling of the Monument to the Dead of March, 1920 in Weimar.** May 1, 1922, design by Walter Gropius (?), Stadtmuseum Weimar. • The monument symbolizes the resistance to the attempted radical right-wing coup d'état by Kapp and Lüttwitz with a "crystal" spike rising up out of the ground.

image which they cultivated, an image that was typical of numerous members of the German educated middle classes. Gropius and his friends can only be understood if it is realized that numerous members of the avant-garde had for a long time expected from the arts what other people in general saw rather as the

province of politics: mediation between antagonistic interests, the transcending of class barriers, the aesthetic reconciliation of man with himself and with nature, along with the creation of a community of solidarity between all races and nations. In this respect art was meta-politics, a utopia which aspired to set

itself apart from the concrete political world and which did indeed often actually do so. The dream of the total artwork arose not solely from aesthetic preferences but also from the shock of realizing that the industrial modernism that was evolving had its menacing aspects. Individual autonomy and liberty, the

**Walter Gropius, Monument in the memorial cemetery in Weimar to the workers murdered during the Kapp putsch.** About 1922 (since destroyed), photographer unknown, BHA. • The design followed a competition in 1920 which other masters from the Bauhaus also entered. Gropius's proposal was accepted despite hostility from the traditionally-minded townspeople.

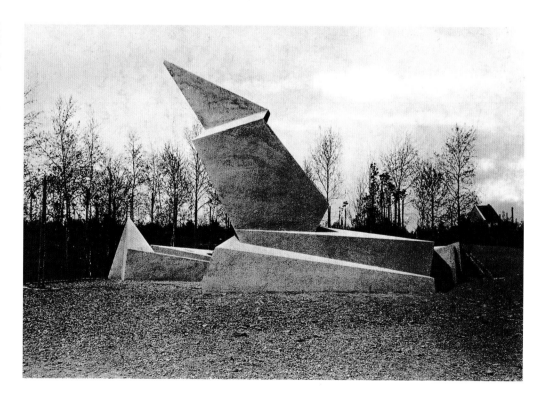

hard-won central values of the modern sensibility, often threatened to tip over into – as people often said – "rootlessness," into isolation and disorientation, leading the individual to call for a new community, a "New Man" and reliable philosophical bearings. Industrial progress made life easier for many but plunged others into misery and created an ugly world. However, such anxieties and concrete experiences awakened corresponding hopes of change and renewal, in many cases intensified to a well-nigh religious degree and becoming a utopia of the redemption of the world by art – and the artist.

Such ideas inspired not only liberal-minded people like Gropius or even those few whose sympathies lay with decidedly left-wing social movements, but also numerous artistic and stylistic reformers of a more traditional conservative stamp. But again and again the lofty expectations of art were shattered by the everyday business of politics in modern society, which was – and still is – marked by the balancing of interests, compromise, speedy change of position and – admittedly – tactical dishonesty. The demands which had been voiced with increasing clarity since the turn of the century by the social majority – glorified by some as the proletariat, feared by others as the masses, but idealized by most as the "people" – these demands for participation posed an overt or latent threat to the claims for recognition of the individualistic artist whose characteristic demeanor was often that of an intellectual aristocrat. In this case also the position of the Bauhaus members was ambiguous. Sometimes it was a matter of giving the masses an aesthetic education and developing formal languages that would be generally intelligible. Sometimes the members dreamed – as Gropius also did – of small conspiratorial communities formed by an elite of initiates who saw themselves as germ cells of aesthetic revolt and thus as the avant-garde of social change.

Bored by the fossilized splendor of the Wilhelminian era and confused by the speed of social change, many people had hoped in August 1914 that the war, of all things, would bring the resolution of all social and political conflicts. When the war was lost, in a welter of savage battles whose outcome depended solely on material resources, and the hapless

emperor had abdicated, all hopes of regeneration were pinned on the new republic and its public figures. The collapse of the empire seemed to create an opportunity for revolutionary change. But as the republic took root and strove for social and political normality, many people's utopian hopes faded. But at the same time the extremes became polarized for those whose radical desire for fundamental change was not satisfied by the day-to-day reality of the republic. Challenged by the radical gestures of the Left and the nationalistic radicalism of the Far Right, the majority of

**Ludwig Mies van der Rohe, Monument to Rosa Luxemburg and Karl Liebknecht in the cemetery in Berlin-Friedrichsfelde.** 1926 (since destroyed), photographer unknown, BHA. • In 1919 the municipal authorities of Berlin refused to allow the two communists to be buried in the Cemetery for the Dead of March, 1848, on the grounds that they were not victims of revolution but agitators. As a result, the monument over the graves was created in a working-class district. A police report of January 15/16, 1935 mentioned its demolition. The red star disappeared while in the "Revolutionary Museum of the SA Standarte 6."

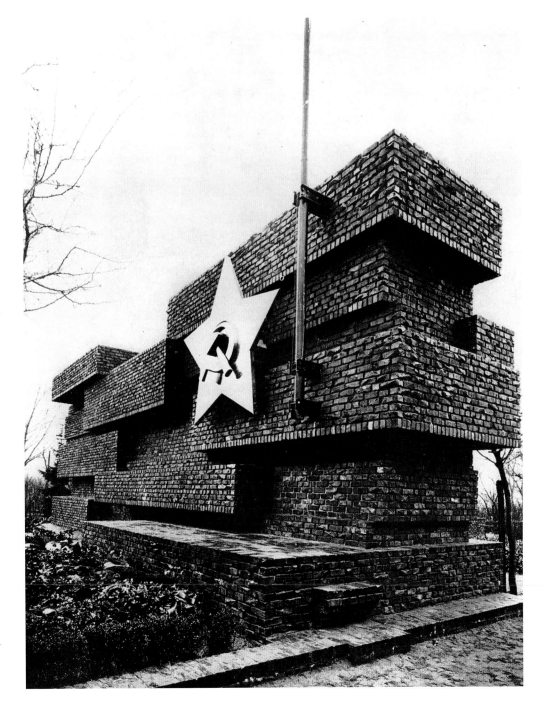

# DER DISTELSEHER

DEdié au BAUHAUS

Zusammenstoß des natürlichen und mechanischen Menschen in Weimar im Jahre 1922 (L'artiste à oublié de retoucher quelques choses)

PETER₁RÖHL

**Karl-Peter Röhl, Der Distelseher (The Seer of the Thistle).** 1922, illustration from "mécano," No. 2, BHA. • The hopeful avant-garde community at the Bauhaus was soon disturbed by a second one from Holland. The criticism "a square on the outside, Biedermeier on the inside" came from Theo van Doesburg. Itten's mystical search for essences, in which thistles were a welcome exercise subject, was also the target of criticism.

the majority of ordinary citizens were convinced that fundamental social change was inevitable, and they made efforts to support it, not least in the area of social and educational policy. Consequently Gropius's memorandum, presented as early as 1916, "Proposals for the establishment of a teaching institution comprising artistic consultants for industry, craft, and commerce," not only raised hopes for the renewal of art education but also offered the prospect of increasing the economic potential of crafts, trade and industry by way of aesthetic innovation, and thus expectations of increased affluence.

However, the revolutionary situation of 1918–1919 and the anti-bourgeois demeanor of young members of the Bauhaus and of individual "masters" elicited more fear and rejection among the general public than they raised hopes. Not a few citizens of Weimar recalled the stylistic experiments of Henry van de Velde and Count Harry Kessler in the "New Weimar" of the turn of the century, the innovative force of which had been met with suspicion at the time, for political reasons. In the real chaos of the immediate postwar period, only a few people were able to respond with enthusiasm to the revolutionary rhetoric and the confusing, form-shattering violence of aesthetic innovations. Furthermore, the Bauhaus community embodied the restless spirit of Berlin, the modernist metropolis which in the Thuringian province had long been regarded with distrust. Since as far back as 1900 stylistic traditionalists along with conservative and nationalist elements had come together in the name of "Heimatkunst" (a sentimentally idealized folksy, regional art) with the slogan "Away from Berlin."

Conversely, private remarks made by individual Bauhaus members reveal the arrogance of urban intellectuals in the face of alleged provincial stuffiness. Gropius was fond of referring to Weimar as a "backward beer village" and "cultural mummies," and was thus always in danger of miscalculating the potential for change which also existed there. Before him, Karl Peter Röhl and Johannes Molzahn had hoisted the banner of aesthetic revolt on the river Ilm. The citizens of the town also included people who had already given their support and help to van de Velde and were now equally willing to welcome the new

ordinary citizens did not manage to develop a positive attitude toward parliamentary democracy, pluralism and emancipation, particularly as most German citizens had already had great difficulty in accepting these notions back in the days of the empire. The old monarchist feudal elites meanwhile rejected the republic with profound conviction.

In the early years of Weimar, in particular, the situation of the Bauhaus, its friends and its opponents, was predetermined by the social, philosophical and aesthetic background outlined above. Even the conservative elites and

avant-garde in Weimar. For example, Paul Klopfer, the director of the Weimar building trade college, came out publicly in support of Gropius and his school in letters to the press. The former Naturalist writer Johannes Schlaf did likewise. Even Friedrich Lienhard, the most influential figure in the "Away from Berlin" movement, was inclined to give the young artists that he saw at work in the Bauhaus a chance. Those members of the workers' and soldiers' council and above all of the Thuringian regional parliament who ensured the political and financial survival of the Bauhaus, that is, the Majority Social Democrats (the main body of the SPD, without the Independents), were in any case on the side of Gropius and his "masters" – even if they were not in a position to recognize, let alone understand, every single aesthetic experiment carried out at the Bauhaus.

However, public opinion in Weimar and the German cultural provinces was dominated by those who saw the political forces of change at work in the Bauhaus, forces which they regarded as disastrous. Consequently, they vilified the new art college as a "center of Bolshevists and Spartacists [in other words Communists]" and proclaimed instead the ideal of a "German" art to express the essence of the nation. The programmatic internationalism of the political Left, on the other hand, was bound to be as distressing as the delight taken at the Bauhaus in aesthetic experimentation, in which all conventional forms were rejected. The shared fascination of both Left and Right with the Middle Ages, with its cathedral masons' guilds in which they thought they recognized their own ideas of the unified work of art and a religion of art, evidently provided no great reassurance. The fact that the art school soon enjoyed high national and international prestige counted for little in the face of the opposition, well organized at local level, from the enemies of the Bauhaus and the fact that insidious political change throughout the state of Thuringia led to a further withdrawal of sympathy for the Bauhaus. The supporters of the Bauhaus idea included the "Reich guardian of art" Edwin Redslob who tried, from Berlin, to come to the support of modern art in his native town of Weimar in its struggle against its conservative opponents. In January, 1920 – the time of the first climax in

the Bauhaus controversy – an "open letter to the state government of Sachsen-Weimar-Eisenach" was signed not only by Redslob but also by Ernst Hardt, the general manager of the Weimar national theater, who had attempted to establish modern drama, thereby openly exposing himself to similar attacks to those faced by Gropius. Gropius also had the support of Count Harry Kessler, who had been a museum director in Weimar from 1903 to 1905 and, like Henry van de Velde, a patron of the "New Weimar," and other sympathizers in Weimar such as Peter Raabe, Robert Reitz and Eduard Rosé, known throughout the town as champions and performers of modern music. Wilhelm Köhler who, as director of art collections in Weimar, had been championing the cause of modern art since 1918, also gave public support to the Bauhaus enterprise. The German Werkbund and its committed president Hans Poelzig likewise declared its solidarity with Gropius, imploring the regional government of Thuringia to continue to finance the work of the Bauhaus and to give it political support. Committed professional people from Erfurt, Gera and Jena, where they too were friends and supporters of modern art, published a statement in support of the Bauhaus in several regional newspapers. It included, among other things, the words: "We emphatically protest

**Press statements in favour of the Weimar State Bauhaus.** 1924, designed by László Moholy-Nagy, BHA. • Scarcely had the Bauhaus opened when it faced a hail of attacks, predominantly from right-wing political circles. Battle was joined, among other things in the form of a brochure showing positive statements in black-and-white.

**Lou Scheper-Berkenkamp, Humorous Street Map.** 1924, pen and Indian ink and watercolor on paper, 28.4 x 25.2 cm, BHA. • How a female member of the Bauhaus seized the "classical" province.

against issues concerning the visual arts being linked with political and even anti-Semitic aspirations." Directors of leading German and Austrian art colleges and craft schools declared their public support for Gropius, albeit without any mention at all of the political intentions of the enemies of the Bauhaus. This group included Peter Behrens, August Endell, Hans Poelzig, Bruno Paul, Bernhard Pankok, Richard Riemerschmid and Fritz Schumacher – the most influential contemporary champions of modern architecture and art who since the turn of the century had taken a stand against any kind of traditionalism and had joined forces in the Werkbund. But their unity in the struggle on behalf of the Bauhaus should not be allowed to obscure the differences in their political attitudes. Like the Bauhaus masters themselves they only agreed when it was a matter of defending thmselves against external enemies: internally, there were considerable personal and artistic differences between them.

In contrast, the opponents of the Bauhaus appeared to present a more united front. They all shared a radical anti-Bolshevism, nationalistic thinking, anti-Semitism (sometimes latent, sometimes overt) and an aesthetic traditionalism – attitudes and beliefs which all entailed a refusal to give either the new republic or the experiments of modern art a chance. The Weimar Studienrat (grammar-school teacher) Emil Herfurth, who shortly afterwards won a seat for the nationalistic Deutschnationale Volkspartei in the Thuringian regional parliament, led the anti-Bauhaus faction in Weimar, which included prominent professors of art and painters: Richard Engelmann, Friedrich Fleischer, Hans Bauer and Max Thedy. From 1921 they were all to be reunited on the teaching staff of the newly opened, somewhat conservative Kunsthochschule (Art College). The journalist and writer Leonhard Schrickel and the painter Mathilde von Freytag-Loringhoven bombarded the general public with dozens of aggressive articles attacking Gropius and his friends, attacks which were often disguised as accounts of Weimar's traditional artistic life and reviews of its exhibitions. The enemies of the Bauhaus, like its friends, did not restrict their activities

to Weimar. In Erfurt Lieutenant-Colonel Corsepp, known throughout the town as an arch-rival of the museum director Walter Kaesbach, campaigned against the Weimar experiment. In Berlin Konrad Nonn spoke out, taking the 1923 Bauhaus exhibition – months later – as a pretext for opening fire on the Bauhaus. Nonn's attacks, the first of which bore the heading "State garbage provision service: the Weimar State Bauhaus," were leveled at the art school until well into the Dessau period. From 1929 Nonn was a prominent member of the Nazi "Battle League for German Culture" and thus a comrade-in-arms of Paul Schultze-Naumburg, who after 1933 proceeded to expunge every trace of the Bauhaus tradition in Weimar.

However, the attacks by the enemies of the Bauhaus, which began in 1919, owed their success merely to the change of political climate in Thuringia in 1923–1924 along with the fact that even the Social Democrats were led by considerations of financial policy to view the Bauhaus with increasing skepticism. Disappointed by the lack of solidarity on the part of the Republican majority in parliament, which became the opposition after the 1924 elections, and worn down by its enemies' attacks, the Bauhaus retreated to Dessau in 1925. Opportunities for work were better there, especially for Gropius and the architects. However, even in this new location, changes in the distribution of seats on Dessau town council and the general radicalization of the political climate in the later years of the Weimar Republic meant that the college was constantly under threat, although at the same time its inter-national renown reached its first high-water mark around 1930 under the leadership, until that year, of Hannes Meyer. In 1932, when Goethe was commemorated in Weimar in republican fashion for the last time, the end came for the Bauhaus in Dessau. The brief period in Berlin, until the summer of 1933 under the directorship of Mies van der Rohe, was no more than an interlude before the final demise of the Bauhaus in Germany. Its exiled representatives then pursued their ideas about modern architecture elsewhere, above all in the United States.

# The Bauhaus and National Socialism – a Dark Chapter of Modernism

Paul Betts

A generation ago the idea of suggesting a relationship between the Bauhaus and National Socialist culture would most likely have been treated as misguided or even blasphemous. For these two things have long been considered antithetical: the one supposedly standing for Weimar progressive modernism, the other for shameful cultural barbarism. No doubt there is much to support this view, not least because the National Socialist propaganda machine relentlessly attacked the Bauhaus as a dangerous "un-German" scourge of "cultural bolshevism" from the late 1920s on. That the National Socialists dramatically forced the closure of the Bauhaus in 1933 seemed to confirm both the Third Reich's anti-modernist politics and the Bauhaus' impeccable political record as a condemned symbol of republican modernity.

This long-accepted view has changed sharply in the last twenty years. In an effort to explore hitherto neglected aspects of National Socialism, scholars on both sides of the Atlantic soon realized that National Socialist culture could not simply be reduced to the monumental architecture of Albert Speer, Teutonic pastoralism and "Blut und Boden" (blood and soil) kitsch. On the contrary, there was ample evidence that the National Socialists – despite their own propaganda – often openly appropriated modernism for their own ends. Now the central question for cultural historians was how modern was National Socialist culture, which prompted a radical rethinking of the relationship between rupture and continuity, complicity and resistance. This of course was delicate business, given that the Cold War construction of West and East German culture largely rested upon maintaining these very distinctions. And even if it occasionally betrayed unappetizing neo-conservative agendas, this multi-faceted revisionist wave did succeed in revealing that the former ideological boundaries demarcating 1932 from 1933 as well as 1945 from 1946 were not so rigid as once presumed.

In this context the Bauhaus was now put on trial. Indeed, there were a range of books – among them Winfried Nerdinger's edited essay collection, *Bauhaus-Moderne im Nationalsozialismus* (Bauhaus Modernism in National Socialism) (1993); Peter Reichel's *Der Schöne Schein* (The Beautiful Illusion) (1991); and *Design in Deutschland,* edited by Sabine Weissler (1990) – that aimed at exploring the strange and shadowy afterlife of (Bauhaus) modernism within the Third Reich. On the one hand, scholars reconsidered the actual careers and politics of the Bauhaus artists themselves, including those who remained in Germany and enjoyed prosperous careers after 1933. On the other hand, new scholarly attention was aimed at how and why Bauhaus modernism survived in various spheres of National Socialist culture.

Architecture is an instructive case in point. Some of the most surprising revelations concern the relationship between the former Bauhaus directors and the National Socialist regime. As Winfried Nerdinger has shown, Gropius and Mies were not condemned by the National Socialists, but were often warmly accepted through the 1930s. Both submitted proposals to the 1934 National Socialist exposition "Deutsches Volk – Deutsche Arbeit" (German People – German Labor) complete with swastikas in the drawings. (Bauhaus artist Joost Schmidt designed a section of this show as well.) Mies' relationship to the National Socialists was even more nebulous. Not only did he design this exhibition's "Bergbau" (mining) section, he was also invited to design the German pavilion for the 1935 Brussels World Exposition. Together with his partner Lilly Reich, Mies was charged with organizing the "Textilindustrie" (textile industry) section of Speer's German Pavilion at the 1937 Paris World Exposition. Equally as strange was that the students of Gropius (for example Ernst Neufert, Hanns Dustmann and Otto Meyer-Ottens) and Mies (e.g., Sergius Ruegenberg,

**German textile industry stand at the International Exhibition of Art and Technology in Paris,** 1937. Designed by Lilly Reich, MOMA, NYC, Lilly Reich Collection, Mies van der Rohe Archive. • Lilly Reich, at one time a teacher at the Bauhaus, shared the awareness of modern exhibition designers that it was not the décor but the exhibits themselves that must be the major design element. The National Socialist textile business in particular would have approved of her aesthetic idea of using large swathes of material to show off their quality, and so help the spread of their new synthetic materials.

**Wilhelm Wagenfeld, "Kubus" storage containers.** About 1941, photograph by Dore Barleben, Wilhelm Wagenfeld Foundation, Bremen. • There seems to be an affinity between Bauhaus thinking and the principle of designing closeable storage containers that could be stacked together in the form of a space-saving cube. Wagenfeld explained in an advertisement of 1941: "Out of the larder and the refrigerator, ready for the table."

Ernst Walther and Eduard Ludwig) enjoyed successful careers under the National Socialist regime, thus underscoring the point that the National Socialists did not regard association with the supposedly hated Bauhaus to be a career hindrance.

The issue here is not to tar these figures, but only to show that the Bauhaus story in Germany did not end so neatly in 1933. Perhaps more importantly was the fact that the main principles and even styling of Bauhaus architecture could be found within the National Socialist building program. Even if National Socialist architecture remained a jumble of monumentalism, neo-classicism and thatched-roof traditionalism, Bauhaus-inspired Neue Sachlichkeit (New Functionalism) architecture was present as well. This was especially true in the non-representational areas of National Socialist architecture, most notably industrial buildings. Another good example of the presence of Bauhaus modernism was the work produced by Speer's "Schönheit der Arbeit" (Beauty of Labor) Office, which served as

a key component of Robert Ley's Deutsche Arbeitsfront (German Labor Front). Entrusted to "make German life more beautiful" and to "redignify" both German work and workers, this office spearheaded a large-scale campaign to renovate factory interiors (including furniture for the dining hall, dishware and even cutlery) along the lines of a more functionalist Bauhaus modernism. The organization eventually became involved in housing for workers as well, often applying the same modernist design principles to some of its new housing construction. In a famous 1978 interview, Speer even admitted that "Schönheit der Arbeit" routinely plagiarized from the Bauhaus canon.

Much of the same could be said for Bauhaus graphic design. While the Nazis "regothi-cized" standard typesets in newspapers, books and official political documents, the regime allowed and even encouraged the usage of Bauhaus graphics in various venues so as to project a modernist self-image. This was clearly the case in cultural magazines such as *Freude und Arbeit* (Joy and Labor) and

*Die neue Linie* (The New Line), household advice literature and even certain architectural journals like *Form*. Where Bauhaus graphics was most visible, however, was in arenas of foreign contact, notably Wirtschaftswerbung (commercial advertisement) and international expositions. The work of Bauhaus graphic designer Herbert Bayer is a famous example. After 1933 he provided the graphic layout for such National Socialist expositions as "Die Kamera," "Deutsches Volk – Deutsche Arbeit," "Deutschland," "Gebt mir vier Jahre Zeit" (Give me Four More Years) and "Gesundes Volk – frohes Schaffen" (Healthy People – Happy Work) Bayer also designed the prospectus for both the German section of the 1933 Chicago "Century of Progress" exhibition and the 1936 Berlin Olympics.

Perhaps the most conspicuous site for the National Socialist reappropriation of Bauhaus modernism was industrial design. Strange as it may seem, German home decoration books and journals such as *Wohnung der Neuzeit* (The Modern Dwelling), *Das schöne Heim* (The Beautiful Home) and *Schaulade* (Schowcase) featured Wagenfeld glassware, Hermann Gretsch dishware, Marianne Brandt tea kettles and Marcel Breuer steel-tube chairs well past 1933. These objects were proudly showcased at many international expositions as well, like the 1933 "Century of Progress" in Chicago; the 1937 World Fair in Paris; the Milan Triennale 1937 and 1940;

**Ernst Hegel, Dr Tornow's house, Berlin-Luckenwalde.** 1937–1938, photographer unknown, BHA. • Here modernism arms itself with solid bourgeois insignia: the freestanding wall is adorned with a mock fireplace, the group of seats on a Persian carpet combine elements of Mies's "Barcelona" chair with rustic oak.

**Kurt Krantz, Illustration of the exhibition hall of the German pavilion at the International Exhibition in Paris.** 1937, from *Neue Linie* No. 5, SMBPK, Art Library. • With its themes and its graphics the magazine *Neue Linie* demonstrated both at home and abroad the continuing presence of modernism in National Socialist Germany. Thus it can be seen that Krantz presented the exhibition hall, designed in Speer's architectural manner, in a more modern way than it was actually built. Instead of the transparency which Krantz suggested by means of the glass cabinets, heavy glass cupboards with massive wooden plinths and tops were installed.

the 1942 Mannheim "Künstler in der Industrie" (Artists in Industry) and 1942 "Deutsche Wertarbeit" (German Quality Work) shows in Switzerland and Turkey. Add to this the fact that there were numerous modern design expositions organized by the Kunst-Dienst (Art Service), the Leipzig Trade Fair and the Grassi Museum all the way until 1944. No less significant was that the "Deutsche Warenkunde" (German Commodity Guide), a 1939 state-produced catalog of select design objects for use by German industry and export merchants, featured dozens of Bauhaus-inspired design pieces. This is not to say that modern design became the exclusive style of the Third Reich. But, what is so striking was that unlike architecture or painting, the National Socialists openly embraced Bauhaus design as official cultural

representation. Why was this so? The common response that modern design was somehow less political than other cultural spheres is patently false. Rather, the first reason was economics. Here it is worth recalling that many of these German design firms, such as Rasch tapestries and Jena Glassworks, enjoyed large export markets and thus the National Socialists had no intention of disturbing this valuable means of national income. The outbreak of the war further underscored the importance of modernist design in that it served as a vital source of export sales to Eastern Europe, while its functionalist design philosophy proved quite suitable to material rationing and goods shortages. The second reason was politics. Indeed, the score of major design exhibitions mounted by the National

**Materials from the Krefeld Textiles College.** 1932–1938, director Johannes Itten, display samples, Deutsches Textilmuseum, Krefeld. • The Bauhaus weaving workshop combined function, material quality and experimentation to create an aesthetic quality of its own. In the 1930s materials were given figurative imprints designed to appeal to a wide range of customers.

**Otto Lindig, Vases.** About 1940, illustration from Hermann Gretsch, *Gestaltendes Handwerk* (Craftwork Designs), published by the German crafts section of the German Labor Front, Stuttgart, 1940, SMBPK, Art Library. • Lindig, who was an independent ceramics worker in Dornburg during the Third Reich, evidently did not need to modify his designs for them to be accepted as exemplary artistic craft work in the "German style."

Socialists indicated that industrial aesthetics played a key role in broadcasting a certain image of National Socialist Germany both at home and abroad as a champion of modern technology and design.

Even so, we must be very careful not to characterize Bauhaus modernism as a strangely forgotten island of progressive culture in an otherwise dark sea of political reaction and racist barbarity. While it is true that Bauhaus modernism enjoyed a notable place in the National Socialist culture, this is by no means intended to suggest that it remained innocent of larger politics. Wagenfeld's design products or Speer's "Schönheit der Arbeit" office bear witness to this. Though both plainly drew upon the Bauhaus canon, it was the ideological reworking of these modernist forms which was at issue. The gravity of such cultural politics becomes clearer if we recall that Wagenfeld's work was displayed as celebrated emblems of "German quality work" (deutsche Wertarbeit) and "German culture." Speer's "Schönheit der Arbeit" too was directed toward decidedly nationalist and even racist ends, whose functionalist artifacts were described as glorifying

"German work," "German genius," "German soul," the "German worker" and the National Socialist "Volksgemeinschaft" (national community). Its significance, however, went far beyond nationalizing the once explicitly international tenets of Bauhaus modernism. For what the National Socialists sought to do was suffuse functionalist design with National Socialist metaphysics, to "rebaptize" these forms as constitutive of the Third Reich's campaign both to aestheticize technology ("Schönheit der Technik" [beauty of technology] was a favorite phrase) and "spiritualize" everyday forms and places. In this sense, the strange career of Bauhaus modernism within the Third Reich not only provides a more differentiated picture of National Socialist culture, it also exposes the fact that modernism and progress share no elective affinity.

**Wilhelm Wagenfeld, Large "Munich" vase.** 1938, illustration from the *Katalog der Vereinigten Lausitzer Glaswerke* (Catalog of United Glass Factories in Lausitz), Dresden, 1939, photograph by Dore Barleben, SMBPK, Art Library. • Historically based forms, as seen in this steel-blue vase exhibited in the Haus der Kunst in Munich, are to be found time and again in National Socialist design, even alongside modern designs. Wagenfeld had been appointed artistic director of the amalgamated glassworks in Lausitz in 1935; for him, the design style of this vase was something of an exception.

**Hans Przyrembel, Teapot.** About 1940, illustration from Hermann Gretsch, *Gestaltendes Handwerk*, published by the German crafts section of the German Labor Front, Stuttgart, 1940, SMBPK, Art Library. • Under National Socialism, arts and crafts clearly received a higher status than previously, in contrast to industrial design. For that reason many Bauhaus artists regularly stressed the craftwork origins of their designs.

# The Bauhaus in the German Democratic Republic –
# between Formalism and Pragmatism
Paul Betts

**Richard Paulick Collective, Main entrance to Block C, Stalinallee, Berlin.** 1951–1953, photograph by Gert Kreutschmann, 1961, Ullstein picture service. • Following the Soviet model, well-appointed blocks of flats would be built for workers. Classicist forms predominated. The recessed middle section, adorned with a series of images, was ideally suited for socialist agitation and propaganda. A roof garden covers the entire block, with pergola-like structures that from a distance suggest mock-Gothic tracery.

**Richard Paulick Collective, Block C, Stalinallee, Berlin.** 1951–1953, Richard Paulick on the left, photograph by Klaus Lehnartz, 1969, Ullstein picture service. • Only selected forms from the "cultural heritage" were used to create a specifically socialist architecture. The "new building," or "egg-box architecture," as Walter Ulbricht put it, became associated with the enemy. Nevertheless, Richard Paulick, who had at one time worked with Gropius and the Bauhaus on a number of projects, was one of the winners in the Stalinallee competition.

The reception of the Bauhaus in the former German Democratic Republic was always ideologically charged. Recent works, notably Thomas Hoscislawski's *Bauen zwischen Macht und Ohnmacht* (Building Amid Power and Powerlessness) from 1991 and the document set *Zwischen Bauhaus und Stalinallee* (Between Bauhaus and Stalinallee), edited by Andreas Schaetzke in 1991, have illuminated the extent to which its significance went far beyond architecture and design. For much of the postwar period the story of its reception was inextricably linked to Cold War politics, where the shifting official views toward the Bauhaus mirrored East Germany's changing attitude toward its own modern industrial identity.

The Bauhaus was subject to extremely divergent interpretations in the first decade after the war. Its immediate postwar reception in East Germany was surprisingly positive. Until 1949 the Bauhaus was lauded by both East and West Germans as a guiding light of anti-fascist culture, German modernism and postwar reconstruction. In 1945 the President of the Kulturbund (Culture League), Johannes Becher, embraced the Bauhaus as a central component in rehabilitating what he called Germany's "rich humanist legacy." Not only did the Kulturbund's mouthpiece *Aufbau* (Construction) routinely praise Gropius and the Bauhaus, other East German cultural journals such as *Bildende Kunst* (Visual Arts) and *Forum* published celebratory articles as well. One 1947 article in *Forum* went so far as to characterize the Bauhaus as a "true socialist working community" and "educational center animated by the spirit

**Selman Selmanagič, Layout of a Konsum textile sales point.** 1951–1952, built by Deutsche Werkstätten, Hellerau, Dresden • While Mart Stam was rector of the newly founded College of Applied Art in Berlin-Weißensee, Selmanagič, an architect and former member of the Bauhaus, took up a post there as professor of building and space management. In this layout of a Konsum (state retail cooperative) sales point, the "kidney shape" that is effective the world over was still deemed acceptable.

of democracy and socialism." Although the postwar effort to reopen the Dessau Bauhaus ultimately miscarried, the Bauhaus enjoyed wide favor in the first few years after the war. All of this changed in 1949. The intensification of the Cold War and the dual founding of the Federal Republic of Germany and the German Democratic Republic dramatically altered the status of the Bauhaus in East Germany. Much of this resulted from the "Stalinization" of East German architecture and culture, where the GDR was now absorbed into the Soviet cultural orbit in the name of denazification and democratization. But this did not mean that East German architecture was simply "Sovietized." Although the "exemplary role of Soviet architecture" and "socialist realism" were always emphasized, the guiding mission was to restore Germany's "national architecture" from its early nineteenth-century humanist heritage. In fact, resuscitating this classical humanist culture (be it in architecture or literature) was seen as the best means of forging a new East German cultural identity in defense against the imperial contrivances of the West. In this context the Bauhaus was attacked as a corrosive bourgeois

influence in that it supposedly embodied antinational ("cosmopolitan," "formalist") and anti-socialist culture. The East German government's rejection of Bauhaus planning principles (much of which was associated with CIAM's [International Congress for New Building] 1933 "Charter of Athens") was inspired by this ideology as well. Condemning the CIAM's idea of "Auflösung der Stadt" (breaking up the city) in the name of individual freedom and automobile traffic as Western decadence, the GDR's Ministry of Construction thereafter codified the East German official reconstruction guidelines: city planning was organized around the idea of the inner-city nucleus and its "organic" integration of work, housing and leisure.

The demonization of the Bauhaus reached its watershed during the famed "formalism debate" of 1951. While it is certainly true that the SED (Socialist Unity Party) had railed against modern art as early as 1948, the state crusade against modernism was most pronounced in the SED's 5th congress, entitled "Kampf gegen den Formalismus in Kunst und Literatur, für eine fortschrittliche deutsche Kultur" (Campaign Against Formalism in Art

**Richard Paulick, House of Sport, Stalinallee, Berlin.** 1951, photographer unknown, about 1954, Ullstein picture service. • The massive Cubist block has a recessed row of columns in place of a portico, and is framed by rows of high windows interrupted by balconies in their lower half. The proportions take into account a protruding area above roof level, on which a relief, added later, announced the function of the building.

and Literature in the Name of a Progressive German Culture). Here the SED initiated a kind of cultural spring cleaning of everything it perceived as decadent "cosmopolitanism." Now its new index of "degenerate art" was scarcely confined to abstract Expressionist painting and subjectivist literature. This time the Bauhaus was singled out for special treatment. In sharp contrast to the immediate postwar period, the SED pulled no punches in proclaiming: "In architecture, which faces great challenges in the framework of the five-year plan, the so-called Bauhaus style and the basic constructivist, functionalist approach of many architects impedes us from developing an architecture which befits the new social relations and reality of the German Democratic Republic." A few months later

Walter Ulbricht lent this auto-da-fé additional state authority during a speech before National Parliament inaugurating the GDR's first Five-Year Plan: "In light of our studied cultivation of national traditions as the very foundations of our architecture, we must clearly recognize the Bauhaus style as a manifestation hostile to the people (volksfeindliche Erscheinung)." (The same refrain could be heard in his December 8, 1951, speech commemorating the opening of the GDR's Building Academy.) Such high-level interventions opened the floodgates of Bauhaus condemnations. That same year one author skewered Bauhaus architecture as a "characteristic manifestation of decadent capitalist society" that was removed "more and more from the true needs of the people." Another 1951 article published

**Edmund Collein Collective and Werner Dutschke Collective, first socialist housing complex between Strausberger Platz and Alexanderplatz, Berlin.** 1959–1965, photograph by Klaus Lehnartz, about 1966, Ullstein picture service. • In the first prefabricated buildings developed under Paulick there was still an attempt to avoid the danger of monotony by means of ornamentation. When it was realized that this was too costly, architects were obliged, when employing the prefabrication method (which by then was politically obligatory), to organize the elements of the complex in a rhythmic manner. The "open" building method arose from the government's demand that the occupants should be given a sense of togetherness.

# form+zweck

**Fachzeitschrift für industrielle Formgestaltung**

2/1983

DDR 5.– M

## 3. Bauhausheft
## Neues Bauen – Neues Gestalten

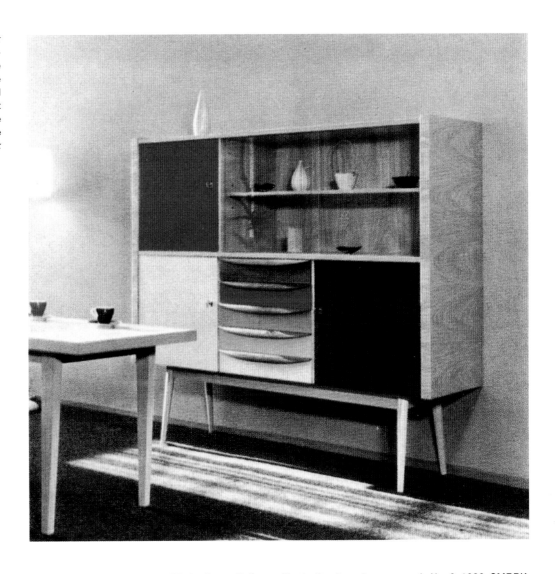

**Franz Ehrlich, Living room furniture, type series 602.** 1956, made by Deutsche Werkstätten, Hellerau. Illustration from *form + zweck*, No. 3, 1986, SMBPK, Art Library. • The former Bauhaus members Franz Ehrlich and Selman Selmanagič rose to important positions in the GDR. In the early 1950s their simple furniture designs had caused them to be accused of "formalism."

in *Neues Deutschland* (New Germany) claimed that: "The Bauhaus style is a genuine offspring of American cosmopolitism; its destruction then constitutes the essential precondition for the development of a true national German architecture." In this charged Cold War atmosphere, the Bauhaus was no longer viewed as a "Cathedral of Socialism" nor even as German cultural history, but simply as bourgeois cultural pollution and American propaganda.

This is not to say that this vilified Bauhaus image went unchanged over the course of the 1950s and 1960s. The 1953 accession of Khrushchev in the Soviet Union represented an unmistakable thawing of this cultural crusade, albeit indirectly. His view of socialist architecture was largely shaped

by pressing economic considerations, particularly the acute housing crisis and material shortages throughout the East Bloc. In 1954 the Soviet Premier delivered his oft-quoted speech entitled "Besser, billiger und schneller bauen" (Building Better, Cheaper and Faster), which called for a stepped-up industrialization and standardization of East Bloc housing and building construction. With this, the emphasis shifted from the formal aspect of social realism to the more technical issues of building fabrication. An article by the Building Academy in 1955 registered this change: "The main mistake which we too have made in our development concerns the overemphasis upon the idealist and intellectual aspect instead of the material aspect." Consequently, the Bauhaus legacy slowly

emerged from its ideological ghetto in East German culture.

But this is not to suggest that the Bauhaus reception in the former East Germany was uniform in all cultural spheres. For example, Bauhaus modernism was quite present in East German industrial design all along. For one thing, former Bauhaus artist Wilhelm Wagenfeld's 1948 book, *Wesen und Gestalt* (Essence and Form) served as the standard work for GDR designers from the late 1940s on. Prominent modernists Horst Michel and Mart Stam occupied important posts at East Germany's Hochschule für Bauwesen und Bildende Künste (College for Architecture and Visual Arts) in Weimar and Hochschule für angewandte Kunst (College of Applied Art) in Berlin, respectively, where

**Franz Ehrlich, Upholstered chair.** 1957, "type furniture" in the Hellerau series, SBD Archive. • Not dissimilar to Scandinavian design in its formal modesty, this chair could find a discreet place in any small socialist household.

**"50 Years Bauhaus":** Gathering of former members of the Bauhaus in front of the reconstructed Bauhaus building on the occasion of its reopening on December 4, 1976. They include, on the far left, Ernst and Lotte Collein, and in the middle Max Bill, photograph by Ernst Steinkopf, BHA • The reception of the Bauhaus in the GDR could not begin until design, within the development of a socialist aesthetic, no longer exclusively served the strategies of struggle and the assertion of a separate GDR identity, but also had to prove its ability to produce exportable goods.

they helped nurture the Bauhaus tradition both in design and design education. What is more, Wagenfeld's glass and metal design work for Jena Glaswerke and Weisswasser were lauded as exemplars of East German design (despite the fact that Wagenfeld resided in West Germany) and remained in production until 1989. Many other design objects produced in the GDR from the late 1950s on bear the signature of Bauhaus design as well. And even if the state worked to convert GDR design into more traditional art and craft work after the 1951 "formalism debate," one could still detect an undercurrent of Bauhaus functionalism throughout. Much of this was thanks to the work of the flagship design journal, *form + zweck* (form + purpose). Founded in 1958, it acted as a key conduit of industrial modernism and exercised remarkable latitude in publishing favorable articles on Western European and even FRG design. The Zentralinstitut für Formgestaltung (Central Design Institute), which later became the Amt für industrielle Formgestaltung (Office for Industrial Design), was also founded in 1963 to help promote modern East German industrial design.

Why did design – unlike architecture and painting – enjoy such autonomy? The chief reason was economics: the government did not want to jeopardize East German export revenues. Modernist design objects were proudly featured as exemplary emblems of GDR socialist modernity at the Leipzig Trade Fairs and other East Bloc exhibitions. (Others have maintained that design's surprising autonomy was in part due to the fact that the wife of Martin Kelm, director of the Office for Industrial Design, happened to

be Honecker's private secretary.) Hence the sphere of design was quite unique in playing virtually no role in the Cold War ideological battles between East and West Germany. In fact, the GDR remained quite open to West German design both before and after 1961, as the Hochschule für Gestaltung (Ulm Institute of Design) and the Braun Company elicited consistent praise in the pages of *form + zweck*.

By the mid-1960s the official vilification of the Bauhaus had been reversed. This was largely the effect of Khruschev's change of course in the mid-1950s and the growing appreciation of the Bauhaus in the GDR. It was at this time that East Germany began to "rediscover" the socialist Bauhaus. Those familiar with Bauhaus history may be perplexed as to why this East German claim upon the Bauhaus took so long. But it was precisely the success of the joint West German and American campaign to rewrite Bauhaus history as an odyssey of Western liberalism – and the SED's endorsement of it in its propaganda – which blocked any official East German acceptance. That the West happened to be in the midst of jettisoning the Bauhaus as unwanted "mousetrap modernism" in the late 1960s doubtlessly smoothed the GDR rehabilitation. Former Bauhaus director Hannes Meyer, once condemned by Ulbricht as a "reactionary constructivist," was now resuscitated as a forgotten prophet of socialist architecture and design. This new Bauhaus celebration continued unabated in the 1970s, culminating in the restoration and reopening of Gropius' Dessau Bauhaus in 1976. After that, the Bauhaus resumed its role as a guiding force in East German architecture and design.

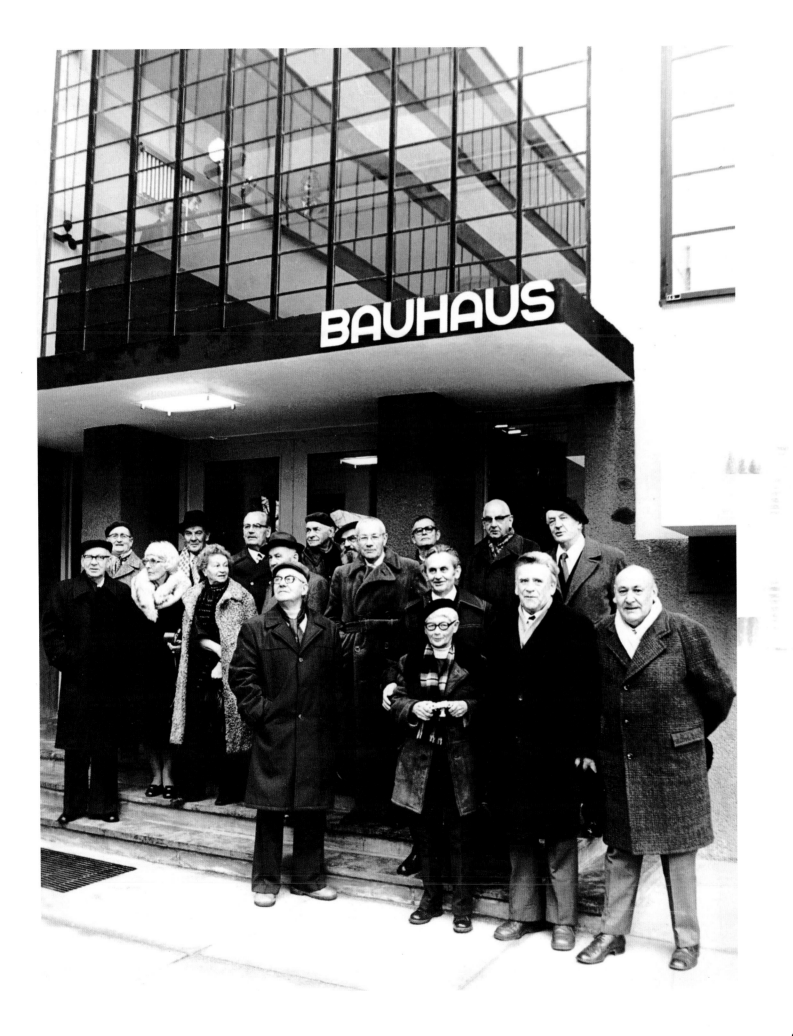

BAUHAUS

# The Bauhaus in the Federal Republic of Germany – A Privileged Legacy from Weimar

Paul Betts

Over the last fifty years the Bauhaus has enjoyed wide reception within West German culture. Despite severe criticism from the ranks of the 1968 protest movement and postmodernists, the Bauhaus has maintained its mythic hold both within and beyond West Germany's architecture and design circles. Indeed, much of its successful popularization after 1945 was linked to the fact that it transcended architectural history proper, having long been identified in the Federal Republic of Germany as welcome testimony of post-National Socialist progress and transatlantic cultural partnership.

From the very outset, the Bauhaus legacy was shaped by postwar imperatives. It served as a vital component in the ongoing reorganization of cultural memory during the early "Bonn Republic." It should be recalled at this point that in order to rehabilitate a non-National Socialist German past to which a cautious West Germany hoped to claim

allegiance, there was a concerted effort during the late 1940s and early 1950s to recover an exiled, threatened and/or destroyed "better Germany." This was no easy task, however. The project to construct a palatable West German identity was continually bedeviled by the fact that most German cultural spheres, be it architecture, painting, film, music, philosophy or history-writing, had been badly contaminated by National Socialist association. Even worse, what little antifascist culture did exist was confounded by its explicit linkage to communism. Much of the attention at the time focused on recounting the glories of exiled Weimar heroes such as Gropius, Thomas Mann and even a reimported Frankfurt School, who were all construed as living testimony of a positive, non-National Socialist German culture. In this setting, the Bauhaus provided timely political service in that it was one of the few German traditions that apparently satisfied

the Cold War criteria of antifascism, anticommunism and international modernism.

What is so interesting is that much of the Bauhaus reception took place outside the sphere of architecture. In fact, West German architects and urban planners paid scant attention to the Bauhaus and its leading figures during the 1950s. A mixture of traditionalists and middle-of-the-road modernists, most of whom had served under the National Socialists, the West German architectural profession still retained a 1930s image of a radical leftist Bauhaus, one that blocked off its potential relevance for postwar planning. Yet this did not mean that the Bauhaus remained unimportant to West Germans; the point was rather that its reception occurred far beyond architecture circles where the Bauhaus and its founder lived on as affirmative icons of an uncorrupted Weimar culture. The so-called Schwarz Controversy – in which Cologne architect Rudolf Schwarz published a

**Bauhaus Archive, Darmstadt, View of the exhibition hall in the Ernst Ludwig Haus on the Mathildenhöhe.** 1962; on the left, an easy chair by Ludwig Mies van der Rohe; on the right, a wall covering by Gunta Stölzl; in front of it, upright chairs by Marcel Breuer; photographer unknown, BHA. • It was not until the establishment of the archive in 1961 and the research connected with it that Hans Maria Wingler made a wider general public in the West once more aware, for the first time since the war, of the contribution made by the Bauhaus to modernism in art and design.

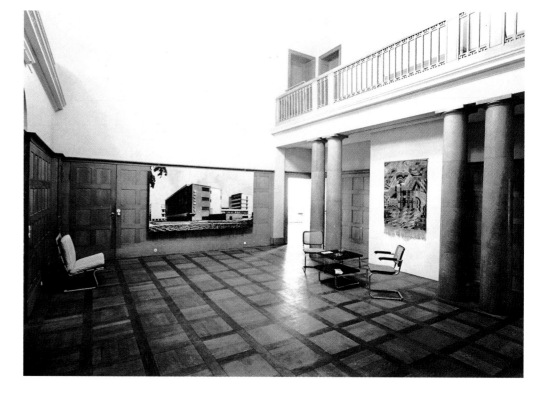

**Hans Maria Wingler and Ise Gropius at the traveling exhibition "50 Years Bauhaus" at the Crown Hall venue in Chicago.** September, 1969, photograph by Taylor Gregg, BHA. • An appropriate setting for the exhibition was provided by the campus building of the Illinois Institute of Technology, built by Ludwig Mies van der Rohe. On the left in the picture is *Homage to the Square* by Josef Albers.

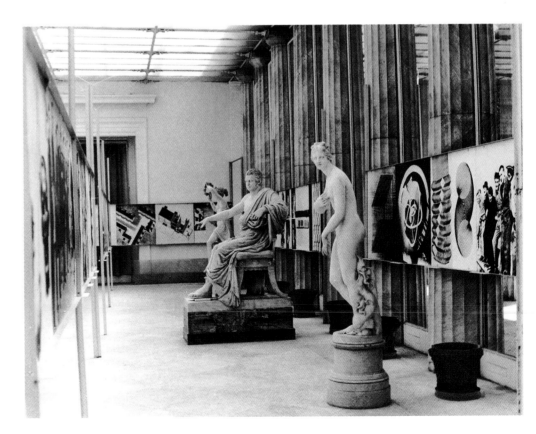

**Bauhaus exhibition in the Villa Pignatelli, Naples.** 1962, photographer unknown, BHA. • The visitor to this exhibition was presented with a strong contrast between ancient and modern design.

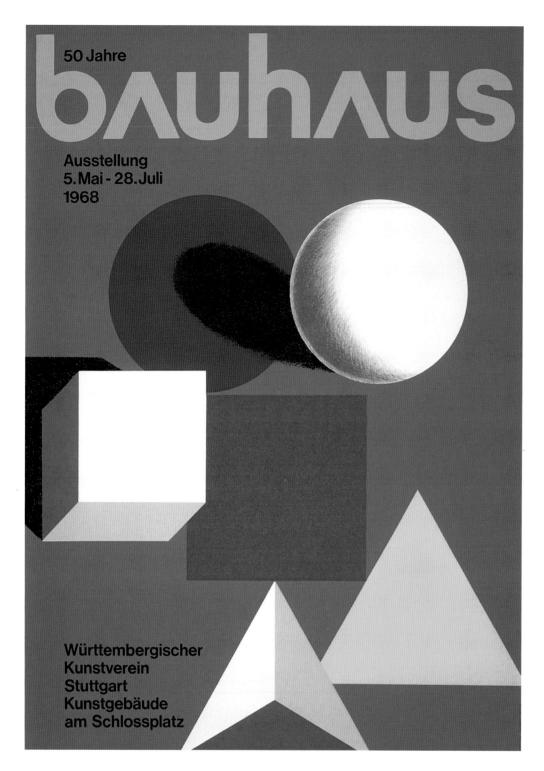

**View of the exhibition hall in the Art Building on Schloßplatz for the exhibition "50 Years Bauhaus," put on by the Württemberg Art Association in Stuttgart.** 1968, exhibition designed by Herbert Bayer and Peter Wehr, photograph by Hans Kinkel, BHA. • The exhibition assembled the first extensive presentation of the German prewar avant-garde at the Bauhaus. The life and work of the school were documented using photographs and models, with the assistance of many former members of the Bauhaus. This successful presentation was to travel all over the world.

**Poster for the exhibition "50 Years Bauhaus" of the Württemberg Art Association in Stuttgart.** 1968, designed by Herbert Bayer, BHA. • In his poster for this Bauhaus anniversary exhibition, Bayer provided a reminder of its fundamental research and teaching on subjects such as primary colors and forms, in two and three dimensions.

shocking article in *Baukunst und Werkform* (Architecture and Craft Form) in 1953 condemning the Bauhaus as a band of "wild and agitated terrorists" who propagated an architectural idiom "that was not German, but rather the jargon of the Communist International" – made this point quite plain. At that time a whole range of West German sympathizers rose to defend the Bauhaus from what was deemed the "spirit of 1934." With this any

historical discussion about the communist elements at the Bauhaus – save for demonizing Hannes Meyer as the Bauhaus Judas – was suppressed in the effort to reinvent the school as a cherished symbol of Western liberalism. (Many of the leading Bauhaus members were often quite skilled in sanitizing their own biographies to suit postwar conditions.) That the Schwarz Controversy enjoyed the most coverage in more mainstream cultural

publications only confirmed the extent to which Gropius and the Bauhaus were identified by the lay public as precious cultural capital in need of safeguarding.

It is well to remember that the postwar rehabilitation of the Bauhaus was already well underway by the time of the Schwarz Controversy. Essential here was that the educated West German public did not view the Bauhaus as a renegade band of radical architects.

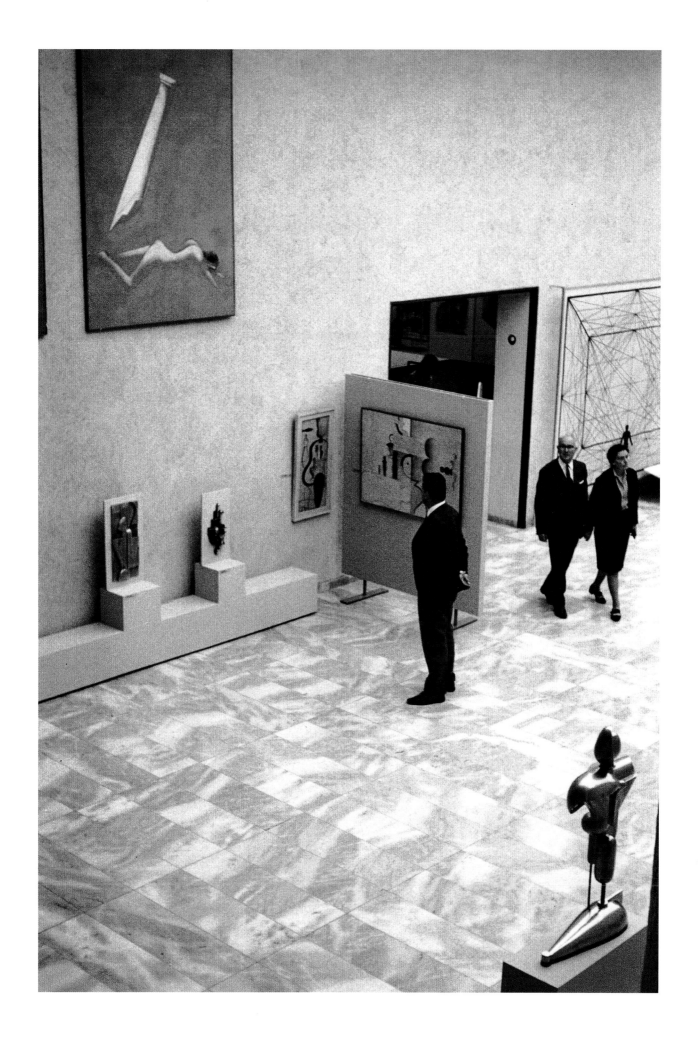

**Ludwig Mies van der Rohe at the topping-out ceremony for the Neue Nationalgalerie in West Berlin**. April 12, 1967, on the left is Mies van der Rohe wearing a trench coat, on the right Hans Scharoun wearing a beret, photographer unknown, BHA. • In Mies van der Rohe's last major work, at the Kulturforum in Berlin, the fluid lower spaces are crowned only by a massive flat roof, recalling constructional aspects of the New Building style and contrasting with the organic and crystalline forms of the buildings opposite by Hans Scharoun.

Thanks in large part to the post-1945 retro-active redemption of those condemned by the National Socialists at the famous 1937 "Entartete Kunst" (Degenerate Art) exhibition, the popular Cold War image of the Bauhaus shifted from a hotbed of leftist architecture to a bold yet innocent school of fine arts. This was especially evident in the first postwar Bauhaus show, the 1950 "Maler am Bauhaus" (Painters at the Bauhaus) exposition held in Munich.

The once central Bauhaus idea of moving beyond the cult of the autonomous artist and its attendant trappings of excessive subjectivity was forgotten amid the postwar rediscovery of the Bauhaus as a key moment in a lost German tradition of liberal humanism. Bauhaus master painters were now celebrated by West Germans as part of a broader Cold War campaign to affix Abstract Expressionism (due to its apparent glorification of artistic freedom and individuality) as the preferred iconography of the West. The dissemination of Bauhaus modernism throughout West German middle-class cultural life (as witnessed in domestic interiors, furniture styling, patterns for wallpaper, poster art and graphic design) further deradicalized the Bauhaus in the eyes of the public, while making its cultural wares available for mass consumption for the first time. Likewise, the Bauhaus approach to education was hailed by West German educators as an exemplary humanist model for training artists, artisans and designers.

The popularization of Bauhaus modernism was particularly evident in the sphere of industrial design. In part this was because the Bauhaus legacy was by no means a fixed and shared heritage, but itself became a bone of contention between West Germany's competing design cultures. On the one hand, the organic design culture (generally known by its more derogatory epithet, Nierentischkultur, "Culture of Kidney-Shaped Tables") identified the abstract organic motifs found in the work of Klee and Kandinsky as its guiding design principles. The brash colors and wild assymetrical shapes of 50s lamps, vases, ashtrays and tapestries were part of this particular design culture's concerted attempt to cast the lively spirit and painterly innovations as the Bauhaus' true heritage. On the other hand, the

more institutionalized design culture of the re-established German Werkbund, the Ulm Institute of Design, the design firms of Braun and WMF, as well as the German Rat für Formgebung (Design Council) all sought to foreground the more austere functionalist dimension of Bauhaus modernism. Rejecting the organic design's "applied Kandinsky" as whimsical and irresponsible, these postwar functionalists embraced Neue Sachlichkeit (New Functionalism) design as more appropriate in assuring the quality production of badly needed everyday household objects after the war. While it is unnecessary at this point to go into detail about the specific battles over this Weimar legacy, the conflict did underline the Bauhaus' cultural authority as a polestar of postfascist cultural liberalism.

For these reasons, the Bauhaus enjoyed continued cultural prestige in West Germany throughout the 1950s and 1960s. This reception culminated in the 1968 Stuttgart "Fifty Years Bauhaus" exposition, which attracted 75,000 visitors. Diplomats and dignitaries were on hand to commemorate the Bauhaus as a vital tradition bridging the Weimar and Federal Republics, West German and American modernism. Even if Josef Albers and Mies van der Rohe disliked the overemphasis upon Gropius and his tenure, it still proved to be the crowning moment in the Bauhaus' cultural canonization.

This is by no means intended to suggest that Bauhaus modernism somehow dominated West German culture. Not only did postwar architecture remain a hodgepodge of traditional and modern styles, Bauhaus modernism had lost its hold in West German industrial design by the mid-1960s. What was important, however, was that it was still showcased as the Federal Republic's quasi-official architectural and design aesthetic. Not only was this evident in its representative architecture such as the 1951 Bundeshaus, the 1957 INTERBAU exhibition and the West German Embassy in Washington D.C. – it was also registered in objects displayed in the West German sections of the Milan Design Triennale. But perhaps the most telling illustration was the West German Pavilion at the Brussels World Exposition in 1958. This event was quite dramatic if we recall that the last world exposition had been the 1937 show in Paris, where Albert Speer's National

**World Exhibition, Brussels, 1958.** Exhibition designed by Gustav Hassenpflug, photograph by Fotodocuments Nemerlin, Brussels, BHA. • Herbert Bayer had installed free-floating photo walls, staggered from the visitor's viewpoint, at the Werkbund exhibition in Paris in 1930. The fact that Gustav Hassenpflug had collaborated with Bayer many times on shop and exhibition design projects helps to explain why he resorted to this presentation technique (which also works well in advertising).

**Bauhaus Archive, Design Musum, Berlin, viewed from the eastern side.** 1979, photographer unknown, BHA. • Walter Gropius's 1964 design for a museum to house the Bauhaus collection was not implemented in Darmstadt as planned, but was taken over as a new project by the Berlin regional authorities. The architect Alexander Cvijanovic was commissioned to revise Gropius's design (1971–1973) and the planning of the execution of the project was taken over by Hans Bandel in 1975. The foundation stone was laid the following year and the building was opened in 1979. The Design Museum houses the world's most comprehensive collection in its field.

Socialist Pavilion broadcast an aggressive self-image of fascist Germany. In order to make it clear that 1958 was not 1937, the West German government together with the German Design Council consciously showcased Bauhaus-inspired modernist architecture and design as testimony to West German regeneration and political change. In the end, the West German appropriation of this modernist style neatly expressed the imagined Cold War linkage between the Bauhaus and Bonn, the 1920s and 1950s, national and international modernism.

In recent years the postwar project to affix Bauhaus modernism as a totem of International Style liberalism has all but disappeared. The post-1968 rereading of the Bauhaus modernism as oppressive and inhumane; the revenge of ornamentation and historicism as the hallmarks of postmodern architecture; and even the recent criticism of Gropius and Mies as less than angelic figures in their personal politics have cast a noticeable pall over the once sunny Bauhaus imperium. The 1980s too left its mark. Amid the early 80s West German nostalgia for the "Golden 50s" and the new

fascination with the unofficial "Alltagsgeschichte" (everyday history) of the postwar period, the 50s popularity of Bauhaus modernism was now criticized as exaggerated and elitist. Overstated as this may have been, it did reveal a postmodern shift in Bauhaus reception history. And even if it is hardly surprising that the Cold War revision of Bauhaus history has now become a historiographical museum piece of West German modernism after 1989, the post-Reunification significance (and future) of the Bauhaus past remains an open question.

# The State Building College in Weimar – a "Gropius Bauhaus without Gropius?"

Justus H. Ulbricht

**Artist unknown, Photo collage with Otto Bartning and various buildings designed by him.** After 1929, reproduction of the original photo collage, Darmstadt Technical University, from the Bartning Estate. • Allusions to Bauhochschule projects: on the left can be seen the water tower in Zeipau (Silesia) of 1922, beneath it is the student hall of residence in Jena (1931), in the center the "Music House in the Country" in Frankfurt an der Oder (1929), on the right below a view of the German Reich's pavilion at the Milan trade fair (1926) along with the steel church seen under construction and in its completed state.

The Thuringian regional elections on February 10, 1924 were won by the bourgeois parties, who, with the support of the radical right-wing faction in parliament, formed the so-called "Ordnungsbund (League of Order) government." This set the scene for the political demise of the State Bauhaus led by Walter Gropius, whose position in Weimar had in any case been a subject of controversy for years. Anticipating their dismissal by the new government, Gropius and all the other Bauhaus masters (Lyonel Feininger, Wassily Kandinsky, Paul Klee, Gerhard Marcks, Adolf Meyer, László Moholy-Nagy, Georg Muche, and Oskar Schlemmer) along with most of the craft masters and journeymen, announced their resignation at the end of 1924. This seemed – especially in the eyes of those members of the German public who took an interest in art – to mark the end, in Weimar, of any modern training of artists and architects in a spirit of receptiveness toward the formal experiments of the European avant-garde. Surprisingly, however, the conservative enemies of the Bauhaus, by

officially appointing the Berlin architect Otto Bartning as director of the newly established Staatliche Bauhochschule (State Building College) in Weimar, made it possible for the "actual father of the Bauhaus idea" (in Oskar Schlemmer's words) to take up Gropius's legacy. Bartning's conception of higher education and his intelligent personnel policies were indeed responsible for the fact that Weimar was given a "Gropius Bauhaus without Gropius ... just very much more expensive," as Albin Tenner, the Communist deputy to the regional parliament, put it at the time. It is only thanks to more recent art-historical research that Bartning's Bauhochschule has emerged from the overpowering shadow of the Bauhaus (and its zealously cultivated myths). Today it is clear that it was only with the demise of Bartning's school in 1930 at the hands of Wilhelm Frick, Thuringia's National Socialist Minister of the Interior and Public Education, that the avant-garde ceased to have a home in Weimar.

Otto Bartning had made a name for himself early on as a theoretician and practitioner of Protestant church architecture. Although he was throughout his life receptive to the artistic impulses coming from contemporary stylistic reform movements, he was nevertheless always thought of as a mediator between aesthetic extremes and more as a cautious innovator than as having radically moved beyond tradition. Bartning was influenced in equal measure by particular elements in the cultural critique of Paul Schultze-Naumburg, art criticism from the Dresden Kunstwart (Guardian of Art) and its associates, and the respectable classicism of his teacher in Karlsruhe, Friedrich Weinbrenner. Even before World War I, as a member of the German Werkbund, he evolved his own formal language as the architect of a small number of churches and apartment blocks. As with others of his generation, his theoretical ideas concerning architecture were closely linked with hopes for sweeping social change, sometimes of a religious intensity. After 1918 Bartning's commitment in the Berlin November Group and the Working Council for Art was characterized by his yearning for a total renewal of society through the arts. In these artistic circles, inspired equally by the enthusiasm and the

**Page from the catalog "Typenmöbel der Staatlichen Bauhochschule Weimar" (Type furniture from the Weimar State Building College).** About 1929, draft design by Erich Dieckmann, BHA. • Dieckmann's interpretation of functionality and economy, of appropriateness of material and production, is in the tradition of Bruno Paul's "Type furniture program" of 1908 rather than that of the Bauhaus. These pieces of furniture are far removed from the "Frankfurt kitchen" in which all domestic functions were organized in the smallest possible space.

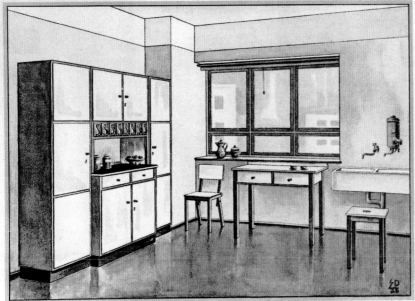

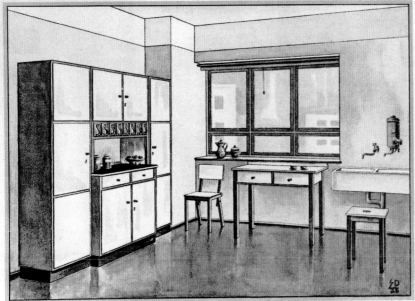

TYPENMÖBEL
DER STAATLICHEN BAUHOCHSCHULE WEIMAR
Entwurf: ERICH DIECKMANN

Reihe VI
KÜCHE

1 Küchenmittelschrank mit 8 Schütten
  Platte mit Linoleum
  H 190 cm (90/100) B 100 cm
  T 54/40 cm

1 Seitenbesenschrank
  H 190 cm B 50 cm T 40 cm

1 Seitentopfschrank
  H 190 cm B 50 cm T 40 cm

1 Arbeitsplatte mit Vorratsschrank, 2 Schub-
  kästen und Abfallschütte
  (wird im allgemeinen ein-
  gebaut), Platte Ahorn
  H 80 cm B 200 cm T 60 cm
  Vorratsschrank B 60 cm
  (auf dem Bild nicht vorhanden)

1 Küchentisch (freistehend), Platte Ahorn
  H 80 cm B 110 cm T 60 cm

1 Küchenstuhl, Hartholz mit Sperrplatten,
  Sitzhöhe 45 cm

1 Hocker, Hartholz mit Ahornplatte
  Sitzhöhe 50 cm

Ausführung:
Weichholz mit Sperrholz, im allgemeinen zwei-
farbig lackiert: Seiten, Stollen und Rahmen leicht
grau getönt, Türen und Schubkästen emailleweiß.

STAATLICHE BAUHOCHSCHULE WEIMAR

chaos of post-revolutionary Berlin, Bartning not only encountered other stylistic innovators such as Hans Poelzig, Bruno Taut, Heinrich Tessenow – and Walter Gropius – it was also here that he formulated key notions of fundamental change in the training of artists and architects. These notions stimulated the contemporary debate on state art school reform in the same degree that they stimulated Gropius's Bauhaus conception and Bartning's own teachings on the unity of art and craft, which he put into practice in Weimar from 1926 on. Already back in 1919, the future director of the Bauhochschule had proclaimed: "The common medium of all artistic activity ... is craft ... from craft to building work is the natural course of evolution for craftsmen, architects and visual artists." In Bartning, as in Gropius, the typical fascination of the age with the medieval idea of the Bauhütten (the church masons' guilds) is unmistakable, as is the intense "hunger for wholeness" which the art and cultural historian Peter Gay once declared to be the essential hallmark of the early Weimar Republic, torn apart as it was by social, political, aesthetic and philosophical differences.

It was Heinrich Tessenow, who, in 1924 recommended to the responsible political authorities in Thuringia that Bartning should be Gropius's successor. The warnings of the conservative Weimar sculptor Richard Engelmann, who, like Schlemmer, regarded Bartning as the real "father of the Bauhaus idea," did not prevent the latter from being short-listed. His outline for the establishment of a "building academy," dating from February, 1925, convinced the politicians. Even before his appointment, Bartning was anxious to reach an amicable agreement with Gropius regarding the material legacy of the Bauhaus. He intended, however, to take up its intellectual legacy in a different manner. In the same month that he was appointed, in March, 1926, Bartning signed binding contracts with the future teachers of the Bauhochschule. Without arousing the suspicions of the conservative majority in the regional parliament, the new director recruited his staff almost exclusively from members of the old Bauhaus and its workshops, along with a handful of people sympathetic to the Bauhaus idea. From Kassel he brought the painter, graphic artist and stage designer Ewald Düllberg, who was to set his

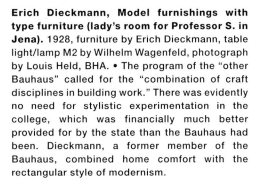

**Erich Dieckmann, Model furnishings with type furniture (lady's room for Professor S. in Jena).** 1928, furniture by Erich Dieckmann, table light/lamp M2 by Wilhelm Wagenfeld, photograph by Louis Held, BHA. • The program of the "other Bauhaus" called for the "combination of craft disciplines in building work." There was evidently no need for stylistic experimentation in the college, which was financially much better provided for by the state than the Bauhaus had been. Dieckmann, a former member of the Bauhaus, combined home comfort with the rectangular style of modernism.

**Ernst Neufert, The Neufert House in Gelmerode.** About 1930, view from the southeast, photographer unknown, BHA. • While for the Bauhaus project "Sommerfeld House," wood was the prescribed material, in this case it was freely chosen. For Gropius's one-time colleague, now the director of the architecture department of the Bauhochschule, the aesthetics of the "block house" were connected with his ideas about standardizing both construction and space.

stamp on the workshops for architectural painting and stage design between 1926 and 1928. Bartning failed, however, in his attempt to recruit the Dutch architect J. J. P. Oud, a friend of the De Stijl theoretician Theo van Doesburg. But he did manage to engage Ernst Neufert from Dessau, the director of the Gropius office there, who was thus allowed to emerge from his mentor's shadow. Neufert and the Dutchman Cornelis van Eesteren, a visiting lecturer in town planning from 1927 to 1930, were to become, with Bartning himself, the most influential teachers of architecture at the college. Wilhelm Wagenfeld set his stamp from the outset on the work of the metal workshop, which was also commercially successful. He was promoted after two years from assistant to workshop director. Wagenfeld's design work in particular clearly shows the continuing influence of particular Bauhaus ideas, to which Otto Lindig, director of the ceramics workshop, likewise felt especially indebted. Wagenfeld, Lindig and Erich Dieckmann, the director of the cabinet maker's workshop, had earlier studied under Gropius in Weimar.

The Bauhochschule was dominated, to a substantially greater extent than the old Bauhaus had been, by its building department, which under Ernst Neufert's authoritative direction succeeded in carrying out a handful of building projects that were widely discussed at the time. Between 1929 and 1930 the new student hall of residence in Jena was built, along with the highly modern new building (known as the Abbeanum) of the mathematics institute of the Carl Zeiss Foundation. Bartning himself designed and built the "Music House in the Country" in Frankfurt an der Oder, an institution initiated and supported by the state for the musical education of adults and young people. Furthermore, Bartning's private building commissions en sured that the Weimar workshops never ran out of interior design work (a children's home in Neuruppin, the German pavilion at the Milan trade fair, the steel church and Protestant library at the Berlin Pressa exhibition.) But substantial recognition also came to the Bauhochschule through the work of Ernst Dieckmann, whose cabinetmaker's workshop left its mark on the history of German design with its "type furniture." Much the same may be said of Wagenfeld and the metal workshop. Furniture, lamps, carpets, wallpaper and other furnishings, stylistic ally less revolutionary but of solid workmanship, and above all considerably less costly – these soon became part of the

image of modern interior décor for homeowners who found the designs of the Dessau Bauhaus too cool, too functional, and too expensive.

The design philosophy of the Bauhochschule had cautiously attempted to reconcile a formal language rooted in tradition with industrial design geared toward mass culture, and the old methods of craft production with industrial forms of manufacture. But this received little support from craftsmen in Weimar and Thuringia. Bartning and his associates found themselves increasingly beleaguered by the coalition, which had earlier proved fatal to Gropius, of organized middle-class lobbying, cultural conservatism and latent or overt anti-democratic convictions. His own munificent contract – he was paid a relatively high salary and was not obliged to reside in Weimar – caused further resentment. Finally, the fundamental change of political climate in Thuringia led to the demise of Bartning's "other Bauhaus." As had happened in the days of his predecessor, the new National Socialist masters used ostensible financial policy arguments in order to

**Otto Bartning, Steel church at the international press exhibition "Pressa" in Cologne.** 1928 (since destroyed), side view, photograph by Hugo Schmölz, Schloß Moyland Museum Foundation, van der Grinten Collection, Estate of Elizabeth Coester. • The church translated features of a Gothic cathedral into simplified steel and glass forms. In this project, as with others, the rest of the college was involved with producing complementary designs for lighting, textiles and furnishings.

# DAS FRANKFURTER REGISTER 17

## WEIMAR BAU- UND WOHNUNGSKUNST G. M. B. H.
### Ehemalige Vertriebsorganisation der Staatl. Bauhochschule Weimar

TYPE:
## M 42
**TISCHLEUCHTER**
mit Zeißspiegelreflektor
Metallteile: Messing vernickelt,
poliert. Gesamthöhe: ca. 42 cm

Entwürfe:
WILH. WAGENFELD
Oberweimar / Thüringen

TYPE:
## M 30
**ZUGPENDEL-
LEUCHTER**
Messing, matt vernickelt. Mit
Cellon- od. Karton-Unterschirm
aus besonders lichtdurchlässig.
Material und innen mattweiß
lackiertem Metallreflektor.
Reflektor ⌀ 24 cm
Unterschirm ⌀ 48 cm

Fordern Sie Kataloge über Leuchten, Metallgeräte, Möbel, Bauteile,
Keramiken und Webereien von der

## WEIMAR BAU- U. WOHNUNGSKUNST G.M. B.H.
### WEIMAR · SCHILLERSTRASSE 14, I

Beilage zu „Das Neue Frankfurt" 1931, Heft 4/5, Verlag Englert und Schlosser, Frankfurt a. M.

**The Frankfurt Register, No. 17.** 1931, supplement to "Das neue Frankfurt", Vol. 4/5, designs by Wilhelm Wagenfeld, SMBK Art Library. • The lamps recommended in this avant-garde periodical as practical and exemplary types of household equipment had their origins in a grotesque situation at the Bauhochschule: in the metal workshop, there was only one trainee in addition to the head of department and his assistant. Thus only designs by Richard Winckelmeyer and Wilhelm Wagenfeld were marketed.

reshape the Bauhochschule in a different spirit. However, the ferocious attacks by the regional Minister of the Interior, Wilhelm Frick, and his protégé Paul Schultze-Naumburg revealed that it was at bottom a profound distrust of Bartning's moderate modernity which led the National Socialists completely to reshape the successor institution. The spirit of a new Germany to come showed itself with frightening clarity when the Weimar art collections were purged of modern painters and the Schlemmer frescoes in the stairwell of the college were destroyed. Otto Bartning remained in Berlin and returned for many years to his original profession, church architecture. The spectacular end of the Bauhaus, which was driven out of Dessau in 1932 and relocated to Berlin, where it was permanently closed down in 1933, along with the fame of the Bauhaus under Gropius, which put every thing else in the shade – for a long time these displaced from our memory of cultural history Bartning's attempts to keep modernism alive in the State of Thuringia up to 1930. Only recently have inquiries into the origins of aesthetic modernity around 1900 provided a clearer view of the new art in Weimar beyond strictly Bauhaus traditions, thanks not least to our increased awareness of the ambivalent characteristics of modernism. It thereby became clear that Walter Gropius and Otto Bartning set out on their journey together, but soon went their separate ways in their attempts to escape from the constricting enclosure of aesthetic historicism.

# Black Mountain College, NC

Paul Betts

The story of Black Mountain College (1933–1956) remains an obscure one. Although Martin Duberman's *Black Mountain: Experiment in Community* from 1993 and Mary Emma Harris' *The Arts at Black Mountain College* (1987) are important monographs, the school is usually relegated to the footnote thickets of Bauhaus historiography. This is quite unfortunate, especially given that the star-studded faculty included Josef Albers, John Cage, Merce Cunningham, Buckminster Fuller, Willem de Kooning, Franz Kline, Charles Olson and Robert Rauschenberg. What made the school so unique was its creative synthesis of American progressivism and European modernism, much of which pivoted upon the ideals of Bauhaus pedagogy.

The school was originally founded by renegade classics professor John Andrew Rice in January 1933. Dissatisfied with conventional American college instruction, he sought to create a more progressive school of higher learning that privileged individual creativity. But unlike other leading American university reformers during the 30s, Rice did not believe reviving the classics was the best tonic against "instrumental reason" and pre-professionalism. For him, such a model still neglected the eye and ear. By contrast Rice developed a John Dewey-inspired "learning by doing" curriculum based on "observation and experiment." As noted in the college's first catalogue, this meant integrating the fine and liberal arts. The school structure was equally as progressive. There was no fixed curriculum, nor required courses; each student designed his or her own program of study with an

**Josef Albers, Black Mountain College logo.** About 1933. BHA. • The logo owes a debt to Oskar Schlemmer's Bauhaus seal, and at the same time makes it abstract: the name of the school is liberated from the closed spheres and – in contrasting black and white – inserted as a circle in a square. The austere profile of the "New Man" has given way to an optical counterpoint: "Homage to the Circle."

**Group portrait of the men and women who founded the Black Mountain College in front of the portal of the Robert E. Lee Hall.** 1933; front row, from the left, Joseph W. Martin, Helen Boyden, Peggy Loring Bouley, unknown person, John Andrew Rice (rector); top row, from the left, John Evarts, Theodore Dreier, unknown person, Mr Lounsbury, William Hinckley; photographer unknown, BHA • The staff before the arrival of the German emigrés.

**Black Mountain College, Robert E. Lee Hall.**
1930s, photographer unknown, courtesy of North Carolina State Archives. • The veranda of the old school building: as a forum and a place to relax it can be compared to the terrace of the Bauhaus canteen in Dessau. Shaker rocking chairs bring a democratic sense of proportion to the "Dixie grandeur" of the southern states architecture.

advisor. Students too shared power in the community, as student officers were obliged to attend all faculty meetings. All important school issues were addressed at joint student-faculty meetings. Participation in community life was thus not only encouraged, but mandatory. The effort to dissolve the distinction between curricular and extra-curricular life could also be seen in communal farming and shared physical maintenance of the school. To best suit this alternative education experiment, the founders chose the majestic 1619-acre site located amid the cool pines of Black Mountain, North Carolina, 18 miles east of Asheville. Word soon spread about the new school, as BMC received a steady stream of important visitors – among them Walter Gropius, Albert Einstein, Ferdinand

Léger, Anais Nin, Aldous Huxley, Henry Miller and Langston Hughes – interested in observing this experiment in living and learning.

The college was also an important outpost for the Bauhaus diaspora. Much of this has to do with the presence of Josef Albers. After conferring with Philip Johnson and Alfred Barr at the Museum of Modern Art in New York, Rice and the school's co-founder Theodor Dreier actively recruited Albers. The Bauhaus had just been closed a few months prior to this and Albers was looking for work outside Germany. In a telegram to Dreier, Albers expressed his interest in "the youthful approach of your institution and its vital intentions." The one problem, as Albers explained, was

"I am a beginner in English." Remarkably, Rice dismissed it as inconsequential; the main thing was to hire the best possible art teacher available. Josef and Anni Albers – who taught in the Bauhaus' Weaving Workshop – arrived at Black Mountain in November 1933.

Albers exerted a powerful influence upon the school. (He was assisted in his teaching by translators until his English improved.) To be sure, his presence seemed at odds with the provincial surroundings; one observer remarked that seeing Albers at Black Mountain's "hillbilly setting, in the Southern Baptist Convention country of the Tarheel State (nickname of North Carolina since the Civil War) was a little like finding the remnants of an advanced civilization

**Black Mountain College Summer Art Institute.** 1944, photograph by Josef Breitenbach, BHA. • Students, visitors to the college and Josef Albers (on the right beside the wooden pillar) listening respectfully at a panel discussion. As at the Bauhaus, guest speakers were invited from the spheres of art, politics and science. Down to the present day the traditional summer school offers American students a variety of further education courses during the summer vacation.

in the midst of a jungle." Even so, Rice and Albers – at least during the first few years – got along very well. Both shared a kindred antipathy toward conventional academic teaching, and both believed that genuine learning began with intellectual and emotional maturity. Albers' teaching nicely meshed with the college's guiding objective of discouraging "imitation and mannerism" in order to "develop independence, critical ability and discipline." At the college Albers continued his Bauhaus work by offering his famous preliminary course, along with more advanced courses in color and craft work. He drew upon this experience to develop his studies of visual perception.

The Bauhaus influence at Black Mountain College was thus unmistakable. Not only was a good part of the curriculum organized around Albers' preliminary course, the Bauhaus presence was also evident in the faculty. Former Bauhaus member Xanti Schawinsky taught painting and drawing along with drama courses based on Oskar Schlemmer's idea of the "total theater." Anni Albers instructed weaving courses; and James Prestini, a colleague of László Moholy-Nagy's at the "New Bauhaus" in Chicago, offered courses on hand and machine sculpture. Even the highly-modernist school building designed for the college's new campus a few miles away on Lake Eden betrayed these Bauhaus loyalties. The Bauhaus influence was also evident in the school's famous summer programs. During the 1940s and early 1950s, for example, Albers organized the Summer Art Institute featuring art classes by Robert Motherwell and lectures on design by Edgar Kaufmann and Buckminster Fuller. What is more, the school arranged something akin to the 1920s "Bauhaus Evenings." Perhaps the most memorable of these events was composer John Cage's *Theater Piece No. 1* (1952) generally regarded as the first staged "happening." In this piece Cage was assisted by painters Robert Rauschenberg and Franz Kline, poet Charles Olson and choreographer Merce Cunningham in producing a medley of texts, images, music and dance.

Yet this great artistic flowering could not abet the school's perennial financial crisis,

which intensified during the war. The end of the war did not improve matters, as radical conservatism took its toll on the left-leaning experimental college. To change course, the college offered the position of rector to modernist poet Charles Olson in 1948, who then shifted the school's focus from visual arts to the literary arts. His successful campaign to turn the college into a key center of American experimental poetry still could not avert its bankruptcy. In 1956 the remaining faculty and students resolved to disband the school. Its legacy, however, continued to live on within American counterculture. And even if sometimes mocked as an isolated "Black Magic Mountain," BMC proved to be a fertile seedbed for the evergreen "Bauhaus idea."

**Title page of "design."** April, 1947, No. 8, design by Lustig, BHA. • The graphic artist, using the amorphous formal vocabulary of the time, plays with the name of the Black Mountain College in North Carolina and the attractive surrounding landscape. The new school premises are "submerged in the lake" in front of the black mountains.

**Xanti Schawinsky, Sketch for 8 stage props for the "Spectodrama."** 1936, tempera, Indian ink and pencil, picture 20.3 x 47.7 cm, sheet 54.5 x 64.4 cm, Schawinsky Estate, Switzerland. • Schawinsky directed the theater class at the Black Mountain College. In collaboration with his students, he developed a concept of "spectodrama" in which phenomena such as form, color, sound, language, music, time and space were analyzed in terms of stageworthiness and the creation of illusion. The props indicate representational or abstract, geometrical décors as stage settings for dancing and other staged events.

# New Bauhaus and School of Design, Chicago

Paul Betts

Amid the handful of post-1933 Bauhaus reincarnations, the story of the Chicago Bauhaus (1937–1949) enjoys the most renown. While little scholarship on the subject existed through the 1970s, recent years have witnessed a growing interest in this important chapter of transatlantic modernist culture. Alain Findeli's *Le Bauhaus de Chicago* (1995), *50 Jahre New Bauhaus:* *Bauhausnachfolge in Chicago* (50 Years New Bauhaus: Bauhaus' Successor in Chicago), edited by Peter Hahn and Lloyd Engelbrecht (1987) and J.S. Allen's *The Romance of Commerce and Culture* (1983) have shown the extent to which the Chicago Bauhaus furnishes a compelling case study in the complex historical trajectory of the "Bauhaus diaspora."

The Chicago Bauhaus was a brainchild of American business. It was first inspired by the Chicago Association of Arts and Industries, which served as a kind of regional American Werkbund. Like the pre-World War I German Werkbund, the Chicago Association was an umbrella organization intent on bringing together artists and industrialists in the name of cultural progress and export

**Exhibition of work from the foundation course at the New Bauhaus.** About 1938, photographer unknown, BHA. • Like the preliminary course at the Bauhaus, the foundation course was intended to inculcate a sense of form and materials and was compulsory for all students. The former member of the Bauhaus Hin Bredendieck, drawing on his own experience, suggested paper-folding to Josef Albers, along with wire and wood sculptures, which, however, were machine produced.

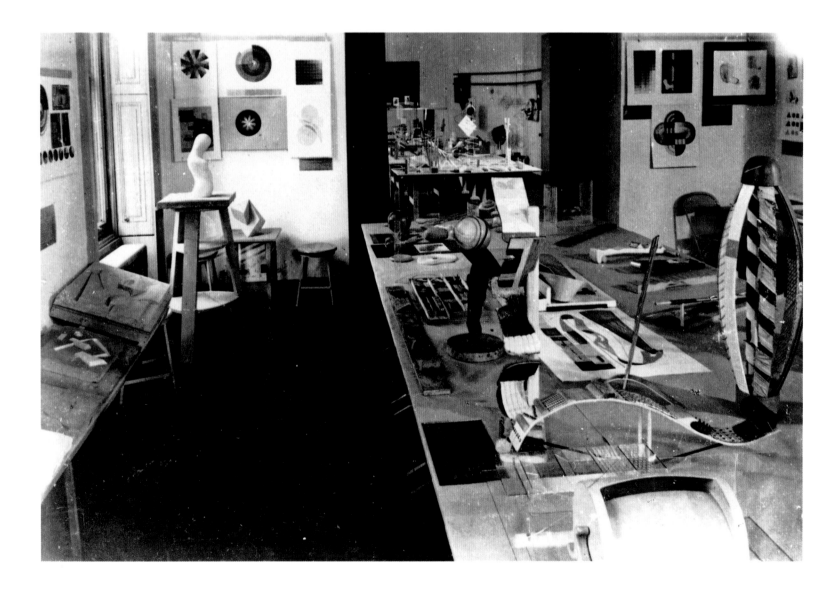

revenues. Above all it sought to liberate American design from its dependence upon the French Beaux-Arts tradition. From this context emerged the idea of a Chicago school dedicated to training commercial artists and designers in the cause of industrial modernism. That the Bauhaus was chosen by these business leaders as a model design school was not so surprising, given that the Bauhaus had enjoyed wide attention in the States since the late 1920s, culminating in the 1938 "Bauhaus 1919–1928" show at the Museum of Modern Art in New York. Chicago too served as an early host to American architectural modernism, having produced the likes of Louis Sullivan and Frank Lloyd Wright. The success of the city's 1933 "Century of Progress" exposition in popularizing modern design seemed to underline the need for an American Bauhaus. The Association then began searching for a director. Though Walter Gropius declined, he recommended his long-time friend and former Bauhaus colleague László Moholy-Nagy for the post, arguing that Moholy had given the Bauhaus its "most passionate stimulus" and was the most qualified person to take on this task. The Association then concurred that Moholy's vision and experience suited the school's larger aims. In 1937 the Association sent a letter to Moholy in England offering him the directorship. He gladly accepted and shortly thereafter set sail for America.

The transplantation of Moholy and the Bauhaus idea to America was not easy, however. Not only did Moholy feel that Chicago was a "strange town" with "no culture, just a million beginnings," he chafed with the school's business patrons about the mission of design education. In his first speech as director of the 'New Bauhaus,' he explained to a group of Chicago businessmen that "from the very first day it was our aim to educate designers for the real necessities of life, and not only 'industrial designers' for the daily routine... Thus not only aesthetically, but morally, we must control the application of our materials, technique, science and art in creating for human needs." Although on one hand many were skeptical that their donations to the school would be squandered on impractical pedagogical experimentation, Moholy

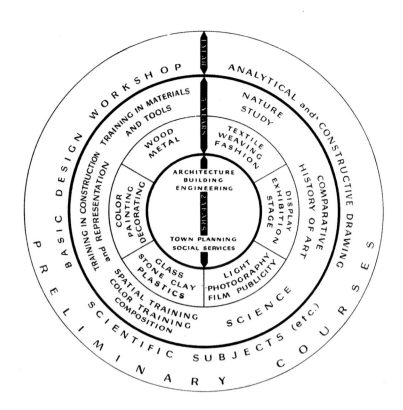

**Curriculum and logo of the New Bauhaus.** About 1938, BHA. • The curriculum aimed at the interpenetration of art and technology, exactly as at the Bauhaus, but now clearly included science. The "New Man" who went there to be educated (once symbolized by Oskar Schlemmer in his logo) was thus to be enriched by a further dimension.

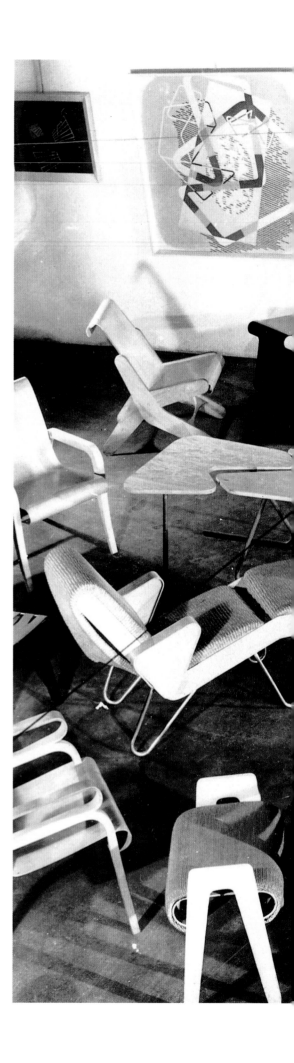

**Portrait of László Moholy-Nagy.** 1942, photograph by William Kessler, BHA. • Garlanded like a hero by his students, Moholy celebrated his birthday in the summer school at Somonauk, Illinois. He directed the school in the conviction that everyone was gifted and capable of creative work provided man's dormant powers could be awakened.

**Joint exhibition by students at the School of Design, Chicago.** 1942, photographer unknown, BHA. • The creative work of the Product Design Workshop attracted both public attention and commissions. This exhibition showed, for example, the results of various experiments in giving chairs a degree of springiness.

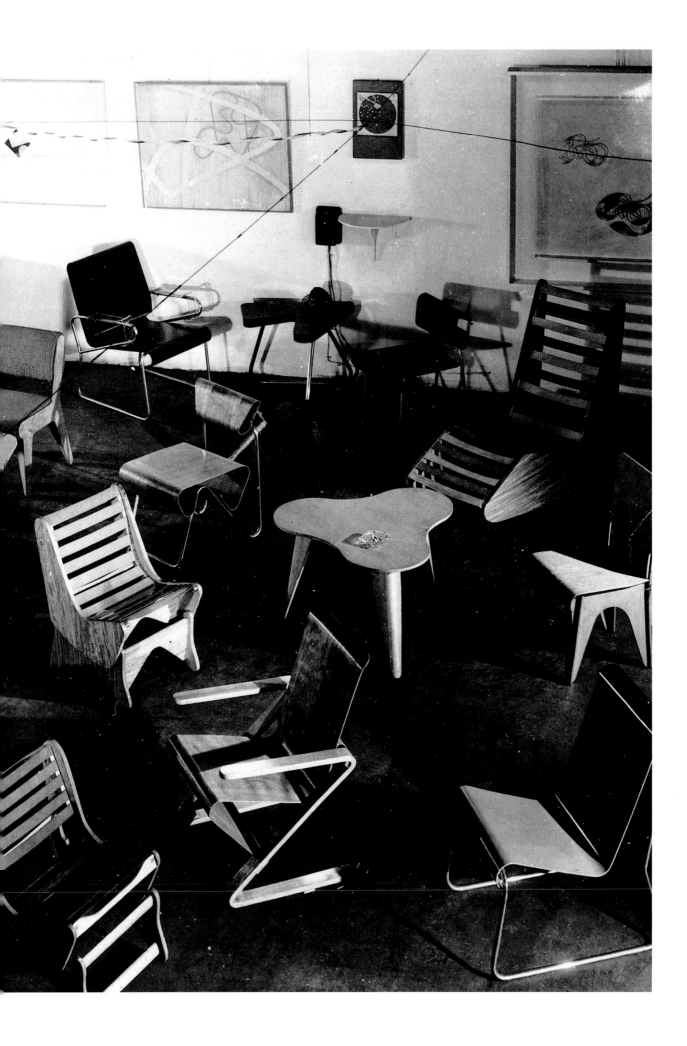

**The School of Design** incorporated not for profit embodies the principles and educational methods of the Bauhaus founded 1919 in Weimar by Dr. Walter Gropius, chairman of Architecture and University. In the 1919-1928

**Title page for the brochure of the Chicago School of Design.** 1939, photo by Nathan Lerner, BHA. • Experiments carried out in the "photography and light workshop," in this case a study incorporating a magnifying glass, were also used in the design of in-house brochures.

**Nathan Lerner, Light Box Study #7.** 1937, photograph, BHA. • The student at the New Bauhaus began his study of photography without a camera, producing photograms. Via "light modulators," used to explore the relationships between light, space and objects, the student approached camera photography by way of the "light box," Lerner's invention, a box painted black inside but perforated in order to let light flood in.

ultimately convinced the business patrons of the merit of his "laboratory for new education." By this he meant a more organic Dewey-inspired "learning by doing" conception of teaching and learning. Moholy contended that since the individual grasps the world with the senses, feelings and intellect, any effective education program must account for all of these factors – as he remarked in his 1947 book, *Vision in Motion* – by bringing "the intellectual and emotional, the social and technological components into balanced play." To the end, the Chicago program encompassed all aspects of design, including technology, drawing, painting, sculpture, design, photography, visual communication, architecture, mathematics and physics.

The Bauhaus influence was clear from the outset. Not only did former Bauhaus members Xanti Schawinsky, Hin Bredendieck and Andi Schlitz serve on the faculty, the school's symbiosis of science, technology and art was obviously indebted to the Bauhaus legacy. Further evidence of this Bauhaus connection could be seen in Chicago's emphasis upon the preliminary seminar. Still, there were important departures from the German Bauhaus. For example, the Chicago Bauhaus' preliminary course differed from its Dessau predecessor in that technology and photography played a greater role. Noteworthy too was that the new curriculum foregrounded the teaching of natural science courses. For this Moholy invited a range of professors

from the University of Chicago to teach courses on semiotics, cybernetics and mathematics as part of the Chicago Bauhaus' "Intellectual Integration" program. Most of these professors were associated with the so-called Unity of Science Movement, a school of thought that was quite analogous to Bauhaus ideas. Originally an extension of the 1920s Viennese school of logical positivism, the American movement sought the unity of language, axioms and analytical method which supposedly underlies all quests for knowledge. Moholy openly embraced this idea since it seemingly dovetailed with his own desire to "restore the basic unity of all human experience."

Small wonder that Moholy's vision of the New Bauhaus found flagging support from business clients. Even though its long-time collaboration with the Container Corporation

**Unknown artist, Untitled.** About 1940, photograph, BHA. • At the New Bauhaus photography, along with product and furniture design, was one of the areas in which outstanding results were achieved. In the "photo-montages without scissors," the cunning placing of mirrors in conjunction with three different motifs created reflective effects with a surrealistic quality.

**Unknown artist, Virtual Volume.** About 1940, photograph, BHA. • At the successor institution in Chicago, as at the Bauhaus itself, Moholy was a model to be emulated, as an artist, a teacher and a visionary. The ultimate goal of all artistic activity was no longer the construction, but rather the kinetic work of art, and in *Virtual Volume* the student found a path leading to it.

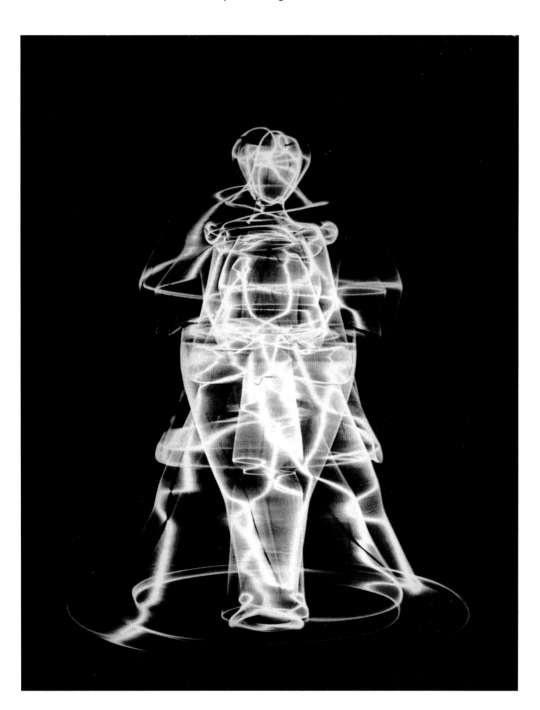

of America in the fields of graphic art and advertising was a high-profile success story and the school received wide attention among art and education circles, the business sponsors viewed the Chicago Bauhaus as elitist and too removed from market concerns. By 1938 the Association decided to stop funding the school, forcing it to close after just one year.

Thanks in large measure to the generous support of Walter Paepcke, the director of Container Corporation, the school was re-opened and rechristened in 1939 as the School of Design. This time the preliminary course was expanded to a full year of instruction, and the term 'design' replaced 'art' in the curriculum so as to broadcast the School of Design's commercial relevance. In 1942 the school even established workshops on camouflage technics to aid in the war effort. But financial problems continued to dog the school. It closed again and was eventually reopened as the Institute of Design in 1944. When Moholy died two years later, the school lost its vision and resolve. In 1949 it was absorbed by Mies' Illinois Institute of Technology, thus concluding one of the most ambitious modernist projects to wed culture and commerce, knowledge and liberation.

73

# The Institute of Design, Ulm

Paul Betts

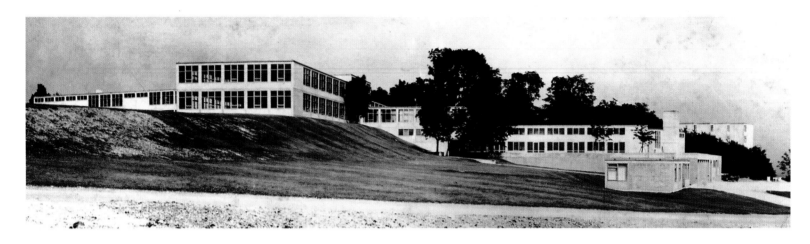

**View of the Hochschule für Gestaltung on the Kuhberg, Ulm.** 1955, photograph by Ernst Hahn, BHA. • The new college was intended as a continuation of the Bauhaus, extended and updated through the reformulation of questions concerning both design and society. To begin with, former members of the Bauhaus also taught there. By the time it was possible to move into the new building, in 1955, the aims and methods of training had become subjects of controversy, and these continued to unsettle the college.

The Institute of Design in Ulm (1953–1968) is commonly regarded as West Germany's last design school of any international importance. Given both its innovative design program and celebrated roster of instructors, which included Otl Aicher, Max Bill, Tomas Maldonado, Max Bense and Alexander Kluge, it was clear that this was no ordinary design school. Its well-publicized christening as the "New Bauhaus" in 1955 illustrated the extent to which it was born of noble pedigree, as both the American High Command and Bonn jointly underwrote the Ulm project in an effort to rehabilitate the affirmative heritage of Bauhaus Modernism as a signpost of enlightened West German culture. But its significance went far beyond converting design into diplomacy. Not only did it embody the dreams and difficulties of refounding another Bauhaus in Germany after 1945, the Institute of Design in Ulm also marked modernism's last real attempt to unite industrial design and genuine social reform.

From the very beginning, the Ulm project was shaped by a large vision of post-fascist cultural regeneration and political reform.

The idea of the Ulm Institute was originally inspired by Inge Scholl, who wished to establish a new school of democratic education in honor of her brother and sister, Hans and Sophie Scholl, both of whom were killed in 1943 as members of the anti-Nazi "White Rose" resistance group. Its primary pedagogic task was to reconcile what they perceived as the fateful historical antagonism of "technical civilization" and German "Kultur." To this end, Scholl (along with fellow resister and graphic artist Otl Aicher) hoped to create a new "crystallization point for a better Germany" where the "spirit of peace and freedom" would help cultivate anti-fascist European culture.

The subsequent appointment of well-known Swiss sculptor, painter and designer Max Bill as school director changed the school's outlook, however. A former Bauhaus student and then-president of the Swiss Werkbund, Bill thought it necessary to subordinate the founders' desire for more political education through courses such as sociology, media studies, and political science to the teaching of art, architecture and design. Bill justified this by

saying that genuine social reform began not with forced political training, but rather with reconstituting the very forms of the social environment, in other words, city planning, architecture and everyday objects. The eventual organization of the school's individual departments (Information, Architecture and City Planning, Visual Design, and Product Form) reflected a compromise of both views.

From this background, the Institute of Design in Ulm developed distinct conceptions of design and the designer. Much of the school's initial model came from Bill, who saw the designer's chief task in re-enchanting the objects of everyday life as "Kulturgüter" (literally, cultural objects) in the name of "the good, the beautiful, and the practical." Yet his lofty vision of the engaged artist-designer who sought to elevate design by treating it not as commerce but culture soon faced mounting criticism from Ulm's younger faculty, principally Tomas Maldonado. While sharing Bill's desire to train socially responsible designers instead of commercial artists, Maldonado rejected his idealism in favor of a more scientific conception of

industrial design. For him, the new industrial designer must be trained as a specialist in the laws of mass production and industrial automation in order to help demystify and coordinate what Maldonado called "our objective and communicative world." Thus if design was to maintain any critical dimension, so argued Maldonado, it needed to be reconfigured as a more scientifically-based operation of product management and systems analysis. With time the feud between Bill and Maldonado divided the school, ultimately prompting Bill's resignation as rector. Maldonado's rationalist vision

**The Institute of Design, Ulm, view of the refectory.** About 1955, photographer unknown, BHA. • Max Bill's architecture of concrete cubes, integrated into the landscape, housed living quarters and workshops.

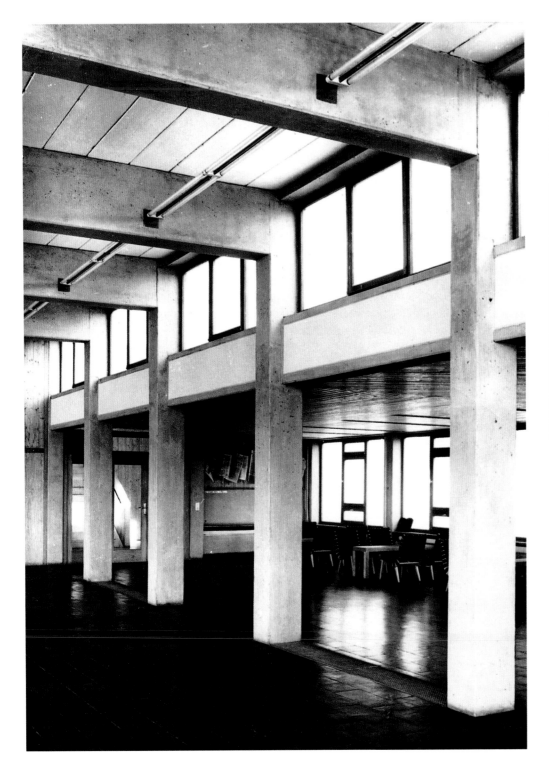

**Max Bill and Walter Gropius at the Design College, Ulm.** 1955–1956, photographer unknown, BHA. • Gropius suggested calling the new college the "Ulm Bauhaus," but some of the teachers consciously wanted to distance themselves from a concept in which aesthetic criteria drawn from art were reimposed on design. The first rector of the HfG, Ulm, Max Bill, resigned from his post when artistic experimentation was ousted by scientific preoccupations.

**Television set on wheels.** 1956, designed by Hans Gugelot and Helmut Müller-Kühn, photographer unknown, BHA. • Hans Gugelot was responsible for product design at the HfG, Ulm. This department was committed, both from a functional and an aesthetic point of view, to the clean lines that were also to make the range of early Braun products so successful.

**"Carousel S-AV 2000" slide projector.** 1963, designed by Hans Gugelot, photograph by Hans-Joachim Bartsch, BHA. • Design was preceded by analysis, which took cultural, economic and functional aspects into account. Members of the new profession of "industrial designer" wanted to influence patterns of production and consumption, and in the case of the "carousel" principle for slide projectors, they succeeded.

of the new Ulm Institute designer was thereafter fully implemented: instruction in colors was dropped; Hans Gugelot and Walter Zeischegg expanded the engineering sciences; and new courses in mathematics, semiotics, ergonomics and systems analysis were added.

The rejection of the art-based heritage of design education inevitably forced the school to re-evaluate its Bauhaus legacy. On this point, Maldonado boldly asserted that the Gropius Bauhaus could no longer serve as the model of industrial education, since its "learning by doing" pedagogy

ignored new scientific research and offered students little preparation for the complicated world of postwar industrial relations. But rather than simply jettisoning Bauhaus history altogether, the young college faculty (including Aicher, Gugelot and Claude Schnaidt) strove to resuscitate Gropius'

**Demonstration at the Schloßplatz in Stuttgart against the closure of the Design College at Ulm, during the exhibition "50 Years Bauhaus."** 1968, photograph by Hans Kinkel, BHA. • Commitment to a new society on the one hand, production commissioned by the industrial masters on the other – when political and financial difficulties increased, this inherent contradiction meant the end of the college.

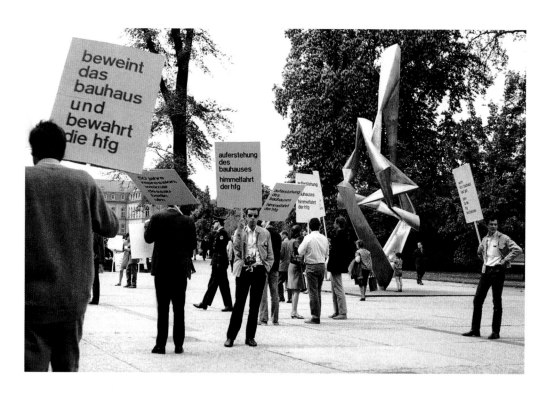

leftist successor at the Dessau Bauhaus, Hannes Meyer. Not only did Meyer advance a quasi-Marxist "Volksbedarf statt Luxusbedarf" (The needs of the people instead of the demands of luxury) design philosophy, he was also responsible for cleansing Bauhaus pedagogy of any lingering artisan ethos and/or expressionist mysticism in favor of a more "secularized" design philosophy grounded in the scientific principles of rational production. Meyer's tenure was thus seen as the most relevant for the postwar period. The fruitfulness of Ulm's new design philosophy was perhaps best illustrated in the Institute's well-known collaboration with the Braun Company. It neatly captured the school's interest in moving away from homey styling toward developing high-tech industrial wares (for example, the famed SK-4 phonograph) based on rational analysis and technical knowledge.

Problems, however, eventually arose at the school. Not only did many faculty and students start to view the "scientization" of the curriculum as excessive, the regional Baden-Württemberg government no longer wanted to fund the Institute's increasing preoccupation with pedagogical experimentation and critical design theory. This was further aggravated by the fact that industrial rationalism itself had lost its cultural authority by the late 1960s, giving rise to a more general "crisis of functionalism" within architecture and design circles. Amid the crisis atmosphere of 1968 the divided Ulm faculty finally decided to disband the school as untenable, thus ending the last concerted postwar effort to radically rethink the role of design in society and to fight the historical elision of industrial culture and the culture industry.

# ulm 10/11

Zeitschrift der Hochschule für Gestaltung          Journal of the Hochschule für Gestaltung

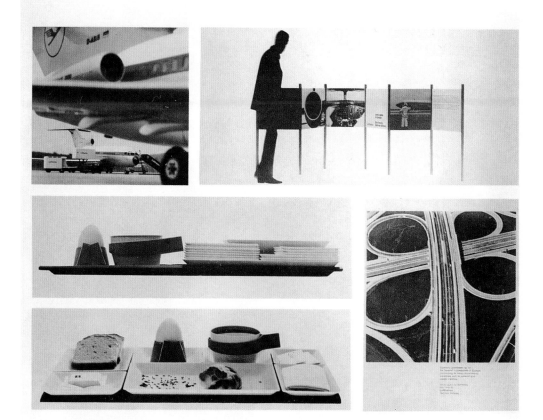

**Title page of the periodical *ulm*, November 10, 1964,** BHA. • This title page presents the branding for Lufthansa developed at the Design College by Otl Aicher, Tomás Gonda, Fritz Querengässer and Nick Roerich. While the Bauhaus demanded clarity and precision in typography, in the expanded subject area of "visual communication" lucidity and variability became the maxims. The rational use of lower-case characters with grotesque fonts was continued, and the simplest forms of notation were employed in an effort to make complex information easy to grasp and recall. But this simplicity soon led to interchangeability in terms of content.

# THEMES

# Daily Life

# The Bauhaus and the World of Technology – Work on Industrial Culture?

Christoph Asendorf

Strictly speaking, the Bauhaus was not founded under the auspices of industrial culture. Work began in 1919 under a different motto: "art and craft – a new unity." This was of course neither an error nor the product of blindness. As a professional from the Werkbund, Gropius knew perfectly well that the importance of craft would be increasingly marginalized in an industrial society. The reference to craft probably owed more to the mood of the period following World War I, with its awareness that industrial planning and technology had added whole new dimensions of horror to the waging of war. Craft signified a change of direction, a recollection of bygone tradition – but not the future. That is why this label also soon disappeared from the Bauhaus's policy statements. From 1922–1923 Gropius used the phrase that was to become closely linked with the Bauhaus idea: "art and technology – a new

unity." However the question of how far this claim was put into practice is not easy to answer.

The Bauhaus was not an institute for the study of the history and theory of technology: its pronouncements left entirely open the questions of what kind of technology was actually regarded as significant, what fields of application were involved, and what were the attendant consequences for specific design work. We are therefore left to look at the works, the architecture and artifacts. The most prominent product was certainly the Bauhaus building itself, and if one looks at it not from an aesthetic point of view but in terms of building technology, one is quickly brought down to earth. The workshop wing, where the heart of modernism beat, could scarcely be heated in winter and was intolerably hot in summer, thanks to its new-style glass curtain-wall. Before long,

there were also complaints about the poor acoustics. Evidently no effort was made to solve these problems. In the Dessau building practical efficiency was neglected in favor of the purity and smoothness of its technological appearance.

At the Bauhaus they proceeded from the assumption (and the same is true of Le Corbusier) that technology and architecture were subject to the same natural laws. Large primary forms were the preferred working material, being regarded as the quintessence of technological rationality. In his programmatic essay *Architectural Prospects*, Le Corbusier commends cubes, cones, spheres, cylinders and pyramids as pure and beautiful, pointing out that they had been used in Egyptian, Greek and Roman architecture. To these he juxtaposed pictures of American grain elevators: pure engineering achievements. These elevators are agglomerations

**Ise Gropius next to the Adler cabriolet.** About 1932, photograph Donath, Presse-Bilder, Berlin, BHA. • The orginal inscription on the back reads: "Frau Professor Gropius was given a special prize for this Adler car, 'the most beautiful car in Berlin' (this was deleted and amended to 'the most beautiful German car')."

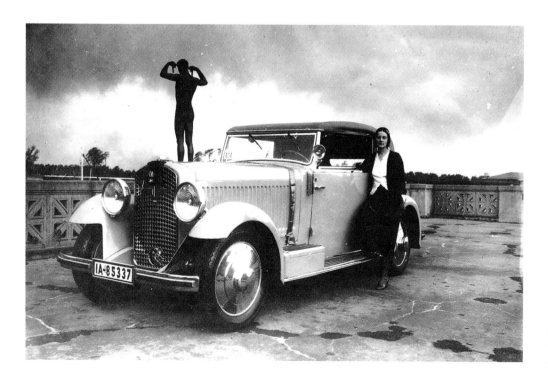

**Umbo (Otto Umbehr), Der rasende Reporter (The Hyperdynamic Reporter), represented by Egon Erwin Kisch.** 1926, reproduction of the original photomontage, BHA. • With one foot in a car, the other in an aircraft, the senses sharpened by means of ear-trumpets and camera, the stomach armed with seismographic apparatus: in this way perception is mechanized, and by mechanical means turned into a press report.

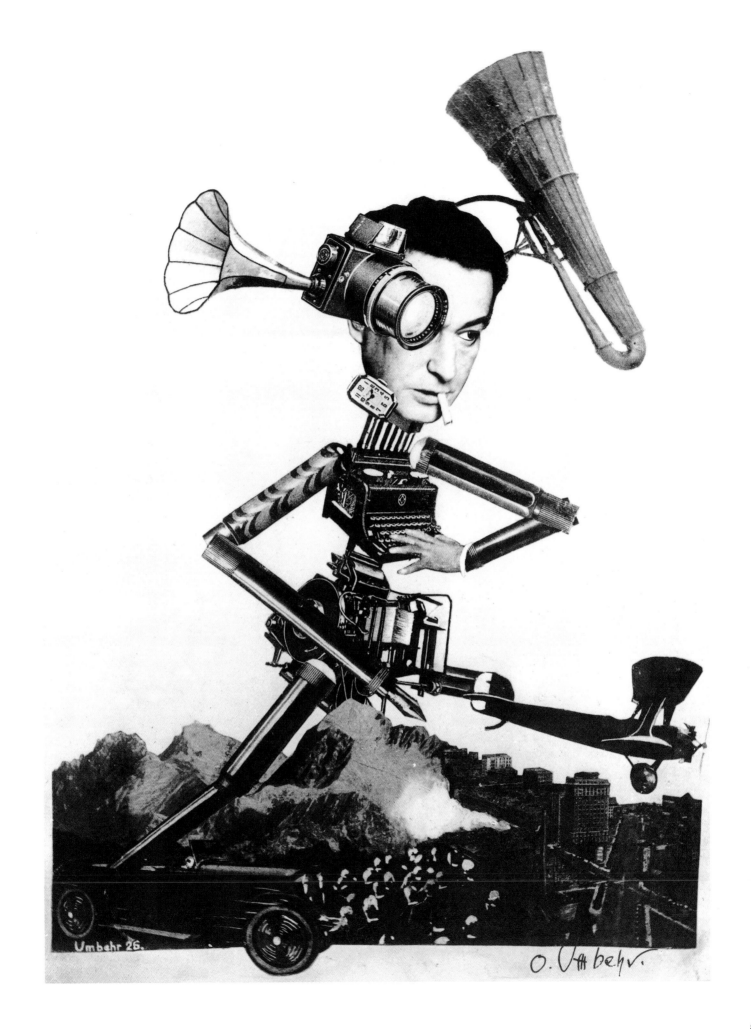

Umbehr 26.

O. Umbehr.

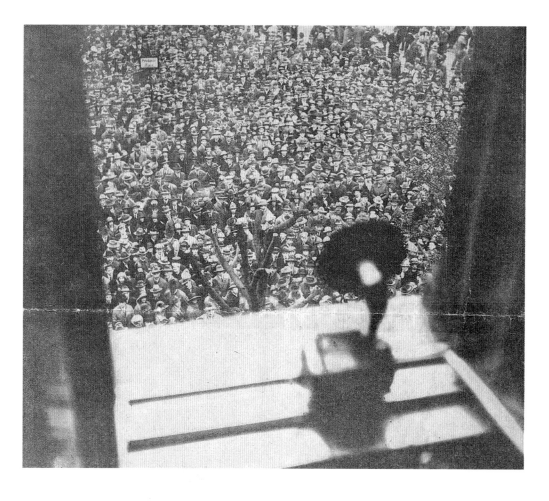

of elementary forms, of cylinders and cubes, and it is precisely this quality which became obligatory for architecture too. Quite apart from the question of how meaningful such a relationship is, the claim of the 1920s architectural avant-garde to be an expression of the machine age is thereby tied to a technology whose constructions are elementary and additive in the same degree. This fundamental dependence on a technologistic formal language was often (as Reyner Banham in particular has pointed out) pushed to the back of its disciples' minds, or left out of the reckoning. With the emergence around 1930 of forms with streamlined casing – to be seen most clearly in aircraft construction – mechanical functionality was no longer directly visible. From then on the avant-garde had to do without this original justification.

Also the widely shared idea that showing the construction constitutes proof of functionality was given up at the end of the decade. In 1931 Wilhelm Lotz, for instance, was talking about concepts which were still perfectly relevant as if they had been at best the expression of a transitional state of affairs. Even so, his article *Die Tarnkappe der Technik* (The Magic Helmet of Technology) appeared in a periodical central to the modern movement, namely *Form*, published by the German Werkbund. The target of his polemical attack was the mannerism of modern architects in making interior pipes and installations visible, along with the general tendency to emphasize the constructional aspect. What was actually important for a house, he argued, was for it to be "built in such a way that it can be lived in easily and practically and that its construction does not entail any disadvantages in terms of its function as a dwelling." What was in fact "practical" was the calming effect of the setting, not its ostentatious overloading with complicated gadgetry. The concept of functionality was detached from that of construction and related to the greatest possible simplicity of use. Lotz did not argue with technology as such, as had the generation before him, but with its present level, characterized above all by a tendency toward minimalism and abstraction. Advanced technology in particular, especially in the field of electrical engineering, could no longer be directly shown. Functions became invisible; an X-ray of a construction would therefore be pointless. Only the components used to operate machines remained visible, along with their protective covering. They were the medium which conveyed the machine's possible functions to the user. With this development the concept of the constructional skeleton providing an analysis was replaced by integrated forms.

On a different level, the controversy surrounding Adler automobiles designed by Gropius also demonstrated the need to move away from elementary, additive design. Moving bodies require different forms from stationary ones. The absolutist notion of a universally valid formal language began to crumble. In 1930 Gropius had designed two versions of a limousine differing only in the number of seats. In a prospectus issued by the firm of Adler, designed by Herbert Bayer, Gropius stated the premises of his procedure. His goal, he said, was to harmonize the external appearance with the logic of the machine's technical functions. But that is a distinctly ambiguous statement. If

one looks at the bodywork of the two cars, one is struck by their decidedly rectangular character, with the additive layout of the engine block and the interior demonstrating a formal repertoire which seems to come straight out of the Bauhaus preliminary course. That was indeed the intention. In a lecture given in 1933, Gropius emphasized that a car and a house, as physical objects, were subject to "the same formal laws." His Adler car, although a luxury product, was also seen as a dwelling place designed for minimal existential requirements. But Gropius, contrary to what he claimed, was following not the functional logic of technology but elementaristic architectural aesthetics, which, however, did have the advantage that a cubic space is the one that can be put to the best use.

The cars appeared on the market at a time when the conditions for harmonizing external appearance and functional technological logic were becoming more complex. The motion factor and the significance of aerodynamics are in direct contrast to the laws of orthogonal spatial economy. This was at the heart of the attacks which Robert Michel launched against Gropius and the Adler cars in the magazine *Die Neue Stadt* (The New City) in 1933: "The same formal laws? We sincerely regret this error." Calculations in the early 1920s had

**László Moholy-Nagy, Sheet from the "1924 18/V" portfolio for Walter Gropius on his 41st birthday, dedicated to him by six Bauhaus masters.** 1924, pencil, Indian ink and watercolor on watercolor paper, sheet 25.4 x 31.7 cm, work 19.1 x 22.0 cm, BHA.

The Bauhaus and Technology

Lösung, ee "der Geburtstags Aufgabe

**Paul Klee, Solution "ee" to the birthday exercise.** 1924, sheet from the "1924 18/V" portfolio for Walter Gropius on his 41st birthday, dedicated to him by six Bauhaus masters, tempera on undercoated card, mounted on card, work 19.4 x 13.5 cm, mount 25.5. x 27.8 cm, BHA.

**Wassily Kandinsky, Sheet from the "1924 18/V" portfolio for Walter Gropius on his 41st birthday, dedicated to him by six Bauhaus masters.** 1924, Indian ink, watercolor and wash on paper, 19.6 x 22.5 cm, BHA.

already shown the clear saving of energy that could be achieved by streamlined bodywork. Since then, the problem for the car builder has been to harmonize the conflicting demands of spatial economy and aerodynamics. Only where this is achieved is it possible to speak of functional efficiency. But the Bauhaus, in contrast, with its elementaristic, additive formal language, whether for buildings or for cars, was projecting an image of technology rather than actually utilizing its principles or making them an integral component of every design.

There are of course individual designs which may be regarded as authentic products of industrial society. Sigfried Giedion has explained this aspect in the context of tubular steel furniture in his epoch-making study of the "dominance of mechanization." But there is only one place at the Bauhaus where a more comprehensive concept of industrial culture is to be found, and that is in the work of László Moholy-Nagy. For example, it was he who drew attention at an early stage to the

fundamental significance of the mass media for a specifically modern experience of the world. For this reason he suggested asking the Bauhaus masters to produce artistic works based on a newspaper photograph showing the results of the 1924 Reichstag elections being announced on the radio. This led to the portfolio presented to Gropius on his 41st birthday. Moholy then presented a synthesis of his thinking in *von material zu architektur* (from material to architecture) which appeared in 1929 and was the last of the "Bauhaus books." Here, in a way that had not been seen before, he amalgamated artistic material with material from the realm of modern living, which he considered with a freedom from prejudice not to be found among his colleagues. Along with magazine photographs and film stills there are more than a dozen photographs from the sphere of air travel – all testimony to the thesis that modern perceptual space no longer knows any separation but must be understood as a perpetual interplay of

relationships between interpenetrating objects and events. In Banham's apt words, Moholy's attitude proves to be "a kind of indeterministic functionalism." The developmental logic to which Moholy subjects his image of the body, with a tendency to increasing dematerialization, remains indebted to the ideas of the early 1920s, when the aesthetic and the technological ideal appeared to meet in the image of the elementary framework of the naked skeleton. But it is in the area of functions rather than shapes that the model of the mechanical is replaced by a more complex, elastic, process-based conception.

Moholy's way of presenting his arguments can be seen with exemplary clarity in his treatment of the subjects of "light" and "space." In the case of light, there are ten pages ranging from works of art, via movies and photographic time exposures of urban spaces at night, to the technology of neon advertisments. They show, quickly and clearly, that in modern civilization "a new area of expression" has been opened

up through the virtual volumes created by light. This element of enrichment applies in an even more comprehensive sense to the modes of spatial perception in general. It becomes possible to grasp space in all its dimensions. Frontiers begin to break down. Moholy demonstrates this in the last chapter of his book with a suggestive sequence of photos ranging thematically over the entire contemporary living environment. They include major sporting events along with traffic, industry and modern architecture. What is interesting is what is implicitly conveyed about the role of the arts. Their autonomy appears to be at the disposal of others. They represent one mode of dealing with contemporary reality enjoying equal rights with other modes. The moviegoers, sportsmen, or an artist who designs "permeable" architecture – they all find themselves, actively or reciprocally, in a world of "condensed spatial experience" in which a "constant fluctuation" has taken the place of static relationships.

If one surveys the relationship of the Bauhaus to the world of technology, two positions emerge. One comprises the directors, notwithstanding all the disagreements between them.

**Oskar Schlemmer, Abstract Figure on the Left (Figure "S"). 1923, sheet from the "1924 18/V" portfolio for Walter Gropius on his 41st birthday, dedicated to him by six Bauhaus masters,** Indian ink and watercolor over pencil on card, 36.0 x 24.8 cm, BHA.

**Georg Muche, Sheet from the "1924 18/V" portfolio for Walter Gropius on his 41st birthday, dedicated to him by six Bauhaus masters.** 1924, pencil, Indian ink and watercolor on paper, 25.8 x 26.1 cm, BHA.

Konrad Wünsche, in his small, very compact book about the Bauhaus, has collected some of their statements, which all amount to the same thing: to combat chaos, to create order and harmony. That is, as it were, the semi-official position of enlightened contemporaries. Friedrich Dessauer, the author of the successful book *Philosophie der Technik* (Philosophy of Technology), also believed, as he explained in 1929 when he was the principal speaker at the Werkbund exhibition in Breslau, that technology had brought intellect and order into nature. Moholy had little to say on matters such as this. Fundamental considerations were for him less important than the heavy stress on interaction, circulation and interpenetration. This stance, unafraid of dissonances, brings him very close to the empirical world of the big cities in the era of New Functionalism. He continued the metropolitan strand in his work, as one might put it, down to his major theoretical work *Vision in Motion*. When it was published in 1947, it provided the basis for new developments. Its first readers included the artists of the Independent Group who at that time were formulating the concept of Pop Art.

**Lyonel Feininger, Sheet from the "1924 18/V" portfolio for Walter Gropius on his 41st birthday, dedicated to him by six Bauhaus masters.** 1924, Indian ink and watercolor on Japan paper, sheet 28.5 x 31.5 cm, work 19.6 x 22.5 cm, BHA.

# Body Concepts of the Modernists at the Bauhaus

Ute Ackermann

"If you think yellow, then it makes tea, if you think brown, then it makes coffee." That was the cheerfully metaphysical instruction on how to use a pot given to Gertrud Grunow as a Christmas present in 1922. This single sentence very aptly summarizes the teachings of the woman who was the "spiritual guardian" of the Weimar Bauhaus but who, with only a few exceptions, has attracted little attention hitherto in writings about the Bauhaus. One is even given the impression that the doctrine of harmonization was a matter of temporary metaphysical confusion in the early days of the Bauhaus, and therefore highly suspect. But this assessment proves to be fundamentally incorrect. Gertrud Grunow's work at the Bauhaus was the starting point for the development of a physical awareness and delight in movement that stand out in numerous photographs, especially from the Dessau period of the Bauhaus. They show young people enthusiastically pursuing sporting activities, convincingly refuting the widespread image of the sluggish, idle bohemian. Modern life, modern building and design seem to enter into a symbiosis with a healthy, physically aware lifestyle. Gymnastics were performed on the roof garden of the Preller-haus in Dessau. The body was liberated from the stuffy gloom of club gymnasiums. Between heaven and earth: man in pure, limpid and harmonious motion. The perfect working of the physical machine had become a symbol of the predictable and natural laws of design and life. This feeling for life was never far from the surface at the Dessau Bauhaus. Karla Grosch taught sport and gymnastics there from 1928 to 1932. She is particularly

**Portrait of Gertrud Grunow at the piano.** 1917, photographer unknown, BHA. • Using a system of correspondences between musical notes and colors, Grunow, a music teacher, taught pupils to concentrate on a particular color, with or without music, and to let themselves be intuitively guided by it. This "educational gymnastics" was intended to lead to a realization of the natural laws governing each individual, to encourage all-round development and ultimately to point the way to "organic" design.

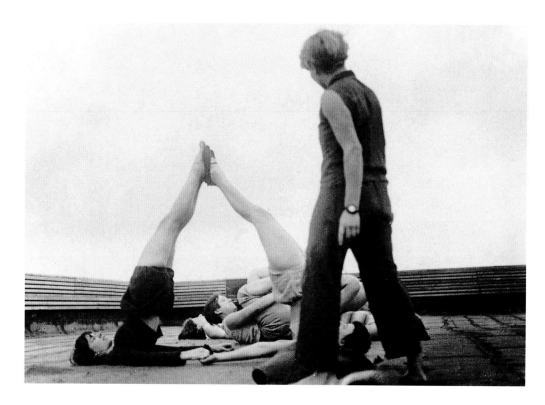

**Karla Grosch with female students performing floor exercises on the roof of the Preller-haus in Dessau.** About 1930, photograph by T. Lux Feiniger, BHA. • The mystical exercise of body and mind, along with psychologically oriented physical education, had long been abandoned when sport became one of the many activities to be pursued.

well known for her extraordinarily inventive, technically perfect contributions to the dance events performed on the Bauhaus stage. A "healthy mind" in a healthy body was the ideal in the late 1920s. Before long it was to loom over Europe in the form of a monstrous idol, blond and blue-eyed, of German heroism, "hard as Krupp steel, swift as a greyhound and tough as leather." However at the time the men and women of the Bauhaus, despite or because of their obvious mental and physical health, joined the ranks of the outlawed and banished and were stigmatized as being highly un-German.

As early as autumn 1919, that is shortly after the Bauhaus had begun its teaching activities, a certain Fräulein Margarethe Trenkel from Weimar approached Walter Gropius with an invitation to a "gymnastics lesson before invited guests." Her aim was not only to train the body but at the same time to impart an experience of it which would be of direct

artistic value. Although Gropius was unable to accept the invitation, he did express great interest in this kind of movement training. About 30 Bauhaus students enrolled for the gymnastics classes. Fräulein Trenkel informed the Bauhaus director of this success with the words: "Perhaps in the course of the term I will be able to present to you in person the 'Bauhaus men and women trained in freedom'" (Thuringian Hauptstaatsarchiv in Weimar; Staatliches Bauhaus [Thuringian State Archive in Weimar, State Bauhaus] No. 129, p. 4). But "training" the Bauhaus students was in all probability a very arduous business, and it is reasonable to suppose that the willful students from Kunstschulstraße remained untamed and soon looked for exercise elsewhere. This is borne out by the fact that in November 1919 Gropius asked the headmaster of the Wilhelm Ernst grammar school for permission for Bauhaus students to use the school gymnasium. According to

**Female students performing floor exercises on the roof of the Prellerhaus in Dessau.** About 1930, photograph by T. Lux Feiniger, BHA. • Exercises were varied according to sex, and intended to counterbalance creative intellectual work. But in the timetable gymnastics ranked well behind the creative subjects.

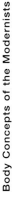

Body Concepts of the Modernists

**Johannes Itten, Sheet with text after Jakob Böhme, "Einatmen, ausatmen" (Breathe in, breathe out).** 1922, crayons and watercolor on paper, 30.9 x 30.5 cm, Itten-Archiv, Zürich. • The body, an equal in the trinity formed with mind and soul. It is malleable and must be treated cleanly. Easy breathing was regarded as a prerequisite for the harmonious integration of life, experience, knowledge and creativity. Taking as his starting point the body, as it tenses and relaxes during breathing, Itten taught his students to perceive and deal with contrasts.

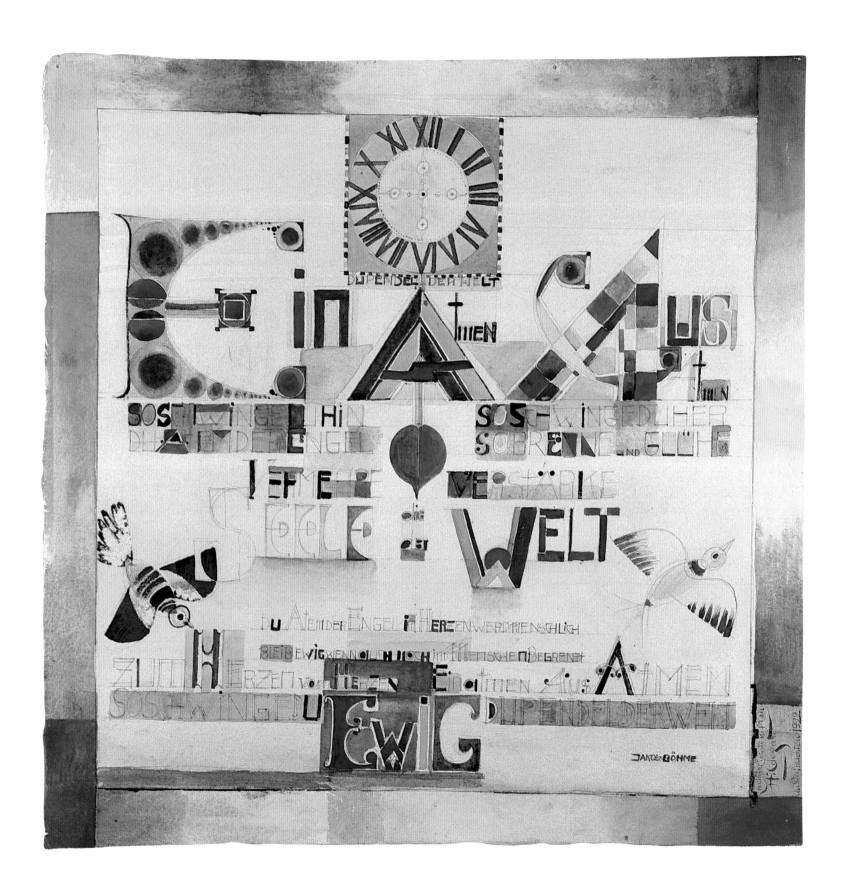

Gropius's letter to Kötschau, the headmaster, it was a question of 30 young men who wanted to form their own gymnastics team led by a student, Erich Kloidt. The students' request to Gropius was indeed signed by 30 students, but at least five of the alleged "young men" were women. Clearly the prospects of allowing the school gymnasium to be used for the activities of a mixed-sex gymnastics team from the Bauhaus, with its extremely dubious reputation, were extremely poor and had no chance at all unless the five women students changed sex immediately, at least on paper.

In any event, and despite such initiatives, sport at the Bauhaus remained a dream for the time being and student sporting activity was left to the ingenuity of the individual. The main problem was that, like all public institutions, the grammar school was suffering from the acute postwar coal shortage and had to keep its gymnasium closed during the winter months. Gropius's aim of educating people in a communal way of life as the shared basis for a new art certainly included physical education. This was already clear in early 1920 when, in conversation with Poelzig, he mentioned links between the Bauhaus and a school of gymnastics. The concept of the body in the early Weimar years was based on current postwar metaphysical, religious and *Lebensreform* ideas; this was fundamentally different from the Bauhaus of the later Dessau period.

The direct connection between physical and mental harmony as the basis of creative potential was also the theoretical center of the preliminary course in Weimar. It is therefore not surprising that it was Joseph Itten whom Gertrud Grunow approached in the autumn of 1919 asking for permission to give a lecture at the Bauhaus on "the education of man through his eyes and ears." Following the lecture, Itten encouraged his students to attend one of her courses, for which he himself also enrolled. Grunow provided a draft program for harmonizing the personality by means of sound, color and movement. It was an obvious decision to let her develop her teaching methods, which had already been tried out, at the Bauhaus while at the same time making use of the results of her work for the development of the Bauhaus students and the preliminary course. The beginning of Gertrud Grunow's work at the Bauhaus coincided approximately

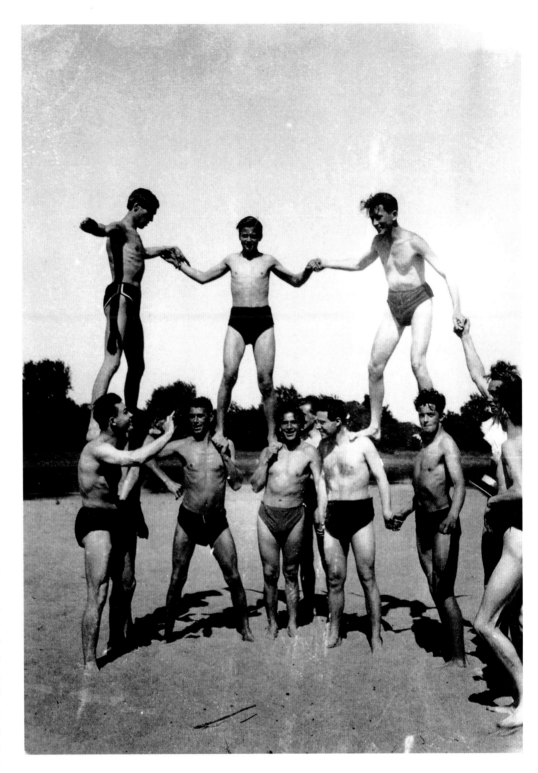

**Members of the Bauhaus on the beach between the Elbe and the Mulde.** About 1927, photograph by Irene Bayer (?), BHA. • Young masters and students enjoying their leisure in an artistic manner: everyone is part of the joint edifice.

**A woman dancing in Gertrud Grunow's class.** About 1918, photographer unknown, BHA. • The second exercise in the lesson was: sound, A/F sharp/E/F sharp/A; color, blue-violet; posture, beginning of dance movement.

**Female student playing sport.** About 1925, photograph by Irene Bayer, J. Paul Getty Museum, Los Angeles. • Between heaven and earth: the human being in lucid and harmonious movement.

with the introduction of the preliminary course in November 1919.

The starting point for Grunow's theories was the discovery of a fundamental relationship between musical notes and bodily movements or postures. From her observations, Grunow, who was a trained singing teacher, deduced that movement followed, with the fixity of a natural law, the enhanced internal perception of color or sound. Via the tonus theory of perception, a practical teaching method evolved of the kind that Gertrud Grunow had been applying to musical education since about 1910. The aim was to create a sense of balance by way of the inner experience of sound and color, that is to say to bring harmony and order into man's vital powers. Thus harmonization theory, as it was called from 1923 onward, pursued the same aims as

the Bauhaus preliminary course. The intention was that after completing the course the student should be able to select the workshop that suited him or her. With the objective of discovering and developing specific talents, Gertrud Grunow transferred the connection between color and music to the qualities of materials and integrated the development of a feeling for materials into the logical sequence of synaesthetic laws.

This landed Gertrud Grunow with an enormous workload because not only were her classes attended by students taking the preliminary course, but harmonization theory also continued to be taught as a subsidiary subject throughout the entire duration of the Bauhaus course. This meant that she was teaching every day from 8 o'clock in the morning until the evening hours. Gertrud Grunow's meager

monthly salary of 200 Marks (in later years 600 and 900 Marks) was typical of her idealism. It cannot be said with certainty to what extent attendance at the harmonization theory course was compulsory for all Bauhaus students. However, Gertrud Grunow's reports to the council of masters give the impression that to the greatest possible extent it was left to the students themselves to decide how far they attended her classes.

In general, Gertrud Grunow operated outside the fixed organizational structure of the Bauhaus. Although she taught at the school from 1919, it was not until 1922 that harmonization theory was mentioned in the college statutes. The integration of this unusual subject into the otherwise consistent division of Bauhaus teaching into the two areas of form theory and work theory evidently caused considerable difficulty. The fact that Grunow's teaching was not established as part of the college statutes until 1922 disproves the widespread view that it was a more or less integral part of Itten's preliminary course with hardly any independent significance. It was in fact made "official" at a time when the Bauhaus program was beginning its shift toward industry and Itten was increasingly withdrawing from the Bauhaus. There were of course obvious correspondences between his theory and Grunow's. But although they concurred in many points, there were also substantial differences between them. The fact that

Gertrud Grunow only ever gave individual tuition – which at first sight might appear to be merely a technical point – can actually be seen, on closer examination, to be a matter of fundamental importance, for her work was exclusively oriented toward the individual. In Itten's preliminary course, on the other hand, the human and religious community had played a fundamental part at least since his intensive study of Mazdaznan.

But the example of the student Lotti Weiß shows that convinced adherents of Mazdaznan did not by any means always become successfully harmonized Bauhaus members. She joined the Bauhaus as a follower of Itten in the winter semester of 1922, and was idolized by the Mazdaznan disciples as a purified, harmonious believer. At the end of the semester, after completion of the preliminary course, when the council of masters had to decide on the final acceptance of students, Gertrud Grunow usually submitted a written report on their development in her classes. In her assessment of Lotti Weiß she wrote: "Fräulein Weiß only attended my class a few times. Because I detect in her a particular weakness as regards feeling for materials, and because real material design necessarily demands serious and regular work, especially in such a case, I dismissed Fräulein Weiß, for she was an amiable person rather than a student who attended regularly and seriously" (Thuringian State Archive in Weimar, State Bauhaus No. 13, p. 25). In this case the Mazdaznan

serenity vis-à-vis the world was evidently more of a hindrance when it came to serious work on inner harmony.

After the first public presentation of her harmonization theory at the Bauhaus in her essay *Der Aufbau der lebendigen Form durch Farbe, Form und Ton* (The Construction of Living Form Using Color, Form and Music), she became the person the Weimar public most loved to hate. A psychopathologist was commissioned by the Vereinigung zur Pflege deutscher Kultur in Thüringen (Association for the Maintenance of German Culture in Thuringia) to produce a public critique of her theory. In May 1924 the newspaper *Weimarer Zeitung* was able to report on the dreadful consequences of harmonization theory: "... the method of teaching seemed so to affect the pupils' nerves that medical help was needed for the frequent fainting fits and convulsions. Indeed, in one well-known case the victim of this method ended up fit only for the lunatic asylum" (quoted from Cornelius Steckner, *Zur Ästhetik des Bauhauses* [On the Aesthetics of the Bauhaus], Stuttgart, 1985, p. 53). Gertrud Grunow's enemies were not afraid of accusing her of employing the illegal methods of hypnotic shock treatment, so branding her as a dangerous criminal. In the end these attacks, which were aimed at inflicting severe damage on the Bauhaus, prevented her from being appointed to one of the posts of master that became vacant in 1923, and ultimately brought about her departure in the spring of 1924.

# Women at the Bauhaus – a Myth of Emancipation

Anja Baumhoff

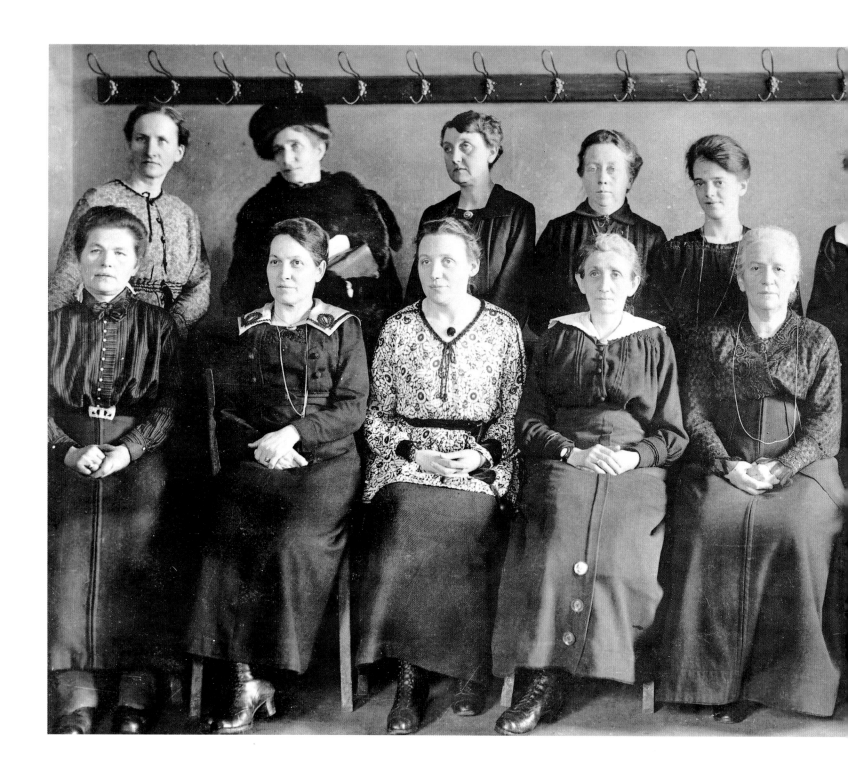

**The first women elected to the Weimar National Assembly.** February 1919, photographer unknown, Ullstein picture service. • After the introduction of the vote for women, female representatives had seats in a German parliament for the first time. Pictured here are the women of the SPD (Social Democrat) parliamentary group.

The Bauhaus is to this day still regarded as the nucleus of the early 20th-century German avant-garde, including relations between the sexes. There are memoirs that give detailed descriptions of life and love in Weimar, Dessau and Berlin. Many art historians have succumbed to the glamor of the period and the aura of famous artists at the college. But in most cases they have not looked closely enough, and the myth remained unchallenged for a long time. The picture is now slowly changing, and the Bauhaus need no longer be made to serve as an exemplary component of the first German democracy, but may be allowed to show its dark as well as its bright side. And it was on the dark side that women, of whom there were a considerable number, around a third of the Bauhaus membership, were particularly to be found.

They all came to the Bauhaus expecting to be able to take full advantage there of the new opportunities for women. The democratic constitution of the Weimar Republic guaranteed women, for the first time, the right to study and the right to vote. During the war, on the home front, they had replaced the men who had been called up in many areas, and had thereby acquired a new self-confidence. Even if demobilization proved a reverse for many, they had still experienced enough to know that the so-called weaker sex could hold its own alongside men. In the process, the roles of the sexes had become very clear, and in cultural life they provided plenty of material for amusement. In the postwar period, women in suits or uniform possessed for both sexes an androgynous charm, admirably personified by Marlene Dietrich. War had, in part, modernized society.

The experience of crisis made life in the Republic and at the Bauhaus more extreme and more animated. Many people had lost their assets, their relatives or their friends. The Bauhaus member Else Mögelin, for example, lost her entire circle of friends in the war and looked for new friends at the sociable Bauhaus. If one were still alive, one lived for the "here and now." Cabaret and entertainment provided the distraction people sought, and, especially in densely populated urban areas, there was a wide range on offer. The center of the whole pleasure cult was definitely the cinema. By the end of the 1920s some six million tickets on average were being sold every week.

In this period there were a large number of new occupations for women to choose from. It had now become possible for women to work as doctors or lawyers. A broad class of lower-level salaried employees had come into being, including secretaries, salesgirls, female telephonists and office workers. But although paid work had become an economic necessity for many women, gender-specific role models remained relatively stable, the image of the housewife and mother retaining its unquestioned validity.

Women of exceptional talent were especially to be found in the sphere of politics: Rosa Luxemburg and Clara Zetkin, for example, or other interesting figures such as Minna Cauer, Alice Salomon and Gertrud Bäumer. In science women were also making their way toward integration. They had a long road ahead of them, however, and even today not more than

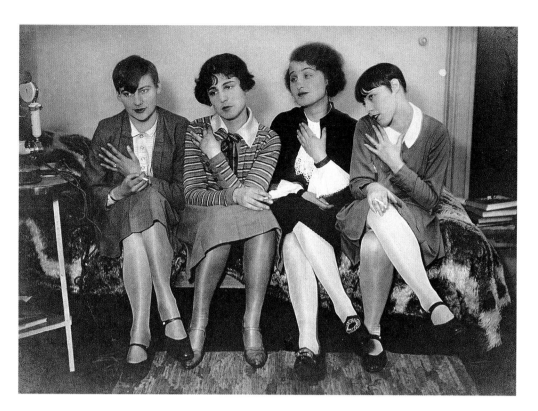

**Untitled (Girls posing).** 1927, photograph by Umbo (Otto Umbehr) and Paul Citroën, Berlinische Galerie, Landesmuseum für moderne Kunst, Photographie und Architektur. • "With head, heart and hand," said Herbert Bayer – "and with legs in silk stockings," claimed Umbo and Citroën.

six percent of professors are female. The pioneers included Marie Curie and Anna Freud. Women were at last able to prove that they could combine competence with femininity.

Women at the Bauhaus also had to prove this. In the early months, few people were delighted to find such a high proportion of women at the college. The female students at the two previous colleges, the Grand Ducal School of Fine Art and the Grand Ducal School of Arts and Crafts, had had those institutions almost to themselves during World War I. But now they were confronted with the young men returning from the war. The Bauhaus became a hive of activity. There were lively discussions about the meaning of life, the laws of art and the universe. They suffered hunger in those crisis-ridden postwar years but tried to find the right personal direction for their lives, partly through artistic work, partly through the Persian sectarian doctrine of Mazdaznan which was so effectively embodied in the charismatic Bauhaus teacher Johannes Itten. Particularly in the Weimar years, a somewhat relaxed style of living predominated at the Bauhaus, stemming from young people's associations such as the Wandervögel, with its roots in the *Lebensreform* movement, from oriental philosophy and, of course, from Nietzsche's writings. After the war, the young men who returned home

were highly motivated to make something of their lives, but in some cases they also badly lacked a sense of direction. In the founding director Walter Gropius, who had seen lengthy service during the war and had been decorated a number of times, the students found a willing listener to their questions and problems. As a result he made a strong and successful impression in his efforts to integrate the very heterogeneous student body.

At the Bauhaus it was soon realized that the war had been a crucial experience which the two sexes had lived through in very different ways. Walter Gropius wanted to forge a closer unity among the students. The principal means of doing this were the many parties held at the college at every opportunity. In addition to traditional occasions such as Christmas or New Year, the birthdays of the Bauhaus masters were celebrated, and, for example, the granting of German citizenship to Kandinsky and his wife. As a rule, these parties were organized by Oskar Schlemmer, the painter and master in charge of the Bauhaus Theater Group. Students and masters designed their costumes to Schlemmer's specifications, made them themselves, and took on appropriate roles.

The women joined enthusiastically in these activities. However, the exclusive meetings of the council of masters, which took place as a

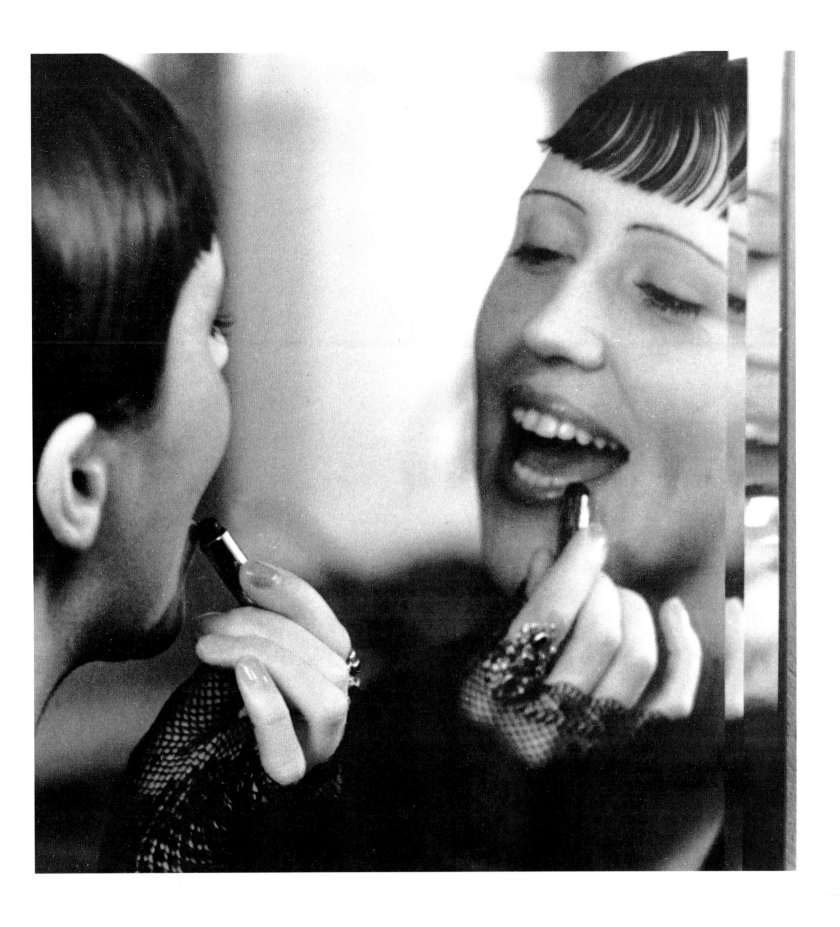

**Eckstein mit Lippenstift (Eckstein with Lipstick).** 1930, photograph by Ellen Auerbach, BHA. • A mirror-image of the young generation – here the artist Eckstein – cheeky and optimistic, but with multiple ambiguities.

Helfen Sie mit!

**Marianne Brandt, Helfen Sie mit! (Join in and Help!).** 1926, photocollage, 68.3 x 50.3 cm, Kupferstich-Kabinett, Staatliche Kunstsammlungen, Dresden. • On the back of her photocollage Marianne Brandt wrote the title *Die Frauenbewegte* (The woman moved). Did "Join in and Help!" mean to give women equal rights? Brandt, a designer and metalworker of genius, would have entirely deserved to be made the second female Bauhaus master after Gunta Stölzl.

**Rudolf Baschant, Portrait of Martha Erps.** 1921, etching, sheet 15.5 x 12.5 cm, print 10.9 x 5.8 cm, BHA. • "Of the beauty of the female Bauhaus knight." The style of the early Bauhaus was expressionist and youthful in its presentation.

**Woman in underwear.** Undated, photograph by Hilde Hubbuch, Getty Research Center, Research Library. • Glamor was not frowned on at the reform-minded Bauhaus.

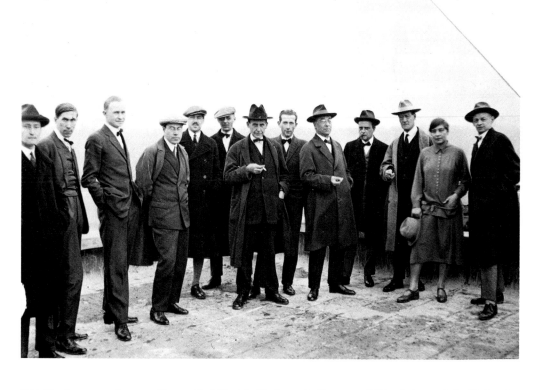

**The Bauhaus masters on the roof of the Prellerhaus in Dessau.** 1926, photograph by Walter Gropius (with self timer), BHA. • Frau Stölzl's colleagues took her courteously into their midst as the representative of female weaving and macramé, but she was not really accepted as a member of the teaching staff.

rule without craft masters or students, soon pointed in a different direction. The senior masters of the Bauhaus, not a single one of whom was a woman, decided early in 1920 to establish a women's class. This made it possible to reserve the small number of workshop places for the male students. The masters were aware that women's prospects of practicing their profession after leaving the Bauhaus were uncertain, for the prejudices of the age made it difficult for them to work in senior positions. This was also Walter Gropius's view of the matter, as he explained in a letter: "In our experience it is not advisable for women to work in heavy craft areas such as cabinetmaking, etc. For this reason a distinct women's department is increasingly developing at the Bauhaus, occupied in particular with textile work. The bookbinding and pottery departments also accept women. We are fundamentally opposed to the training of women as architects" (letter to Annie Weil dated February 23, 1921). It is true that the Bauhaus masters were not in general opposed to the sexes being treated evenly, but wherever possible they did not want it to cost them anything. This was in spite of the fact that the first college prospectus clearly stated: "Any

person of good character whose previous education is deemed adequate by the council of masters will be accepted without regard to age or sex...." (program of the State Bauhaus in Weimar, April 1919). This statement remained in the prospectus despite the establishment of a separate workshop for women in 1920. It could have damaged the college's reputation to have had to stand by its gender policy in public.

Although under the new constitution women in Germany had also acquired the right to vote, there was no desire at the Bauhaus to allow them a great deal of choice. In deciding on a workshop, as they had to do after completing the preliminary course, they were advised and influenced, as some of the male students also were. Thus Itten's preliminary course sometimes produced the assessment that women allegedly showed a "weakness" in three-dimensional visualization and would therefore do better to devote their studies to two-dimensional surfaces. This led almost unavoidably to the choice of the weaving workshop with its two-dimensional artifacts. Wall painting was also centrally concerned with surfaces, but under its craft master Carl Schlemmer it was never able to accommodate a woman for any length of

**Cleaning woman at the Bauhaus.** About 1931, photograph by Irena Blühova, BHA. • At the Bauhaus photojournalism was practiced in the style of New Functionalism. Blühova was one of the young documentary makers of the Weimar period.

time. There were hardly any women painters at the Bauhaus, and it was not until 1928 that the college could afford to open a photography workshop. After many female students had joined the women's class, it was soon amalgamated with the weaving workshop. The class had no particular objective, and no description of its activities is known to exist. Even as late as 1921, that is to say two years after the establishment of the college, there was talk of excluding women altogether (Oskar Schlemmer's diary, March 2, 1921). In that same year the last German academy of art, in Munich, opened its doors to the female sex. As to the reason why such a retrograde step was considered at the Bauhaus, one can only speculate. It seems that for a long time the masters did not succeed in redirecting all the female students into the women's class. To begin with, there were a large number of women in the wood-work, bookbinding and pottery workshops. There was a long-standing tension between their professional ambitions and love of experimentation and the traditional utilitarian mentality of the Bauhaus teachers as far as women were concerned. Since the council of masters, the highest self-management body of the college, did not discuss these questions in public and also concealed its gender policy as far as was feasible, there was very little movement in the college on this issue. Only public discussion could have changed anything.

The women at the Bauhaus had different ways of dealing with the problem, but the general tendency was for the female students to conclude that they had failed personally if the Bauhaus masters did not accede to their wishes concerning the choice of a workshop or occupation, particularly as lack of aptitude was often used an an argument. Legally speaking, they could

**Female weavers at the Bauhaus.** About 1927, photograph by Lotte Beese, BHA. • Emancipation of the former women's class. Gunta Stölzl, wearing a tie, is standing next to the craft master of the weaving workshop. Bottom right of the picture: Annie Albers.

**Artist unknown, Female nude.** Undated, pencil on paper, 40.8 x 28.7 cm, Misawa Bauhaus Collection, Misawa Homes Co. Ltd., Tokyo. • Not many free nude pictures are known, and this one, which thematicizes the bobbed hairstyle of the period, has rarity value.

**Group of Bauhaus members.** About 1929, photograph by T. Lux Feiniger, BHA. • In the student community, whether experimenting in the workshop or in their leisure time, the equality of the sexes was for the most part no problem.

**Marcel Breuer and his "Harem."** 1927, photograph by Erich Consemüller, private owner in Bremen. • The wildly disreputable appearance of the ladies belies the title of this tableau. Left to right, Marthe Erps-Breuer, Katt Both and Ruth Hollós as lobbyists for women's new power.

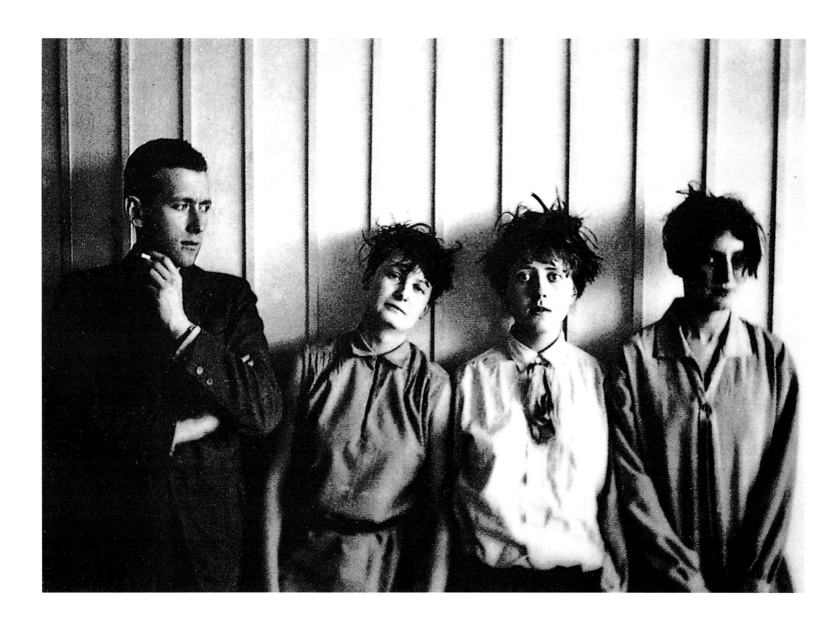

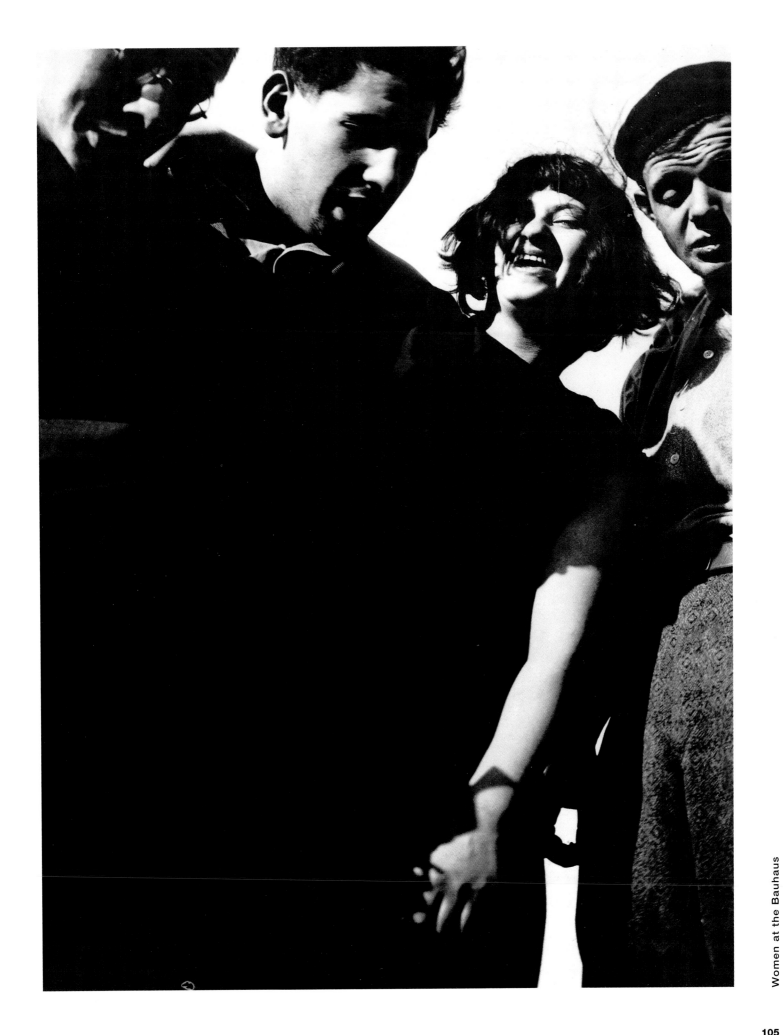

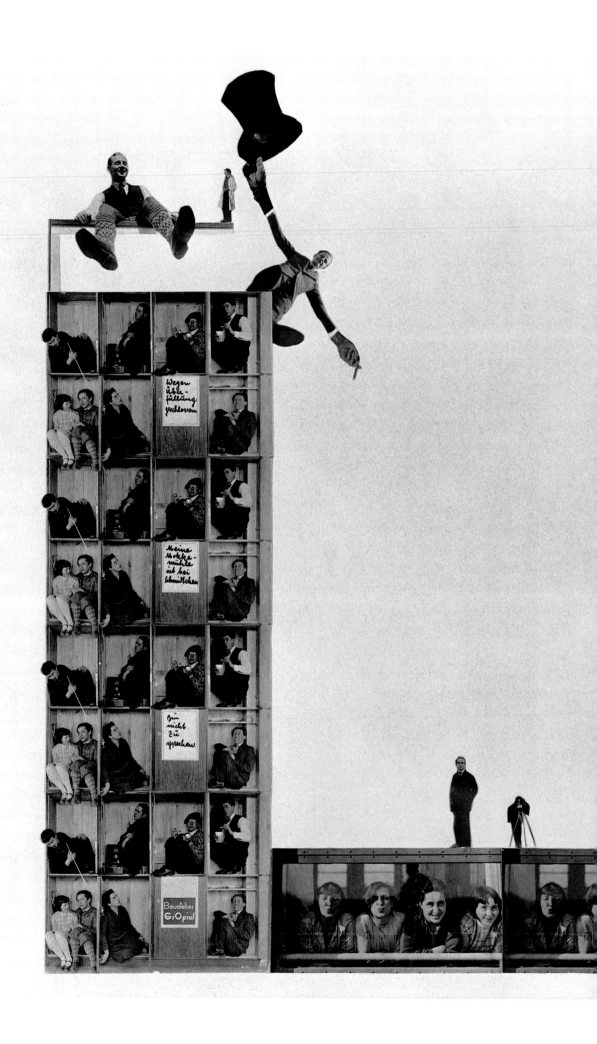

„erweiterung"
des prellerhauses

have insisted on their right to choose, especially as no women's class was envisaged in the Bauhaus statutes. That is why it was part of the masters' strategy when advising students, as was obligatory, to cast doubt on the qualifications of female students.

The case of Johanna Hummel is an interesting one. Her application to be admitted to the college was answered by Gropius in a positive spirit. He wrote that she would be welcome in the metal workshop, and that technically speaking her work was excellent. But he also told her that he could not permit her to continue selling her products at the same time, as these were not yet artistically mature. "You must completely put aside what you have done up till now in order to place yourself under the guidance of our master" (letter to Johanna Hummel, December 8, 1919). The master in question was Naum Slutzky, who had himself not yet passed his craft guild master's examination and was technically speaking at a similar standard to the journeywoman Hummel. She would undoubtedly have been a gifted student for the metal workshop, but, as she informed Gropius, she could not afford to study at the Bauhaus unless she either had a grant or was able to sell her products. She was therefore offered a place, even though it was known that the strict conditions imposed on her would prevent her from joining the Bauhaus. Meanwhile at the Bauhaus itself female students had to deal with male defensive behavior. A detailed account of a case

in point has been given by Marianne Brandt: "At first I was not exactly made welcome: the general opinion was that the metal workshop was no place for a woman. They admitted this to me later. They gave expression to this opinion by giving me mainly tedious and laborious work to do. The number of bumps that I forced myself with great endurance to beat out of brittle new silver on the swage block – telling myself that that was how it had to be and that everything is difficult to start with!" ("Letter to the Young Generation" in Eckhardt Neumann [ed.], *Bauhaus und Bauhäusler. Erinnerungen und Bekenntnisse* (The Bauhaus and its Members. Memoirs and Confessions), Cologne, 1985, p. 158).

Nevertheless she did manage to find her feet in the workshop, perhaps partly because she was older and married and had already been trained as a painter. Moreover her exceptional talent was discovered and encouraged by László Moholy-Nagy, the Bauhaus master and head of the metal workshop. Patronage such as this was the surest way for her to establish herself in a male-dominated field. Marianne Brandt's modern artifacts with their timeless appearance can still be obtained today, and she has now come to rival the weaver Gunta Stölzl, formerly the sole female young master at the Bauhaus, as its token woman. Marianne Brandt was recently honored as a representative of good German design by the issue of a special German postage stamp.

**Edmund Collein, Extension to the Prellerhaus.** 1928, sheet from the portfolio "9 jahre bauhaus. eine chronik" (9 years of bauhaus. a chronicle), photocollage, 41.6 x 59.2 cm, BHA. • The studio house in Dessau, a block full of singles and couples, but also a whole wing with female weavers behind glass. A myth of emancipation?

Women at the Bauhaus

# The Bauhaus – an Intimate Portrait

Ute Ackermann

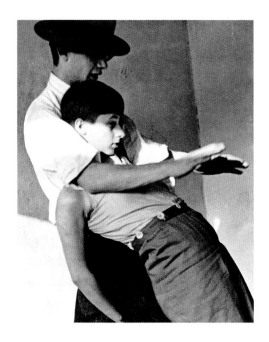

**Albert Mentzel and Lotte Rothschild.** About 1930, photograph by Etel Mittag-Fodor, BHA. • In an exhibition catalog – devoted to Albert Flocon-Mentzel among others – the atmosphere here is described as a "dance in the manner of the Threepenny Opera."

**Double portrait of Ilse Fehling and Nicol Wassilieff.** 1927, photograph by Umbo (Otto Umbehr), BHA. • To turn the world upside down together in the evening, to stand on one's head and so spread irritation among "the others," represents the other side of a community spirit which in the daytime is concerned with maintaining aesthetic order.

"And then the logical downfall ... in the social life of the Bauhaus community!!! Even for a German who is very broadminded in these matters, as long as some sense of the original national ethos lives on, that certain reticence required by social tact must be considered an indispensable prime requirement to be made of outsiders such as these. But instead, this association has seen fit to adopt a blatantly provocative demeanor even in the most private matters. One need not adduce, for instance, the cases of Bauhaus people of both sexes disporting themselves naked somewhere in the great outdoors, and regarding this as so natural that they were not even surprised when other people somehow chanced upon them. Nor need one join in the accusations relating to those cases where such unusually free behavior of the two sexes together led in due course for the female parties involved to become mothers. But I cannot help but castigate it as the product of an utterly depraved sensibility and, furthermore, as the outcome of the destructive methods as regards teaching and upbringing at the Bauhaus, when such motherhood is also publicly celebrated with all manner of ballyhoo, when, for example, a cradle is made in the Bauhaus workshops by the young men involved and then taken in a kind of triumphal procession to where the victim lives, as has been known to occur. Anyone who is capable of forming a clear mental picture of the psychological effects of such events, must urgently warn everybody not to allow a son, let alone a daughter, to enter this institute ...."

With this lengthy warning the *Weimarische Zeitung* of June 13, 1924 made a serious appeal to responsible national-minded German parents. The Bauhaus as a den of vice, with the inevitable consequence of unwanted pregnancies. Guard your children from these goings-on! The question which inevitably comes to mind in this connection – Bauhaus or disorderly house? – is of interest today as it was at the time, but it is treated with extreme reticence, indeed shunned as positively indiscreet. There are many different reasons for this, and they are inherent in the subject itself. People like to see the Bauhaus as a radiant, untroubled community of modern-minded young people leading a "quasi-functionalist" life under the control of reason and guided by the brain. Love life cannot easily be fitted into such a concept. At the same time this image is continually obstructed by a jumble of legends and our own imagination. What was love like at the Bauhaus? This is a problem because we prefer to imagine the members of the Bauhaus as golden spheres or mechanical cabaret artists rather than as human beings of flesh and blood. But this is to diminish the Bauhaus and to rob it of its elusive emotional aspect. This dilemma faces anyone who looks into the current literature on the subject: manifestos, debates, lifestyle features – occasionally a heavily theoretical essay on the Bauhaus community and its social structure. As a result the rumors concerning the college remain unconsidered. Of course, the extant evidence concerning this delicate subject is, in comparison with other areas, extremely meager and is more or less limited to personal recollections. This "mirror of the past" is dangerous inasmuch as it shows what the observer wishes to see: reflections in a mirror are closer than they appear. One is walking on the thin ice between idealization and the self-righteous tirades of the contemporary press. Nevertheless it is worth trying to construct an image from the few known facts. It is a risky business, no doubt about it.

The members of the Bauhaus had to put up with accusations that they went swimming in the nude in the Ilm or the Elbe. The question is merely: what were the anatomical characteristics that enabled those who were out walking, when this breach of the peace occurred, to identify the culprits specifically as members of the Bauhaus? But let us not split hairs. It is of course possible that the girls had short hair and the boys had long hair, or no hair at

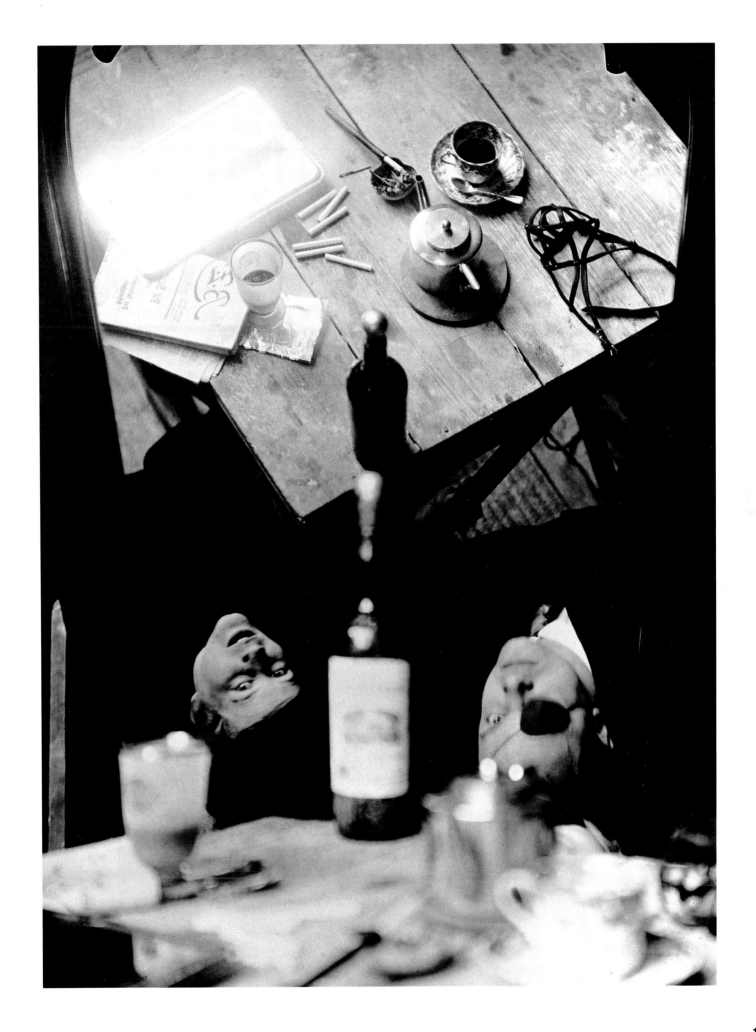

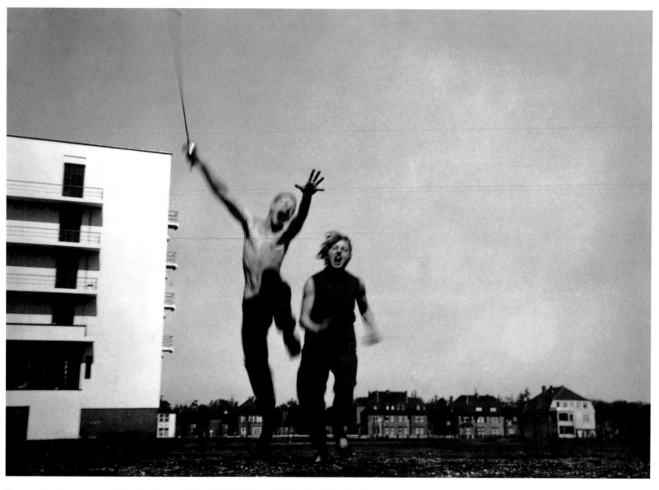

**Georg Hartmann and Karla Grosch in the field outside the Prellerhaus, Dessau.** 1929, photograph by T. Lux Feininger, J. Paul Getty Museum, Los Angeles. • Demonstrating gaiety and dynamism as a "couple."

**View of the Bauhaus canteen terrace, Dessau.** About 1927, photograph by Irene Bayer, BHA. • Canteen food was – evidently – served even to the youngest person at the Bauhaus. The integration of young children into the community was evidently accepted, but there are no accounts of what happened in the studios.

**Gerhard Kadow and Elsa Franke.** 1929, photographer unknown, J. Paul Getty Museum, Los Angeles. • Members of the Bauhaus light up together.

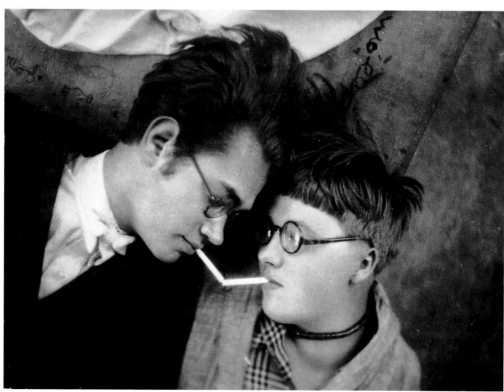

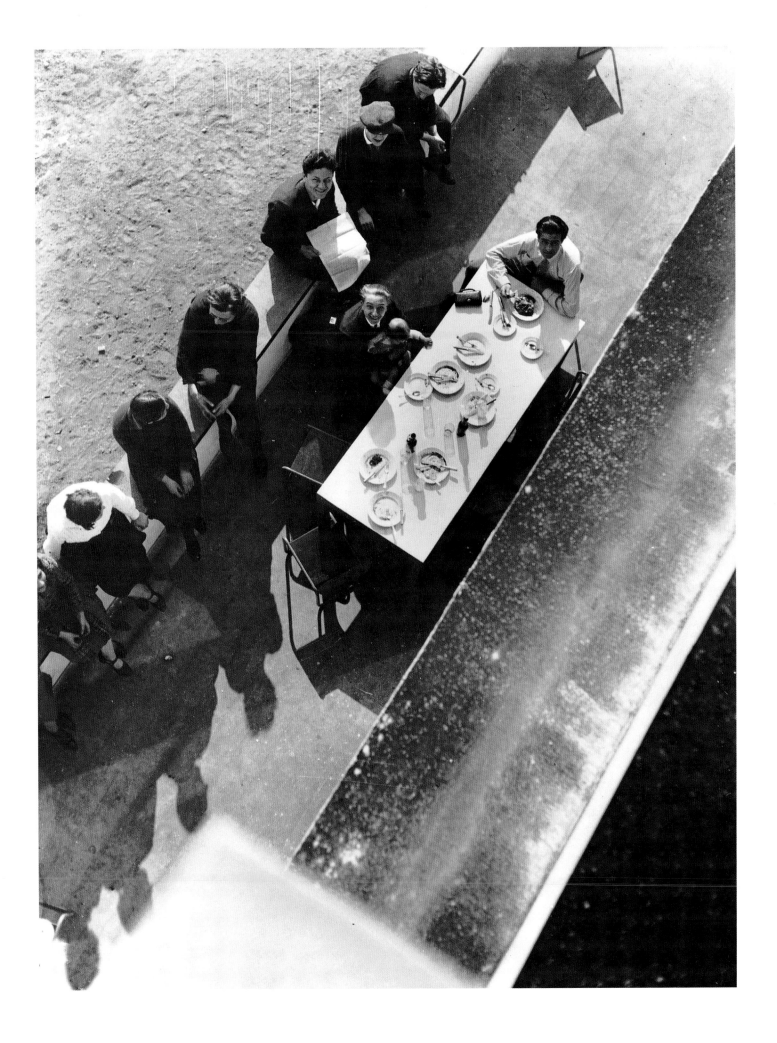

all, and that was proof enough. To move about freely, naked, out of doors – this was extremely offensive to the inhabitants of Weimar. The place for it was not the city of the classic masters, but Babylonian Berlin, a sink of iniquity from which the new director of the once so venerable art school had come in order to corrupt the young. In their agitation the worthy citizens completely forgot that in their naked frolicking the men and women of the Bauhaus were acting in the best classical tradition. After all – and this is an established fact – even Goethe, the supreme Weimar icon, did not despise a swim in the Ilm. Since this anecdote has been preserved, someone must have been present at the spectacle. But in his case nothing is said either about the bathing costume worn by Herr Privy Councillor Goethe or the question of how far the observer was embarrassed by this "poetic license."

work? In the end it was not the difference between two such movements which mattered, the bare facts spoke quite adequately for themselves. They alone provided bearings in the chaos of all the new, incomprehensible, unclassifiable movements in postwar Germany. Immorality or strict morality were the criteria by which any new and different lifestyle was assessed. What a scandal when a female Bauhaus student – unmarried, of course – gave birth to a child! Of course, such an event scarcely distinguished the Bauhaus from the rest of society. But a baby at the Bauhaus seemed to be a greater disgrace than the illegitimate offspring of an ordinary girl. How is this difference to be explained? It was hardly because the Bauhaus students were unbridled in the pursuit of their passions and were irresponsibly working to beget a new messiah like, for example, Muck Lamberty with his "New Party" on the Leuchtenburg,

**Kitchen in the accommodation shared by Hans Keßler, Günter Conrad and Fritz Rohwer.** 1932–1933, photograph by Karl Keßler, BHA. • An early form of shared accommodation, the outward appearance of which has not changed much in the course of the century. Keßler himself described it as a "kitchen idyll before the battle against disorder!"

**Inhabitants of the masters' duplexes.** 1927, on the veranda, Hinnerk Scheper, Natalie Meyer-Herkert (Hannes Meyer's wife) with their daughters Claudia and Livia; first story balcony, Georg Muche, Lucia Moholy; top balcony, Lou Scheper, Oskar Schlemmer, photographer unknown, BHA. • There was a tight web of relationships between the people to whom Gropius granted the colony of masters' houses.

It is hardly surprising that the people of Weimar took offense at the goings-on at the Bauhaus, for in the early 1920s their own moral concepts were beginning to waver. What with the vote for women and the advertisements for so-called "midnight novels" such as *Mutter. Aus dem Freudenhaus in die Ehe* (Mother. From the Brothel into Marriage) – which was worth a newspaper advertisement announcing that it had been removed from the Index – the ordinary citizen vacillated between desire and discipline. So of course he gratefully used the Bauhaus as a screen onto which to project his own dark and unfulfilled fantasies. Between the scullery and the potted plant there was a hazy image of frivolous goings-on at the art college. The Thuringians had in any case been warned by various trends in the youth movement and their occasional dubious excesses. Who would expect them to see the difference between the Bauhaus and the "New Party" on the Leuchtenburg (a castle near Kahla) with their banners, just like those of the Bauhaus, bearing in large letters slogans about the salvation of society through craft

some twenty miles away from Weimar. The difference between them and the ordinary girl was that the latter did in fact accept the role of the "victim" and bowed to the demands of society, that is to say as a rule either by being disgraced and cast out, or by marrying a more or less well-meaning representative of the male sex.

In the case of a Bauhaus baby, it was hardly possible to speak of a "victim." The birth of a genuine Bauhaus child was regarded by the students as a joyous event to be welcomed and celebrated. For them it was no more and no less than the arrival of a new citizen of the earth. Was a living Bauhaus child not a better thing to lay in a cradle than a block of wood? In contrast to the usual wailing and lamentation in such cases, the inmates of the Bauhaus bore the consequences jointly and, it is clear, with pleasure. That was the real scandal! Maybe a trace of provocation did creep into the public commitment to this child: defiance and pride at standing so emphatically apart from the moral norms of society and basing their behavior on their

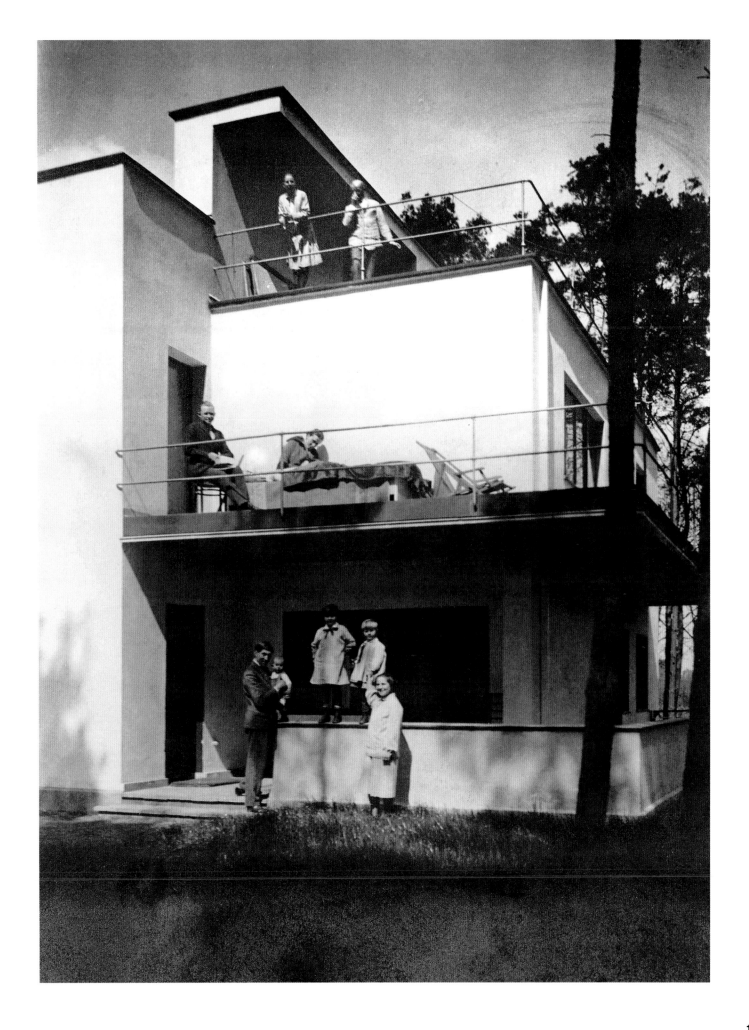

**Farkas Molnár, Liebespaar vor Haus am Horn (Lovers in front of the House on the Horn).** 1923, drypoint etching, plate 24.8 x 19.7 cm, print 41.6 x 32.4 cm, BHA. • Molnár dedicated his print to Georg and El Muche, the ideal couple in front of their ideal accommodation – the experimental "House on the Horn" which Muche had designed for the Bauhaus exhibition in 1923.

own ideas of life. Who would expect the public to be willing to accept this, a public for whom an unwanted pregnancy was a disgrace, a stigma? People preferred to see what was not there, to project any conceivable fantasy onto the Bauhaus, although nothing different actually happened there than in the rest of the world, it just did not happen behind the frosted glass screen of bourgeois hypocrisy.

We can be sure that there was no such thing as a special kind of love life exclusive to the Bauhaus, taking a different form from that common to the human species. The Bauhaus inmates merely cultivated freedom and tolerance in their dealings with one another. In this respect they lived up to the often-invoked ideal of the "New Man." Tolerance was one of the freedoms claimed by young people when they described themselves as members of the Bauhaus. Thus one reads the following words in an application dating from 1920: "Since the end of September of this year I have permission from the authorities to wear men's clothes, a permission of which I am now making use. Johanna Voelcker, known as Hans Voelker" (Thuringian State Archive, Weimar, State Bauhaus No. 156, sheet 152). One must also not forget that in addition to the brave declarations of commitment to personal pleasure and its consequences, and to simply being different, there were also entirely respectable announcements of engagements or marriages between Bauhaus members. This attitude also found its place in life at the Bauhaus and was not in any way frowned on. But the rumormongers said nothing of this, preferring to peddle wholesale allegations of licentiousness. At no time during the college's existence was there any question of a standard lifestyle that was obligatory for the individual student. On the contrary, what did evolve over the years was a living, functioning, pluralistic community.

Relations between the sexes at the college were well balanced and remained so afterward. That must of course be regarded as exceptional. Anyone who was lured by Gropius's program and came to Weimar or Dessau was certainly different from an academic art student and wanted more than a renewal of art. Thus it was not unusual for students to find each other and to build a life together according to their own ideas, possibly failing in the process

**Walter and Ise Gropius with guests on the roof terrace of their master's house.** About 1926–1927, photographer unknown, BHA. • The founder of the Bauhaus also had his casual moments, albeit protected from the eyes of the curious by a parasol/screen extending across the entire terrace.

**Herbert Bayer and Xanti Schawinsky on the beach in the south of France.** 1928, photograph by Irene Bayer, Getty Research Institute, Research Library. • The close male friendship of the two former Bauhaus members was also based on shared artistic interests, not least in Ise Gropius, and it continued into the period of exile in America.

and then risking another such attempt. The charisma of artists such as Itten, Gropius and Meyer of course led many a woman to become enraptured with them. This sometimes led to provocative fainting fits in Itten's presence which, however, were instantly and permanently cured by Gertrud Grunow in her inimitably direct manner. Here it could be seen that the Bauhaus community did have appropriate regulatory mechanisms at its disposal for preventing excesses. That deprived the petit-bourgeois of a few scandals! But what is sensational or scandalous when like-minded young people love each other?

The watching public compensated for the lack of details by spreading malicious rumors, most of them very dubious and most of which have been disproved. Walter Gropius suffered particularly from immoderate moral reproaches. The conservative press offered its readers this chain of associations: Expressionism – Bolshevism – mental illness – perversion – ruin. Thus the Spartacist leader could be included as easily as the Expressionist artist. The outcome was always the end of the Germans as a cultured people, the guilty party could be selected at will from the chain, and the term "Bauhaus" was interchangeable, depending on the requirements of the day, with lunatic asylum, brothel or Communist Party headquarters. Of course students came to the Bauhaus with their own histories and biographies. Of course they brought with them ideas of every shade about a new society and how life might be reshaped, and of course the Bauhaus, with its curriculum, offered a base for putting designs for living into practice, including those that clearly differed from the bourgeois ideal. One thing must be made clear: the Bauhaus was certainly not a monastery,

**Ernst Kallai, co-op, der Bauhausverkehrssittenschutzengel (the Bauhaus's Guardian Angel of Morals), a caricature of Hannes Meyer.** About 1930, photograph of a collage (portrait photo by Lotte Beese), BHA. • This malicious caricature shows Meyer as a guardian of morals in the robes of Justice, even though his contacts with female students were not always of a purely educational nature and produced a child called Peter.

**Hannes Meyer and his son Peter.** About 1930, photograph by Lotte Beese, Getty Research Institute, Research Library. • Clearly, Meyer's new girlfriend fully accepted his role as a father, begun long before she came on the scene.

but – and let this be said equally clearly – nor was it by any means a "brothel."

The "Model House on the Horn," built in 1923, gives us a glimpse of the way life was lived according to Bauhaus ideas. This house was hardly created for a commune to occupy and was not very suitable for a harem. The basic ideal here was one of respectable family life, and this is hardly surprising. When all social values had begun to crumble in postwar Germany, people held fast to a dream of private happiness. In the House on the Horn, however, space was provided for the individual needs of all members of the family. Communal life was lived in a large central room, and there were adjacent private rooms to which individual family members could retire. Another accepted idea, that of a Bauhaus colony consisting of individual single-family

houses, shows that the community did not by any means take precedence over the family, and that the family should feel well cared for in its midst. That was different from the ways of society at large. The ideal also catered for the needs of children, who played an important part in all deliberations at the Bauhaus. Since the founding of the school, members of the Bauhaus explored ways to design child-friendly furniture and toys.

Farkas Molnár's 1923 etching of Georg and El Muche, set against the background of the exhibition house, presents the "New Man" as the ideal occupant of such a house, with its frankly erotic representation of two nude lovers. This is no untamed voluptuary frolicking with an available Bauhaus student, but two beautiful young people building their house. It was an alternative concept about

The Bauhaus – an Intimate Portrait

**Masters' children on the balustrade of a master's house (children of Schlemmer and Scheper).** About 1927, photograph by Ise Gropius (?), BHA. • Children of Bauhaus marriages and other relationships played a surprisingly small part as an element in the life of the school, where everything was "seen anew" in all its facets and documented in photographs.

love and the future. The ideal of the Bauhaus family developed according to its own dynamics, as can be seen in particular in the close integration of the lives of the masters' families into the social structure of the Bauhaus. The members of these families were more part of the Bauhaus than citizens of Weimar or Dessau. They took just as much interest in the birth of Oscar Schlemmer's daughters as they did in the child of Hannes Meyer and the student Lotte Beese. In the Dessau period, the Bauhaus had more opportunity than in Weimar to give shape to its ideas. Freed from the stuffiness of the early years in Weimar, life there was more liberated.

The Prellerhaus in Dessau became the home of many students and the center of a tolerant community. Children and young adolescents such as Felix Klee, who grew up in this environment, were freer than children of the same age brought up within more narrow social conventions. Certainly, this was one of the reasons why Manon Gropius, the daughter from Gropius's previous marriage to Alma Mahler, found it so difficult to cope with the other "Bauhaus children" during a visit to her father in Dessau. In the city of Vienna where she lived, Manon, who was 11 at the time, was given an upper middle-class upbringing, surrounded by tutors and a governess. Although the children of the Bauhaus masters paid courtesy visits to the director's daughter, no friendships developed. The contrast between freedom and convention was simply too great. Lest there should be any misunderstanding about this, the Bauhaus did not invent the idea of antiauthoritarian upbringing. To what extent a Bauhaus child had to comply with convention was decided solely by what was customary within the families. Looking back at the Bauhaus today, there is little evidence of either the large-scale collectivism or of the comprehensive approach often attributed to it.

# Mazdaznan at the Bauhaus – the Artist as Savior

Norbert M. Schmitz

**Paul Citroën, Georg Muche in Bauhaus dress.**
1921, pen over graphite on paper, 14.5 x 12.0 cm, KW. • Itten and Muche introduced Mazdaznan, a view of the world which aimed to embrace both philosophy and religion, in their teaching at the Bauhaus. The word means "master of the idea of God" or "the good idea, which masters everything for the best." Followers wore a wine-red monastic garment and had their hair shorn or their heads shaved.

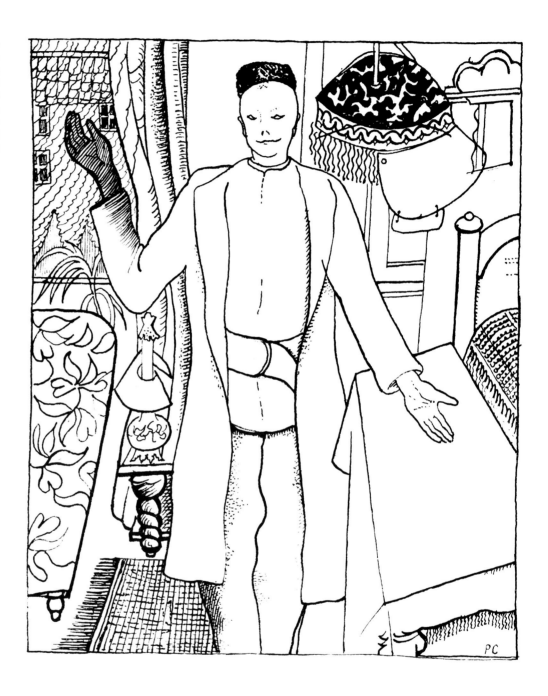

Paul Citroën's description of the "phenomenon" of Johannes Itten reads like a passage of medieval hagiography. He "emanated something demonic. As a master he was profoundly revered or – by his adversaries, of whom there were a whole host – hated in equal measure. What you could not do was ignore him. For us members of the Mazdaznan group, a special community within the student body, Itten was surrounded by a very special aura. It was almost impossible to approach him other than in a whisper. We felt enormous reverence, and we were always utterly delighted and exhilarated when he was easygoing and unselfconscious with us" (translation of "Mazdaznan am Bauhaus," in *Bauhaus und Bauhäusler*, ed. Eckhardt Neumann, Berne, 1971, p. 34). Itten came into contact with the

Mazdaznan doctrine for the first time in 1906. In 1920 he traveled with Georg Muche from Weimar to a Mazdaznan congress in Leipzig. He then left the Bauhaus for a considerable length of time and joined the Mazdaznan temple community in Herrliberg near Zürich. In 1926 he protested against accusations of sectarianism, saying that "Mazdaznan is not a sect or an association or an external organization of any kind, but constitutes a system of teaching and upbringing the goal of which is man's basic pre- servation and higher development" (Johannes Itten, "Mazdaznan" in *Werke und Schriften* (Works and Writings), ed. Willy Rotzler, Zürich, 1972, p. 229). Even so, he also pursued the esoteric cult at the Bauhaus to an extent that seemed unacceptable even to the liberal-minded Gropius. Not only did a group form that was outwardly distinguished by its special clothing, with all kinds of meetings and religious services, but there is also some evidence that the followers of this sect made a real attempt to impose their teachings on the entire Bauhaus, going far beyond breathing exercises and vegetarianism. Of course, such disagreements also reflect the personal and professional conflict between Gropius and Itten, especially since the latter, as master of innumerable workshops and of the pre- liminary course, sometimes threatened to dominate the entire Bauhaus. But more than a power struggle was involved. What is more interesting is what made this sect, now com- pletely forgotten, so attractive at the time – a sect which among other things disseminated, to some degree, racist speculations about Aryans and the superior qualities of the white man. On the surface, Itten was initially fascinated by the curious teachings of the founder of the sect, Hanish, on breathing and eating. Cooking with garlic – which at times became the ultimate hallmark of the Bauhaus canteen – soon gave rise to many a dispute. But in order to understand more clearly how such an abstruse doctrine could, at times at least, set its stamp on an institution like the Bauhaus – supposedly an elite school of modernism – one must take a closer look at its theology.

The Mazdaznan doctrine was founded by one Otoman Zar-Adusht Hanish. Said to have been a Russo-German born in Teheran, he spent his youth – according to hagiographic legend – in a Zoroastrian order in Tibet. He was preaching in the United States from 1926, and later also in Europe. His teachings began to spread through Germany from 1907, and from 1915 there were lodges in numerous larger German cities. Elevated by his disciples to the same level as Jesus and Zarathustra, he died in Los Angeles in 1936. The editors of the German Brockhaus encyclopedia have amended his exotic biography, giving prosaic details of his birth: he saw the light of day not in the dis- tant magic land of Persia but in Posen, on December 19, 1854. Moreover, Tibet is a Buddhist-Lamaistic country where until then little had been heard of such obscure prophets. A fundamental feature of this syncretistic phi- losophy (as of theosophy, which at the time was also popular in many artistic circles) is the notion of an original universal religion. It is

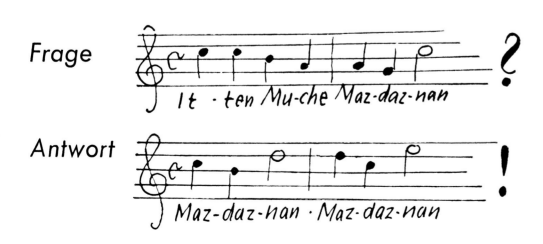

Frage

*It - ten Mu-che Maz-daz-nan*

Antwort

*Maz-daz-nan · Maz-daz-nan*

**Bauhaus signature tune (to be whistled).** Illustration from "Bauhaus 1919–1928," MOMA, NYC catalog, BHA. • By developing the pre- liminary course from the outset and directing almost all the workshops in the spirit of the Mazdaznan doctrine, Itten had an enormous influence on the organization and teaching work of the Bauhaus, with the result that many observers identified the college with Mazdaznan.

"the knowledge, gained from primal revelation and elaborated in a great system, of the origin of the world, the sequence of its stages of emergence, the divine laws of its development...." (K. H. Hutten, *Seher, Grübler, Enthusiasten* [Seers, Brooders, Enthusiasts], 1962, p. 89). According to Zoroastrian teaching the world is ruled by two primal beings: the supreme God Ahura-Mazda and his adversary Ahriman, the evil spirit. The doctrine of light and dark, or more broadly of contrast and polarity, also left its mark on Itten's general design teaching, in particular the light-dark analyses. Teaching at the Bauhaus was thereby provided with a religious foundation. Otoman Zar-Adusht Hanish stresses the essence of polarity: "All the laws of the universe, all the truths of immortality are based on duality, opposition, and difference" (Otoman Zar-Adusht Hanish, *Mazdaznan-Denklehre, Meister-Vorträge* [Mazdaznan-Theory, Master Lectures], Leipzig, 1924, Vol. 2, p. 13). The human soul, entangled in the realm of the earthly, strives for redemption, which is always self-redemption in the sense of achieving freedom from desires and passions. The

artist has a prominent part to play in this, namely "the task of presenting earthly models of spiritual or physical perfection or of developing such qualities in men and women, thereby awakening a desire to emulate what is noble and beautiful, and to keep the memory of this alive" (ibid., Vol.1, Appendix: "Die Botschaft der weißen Rasse," Punkt 18 [The Gospel of the White Race, point 18]). It is precisely this central point that explains the close affinity between mystical and occult speculation and the artistic avant-gardes since the end of the 19th century, from symbolism to, for instance, Malevich's "nonobjective world." It is the assertion that the artist and the work of art occupy a very special position. This sectarian concept of universal salvation not only promised the artist a self-therapy that would provide a cure for the constraints of civilization, but, above all, having just been excluded from scientific and philosophical discourse and hence socially marginalized, he now became the central interpreter and mediator of recondite eternal truths.

The fascination of such an out-of-the-way esoteric doctrine is principally to be explained

**Paul Citroën, Mazdaznan.** About 1922, graphite on paper, 21.5 x 19.3 cm, BHA. • At the heart of the doctrine was the individual, who was taught to awaken his own hidden gifts, especially spiritual ones. It was regarded as a prerequisite that the body should be taken care of, nourished and clothed according to particular rules.

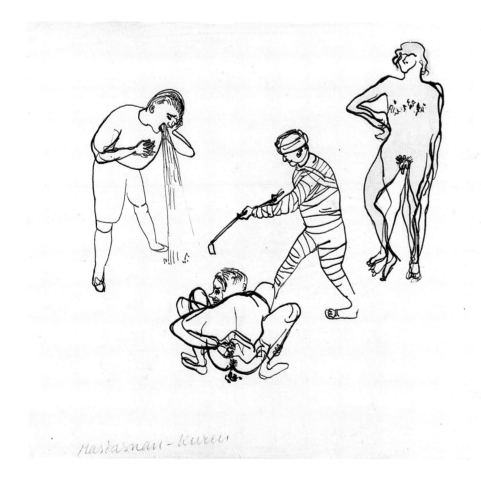

**Paul Citroën, Mazdaznan Cures.** About 1922, Indian ink pen and watercolor on waxed tissue paper, 24.5 x 30.5 cm, BHA. • Paul Citroën, Georg Muche's long-standing friend, must have been particularly fascinated during his first semester at the Bauhaus by the exotic rites for the purgation of the body: from fasting and vegetarianism, exercise and defecation, nudity and clothing, to mortification of the flesh.

**Johannes Itten, illustration of text by O. Z. Hanish which reads (in translation): "Greetings and hail to the hearts that are illuminated by the light of love and are not misled either by hopes of heaven or fear of hell."** 1921, sheet 3 from *Bauhaus-Drucke. Neue Europäische Graphik*, first portfolio: masters at the State Bauhaus in Weimar, color lithograph, sheet 34.7 x 24.7 cm, BHA. • With its strongly contrasting forms and colors, the text demonstrates the superiority of the Mazdaznan principle of universal love in comparison with the church's heretical belief in the dual system of heaven and hell.

**Johannes Itten, The White Man's House, architectural study.** 1921, sheet 4 from *Bauhaus-Drucke. Neue Europäische Graphik*, first portfolio: masters at the State Bauhaus in Weimar, lithograph, sheet 35.0 x 28.0 cm, BHA. • This sheet, an unusual part of Itten's output, was interpreted in 1984 by H.C. von Tavel in light of Itten's second contribution to the portfolio, "Gruß und Heil." Because the cubic construction lacks Itten's

typical themes of "contrast" and "movement," von Tavel interpreted it as a counter-image to the Mazdaznan doctrine to which "Gruß und Heil" introduces us. The static architecture, he argued, was a kind of "constructivist prison" for the "white man," regarded by Itten as the upholder of the dominant culture. The contrast between the two sheets could refer to the emerging conflict with De Stijl.

**Georg Muche, Im Anfang war das Wort (In the Beginning was the Word).** 1922, etching, sheet 28.0 x 18.2 cm, print 16.7 x 11.8 cm, BHA. • In the Mazdaznists' all-embracing vision of the world, the supreme goal was self-redemption. The doctrine drew not only on ancient Persian and Egyptian religious myths but also on elements of Judaic and Christian mysticism.

by its exclusivity, which allots to the artist the extraordinary role of prophet and mediator. And Itten wanted to be a seer. Mazdaznan offered him, along with many a young student in search of spiritual peace in the confusion of the turbulent postwar years, a workable framework for translating spiritual renewal into a practical, living form, rather than leaving it as a matter for theoretical speculation. The utopia of a monastic community in the service of a sacred art, first established by the Nazarenes in the early 19th century, had here found a unique framework.

When Itten was dismissed by Gropius, these occult birth pangs of modernism at the Bauhaus came to an end for the time being. However, the artist's claim to possess exclusive knowledge of the world and the ability to interpret its meaning is to this day still to be seen often enough in the everyday self-awareness in studios and academies.

**Johannes Berthold, Kronos.** 1924, limewood, painted and partly gilded, height 106.1 cm, SBD, collection archive. • The search for meaning after the disaster of World War I occasionally led also to visionary Romantic embodiments of a cosmic religious idea of the world. An example is to be seen in this presentation of the primal myth of the world-creator Kronos, son of Uranus and father of Zeus.

# Bauhaus Parties – Histrionics between Eccentric Dancing and Animal Drama

Ute Ackermann

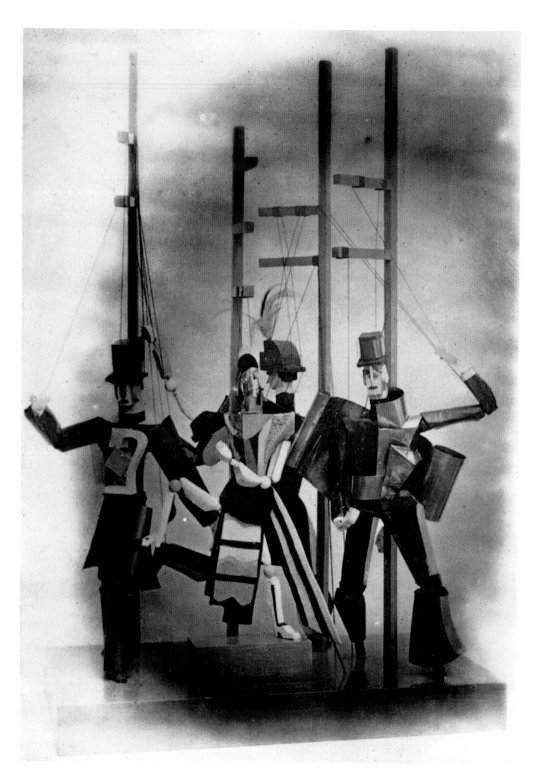

It is getting dark over Weimar. The linden trees in the park are already beginning to blossom. Early, this year. The first garden chairs on the café terraces await strollers and respectable citizens in the mild night. Money is short, it is true, but a little frivolity is part of what spring is all about. Young people are gathering in front of the art college building. They come strolling up, singly, in pairs or in small groups, speaking softly, here and there a girl's laugh, and from quite close by the scraps of a melody announced by Ludwig Hirschfeld-Mack on his accordion as he slowly approaches. By now it is night, and something marvelous happens: sun, moon and stars, Chinese lanterns large and small, splendid moon faces, little ghosts and many lights come on that are quite simply magical, and quietly a gleaming procession forms. Where is it going? What a question! It is May 18 and Gropius's birthday. It is to call on him that the men and women of the Bauhaus have set off with their bobbing lights, down to the Ilm and up to the Horn, to Master Klee and Helene Börner, the weaver, then to Gropius. Finally the procession is joined by the writer Johannes Schlaf. The members of the Bauhaus walk the whole long way through the park with their lanterns to the Ilmschlößchen, the "little castle on the Ilm," where there is to be a party. The Bauhaus Band is playing, the Bauhaus dance is being danced and perhaps Felix Klee's glove puppet will give away another Bauhaus secret. The Theater Group workshop will probably contribute a splendid masquerade. Oskar Schlemmer's students are said to have been seen in mysterious masks and strange costumes. The Bauhaus year has reached its first high-water mark: the Lantern Party. Four times a year Weimar becomes the backdrop to a wondrous transformation, for the Bauhaus has its own high days and holidays, each of which

**Friedl Dicker, Puppets.** Before 1923 (not preserved), photographer unknown, BHA. • Puppets, manual or electrical; puppets, mechanical and comical; figures grotesque or virtual – they all created new artistic scope, or at least an enthusiastic group of insiders.

ushers in a new season of the year. In spring, when the lanterns are lighted, they compete with the starry sky, in the summer the solstice is celebrated, the new semester begins with the Kite Party, and Christmas is celebrated with Yuletide presents. Each time, for weeks in advance, students and faculty work together in the workshops to prepare the great event. Ideas are elaborated, and however unusual they may be, the people at the Bauhaus turn them into reality. Backdrops, masks, costumes – from the outset, life at the Bauhaus means working together and partying together.

Everything was improvisation, play, experiment. "The Kite Party was celebrated with ... fantastic artifacts which, admittedly, were sometimes so beautiful that they could not fly. They were carried proudly through the town, which conciliated many a frustrated participant" (Tut Schlemmer, "... vom lebendigen Bauhaus und seiner Bühne" [The Living

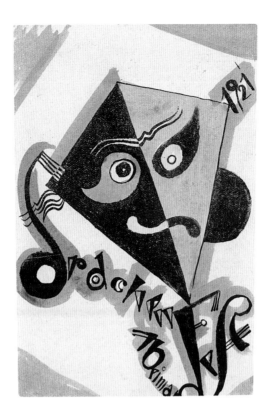

**Oskar Schlemmer (?), Invitation Card to the Kite Party at the State Bauhaus in Weimar.** 1921, lithograph, watercolored, 15.6 x 10.6/10.2 cm, Bühnen Archiv Oskar Schlemmer. • There were imaginative invitations to the annual October Kite Party on the Weimar hills, creating the mood for the amusing abstract flying objects to be expected – here the letters have already become a fluttering kite tail.

**Paul Klee, Postcard of the Lantern Party at the State Bauhaus in Weimar.** 1922, lithograph, 9.6 x 14.1 cm, private collection. • It was not only Gropius's birthday that was celebrated in Weimar on May 18, but also the Lantern Party with home-made lighting. In the night the lights were carried through the park up to the Horn to Klee and Börner, and then finally back into the town to Gropius or to the writer Johannes Schlaf.

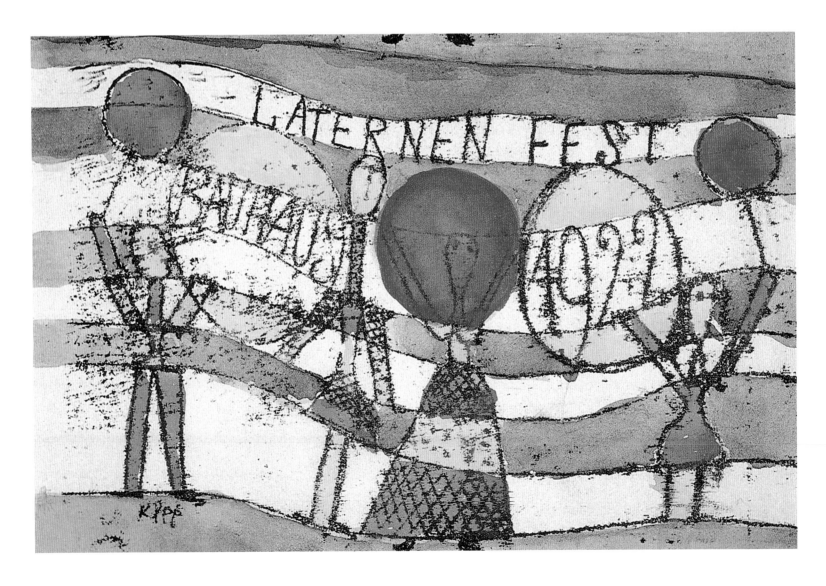

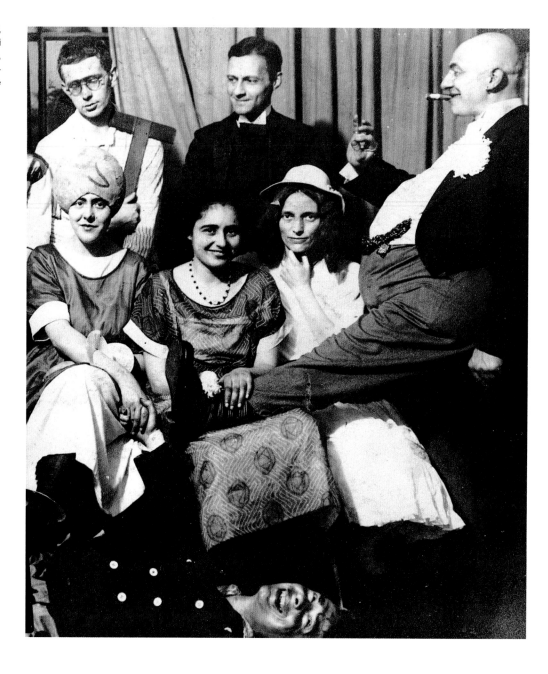

Bauhaus and its Theater] in Eckard Neumann [ed.], *Bauhaus und Bauhäusler* [The Bauhaus and its Members], Cologne, 1985, pp. 121f). The favorite venue for the parties was the Ilmschlößchen in Upper Weimar. "What an imaginative, elegant name! And what a hovel to adorn itself with it! You go down a narrow corridor to get to a medium-sized dance hall of quite extraordinary ugliness. The murals must surely date from the 1880s; they show maidens playing harps in a green heavenly meadow. Do the students of artists like Kandinsky, Feinniger or Klee really want to dance here? Is it at all permissible for a Constructivist to enter this room without taking action against the harpists with iconoclastical fanaticism? Foolish reservations.

After half an hour of zealously joining in they have disappeared. In this throne room of kitsch there rules … a youthful artistic delight.... Everything is primitive, there is not the slightest subtlety, but nor is there either that blasé attitude that can be found yawning audibly at our masked balls, nor that febrile atmosphere which makes it necessary to post a policeman in front of every dusky corner" (Kole Kokk, "Das Bauhaus tanzt" [The Bauhaus dances] in Hans M. Wingler, *Das Bauhaus 1919–1933*, Bramsche, 1962, p. 98).

People at the Bauhaus knew how to have a party – and how! Apart from the four big "official" parties there was a masked ball every month. There was dancing, jazz was played

**Marcel Breuer, Poster for a party at the Ilmschlößchen.** 1923, illustration from Oskar Schlemmer, László Moholy-Nagy and Farkas Molnár, *Die Bühne am Bauhaus* (The Bauhaus Theater Group), Munich, 1925, Bauhausbuch 4, BHA. • The first letter of "Ilmschlößchen" turns out to be a nickel curtain with turbodrive, which opens to show Molnár's "Red Cube." In front of it, geometric-stereometric figures are dancing like an electric whirlwind, representing also the intimate flirtation of physics with a slim elementary figure.

Plakat zum Bauhaustanz

MARCEL
BREUER

on remarkable instruments, but all in all the Bauhaus students did not live up to their bad reputation. If memoirs and contemporary accounts are to be believed, the atmosphere at these parties was markedly friendly and civilized. Indeed, it would appear that the cordiality and respect with which the members of the Bauhaus behaved toward one another were in fact the greatest provocation for the general public, being completely at odds with the rumors about the new art college which were to be heard on all sides. Even Gropius was impressed by the way his students behaved toward one another. After one masked ball, Gropius wrote to the mayor of Weimar: "I ... can only say that the tone adopted by the students toward one another, and also toward other people, is excellent and that the criticisms leveled by some gentlemen at these young people are really

completely unjustified. I feel the need to inform you in person of this" (Letter to Donndorf, November 27, 1919, Thuringian State Archive, Weimar, State Bauhaus No. 27, p. 3). That it was not entirely a matter of mere friendliness between the members of the Bauhaus is proved by the 71 marriages which were entered into during the college's existence by male and female students, masters and female students, and young masters and students of both sexes. Of course the members of the Bauhaus were not innocent little lambs. Various pranks kept the Weimar citizenry on tenterhooks. When the Brütt figure was painted over during the night by members of the college, it went without saying that the council of masters had also to step in and punish the wrongdoers. It was the sculptor Adolph Brütt who, around 1906, had suggested holding masked balls at the Weimar art

**Street scene during the "Indian Party" of the Grand Ducal School of Fine Art, Weimar.** February 5, 1913, during the carnival season, photographer unknown, BHA. • The "wild" inmates of the Bauhaus were not the first to bring an artistic aura to the provincial town of Weimar. Their predecessors at the art college, directed by Henry van de Velde, were already experts in the art and pleasures of disguise. On the right, the future Bauhaus teacher Joost Schmidt.

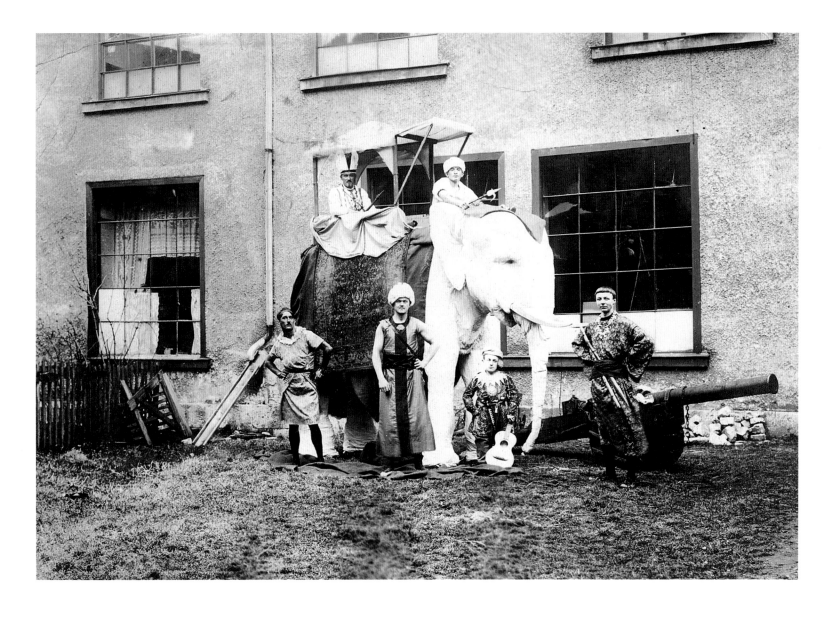

college. The idea was enthusiastically adopted, the balls soon became regular events, and were continued in the Bauhaus parties.

That students and masters should coexist, and treat each other in a friendly way, was one of the explicit demands made by the Bauhaus. This point in the program was fulfilled from the time the college was founded. The Free Union, i.e. the student representatives, which had existed even in the days of the old art college, organized a party to welcome Walter Gropius on June 5, 1919. In the students' welcoming speech they expressed their support for their new director and his program. On June 7, 1919, Gropius sent a telegram from Berlin to the Bauhaus students: "I wish to express once again my sincere thanks to you all and my delight at the splendid, successful party. You have made yourselves my friends and helpers and have put me greatly in your debt. Yours, Walter Gropius" (Thuringian State Archive, Weimar, State Bauhaus No. 131, p. 48). Every Saturday the members of the Bauhaus went on an excursion together. The invitation included the words: "Music included!" By 1919 the Saturday excursions

had become a permanent part of life at the Bauhaus, and in June of that year the masters were invited for the first time, along with their families and friends. In addition to the in-house parties, Gropius was at pains to cultivate relations with those Weimar townspeople who took an interest in culture, some of whom had an open mind about the Bauhaus. Bauhaus family parties took place in these circles and the townspeople for their part made an effort to bring the young people of Weimar into contact with the Bauhaus. These were no doubt very convivial occasions. After one evening gathering for Bauhaus members and invited guests at the home of Countess Dürckheim, a "stray" muffler was found in Kandinsky's coat pocket, the true owner of which could not be identified despite intensive investigations.

When a particularly beautiful piece of work had been completed, this was celebrated in the small circle of the workshop. Lothar Schreyer gave an account of one such celebration: "When Ida Kerkovius had completed her first large carpet in the weaving workshop, we celebrated the event in my small apartment in Frau von Stein's old house by the park. The

**Xanti Schawinsky, Self-portrait in Dadaist Pose.** 1927–1928, sheet from the portfolio "9 jahre bauhaus. eine chronik" (9 years of bauhaus. a chronicle), 1928, cutout photograph with writing in Indian ink, mounted on gold foil and card, picture 16.5 x 12.5 cm, card 41.9 x 59.5 cm, BHA. • Kurt Schwitters' "primal sonata" was in everybody's ears, everybody was familiar with Raoul Hausmann's monocle – this thank-you for Gropius when he left the Bauhaus in 1928 was sent by a stylish Dada dandy.

**Party at Xanti Schawinsky's studio.** About 1925. Left to right, Heinrich Koch ("piano"), Herbert Bayer, Xanti Schawinsky (banjo), Andor Weininger (cymbals), photographer unknown, BHA. • Xanti Schawinsky was the college's "enfant terrible" and, in collaboration with Weininger, the impresario of numerous parties and off-beat shows.

**Bauhaus party at the Ilmschlößchen near Weimar.** November 29, 1924, photograph by Louis Held, BHA. • The group photo was taken by the "court photographer" Louis Held. The signs acted as prompts for the audience, indicating the dramatic sequence of the party.

**Werner Siedhoff in costume for the "White Party, 2/3 white, 1/3 polka-dotted, checkered, striped," Dessau.** March 20, 1926, photograph by T. Lux Feininger, J. Paul Getty Museum, Los Angeles. • For two whole days and nights, invited guests had the chance to get to know the special features of the new Dessau Bauhaus. The fancy dress party was based on abstract models and prescribed colors. The topping-out ceremony was more official. The theme and the décor were based on ideas by the two professional wall painters, Herbert Bayer and Alfred Arndt.

bewegung

**"New Functionalism:" party at Giebichenstein Castle.** December 4, 1925, photograph by Irene Bayer, BHA. • This sketch is a physical presentation (or a caricature) of the concept of New Functionalism that had just been invented.

**Lis Beyer in a costume for the "White Party, 2/3 white, 1/3 polka-dotted, checkered, striped," Dessau.** March 20, 1926, BHA. • A girl in a tutu striking a dainty pose. The inspiration for this costume may well have come from Schlemmer.

gravely beautiful carpet, measuring four square meters, filled almost the whole room. We had framed it with burning candles and squatted on the floor around it, talking quietly and happily, with the murmur of the fountain beneath the window" (*Erinnerungen an Sturm und Bauhaus* [Memories of Storm and Bauhaus], Munich, 1956, p. 195).

Social life at the Bauhaus developed more rapidly than the workshops could be set up and refurbished. This is not surprising, for while the latter depended on state funding, enthusiasm and hope were the foundations on which the Bauhaus community was able to prosper. Students gave lectures to their fellow students, and there were readings followed by relaxed socializing. When such soirées were announced, the musicians were always expressly asked to bring their instruments and music with them. In 1920, public Bauhaus soirées were organized. However, the students themselves played less of a part in them. A reading by Else Lasker-Schüler on April 14, 1920 was the first in a series of such events. It was followed by lectures and musical recitals, which were very popular in the intellectual circles of Weimar. The Bauhaus presented itself as a cultural institution. These soirées, for which an admission price was charged, also provided a secure source of income. The activities culminated in the Bauhaus Week on the occasion of the 1923 Bauhaus Exhibition. From August 15 through 19, there were performances in the national

theater of, inter alia, Hindemith's *Marienlieder,* Busoni's *Six Piano Pieces* and works by Krenek and Stravinsky. Walter Gropius, Wassily Kandinsky and J. J. P. Oud gave lectures, and the Bauhaus Theater Group gave the première of the "Mechanical Ballet" by Kurt Schwerdtfeger and Georg Teltscher. Ludwig Hirschfeld-Mack contributed two of his reflected-light presentations, and the entire week was accompanied by appearances of the Bauhaus Band providing music for dancing.

On March 28 and 29, 1925 the Bauhaus danced for the last time at the Weimar Ilmschlößchen, after which peace and quiet returned to the old inns of Upper Weimar. However many changes the college may have undergone throughout its existence, and notwithstanding the most adverse circumstances to which it was exposed, one thing did not change: the pleasure of partying together. Even before the Bauhaus was able to take possession of its new premises in Dessau, there were more celebrations: under the banner of "New Functionalism," for example, on December 4, 1925, then "The Tube" the following year at Giebichenstein Castle, and the "White Party" in March of 1926, at which, in addition to white, only the primary colors red, blue and yellow were allowed, and then only if they were striped, polka-dotted or checkered. There were particularly solemn ceremonies to mark the topping-out and the opening of the new college building in Dessau. The carnival

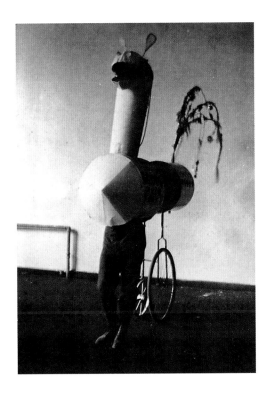

**Fantasy costume for a Bauhaus party.** 1924–1925, photographer unknown, J. Paul Getty Museum, Los Angeles. • Half man, half fantasy horse – driven by a penny-farthing: a Bauhaus Pegasus.

**Fantasy costume for a Bauhaus party.** About 1924, photographer unknown, J. Paul Getty Museum, Los Angeles. • It is scarcely possible to determine whether we are being shown a costume here, or a routine for a "mechanical ballet."

**"The Tube:" party at Giebichenstein Castle.** 1926, costumes by W. Tümpel, photograph by Irene Bayer (?), BHA. • There were a number of personal and intellectual contacts with the art and craft college in Halle at the nearby "castle." The functionalization of man was here caricatured in the guise of a four-legged tube on floats with three cylinders, two genuine heads plus one mask, and three arms economically dispensed with.

season 1927–1928 was opened on November 11, 1927 by "Elf Elfen" (Eleven Elves). In December of 1927, the Bauhaus celebrated Kandinsky's birthday and the first anniversary of the Dessau college building. On this occasion students and teachers made lavish fun of themselves, for their theme was "Slogan Party." "The Weimar Matter," the play put on for this celebration, consisted solely of slogans, while Moholy's "feelers" (an exercise from the preliminary course at which, with closed eyes, the qualities of materials were to be deduced by touch) were expanded to gigantic proportions and constructed from sausage, wire, brooms and wool. The lives of the masters and students were so closely bound up with the college that private events were often celebrated by a Bauhaus party. In July, 1927, the Bauhaus bade farewell to El and Georg Muche, at first somewhat formally, in the presence of a few "experts in starchiness," but later in the exuberant fashion of the Bauhaus. Kandinsky's acquisition of German citizenship provided another opportunity; it was duly celebrated in March of 1928 with comic addresses. The bureaucratic act in particular provided raw material in plenty for satirical parody and dressing up. So Schlemmer, Scheper, Breuer and Wittwer as Prussian army officers, Ludwig Grote as a municipal deputy, Hannes Meyer as a representative of the people, Bayer as an Austrian officer, and Moholy-Nagy dressed up as an old citizen of Dessau, all paid their respects to the new nationals. A bare fortnight later, the last evening was spent together with the founder of the Bauhaus, at his college.

The carnival parties at the Bauhaus acquired a legendary reputation. What in the old days in Weimar had been imaginative improvisations

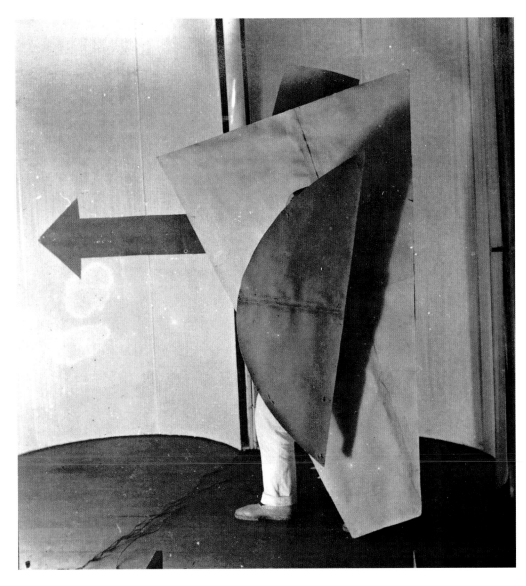

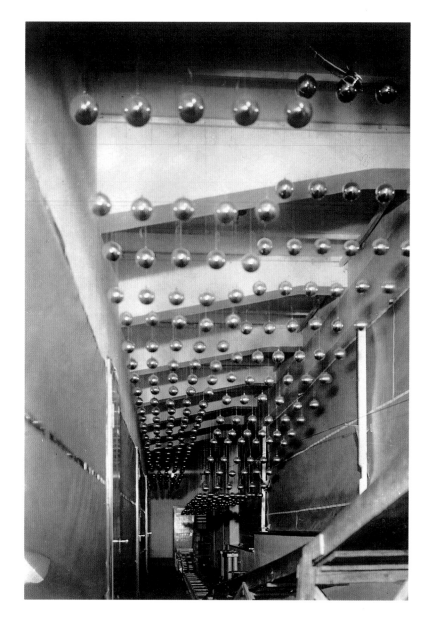

Couple at the "Metallic Party" or "Church Bells, Doorbells and Other Bells Party" in Dessau. February 9, 1929, photographer unknown, Getty Research Center, Research Library.

Couple at the "Metallic Party" or "Church Bells, Doorbells and Other Bells Party" in Dessau. February 9, 1929, photograph GELOTT Photo Service, Getty Research Center, Research Library.

"Metallic Party" or "Church Bells, Doorbells and Other Bells Party" in Dessau. February 9, 1929, photograph by Robert Binnemann, J. Paul Getty Museum, Los Angeles. • Like the invitation cards, the entire Bauhaus was given a glittering metallic look – including the guests, who took to the dance floor wrapped in metal foil or with spoons, saucepans and frying pans. To the sound of church bells, doorbells and other bells they hurtled down the slide, went into the "laughter closet," or tried their luck at the wheel of fortune, the shooting range and the tombola, where a "Kandinsky" was to be won.

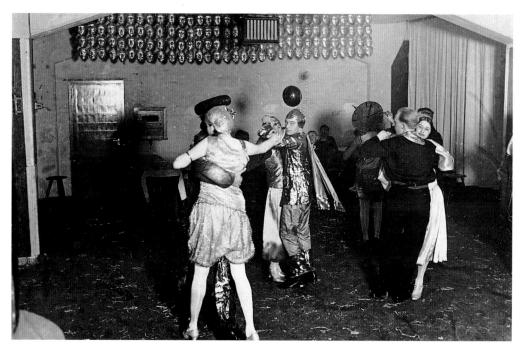

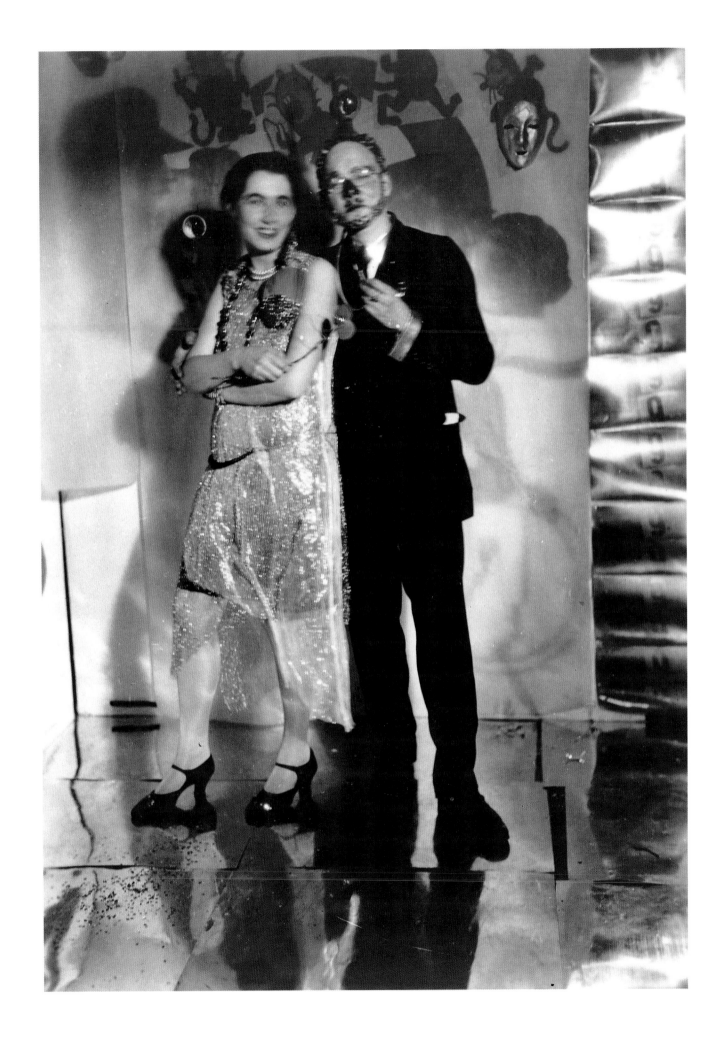

became in Dessau brilliant stage performances. In March of 1928, the "Beard, Nose and Heart Party" was given, with the Bauhaus Theater Group performing the "backdrop play." Probably the most resplendent of all the masked parties ever seen at the Bauhaus was the "Metallic Party" on February 9, 1929. The original idea had been to have a "Church Bells, Doorbells and Other Bells Party." But the idea of such a party must have been so ear-splitting that it evolved into the "Metallic Party." On a bitterly cold February night, the Bauhaus was lit up like a gleaming metallic fairyland. The décor was magnificent: reflecting walls faced with white metal, mirror-images of the dancers distorted by brass-colored fruit dishes attached to the ceiling, an amazing number of glass balls, like those on Christmas trees, the sound of bells everywhere, a musical staircase in which each step played a different note when it was trodden on. The guests made their way via a metal slide to the main party hall, and this unusual entrance, accompanied each time by a flourish from the band, elevated the newcomer from the outset above the empirical world. No distinctions were made between the various guests. Even Hess, the mayor of Dessau, was given this reception at the Bauhaus. A hardware shop provided the guests with all manner of tools and utensils such as spanners and tin openers.

"The Bauhaus Band had donned party clothes, with coquettish silver top hats, and excelled themselves in the musical side of things with élan, rhythm, life. On stage brazen-tongued nonsense was spoken. An amusing women's dance performed by men, and a sketch in which metal was actually represented only by the top of a helmet, satisfied the desire for spectacle and laughter. The best fancy dresses seen at the party also deserve to be remembered: a death's-head hussar in black with an aluminum pot and a skimming spoon as a helmet, his chest embellished with silvery metal spoons; the lady in round white metal discs coquettishly wearing a spanner on her bracelet with which she invited each of her escorts to tighten the loose nuts … on the stroke of twelve the 'Iron Stock of the Bauhaus' arrived: twelve fearless knights rattling and stamping their feet … the next morning there were frostbitten ears: the gentlemen with ladies on their west side had their left ears blue with frostbite, for those with ladies on their east side it was the right ear. But everyone agreed with Paul Scheerbart: 'What would the universe be without metal?'" (from Oskar Schlemmer's letters, diaries and other writings in *Idealist der Form. Briefe, Tagebücher, Schriften 1912–1943* [Idealist of Form. Letters, Diaries, Writings], Leipzig, 1990, p. 205).

The Bauhaus parties were known beyond Thuringia. Guests came especially from Berlin

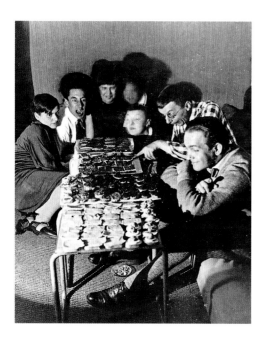

**Banquet with cold dishes, Dessau.** 1927–1928, photographer unknown, BHA. • Party at "Schmidtchen's" (Joost Schmidt's) house, with Schmidt pointing things out. Breuer's stools serve as a food trolley.

**Invitation to the "Beard, Nose and Heart Party," Berlin.** March 31, 1928, designed by Herbert Bayer, BHA. • The Bauhaus Band arranged a party in Berlin where guests paid for their admission. Xanti Schawinsky recorded that "hair was shaped and combed, curled and waved to form wigs and all kinds of beards, from Sudermann to Chaplin; noses were fashioned…." Huge chandeliers were transformed into colorful sculptures, and a hairdresser's shop and a photographic kiosk for Umbo were set up.

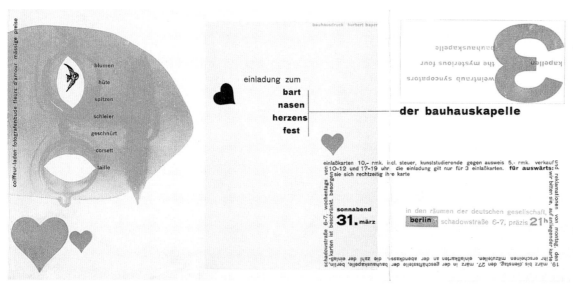

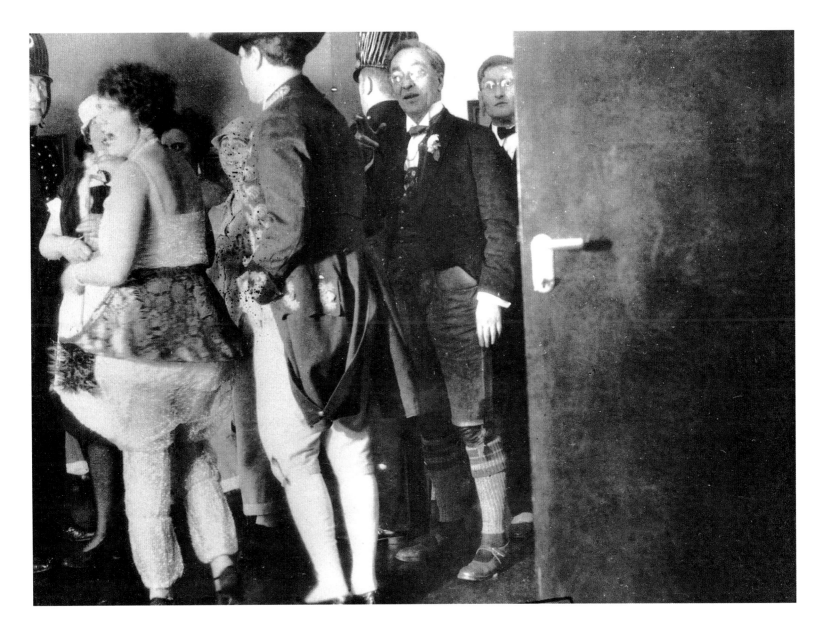

and Leipzig, and press reports fueled public curiosity. The rhythm of the seasons that had been followed in Weimar was not retained in the Dessau period. The only exceptions were Christmas and the summer solstice. Parties were held entirely according to circumstances relating to teaching and the Bauhaus's own history. From 1931, each semester began with the preliminary course party, which in November of 1931 had become known as the "Hack Writers' Party." In Dessau also, every opportunity for a party was of course seized, and the Prellerhaus provided an ideal venue for the many student fêtes, both large and small. After the Dessau Bauhaus was closed down and the college re-established in Berlin, the tradition of great parties was resumed. But in contrast to Weimar and Dessau, the Bauhaus did not so much hold parties itself as act as their

organizer. The difficult financial situation of the college, which was now a private institute, made it seem sensible to take advantage of the good reputation of the Bauhaus parties as a source of income. The last carnival parties at the Bauhaus, in February of 1933, were brilliant, but they were public events. About 130 Bauhaus members organized a fancy dress party for about 700 visitors. The masters and friends of the Bauhaus had donated numerous pieces of work as tombola prizes in order to obtain additional income for the college. Once again something of the perfect staging of the "Metallic Party" in Dessau was to be seen. Nevertheless, a few weeks after this final glittering manifestation of partying at the Bauhaus, nothing could prevent the permanent closure of the college in Germany.

**Party to celebrate the granting of German citizenship to Wassily and Nina Kandinsky, Dessau.** March, 1928, left to right, Hinnerk Scheper, Nina Kandinsky, Lou Scheper, László Moholy-Nagy, Wassily Kandinsky, Josef Albers,... photographer unknown, BHA. • The government's act was sealed in a highly disrespectful manner "in uniform."

# Non-stop Music – a Brief Musical History of the Bauhaus

Christoph Metzger

As elsewhere, the impact of contemporary music and its reception was also felt at the Bauhaus. In the years of its existence, from 1919 to 1933, the development of music underwent decisive changes, coming under the influence of such diverse phenomena as the revival of chamber music, the discovery of jazz, the musical fringe of the Wandervogel (an outdoorsy scouting) youth movement, and advanced atonal compositions. The turn toward elementary forms, for example in architecture, sculpture or typography, which became a central feature of Bauhaus aesthetics, had its equivalent in the sphere of music in the preference for music for small groups. In the 1920s, musical compositions for full orchestra were the exception. In music, as in almost all artistic genres, ornamentation was strictly rejected as non-functional elaboration.

It was Italian Futurism that most radically disowned the intellectual heritage and the aesthetics of the 19th century. From 1913 on, Luigi Russolo, the leading mind among the Futurist composers, declared in manifestos and compositions that sounds and noises from the everyday environment were aesthetic raw material. This constituted a profound break with the musical traditions that had been valid until then. Russolo's *Concerto for Factory Sirens* (1920) has become famous. In this composition the notes are liberated from any kind of function.

Traces of the avant-garde are also to be found in works coming from the Bauhaus, albeit in a more moderate form. For example, echoes of Futurism can be discerned in László Moholy-Nagy's light sculptures and mechanical artifacts. He then went beyond this to attempt a completely new way of making music by mechanical means.

**Still Life with Banjo and Clarinet.** About 1928, photograph by T. Lux Feininger, J. Paul Getty Museum, Los Angeles. • The Bauhaus Band comprised: banjo and clarinet, saxophone, percussion, occasionally cello, drone bass, "lotus flute" and of course piano and singing voices. Their themes: music from the members' native countries – Hungary, Czechoslovakia, Poland, Russia, Switzerland and others. The treatment: jazzy rhythms, send-ups and alienation.

Although the music of the 1920s still took its bearings for the most part from the conventions of the previous hundred years, an anti-Romantic stance was beginning to emerge. This was the result of avant-garde experiments turning to more simple forms and modes of composition, which led to a fundamental revolution in the understanding of music. But popular influences also brought about a lasting change in contemporary taste: these included jazz and other modern rhythms, for example the tango which, coming from America, took the European continent by storm.

If one were to devise a slogan for the musical aesthetics of the 1920s in contemporary composers such as Paul Hindemith or Arnold Schoenberg, it would have to be: away from the religion of art, back to craft. This was in line with the practical orientation of the Weimar Bauhaus as already proclaimed in the famous founding manifesto of 1919. Schoenberg, in the introduction to his widely-noted *Harmonielehre* (Teaching Harmony), published in 1911, the year Gustav Mahler died, was quoted as saying: "If I should succeed in imparting to a pupil the craft element of our art as completely as a cabinet-maker can always do, then I will be content. And I would be proud if I could vary a well-known dictum and say: 'I have taken a bad aesthetic away from my composition pupils, but I have made up for it by giving them a good grounding in craft.'"

In the same year the painter Wassily Kandinsky had published his pioneering essay *Über das Geistige in der Kunst* (Concerning the Spiritual in Art), which contains passages on the theory of abstraction. Schoenberg's friendship with the later Bauhaus master Kandinsky is documented in a lively correspondence, which also began in 1911. The correspondence focuses essentially on the phenomenon of abstraction in musical composition and pictorial structure.

The correspondence between the Bauhaus master and founder of the preliminary course, Johannes Itten, and the composer Josef Matthias Hauer is also concerned with compositional issues that extend beyond specific genres, among them the problem of transferring the foundations of visual art, as they apply to drawing and color, to the musical

sphere. The friendship between Itten and Hauer began in 1919, but their idea of setting up a music college together in Weimar proved impossible to put into practice. Here what was probably the only opportunity of establishing an independent musical tradition at the Bauhaus was missed. In this context the "colored spheres" conceived by Itten in 1921 are interesting, because they echo Hauer's sketch of a "color circle" based on the division of the octave into 12 semitone steps. Less formally set out are the abstract colored

**Gramophone and Percussionist.** 1927–1928, photograph (double exposure) by Heinz Loew, Folkwang Museum, Essen. • Given the high-tech means of reproducing blues rhythms, the original percussionist now seems to be reduced to a record label.

**Kurt Schmidt, Konstruktives Relief.** 1923, colored wood construction, 103.6 x 103.6 x 7.4 cm, KW Bauhaus Museum. • Twelve color shades between yellow and red, white and black, develop rhythmically in three dimensions. This relief in the manner of De Stijl suggests an analogy between musical notes and colors. As in a musical score, the colors are to be read from left to right and inward from the outermost surfaces.

**Josef Albers, Fuge (Fugue).** About 1925, opaque glass, sandblasted, 24.8 x 65.7 cm, Collection The Josef Albers Foundation. • In Albers's work, the rhythmical recurrence of simple motifs and colors serves more to create an effect of depth using materials and technique rather than a musical effect.

transpositions to which Vogelmeyer and Hauer gave the title *Melosdeutungen* (Melo-interpretations).

There are two compositions for piano dating from 1922–1923 by the Weimar Bauhaus student and later journeyman Ludwig Hirschfeld-Mack: *Farbsonatine I + II (Rot)* (Color sonatinas I + II [Red]). The pieces, which are of moderate difficulty and lyrical in character, have been performed in Weimar and Berlin on a number of festive occasions. The indication of color in the title is to be understood associatively rather than as a direct reference to the combination of music and color. In the same year in which his sonatinas were written, Hirschfeld-Mack gave a seminar on color at the Bauhaus which was so well received that the masters Klee, Kandinsky and Itten also participated. In the seminar Hirschfeld-Mack investigated the effect of primary colors, coming close to a musical form of thinking with his numerous color tables showing different arrangements and intensities. Hirschfeld-Mack even entitled one arrangement of 12 small colored surfaces, each with three segments: "Intervals of a fifth. The four triads of the 12-part color circle." This is an allusion to a pheno-menon from compositional theory, namely. the fact that the overall shape of a melodic figure remains recognizable despite various twists and reflections.

A few years earlier Schoenberg had written his orchestral piece Op. 6, No. 3 *Farben* (Colors) and Kandinsky had produced his painting *Gelber Klang* (Yellow Sound). Many artists felt challenged increasingly to break down the boundaries between the genres of music and painting. In this context, Hirschfeld-Mack's color seminar must be seen as playing a crucial part, as it was here that the systematic study of color inter-vals and chords was developed to the furthest extent. In general, it is only possible to reconstruct the concern with music at the Bauhaus in a fragmentary way, since it often occurred more on the fringes of artistic production. The personal contacts between composers, visual artists and architects, which may have promoted an exchange of views on synaesthetic phenomena between the various genres, were, however, certainly important.

**Josef Matthias Hauer, 12teiliger Farbkreis übereingestimmt mit den zwölf Tönen der chroma-tischen Skala (12 part Color Circle corresponding to the 12 Tones of the Chromatic Scale).** 1919, collage with graphite, Indian ink and colored card, 27.1 x 20.8 cm, commentary in pencil by Johannes Itten, Dieter and Gertrad Bogner Collection, Vienna. • Between 1919 and 1922 the Viennese composer Hauer had intensive discussions with Itten about the correspondence of the color and tonal circles. Hauer's first 12-tone compositions, in which he departed radically from the rules of tonality by declaring all notes to be of equal status, were performed at the Bauhaus.

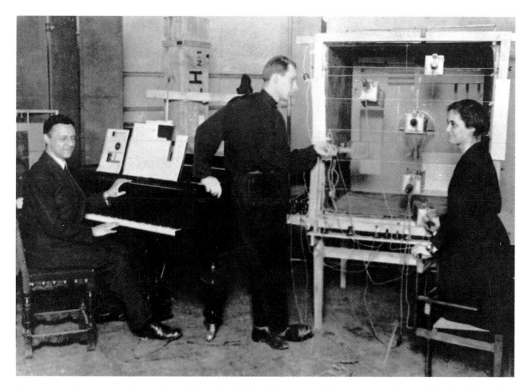

**The projection room for Ludwig Hirschfeld-Mack's color-light presentations.** About 1924, at the piano, Ludwig Hirschfeld-Mack; center, unknown; on the right, Marli Heimann, photograph by Frankl, BHA. • At these performances elementary forms in the shape of interchangeable patterns were projected onto a screen to a piano accompaniment. The use of various light sources produced overlapping shadows and color mixtures.

In practice, the spectrum of musical performances at the Bauhaus ranged from music provided as required by the Bauhaus Band, via the stage music used by Oskar Schlemmer, to experiments in the production of notes and noises carried out by László Moholy-Nagy in the spirit of futuristic sound manufacture. The source material for music at the Bauhaus comprises numerous sketches, diary entries and exchanges of letters. It documents above all the systematic transposition of extracts from musical scores to color spectrums and drawings. There are sketches relating to this by Hauer, Hirschfeld-Mack, Itten, Kandinsky, Klee and Neugeboren. Furthermore, in the output of the Bauhaus there are quite a number of allusions to musical compositions in the picture titles of pieces of free work – a reflection of the way the members of the Bauhaus saw themselves as transcending the individual artistic genres. In the picture series used in color teaching, the systematic nature of the laws of form and color was the subject of investigation. Concepts such as "Klangfarbe"

**Kurt Schwerdtfeger, Reflected Light presentation.** About 1923, photographer unknown, BHA. • Photograph of a phase produced with movable patterns. This kind of virtual painting was presented on the occasion of the major Bauhaus exhibition in 1923. It provided an experience of time and music.

(sound-color) and "Farbklang" (color-sound) were often used synonymously, although they denote different phenomena in music and painting: in the first case the selection of instruments and the resulting techniques for producing notes, in the other the combination of different colors in a single picture. Both phenomena, however, have in common the fact that they explore comparable effects in the perceptual process.

### The Bauhaus Band

A significant part of the music performed at the college was provided by the Bauhaus Band. There are references by T. Lux Feininger, who was the youngest member of the band at the time, and by Eva Weininger to the original Bauhaus Jazz Band, describing the nature of the instruments used and the band members' style of ensemble playing. The founder of the ensemble was Andreas Weininger, who established the band in 1924. Weininger's piano playing and singing were described as "improvised fantasy music." He was self-taught in both skills, and eventually mastered various jazz standards, which were noted down on small pieces of paper in the form of brief instructions to the performer. The band was later enlarged by the addition of Heinrich Koch, Hans Hoffmann and Rudolf Paris; they accompanied "Andor" Weininger – improvising, to begin with, like him – on home-made percussion, string and wind instruments.

In addition to kettledrums, side drums, cymbals and cowbells, the percussion section included a homemade pedal machine for the large side drum, also with which an infernal din could be produced. The unusual "flexaton" is also worth mentioning: it was used as a string instrument in conjunction with a tambourine (as a resonating body). Automobile horns attached to the bass drum give one an inkling of the kind of sound produced in this early phase of the band's existence, which must have had a gay, lively effect. There was also a variant of the "lotus flute" which had a variable piston for modulating the tone.

In addition to humorous musical entertainment by the Bauhaus Band, a Berlin jazz band was invited to perform the latest forms of American jazz in dinner jackets at the

legendary college parties. After 1928 the Bauhaus Band was augmented by a wind and brass section and its members changed respectively. With the new musicians Eddie Collein, Ernst Egeler and Roman Clemens the character of the group also changed. Moreover, new dances were in vogue. The humorous aspect no longer played the most prominent part in the band's repertoire. Unfortunately there are no extant recordings to convey the spirit of these years. The band's existence continued

**Henri Nouveau (also known as Heinrich Neugeboren), Plastische Darstellung der Es-Moll-Fuge von Johann Sebastian Bach, Takte 52–55 (Plastic Representation of the Fugue in E flat minor by Johann Sebastian Bach, bars 52–55).** 1928, photograph by Robert Binnemann, BHA. • Reconstructed from the model by Gerda Marx at the Bauhaus, Dessau. "In two zones, one behind the other, the following are visually presented: (1) horizontally, the constructional process, (2) vertically, the distance of each note from the keynote, the tonic, (3) from front to rear – both on the base and rising at an angle of 45 degrees – the distance of the voices from one another."

**Portrait of Lotte Gerson with saxophone.** About 1929, photograph by T. Lux Feininger, J. Paul Getty Museum, Los Angeles. • Lotte Gerson was probably the only woman ever to play in the Bauhaus Band.

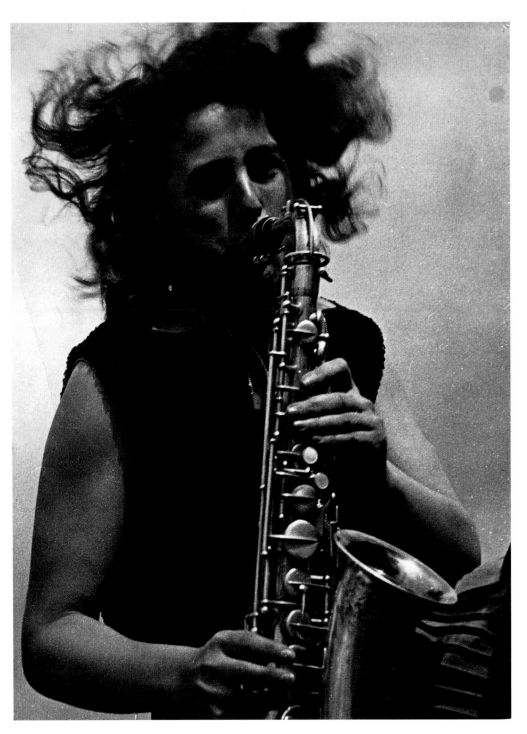

**(Self?) portrait of T. Lux Feininger with banjo.** About 1927, photograph by T. Lux Feininger, J. Paul Getty Museum, Los Angeles. • The young Feininger played banjo and clarinet in the Bauhaus Band although he was completely unmusical in the classical sense. He had acquired a visual musicality which consisted in a perfect memory for sequences of chords. The rest was provided by the infectious rhythms.

**Portrait of Andor Weininger.** Before 1930, photograph by Walter Peterhans, courtesy of Barry Friedman Ltd, NYC. • Weininger was one of the students who took an intense interest in the stage and music. He devised an abstract mechanical cabaret and performed "abstract" songs at many a party, which are said to have moved listeners to tears.

until the Bauhaus was closed down by the National Socialists in 1933.

### Stage music

In the course of the 1920s, Schlemmer, either single-handedly or with the assistance of Bauhaus students, stage-managed productions of his own ballets as well as performances by colleagues from the German musical avant-garde. Paul Hindemith's operatic comedy *Das Nusch-Nuschi,* with a libretto by Franz Beil, first performed in Stuttgart on June 4, 1921, was the first production to emerge from the Bauhaus and from Schlemmer's extramural projects. In 1923 Hermann Scherchen, the leading conductor of the works of Gustav Mahler and the second Viennese school, staged one of the first performances of Stravinsky's *Soldier's Tale.* During the Bauhaus Week in Weimar, which had been organized as a parallel program of musical and literary offerings to the college's famous first exhibition, in the autumn of 1923, there was a soirée with Schlemmer's abstract figures from

the *Triadic Ballet*. But ultimately it proved impossible for Scherchen to produce incidental music for the *Triadic Ballet* from Schlemmer's director's copy. Scherchen's staging of the dance version of Stravinsky's *Les Noces,* also planned for 1927, was never realized due to lack of funding. An additional outstanding event worthy of mentioning is the performance of Schoenberg's drama with music *Die glückliche Hand* (The happy Hand), Op. 14 at the Kroll Opera in Berlin, conducted by Otto Klemperer, and which is considered part of musical history.

In addition to advanced compositions, Schlemmer also used stage music by Enrico Bossi, Salvino Betuch, Giovanni Schicci and Giacomo Puccini for his work. The last production designed by Schlemmer, under the title *Reigen in Lack* (Round-dance in Paint), was staged in the Concordia-Halle in Wuppertal on December 6, 1941 to mark the 75th anniversary of the Herbert paint factory. Music by Georg Friedrich Handel was played.

## Music and Drawing

Although the Bauhaus did not provide a proper musical training, music did have a specific function in learning to understand the laws of form. Numerous transpositions of musical scores give evidence of this search for the laws of form and color. Kandinsky made an illuminating comparison in 1926 between the dimensions of space and time:

"The question of time in painting is an issue in its own right and is very complex. Here also, people began a few years ago to build a wall. Until now this wall has kept two spheres of art apart from each other, the spheres of painting and music. The ostensibly clear and legitimate separation of painting (space/plane) and music (time) has on closer examination (albeit a cursory one hitherto) suddenly been called into doubt – by painters at first, as far as I am aware. This is not the place to treat this subject in detail, but some of the factors which clearly reveal the element of time must be emphasized. The point is the shortest form of time" (Wassily Kandinsky, *Punkt und Linie zu Fläche* [Point and Line to Plane], Munich, 1926). The titles of some of Kandinsky's

**Friedhelm Strenger and T. Lux Feininger/Ernst Egeler (photographs), Folding card advertising the Bauhaus Band.** About 1931, BHA. • Text: As you can see, we survive all the storms. We play our music, a bone-rattling rhythm that makes its mark! You just have to hear us and you'll think of us! For your festivals, the Bauhaus Band

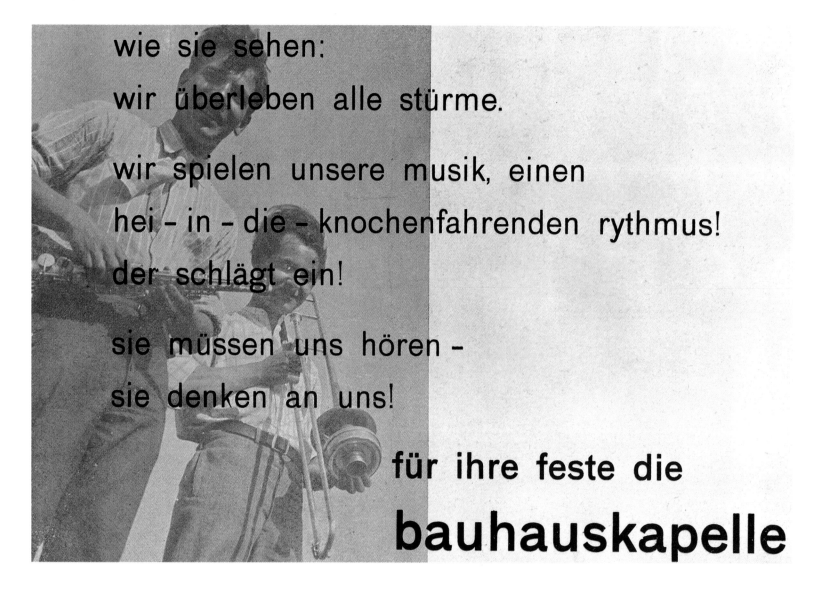

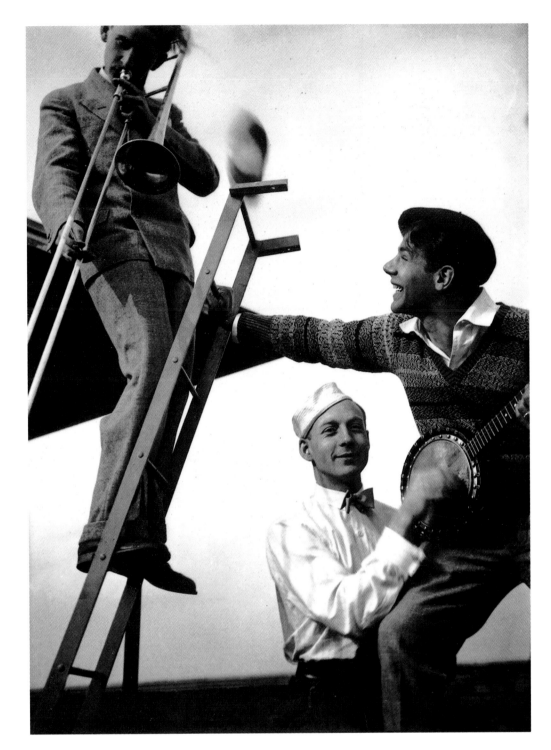

pictures also suggest musical origins (like those of Alexey von Javlensky), e.g. *Composition* and *Improvisation*.

References to the fugal technique of baroque music and to Johann Sebastian Bach are to be found in every phase of the work of Paul Klee, who was himself a trained viola player with practical experience of orchestral and string quintet playing. The picture titles of the watercolor *Fuge in Rot* (Fugue in Red) of 1921 and

the oil painting *Ad Parnassum* (1932), which refers to the *Gradus ad Parnassum* (1725) of Johann Josef Fux, are evidence of Klee's interest in the formal principles of baroque music. This predilection is the basis for the transference of musical principles to the use of line in drawing. There is an extant working sketch from the early 1920s which Klee used in his teaching to illustrate the idea of analogy: "A number of things can be learned from the

**Wassily Kandinsky, Bild XV: Die Hütte der Baba Yaga (Picture XV: The Hut of Baba Yaga).** 1928, stage design for Mussorgsky's "Pictures at an Exhibition," tempera, watercolor and Indian ink on paper, 19.9. x 29.9 cm, Cologne University. • Kandinsky translated this "program music" into 16 pictures of abstract movement. For the performance at the Friedrich Theater in Dessau, the "witch's hut" in the center was at first draped in black, while spotlights lit up from behind the sequences of dots and dashes cut out from the wings, then the center-stage circle glowed yellow while the arrow rotated.

example of three-part musical writing. Firstly, the possibility of a new form of presentation which is at the same time both abstract and compellingly real. Also the relationship of two or three voices to one another, seen in terms of location according to length and height." In Klee's paintings the rhythmic and dynamic process is emphasized by means of a systematic horizontal arrangement. The staves used in sheet music, which are arranged both horizontally, corresponding to a temporal, that is a metrical musical articulation, and vertically, to indicate musical pitch – gave Klee the idea for his line pictures of the 1920s. Klee's technique of transference breaks the musical process down into single events, whereas Kandinsky, by contrast, presents the musical score in terms of dots, in a pointillistic manner. In both painters, visual thinking is determined by the graphic presentation of the music. Against this background, many of Klee's works can be regarded as graphic notations originating in music.

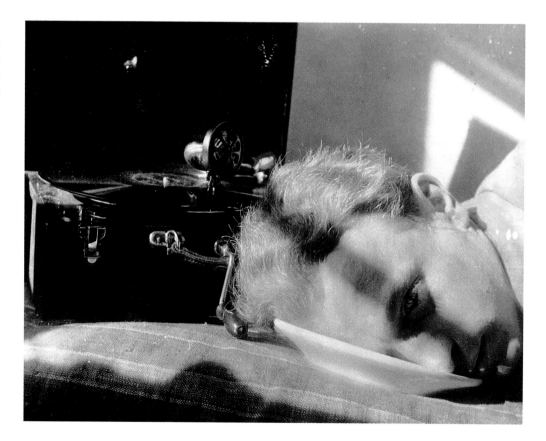

## Futuristic aspects

The Bauhaus member most strongly affected by the ideas of Futurism was probably the master László Moholy-Nagy, who at an early stage had already experimented with unusual materials in the most diverse areas of visual design. His attempts at synaesthesia culminated in the "Sketch of a Score for a Mechanical Eccentric," which he had conceived as a unity of form, movement, sound, light (color) and smell. As early as 1923 he devised gramophone music in which the record was treated with needles and knives originally meant for cutting linoleum. When the record was played, this produced rhythmical noises, glissandi of notes, accompanied by scratching and hissing. By thus creating music in an artistic experiment, Moholy-Nagy (ten years after the Futurist Luigi Russolo) violated a taboo of the world of Western music, which in its obsession with a kind of tonal hygiene had been at pains precisely to purify music of all incidental noises. Moholy-Nagy, on the other hand, evaluated noise as an expression of the increasing mechanization of the industrial environment, and used it as a symbol of modernity. In so doing he stood at the very beginning of that pioneering DJ movement which, since the end of the 1980s, has opened up new paths for popular music, for example in rap, hip-hop and trip-hop, by using the techniques of scratchers and samplers.

**Joke photograph.** About 1925, from left to right, Marianne Brandt, Wolfgang Rössler, Otto Rittweger, photographer unknown, BHA. • The metal workers added private "harmonics" to the mechanical sound world of their workshop.

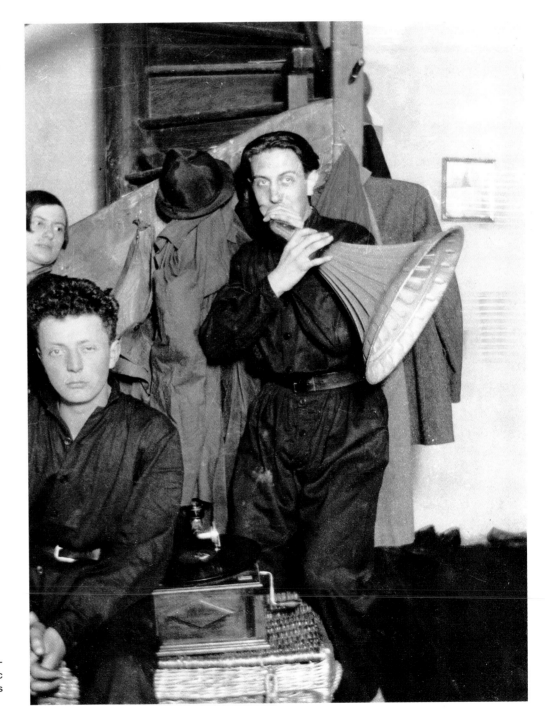

**Joke photograph.** About 1927–1930, photographer unknown, BHA. • Music from the shellac groove is enhanced, it seems, if the outer ear is enlarged.

# The Self-Portrait – Photography as the Trigger of Reflected Perception

Jeannine Fiedler

To make an image of oneself or of somebody else is one of the oldest ways of discovering form, and in the artist's dialogue with the world it is the way that is closest to hand. Now that "the invention of photography has dealt a mortal blow to the old means of expression" – a dictum of André Breton – the art of portraiture is no longer reserved solely for those with a talent for drawing. By pressing the shutter release button on a camera, one captures a beloved face and thus not only an image of a happy moment but also a souvenir with eternal value – no matter whether or not the result is distinguished by any technical or artistic skill. Photography bestows a similar long-term value on documentary portraits of people in the public eye. As the executor responsible for these faces, photography illustrates politics and culture and personalizes history, lending it a visible presence.

After the "New Vision" had carried out, in the 1920s, a reassessment of all previously valid photographic conventions, the traditional conception of a portrait was also demolished. In the wake of the new beginning, when all the arts set out to find unknown, new forms of visual expression, photography, in addition to the reproductive function of the medium, also discovered its own particular abstract formal qualities. It thereby put an end to its epigonal dependence on painting as the genre which made use of its motifs and took the place of its sketches. The vocabulary of the "New Vision," with its wealth of ideas and "breaches of the rules," enabled photography to escape from the monotony of its reproductive, copyist's role and rise to the level of artistic productivity. Improved, easy-to-use cameras and techniques went a long way to establish the new spectrum of image-making. For almost a hundred years portraits had been the domain of art photographers who made their models adopt static poses derived from painting, or embellished them with the insignia of their professions. But now the photographic dialogue enabled them to abandon theatrical poses and adopt their own creative gestures.

The "new photographer" and portraitist also moved into the Bauhaus and began to explore the inherent potential of the medium: fragmentation, distortion, unusual perspective, multiple exposure. The only limits to the catalogue of exotic compositional approaches bequeathed by the pioneers of the "New Vision" were technical limits. The (self-)portrait came to be the governor of a modern iconography, and the Bauhaus student, without any technical expertise, put himself at its service. The camera became for him an everyday means of spontaneously photographing the college and its living inventory. The decisive qualitative leap, however, developed from the casual snapshot of a friend to the carefully composed single picture which elevated the impact of face and "artistic body" to its theme. The certainty of being part of the great

**Self-portrait by Ise Gropius.** 1927, enlarged from an original negative, BHA. • The mirror works its magic in the infinite multiplication of the female face. The motif of the mirror in self-portraiture is, as it were, a meditation on the medium of photography itself.

**Self-portrait by Moses Bahelfer.** About 1929, J. Paul Getty Museum, Los Angeles. • Bahelfer demonstrates the appropriation of the mirror, along with the convex surface of a flashbulb holder, as an emblem of vanity and transitoriness in a modern variant of "vanitas."

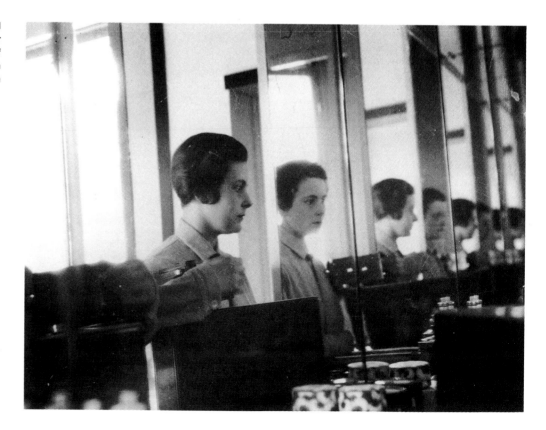

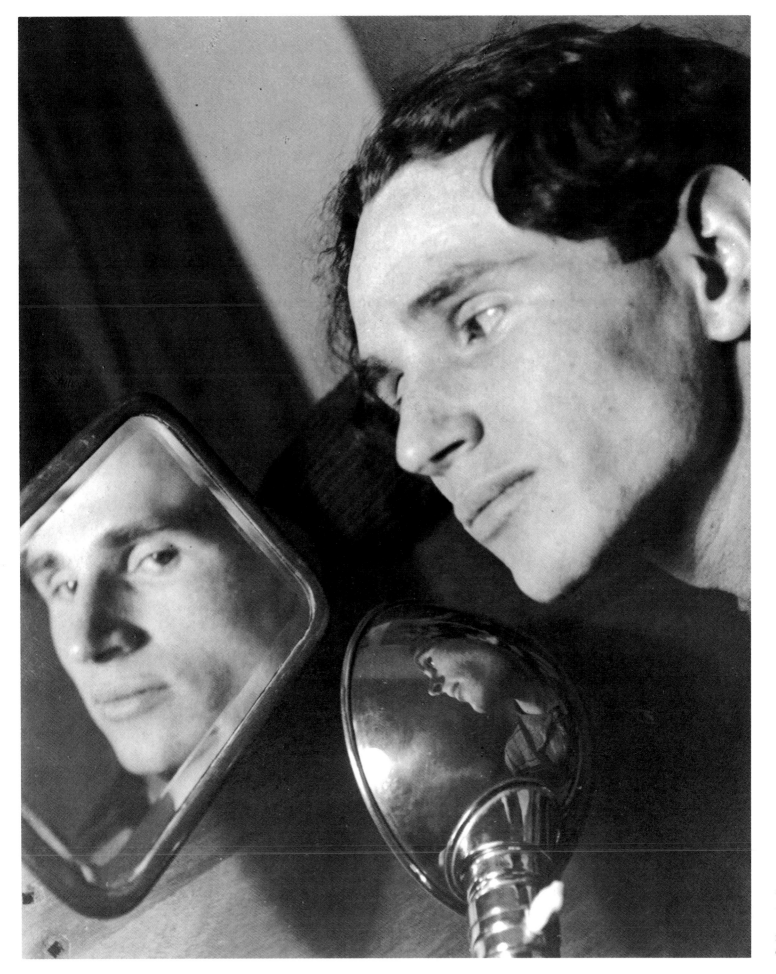

Self-portrait

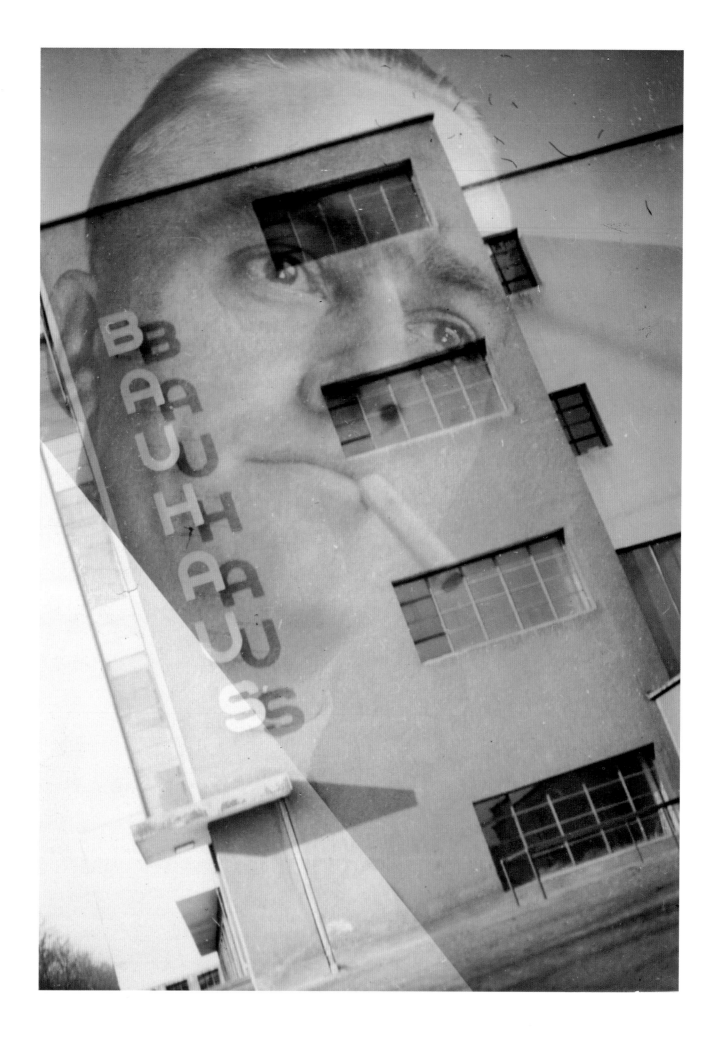

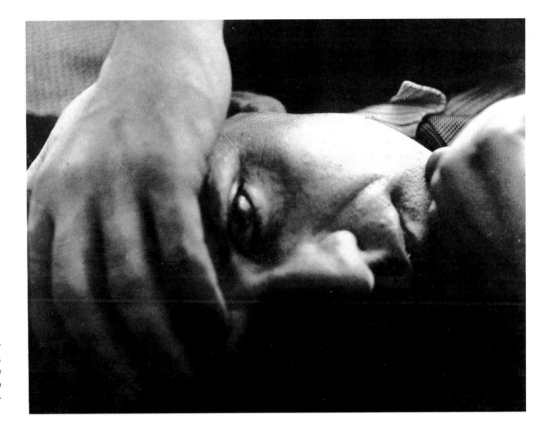

**Portrait and Bauhaus (Willy Hauswald).** 1930, photograph by Kurt Kranz, BHA. • In this "mediated self-portrait" Kranz, by way of the portrait of his teacher and the word "Bauhaus," enrols as a student at his college. If one wishes: a work on the subject of the Bauhaus community spirit.

**Portrait of Hannes Meyer.** About 1928, photograph by Lotte Beese, BHA. • Not a self-portrait, but a photo session between new lovers. To take possession of the other person's body – above all the face and the hands – in the act of photography: an assurance of mutual affection.

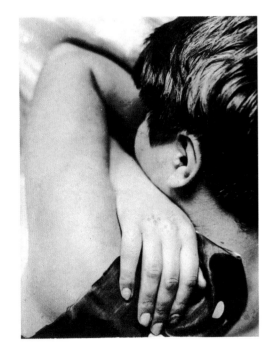

**Portrait of Lotte Beese.** About 1928, photograph by Hannes Meyer, BHA. • To portray a comrade or a girlfriend was an almost daily exercise. The portraits by Meyer and Beese derive their special effectiveness from the unusual camera angle and above all the close focus which suggests great intimacy with the other person.

Bauhaus experiment, the attempt, no less, to reshape society and its living worlds, led to the self-confident staging of personal cults of genius. Well-nigh every member of the Bauhaus secretly felt him/herself to be an artist, and was animated by the thought of the legendary painters and architects by whom he/she was privileged to be taught. On the way to a future as an active artist or shaper of the world, what was more natural than to declare one's own image to be one's first independent work? The numerous extant self-portraits indicate that although the members of the Bauhaus were not the first to have regarded their own physical body as the culmination of the relationship between an artist and his work – they had been preceded by Marcel Duchamp's exhibitionism in the pre-Dadaist tumult between tonsure and travesty – the women in particular, Marianne Brandt and Gertrud Arndt, created ambiguous, enigmatic images of themselves and, long before Cindy Sherman, made the body with its changing demeanor into a source of authoritative images of femininity.

Other favorite "props" in the private studios at the Bauhaus included the hands – along with the face the most personal detail of the artist's appearance – and the mirror. The latter has always been part of basic studio equipment. If the hand is the most aristocratic instrument, the mirror is the artist's teacher and is sometimes more accurate than the eye. As the motif of a picture within a picture or, in the case of a metal sphere, a distorting mirror of the selected centering of the image, it duplicates concrete spatial arrangements and is the climax of the composition. Furthermore, in a self-portrait it "explains" the causal connection between the mirror and the photograph: a picture is created by the self-reflective object and acquires presence through it. Thus the mirror becomes a symbol of meditation on the medium photography and illustrates the dual role of the photographer as model. By virtue of its direct relationship to reality, his/her own image in the mirror as in the photograph directly affects the viewer. Both media reflect the theme of Narcissus, catching sight of his own face on the surface of the water and falling in love with it.

To hold the viewer's attention by the image of the portrait's subject constitutes an ideal form of reception, which Charles Baudelaire incorporated in his aesthetics of perception as the category of *plaisir primitif*. The distinguishing feature of a successful portrait was successful immediate "eye contact" with the

person portrayed. Throughout the history of artistic reception, however, such portraiture has been allotted a lower status than a composition that is intellectually constructed, and therefore reveals itself to the viewer only one step at a time.

In the case of self-portraits, on the other hand, the factor of intimacy must be evaluated differently than for a picture that the artist creates from his model. The subject, from his/her own resources, affects the external appearance from within, in order to give the face a "subtle moral texture" far removed from everyday imitation. A quite different determination to be truthful is involved here. The identification with the third party, i.e. the portraitist, who predefines the model and, so to speak, overlays the observer's view with his own projections, is eliminated.

Thus an artificial "face-to-face" dialogue is created of a kind that does not occur in ordinary encounters with pictures, for in this process the spark of recognition in the viewer's eye is always one-sided, the gaze of the person presenting him/herself retains a rigid axis. Yet the self-portrait artist proceeds from an acceptance of the artificial nature of the situation: "artificiality" is written into the pose.

The "art" of self-representation consists, however, in eliciting from the interpreter of the picture both respect for the pose and an understanding of the operation in front of the camera and the operator behind it. To impart a staged image of oneself – is that not to establish the rules of self-perception in everyday life too? The task of a portrait is to bring out the intensity of presence in the uniqueness of detail, instead of providing a representative image which by means of various codes and analogies, that is to say by means of incidental detail, quotes its way into an iconography. There is a correlation here between Roland Barthes's invention of the "punctum" that strikes a nerve, the detail that captures the viewer's attention (see Barthes, "Phenomenology of the Look" in his remarks on photography in *Camera lucida,* New York, 1981)

**Self-portrait by Karl Straub.** 1923–1924, courtesy of Kicken Gallery, Cologne. • Votive picture or legacy? In this early photographic experiment, Straub uses double exposure to intensify the impact of the subject.

**Copper vase (self-portrait by Gyula Pap).** 1930, BHA. • A popular motif of self-portraitists at the Bauhaus: reflections in gleaming spheres and vases. Here modern photographic technique alludes to the long painterly tradition in the history of Western art.

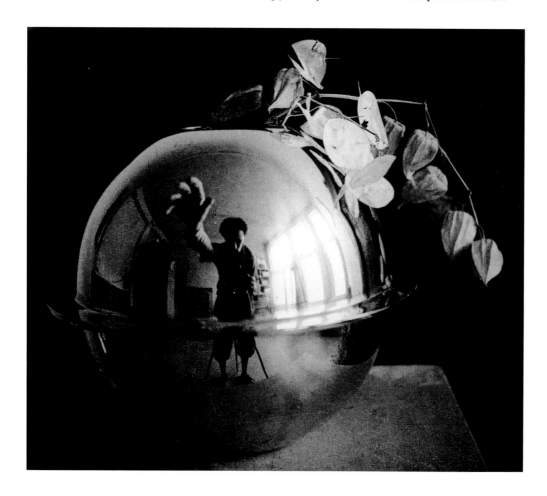

**Self-portrait by Walter Funkat.** 1929, BHA. • For his unsettling "constructivistic" self-portrait Funkat used the lobby of the Dessau Bauhaus, which was adorned with glass balls for the "Metallic Party." Perhaps he was inspired while watching the preparations.

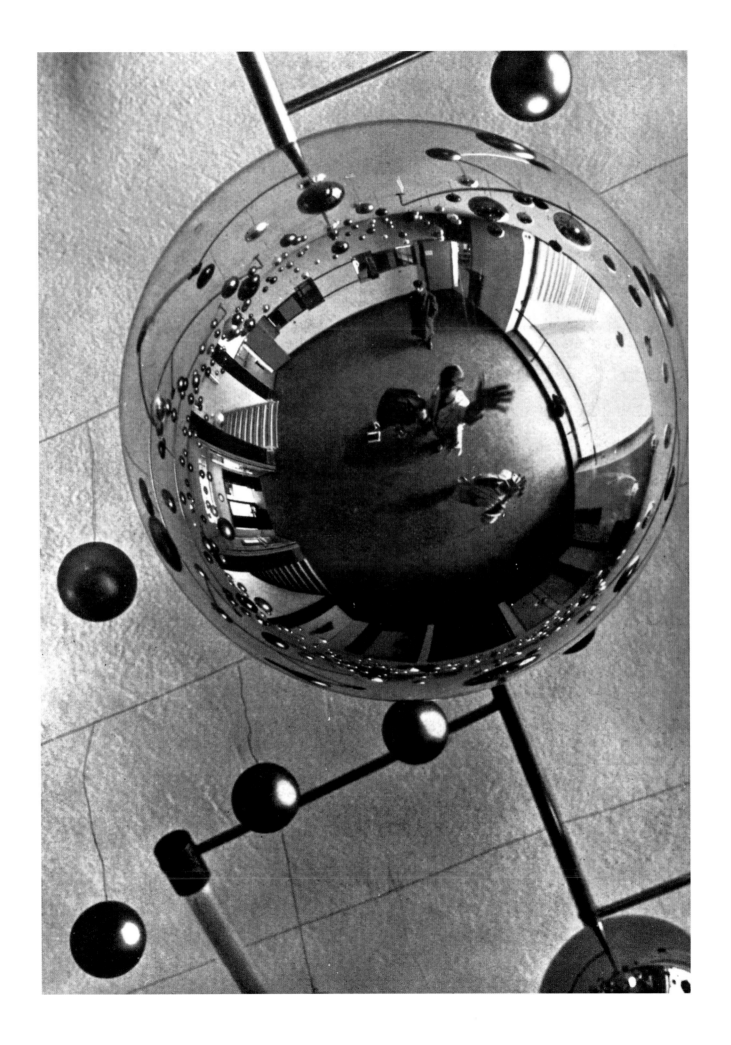

Self-portrait

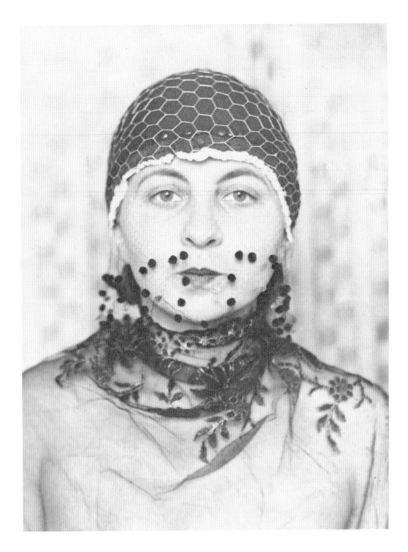 

**Masked self-portrait No. 13.** 1930, photograph by Gertrud Arndt, Folkwang Museum, Essen. • In Dessau, Gertrud Arndt, a trained photographer, created a series of 43 "masquerade" photos. With the help of "typical" feminine attributes she ran through the entire repertoire of the masquerades of womanhood – from well-behaved and moral to lascivious and frivolous.

**Masked self-portrait No. 16.** 1930, photograph by Gertrud Arndt, Folkwang Museum, Essen. • Arndt as an enigmatic "queen bee" uses double exposure to enhance the veiled effect. An alert gaze confronts the viewer, yet the eyelids are also humbly lowered. An unconventional allusion to Edward Steichen's famous portrait of Gloria Swanson.

and Baudelaire's quick-closing "eye-trap" between the viewer and the portrait. A "study" would therefore mean a cold, indifferent approach to the subject. The person who photographs himself performs a balancing act: his own essential being must be concentrated, because without it the portrait would show only one among many nameless faces. In the finished, frozen structure of imitation either a "mimetic exorcism" occurs and the viewer is presented with an empty mask, or an emotional force field unfolds its magic – directed by those vectors which the self-portraitist was prepared to exempt from censorship.

The artistic process of mimetic selection can rarely encompass the whole human being. Even for those possessing the knowledge, it will merely touch on segments of personality. At this point the ostensible "truth" of the photographic image is taken ad absurdum. That the image shown is subject to a process of artistic interpretation has always been a criterion in the assessment of portrait painting, and even if the artist's vision does not dominate the portrait, it does at least rank equally with the personality of the model. A photograph, on the other hand, is always assumed to be authentic. The self-portrait must begin by avoiding these pitfalls of the medium, yet it is confronted by definition with an impossible task: to create an image that is at once staged, and yet authentic. Connoisseurs of the human psyche such as Oscar Wilde have seen truth only in poses. But whether a pose does in fact help to give a deeper insight into the

personality of the subject of a portrait is something that only the viewer himself can read from the camera's mechanical transformatory act. Only the receiver lends the portrait, by looking at it, aesthetic sovereignty, or else he condemns it to remain insignificant.

In its anxious skepticism when faced with the magic photochemical formula, the 19th century devised the fiction of the power of photography to minimize existence. Captured by light rays on the silver plate, the human face took on a fateful aura as the subject of the portrait, in the Faustian bargain with incomprehensible technology, yielded up layers of his being in order to obtain a picture of himself: photography as alchemistic flaying. With the increasing dominance of technology and media at the beginning

**Self-portrait of Gertrud and Alfred Arndt.** 1928, J. Paul Getty Museum, Los Angeles. • A rare example of a double portrait using a delayed-action shutter release. Demonstrating the independence of the partners in the spirit of the age, he is entirely skeptical (about the success of the photo?) whereas she (as the probable instigator) shows her amusement at the unusual perspective.

**Self-portrait by Marianne Brandt with neck and head adorned for the "Metallic Party."** 1929, BHA. • The metalworker in the "harness" of her own products – a programmatic profile of women's new self-assertion.

of the 20th century the photograph became a picture among other pictures and lost its gloomy charm. The theoretician of the "New Vision," László Moholy-Nagy, even predicted that a person who did not possess the "optical prosthesis" (i.e. a camera and the ability to make use of its versatility) would be a future illiterate, no longer able to read the world, which, by virtue of the ability of photography to produce multiple copies, was about to be transformed into one great picture book. In the present, the fact is that even computer-generated photographs are understood and "read": advertising and the media are dominated by the idealized portrait. An existential definition of art and creativity is now of secondary importance; in the day-to-day personality cult the portrait photo is not only a substitute for the living human being, but within a culture that feeds off idolatry, it superficially possesses, in its mass, variety and inexhaustible supply, the ability to constitute being. "I am looked at, therefore I am." The magical dimension of the photographic medium in the enigmatic quality of the unique picture scarcely exists any more today. In the self-portraits of the Bauhaus it can still be discerned.

**Self-portrait by Marianne Brandt.** 1923 (?), BHA. • Entirely the visual artist, Marianne Brandt presenting a stylized image of herself, in line with the Weimar Bauhaus idyll, as an elegiac flower bride. The first of a series of biographical self-portraits, it still draws on the conventional half-length portrait.

# Free painting at the Bauhaus

Eva Badura-Triska

**Hans Haffenrichter, Interieur mit blauer Vase (Interior with Blue Vase).** 1921, watercolor on paper, 32.2 x 22.6 cm, Misawa Bauhaus Collection, Misawa Homes Co. Ltd, Tokyo. • This slight Indian ink exercise combines the thematic areas of window picture and still life. In line with the fundamentally unpolitical attitude of the Bauhaus painters, it is executed in the manner of neo-Romanticism practiced by the "Idyllists" Alexander Kanoldt and Georg Schrimpf and their circle.

**Georg Hartmann, Das ist mein Frühlingsmädchen (This Is My Girl for Spring).** 1925, Indian ink on waxed tissue paper, 27.8 x 18.2 cm, Misawa Bauhaus Collection, Misawa Homes Co. Ltd, Tokyo. • In this "friendship" picture the heart of the Bauhaus artist belongs to this ethereal little nymph, this floating sprite. The drawing was derived from a jointed doll in the studio.

Gropius's dictum that the "building" was the "ultimate goal of all artistic activity" entailed the view that painting, along with sculpture and applied arts and crafts, would only have a subservient part to play as an "inseparable component" of a great "unified work of art." Despite this, "free," that is to say non-applied, painting always enjoyed an essential role at the Bauhaus. Nor is it really surprising, even though the directors of the college were all architects, that responsibility for aesthetic education was predominantly in the hands of free painters and sculptors. These staffing arrangements alone suffice to explain the fact that "free art" was de facto practiced throughout the Bauhaus by both teachers and students. But its role and raison d'être in relation to the aims of the college was from the beginning a controversial and much-discussed issue.

The basic orientation of the college as a workshop school provided for equal emphasis on craft and on formal creative training, but not the training of painters and sculptors in the classical sense. Accordingly a distinction was made in the teaching staff between "craft masters" whose job was to impart craft skills, and "form masters" who taught the principles of design, but no distinction was made between free and applied art. This makes it all the more interesting that for a long time Gropius did not appoint a single architect or applied art specialist to implement his aims, but exclusively representatives of the "free" visual arts. He was evidently convinced that what mattered was basic attitude. Hence his primary selection criterion was "progressiveness," as is confirmed by Itten, who in November of 1920, when the appointments of Klee and Schlemmer were imminent, wrote to Klee: "If we ... appoint two more modern artists with the same outlook, then I believe that Weimar will become a center for the most intensive artistic work in a progressive spirit, beyond the reach of reactionary elements" (letter in the Itten archive of the Kunstmuseum in Bern). The artistic evolution of the Bauhaus was to prove that Gropius's approach was the right one.

Of course, his ideas could not be put into practice immediately without any transitional stage. The teaching staff of the new institute (which had after all been formed by merging the Weimar Schools of Fine Art and of Applied Arts) included to begin with Professors Max Thedy, Walther Klemm, Richard Engelmann and Otto Fröhlich from the old schools. Thedy, who had taught at the School of Fine Art since 1883, was a painter whose thinking was extremely conservative and who worked in an academic, old-fashioned style derived from the old masters. He openly opposed the new direction taken by the Bauhaus. both Engelmann, who had studied with Böcklin and Rodin, and Klemm, who did try to come to grips with Expressionism, made an effort to be open-minded but remained outsiders, artistically speaking, until they left the college in the winter semester of 1920–1921.

Since Lyonel Feininger and Gerhard Marcks, the first form masters appointed by Gropius with effect from May 1919 on, did not have the necessary qualifications to translate the Bauhaus concept into a concrete syllabus or an adequately structured curriculum, teaching was initially little different from that of a classical art academy. The syllabus included subjects such as portrait and nude drawing as well as anatomy lessons. It is interesting to note however that nude and figure drawing remained on the course schedule and was taught by Schlemmer, among others, under the title of "Lehre vom Menschen" (studies of people). As is well known, the decisive turning point did not come until October of 1919, in the figure of Johannes Itten, who established the fundamental principle that the aim of art teaching was to impart a basic knowledge of artistic materials and techniques, thereby equipping the student for independent creative work. His conviction was based on a way of thinking that played an essential part in the early 20th-century avant-garde. Now that the resources of painting had been released from their function in the service of representational illusion, and abstract art had isolated them and

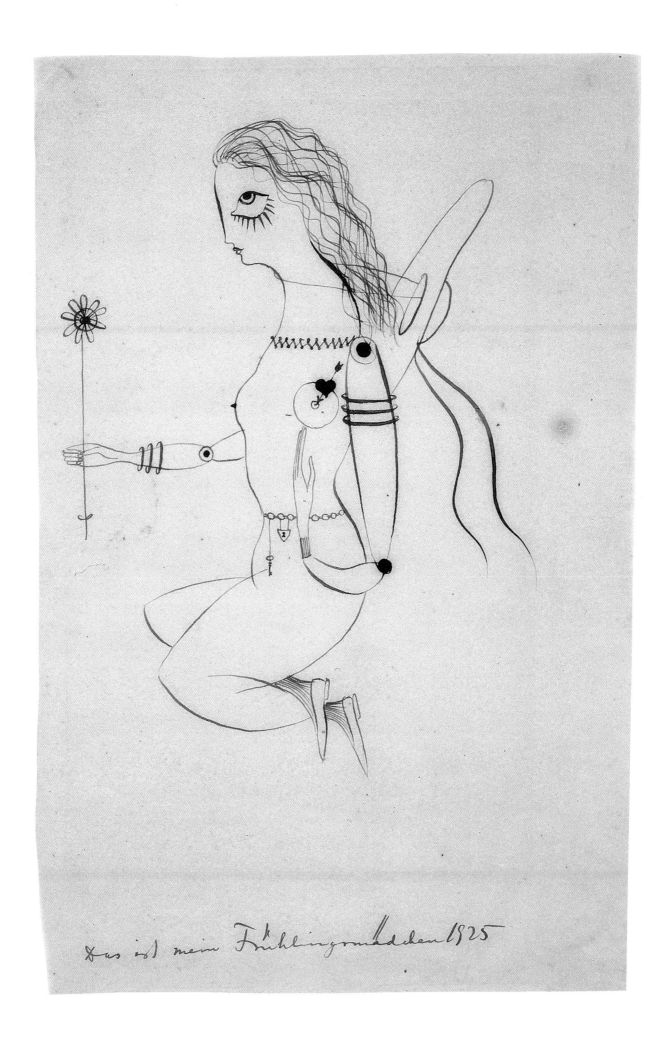

Das ist mein Frühlingsmädden 1925

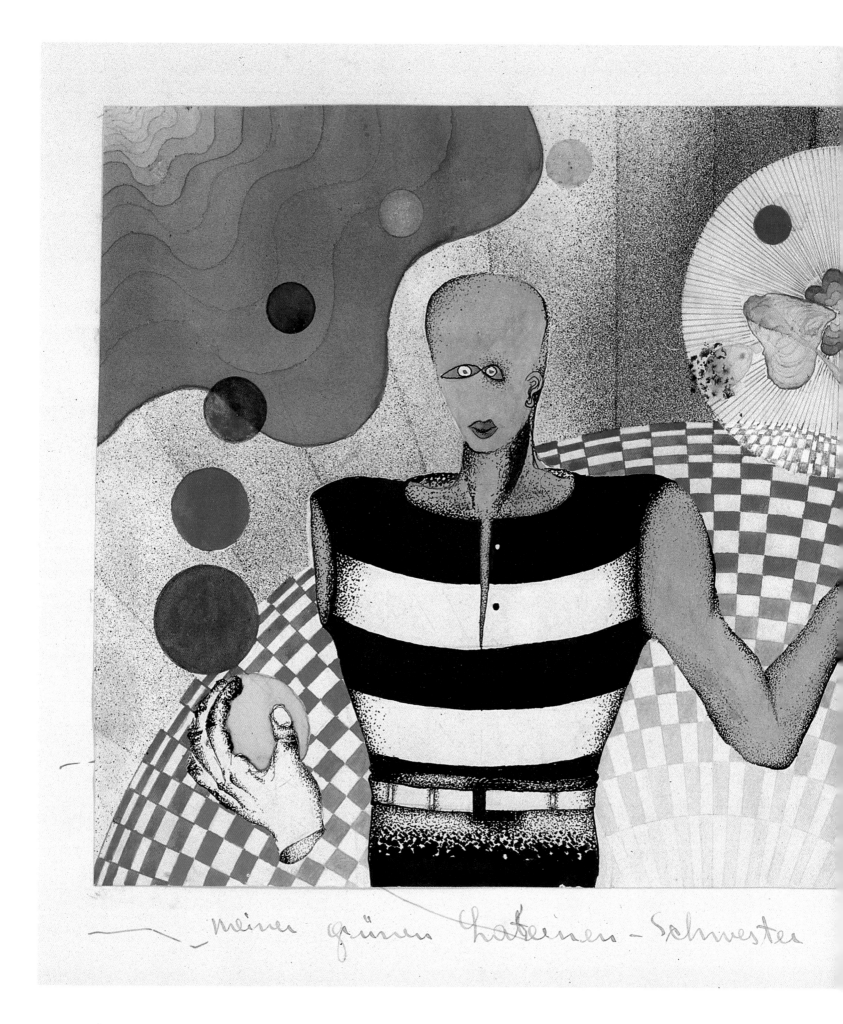

meinen grünen Lateinen - Schwester

Hilde Rantzsch

August 1927

**Franz Ehrlich, Blau mit Gelb auf weißer Spitze (Blue with Yellow on a White Vertex).** Around 1930, oil on canvas, 49.2 x 63.6 cm, SBD, collection archive. • The magical power of the color blue in an abstract measurement of color temperature: with this picture the furniture and exhibition designer Ehrlich gave expression to his artistic energies.

**Hilde Rantzsch, Meiner grünen Laternenschwester (To My Green Lantern Sister).** August 1927, mixed media, 24.0 x 33.0 cm, Misawa Bauhaus Collection, Misawa Homes Co. Ltd, Tokyo. • The weaver Rantzsch looks far into the future with her asteroid cosmic juggler, for the picture's coloring and choice of motif reveal a greater affinity with Richard Lindner's pop figurines from the 1960s than with New Functionalism.

allowed them to speak for themselves, increased efforts were made to achieve a clear understanding of their nature. The conviction that was now heavily encouraged, that "art lies in the means" (Adolf Hölzel in *Hölzel und sein Kreis* [Hölzel and his Circle], exhibition catalog, Freiburg, 1916, p. 5) resulted in an increasingly systematic analysis of those means, not infrequently based on the belief that abstract forms and colors were directly and universally readable. Essentially, the father figures of abstraction such as Adolf Hölzel and his pupils (who included Itten and Schlemmer) held this idea, albeit in a different specific form in each case, to the same extent as, for example, Robert Delaunay and Paul Klee, also the Russian Constructivists – to whose circle Kandinsky of course belonged – and the artists of De Stijl.

The Bauhaus teaching staff, with their shared aims, were a gathering point for the leading spirits of modernism and consisted exclusively of artists who shared this approach. In their teaching, the masters Klee, Kandinsky, Schlemmer, Moholy-Nagy and Albers, who were appointed after Itten and in some cases on his advice, all followed his conception. The systematic analytical study of line, form, dark and light contrasts, color, texture and the properties of materials, which has come to be seen as the hallmark of Bauhaus thinking, was to a high degree in line with the aims of the curriculum, for it opened up the possibility of applying design principles or a formal vocabulary in various media, and hence also in the craft disciplines. It is not for nothing that the style of all Bauhaus products is marked by a pure concern for basic formal elements. At the same time this concept of teaching also equipped less creative people with the skill to take up the elementary design principles of other artists – as is borne out by many of the "free" artistic products of Bauhaus students.

**Max Bill, Der Eilbote (The Messenger).** 1928, watercolor on thin handmade paper, fixed to card, sheet 13.4 x 23.0 cm, card 42.6 x 30.6 cm, Huber Collection, Offenbach. • A free work produced at the Bauhaus under Paul Klee's influence. Bill's comment on his picture reflects the attitude of many of his fellow students: "Sometimes I also paint when I want to, I very often want to, sometimes so often that I think I am a painter. Dessau, December 9, 1928." Deep down, most of them wanted to adorn the "white wall" of modernism.

**Petra Petitpierre, Handicap.** 1932, zinc etching, 13.1 x 20.3 cm, Misawa Bauhaus Collection, Misawa Homes Co. Ltd, Tokyo. • Petitpierre (also known as Kessinger-Petitpierre) followed Paul Klee to the Düsseldorf Academy in 1932 in order to become a painter. This grotesquerie is her most personal development of the master's figurative elements and motifs in the unusual medium of a zinc etching.

But even though they worked together constructively to implement the ideals and aims of the Bauhaus, artists such as Feininger, Klee, Kandinsky or Albers remained, in their heart of hearts, "free." Even Oskar Schlemmer, who with his murals and reliefs put himself most fully at the service of the Bauhaus idea (even at the expense of his own "free" painting work), spoke of "art" as being for him the "most primal and special thing" for which he had always "striven." "I cannot wish for any applied art that is merely a watered-down form of concentrated ideas. I cannot wish to build houses, unless it were the ideal house that can be derived from my pictures, where it is anticipated. I cannot wish to do anything that is already being done better by industry, and nothing that engineers do better. What is left is the metaphysical: art" (diary entry, November, 1922, in Oskar Schlemmer, *Idealist der Form. Briefe. Tagebücher. Schriften 1912–1943* [The Idealist of Form: Letters, Diaries, Writings], Andreas Hünecke [ed.], Leipzig, 1990, p. 103). It is true that Itten produced less work of his own, quantitatively speaking, in comparison with the years before and after his period at the Bauhaus. But the works which Feininger, Klee, Schlemmer and Kandinsky produced in Weimar and Dessau occupy an essential position, in terms of both quantity and quality, within their respective total output. Even László Moholy-Nagy, who with his enthusiasm for technology heavily encouraged the use of new media such as photography and film, always painted pictures as well. In Dessau, where functionalist, product-oriented thinking increasingly gained ground, the conviction that non-applied painting should be retained was not ignored: from 1927 there was a seminar in "free painting and design." Then in 1929, when Hannes Meyer was at the helm, came the introduction of "free painting classes" taught by Kandinsky and Klee. These were two steps in the direction of independence and ultimate isolation, steps which fundamentally breached the original concept of the unity of all the arts.

For the teachers, there was always an interaction between their painting and teaching work. We know, for example, that Paul Klee always studied the topics of his very systematic painting classes beforehand in his own practical work as a painter, and even produced "model pictures" for demonstration purposes in his teaching.

In general, the masters' "free" work played an important part in their position as role models, and the students were from the outset offered a wealth of material to look at. In addition to studio visits, individual and group exhibitions in

Der Eilbote.

Max Bill $ 1928. No. 40.

Ich male auch manchmal, wen es mir beliebt, es beliebt mir sehr
oft, manchmal so oft daß ich mich für einen maler halte.

Dessau, 9. XII 1928.

Weimar and its surroundings enabled the students to view their teachers' output and kept them up to date with the artistic developments of the moment. Thus, shortly after joining the teaching staff, Feininger, Marcks and Itten all introduced themselves in the skylight room of the van de Velde building with a selection of their work. Until 1923 the Bauhaus masters participated in the annual Thuringian art exhibitions, and Wilhelm Köhler, the director of the art collections of the Weimar Museum, not only devoted a comprehensive retrospective to Feininger in 1920 but also dedicated rooms in the museum for works by the masters to be hung there. Their work was also put on show in the nearby towns of Jena and Erfurt.

Finally, the great Bauhaus exhibition of 1923 in Weimar also included a section for "free" art works, in which creations by both masters and students were represented. Even so, the relationship of the Bauhaus to "free art" remained an ambivalent one, as can be seen from a leaflet that was produced on this occasion. In it, the inclusion of non-applied painting is justified on the grounds that the "individual picture" fulfills a preparatory function with regard to the total art work, namely that of the building (Gerda Wendermann, "Es bleibt das Metaphysische: Die Kunst." [There remains the Metaphysical: Art] in *Das frühe Bauhaus und Johannes Itten* [The Early Bauhaus and Johannes Itten], exhibition catalog, from Weimar, Berlin, Bern 1994–1995, p. 431).

The students were of course not by any means only familiar with their teachers' work. Pictures by the Expressionists or by Schwitters and Doesburg could regularly be seen in the galleries of Weimar and other nearby towns, and the college provided constant information about the work of the contemporary avant-garde by making the most important international art magazines available to the students.

In the field of painting, a few Bauhaus students created works which may be considered essentially independent contributions to the art of the 20th century. They undoubtedly include Josef Albers, Max Bill and Herbert Bayer. Albers, who was taught by Itten and then himself taught at the Bauhaus between 1923 and 1933 before emigrating to America, laid the basis in Weimar, Dessau and Berlin for his consistently abstract-geometric work. With his works, which explore the readability of the "means" of art and thus

**Konrad Püschel, Freie Komposition mit Farben und Formen (Free Composition with Colors and Forms).** 1926, Indian ink sprayed over pencil, 21.2 x 15.3 cm, SBD, collection archive. • Püschel's delicate study from Kandinsky's classes uses the technique of spraying which Klee and Kandinsky used in their works from around 1926 (inter alia in picture-letters which they wrote to each other). Circles, spheres and their segments dissolve in a mist of color and lose their concrete reality.

**Erich Mende, Stilleben (Still Life).** 1928, watercolor on paper 35.0 x 22.7 cm, SBD collection archive. • In this free composition, which grew out of classwork, the hand of the master is not difficult to discern. Kandinsky's metaphysical will to create art and his theories of "point and line to plane" naturally affected his students, resulting in derivative works.

ultimately of our faculty of perception in general, he became not least an important pioneer of American Minimal Art. Max Bill, who later worked as an architect, a graphic artist and a product designer as well as a painter, and was a leading representative of Concrete Art in Switzerland, also developed his consistent formal language of strict geometrical forms while still a student at the Bauhaus. Herbert Bayer, after completing Itten's preliminary course, studied mural painting with Kandinsky between 1921 and 1923, took over the printing and advertising workshop in Dessau in 1925 and made his mark equally as a typographer, a

designer, a photographer, and an exhibition designer. In addition, he also left a remarkable body of painting, occupying a position between geometry and surrealism.

There was of course a whole host of Bauhaus students who painted. Their works might be described as "second-generation avant-garde" inasmuch as they were dependent, to a greater or lesser degree, on the artistic example set by the masters, or because they synthesized something new of their own from the formal vocabulary of modernism. Even at the old Weimar School of Fine Art there were students working in a progressive vein, some of whom became

**Hajo Rose, Gestaltungsübung (Design Exercise).** 1931, watercolor, Indian ink over pencil on white card, 51.0 x 36.5 cm, SBD collection archive. • Man as the center of things or as the target of art? Rose imprints his own artistic signature on this self-imposed design exercise by way of his handprint, thereby revealing himself as an obedient student of Moholy, whose assistant he became in Berlin.

**Karl-Peter Röhl, Abstrakte Komposition (Abstract Composition).** 1926, mixed media, 50.0 x 64.5 cm, SBD collection archive. • Karl-Peter Röhl was one of the most devoted disciples of Theo van Doesburg, the intruder in the Ilm idyll in Weimar and the harshest critic of the "expressionist" Bauhaus of the early years. With this work he was treading a direct path from De Stijl to Concrete Art.

**Gyula Pap, Sitzender Tänzer (Seated Dancer).** 1927, oil on card, 55.0 x 42.1 cm, SBD collection archive. • The metalworker Gyula Pap also produced free artistic work in painting and photography. In its massiveness and earthy coloring, his figure of the seated nude dancer conveys the relaxation of tension and contemplation after performing a leap.

Bauhaus students in 1919. In the early days of the Bauhaus, the realization that these students had to be given a chance to complete the training as free artists on which they had embarked even resulted in the acknowledgment of the "special position of particularly able free painters and sculptors" – a measure which entailed among other things "the creation of a special area for particularly able students." This special status was enjoyed by, for example, Eberhard Schrammen, who worked in an expressive, naturalistic style, and Karl-Peter Röhl who designed the first Bauhaus logo. In his painting Röhl absorbed a broad spectrum of influences over the years. Already familiar with avantgarde tendencies from Walden's Berlin Sturm-Galerie and through his friend Johannes Molzahn, he created pictures inspired by, in succession, Expressionism, Futurism and the works of Itten, Feininger, and finally Doesburg too. There was similar variety and change in the artistic development of Werner Gilles and Johannes Driesch, who likewise looked for signposts to Expressionism, Futurism, the new representationalism and geometrical abstraction. Max Pfeiffer-Watenphul had taken a law degree but resolved to study art after having experienced the impact of a Klee exhibition which he visited in Munich in 1918. After moving to the Bauhaus, he completed Itten's preliminary course, among other things, and ended up painting in a naively realistic idiom. Johannes Itten was followed to Weimar by over 20 students from his private art school in Vienna. This again brought students to the Bauhaus who had already undergone part of their training as free artists. Although they all felt committed to the spirit of the Bauhaus and were in some cases to achieve noteworthy successes in areas of applied art, painting played an essential part for many of them throughout their lives. Personalities such as Carl Auböck, who from the 1920s created outstanding products of Austrian design at his art and craft workshop in Vienna, Friedl Dicker and Franz Singer, who achieved excellence in the fields of architecture and spatial design, and Gyula Pap, who later worked in Transylvania as, among other things, a lithographer – they all produced "free" artistic work, and not only during their years at the Bauhaus. While Dicker's work, for instance, sometimes very clearly reflects the formal possibilities that were discussed in Itten's classes,

such as the use of striking contrasts between light and dark, the work of Auböck also utilizes the artistic principles of Klee, Schlemmer and other masters of early modernism.

What was true of the early pupils who started out as classical art students can in principle be said by analogy about many of those who arrived at the Bauhaus without previously having set out on the road to becoming a painter, and who nevertheless pursued "free" painting while at the Bauhaus. From among the wealth of names one might single out Hans Haffenrichter, Werner Drewes and Lou Scheper, who were students of Itten, Klee and Kandinsky back in the Weimar years, or Eugen Batz and Petra Petitpierre, who became students of Klee and Kandinsky in Dessau. Trained according to Bauhaus principles, they created works which, whilst still committed to the spirit of the avant-garde, sometimes clearly showed the influence of their masters. Finally, an interesting phenomenon that deserves mention is perhaps the tendency of many female Bauhaus students to create pictures with a fairy-tale content. The paintings of Lou Scheper-Berkenkamp, Margarete Willers, Else Mögelin, Ima Breusing and Martha Erps may be cited as examples. The work of the students who painted were shown in public on innumerable occasions. Apart from the Bauhaus exhibition of 1923, which included students' "free" paintings, there were exhibitions of these young artists' work in Dessau and Halle in 1928; and in the summer of 1929 there were shows in four places simultaneously: at the Society of Friends of new Art in Braunschweig; at the Association for Art and Craft in Erfurt; at the Association for new Art in Krefeld, and in a special room at the "jury free" exhibition in Berlin. Overall it may be said that the Bauhaus, exemplary in its questioning of the role and significance of non-applied painting, entered early into a discussion which was to continue throughout the 20th century. Subsequently voices were repeatedly heard, as they had been at the Bauhaus, which denied such free painting any validity, while many artists – even including some that had come out against it – nevertheless continued to create painterly works. This is one more aspect which testifies to the continuing relevance of many of the questions first raised at the Bauhaus.

**Erich Borchert and Grete Reichardt, Studie VII zum Industriebild XIII (Study VII for Industrial Picture XIII).** 1928, watercolor over Indian ink, partially sprayed, mounted on white card, 22.2. x 28.0 cm, SBD collection archive. • The technique and skillful execution are reminiscent of Lyonel Feininger, who never had a painting class of his own but did have many admirers at the Bauhaus. But for his pictures of "staggered" and crystalline architecture Feininger never chose the subject of the industrial landscape.

# "Actually they're all crazy at the Bauhaus" – an Anthology of Quotations

**Emil Bert Hartwig in his studio.** About 1928, photographer unknown, BHA.

## Felix Klee (1907–1990)
## On the Urge for Renewal and Parties at the Bauhaus:

But back to master Itten. He gave his preliminary course three times a week. At one, the splendid limbering up exercises, where in particular the tense, defensive students slowly opened up like flowers. Here we also presented the free work that we had been doing during the week. There were material studies which we could create in a special workshop. They were necessary in order to come into contact with the material of one of the Bauhaus workshops, for after the preliminary course we were naturally obliged to learn a craft. What splendid artifacts we can still see today in the 1923 Bauhaus book! The whole present-day development in art, the effort to create something new at any price – we were going through all this 45 years ago, with no great effort and without claiming to be doing anything special. One fellow student, for example – his name was Pascha – had long hair reaching down over both shoulders, like the Beatles today. One day this adornment was cut off in public. What was more natural than for Pascha to use the hair in an artistic way in his material study?

Four parties, one for each season of the year, were the highlights. We worked on them as if obsessed. Oskar Schlemmer prepared his stage plays especially for them. On May 18 we celebrated Walter Gropius's birthday. Every year there was the traditional Lantern Party. Schlemmer had set up two continuous pieces of scenery with headless people on the stage of the Ilmschlößchen. Boys put their heads on women's bodies and vice versa. An improvised band with fantastic instruments was conducted by Oskar Schlemmer wearing a tailcoat and a long black wig, while the chorus sang, also improvising, "Hang it up" (in the first part) "the laurel wreath!" (in the second part). Before the party we assembled at the Bauhaus where we lit our homemade lanterns as night fell. Then, competing with the glowworms, we walked through the park to the Horn, to

Klee and Frau Börner the master weaver, then to Gropius and finally to the prince among writers, Johannes Schlaf.

A month later we celebrated the pagan festival of the summer solstice. Once, halfway to the Belvedere in "Little Coffee Valley," Hirschfeld and Schwerdtfeger performed their reflected light show, namely the "Story of the Creation." I contributed to the party myself with a puppet theater story of how Emmy Galka Scheyer wanted at all costs to foist a Jawlensky on my father, but my father refused and Emmy beat him over both ears with the Jawlensky. That was the story acted by the puppet theater. At that moment Emmy and Klee joined the party just as the point of the story was past, and the originals were wildly applauded, without any idea why. Later the solstice fire was lit and we jumped over it boldly and bravely.

In October, after the vacation, there was the Kite Party. Here too a great deal of work beforehand went into the boldest designs. We climbed up one of the nearby hills, such as the Gehäderich, where, to the amazement of the local people, we flew our abstract constructions in the autumn winds. The fourth party, the Christmas Party, was held at the Bauhaus in the skylight room on the second floor next to Klee's and Itten's studio. Of course we called this festival by its pagan name of Yuletide – just as we only ever greeted one another in the Roman manner, with a raised hand. A stepladder from the murals workshop with candles on a crosspiece served as a substitute Christmas tree. Amid noise and shouting a student dressed up as an angel dragged in a closed laundry basket, flung open the lid and threw presents into the midst of the group gathered there. There were large and small parcels with names on them. They were unpacked expectantly, only to find a smaller parcel with a different name on it. This was handed on until the last person finally got the present. Gertrud Grunow, the spiritual guardian of the Bauhaus, was given a pot with the words "If you think yellow, then it makes tea, if you think brown, then it makes coffee." Two

daughters, called Karin and Jaina, had just been born to the Schlemmers in the "Kavalierhaus" of Schloß Belvedere: this provided an opportunity to present Oskar, that same evening, with 13 more daughters with splendid fantastic names. My father was given a "bull of excommunication" by the Thuringian state government, to the effect that he had hung monarchist pictures in his home such as *The Great Emperor Rides to War*, which was incompatible with his post as a civil servant of the republic. The document was signed "Graupe" (Pearl Barley = Gropius), "Kantinsky" (Canteensky = Kandinsky), "Leinöl Einfinger" (Linseed Oil One Finger = Lyonel Feininger), etc.

## Paul Citroën (1896–1983)
### On Mazdaznan and its Consequences:

I, for example, with my natural yellowish complexion, could turn green and gray the moment my insides were upset, which was often enough the case. But Muche, who had a light, pinkish complexion, as did Itten, bore up well. They each had their own separate household and were both familiar with all kinds of vegetarian cuisine, so that we bachelors had a feast whenever we were invited to eat with them. We were served wonderful and subtle dishes made from the purest ingredients. But it was really a difficult time for those

Mazdaznan followers who were poorer and less adept at cooking. For whereas ordinary mortals ate whatever they could get hold of, those of us who were concerned to live in a purer manner were obliged to pick and choose even from the little that was to be had, and then the foodstuffs selected had to be prepared in a special way, and consumed concentratedly and in the correct sequence.

This made heavy demands on our self-discipline, but even though we sinned occasionally, when conditions were too difficult and hunger and thirst were too strong, we felt on the whole happy and privileged to have, in our doctrine, something to hold fast to, to know the right path to take, so that we did not just drift along like the others in the general chaos. In spite of all the difficulties we did not allow ourselves to be wholly dominated by circumstances but adhered as faithfully as possible to our own insights or, more correctly, the rules laid down by our doctrine. And this gave us enhanced self-confidence.

## Alfred Arndt (1898–1976)
### On Ritual Greetings at the Bauhaus and Itten's Classes:

when i went into the canteen with kube, there was a huge outcry about long-haired young ramblers. suddenly somebody put

his arms around me from behind: "man, emir (my "wandervogel" nickname), how did you get here?" it was kurt schwerdtfeger from pomerania, whom i had got to know as a soldier at a wandervogel meeting during the war. schwerdtfeger said: "stay here, man, this is the place for us, it's ok here, you'll be surprised!" in the afternoon, in the bauhaus office, a tall secretary – hirschfeld's sister – received me and asked me what i wanted. "i would like to speak to the director." i must have sounded rather shy, for fräulein hirschfeld said that the director was a friendly, approachable man. i was announced, and admitted straight away. i bowed, introduced myself, and explained that i had eaten in the canteen and that someone i knew had invited me to stay. "hm, well," he said and pushed me into one hell of an armchair – angular and yellow. "you can't stay here just like that, first you must show what you have learned up to now: submit some drawings or photographs with a résumé, then the council of masters will examine them and decide whether you have sufficient talent.

"you can have a week to practice without distractions, then bring me the material study which you think is the best in view of the task set," Itten explained. on the great day

**Members of the Bauhaus.** About 1928, left to right, Werner Siedhoff, Günter Menzel, Naftali Rubinstein, photograph by T. Lux Feininger, J. Paul Getty Musuem, Los Angeles.

**Self-portrait by Grit Kallin.** About 1928, photograph, BHA.

everybody came with their sculptures, the work was very varied, the girls brought dainty little things, about the size of their hand, which they had made, some of the guys had stuff that was a meter high. in many cases they were real piles of rubbish, sooty and rusted. some of them dragged in individual items like logs of wood, stove-pipes, wire, glass, etc., and assembled them in the classroom. itten, as always, let the students decide for themselves which were the best pieces of work, all the students were quite unequivocally in favor of mirkin, a pole, being the winner. i can still see the "horse" in front of me; it was a thick wooden plank, smooth in some places, rough in others. on top of it was an old petroleum lamp cylinder with a rusty saw stuck through it, ending in a spiral. after this, drawings were made of the material studies; we were told to sculpted enhanced material contrasts and movement. everyone was left free to invent drawings of such visual constructions.

**Lothar Schreyer (1886–1966)**
**On Visions at the Bauhaus:**
We plunged into the intellectual adventures of that difficult time. The Bauhaus became the stronghold of Expressionism, which the outside world regarded as a symptom of universal decline. In our artistic work we were scarcely bothered at all by the various philosophies that swept through the Bauhaus: the wandering apostle Häuser with his vagabond life, the Mazdaznan doctrine which Johannes Itten brought with him – cooking in the Bauhaus kitchen complied with this doctrine – anthroposophy, theosophy, Catholicism, spiritualism, all borne along by the hope of a new world. We took everything ironically, especially ourselves, and were thereby set free for the reverence which by nature we felt for life and man. The Bauhaus years in Weimar were a fiery period of purification and forged a unity out of our forlorn little group. "Bauhäusler" – it sounded like "Zuchthäusler" (convicts in a penitentiary) – was what many

**Portrait of Otti Berger.** 1927–1928, photograph by Lucia Moholy, BHA.

of the citizens of Weimar called us, with a shudder and not without fear. But many of them were forbearing toward us and treated us well, in ways that none of us have forgotten. We needed forbearance. We had invented a custome for men which we wore in public – the masters too, if they wished. I still have – and use – my old Bauhaus outfit. When Itten declared one day that hair was a sign of sin, the most enthusiastic students shaved their entire heads. In such a way we became part of the population of Weimar and its immediate surroundings.

## Gyula Pap (1899–1983)
### On Bauhaus Colors and the Phenomenon of Synaesthesia:

I heard that a working group was attempting to clarify what colors corresponded, according to a natural law, to the circle, the square and the triangle. I became curious and went along one day. In addition Klee and Kandinsky, Schlemmer was there with other Bauhaus members, mainly older ones. They were just discussing the color yellow. Somebody said it reminded them of a blackbird's high-pitched twittering, and so yellow was related to the triangle. Klee retorted that an egg yolk was also yellow, but circular. After I while I joined in and spoke with a superciliousness of which only a young person is capable. I asked how they could discuss things that were obvious. Let us examine, I said, the inner qualities of metals (I was working at the time in the metal workshop): when I am working with silver, it seems to me to be the supplest of metals, so it corresponds to the circle and, as a color, to blue. Brass, on the other hand, is hard and its burrs can do you the most harm with their sharpness, therefore it corresponds to the triangle and the color yellow. Copper, crude and heavy, is not oversoft and not overhard, thus corresponding to the square and the color red. My intervention came too unexpectedly, nobody contradicted me and if I am not mistaken that was the end of this series of discussions.

## Marianne Brandt (1893–1983)
### On Proofs of Camaraderie and the Meager Everyday Life at the Bauhaus:

In our workshop we always had a craft master standing next to us, and we got on quite well with this division – design on the one hand,

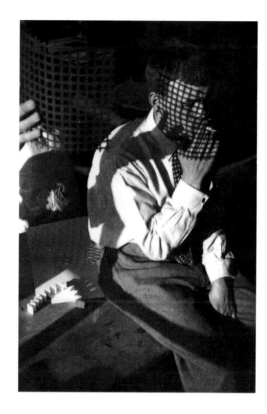

craft on the other – although there were a number of times when a change proved necessary. The tools we had were a lathe-cum-press, drilling machines, large metal shears, etc.

Even in Weimar a journeyman was appointed to use craft techniques for serial production. Later he became one of us, after submitting to a Bauhaus preliminary training course. Comradely relations in our workshop were in general good, although naturally when people left or joined, it inevitably entailed new impulses and hence difficulties in this area. Of the license fees we received for our models, the Bauhaus, if I remember rightly, took half, and the rest was shared out between master, designer and workshop.

We also received part of the income from our Sunday guided tours of the house. Thus I usually had money in my pocket, but to my chagrin I was unfortunately also envied on occasion, though this did not prevent people from regularly borrowing small sums of money from M.B. at the end of the month. It was often a problem to get enough to eat for the "boys," most of whom were very poor. At first, when we were still accommodated in the Seiler factory (while the Bauhaus building was being constructed in Dessau) and did not as yet have a canteen, we were "allowed" to eat in the soup kitchen for ten

**Portrait of Albert Kahmke.** 1930, photograph by Irene Hoffmann, J. Paul Getty Museum, Los Angeles.

**Bauhaus canteen, still life.** Undated, photograph by Mathilde Reindl, BHA.

pfennigs. Dreadful! Then we bought two pots and an earthenware saucepan, and had to go alternately in pairs to get buttermilk and rolls. In this way the workshop did have a cheap and modest breakfast. In the new building everything was much better. There was a canteen and proper meals.

When Gropius took it into his head to contemplate his work (and he did so with pleasure, or so we supposed) – the Bauhaus in Dessau which we had just moved into – he was not a little shocked to discover that his Bauhaus members were using the flat roof and the studio frontage for balancing and wall-climbing exercises. People got used to it later, I suppose, there are attractive photographs showing this. I too got at least as far as sitting freely on the railing of my little balcony, although I only felt dizzy when others did it! How enjoyable it was, living in the studios, and what fun it was occasionally to hold a conversation from one little balcony to another! The gymnasium was in the basement. There was a big soft carpet there and, although it was strictly prohibited, some people who had no money at all spent the night there. Showers, baths. Everything very comfortable. Not bad. "Päpchen" (i.e. Gyula Pap) also frequently came from down there with his beautiful German shepherd bitch. (But all that is top secret!)

What I was not very happy about were the guided tours of the workshops for visitors. Every Sunday morning for two years: a lot of questions, quite a lot of annoyance, though also some occasional satisfaction. A tour with two hundred bookprinters left a particular impression on me: they became furious when I talked about using lowercase letters and saving labor and time. A small-scale revolt, they even threatened me with sticks.

### Xanti (Alexander) Schawinsky (1904–1979)
### On Stage Spectacles, Young Geniuses and Other Festivities:

on such occasions the closest contact was between the band and the stage, whose members presented their theatrical experiments, which were often still evolving. oskar schlemmer as a musical clown, for instance, siedhoff in a tire-, box- or staircase-dance,

joost schmidt wrestling with himself, kurt schmidt's "mechanical ballet" with bogler and teltscher, schawinsky's jazz and tap dance machine, parts of the triadic ballet and mechanical cabaret, group work such as the "man on the switchboard," the mime dances, proclamations such as "square and flower – a new unity," sketches like "climax" or "olga-olga," "circus," or "rococo-tte"; the colored light presentations by hirschfeld and schwerdtfeger, lavish masks and ghostly groups at table, wanda von kreibig's feminine incursion into this predominantly masculine theater production ... all this was enough to transform the dance banquet into a group of breathless onlookers, to the music of bach, handel, mozart, antheil, stuckenschmidt, stravinsky, hindemith or the band's improvisations. guests also appeared, the most distinguished of them being kurt schwitters with his primal sound sonata: laanketer-glll, pepepepepe-oka oka oka langketerglll pepe-pepepe-zuekazueka-zueka-ruemph, rnph, etc., or acting in his solo one-act play, in which he managed to go on varying the "entire" text of "i was guarding my sheep" until, in spite of his blue sunday suit, everybody could see both the shepherd boy and the sheep visibly appear on stage. and when palucca performed her provocative "limbering up exercises," the result – not without danger – was that the bauhaus members climbed up the glass frontage of the bauhaus and would have jumped off the roof had not krayevsky urged them in a stentorian voice to be reasonable.

inspired by the bauhaus band, lux feininger, who was still very young, produced a series of wonderful drawings, some of them in the most garish colors. he gave us drawings like this as gifts and one day he came to see me in order to ask me to support his request to join the band, which he very much wanted to do. as the theater's spokesman i knew him quite well and i knew that he was tone deaf. i realized that this was a difficulty that might stand in his way and it did indeed lead the other members of the band to turn down the request, despite my reminding them of kurt schmidt's theory that it was possible to sing the whole of "carmen" even if you couldn't tell two notes apart –

as long as the rhythm was correct! it was no use, the request had to be turned down in as kindly a way as possible. after a few months lux came to my studio again, this time carrying a long case, from which he took the parts of a clarinet, assembled them speedily, went and stood in a corner and played a bauhaus tune, then another, on the instrument without any mistakes. i was utterly amazed and couldn't stop laughing. he had taken lessons in secret and with his teacher's help had learned everything by heart. he had learned the fingering visually, and so precisely that in the end it came to the same thing as if he had had normal hearing. we arranged a rehearsal and it went well. from then on, if during a tumultuous night of dancing the awkward question arose of whether the next dance began with f or g, we could safely rely on lux, whose visual musicality never confused him. this happened mainly during engagements at artists' parties outside the bauhaus, in hanover, halle, berlin or magdeburg, as a result of the somewhat too freely flowing champagne and brandy to which the band was treated by the guests.

### Josef Albers (1888–1983)
### On the Bauhaus Idea:

I was a student for three years and a teacher for ten years at the Bauhaus (which is longer than anybody else). In 1919, when the Bauhaus was established, I was in Munich, and in early 1920 I was studying under Franz von Stuck at the Munich Academy, where Kandinsky and Klee had also previously studied. Although I became particularly fond of Munich, I soon felt a strong urge to go to Weimar, lured by the prospects of studying under a most unusual name, the name of "Bauhaus." This name evidently implied something other than an "academy." Nor was it as intimidating as calling it an institute or a college would have been. And instead of "workshop," which in fact is what it was, it merely called itself very modestly a "house," and, typically, not a house of art, or craft, or any mixture of the two, but "Bauhaus," a "Haus fürs Bauen" (house for building), and (again modestly and reticently), for form and design. I still believe to this day

that the invention of this name, the invention of the word "Bauhaus" was a particularly felicitous and significant act on Gropius's part. This happened at a time when Art was written with a capital "A," and after an excessively backward-looking 19th century, in which there was too much talk, too often, of golden ages and renaissances, leaving scarcely any time for one's own work. Even in Weimar, despite the independent, unconventional name of "Bauhaus," we were not left without retrospective pointers and warnings. But the more we studied the old memoirs, the more certain we learners became that analyzing and dissecting do not constitute a goal. More importantly, we realized that the old masters themselves did not look around for even older masters, but consciously opposed what had already been done and said, in order to devote themselves more intensely to their own development. So we preferred to watch new, living masters who were determined not to follow in the footsteps of others, and it was Gropius who bravely introduced us to such masters.

All quotations translated from: Bauhaus und Bauhäusler. Erinnerungen und Bekenntnisse (The Bauhaus and Its Members. Memories and Confessions), Eckhard Neumann (ed.), Bern, 1971 (Hallwag AG, first impression), Cologne, 1996 (DuMont Buchverlag, 5th extended impression), with sincere thanks for the kind permission of Eckhard Neumann.

**Ernst Kallai, Letter to Naum Gabo.** About 1928, BHA.

WORK

# Personalities

# The Three Bauhaus Directors

Karin Wilhelm

Along with the American Frank Lloyd Wright, the Viennese modernists of the circle round Adolf Loos and the Swiss Le Corbusier, modern architectural thinking has been permanently shaped, and the face of the modern, urban, 20th-century world in which we live has been decisively influenced by the three Bauhaus directors Walter Gropius, Hannes Meyer and Ludwig Mies van der Rohe. Gropius, who established the Bauhaus in Weimar in 1919, was cast in a Bauhaus mold in the prosperous industrial Berlin of the turn of the century. The Swiss Hannes Meyer, who succeeded him as director in 1928, came from the tradition of Johann Heinrich Pestalozzi's social and educational thinking and was an enthusiastic supporter of new town projects, which were closely related to those of the group of social reformers in the English garden city movement. Finally, Ludwig Mies van der Rohe, who had also spent his formative years in Berlin, replaced the hapless Hannes Meyer in 1930 and led the Bauhaus until it was closed down in 1933. With him, Western

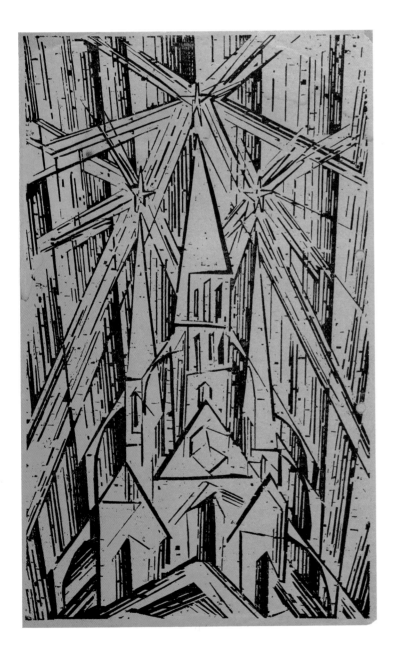

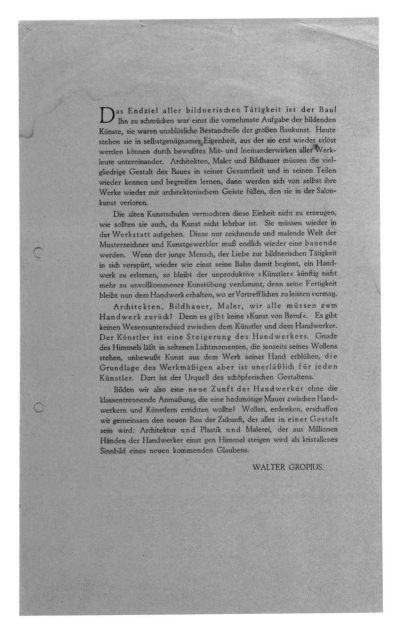

Das Endziel aller bildnerischen Tätigkeit ist der Bau! Ihn zu schmücken war einst die vornehmste Aufgabe der bildenden Künste, sie waren unablösliche Bestandteile der großen Baukunst. Heute stehen sie in selbstgenügsamer Eigenheit, aus der sie erst wieder erlöst werden können durch bewußtes Mit- und Ineinanderwirken aller Werkleute untereinander. Architekten, Maler und Bildhauer müssen die vielgliedrige Gestalt des Baues in seiner Gesamtheit und in seinen Teilen wieder kennen und begreifen lernen, dann werden sich von selbst ihre Werke wieder mit architektonischem Geiste füllen, den sie in der Salonkunst verloren.

Die alten Kunstschulen vermochten diese Einheit nicht zu erzeugen, wie sollten sie auch, da Kunst nicht lehrbar ist. Sie müssen wieder in der Werkstatt aufgehen. Diese nur zeichnende und malende Welt der Musterzeichner und Kunstgewerbler muß endlich wieder eine bauende werden. Wenn der junge Mensch, der Liebe zur bildnerischen Tätigkeit in sich verspürt, wieder wie einst seine Bahn damit beginnt, ein Handwerk zu erlernen, so bleibt der unproduktive »Künstler« künftig nicht mehr zu unvollkommener Kunstübung verdammt, denn seine Fertigkeit bleibt nun dem Handwerk erhalten, wo er Vortreffliches zu leisten vermag.

Architekten, Bildhauer, Maler, wir alle müssen zum Handwerk zurück! Denn es gibt keine »Kunst von Beruf«. Es gibt keinen Wesensunterschied zwischen dem Künstler und dem Handwerker. Der Künstler ist eine Steigerung des Handwerkers. Gnade des Himmels läßt in seltenen Lichtmomenten, die jenseits seines Wollens stehen, unbewußt Kunst aus dem Werk seiner Hand erblühen, die Grundlage des Werkmäßigen aber ist unerläßlich für jeden Künstler. Dort ist der Urquell des schöpferischen Gestaltens.

Bilden wir also eine neue Zunft der Handwerker ohne die klassentrennende Anmaßung, die eine hochmütige Mauer zwischen Handwerkern und Künstlern errichten wollte! Wollen, erdenken, erschaffen wir gemeinsam den neuen Bau der Zukunft, der alles in einer Gestalt sein wird: Architektur und Plastik und Malerei, der aus Millionen Händen der Handwerker einst gen Himmel steigen wird als kristallenes Sinnbild eines neuen kommenden Glaubens.

WALTER GROPIUS.

# PROGRAMM
## DES
# STAATLICHEN BAUHAUSES
# IN WEIMAR

Das Staatliche Bauhaus in Weimar ist durch Vereinigung der ehemaligen Großherzoglich Sächsischen Hochschule für bildende Kunst mit der ehemaligen Großherzoglich Sächsischen Kunstgewerbeschule unter Neuangliederung einer Abteilung für Baukunst entstanden.

### Ziele des Bauhauses.

Das Bauhaus erstrebt die Sammlung alles künstlerischen Schaffens zur Einheit, die Wiedervereinigung aller werkkünstlerischen Disziplinen ~ Bildhauerei, Malerei, Kunstgewerbe und Handwerk ~ zu einer neuen Baukunst als deren unablösliche Bestandteile. Das letzte, wenn auch ferne Ziel des Bauhauses ist das Einheitskunstwerk ~ der große Bau ~, in dem es keine Grenze gibt zwischen monumentaler und dekorativer Kunst.

Das Bauhaus will Architekten, Maler und Bildhauer aller Grade je nach ihren Fähigkeiten zu tüchtigen Handwerkern oder selbständig schaffenden Künstlern erziehen und eine Arbeitsgemeinschaft führender und werdender Werkkünstler gründen, die Bauwerke in ihrer Gesamtheit ~ Rohbau, Ausbau, Ausschmückung und Einrichtung! ~ aus gleichgeartetem Geist heraus einheitlich zu gestalten weiß.

### Grundsätze des Bauhauses.

Kunst entsteht oberhalb aller Methoden, sie ist an sich nicht lehrbar, wohl aber das Handwerk. Architekten, Maler, Bildhauer sind Handwerker im Ursinn des Wortes, deshalb wird als unerläßliche Grundlage für alles bildnerische Schaffen die gründliche handwerkliche Ausbildung aller Studierenden in Werkstätten und auf Probier- und Werkplätzen gefordert. Die eigenen Werkstätten sollen allmählich ausgebaut, mit fremden Werkstätten Lehrverträge abgeschlossen werden.

Die Schule ist die Dienerin der Werkstatt, sie wird eines Tages in ihr aufgehen. Deshalb nicht Lehrer und Schüler im Bauhaus, sondern Meister, Gesellen und Lehrlinge.

Die Art der Lehre entspringt dem Wesen der Werkstatt:

Organisches Gestalten aus handwerklichem Können entwickelt.
Vermeidung alles Starren; Bevorzugung des Schöpferischen; Freiheit der Individualität, aber strenges Studium.
Zunftgemäße Meister- und Gesellenproben vor dem Meisterrat des Bauhauses oder vor fremden Meistern.
Mitarbeit der Studierenden an den Arbeiten der Meister.
Auftragsvermittlung auch an Studierende.
Gemeinsame Planung umfangreicher utopischer Bauentwürfe ~ Volks- und Kultbauten ~ mit weitgestecktem Ziel. Mitarbeit aller Meister und Studierenden ~ Architekten, Maler, Bildhauer ~ an diesen Entwürfen mit dem Ziel allmählichen Einklangs aller zum Bau gehörigen Glieder und Teile.
Ständige Fühlung mit Führern des Handwerks und Industrien im Lande.
Fühlung mit dem öffentlichen Leben, mit dem Volke durch Ausstellungen und andere Veranstaltungen.
Neue Versuche im Ausstellungswesen zur Lösung des Problems, Bild und Plastik im architektonischen Rahmen zu zeigen.
Pflege freundschaftlichen Verkehrs zwischen Meistern und Studierenden außerhalb der Arbeit; dabei Theater, Vorträge, Dichtkunst, Musik, Kostümfeste. Aufbau eines heiteren Zeremoniells bei diesen Zusammenkünften.

### Umfang der Lehre.

Die Lehre im Bauhaus umfaßt alle praktischen und wissenschaftlichen Gebiete des bildnerischen Schaffens.
A. Baukunst,
B. Malerei,
C. Bildhauerei
einschließlich aller handwerklichen Zweiggebiete.
Die Studierenden werden sowohl handwerklich (1) wie zeichnerisch-malerisch (2) und wissenschaftlich-theoretisch (3) ausgebildet.
1. Die handwerkliche Ausbildung ~ sei es in eigenen, allmählich zu ergänzenden, oder fremden durch Lehrvertrag verpflichteten Werkstätten ~ erstreckt sich auf:
a) Bildhauer, Steinmetzen, Stukkatöre, Holzbildhauer, Keramiker, Gipsgießer,
b) Schmiede, Schlosser, Gießer, Dreher,
c) Tischler,
d) Dekorationsmaler, Glasmaler, Mosaiker, Emallöre,
e) Radierer, Holzschneider, Lithographen, Kunstdrucker, Ziselöre,
f) Weber.
Die handwerkliche Ausbildung bildet das Fundament der Lehre im Bauhause. Jeder Studierende soll ein Handwerk erlernen.
2. Die zeichnerische und malerische Ausbildung erstreckt sich auf:
a) freies Skizzieren aus dem Gedächtnis und der Fantasie,
b) Zeichnen und Malen nach Köpfen, Akten und Tieren,
c) Zeichnen und Malen von Landschaften, Figuren, Pflanzen und Stilleben,
d) Komponieren,
e) Ausführen von Wandbildern, Tafelbildern und Bilderschreinen,
f) Entwerfen von Ornamenten,
g) Schriftzeichnen,
h) Konstruktions- und Projektionszeichnen,
i) Entwerfen von Außen-, Garten- und Innenarchitekturen,
k) Entwerfen von Möbeln und Gebrauchsgegenständen.
3. Die wissenschaftlich-theoretische Ausbildung erstreckt sich auf:
a) Kunstgeschichte ~ nicht im Sinne von Stilgeschichte vorgetragen, sondern zur lebendigen Erkenntnis historischer Arbeitsweisen und Techniken,
b) Materialkunde,
c) Anatomie ~ am lebenden Modell,
d) physikalische und chemische Farbenlehre,
e) rationelles Malverfahren,
f) Grundbegriffe von Buchführung, Vertragsabschlüssen, Verdingungen,
g) allgemein interessante Einzelvorträge aus allen Gebieten der Kunst und Wissenschaft.

### Einteilung der Lehre.

Die Ausbildung ist in drei Lehrgänge eingeteilt:
I. Lehrgang für Lehrlinge,
II. „ „ Gesellen,
III. „ „ Jungmeister.

Die Einzelausbildung bleibt dem Ermessen der einzelnen Meister im Rahmen des allgemeinen Programms und des in jedem Semester neu aufzustellenden Arbeitsverteilungsplanes überlassen.

Um den Studierenden eine möglichst vielseitige, umfassende technische und künstlerische Ausbildung zuteil werden zu lassen, wird der Arbeitsverteilungsplan zeitlich so eingeteilt, daß jeder angehende Architekt, Maler oder Bildhauer auch an einem Teil der anderen Lehrgänge teilnehmen kann.

### Aufnahme.

Aufgenommen wird jede unbescholtene Person ohne Rücksicht auf Alter und Geschlecht, deren Vorbildung vom Meisterrat des Bauhauses als ausreichend erachtet wird, und soweit es der Raum zuläßt. Das Lehrgeld beträgt jährlich 180 Mark (es soll mit steigendem Verdienst des Bauhauses allmählich ganz verschwinden). Außerdem ist eine einmalige Aufnahmegebühr von 20 Mark zu zahlen. Ausländer zahlen den doppelten Betrag. Anfragen sind an das Sekretariat des Staatlichen Bauhauses in Weimar zu richten.

APRIL 1919.                    Die Leitung des
                   Staatlichen Bauhauses in Weimar:
                              Walter Gropius.

**Manifesto and program of the State Bauhaus in Weimar.** 1919, title page, woodcut by Lyonel Feininger, and three text pages, book printed on pink tinted paper, 31.9 x 19.6 cm, BHA.

metaphysics became once again the guiding star of an architectural aesthetic which emphasized the primacy of construction. This intellectual amalgam and the unconventional personalities of the directors meant that the training in architecture at the Bauhaus was different from that given in design. The architectural concepts, the theories and projects with which the students were familiarized, were also as disparate as the directors and the teachers whom they appointed. But they were always united by a common goal: teaching at the Bauhaus was intended to impart technical knowledge and craft skills, and above all to train artistic ability in order to reshape the everyday human world with the aid of a comprehensive knowledge of design, from urban building to practical utensils. Thus the search for a new aesthetic was at the same time the search for a modern ethic, the political dimension of which was underlined fairly directly in the training course under the three directors. When Walter Gropius took up his post at the Bauhaus in Weimar, he was one of those new "Weltbeglückern" "world benefactors" (Thomas Mann) who were demanding radical cultural change following the trauma of World War I. Like many of his fellow architects he thought that the arts in particular, and above all architecture, would have a pioneering role to play in this process. This impulse determined the educational values of the early Weimar Bauhaus, with its emphasis on returning to the principles of craft work in conjunction with the vision of "building the future anew." In the program, therefore, the teaching of

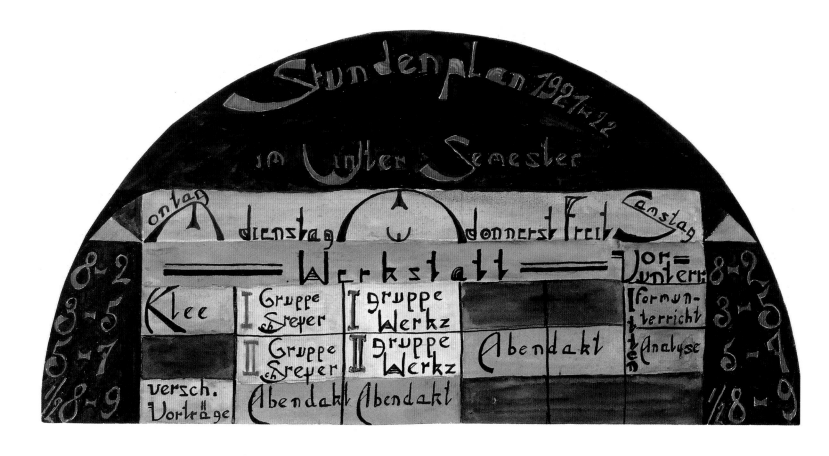

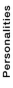
**Lothar Schreyer, Timetable.** 1921–1922, Indian ink and watercolor over pencil on paper, 16.5 x 32.7 cm, BHA.

architecture occupied the central position in training, with the other arts and crafts having to relate their work to it. But in fact this training structure only gradually took on a practical shape, for as a result of the post-1919 economic and social upheaval the training of architects in the Weimar period remained de facto somewhat marginal. Only after postwar society had been stabilized was architectural training at the Bauhaus given a regular structure with independent design teaching.

An intellectual change of direction in the Bauhaus program became evident as early as 1922. In February of that year Walter Gropius, who, with his partner Adolf Meyer, had made a name for himself as an industrial architect, was given a promising large-scale commission for the first time since the war. In Alfeld an der Leine, where they had caused an international stir before World War I with the Fagus Factory, the firm of Kapp Bros. & Co. intended to build a new warehouse and showroom. Only a few months later, in July of 1922, a further project aroused enthusiasm on the international architectural scene. The American newspaper *The*

*Chicago Tribune* had announced a competition to design a new administration building, and the Gropius Building Studio entered the competition. As a result of these building assignments, topics which had occupied Gropius's close attention before the war shortly re-emerged in the architectural debate at the Weimar Bauhaus: problems of rationalization, problems of industrial building, and American culture. The intellectual impetus to reassess the value of the priority enjoyed by craft work, and its importance for up-to-date architecture, ultimately led Gropius to formulate a different vision of training at the Bauhaus, under the slogan "Kunt und Technik – die neue Einheit" (Art and Technology – the New Unity.) What this meant was documented in 1923 at an exhibition entitled "International Architecture." Between Peter Behrens's 1909 turbine room in Berlin, the housing developments by J. J. P. Oud in Rotterdam from 1922 and Le Corbusier's "Ville Contemporaine" from 1922, Gropius placed works of his own from the prewar period, along with projects for educational buildings which he had designed in

**Walter Gropius, Diagrammatic presentation of the Bauhaus syllabus.** 1922, published in the statutes of the Bauhaus, 1922, BHA.

**Portrait of Walter Gropius.** 1922, photograph by Hugo Erfurth, BHA. • Walter Gropius was appointed to succeed Henry van de Velde as director of the School for Fine Art in Weimar. He founded the Bauhaus and was its director from 1919 to 1928.

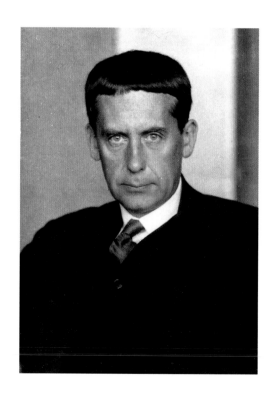

collaboration with Adolf Meyer. These now gave notice of a concept of architecture occupying a position between De Stijl and the "machine for living" (Le Corbusier). As for the wooden houses which Gropius, in conjunction with the Bauhaus workshops, had built in a nostalgic spirit of craft-oriented medievalism for the Berlin builder Adolf Sommerfeld in 1920–1921, he did not at that point even consider them worth mentioning in the context of modern building. Enthusiasm for wood as a material, and the craft of working with it, had now been ousted by a celebration of the new building potential of reinforced concrete and glass-and-iron architecture. The expansive, unconventional, expressive design of building units had given way to elementary geometry. Nor was there any further talk of crafting individual items. Instead, standardized production for industry was propagated and the study of the formal laws of mechanical standardized production was intensified.

After 1924 Walter Gropius, like many of his fellow architects at home and abroad, worked on models of urban land use in order to rationalize, through means of town planning and architectural initiatives, the use of public space and – especially in Gropius's case – to regulate its urban functions and find scope in private housing projects for a sense of community and the individual pursuit of happiness. The great typological variety of the Dessau buildings, the Bauhaus building itself, the masters' houses, the Törten estate and the Labor Office, which was not built until after Gropius's period as director, provide a unique testimony of what he was trying to achieve. Moreover, in the transparent glass architecture of the school building Gropius had devised a pioneering spatial model: the building did not stake a claim to "eternal value as a bastion" (Sigfried Giedion), but revealed itself to be a functioning envelope linking interior and exterior space.

When the Bauhaus moved to Dessau, the architecture department was for the first time given a serious structure. In 1927 Hannes Meyer, who had produced a model example of mass housing construction in the countryside with the Freidorf cooperative housing estate near Basel

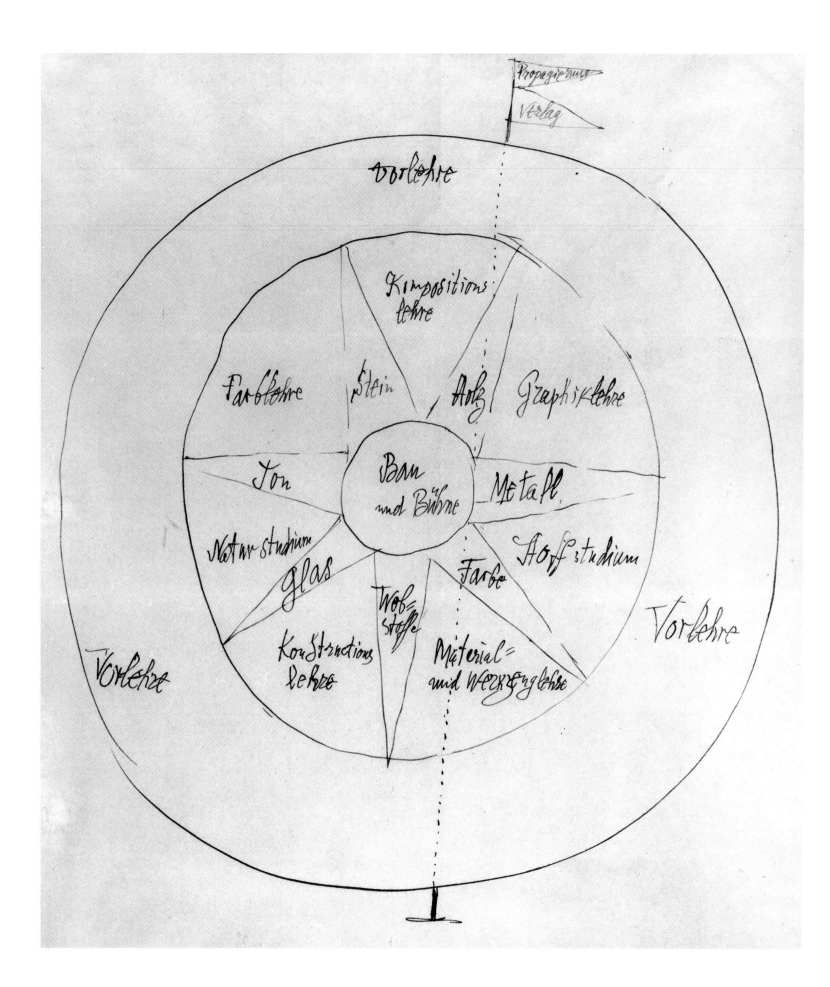

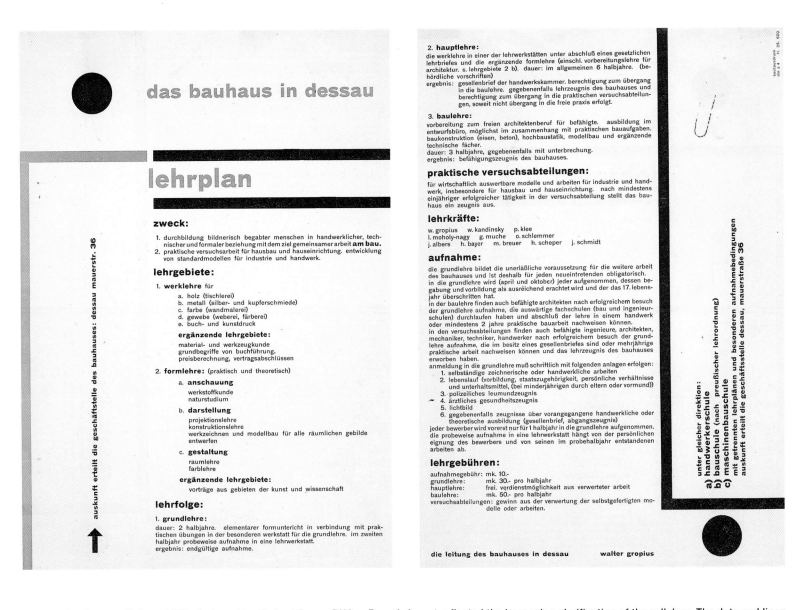

**Dessau Bauhaus syllabus.** 1925, designed by Herbert Bayer, BHA. • Bayer's layout reflected the increasing clarification of the syllabus. The dots and lines in DIN sizes become a functional fanfare. The purpose and structure of the course are bracketed together at right angles to the main text.

**Paul Klee, Idea and Structure of the Bauhaus.** 1922, pen and Indian ink on paper, 25.0 x 21.5 cm, BHA.

(1919–1924), was appointed to set up a building department. He was followed by Hans Wittwer, with whom Meyer was collaborating at the time on an unusual school building project for Basel. The Petersschule, which they had developed for a competition in 1926, revealed the influence being exerted at that time by the Soviet Russian Constructivist architects. The lucid cubic structure of the multistory building was framed by functional constructional details – for example, a light stairway along the outside of the building, an element which Meyer subsequently reused. Particularly impressive was the schoolyard situated in a terrace that was freely suspended above the street. Efforts to develop architecture out of its dominant constructional elements

were likewise to be seen in a design for the League of Nations building in Geneva, for which an international competition was held in 1927. Like Le Corbusier, who also entered the competition, Meyer and Wittwer opted for the semantics of modernity, which were related to the typologies of American architecture at the time. For the administration they proposed two multistory steel-frame buildings, and for the plenary chamber a structure of parabolic arched girders filled in with "soft, sound-absorbent building materials" (Hannes Meyer) to form a protective skin. Meyer had impressed Gropius, the director of the Bauhaus, and others with these projects, and it was from this starting point that he developed his plan for the teaching of architecture.

Meyer retained the idea of the "work school principle" that had been initiated by Gropius, that is to say, he too emphasized the application-oriented side of training, the combination of theory and practice. In between the teaching of artistic design and of basic science, the teaching of building was increasingly directed toward a concept of architecture that was determined by functional and biological factors. The building of the Bundesschule des Allgemeinen Deutschen Gewerkschaftsbundes (federal school of the General German Trade Union Federation) between 1928 and 1930 gave Meyer the opportunity to create, in accordance with this concept and in conjunction with the Bauhaus workshops, a companion piece to the Bauhaus building in Dessau. Spatial organization and interior design were marked by simplicity and clarity. This architecture regarded itself as the expression of a society of the future, which was to be based on similar principles.

When Ludwig Mies van der Rohe took over the Bauhaus, facilities existed for teaching architecture on a substantial scale. Nonetheless it was left to him to implement the claim of the Bauhaus to make building, that is

architecture, the central concern of the school's training. By the time he took up the position, Mies was already regarded as an exceptional architect on the basis of his forward-looking projects such as the glass office tower blocks which he had designed around 1920 for the Friedrichstraße in Berlin. In 1927 he had been the chief architect of the plan for a municipal model housing development at the Weißenhof in Stuttgart. The rental house he designed for this estate had a new feature which previously had only been tried out in the building of more exclusive villas: a variable open-plan living space. Many commissions, such as the German pavilion at the world exhibition in Barcelona (1929) or the Tugendhat villa in Brünn (1930) incorporated elements from these experiments, achieving a high degree of structural transparency by means of loadbearing pillars and glass walls.

Mies's "skin and skeleton" principle, which was technically perfected in his American high-rise buildings, had originated in discussions concerning the renewal of architecture in Europe. Mies and Gropius also continued to work on concepts of this kind after going into exile in the longed-for land of the United

**Portrait of Ludwig Mies van der Rohe.** 1933, photograph by Werner Rohde, BHA. • Ludwig Mies van der Rohe was the last director of the Bauhaus, from 1930 until its voluntary closure in 1933, yielding to pressure from the National Socialists.

**Berlin Bauhaus syllabus.** October 1932, designer unknown, BHA.

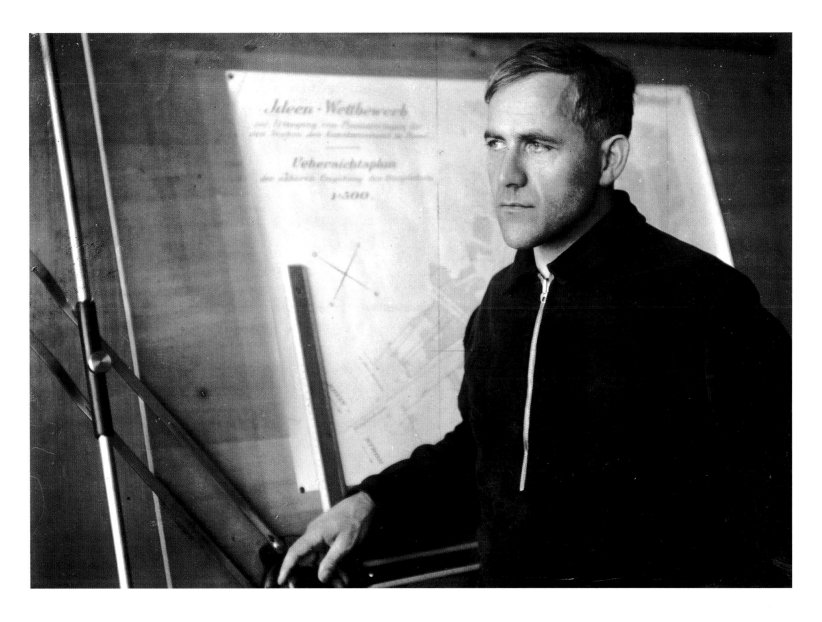

States. As a Harvard University professor, Gropius introduced issues of urban building and rationalized building to the United States in the wake of the CIAM (international congresses on new building) debates. Mies, who later taught in Chicago, became a master of paring down structures and well thoughtout detail. Hannes Meyer, who wished to put his political ideals into practice in the sphere of urban building in the Soviet Union of the 1930s, was compelled to realize that there was no future for his concepts of modern

simplicity in the building of Soviet housing under Stalin's rule. His achievements were forgotten. Only the architecture of our own time has turned back, after the postmodern interlude, to Meyer's ideas and those of his two comrades-in-arms. Transparent building units, the idea of the house envelope, and the problems of the big urban centers which have made housing once again a principal architectural topic: these have now become accepted aspects of modern building and its attendant debates.

**Portrait of Hannes Meyer.** 1924, photograph by Umbo (Otto Umbehr), BHA. • The Swiss architect Hannes Meyer was appointed on Gropius's recommendation. From 1928 to 1930 he was the director of the design college and head of its architecture department.

# A Review of Personal Life and Work – Walter Gropius, the Architect and Founder of the Bauhaus

Martin Kieren

The State Bauhaus in Weimar was founded by the architect Walter Gropius in 1919. He was 36 years old at the time and had already designed a number of buildings which placed him in the front rank of German architects. This was, however, also due to the fact that he had managed to attract a high degree of attention in influential cultural circles in Germany by virtue of his strong personality – a blend of talent and ambition, intelligence and circumspection, adaptability and powers of observation, along with a considerable ration of vanity. This public impact, which he himself strongly and repeatedly encouraged by means of publications and private contacts, eventually led to his appointment as director of the former Grand Ducal School of Fine Art, which he immediately amalgamated with the School of Applied Arts that had been officially closed down in 1915, and renamed the State Bauhaus in Weimar. The Bauhaus manifesto, the program

setting out the aims and nature of instruction at the new school, appeared in that same foundation year. It shows clearly that, measured against his previous career as an architect, Gropius had performed a drastic intellectual change of direction, the full import of which can only be appreciated against the background of the buildings which he had previously designed. But Gropius was not alone in this transformation of his architectural thinking. The social and political, intellectual and cultural conditions in the postwar turmoil of the young Weimar Republic had produced a revolution in all areas of thought. It is, however, surprising that Gropius's vision was derived from, of all things, the "Bauhütten," the medieval church masons' guild movement with its emphasis on craft work. For Gropius's prewar buildings, with their specific constructional features and their expressive quality, were much closer to the goal defined in 1923,

namely the "new unity of art and technology," than what was proclaimed in 1919 as the ideal goal of the profession. But how did this change of heart come about?

In 1910 Gropius founded his own "building studio" in Berlin. In the preceding years he had worked as a volunteer in an architect's office, had studied architecture more or less unsuccessfully at the technical colleges in Munich and Berlin, and had finally worked in the studio of Professor Peter Behrens from 1908–1910. Here he was one of the architects working on projects for the AEG in Berlin as well as on building projects in Hagen-Westphalia. In 1906–1907 he was given the opportunity, chiefly through family connections, to build individual country houses and agricultural buildings in Pomerania. Hence his image of architecture was shaped on the one hand by the imposing AEG buildings designed by Peter Behrens, and on the other by a rural idyll. This blend

**Walter Gropius with Adolf Meyer, the Fagus Factory in Alfeld an der Leine.** 1911–1925, view after the building's extension, photograph by Edmund Lill, BHA. • With this building Gropius created an early model of modernism with its exemplary use of a curtain-wall façade. The structure of the building, on the other hand, still incorporates classical principles of composition.

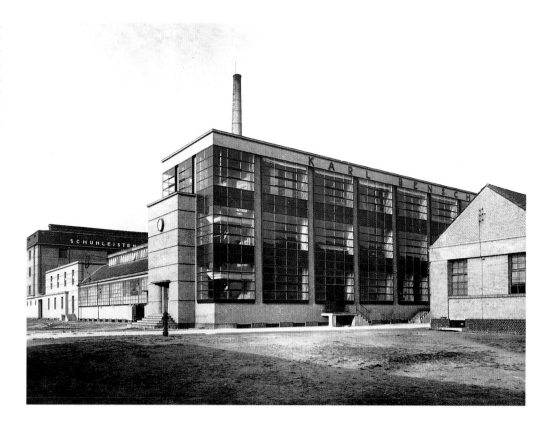

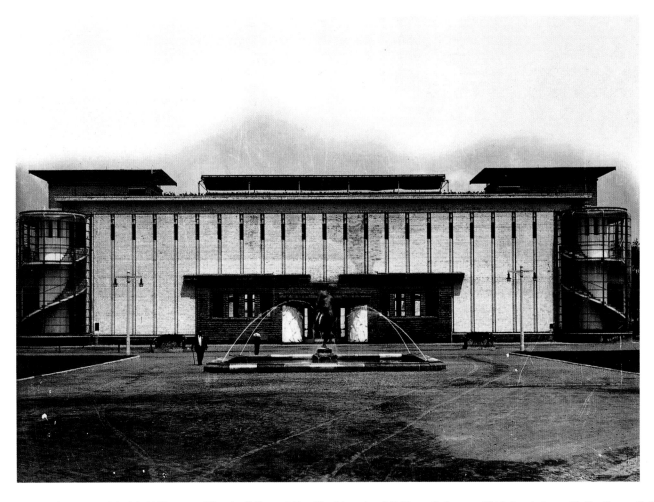

**Walter Gropius with Adolf Meyer, office building at the Werkbund exhibition, Cologne.** 1914, front view with the Georg Kolbe fountain, photographer unknown, BHA. • The effect oscillates between temple type, American monumental buildings and others which Frank Lloyd Wright was designing at the same time in the USA.

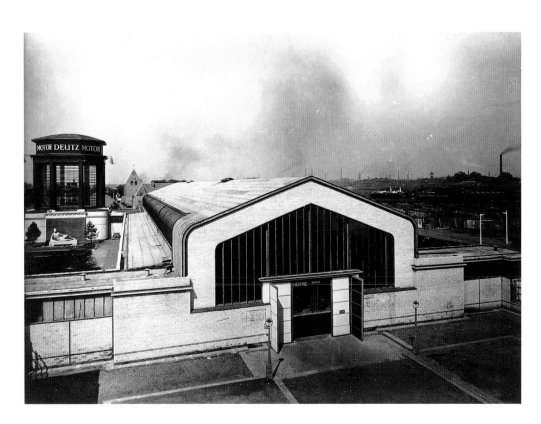

**Walter Gropius with Adolf Meyer, machine room and Deutz pavilion for the Werkbund exhibition, Cologne.** 1914, photographer unknown, BHA. • The characteristic steel truss construction, creating space and volume, is given visible expression on the façade.

of energetic, monumental, big-city architecture and utilitarian rural buildings created a very special formal, objective tension, which was to reappear in Gropius's work in a rich variety of forms during the following years. In 1911 he joined the German Werkbund and was responsible for its annuals from 1912 to 1914. This activity gave him the ability to gauge the effectiveness of aggressive publication strategies. Along with joining the Bund Deutscher Architekten (German Architects' League) in 1912, it was in particular his membership in the Werkbund that in the following years helped him to obtain commissions and participate in important theoretical debates in the field of architecture. These debates were led primarily by the ranks of the Werkbund, which was committed to high-quality work within a system where the production of all material goods was increasingly governed by technology.

Evidence of Gropius's architectural thinking during these years is provided especially by the Fagus Factory (a shoe-last factory) built from 1911 in Alfeld an der Leine and the two buildings at the Cologne Werkbund exhibition of 1914, viz. an office building and a machine room. Ever since it was built, the Fagus Factory has been internationally lauded and celebrated as the cradle of German prewar architecture, but it has also been often overinterpreted and misunderstood. It catches the eye by virtue of a constructional and artistic innovation, the "curtain wall." What was especially new was running glass to the corners of the building, thereby rejecting the rule that had been handed down for centuries which said that the corners of buildings had to be the guarantors of both the constructional and the visual solidity of a building.

At Alfeld, anticipating the Dessau Bauhaus building of 1925–1926, Gropius managed to bring off an ingenious coup. However, the construction of the façade lacks any constructional or functional basis, as is also true of the Bauhaus building: the glass frontage later caused damage to the building and revealed functional deficiencies. In winter it was too cold in the rooms behind the façade, in summer it was too hot. But the image of the "glass wall" seemed suitable for giving visible form to his thesis of the day, namely that only an independent art form, as an "intellectual idea," would open up the possibility of replacing "unintellectual technological form."

With his office building at the 1914 Werkbund exhibition he struck out once again on a new path. Here in his own way he monumentalized the technological form, taking a utilitarian structure that was really a matter of engineering and applying strict symmetry, treating walls as large planes and arranging the supporting materials (iron frames and pillars) in a tightly rhythmic pattern. The result is a building which amalgamates various architectural tendencies and styles from a variety of cultural backgrounds and historical eras. The sublime spectacle of anonymous concrete grain elevators and Frank Lloyd Wright's prairie houses in the United States, Egyptian pyramids and temples and German Jugendstil buildings – these were, in differing degrees and with varying importance, the inspiration. Aspects of this compositional technique, peculiar to Gropius, can be detected again and again in his later buildings.

This fragmentary overview of Gropius as he was before the establishment of the Bauhaus makes it clear what distinguished him throughout his life: his exceptional gift for looking attentively at the scene around

**Walter Gropius with Adolf Meyer, Sommerfeld log house, Berlin-Steglitz.** 1920–1921, view from street side, photographer unknown, BHA. • Here too one can see the compositional principles of Frank Lloyd Wright's American prairie houses: strict, almost classical composition and a rhythmic alternation of horizontals and verticals.

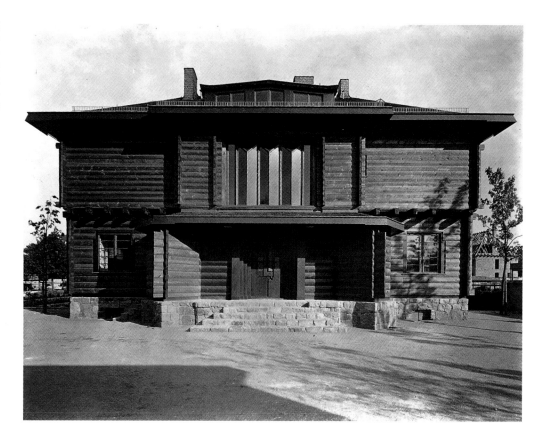

him and drawing from all its styles and features, among which were trends that were just beginning to emerge. "Scene" here denotes the intellectual and cultural background against which the theoretical debates about industrialization, rationalization, artistic and technological forms took place, and, equally, building projects that had been carried out and designs by other architects and from other countries that appeared in various specialist publications. It is important to note in this connection that since establishing his building studio Gropius had worked with Adolf Meyer, who was able to implement Gropius's ideas in his own, equally original way.

It is well known that Gropius did not draw – he could not. He himself said that his hand was actually afflicted with cramp as soon as he started to rough out his ideas. He compensated for this traumatic experience by rhetorical skill and verbal ability. He had the ability to convey his ideas in such a precise and realizable form that his colleagues were able to translate them into designs ready for building. Traditional architectural history therefore faces a problem when it attempts retrospectively to separate the original achievements

of Gropius from those of his colleagues in matters of composition, detail and design. This has in the past frequently led to errors of judgment and misattributions. Gropius's period at the Bauhaus was marked by this conflict between, on the one hand, generating ideas and, on the other, seeing them implemented by others. However, this problem only arose with architecture, not with the organization of the Bauhaus. In this area he developed a lively talent for communication which was to make the school one of the most famous artistic establishments of the century. Until he gave up the post of director of the Bauhaus in 1928, Gropius's efforts were directed both toward the survival of the college, its consolidation as part of cultural life and the propagation of the ideas and aims which it pursued, as well as toward the architectural production generated by Gropius's building office. The latter was also always intended to reflect the school's self-image.

Finally, it should be pointed out that Gropius, according to all the extant evidence, did hardly any teaching himself. He was at pains to appoint teachers who shared his ideas, he cultivated the contacts which were needed for the school's survival, and he also developed

the teaching syllabuses. But he rarely stood in front of students himself as a teacher. It has been repeatedly noted with surprise that the assertion in the first manifesto that "the ultimate goal of all artistic activity is building!" was never put into practice. This was precisely because the necessary basis for turning this vision into reality, specifically an architecture department, did not exist. It is therefore possible to follow Gropius's thinking and actions only where they took material form: in completed building works. And these always started as a design from the Gropius building studio, for which students at the Bauhaus or even individual departments or workshops were brought in, but these projects were not a taught subject.

The first outstanding result of this teamwork between the building studio and the Bauhaus was the Sommerfeld log house built in Berlin-Steglitz in 1920–1921. The building was commissioned by Adolf Sommerfeld, Gropius's patron in the 1920s. The client bought up the materials from a superannuated ship and had them adapted and the house built from them. Two aspects of the design are significant. To understand the first, the ideological superstructure as it were, we must refer back to a

passage from the first Bauhaus manifesto: "Architects, sculptors, painters, we must all return to craft! Let us therefore form a new craftsmen's guild. The Bauhaus strives to bring together all artistic creativity in a unity, to reunite all craft-based artistic disciplines – sculpture, painting, applied art and craft – as inseparable components of a new art of building. The ultimate, though distant, goal of the Bauhaus is the unified work of art – the great building – in which there is no frontier between monumental and decorative art." The second aspect relates to projects by the American architect Frank Lloyd Wright, whose book *Buildings, Plans and Designs*, published in German in 1910 as *Bauten und Entwürfe*, was Gropius's regular reading material during those years.

The Sommerfeld house seemed like a stagey transformation of a building by Wright, with its protruding beam heads, its symmetry intensified to create a sublime, monumental effect, its hipped roof jutting out like the brim of a hat, and the layered construction of the block-like building unit with the resulting horizontal line of the planes. In addition there was the expressive interpretation of individual building components, which in its turn had its roots in postwar German Expressionism, and the craft-like effect which set the relatively large building apart from the architectural canon of the time. It was thus also testimony to the ideas which Gropius developed in the circle of the so-called "Glass Chain," an association of architects who exchanged their thoughts and plans for a new architecture by correspondence in the form of chain letters.

The interior design was in line with the Bauhaus manifesto inasmuch as Gropius involved individual workshops in the design. A seating group and a bookcase were made by the cabinetmaking workshop under the direction of Marcel Breuer, heating and lighting

**Walter Gropius with Adolf Meyer, competition entry for the Chicago Tribune Tower.** 1922, perspective view, Indian ink with wash on card, fixed to a sheet of hardboard, 135.0 x 71.5 cm, BHA. • Conspicuous here is the unrhythmic interruption of the otherwise sheer skeleton, carried out in reinforced concrete.

**Walter Gropius and the building department of the Dessau Bauhaus, Dessau Bauhaus building.** 1925–1926, plan of the ground floor, Indian ink on waxed tissue paper with pasted-on inscriptions, 28.2 x 33.6 cm, BHA.

**Walter Gropius and the building department of the Dessau Bauhaus, Dessau Bauhaus building.** 1925–1926, plan of the first floor, Indian ink on waxed tissue paper with pasted-on inscriptions, 27.8 x 34.4 cm, BHA.

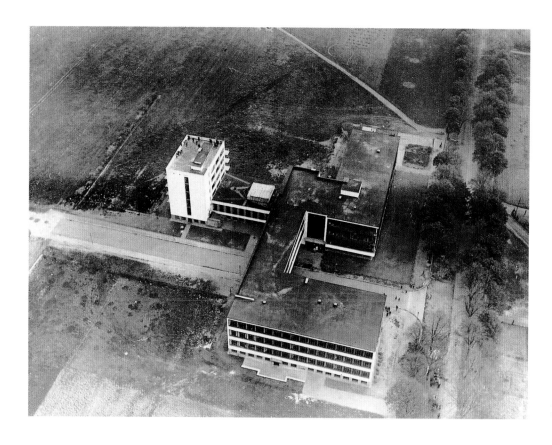

**Walter Gropius and the building department of the Dessau Bauhaus, Dessau Bauhaus building.** 1925–1926, bird's-eye view of the entire site, aerial photograph by R. Petschow, Berlin, BHA. • The inter-relationships of the various building units can be seen to best effect in this aerial photograph, also the interlinking of the various functional areas.

units were done by the metal workshop, and the stairwell windows by the glass painting workshop according to designs by Josef Albers. The Bauhaus weaving workshop also supplied three carpets from its production. To these were added the sculpting of various individual wooden components by Joost Schmidt. Thus the log house can indeed be regarded as a small total artwork in the spirit of the Bauhaus's original goal.

This early Weimar phase also includes the Monument to the Dead of March, 1920 (the Kapp putsch) in the Weimar cemetery (1920–1922), the rebuilding of the Jena Municipal Theater (1921–1922), the house for Fritz Otte in Berlin-Zehlendorf (1921–1922), the designs (which were not implemented) for Dr. Kallenbach's house in Berlin and the Bauhaus housing estate, which were worked out under Gropius's direction at the Bauhaus and in Walter Determann's building office. But in the monument, the Otte house and the theater building we can see a new attempt being made to achieve a different surface effect, by using smooth rendering and the color white. Whereas the private house was still committed to a monumental,

symmetrical but transmuted classicism, in the monument, which was cast in concrete, an expressive quality appeared which in its "lightning" symbolism appears strangely autocratic, pointing into the void in a politically motivated gesture. However what these last-mentioned designs indicate above all is an intellectual about-face in Gropius's attitude toward non-craft production. This is clear from the chosen materials and their use, and also formally from the use of more soothing horizontal and vertical lines and an increasing lack of ornamentation. To these were added growing influences from America, the land of the "most resolute inhabitants on earth," as Gropius himself wrote during this period. In his biographical book *Der Architekt Walter Gropius*, Winfried Nerdinger demonstrates that Gropius was strongly influenced by Le Corbusier's book *Vers une architecture* and by rationalized building methods in the USA. In Germany it was Martin Wagner above all, whom Gropius knew from his Berlin period, who used the "Bauhütte" approach – far removed from any mysticism and based on pragmatic calculation – in an attempt to make building cheaper and

thereby providing good-value housing for the less well-off. Taking automobile production in the United States as his starting point, with the "Ford system" and Taylor's "scientific management," in other words, intensified assembly line production, Gropius now also tried to adapt to the conditions and requirements of the new age in matters of production technology.

The plans for a Bauhaus housing estate, begun by Determann in 1920, were now radicalized in terms of design and industrial manufacture under Fréd Forbát, who was employed in Gropius's building office. What they now aimed for was the standardization of individual building components that could be assembled to form a kind of "honeycomb" structure. The basic idea was to develop a "large-scale construction kit" from a small number of components which would permit house types of various sizes to be constructed within a recognizable typology "depending on the number and needs of the occupants while on principle using straight roofs that could be walked on" (inscription on the original plan). The goal was "great variability of the same basic type by the systematic addition of extra spatial

**Walter Gropius and the building department of the Dessau Bauhaus, Dessau Bauhaus building.** 1925–1926, preliminary draft, west view, drawing by Carl Fieger, 1925, SBD collection archive. • This preliminary draft shows a still somewhat rough version of the composition that was subsequently refined, particularly the arrangement of the building units and the development of the glass frontage. In this draft, the bridge still has three floors.

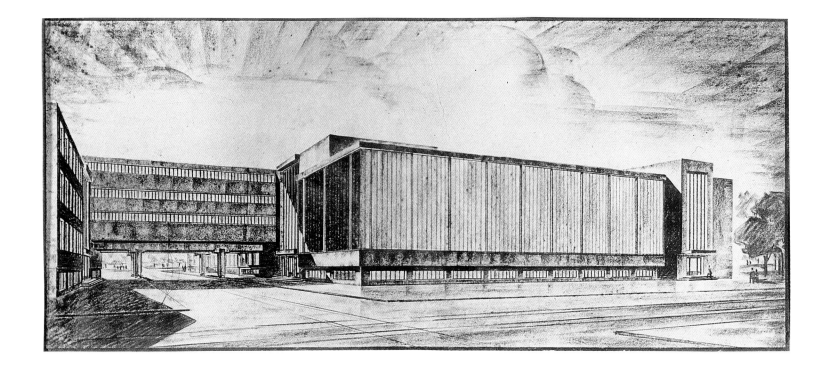

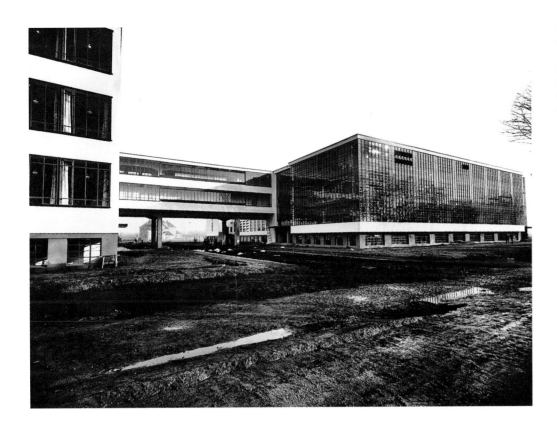

**Walter Gropius and the building department of the Dessau Bauhaus, Dessau Bauhaus building.** 1925–1926, north-west view, photograph by Lucia Moholy, BHA. • The clarity of the design idea finds expression above all in the large area of glass frontage, behind which the workshops were located.

**Walter Gropius and the building department of the Dessau Bauhaus, Dessau Bauhaus building.** 1925–1926, south-east view of the students' studio house (Prellerhaus), photograph by Erich Consemüller, BHA. • The clear, practical arrangement of the windows and balconies gives the building its own special appearance. On the left is the walkway to the main building.

cells." Here the terminology, which can be regarded as the basis for all subsequent Bauhaus designs, appeared in written form for the first time. It included the key terms used to describe "Bauhaus architecture" down to our own time: basic type, spatial cell, flat roof. To these were added the color white, the flat rectangular shape of all components, and prefabrication. The sum total of these elements generally produced an orthogonal configuration of the building volumes, and thus the prototype of "Bauhaus architecture." And this regardless of the fact that back in 1914 Le Corbusier, with his "box of dominoes," had anticipated both the strategy of modern architecture and the image which was thereby established.

The Bauhaus housing estate did not materialize; there were no funds available for it. However, on the occasion of the Bauhaus exhibition in August 1923 an "experimental house" was built under the direction of Georg Muche on the proposed site on the Horn in Weimar, in the spirit of this "construction kit." As with the Sommerfeld house, the Bauhaus workshops were brought in for the interior design. In this respect each room breathed the spirit of the school as it sought with this project to summarize its work over the previous four years. Even

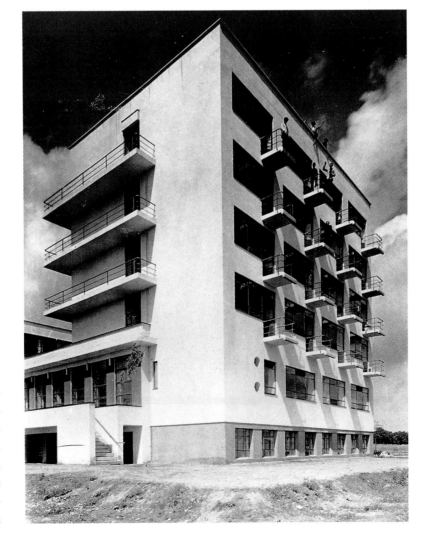

Walter Gropius

**Walter Gropius, houses for the Bauhaus masters.** 1925–1926, perspective view, drawing by Carl Fieger, 1925, SBD collection archive. • The drawing illustrates the "picturesque" location of the houses in a small birch forest near the Bauhaus building, and the villa-like amplitude of their proportions, which was criticized, sometimes in a polemical manner, by many contemporaries.

**Marcel Breuer, design for "Type Bambos 3" terraced houses. 1927, illustration from "bauhaus", No. 1, 1928, BHA.** • Breuer experimented at an early stage with terraces of minimalist houses. A development such as this one, to the west of the Bauhaus building, was originally planned for the young masters, but the plan was never carried out.

**Walter Gropius, houses for the Bauhaus masters.** 1925–1926, site plan, BHA.

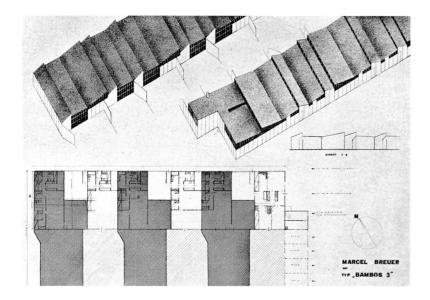

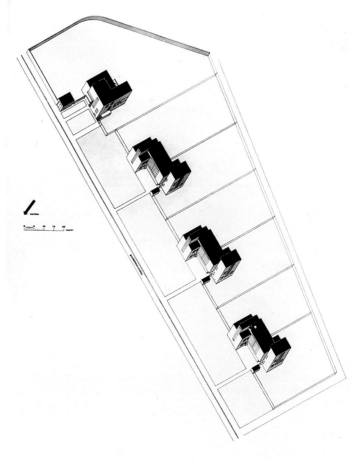

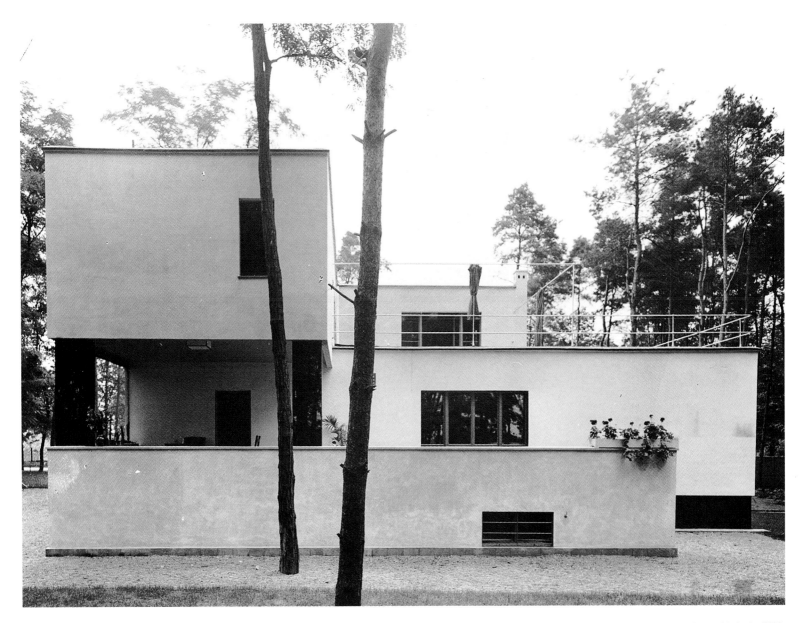

**Walter Gropius, houses for the Bauhaus masters.** 1925–1926, Gropius's house, view of the garden side from the south, photograph by Lucia Moholy, BHA.
• The clear articulation and distribution of the building masses is slightly reminiscent of villas by Le Corbusier. Here too white surface areas dominate, with sharply incised window apertures.

more importantly, this exhibition, which lasted from August to September and was accompanied by a presentation of international architecture initiated and compiled by Gropius, was the point at which he promulgated a new slogan for work at the Bauhaus: "Art and technology: a new unity." This slogan had its roots in his experiences and observations during the preceding two years (including internal disagreements, especially with Johannes Itten, after whose departure in spring 1923 Moholy-Nagy was appointed). That is to say, it grew out of the realization that the mystical religious evocation of medieval craft production was a thing of the past.

In spite of the school's widely noted record of achievement, the regional government of Thuringia made it increasingly difficult for the Bauhaus to continue to provide orderly and effective teaching and training. As the year 1924 drew to a close, the demise of the Bauhaus was immanent. This led Gropius and the council of masters to negotiate re-establishing the school in a different place with various municipalities. The town of Dessau, under its mayor Fritz Hesse, agreed to accept the college, promising in addition to establish a new school building and houses for the Bauhaus masters. Whereupon the Bauhaus council of masters resolved, on December 26,

1924, to close down the college with effect from April 1, 1925 and move to Dessau. This decision gave Gropius the chance to design a school building in which he could realize both his conception of communal living at the Bauhaus and his architectural ideas for a modern building appropriate to the age. He collaborated initially on the design with Carl Fieger, then with Ernst Neufert, the new office manager at the building studio. The school building was to be used at the same time by the town's School of Applied Arts, which resulted in a spatial and functional scheme for a relatively large building complex. This in its turn allowed various building units to be worked

out and placed in a dynamic relationship with one another. Clear functions were allotted to each of the individual building units, which were interconnected both horizontally and vertically within a clear development concept. The alternation of rendered surfaces, perforated façades and window bands also gave each separate building a distinctive appearance. They were, however, dominated by the workshop area with its large glazed planes on the street side. This glass wall, regardless of how awkward it may have been in terms of its technical construction and ecological merit (a hereditary defect which persists to the present day), has always been regarded as a symbol of the "Bauhaus community" whose spirit was to gather, cluster and, so to speak, crystallize here.

At the opening of the Bauhaus building in December of 1926, the three masters' duplexes and the director's house were also presented to the public. These buildings were basically a further development of the standardization that had begun with the "large-scale construction kit." They are conceived in terms of interlinked cubes, dwellings with a

generous ground plan arrangement and façades with narrow-profile window frames and balcony parapets. They were painted white, arranged in a rhythmic, additive manner, and conveyed at the time an image of orderly middle-class comfort with a dash of Bauhaus snobbery. But this was a reductio ad absurdum of the original initiative to devise and apply a rationalized method of building. The whole idea was to make building cheaper, and so be able to build houses and apartments which less well-off social groups could afford. In fact, however, purely formal considerations resulted in building costs that were double the estimated amount; this in turn pushed rents up by 100%. The students, some of the Bauhaus masters – Schlemmer more than anyone else – and the public were consequently sharply critical of the building costs. The accusation of formalism was also heard, and there were malicious references to a design concept virtually borrowed from Le Corbusier. Despite all this, the masters' houses do constitute a kind of "masterpiece" among the building projects carried out by Gropius.

The conflicts at the Bauhaus, especially in connection with Gropius's role and "building as the ultimate goal," did not disappear after the move to Dessau and the establishment of an architecture department under Hannes Meyer. On the contrary, looking back it can be seen that Gropius continued to do more for his private building studio and its commissions than for the school. Eventually this led even the mayor, Fritz Hesse, to complain about the director's continual periods of absence. The building department was literally penniless, while "Gropius's building office constantly has building work to do," as Hannes Meyer wrote to the architectural critic Adolf Behne in late 1927. Commissions which the building department had initially been promised did indeed fail to materialize, whereas Gropius's building studio was commissioned to design the Dessau-Törten housing development (1926–1928), the Dessau Labor Office (1927–1929) and finally, in 1928, the Konsum building in Törten. In 1927 Gropius's building studio also produced the designs for two houses at the Werkbund exhibition "Am Weißenhof" in Stuttgart (organized by the

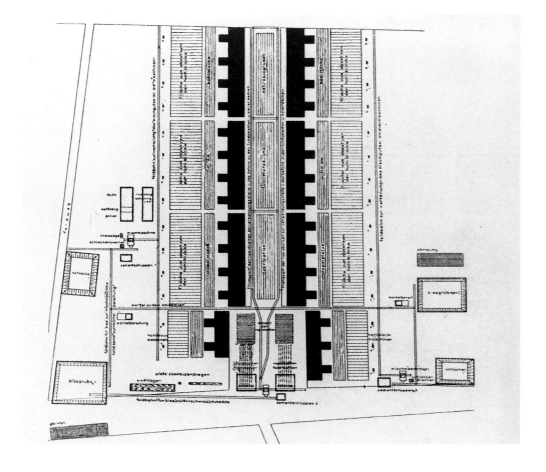

**Walter Gropius and the building department of the Dessau Bauhaus, Dessau-Törten housing development.** 1926–1928, plan for the rational arrangement of the building site, 1926, BHA. • The development site was designed for prefabricated components to be assembled on the spot. The individual buildings were erected in assembly-line fashion on either side of the development.

**Walter Gropius and the building department of the Dessau Bauhaus, Konsum cooperative building on the Dessau-Törten development.** 1928, view from the south-west, original condition, photograph Theis-Dessau, BHA. • The Konsum building is located at the center of the housing development; the shop on the ground floor sold provisions for the development's residents.

German Werkbund under Mies van der Rohe) and the design for a so-called "total theater" which Gropius conceived following an approach by the Berlin theater producer Erwin Piscator, for whom experiments with new kinds of staging were central to a new concept in theater building.

Gropius's most important successful experiment with regard to the "Taylorization" of building was probably the Dessau-Törten housing development, and its outstanding feature was the assembly line production of the housing units. Both the ground plan of the development and the apartments, and the construction and choice of materials were subjected to rigorous rationalization, which subsequently led to not a few cases of damage to the buildings. The box-like effect of the neat rows of houses directly reflected the serial production method. The Konsum building,

by contrast, was a "normal" brick construction, located at the center of the development and designed with a different spirit in mind. Here, considerable spatial and physical tension was achieved by the combination of two building units, the flat one providing the sales area while the four-story building unit housed apartments and, on the top floor, communal rooms.

At the Bauhaus itself, Gropius's buildings on the Weißenhof estate in Stuttgart were judged most severely, as was to be expected in view of what transpired. For in the context of the buildings erected there, with their delight in experiment – and the quality they achieved – those by Gropius were in every respect something to be ashamed of. On this point, Winfried Nerdinger writes: "In the official critique in the concluding report of the Reichsforschungsgesellschaft (Reich Research

Association) it was pointed out that the basic plans were systematic but not innovative, that the construction was one of the most costly of the entire development, and that some constructional errors had been made." He ends by quoting the association's overall verdict: "The doctrinaire constructivism of the Bauhaus gives the houses a strangely dry, pedantic quality and at the same time something provisional and hut-like." With another building, the Labor Office in Dessau, Gropius more or less said farewell to the Bauhaus. The elaboration of the ground plan, which was well thought-out and, organizationally speaking, skillful; the cohesion between the chosen construction and the architectural shape, which appears austere and modern while at the same time having the flexibility required of urban architecture – these qualities elevate this building far

**Walter Gropius and the building department of the Dessau Bauhaus, Dessau-Törten housing development.** 1926–1928, improved "type" houses of 1927, built in 1928, photograph by Gropius's building office, BHA. • The box-like houses and their arrangement reveal their origins in industrial production: they look, so to speak, as if they had come straight off the assembly line.

**Walter Gropius and the building department of the Dessau Bauhaus, Dessau-Törten development.** 1926–1928, axonometric section of the small-house development (60 houses under construction), illustration from the Bauhaus magazine *Offset, Buch und Werbekunst* No. 7, 1927, Kieren Collection, Berlin. • With only one type of house, Gropius tries to design an urban environment, a piazza-like extension of strictly linear arrangement of the site.

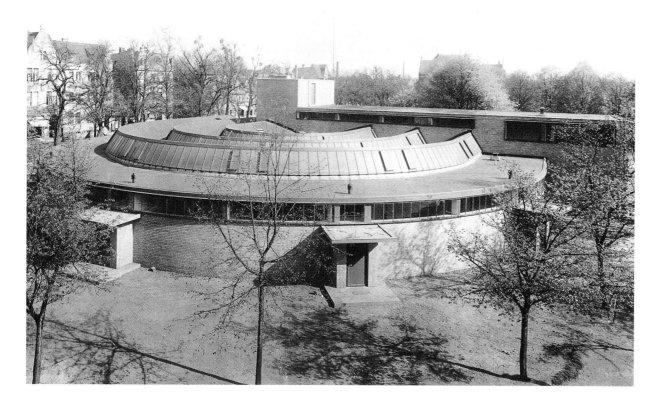

**Walter Gropius, Dessau Labor Office.** 1927–1929, view from the north, photograph by Theis-Dessau, BHA. • One of Gropius's most successful buildings, both in architectural terms and in terms of urban building. Its external appearance entirely accords with the architectural organism, which is determined by functional criteria.

**Walter Gropius, Dessau Labor Office.** 1927–1929, internal circular walkway, photograph by Theis-Dessau, BHA. • A masterpiece of logistical planning and functional analysis: the separate entrances guided the jobseeker directly to the appropriate department.

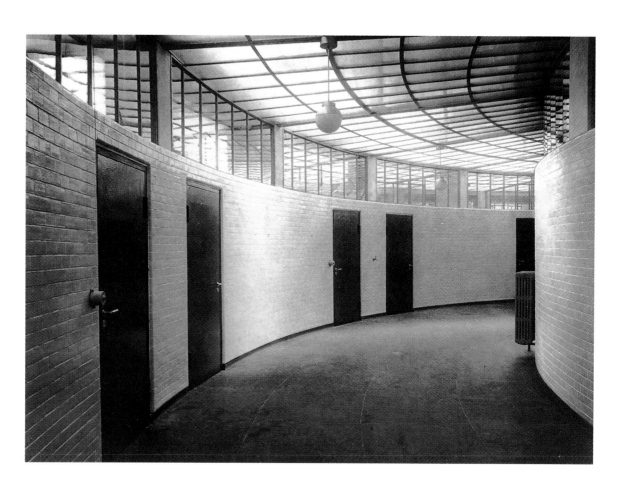

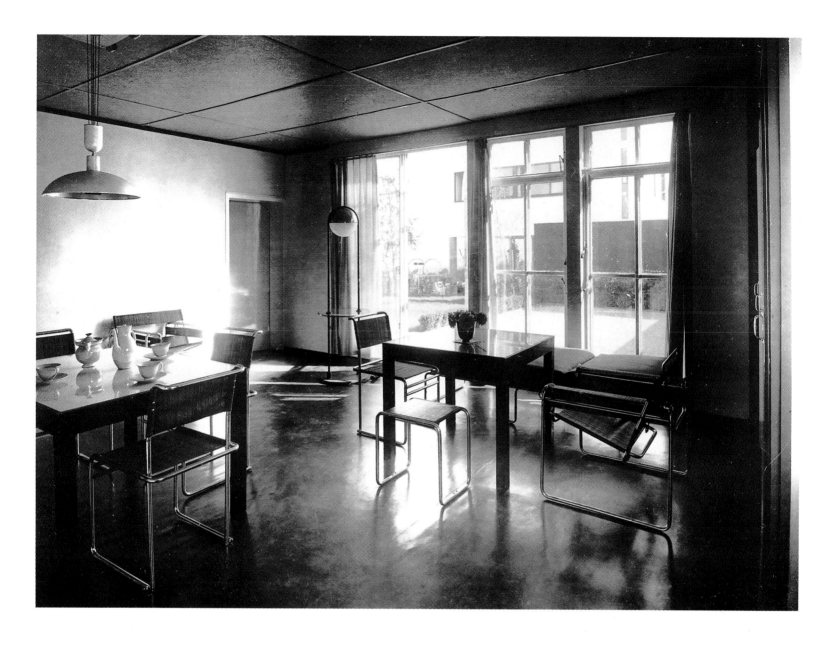

above the canon of work created by Gropius during his years at the Bauhaus.

After resigning as director of the Bauhaus on April 1, 1928, Walter Gropius worked as an architect, exhibition designer and architectural expert, at first in Germany, then in England and the United States, where in 1937 he was appointed as professor at Harvard University's Graduate School of Design. His further career as an architect did not produce any achievements worth mentioning, let alone any that stood out above the contemporary architectural scene, with the possible exception of the Karlsruhe-Dammerstock housing development of 1928–1929. For the rest of his life he was principally occupied in recording and appraising the history of the Bauhaus, that is to say of the phase in which he himself had been its director

and had developed its program. Throughout his life he was almost anxiously concerned to emphasize, and sometimes to exaggerate, his own contribution to the Bauhaus. He was mostly afraid that this contribution might be disputed in one quarter or another, and this often caused him to belittle the achievements of his colleagues and comrades-in-arms, especially those of his successor Hannes Meyer, in unjustified attacks and a somewhat crude emphasis on his own achievements. Nevertheless, Gropius is now, at the end of the 20th century, named in the same breath as Le Corbusier and Mies van der Rohe, which (as we can see, looking back) is not so much a matter of his outstanding achievements as an architect as of his undisputed talent for organization and a not wholly misplaced flair for self-advertisement.

**Walter Gropius, two houses for the Werkbund housing development Am Weißenhof, Stuttgart.** 1927, living room with furniture by Marcel Breuer, photographer unknown, BHA. • At the time, the coldness of the materials and the asceticism of the interior elicited not only admiration but also criticism. The houses were felt to lack "friendliness."

# The Bauhaus on the Road to Production Cooperative: the Director Hannes Meyer

Martin Kieren

From 1928–1930 the Dessau Bauhaus had in Hannes Meyer its most controversial director. His appointment, his work at the Bauhaus and his theoretical stance were controversial, but it was above all his political activity which led in the end to the termination of his employment as director. The circumstances leading up to this have been repeatedly discussed, marking as they do the interface between democracy and rising fascism in the Weimar Republic. Yet for a long time our historical perception both of his period as director and of his personality have been determined more by his dismissal from the Bauhaus on political grounds than by the work which he did at the Bauhaus and with the students of the architecture department. Also relevant are his contribution to the restructuring of the school and the cooperation with industry and opening up of the school to the outside world which he forcefully encouraged.

This faulty assessment, especially in relation to the other directors, Walter Gropius and Ludwig Mies van der Rohe, can first of all be attributed to their strong but enigmatic personalities and Gropius's publicity work. Gropius had an excellent grasp of how to make use of media such as exhibitions, brochures, books and the art of photography to spread the word about his concerns and achievements. But Hannes Meyer's achievements remained unnoticed for just as long as Gropius's reputation shone out unopposed. Today it is still useful to look at Meyer's personality and his practical and theoretical work, and to shed light on them in the context of the architecture of those years and especially that pursued at the Bauhaus. For by looking more closely one can appreciate the radical position he took in response to social conditions and experiences, but which since then seems to have been stigmatized because of its proximity to a theory of architecture grounded in Marxism. Granted, this position is not entirely free of contradictory elements, but looking at it helps us to see and reappraise

**Portrait of Hannes Meyer, photographer unknown (Hannes Meyer?).** 1928, sheet from the portfolio "9 jahre bauhaus. eine chronik" (9 years of bauhaus. a chronicle), 1928, collage of photographs, mounted on white card, 23.5 x 18.5 cm, BHA. • Program picture for an architect: the portrait "hung" on the dynamically arranged axes of a crane construction.

the other, opposing aesthetic positions and how history has received them.

Before his appointment, Hannes Meyer had gone his own way. He was born in Basel in 1889 and trained in technology and craft. Like Gropius, Mies or Le Corbusier, he had no higher education in the classical sense. He began working as an independent architect during World War I. He carried out his first major project in Basel from 1919–1922: the "Freidorf" housing development for the Swiss Cooperative Society. This housing development reveals its origins in the various programs which generated its conception as well as its typological and constructional development. Its architecture is in the classicizing mold of figures such as Friedrich Ostendorf, but tied to a strict but nonetheless symbolic urban architectural composition. Meyer wrote: "externally, an attempt has been made to produce a building typical of the Jura" (Hannes Meyer, *Bauen und Gesellschaft. Schriften, Briefe, Projekte* [Building and Society. Writings, Letters, Projects], Lena Meyer-Bergner [ed.], Dresden, 1980, p. 11).

The modular layout of the housing development owes much to an intensive study of the Renaissance architecture of Andrea Palladio and to the efforts to normalize and standardize which were necessitated by economic factors. The rhythm of the rows of houses arises from a striving for harmony which ties all architectural elements and all housing units into an urban architectural site with aspirations to formal balance. The basis is provided by the system of "small circles," which have their rationale in social, educational and functional considerations derived from the educational model of Johann Heinrich Pestalozzi. Here, the "family cell" is the starting point for a spatial architectural model which acts as a symbolic metaphor for the cooperative venture. Meyer's model of life and the world is based on this "system of small circles." It leads equally to "Hannes Meyer's architecture class" at the Bauhaus and to the explanation and, as it were, demystification of all his projects, whether they were actually realized or remained projects only. And finally this system of small circles leads via the "collectivist factor" to his concept of knowledge and science and to his Marxist theory of design, as he was later to call it.

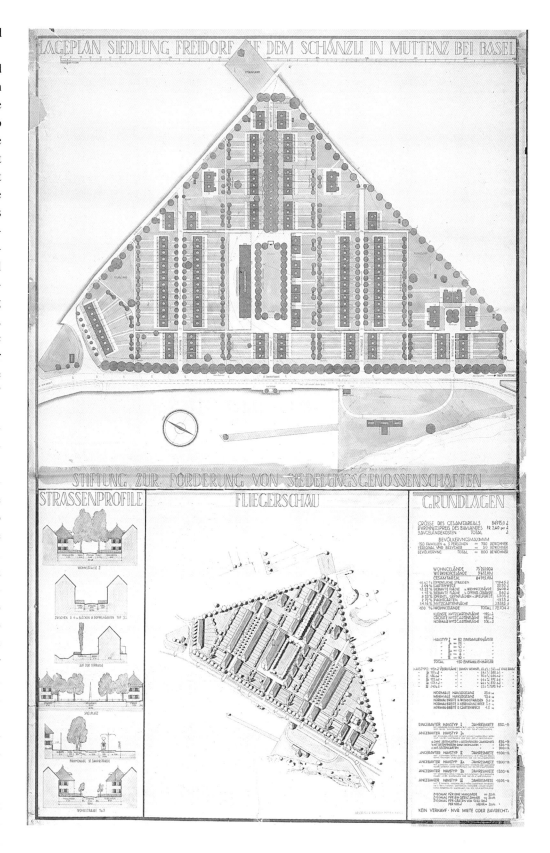

**Hannes Meyer, Site plan, street profiles, aerial axonometric view and factual summary for the "Freidorf auf dem Schänzli" housing development in Muttenz, near Basel.** December 8, 1920, Institut für Geschichte und Theorie der Architektur at the Eidgenössisch-Technische Hochschule in Zürich. • The site for the development, Meyer's first major project, caused a stir, particularly because of its clear articulation and the arrangement of the houses. Here Meyer "translated," for the first time, his "system of small circles" into a spatial, architectural structure.

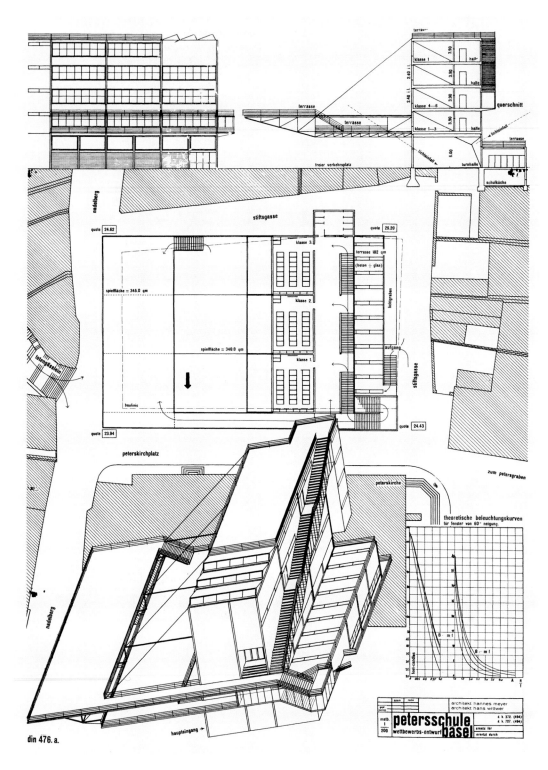

labels visible in the diagram include: terrasse, klasse 1, halle, klasse 4–6, klasse 1–3, querschnitt, terrasse, freier verkehrsplatz, lichtschacht, terrasse, turnhalle, schulküche, lichtentfal, 3.90, 2.40, 2.40, 3.90, 3.90, 6.00

nadelberg, stiftsgasse, quote 24.62, quote 25.20, klasse 3, terrasse 182 qm, (beton + glas), spielfläche = 345.0 qm, klasse 2, lichtgraben, spielfläche = 340.0 qm, aufgang, klasse 1, baulinie, stiftsgasse, quote 23.94, quote 24.43, peterskirchplatz, zum petersgraben, peterskirche, nadelberg, din 476.a., haupteingang

theoretische beleuchtungskurven für fenster von 60° neigung

architekt hannes meyer
architekt hans wittwer
mstb. 1 : 200  petersschule basel  wettbewerbs-entwurf
d. k. 372. (494)
d. k. 727. (494)
ersatz für
ersetzt durch

**Hannes Meyer and Hans Wittwer, Design for the Petersschule in Basel.** 1926, revised version of the competition design entry from "bauhaus," 1927, No. 2, BHA. • It was the idea of building a school yard suspended by cables which surprised Meyer's contemporaries most of all. He and Wittwer spoke of a "scientific" design method with calculable parameters.

From 1922–1926 Meyer moved at high speed through all the phases of the modernist movement of those culturally stormy years. His social and cultural stance vis-à-vis architecture and the contemporary "culture of expression" became a radical one. He worked as an artistic seeker in a variety of disciplines: as an editor and comrade-in-arms for theoretical magazines that put forward extreme and uncompromising arguments, as the author of poetic manifestos with a radical message, as a mime, a propagandist, an exhibition organizer and decorator. Meyer absorbed the technological, artistic and scientific knowledge of the time and worked out for himself a theory which from our present-day point of view appears highly eclectic. His work during the years 1923–1926 culminated in the so-called "Meyer-Wittwer laboratory" in Basel. There, during the summer of 1926 and the winter of 1926–1927, that is to say shortly before his apppointment at the Bauhaus, he developed, with the Swiss architect and later Bauhaus teacher Hans Wittwer, the legendary designs for the Petersschule in Basel and the League of Nations building in Geneva – as "constructional inventions," in the words of the explanatory notes on the Geneva project.

At the opening ceremony of the Dessau Bauhaus in December 1926, at which Meyer was present, he attracted Walter Gropius's attention. Shortly afterwards Gropius told him that he wanted him to be the head of the newly established building department and to take over a master class in architecture. Mart Stam and Ludwig Mies van der Rohe had already turned down similar invitations. Meyer's initial hesitation, which can be clearly seen in his correspondence with Gropius, arose on the one hand from his great desire to live and work independently in the future: "in recent years i have been obliged to turn down several offers, because my scope for living would have been too restricted if i had accepted them." But on the other hand it also arose from his skeptical view of the work done at the Bauhaus hitherto: "what i saw at the opening ceremony are mere externals, apart from the illuminating and valuable conversation with yourself and the masters kandinsky, moholy, schlemmer and breuer. from my limited position as a learner i am highly critical of most of the work that was exhibited at the opening,

except for the things that have a major potential for development, such as the steel house, steel furniture, parts of schlemmer's theater and kandinsky's fundamental teaching along with parts of the school's basic teaching. A lot of things reminded me spontaneously of 'dornach – rudolf steiner' – sectarian and aesthetic" (ibid, p. 42). Gropius was especially impressed by Meyer's designs for the Petersschule and the League of Nations building. Meyer's lengthy stay during the opening ceremonies also brought him into closer contact with other Bauhaus masters, who, if one looks back at their letters, were in the beginning full of unanimous enthusiasm for his strong personality, his élan and his professional competence. Given that a building department was at last to be established at the Bauhaus, they saw Meyer as the type of architect they wanted: not from their own ranks, a practitioner and theoretician, someone who got things done, and evidently someone who could awaken the enthusiasm of young people, and who was thus a suitable teacher for the Bauhaus.

Meyer's work at the Bauhaus, from spring 1927 to summer 1930, must be considered from three different points of view:

- Work as head of the building department ("architectural teaching")
- Project designs and buildings realized with students from the building department
- Restructuring of the Bauhaus as director, 1928–1930.

His work in the building department is described in more detail in the section "From Bauhaus to Building Houses." Let it suffice to note here that in his first year, that is to say from spring 1927 to spring 1928, Meyer presented courses devoted to general building issues. "First, basic issues of architectural organization are explained," as Meyer wrote to Gropius. Then a further difficulty arose. The building department had been officially established – but there were no students. There were never more than ten students per semester who studied architecture at the Bauhaus or completed the building course. Meyer did not do much teaching during the first year. He amended his designs for the Petersschule and the League of Nations Palace in order to publish them in the *bauhaus* magazine, and at the same time he tried to obtain commmissions for the building department. For even during the preliminary talks with

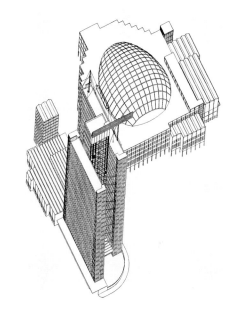

**Hannes Meyer and Hans Wittwer, Design competition entry for the League of Nations Palace in Geneva.** 1927, axonometric view, BHA. • With this competition entry, which was short-listed, the architects acquired an international reputation. Gropius was so taken with this design that he appointed Meyer to the Bauhaus a little later.

## semesterplan

| | | 1. semester | 2. semester | 3. semester | 4. semester | 5. semester u. folg. |
|---|---|---|---|---|---|---|
| **1** architektur a. bau b. innenein-richtung | vermittlung der grundbegriffe der gestaltung | allgemeine einführung: a) abstrakte formelemente analytisches zeichnen b) werklehre, materialübungen ca. 2 std. ca. 12 std. allgemeine fächer: a) darstellende geometrie ca. 4 std. b) schrift ca. 2 std. c) physik oder chemie ca. 2 std. d) gymnastik oder tanz (fakultativ) ca. 2-4 std. | einführung in die spezialausbildung praktische arbeit in einer bauhauswerkstatt ca. 18 std. vorträge und übungen: a) primäre gestaltung der fläche ca. 2 std. b) volumen raumkonstruktion ca. 2 std. allgemeine fächer: a) darstellende geometrie ca. 2 std. für fortgeschrittene: b) fachzeichnen ca. 2 std. baukonstruktion ca. 4 std. c) schrift ca. 2 std. statik ca. 2 std. d) physik oder chemie ca. 2 std. übungen ca. 2 std. | **a. bau** spezialausbildung prakt. arbeit in einer werkst. 18 std. baukonstr. 4 „ statik 4 „ entwurf 4 „ veranschlag. 2 „ baustofflehre 2 „ **b. inneneinrichtg.** praktische arbeit in einer werkstatt, mit entwerfen, detaillieren, kalkulieren 36 std. fachzeichnen 2 „ | spezialausbildung unter bevorzug. der theorie entwurfsatelier mit anschließender baupraxis einzelvorträge über baukonstruktion eisenbeton-bau statik wärmelehre installation veranschlagen ausschreibung normenlehre sonderkurse über stadtbau verkehr wirtschaftliche betriebsführung praktische arbeit wie im 3. semester 18 std. gestaltungslehre fachzeichnen fachwissen | erhöhte spezialausbildung wie im 4. semester mit wechselnder selbständigkeit der aufgaben wie im 4. semester wie 4. semester selbständige laboratoriumsarbeit in der werkstatt 36 std. |
| **2** reklame | | | | einführung in das werbewesen untersuchung der werbemittel praktische übungen | wie im 3. semester und einzelvorlesungen über fachgebiete | selbständige mitarbeit an praktischen werbeaufgaben |
| **3** bühne | | | | werkstattarbeit gymnastisch-tänzerische, musikalische, sprachliche übungen | werkstattarbeit choreographie dramaturgie bühnenwissenschaft | werkstattarbeit, selbständige mitarbeit an bühnenaufgaben und aufführungen |
| **4** seminar für freie plastische und malerische gestaltung | | | | korrektur eigener arbeiten nach vereinbarung selbstwahl der meister praktische arbeit in einer werkstatt 18 std. | wie im 3. semester ohne werkstatt | wie im 4. semester |

**Semester plan for the Dessau Bauhaus.** 1927, BHA. • The plan demonstrates the new teaching structure, especially the division, from the third semester onward, between the areas of interior design and building.

Hannes Meyer

Gropius prior to his appointment he had made it clear that "proper teaching of building design is only possible if directly linked to actual building practice" (ibid, p. 44).

Finally, in April of 1928, Hannes Meyer was appointed to succeed Walter Gropius as director of the Bauhaus. The following two years, during which he held this office, were marked by internal and external difficulties. The contradictions in society and in the sphere of social security provision, the economic crisis with rising unemployment and falling wages, but above all the financial crisis that affected the entire economy – these inevitably affected the Bauhaus as well. Gropius had already sought contacts with industry in order to strengthen the school's financial position, and thereby make it independent of state subsidies, while at the same time making it possible to open the school to working-class students. Meyer carried this on, reinforcing Gropius's previous work. Thus the economic situation of the Bauhaus at that time was directly linked to productivity, efficiency and sales potential in the free market. The school was consequently on the verge of a permanent dilemma: it had to keep mass demand in view and adapt to the mechanisms of mass production, but the members also wanted, and were compelled, to satisfy the demands for luxury goods on the part of the bourgeoisie and the intelligentsia, with their refined aesthetic tastes. What they were seeking was mass-produced goods of artistic value. This problem had to be solved against the background of an educational institution which had always had difficulty in freeing itself completely from the shackles of artistic good taste and the arts-and-crafts aestheticism of the Weimar era.

At the beginning of 1926 Gropius formulated this problem in a letter to the Bauhaus masters: "the general aim of the bauhaus, the combination of its ideal and practical elements, still does not find sufficient expression in the individual workshops. consequently they still present an arts-and-crafts image. the links with industry that we want to seek, must be systematically … prepared …

**Hannes Meyer (co-op), Title page of the prospectus "young people, come to the bauhaus!"** 1928, photograph by Andreas Feininger, BHA. • Page from a 44-page prospectus which Hannes Meyer produced while alone during the vacation in Dessau. Design and typography are also by him. As so often, he used his pseudonym "co-op" here.

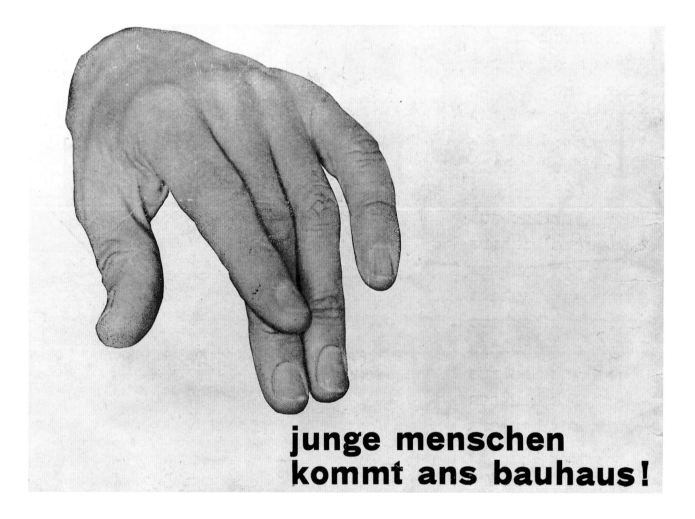

junge menschen
kommt ans bauhaus!

**Group portrait at the building site of the Central College of the ADGB (German Trade Union Federation) in Bernau.** 1928, left to right Hans Wittwer, Thomas Flake, Hannes Meyer, Hermann Bunzel, photographer unknown, Kieren Collection, Berlin.

in the long term [there is a need for] a carefully worked-out production plan" (letter dated January 21, 1926 in Klaus-Jürgen Winkler, *Der Architekt Hannes Meyer*, Berlin, 1989, p. 111). It took a long time to go beyond a sectarian, elitist art (or art and craft) school, it was a laborious task. But Hannes Meyer rose to the challenge presented by Gropius. This meant, however, that the Bauhaus had to confront social reality to a greater extent. Its work and its goal were soon to find expression in the slogan "The needs of the people instead of the needs of luxury!" And this slogan, this demand for a production geared to society, affected all the workshops. As Meyer saw the matter, the Bauhaus had to be like a "collective for the people," comprising many small collectives, brigades, groups or cells. As regards products and labor, the school should be anonymous rather than individually personalized, in the manner of a

standardized mass-produced commodity that had to take the place of luxurious individual products. In the social configuration which he called a "collective," Meyer's "system of small circles," mentioned at the beginning of this section, reappeared, but now established, as it were, and consolidated by new internal structures and teaching.

At the beginning of Meyer's period as director there were 166 students at the Bauhaus (35 of them foreigners): 121 male and 45 female. The teaching staff comprised Albers, Arndy, Brandt, Feininger, Kandinsky, Klee, Meyer, Scheper, Schmidt, Stölzl and Wittwer. Moholy-Nagy, Bayer and Breuer left Dessau (and hence the school) along with Gropius. One of Meyer's first considerations concerned the establishment of an effective curriculum. In keeping with his own professional specialism he looked principally at architecture in order at last to fulfill the wish expressed in

the first Bauhaus manifesto in 1919: "The ultimate goal of all artistic activity is building." The architecture course was now extended from seven to nine semesters and the workshops were more or less obliged to subordinate, adapt or channel their work toward architecture. It was precisely at the time he was appointed director that Meyer obtained the commission to build the Central College for the ADGB (German Trade Union Federation) in Bernau near Berlin. Looking back, we may observe that almost all the workshops were in one way or another included in the idea of creating a building ensemble. Meyer had won the competition, which he entered jointly with his Swiss colleague Hans Wittwer and a few Bauhaus students. When asked by Adolf Behnes what he felt about the competition, Meyer replied: "i need hardly tell you that i am extremely keen to obtain a commission with our building department. so yes, i

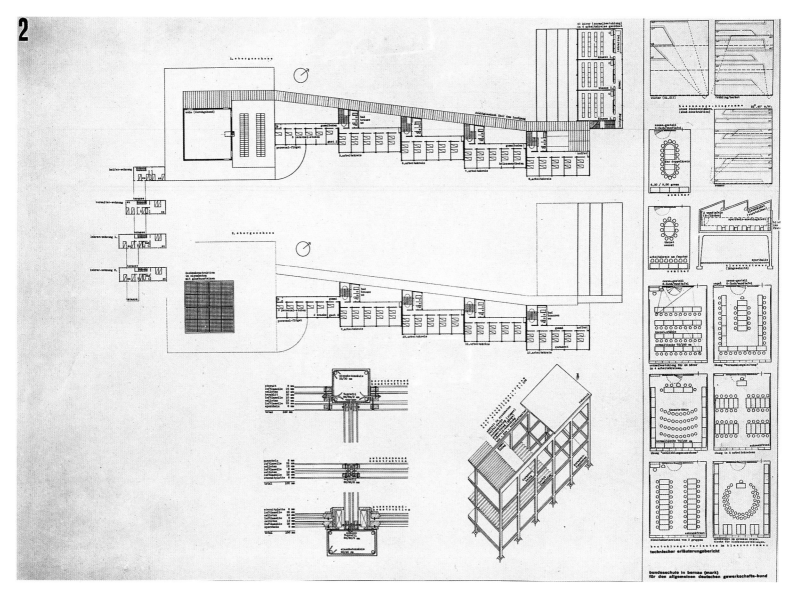

**Hannes Meyer, Hans Wittwer and the building department of the Dessau Bauhaus, Competition entry for the Central College of the ADGB in Bernau.** 1928, the second of four sheets, ground plans and details, photograph from a drawing, BHA. • The right-hand margin of the sheet once again provides information about how Meyer worked: he tried to provide "scientific proof" of everything. On the whole technological data outweigh artistic effects.

am very glad, of course. we have been doing nothing but theory in our building department for three or four years now, while observing that gropius's private office constantly had work to do. between ourselves, we will soon be involved in arguments affecting the whole problem of the bauhaus" (letter dated January 8, 1928, in *Hannes Meyer*, Lena Meyer-Bergner [ed.]).

In order to meet the increasing demand from industry for Bauhaus designs in this initial phase, the workshops had likewise to be fitted into the new structural plan. Along with the creation of two free painting classes under the masters Paul Klee and Wassily Kandinsky, the workshops were restructured as a kind of

production works. Their efficiency improved after teaching was made subject to a new rhythm: on one day of the week students continued to pursue artistic activities. The next day they did "science" in the form of courses, lectures and seminars. However, on three days of the week students were required to spend eight hours on workshop work, with work geared to experiments and direct production and no longer to the search for poetic formal qualities. In order to master this new program and to meet the substance of these new demands, extra teachers were appointed under Meyer. Hans Wittwer became head of design teaching and for a short time head of the building office that was set up for the ADGB Central College

project. The dispute over the authorship of this college – Meyer claimed it for himself – led to a serious quarrel, and Wittwer left the Bauhaus in the spring of 1929 to take up an appointment at the Burg Giebichenstein School of Applied Arts in Halle. His place was taken by the architect Anton Brenner; Ludwig Hilberseimer became head of the building office and taught urban building and design. Walter Peterhans joined the Bauhaus in 1929 to build up a photography department. Scheper took leave of absence and the murals workshop which he had directed until then was subsumed in the new building workshop, as were the cabinetmaking and the metal workshops. Alfred Arndt became their master.

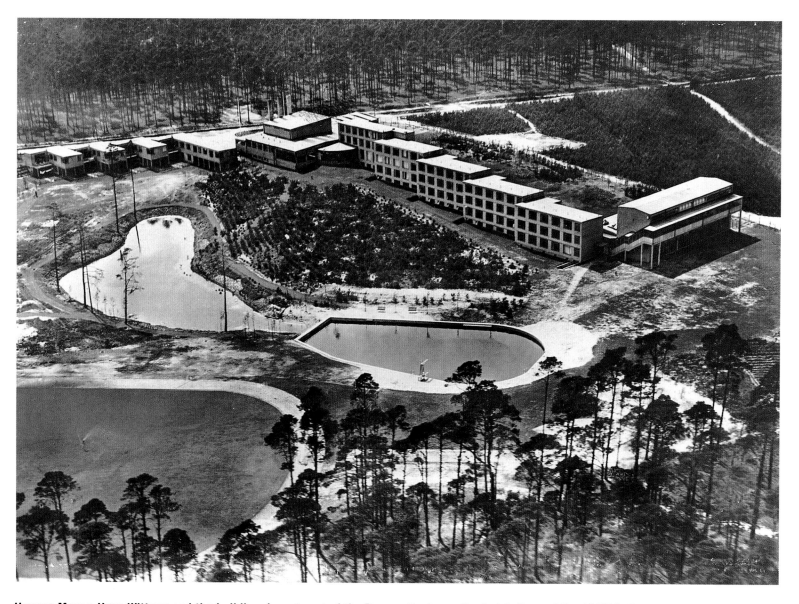

**Hannes Meyer, Hans Wittwer and the building department of the Dessau Bauhaus, Central College of the ADGB in Bernau.** 1928–1930, the entire complex seen from the south-east, photograph by Junkers Luftbild, BHA. • The ground plan and the individual building units arising from it were adapted to the terrain's irregular topography. To the right of the picture the gymnasium with the classroom area, on the left the entrance building with the refectory.

The organizational structure of this building workshop comprised the commercial administration, which was responsible for commissions, pricing and sales; the workshop cell, that is to say the productive colleagues and students, and unskilled students who completed a preliminary semester here as a kind of apprenticeship. This was the pattern of a productive workshop as Meyer imagined it and which had its direct origins in his world of cooperative ideas. He himself had adopted the abbreviated pseudonym of "co-op" in 1926 to show his concern for the anonymity of the individual and to indicate his experience of a viable cooperative economy. Productivity rose in 1928 and 1929 resulting in the need to decide whether the Bauhaus wished to be a school or a small factory annex of the free-market manufacturing industry. The Bauhaus supplied wallpaper and textile patterns for industry, designs for lighting equipment and furniture, and the advertising workshop increasingly took on both ongoing and one-off orders. From 1927–1928 to 1928–1929, the turnover of Bauhaus products rose from 126,500 Marks to 146,500 Marks. In the budget year 1929–1930, the previous year's production was again almost doubled, so that in 1929 alone it was possible to pay out 32,000 Marks as wages to the students.

The products the school manufactured, in accordance with the slogan "The needs of the people instead of the needs of luxury!" were simple, sturdy and practical. Their lines followed constructional and functional requirements, not a particular style. Experiments were concerned with new materials and their use, not with formal qualities derived from painting. The use of color was determined by psychological considerations, not by subjective feelings. Patterns and surface structures followed the qualities of the materials and conditions of mass production, not traditional designs. Meyer's stubborn pragmatism and rationalism gradually eroded the elitist Bauhaus products of the early years, transmuting them into a "New World" in which they could fulfil a function and be purchased

**Hannes Meyer, Hans Wittwer and the building department of the Dessau Bauhaus, Central College of the ADGB in Bernau.** 1928–1930, the study group pavilions seen from the north, with the pergola garden of the refectory, photograph by Walter Peterhans, BHA. • In addition to "working cells," teaching rooms and a sports ground, airy places for the students to congregate were also integrated into the complex.

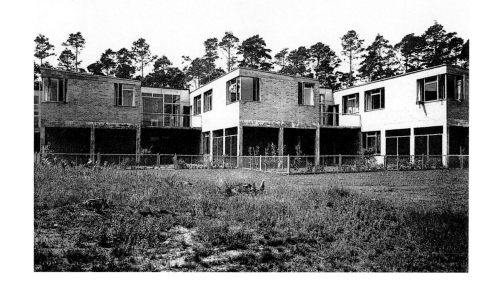

**Hannes Meyer, Hans Wittwer and the building department of the Dessau Bauhaus, Central College of the ADGB in Bernau.** 1928–1930, view of the teachers' houses from the south-east, photograph by Walter Peterhans, BHA. • A particularly impressive view of the simple, functional style, which was achieved using nothing but reinforced concrete, brick walling and steel windows.

**Hannes Meyer, Hans Wittwer and the building department of the Dessau Bauhaus, Central College of the ADGB in Bernau.** 1928–1930, seminar room, photograph by Arthur Redecker, BHA. • The eye is directed to the glass walkway connecting the living pavilions with one another and with the gymnasium and the refectory.

by many people at the same time, without artistic and design standards having to be abandoned.

Oskar Schlemmer left the Bauhaus in October 1929, and under Albert Mentzel's direction the Bauhaus Theater Group became increasingly restricted to political sketches concerned with social problems. Thus to the same extent that the Bauhaus opened its doors to the outside world in order to take its place in the capitalist world of accumulation, commodities and money, and to escape from its dependence on government departments and municipal grants, the social contradictions and struggles that arose from them were brought into the school. From 1927 there was a Communist Party cell at the Bauhaus which, as the global economic crisis began, directed its propaganda with increasing frequency at the Bauhaus itself. As director, Meyer did not prohibit this, but indirectly encouraged it. In addition, from 1929 he pushed for more lectures to be given at the Bauhaus by well-known personalities from the spheres of politics, business, philosophy and the economy. In this connection philosophical and sociological issues were increasingly discussed and lectures were given on Marxism-Leninism and the working-class movement. Meyer himself

represented the Bauhaus vis-à-vis the outside world. He traveled a good deal, lecturing on topics such as "Bauen und Erziehung" (Building and Education), "Entfesseltes Bauen" (Building Unchained), "Bauhaus und Gesellschaft" (Bauhaus and Society). His main concern was that the Bauhaus had to be freed from its role as a supplier of styles and oriented more toward nature, general social conditions and the people, in order to be different from other schools and thus have a raison d'être. This required both external and internal support, but this was increasingly withheld from Meyer because in the eyes of some Bauhaus masters he had stood by and done nothing to prevent the work of the Communist Party cell. And it was this group of Bauhaus masters who sent a report to the Anhalt government and to the mayor of Dessau, leading to Meyer's dismissal.

Hannes Meyer described himself at this time as a scientific Marxist propagating a "Marxist theory of form," as he put it in a letter to the Marxist theoretician Karel Teige in 1930. After his dismissal, before the year was out, he moved to the Soviet Union with a few Bauhaus students, who had also been expelled and shared his views and his sympathetic interest in the work of reconstruction in the

**Hannes Meyer and the building department of the Dessau Bauhaus, Trellised-walkway houses for the Dessau-Törten housing development.** 1930, north façade with trellised walkways (on the left) and the south facade (p. 215, below), photographer unknown, Kieren Collection, Berlin. • These houses with trellised walkways were part of the realization of the second building section of the Dessau-Törten development. This type of house was being built in many towns at the time because only one stairwell was needed, which reduced the cost. The simple, functional formal language accorded with the spirit of the Bauhaus at the time and its slogan "The needs of the people instead of the needs of luxury!"

USSR. He lived and worked there for the next five years, but without doing any building, after which he returned to Switzerland. In his homeland, between 1936 and 1939, he built a kindergarten, but otherwise he had no commissions whatsoever. This was also true of the years 1939 to 1949, which he spent in Mexico as a teacher and architectural expert. He devoted his last years, up until his death in 1954 in Switzerland, to theoretical studies. The history of Meyer's reputation, with its many legendary elements, developed out of the highly theoretical nature of his position in the 1920s and his left-wing political stance after 1930. From around 1925 to 1935 he was part of the avant-garde working in a rationalist-Constructivist vein. Throughout his life he combined social commitment with ideas

**Alfred Arndt and Wilhelm Jakob Hess, Combination furniture in the trellised-walkway house.** 1930–1931, photograph of a drawing, BHA. • These furniture studies were made around the same time as the designs for the houses with trellised walkways, even though in this case a different ground plan was used for the house.

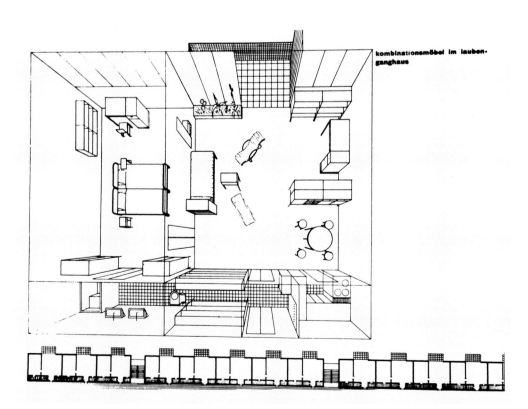

kombinationsmöbel im laubenganghaus

relating to theories of art and design, which he expounded in a radical and poetic manner. His Petersschule and League of Nations Palace projects stand out as model manifestos, so to speak, of Constructivism and Functionalism. For Meyer, architecture was always something more than its purely formal aesthetic components. For him, architectural form was a "calculable" product of his (unfortunately never very clear) logic of "scientific" design. As he saw it, all one had to do was grasp, analyze and interpret all the innumerable factors involved, and then translate them into a "building." In this sense the trade union college in Bernau, near Berlin, seen as a collective Bauhaus project, is probably his real legacy.

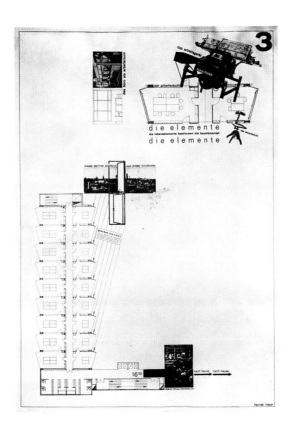

**Hannes Meyer, Competition entry for the building to house the ADGB offices and bank and for the Bank der Arbeiter, Angestellten und Beamten AG (Workers, Employees and Clerical Bank) in Berlin.** 1929, sheet 3 of the competition entry, ground plan and organization of a floor of offices, BUW, photographic archive. • The interesting thing about this design is Meyer's attempt to develop the entire building, both architecturally and in terms of urban building, from the individual office and its windows.

**Hannes Meyer and the building department of the Dessau Bauhaus, trellised-walkway houses for the Dessau-Törten housing development.** 1930, north façade with trellised walkway (p. 214 top) and south façade (below), photographer unknown, Kieren Collection, Berlin. • These houses were part of the realization of the second building section of Dessau-Törten. This type of house was frequently built because only one stairwell was needed, thereby reducing the cost. The simple, functional formal language coincided with the Bauhaus spirit and its motto "The needs of the people instead of the needs of luxury!"

# Ludwig Mies van der Rohe – Dessau, Berlin, Chicago

Christoph Asendorf

**Ludwig Mies van der Rohe, Brick country house.** 1923, ground plan, project not carried out, BHA. • This plan shows Mies turning rigorously to a free ground plan design using wall panels which make it possible for spaces to be fluid instead of rigid and firmly defined.

**Ludwig Mies van der Rohe, Corrections to a piece of classwork by Wilhelm Jakob Hess.** 1932, pencil on drawing paper, 44.1 x 56.9 cm, BHA. • This plan was suggested by the villas designed by Mies van der Rohe while he was director of the Bauhaus. Mies had the ability to correct his students' work with a few concentrated pencil marks.

**Ludwig Mies van der Rohe, Riehl house, Berlin-Neubabelsberg.** 1907, photographer unknown, BHA. • Mies introduced himself at the outset of his career with a refined classical architectural language, using exact symmetry, smoothly rendered walls, and vertical projections at the center and sides.

**Ludwig Mies van der Rohe, Esters house, Krefeld.** 1928, view of the garden with terrace, photographer unknown, BHA. • With this house Mies created a model of the modern brick building with large window apertures, bringing a fresh interpretation to the notion of a villa.

Wasn't it a good idea of Mies's to invent lightning? (John Cage, after observing an approaching thunderstorm through the glass frontage of the Lake Shore Drive Apartments.)

### The Bauhaus stopover

Ludwig Mies van der Rohe is identified with the Bauhaus to a far lesser degree than is the case, for instance, with Walter Gropius. There are several reasons for this. To begin with, none of his major works was created while he was director – in contrast to Gropius, who, with the Dessau building, created one of his best works for the Bauhaus itself. Hannes Meyer's period as director also coincided with an important work, viz. the ADGB central college in Bernau near Berlin. The fact that Mies was an exception in this respect was, however, mainly a consequence of the severe economic crisis at the end of the 1920s and the resulting slump in the building market. Quite apart from this, he had not taken up office in 1930 merely in order to take over Gropius's legacy. Cooperation in dealings with students and masters,

fundamental openness to all kinds of experiment, and the politicization of design work – these were not for him. He used entirely authoritarian methods to reorganize the syllabus and turned the Bauhaus, practically speaking, into a purely architectural college. In his work he also pursued goals that clearly differed from Hannes Meyer's radical functionalism. For Mies, architecture was neither a technical problem nor applied sociology but rather, as he wrote in 1928, using words that are as ambiguous as they are emphatic, "the spatial implementation of intellectual decisions." Nonetheless, the Bauhaus was of course significant for his career, but perhaps rather in the sense of a watershed, a break in continuity that enables us to perceive a period before it and a period after it.

### Dissolving configurations

Until the mid-1920s Mies's work, which had begun in 1907 with the Riehl house, consisted, as far as actual buildings are concerned rather than projects, of conventional but painstakingly detailed buildings. What is

unusual about these houses, for example the Urbig villa of 1917 (where Winston Churchill later stayed during the Potsdam Conference), is above all the link between the house and the garden, indeed one might almost speak of their interpenetration. In a manner reminiscent of Schinkel's country houses from a century earlier, verandas, pergolas and terraces on various levels are used, along with stretches of wall and hedges, to create a fluid transition from the house to the realm of nature. But this effect of sophisticated blending is restricted to the transitional zones. Nothing is to be seen of it in views from the street or in the compact forms of the houses themselves.

The real, radically modern Mies developed, to begin with, on paper. A fundamentally new concept of architectural space was indicated by the design for a "brick country house" of 1924. The ground plan shows freestanding stretches of wall, the organization of which remains strangely indeterminate. Three blank walls extending like the sails of a windmill to the edge of the drawing sheet suggest the idea

**Ludwig Mies van der Rohe, German pavilion at the international exhibition in Barcelona.** 1928–1929, interior view, BHA. • Here Mies demonstrated his idea of a free ground plan using materials of the highest quality: behind the free-standing onyx wall is a gleaming multifunctional wall made of panes of frosted glass.

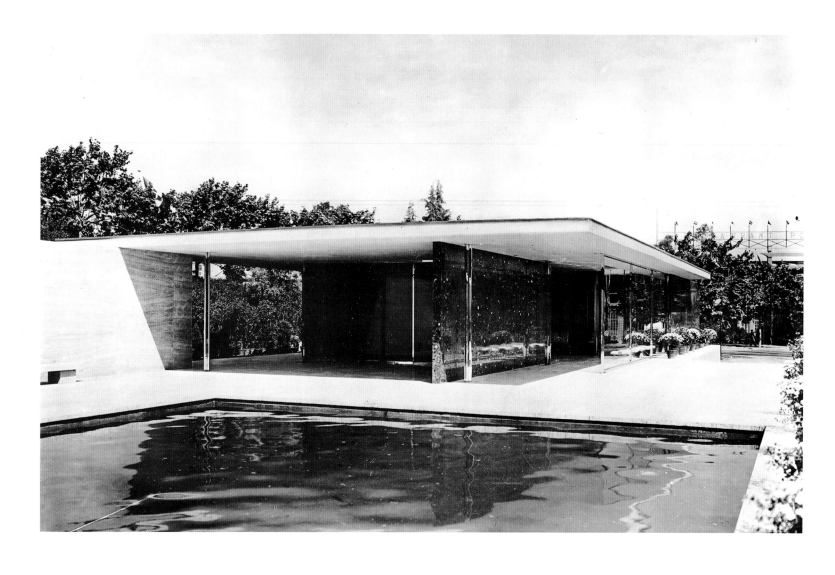

Ludwig Mies van der Rohe, German pavilion at the international exhibition in Barcelona. 1928–1929, exterior view with swimming pool, BHA. • The thoroughgoing separation of supporting and space-defining elements finds its ultimate application in the Barcelona pavilion.

of centrifugal movement, while, vice versa, their thickening toward the middle can be read as centripetal. This orthogonal configuration is located exactly between concentration and expansion, closure and opening.

Whereas for the country house Mies envisaged supporting brick walls freely arranged to create spaces that merge into one another, while at the same time opening up the building, he went a step further in the Barcelona pavilion. For the first time he consistently separated the supporting and the space-defining elements, thereby creating the possibility of a variable ground plan. The roof is supported by eight steel members, and the walls do not bear any weight but are merely inserted. Thus the building consists of two completely separate systems. The walls could of course also have supported the roof; but, as it is, the spatial conception is visibly articulated. The theme of closing and simultaneously opening a space is played through in a sovereign manner on a

plinth which raises the building, making it somewhat remote from its surroundings. Almost as in an exploded drawing – though only in a single plane – the space-enclosing surfaces slide apart. An X-ray picture taken from above would reveal that with the exception of the enclosing side walls the edges of the individual planes are nowhere in direct contact. The ground surface, the freestanding interior walls and the roofs are arranged with respect to one another in a free rhythm. The interior also presents an ambiguous picture. In addition to marble surfaces, several kinds of mirror and frosted glass serve as walls which, in differing degrees, filter the spatial zones that lie behind them. Between the polished marble, the chromium-plated supports, the glass and the water of the outdoor swimming pool, a rich spectrum of reflections and overlaps unfolds, while every movement modifies the effect of the sky and the background – an open space flowing apart in all directions,

**Ludwig Mies van der Rohe, Tugendhat house, Brünn (Brno).** 1928–1930, interior view of the living area with Markassa screen, photographer unknown, BHA. • Mies's articulations separate individual spatial zones yet allow the user to perceive the entire space.

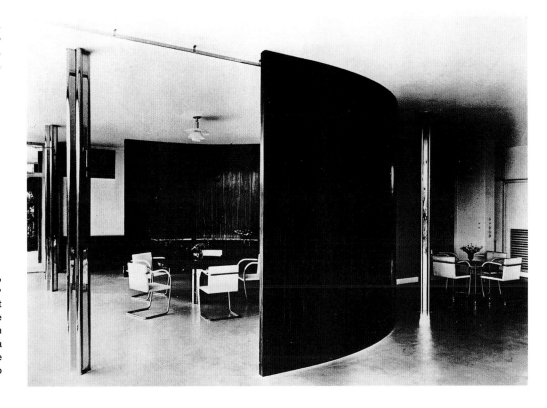

**Ludwig Mies van der Rohe, Tugendhat house, Brünn (Brno).** 1928–1930, ground plan, BHA. • Parts of the large glass wall facing the garden (at the bottom of the ground plan) were sunk into the ground, thus linking nature and the living area in a new way. On the right of the ground plan is a winter garden, constituting a transitional zone between inside and outside. It lies between two glass walls and is almost invisible at first sight.

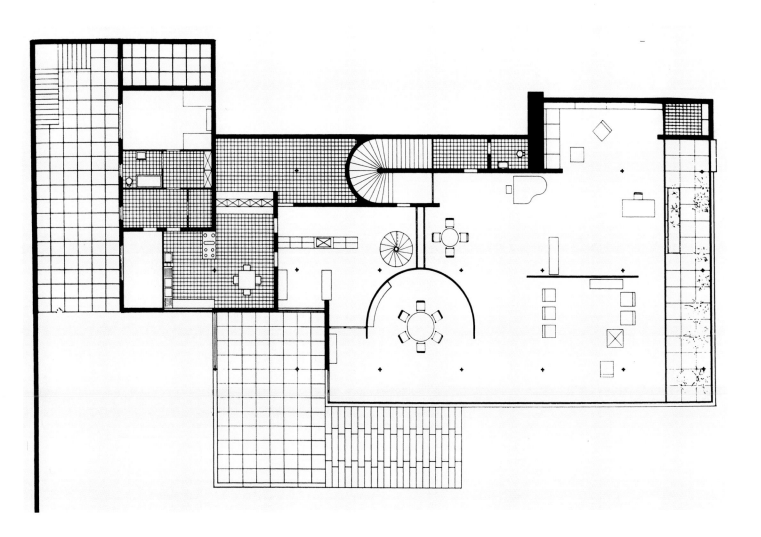

**Ludwig Mies van der Rohe, Competition entry for an office building in Friedrichstraße, Berlin.** 1919, high-rise glass building with a prismatic shape, charcoal drawing on photograph, various media, 70.5 x 200.5 cm, BHA. • This is the first attempt to develop a high-rise building exclusively from steel and glass. Although never actually built, this is one of the icons of 20th-century architecture.

**Ludwig Mies van der Rohe, Competition entry for an office building in Friedrichstraße, Berlin.** 1919, ground plan, BHA. • The prismatic shape of the ground plan was derived from the site: a triangular piece of land adjoining Friedrichstraße railway station, where today the "Palace of Tears" theater stands.

**Overall view of the Werkbund's Am Weißenhof housing development in Stuttgart.** 1927, photograph by Dr Lossen & Co, Stuttgart, BHA. • Mies conceived the overall layout of this development. For the design of individual buildings he mainly brought in colleagues from the politically left-wing architects' association "Der Ring." The ground plans for the largest building in the development – which Mies built – were variable.

oscillating in a virtuoso manner between figuration and disintegration.

Some of the lectures given by Mies while the Barcelona pavilion was being built help clarify the background to his architectural thinking toward the end of the Weimar Republic, shortly before he took up the post of Bauhaus director. As Fritz Neumeyer has established, the writings of the Catholic theologian and cultural philosopher Romano Guardini exerted a strong influence on him. When, in 1928, Mies talked about the "prerequisites of architectural creativity" in the Berlin Art Library, he developed the image of a world governed by technology. He argued that it liberated man from servitude, bridged distances and made it possible to survey the world as a whole. But the dynamics of this development gave rise to a problem, which other authors of the age had defined in similar terms: "Man has been sucked into a maelstrom. Every individual tries to assert himself, to cope with the forces involved using his own resources." But here Mies, before launching into an exact analysis or even a lament for the state of culture, formulated a program: "We must master the forces we have unleashed and integrate them into a new order, an order which will allow life full scope for development." It may not be entirely wrong to see the Barcelona pavilion as an expression of these intentions: the plinth which mediates the present by way of the classical past, and the arrangement of the wall sections which demonstrates openness, presumably in an intellectual sense also, demonstrating Mies's sense of the possible, so to speak. The subtly balanced qualities of the pavilion and its interior, which both stands aloof from its surroundings and is, equally, open to them, create for a brief historical moment a precarious balance between activity directed outward and contemplation, or, in Mies's words, between "unleashed forces" and a "new order."

### The non-material qualities of glass and light

In the 1920s Mies van der Rohe pioneered an architecture with complex qualities that cannot be definitively described. His buildings and spaces change depending on external circumstances, increased energy or the point of view adopted. They interact with users or passersby, and take on, so to speak, mediatory qualities. The means employed to achieve this

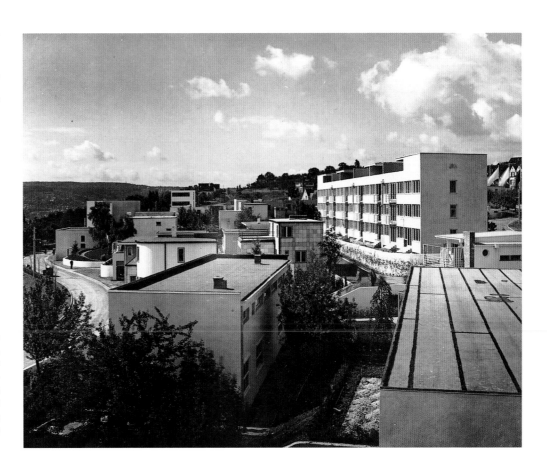

**Ludwig Mies van der Rohe, Illinois Institute of Technology, Crown Hall, Chicago.** 1950–1956, main entrance, photograph by Hedrich Blessing, Chicago Historical Society. • The construction has been pared down to the essentials, so that the long glass front works either as a façade or as a window. Such an approach to design requires precise control of the detailing of all elements.

**Ludwig Mies van der Rohe, Farnsworth house, Plano, Illinois.** 1951, photograph by Hedrich Blessing, Chicago Historical Society. • The interior of this single-room weekend house was designed using neutral color shades in order not to lessen the effect of the strong natural colors outside. Eight external steel supports keep the house above ground level.

end is the sophisticated use of glass and light. As early as 1922, when he presented his high-rise projects for the Friedrichstraße in Berlin in the magazine *Frühlicht* (Early Light), it was a striking fact that the aspect of the steel skeleton construction with a glass façade in front of it was immediately overlaid by other considerations relating to non-material, ephemeral things. As the use of large-surface glass curtains runs the risk of creating a "dead" effect, Mies planned to set the individual sections of the frontage at a slight angle to one another, and chose a prismatic form to create a play of reflections. The ingenious skeleton, which he repeatedly described as a system of skin and bones, was here the prerequisite for something else, viz. the phenomenon of architecture as the play of light.

Then in 1927, when he obtained a commission from the German manufacturers of mirror glass to create a demonstration room for the Werkbund exhibition in Stuttgart, he went a step further and adopted a solution that was as purist as it was bewildering: in order to demonstrate the space-shaping potential of glass, he subdivided the individual spatial zones with walls made exclusively of various kinds of glass. When the film theoretician Siegfried Kracauer visited this room for the *Frankfurter Zeitung* in July of 1927, he perceived it entirely in terms of projection: "A glass box, translucent, the adjacent rooms penetrate it. Every gadget and every movement in them creates a magical play of shadows on the wall, disembodied silhouettes that float through the air and mingle with the mirror images from the glass room itself." This architecture seemed to him like "intangible, glassy ghosts, changing like a kaleidoscope."

Shortly afterward Mies developed an entire wall as a self-illuminating plane. This unique element was to be found in the Barcelona pavilion. The shining wall consists of panes of frosted glass with lighting units positioned between them. The latter are not visible, rather the whole wall appears to be a homogenously shining surface. Mies transforms one of the techniques of urban advertising into architecture, in order to preserve the integrity of the pure plane. The illuminated wall stands on an equal footing alongside the other walls of glass and marble. But at the same time it is, in its formal clarity, the most complex element of the building, for it fulfills three functions: by day it lets in light like a window, by night it is a source of light, and in addition it is the impenetrable end of the room. The wall becomes multifunctional.

From here it is not so very far to the idea of developing an entire house as a lighting unit and its façades as displays. In an unrealized project for business premises for the Adam company, all stories except the ground floor were faced with matt glass. By day this produces a mild, even light. But in the evening the building, as Mies described it to the commissioning firm, was one "mighty lighting unit. You may affix whatever advertisements you wish, you can do what you want, no matter whether you write on it 'For a summer journey,' 'For winter sport' or '4 cheap days.' A gleaming inscription of this sort against the evenly illuminated background will always produce a fairytale effect." This project by Mies would have been a forerunner of present-day media façades – an entire building as a lighting unit on which writing appears as if on a screen. Such architecture changes its entire appearance at the push of a button.

## Universal space

After Mies emigrated to the United States, a radical change in his concept of space can be observed. It can perhaps be described as a transition from the subtle equilibrium of many of the projects from the 1920s to an overriding structure with, at the same time, an emptying of the interior. Two smaller works reveal this tendency: whereas the Barcelona pavilion from 1928–1929, by means of the freestanding non-supporting walls, provided a pronouncedly multilayered spatial image, the equally delicate Farnsworth house (1950) shows a unified room flowing freely around the installation island in the center. The photograph of a hi-tech industrial building – the assembly shed of an aircraft factory – was the turning point in Mies's development. For the Martin Bomber Plant, Albert Kahn had constructed a space free of any interior props and provided the

**Ludwig Mies van der Rohe, Illinois Institute of Technology, St. Savior Chapel, Chicago.** 1949–1952, photograph by Hedrich Blessing, Chicago Historical Society. • The elementary form makes a particularly strong impact through the closed wall surfaces, the use of slim steel profiles for the construction and the large window at the entrance.

Ludwig Mies van der Rohe

shed with a series of external supports. In 1942 Mies used this very photograph as the basis for a collage, added a ceiling beneath the upper steel structure, divided up the space by means of a few wall elements, and called the result a "project for a concert hall." The possibility of adapting the design of Kahn's aircraft construction shed to various industrial production processes was thereby elevated to a general architectural principle. The subtleties of the Barcelona pavilion are still there, and the discriminating use of materials and the free distribution of the

walls, but the idea of variable ground plan design has been taken to an extreme of indeterminacy. All constructional components have been removed from the interior space and transferred upward and sideways. Mies realized this concept on a large scale in 1950–1956 in the Crown Hall on the site of the Illinois Institute of Technology (IIT) in Chicago. A trussed-roof construction on external supports with underhung roof and glass skin provides a universal space available for any use. This openness, the negation of rigid limitations as regards both interior

**Ludwig Mies van der Rohe, Apartment blocks, 860 Lake Shore Drive, Chicago.** 1948–1951, photograph taken from the landward side shortly after completion, photograph by Hedrich Blessing, Chicago Historical Society. • Standardized light-reflecting blinds behind panes of glass create an animated contrast to the constructional elements, which are painted black.

DER RAUM
ALS
MEMBRAN

**Siegfried Ebeling, "Der Raum als Membran" (Space as a Membrane),** Dessau, 1926, wrapper design and text by Siegfried Ebeling, BHA. • Ebeling's book, written under the influence of the Bauhaus, was a plea for "open," undivided architecture; Mies was also familiar with the book.

**Ludwig Mies van der Rohe, Apartment blocks, 860 Lake Shore Drive, Chicago.** 1948–1951, assembling the curtain wall, 1950, photograph by Hedrich Blessing, Chicago Historical Society. • The outer skin is formed by disguised ceiling girders and the external support members. In this way Mies made the skeleton structure a theme of the two 26-story high-rise apartment blocks on the bank of Lake Michigan.

and exterior, creates the vision of an undivided space. Building and non-building, in other words interior space and exterior space, become generally indistinguishable. The glass curtains that surround the Farnsworth house and Crown Hall implement the idea of an overriding continuum. Many things may have coalesced here: the inspiration given by Kahn's great construction sheds, the experience of the vastness of the American landscape, perhaps also the memory of a work written under the influence of the Bauhaus, which Mies knew well, as Neumeyer has shown, namely Siegfried Ebeling's little essay: "Der Raum als Membran" (Space as a Membrane) which was a plea for a consistently "open" architecture. But Mies, with his well-known deep interest in morphology, might also have seen the design qualities that he was looking for in a painting from his private collection, Paul Klee's delicate picture *Die Frucht* (The Fruit) of 1932. It shows the irregular orbit of a dot which creates ephemeral constellations of color planes that overlap and momentarily condense – another example of thinking in terms of process and indeterminacy.

**Ludwig Mies van der Rohe and Philip Johnson, Seagram Building, 375 Park Avenue, New York City.** 1954–1958, photograph by Ezra Stoller, BHA. • The façade consists of brown-tinted panes of glass and a bronze-colored steel skeleton, underlining the homogeneity of the outer skin.

**Ludwig Mies van der Rohe and Philip Johnson, Seagram Building, 375 Park Avenue, New York City.** 1954–1958, constructional detail, photograph by Ezra Stoller, BHA. • This is probably the most "famous" 20th-century constructional solution of the corner problem. The distinguishing feature of the work is the minimalization and slimming-down of all material.

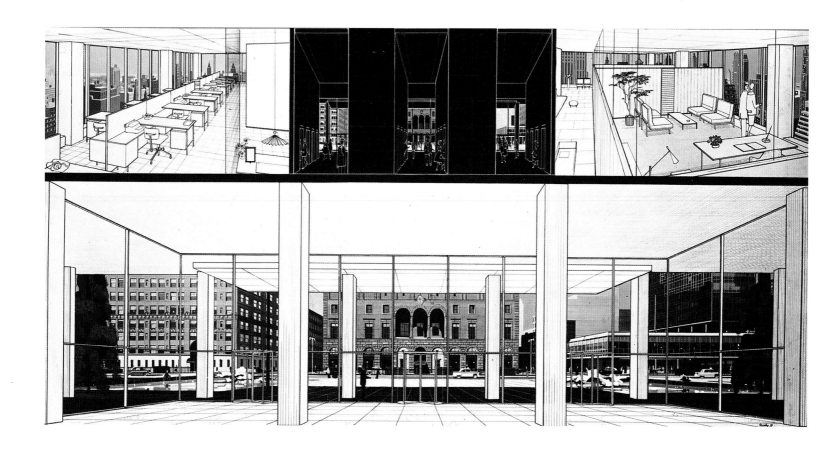

**Ludwig Mies van der Rohe and Philip Johnson, Seagram Building, 375 Park Avenue, New York City.** 1954–1958, plans for the interior design of the foyer, elevator areas, offices and living rooms, photograph of a collage, BHA. • The Seagram building as an example of interior design for Mies's glass architecture. The transparency of the outer skin is continued in the areas to be utilized or lived in.

### High-rise buildings and pavilions

If one wished to give a typological definition of the late architecture of Mies van der Rohe, this would not take long: his work concentrated on high-rise buildings and pavilions, but with positively infinite variety. In what was only the second high-rise project that Mies was able to realize at all (the Promontory apartments that had been designed immediately beforehand were amended after the war due to the shortage of steel), he straightway created a type of building which for decades to come was to influence international architectural developments. The two apartment blocks at 860–880 Lake Shore Drive, Chicago, with their sophisticated geometrical balance in relation to each other, put into practice what he had in theory intended since his designs for the Friedrichstraße, that is to say, high-rise buildings with a clearly visible steel skeleton and a surface made to a large extent from glass. The rhythm of the façade, of which

Franz Schulze has provided an exact description, is determined by the exterior supports and the ceiling edge supports. Since the windows are located in the same plane, there was a danger that the façade would create a flat effect. Mies offset this with something that in strictly functional terms was not legitimate, but was of decisive importance for the quality of the design: the double-T profiles of the window posts and supports that provide the desired relief; they appear to be part of the construction, without in fact being so. He had already followed a similar pattern in his famous corner solutions, beautifully carried out in the Alumni Memorial Hall on the IIT campus. Here the supporting steel skeleton is surrounded by a skin of brick and glass which in its turn is held in place by steel parts. The primary and secondary structures are only exposed at the stepped corner. The inner construction, which is actually invisible, is elaborately displayed at the edges, and only there.

The Lake Shore Drive apartments offer their occupants very specific perceptual pleasures. The glass outer walls, especially on the upper floors, create a feeling of being out of doors. This direct presence of the outside world, of the natural surroundings, was probably what John Cage meant when, after a visit, he said that Mies had invented lightning. Nature is made visible as if the building did not exist, or, to put it differently, the glass house makes nature visible in a new way. In the Seagram building, Mies also utilized the special qualities of his almost transparent high-rise buildings. During the day the use of glass makes the structure of the building visible, but at night it looks like a piece of light sculpture. The illuminated ceilings dematerialize the separate spatial levels, turning them into layers of light that float one above the other.

In the Federal Center in Chicago, Mies developed a type of inner-city ensemble which he repeated in the Toronto Dominion

Center: two high-rise buildings, related to each other in a free rhythm, and a large pavilion for a post office or bank. These three buildings, with large empty planes between them, structure a space without unambiguously defining it. Franz Schulze, in an inspired remark, said that unlike the interiors of the 1920s, "the buildings themselves take the place of the freestanding walls between which space can flow freely." In a kind of inversion, the formal laws of interior space have been transferred to exterior space.

The type of pavilion used here is new, and constitutes at the very least an evolutionary leap from the level of development achieved in Crown Hall. The large pavilions of the 1960s with their square ground plans aim to be balanced in a universal sense. Single-storyed in each case, their steel and glass structure is visible, except for the roof of the post office in Chicago, where this was not possible because, as in all US post offices, observation galleries had to be built beneath it. The third significant pavilion of this type, along with Chicago and Toronto, and certainly a highlight of the series, is the New National Gallery in Berlin. Derived from a project for the firm of Bacardi in Cuba which had to be abandoned after Castro took power, the gallery rises like a solitaire on a granite-covered platform. What the great hall exhibits is primarily its own emptiness. To preserve this impression, the entrance doors and cloakrooms have been marginalized as far as possible and the stairs can scarcely be seen at first sight. The emptiness has a sublime quality – an austerely ordered space with coordinates which are nevertheless difficult to grasp. At nighttime, from the outside, the building looks like an incorporeal space full of light. The floor area is illuminated, but the lighting units in the ceiling are concealed and the glass walls are invisible.

**Ludwig Mies van der Rohe, Neue Nationalgalerie, Berlin.** 1962–1968, overall view of the art gallery, looking toward the Matthäi-Kirche and the Philharmonie concert hall, photograph by Hedrich Blessing, Chicago Historical Society. • Berlin's most spectacular museum building, situated opposite the Potsdamer Platz, forms part of former West Berlin's "Culture Forum." Only the upper floor can be seen – the roof, resting on eight exterior supports, and the glass walls. The lower floor constitutes the plinth of this basic form.

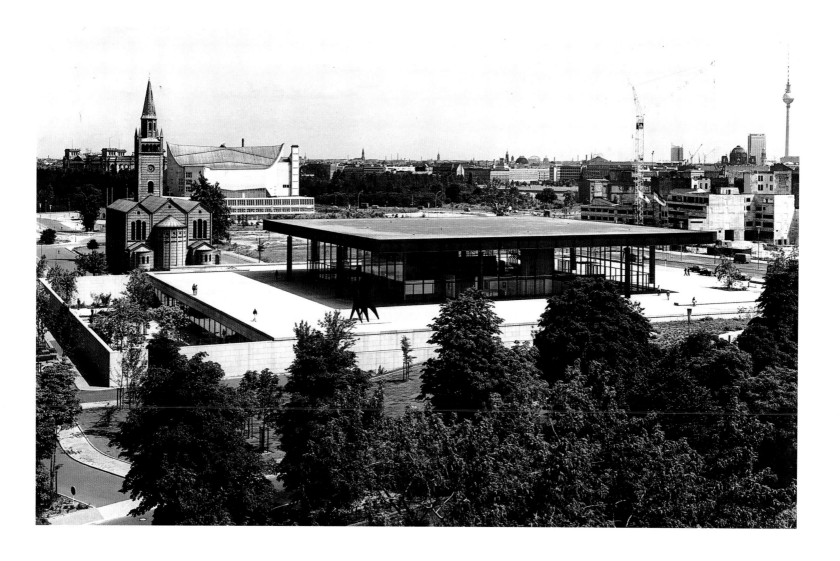

# Johannes Itten

Norbert M. Schmitz

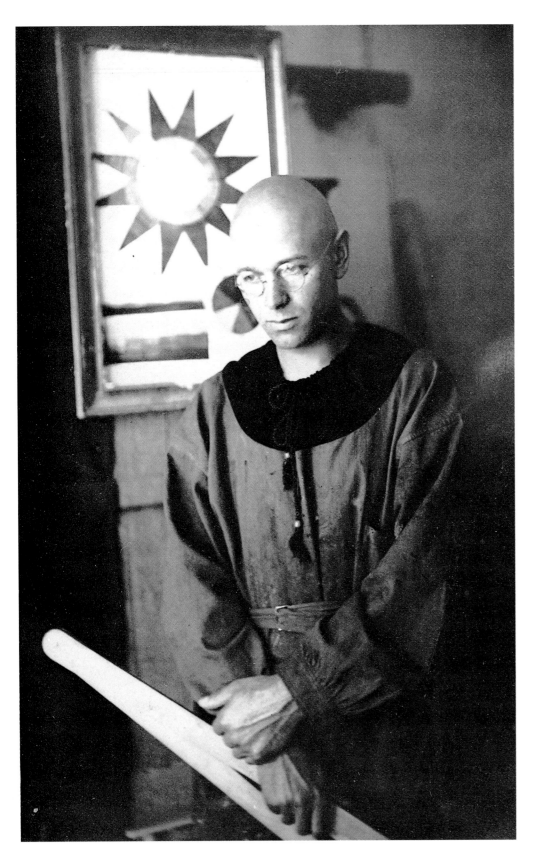

To give an account of Johannes Itten inevitably also entails speaking about a repressed irrationalism in modernism, for his art was first and foremost a form of esoteric propaganda. Beat Wyss identifies the reason why this dark side of modernism was suppressed in the later, postwar period: "It is easy enough to understand the reasons why, after the disaster of World War II, the avant-garde should be presented in terms of 'Enlightenment.' The victims of National Socialist and Stalinist cultural policies could not be both rehabilitated and at the same time put under suspicion of obscurantism. In the postwar period, art history repressed the esoteric aspect of the avant-garde, and where this could not be denied it was regarded as a childhood disease of genius" (*Mythologie der Aufklärung* [Mythology of the Enlightenment], Munich, 1993, p. 11).

Today the time would appear ripe for a fresh look at that other side of modernism. Itten's eccentric behavior as a Mazdaznan prophet in the monk's habit that he made for himself, like his decisive contribution to the Bauhaus as director of the preliminary course, is dealt

**Portrait of Johannes Itten.** 1920, photograph by Paula Stockmar, BHA. • Johannes Itten in Mazdaznan dress. In the background is his "color sphere."

**Johannes Itten, Color Sphere in Seven Degrees of Light and Twelve Tones.** 1921, supplement to *Utopia. Dokumente der Wirklichkeit* (Utopia, Documents of Reality), lithograph, 18 colors, 47.0 x 32.0 cm, BHA. • Here the sphere is opened out as a star, with complementary colors opposite each other. Toward the center it becomes lighter, moving toward white; at the points it becomes darker and darker until black is reached. Itten's note on how to use it: "I do not have to go for a walk on the surface. The inner gray is indeterminate, mysterious: I can follow one path or combine two, three or more paths ... so I can steer to and fro through the sphere in qualitative contrasts."

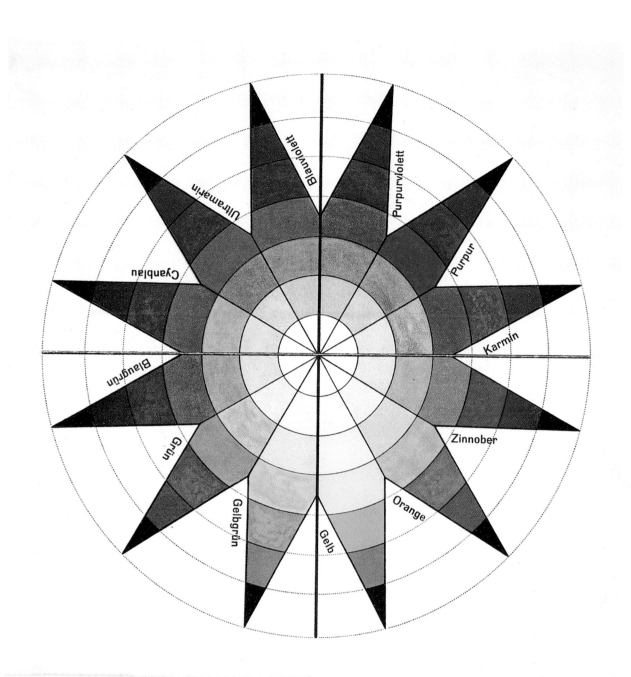

# Farbenkugel

in **7** Lichtstufen und **12** Tönen

von

**Johannes Itten.**

Johannes Itten

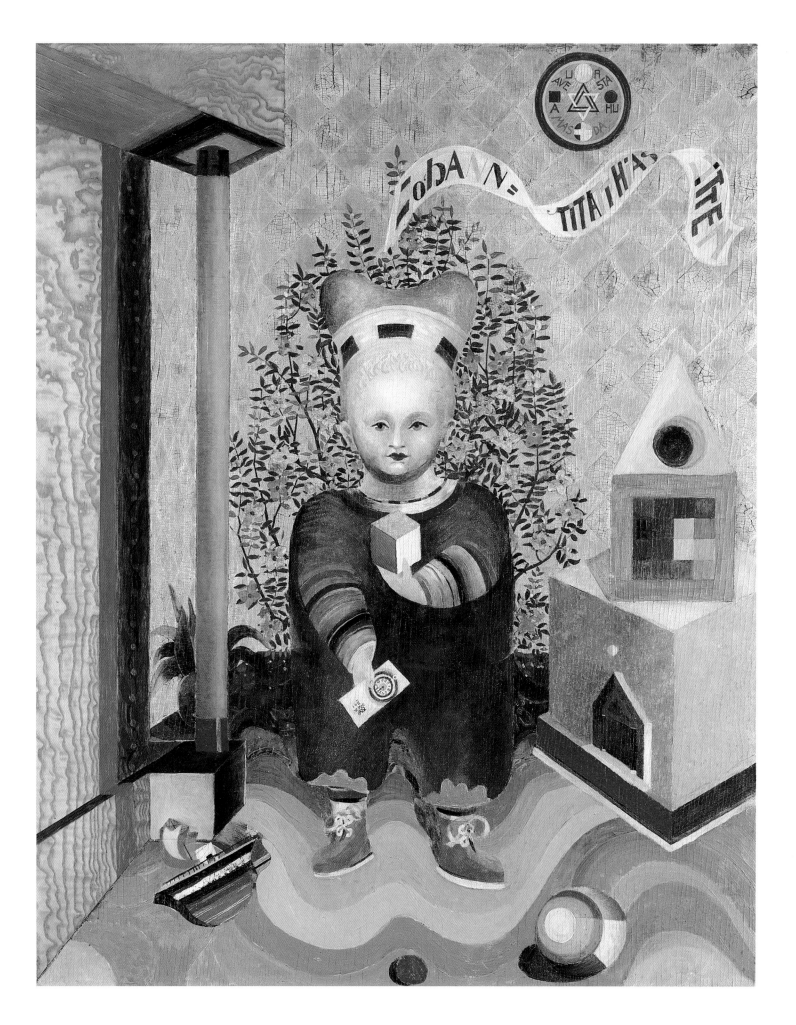

Johannes Itten, Aufstieg und Ruhepunkt (Ascent and Resting Point). 1919, oil on canvas, 230.0 x 115.0 cm, Kunsthaus Zurich. • In a chaos of multicolored circles and spirals, points ascend at the center, cut by opposing diagonals which, coming from the darkened edges of the picture, constantly break up the play of colors. The strongly contrasting movement of color is held back at a horizontal in the upper third of the picture, where a circle allows the eye to rest for a moment and mediates between the resulting color planes.

Johannes Itten, Mädchen (Girls). 1922, page from a diary, graphite and crayon on paper, 23.9 x 21.6 cm, Matthias Itten. • The children, who are growing – symbolized by the dainty sapling in the background – are kept in their fragile, statuesque state by a dense nexus of irregular squares in the complementary colors red and green, lightening from yellow to white toward the upper edge of the picture.

Johannes Itten, Kinderbild (Picture of Childhood). 1921 – 1922, oil on wood, 110.0 x 90.0 cm, Kunsthaus, Zurich. • The birth of the younger Itten elicited from his father a positively festive cult of childhood. This "altarpiece" shows the evolving human being as a future mediator between the physical and the spiritual realms: crowned like a priest he sits enthroned between two temples – that of nature and that of the arts – which call to mind form, color and spirit from Itten's abstract thinking.

with elsewhere. The intention here is to give an account of that strange combination of education, aesthetics and esoteric beliefs that constituted his real essence as an artist and made him one of the most ambiguous and controversial personalities at the Bauhaus. Itten united within himself, as did scarcely any other artist of his time, three elements: an avant-garde approach to form, the impulse to provide universal education, and an absolute faith in a mystical goal made up of theosophy and spiritualism.

When Gropius brought him to the Bauhaus from Vienna in 1919, on the recommendation of his wife Alma Mahler, Itten, who was born in 1888 in Süderen-Linden in the Bernese highlands, already had a wealth of educational experience to look back on. After training at the school of education in Bern and the École des Beaux-Arts in Geneva under the reform-minded Eugène Gilliard, he was influenced above all by the pioneering modern teaching and aesthetics of Adolf Hölzel, a professor at the Stuttgart Academy. At least equally important for the young

Itten was his avid reading of the great modernist manifestos from Worringer to Kandinsky along with many esoteric religious writings that were popular at the time but are in many cases now forgotten. By the time he opened a private school in Vienna in 1916, a complex artistic and philosophical view of the world had taken shape. In the early years of the Bauhaus, in addition to the preliminary course, Itten directed a whole series of workshops, but from 1921 this was reduced to the metal, glass and murals workshops. Growing rivalry with Gropius and

**Johannes Itten, Page from "Analysen alter Meister" (Analyses of Old Masters), Master Francke, Adoration.** 1921, from *Utopia, Dokumente der Wirklichkeit* (Utopia. Documents of Reality), lithograph, 33.0 x 24.0 cm, BHA.

**Johannes Itten, Page from "Analysen alter Meister" (Analyses of Old Masters), Master Francke, Adoration.** 1921, from *Utopia, Dokumente der Wirklichkeit* (Utopia. Documents of Reality), lithograph, 33.0 x 24.0 cm, BHA (illustration on the left). • To Itten, rational analyses of pictures, as for example in art history, seemed inadequate. He countered them with creative processes which have movement – in the sense of the prime mover of the universe – as their subject. Here, the principal movements are conveyed by lines and broken down at the bottom into detailed schemata. The Christian picture generates associations with found and felt forms. Elements of Mazdaznan – such as "Ormuzd" and "Parse" – offer another way of absorbing references in the "Adoration" to eternal laws relating to measures and numbers from classical antiquity.

Johannes Itten, Study for "Turm des Feuers" (Tower of Fire). 1919, sketch from Itten's diary (July 30, 1918 – June 14, 1920), pp. 181–182, Indian ink on paper, 28.0 x 21.5 cm, Itten Archive, Zurich. • The spiral, a pictorial image of infinite movement, is here given a finite form. Later studies for the "Tower of Fire" contain commentaries which present the tower as a symbol for the cosmological meaning of the universe. In 1994, Itten's description "Landmarks of a City for Fliers" was given a concrete background by Rolf Bothe in the catalog book *Das frühe Bauhaus* (The Early Bauhaus): the inauguration of the first civil airline flights from Berlin to Weimar.

Johannes Itten, Page from "Analysen alter Meister" (Analyses of Old Masters), Master Francke, Adoration. 1921, from *Utopia. Dokumente der Wirklichkeit* (Utopia. Documents of Reality), proof sheet for sheet 10, book page size 33.0 x 24.0 cm, BHA. • Sheet 10 not only provides an overall view of these tenets but also links them with the specimen analyses and formulates the system of axial composition that is valid for all sheets.

arguments over the latter's increasing orientation toward the needs of industry eventually led to his spectacular departure from the Bauhaus in 1923. After an intermezzo at the Swiss Mazdaznan center he first directed a private school in Berlin from 1926. Then, from 1932 to 1938, he did in fact put himself at the service of industry, albeit a branch with a strongly craft-oriented heritage, as director of the textiles school in the silk-producing town of Krefeld. From 1953 on

he was director of the School of Applied Arts in Zürich. He died in 1963.

Itten found his way to abstract painting at an early stage. From 1915 he painted a series of geometrically composed pictures in which the relationship of form and color was thematized in an ostensibly cool fashion. Dynamic compositions with diagonal and spiral contrasts of form and color were predominant. Such contrapuntally composed pictures contrasted

with drawings in which, inspired by Hölzel, he captured the feel of objects with quick, loose brushstrokes. In addition to these early abstract works, Itten occasionally based pictures on his spiritual ideas, using concrete symbols in a wholly traditional manner.

The link between these ostensibly unconnected groups of works – which corresponded to the later exercises in the preliminary course – can only be understood by taking Itten's aesthetic,

**Johannes Itten, "Turm des Feuers" (Tower of Fire).** 1920, based on an idea by Marco de Michelis, reconstructed by the glass painter Ernst Kraus, Weimar, and the theater sculptor Rainer Zöllner, Weimar, 1995 – 1996, stained glass, wood and metal, 404.0 x 133.5 x 133.5cm, KW. • The coloring of the "Tower of Fire" is to this day unknown. It can only be supposed that a sequence of at least 12 shades ascending from dark to light was envisaged.

**Johannes Itten, "Turm des Feuers" (Tower of Fire) outside the studio of the Tempelherrenhaus in Weimar.** 1920 (lost), photographer unknown, stained glass, wood and metal, height 360.0 cm, BHA. • Twelve cubes tower up one above the other, becoming smaller from one stage to the next by one-third of the previous one, and rotating in the same rhythm. They form the supporting structure for fan-like glass screens which – opening downward – arch diagonally over the planes of each cube, so that the structure spirals upward. Itten's goal was to unite rest and movement harmoniously in art and life.

with its strong metaphysical component, into consideration. He himself presented it programmatically, using both words and images, in his famous manifesto "Analyses of Old Masters." Its essence lies in five analyses of pictures. In each case a reproduction of a past masterpiece is juxtaposed with a sketch-like free copy, supplemented by marginal notes and a sheet of calligraphy with words that are intended to reveal the deeper meaning of the original. Geometrical forms are placed next to the free Indian ink drawing, and representational religious iconography alternates with highly individual typography: a tension to be found throughout Itten's entire oeuvre. A closer look at this occasionally abstruse manifesto is revealing. Whereas the mystic claims to make the essence of these pictures accessible here in the spirit of a "lebendige Kunstwissenschaft" (living art scholarship), the sober-minded onlooker is to say the least surprised by the arbitrariness with which, for example, in an analysis of an *Adoration of the Magi* by Master Francke, Itten uses carbon paper to distill a Pythagorean triangle out of the altar picture that does not exist as such in this late medieval painting. Only when this triangle is understood as a sacred symbol in the theosophical sense can this deviation be explained in terms of the occult connections between the teachings of Pythagoras and the birth of Christ. Itten's source here was Eduard Schuré's best-seller on the subject, *Les grands initiés* (The Great Initiates), in which it is stated, in the syncretistic vein, that "all great religious initiators (such as Pythagoras, Buddha or Zoroaster) were aware of it, all theosophers had an inkling of it. An oracular pronouncement by Zoroaster: the number 'three' governs the universe everywhere, and the monad is its principle" (Eduard Schuré, *Les grands initiés*, Paris, 1889, p. 277 [translated here from the German edition, Munich, 1956]). For Schuré the birth of Jesus was accordingly also determined by a Pythagorean constellation in the heavens: "The hour of destiny for the world grew solemn: the sky of the planet was dark and full of ominous foreboding ... the initiated had proclaimed that one day the world would be governed by one of their number, by a son of God" (ibid, pp. 386 ff.). The author draws on astrological research of this kind to "prove" that the "beautiful legend of the Three Kings" is the story of a

**Johannes Itten, Alles in Einem (Everything in One).** 1922, page of a diary, Indian ink and watercolor on paper, 29.0 x 23.0 cm, Matthias Itten. • How closely knowledge, experience and artistic expression were interlinked for Itten can be seen in the appearance of this diary entry for the day on which his son Johannes Matthias was born. Within the area of tension between "Alles" (everything) and "Nichts" (nothing) is the revelation "Alles in Einem – Alles im Seinen" (Everything in One – Everything in His). Between them there is a colorful proliferation of the names of Itten and his closest relatives. Contrasting pairs such as chaos and order, significance and nullity, intonation and form of words are placed in close proximity to each other.

**Johannes Itten, Tanzender Akt (Dancing Nude).** 1918, graphite and wax crayon on paper, 52.0 x 36.0 cm, BHA. • Dance, the classical form of the unification of opposites, such as body and mind; Itten represents rhythmic movement and countermovement by allowing sharp, dark scraps of shadow to have an intense life of their own alongside the bright curves of the body.

journey by three initiates. Itten accordingly places the infant Jesus at the center of a Pythagorean triangle, using this trivialized cabbalistic form to illustrate the "secret numbers of the Bible." "Since it (the secret science of numbers) contains the key to the entire doctrine, it was carefully hidden from the profane. The numbers, the letters, the geometric figures or the human images that served as symbols in this algebra of the occult world, were only understood by the initiated.... NUMBER was not regarded as an abstract entity, but as the essential and active quality of the highest ONE, of God, the source of the cosmos" (ibid, p. 270). The logic of this is, however, bound to remain concealed from the uninitiated just as it gives the artist the freedom to ignore the composition of the original. Finally, flames that are not to be found in the picture itself are invented and added by Itten with the words "Feuer" and "Parse" to round off the whole thing with the Zoroastrian fire cult of Mazdaznan.

This analysis is only one of five, which, enriched with widely differing texts from mystical literature, illustrate a history of the world and of art as the reflection of eternal flux and incessant motion as the revelation of a secret esoteric knowledge. For Itten, in line with the popular vitalism of Ludwig Klages and Henri Bergson, art is the expression of a metaphysical experience of time: "All living things reveal themselves in forms. Thus all form is movement, and all movement is evident in form" (*Utopia. Dokumente der Wirklichkleit* [Utopia. Documents of Reality], Weimar, 1921, p. 33). The vigor of his nude drawings, the rhythmic studies in his teaching and the free handling of the brush on the pages of text in *Utopia* come together in this cult of movement. All those elements which often appear contradictory in his many-sided work and teaching are to be found, synthesized in a symbolic manifesto of occult knowledge, in his "Analyses of Old Masters." To translate this spiritual program into aesthetic practice was the ultimate goal of all Itten's efforts as an artist and a teacher: "I do not want to produce any more works of art in future, only to present concentrated thoughts. Prayer is also the concentration of one's thoughts on God. To paint means to concentrate on color and form. The soul is the subtle chariot that bears the spirit from earthly matter to the divine spheres" (Diary entry of 1916, in *Werke und Schriften*

[Works and Writings], Willy Rotzler [ed.], Zürich, 1972, p. 54).

The view of the world revealed here was also the real background to Itten's rejection of the economic and social realities of his time, particularly concerning questions about the artist and his craft. This rejection grew out of a nostalgia for the past and the ideas of the "Lebensreform" movement. In 1922, in connection with the first major commission for the Bauhaus, the Sommerfeld house, which was still conceived very much in terms of craft and expressivity, Gropius noted: "Master Itten recently

demanded of me that we should decide either to produce individual work, in complete contrast to the outside economic world, or else seek a rapport with industry" (Walter Gropius, "Die Tragfähigkeit der Bauhausidee" [The Viability of the Bauhaus Idea], quoted in Hans M. Wingler, *Das Bauhaus*, Cologne, 1975, p. 62). For Itten, however, industrialism was the expression of a rationalistic culture which had to be combatted, primarily with the resources of art. Thus it was not only inevitable but also inwardly consistent that he should break with the Bauhaus.

# The "Analyses of Old Masters" or the Modernity of Tradition

Norbert M. Schmitz

not more characteristic of the 19th-century academies to take their bearings from the great exemplary artists of the past?

The iconoclasts of modernism are well known. They were spearheaded by the Futurists, who wanted to close down all the museums, if not to destroy them entirely, as strongholds of cultural stagnation. But this was, if anything, an exception. Even Manet justified his *bonne peinture* in terms of competition with old Dutch painting, and with the classical avant-garde the Old Masters became the central authority from whom they derived their legitimacy – precisely because the newness of their art still encountered incomprehension on the part of the public.

If the "Analyses of Old Masters" at the Bauhaus are purged of their esoteric background material, then, in the sense of Nietzsche's question about the "advantages and disadvantages of history for life," another, radically modern aesthetic concept can be discerned, which entailed more than the simple search for models in the past. Itten was able to explain the most disparate works of art – whether Egyptian sculpture or the Madonnas of Grünewald – in terms of one and the same formal law, namely "counterpoint in painting." This could refer either to the use of line, or the distribution of color, or chiaroscuro effects. In class, therefore, instead of the faithful copying, which was the usual practice at art academies, schematic drawings were repeatedly made of

It was with a lecture on the Old Masters that Johannes Itten began his work in Weimar, and it was one of the analyses which he carried out during his teaching that brought the conflict that had been smoldering for some time out into the open. "An analysis class in 1923 caused Walter Gropius to comment that he could no longer take responsibility vis-à-vis the government for my teaching. Without any further argument I spontaneously decided to leave the Bauhaus" (Johannes Itten, *Mein Vorkurs am Bauhaus* [My Preliminary Course at the Bauhaus], Ravensburg, 1963, p. 18). Why did this return to the art of the past play such a part at the Bauhaus, which is, after all, usually equated with a complete break with tradition? Was it

individual aspects. These related to the original picture in very varying degrees and in some cases took on such an independent quality that they may almost be regarded as autonomous compositions. The intention was to use such "extractive drawings" as a means of distilling from the work of art the "true essence of art" as an abstract formal law over and above historical and cultural differences. In terms of chiaroscuro it was now possible to compare such disparate works of art as a Chinese Indian ink drawing and a Dutch still life, or a piece of Egyptian sculpture and a modernist work. It is precisely this that reflects a central element of Bauhaus aesthetics: when Gropius repeatedly rejected the notion of a "Bauhaus style,"

**Paul Citroën, Color Analysis of a Madonna Painting.** About 1921, collage of colored paper, Indian ink and opaque watercolor on paper, 23.5 x 19.5 cm, BHA (illustration on the left). • In the "Analyses of Old Masters" Itten saw a way for a preliminary course student to approach the "essence" of a work by looking, feeling and practical artistic activity. Citroën only paid attention to the animated center. He produced a contrast of textured middle ground framed by a series of colors.

**Anni Wottitz, Rhythmical Analysis after a Painting by Lucas Cranach.** 1919, charcoal drawing on yellowish paper, 26.5 x 25.0 cm, BHA. • The sweeping movement of the charcoal "extracts" the dynamic line in Cranach's composition.

**Franz Singer, Study after an Adoration.** 1919–1920, watercolor on drawing paper, 19.1 x 30.3 cm, BHA. • In addition to emotional empathy with a work of art, Itten's teaching featured rational analysis of a picture and its composition.

what he meant was that it was not enough to refer to one historical style as a chosen model. Instead, the Bauhaus should impart a sense of fundamental aesthetic laws over and above any specific stylistics. The analytical drawings are thus elements of an abstract teaching of art on which they also confer legitimacy, a teaching which saw itself as the fulfillment of the legacy of the entire history of art. It is evident that this "regenerated art scholarship" scarcely does justice to the variety and complexity of any historical reality. Even so, the significance of such aesthetic approaches should be emphasized. Such projections of current artistic criteria onto the past did open up perspectives which necessarily remained closed to classical philological scholarship, which was only retrospectively able to integrate it into its own scholarly methodology. It would be naive to believe that even art scholarship with a rational, critical approach could ever have dispensed with such aesthetic inspiration. Even the pursuit of "objectivity" in 19th-century art history was merely the expression of an aesthetic stance toward the world, namely historicism. Since Vasari, the notion of art history, which is obvious to us today, has been not least the product of artistic efforts, whether in art or scholarship. Bazon Brock once defined the avant-garde as "what makes us see the ostensibly secure inventory of tradition in a fresh way, that is to say, to build up new traditions" ("Ästhetik gegen erzwungene Unmittelbarkeit. Die Gottsucherbande" [Aesthetics against Enforced Immediacy. The Band of Seekers after God] in *Schriften, 1978–1986*, Cologne, 1986, p. 106). Thus in this sense the significance of the Old Masters for the self-image of the Bauhaus artists was a sign of their modernity and not of an epigonal relationship. That is another reason why the analyses triggered off the conflict between Gropius and Itten that had been smoldering for a long time. Control over history was too important to be left to the obscurantism of a Mazdaznan prophet.

# Paul Klee

Martin Faass

Like many important pieces of news, this one also arrived by telegram: "Dear, revered Paul Klee. We have unanimously decided to invite you to join us as a master at the Bauhaus in Weimar" (Christian Geelhaar, *Paul Klee und das Bauhaus*, Cologne, 1972, p. 9). It was signed by Gropius, Feininger, Engelmann, Marcks, Muche, Itten and Klemm. It had become necessary to appoint new staff due to the departure of Klemm and Engelmann, the last two of the professors who had come from the old art school in Weimar. Itten wished to replace them with "modern artists with the same outlook" in order thereby to make the Bauhaus, as he wrote in a letter to Klee, "a center for the most intensive artistic work ... beyond the reach of reactionary elements" (*Das frühe Bauhaus und Johannes Itten* [The Early Bauhaus and Johannes Itten], exhibition catalog, Ostfildern, 1994, p. 387). Klee was by then no longer unknown. Like Itten, Muche

and Feininger, he belonged to the Expressionist circle which was represented in Berlin by Herwarth Walden's Sturm Gallery. He had taken part in the epoch-making exhibitions of Der Blaue Reiter and at the first German fall salon, had organized widely-noted collective exhibitions, and had written an illuminating essay for Kasimir Edschmid's collection, *Schöpferische Konfessionen* (Creative Confessions) of 1920. Moreover, there were books with illustrations by him on the market, along with two monographs. He was born in Bern in 1879 and began his career at the Munich Kunstakademie where, like Wassily Kandinsky, he studied under Franz von Stuck. His academic training and the obligatory trip to Italy were followed by his first free works. They are for the most part figural etchings which on account of their bizarre subjects and the excessively clear visual modeling have an almost surreal quality. In his early work Klee

was intensely preoccupied with this kind of picture. A decisive change in his artistic development came about in 1911 when he met the artists of Der Blaue Reiter, Kandinsky, Franz Marc and August Macke, along with the French avant-garde associated with them. Their compositional innovations brought Klee closer to color and enabled him to develop that ostensibly playful form of expression, marked by elements taken from children's drawings, which made him an important exponent of classical modernism.

The idea of working as a teacher was by no means new to Klee. Oskar Schlemmer, for example, wanted him to go to Stuttgart to succeed Adolf Hölzel, a project which ultimately failed due to the resistance of the traditionally minded teaching staff. Klee himself seems at the time to have felt a kind of political obligation to teach. After the Munich "Räterepublik" (Socialist republic) had been suppressed, he

**Josef Albers, Paul Klee in his studio.** 1929, series of photographs mounted on card, 29.69 x 41.75 cm, Collection The Josef Albers Foundation. • An attempt to achieve rapport using the medium of photography, which Albers had just discovered for himself, and a sensitive study of the melancholy artist's face.

**Paul Klee, Geisterzimmer mit der hohen Türe (neue Fasssung) (Ghostly Room with Tall Door [new version]).** 1925, work index no. 102 (=A2), watercolor, sprayed, and oil paint drawing on hand-made paper, edged with gouache and black ink, mounted on card, 48.7 x 29.4 cm, MMA, The Berggruen Klee Collection, NYC, 1987. • The picture appears to symbolize the frontier to Klee's magic world with its "remote, original point of creation." Thus pictorial spaces are created as cosmic nature alongside nature, without simply illustrating it.

1925 A.2  Geisterzimmer mit der Hohen Türe  (neue Fassung)

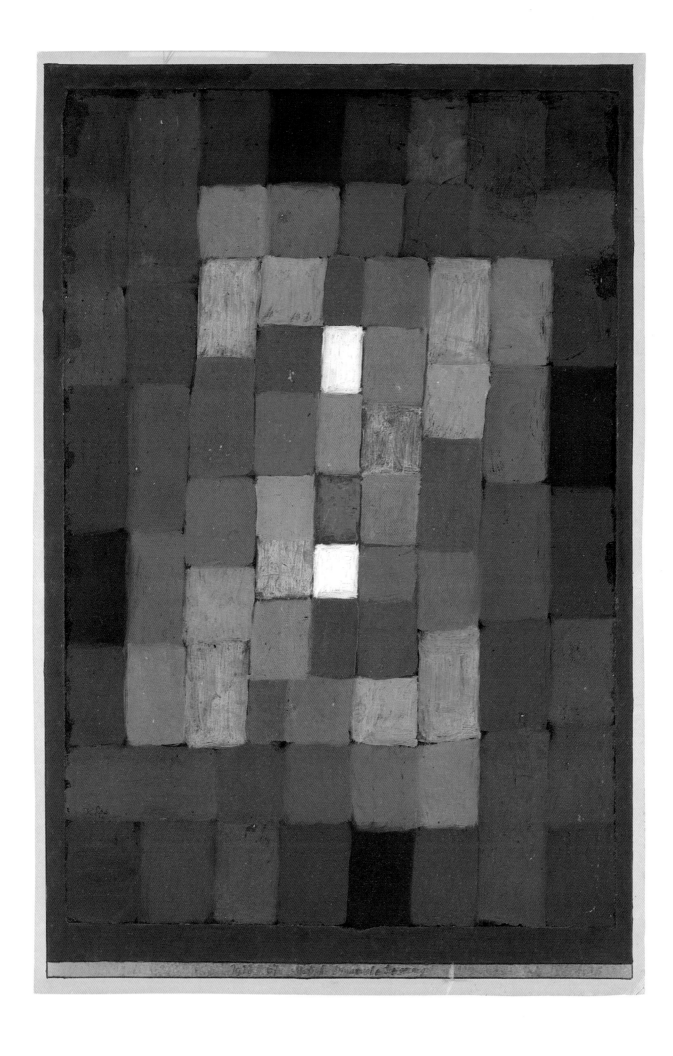

declared himself convinced that modern artists in particular, by virtue of the originality of their thinking, could contribute to the future shaping of society. The precondition of this, he thought, was a new concept of education that would make their insights accessible to as many people as possible. Even before his first meeting with Gropius he envisaged an "art school for craftsmen" (Jürgen Glaesmer, *Paul Klee*, Bern, 1976, pp. 134ff.). What art school could have been more attractive to him than the State Bauhaus?

Klee took up his new appointment in January 1921. To begin with it was still quite unclear what were to be his tasks at the Bauhaus. When the responsibilities for the workshops were reallocated, on March 15, 1921, Klee became head of bookbinding. "Tomorrow I take over the bookbinding workshop here ... perhaps in time I can bring some élan into it" (quoted in Magdalena Droste, *Bauhaus*, Cologne, 1985, p. 28). The bookbinding workshop and its products did not at the time show much evidence of the "new spirit" which was supposed to distinguish the Bauhaus. It offered little more than decent craft work, albeit of high value. Nor did the hoped-for change come about under Klee, the new form master, because he was ultimately unable to assert himself against the craft master Otto

Dorfner. Following the closure of the bookbinding workshop, Klee took over the stained glass workshop on October 3, 1922. However, the opportunities for exerting any influence were scarcely any greater there, since the new architectural approach at the Bauhaus deprived the workshop, practically speaking, of its commercial basis. There was no place for stained glass in the new architecture. Later, in Dessau, Klee did sometimes teach form in the weaving workshop led by Gunta Stölzl, but "on the whole the effectiveness of the artist in the realm of the workshops must be rated as relatively low" (Rainer K. Wick, *Bauhaus-Pädagogik* [Teaching at the Bauhaus], Cologne, 1982, p. 230).

Klee's contribution was theoretical teaching. He gave his first lesson in May 1921. It was devoted, as he put it, to "practical composition," with Klee discussing and analyzing his own work and that of the students. "Today I gave my first class, and an extraordinary thing happened: I talked freely with the people for two hours. First I discussed some pictures and watercolors by Watenphul, Fräulein Neumann and others. Then I passed watercolors of my own around and discussed them in detail with regard to their formal elements and compositional structure. Only I was so careless that I got through all my material, which means that

I shall have to paint more pictures for discussion next Friday" (Paul Klee, *Briefe an die Familie* [Letters to his Family], Cologne, 1979, Vol. 2, p. 977).

The following semester, on the basis of this experience, he began his lectures on the theory of artistic form. Whereas until then he had left a good deal to the inspiration of the moment, he was now prepared down to the last word. His concern was to introduce his students to basic artistic forms, which in Klee's opinion could be derived from the structural principles or the functional laws of nature. These basic forms included the organic connections between pictorial elements and the balancing of the forces emanated by them. "Today," he said to his students on December 12, 1921, "I would like to make the balancing of forces on one side and the other the object of our investigation (I mean those forces that arise from the earth's power of attraction), that is to say the balancing of heavy weights. Forces of this kind are closest to hand for us because we ourselves are physically subject to these laws of weight" (Paul Klee, *Beiträge zur bildnerischen Formlehre* [Contributions to the Theory of Artistic Form], Stuttgart-Basel, 1979, p. 27). No wonder that, faced with such hazardous leaps between art and nature, his students often lost the thread and, as one of them wrote, could not attend the lectures "without inner preparation." (quoted in Frank Whitford, *Das Bauhaus*, Munich, 1994, p. 76). Other aspects of Klee's teaching were reflections on movement in pictures in terms of the psychology of perception, or attempts to translate musical structures into visual artistic forms. During the winter semester of 1922–1923 he began to talk about color and developed a wholly independent theory of color from ideas extracted from Goethe, Runge, Delacroix and Kandinsky.

**Paul Klee, Wandbild aus dem Tempel der Sehnsucht – dorthin – (Mural from the Temple of Longing – there – ).** 1922, work index no. 30, oil paint drawing, watercolored, on gauze primed with plaster of Paris, mounted on card, 26.7 x 37.5 cm, MMA The Berggruen Klee Collection NYC 1984. • Klee attempted to visualize an "inner world" beyond external nature. The mural, with many arrows pointing upward to a suggested firmament, bears witness to the artist's longing to transcend the banality of a material life on earth.

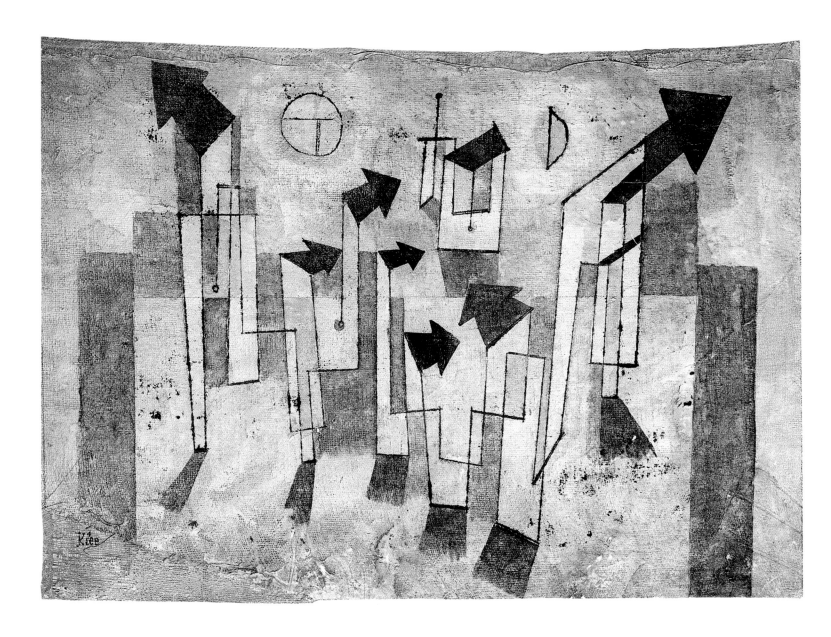

Klee's efforts to provide a theoretical basis for the creative process had clearly visible effects on his own artistic work. His compositions increasingly became a testing ground for his ideas, thereby forfeiting their playful character. They were now dominated by geometrical structures, spatial forms, color constellations and symbols such as the arrow, for example, which Klee saw as an image of spiritual escape from earthly shackles. In the early years Klee's organic, natural approach had perfectly accorded with the expressionistic self-image of the Bauhaus. But as a result of the fundamental changes following Itten's departure in 1923, his position at the school became more and more that of an outsider. His new colleagues, the Hungarian Constructivist Moholy-Nagy and his assistant Albers, were radically opposed to such theorizing, which they countered with their belief that teaching should concentrate above all on the technologically oriented analysis of materials. Moreover, Moholy openly argued for the abolition of traditional "static" painting, as he put it, and suggested replacing it with the use of slides. Such ideas came as a shock to Klee. In view of these new tendencies Klee considered very carefully whether or not to follow the Bauhaus to Dessau for the 1925 summer semester. A further factor was that he felt exhausted by his teaching work and was finding it increasingly difficult to combine his job as a teacher with his work as a creative artist. For a time he considered the possibility of a post at the art school in Frankfurt, which, given the threat of closure in Weimar, had indicated an interest in taking over the Bauhaus or some of its masters. In the end Klee opted for Dessau after all. For him too the idea of "being able to stay together was perhaps the most important and consoling idea" (Lyonel Feininger, letter to Julia Feininger, Weimar, March 9, 1925). His teaching situation also improved briefly when he obtained permission to commute from Weimar until the masters' houses were ready, and to take his classes in blocks of a fortnight. Klee was very pleased with this rhythm, which left him sufficient time for his own painting. He therefore subsequently tried a number of times to organize his teaching in this way without official approval, which led to severe disagreements with Gropius and

**Paul Klee, Architektur der Ebene (Architecture of the Plane).** 1923, work index no. 113, watercolor over pencil on paper, mounted on card, 28.0 x 17.2 cm, Berggruen Collection in the SMBPK. • The geometry of sunrise or a design for a wall covering: the *Architecture of the Plane* is an exemplary demonstration of Klee's own color theory and at the same time a showpiece of color oscillations like those produced by a weaver's shuttle.

Klee's fellow teachers. But it was not just these disagreements that contributed to Klee's growing feeling of estrangement, it was also the new organization of training at the Bauhaus. The previous dual-track training model was abandoned and the craft-and-form master was replaced by a teacher trained at the Bauhaus. This meant that the painters were now completely excluded from the real work of the school. Hannes Meyer, who succeeded Gropius as director in 1928, acknowledged the implications of this change. He established two classes in free painting, which were eventually directed by Klee and Kandinsky. The exclusion of painting from the curriculum proper did, it is true, bring greater freedom for the painters at the Bauhaus, but even so by 1929 Klee was considering giving notice: "I no longer become agitated about the Bauhaus, but things are demanded of me which are only fruitful to a certain degree. That is unpleasant, and will remain so. Nobody can help it, apart from me, but I have not the courage to leave" (Paul Klee, *Briefe an die Familie* (Letters to his Family), Cologne, 1979, Vol. 2, p. 1100). By then he was negotiating with Walter Kaesbach, the director of the Art Academy in Düsseldorf. Agreement was reached in July of 1930. The municipal authorities of Dessau tried to keep him there by offering him exemption from teaching, but in vain. Klee left the Bauhaus on April 1, 1931.

Due to the political upheavals in Germany, his teaching work in Düsseldorf was to be no more than a brief guest appearance. Klee was given notice immediately after the National Socialists had taken power and he returned to his homeland in Bern. Seven years of creativity were left to him there, and they were full years though marked by illness. In his late work Klee, who had previously preferred small forms, developed a liking for large-scale pictures with strange black hieroglyphics, labyrinthine line drawings with obscure meanings. They frequently touch on the subjects of death and redemption, for the artist had a premonition of his approaching end. Paul Klee died in June of 1940.

**Paul Klee, Eroberer (The Conqueror).** 1930, work index no. 129, watercolor and pen on cotton, edged at the top and bottom with stripes in gouache and pen, on card, 40.5 x 34.2 cm, Paul Klee Stiftung, Kunstmuseum, Bern. • The arrow, even though Klee complicates its conventional symbolism, appears in many of his works as an image of movement. Here it represents conquest as a dynamic force. Klee occasionally interprets a turn to the left as an "adventure," a "movement into the distance," an "increase in intensity and speed."

**Paul Klee, Baldgreis (Senecio) (A Man soon to be Old [Senecio]).** 1922, work index no. 181, oil on gauze on card, 40.5 x 38.0 cm, Öffentliche Kunstsammlung Basel, Kunstmuseum. • Whereas the figurines, with their representational effect, frequently appear to float almost independently in front of a color space articulated in planes, here the firmly drawn nexus of planes in various colors is itself shaped into a portrait which has an archaic effect.

# Playfully to the Essentials

Martin Faass

The very title sounds odd: Die "Zwitscher-maschine" (*The Twittering Machine*). Klee's drawing of 1922, dashed off with a few strokes and casual watercoloring, shows a weird and wonderful piece of apparatus: a horizontal axle with a crank, secured on the left-hand side by a four-legged stand, hanging in the air without support on the right-hand side; on it there are four long-legged bird-like figures which are made to twitter by turning the crank. The apparatus is being used, as can be clearly seen from the open beaks. But the cranked-up recital seems to be approaching its end, for only one of the birds is still stretching its beak cheerfully up toward the sky, whereas the others are more or less slumped on the axle. The manner of representation befits the subject. It is crudely schematic and uneven. Nothing but thin, apparently awkwardly drawn lines. A horizontal line for the cranking axle, three lines for the birds' legs and tails and three more for their claws, with no regard for anatomical details. Further inconsistencies are to be seen in the proportions of the birds' bodies and the construction of the machine. The birds' heads are depicted as disproportionately large and are much more detailed than the other body parts. The cranking mechanism, on the other hand, pays no heed to what is possible as regards mechanics or statics. The rods are far too fragile to bear the weight of even

**Paul Klee, Die Zwitschermaschine (The Twittering Machine).** 1922, work index no. 151, oil paint drawing and watercolor on French Ingres paper, 35.0 x 21.0 cm, MOMA, NYC. • Klee's delicate inventions – developed from the spontaneity of the graphic line – are reminiscent of the Surrealists' "automatic writing." But whereas they wished to give the concrete individual a voice that would transcend reason, Klee's aim was to record a mystical artist's vision.

**Paul Klee, Der Seiltänzer (The Tightrope Walker).** 1923, work index no. 121, pencil, watercolor and oiled carbon paper on paper, mounted on card, 48.7 x 31.3–32.2 cm, Paul Klee Stiftung, Kunstmuseum, Bern. • One of the "discoveries" of the avant-garde was the "genius in the child." To a greater degree than any other artist who held this view, Klee took this world beyond adult rationality seriously as the place where creativity originated.

1923  121  Der Seiltänzer

1923/ 21 Puppen theater

1939 XK 9 Schulschiff

**Paul Klee, Schulschiff (School Ship).** 1939, work index no. 699, pencil on paper dotted with glue, mounted on card, 27.0 x 21.5 cm, Paul Klee Stiftung, Kunstmuseum, Bern. • Klee retrospectively added his own extant childhood drawings to the catalog of works which he compiled himself. The *School Ship*, dating from 1939 during the dark period of National Socialist dictatorship, speaks of escape to an intact world of spontaneity away from all the gloom of the present.

**Paul Klee, Puppentheater (Puppet Theater).** 1923, work index no. 21, watercolor on double paper primed with chalk and glue, framed in watercolor and pen, edged at the bottom with watercolor and pen, on card, 52.0 x 37.6 cm, Paul Klee Stiftung, Kunstmuseum, Bern. • Klee saw his filigree figures, the expression of an imagination that seems almost childlike, as creations similar to nature. His pin-men, in their endless variety, inhabited a magic world of art – with a close affinity to the humour of a writer like E.T.A. Hoffmann, sometimes inscrutable, sometimes scurrilous.

one of the birds, and on the right-hand side float entirely freely in space. In many of Paul Klee's pictures we find dreamlike themes and a mode of representation that appears oblivious to reality. They are the result of an intensive artistic investigation of children's drawings going back to 1902. It was then that the 23-year-old artist discovered in his parental home drawings from his early youth. Klee was enthusiastic about the find, as the drawings seemed to him to be among the most significant that he had ever done – "highly stylish and naive" (*Briefe an die Familie* [Letters to his Family], Cologne, 1979, p. 273). He was for ever taking out these old drawings, and he also made an

intensive study of other children's pictures, in particular those drawn by his son Felix. Large numbers of these came into being from 1911, when Felix was four years old. Klee collected them and obtained important stimuli from them for his own work. Thus he knew exactly what he was talking about when he provocatively remarked: "The critics, those gentlemen, often say that my pictures are like the scribbling and daubing of children. May it be so! The pictures that my little Felix has painted are better pictures than mine" (Lothar Schreyer, *Erinnerungen an Sturm und Bauhaus* [Memories of Sturm and Bauhaus], Hamburg-Berlin, 1956, p. 110).

What Klee appreciated above all in children's drawings was their unspoilt view of the world. They became his inspiration in the struggle against a traditional artistic practice that had grown blind from routine. "Children can do it too," Klee wrote in his review of the first exhibition of Der Blaue Reiter, "and that is not at all devastating for the most recent efforts, on the contrary there is positive wisdom in this fact. The more helpless these children are, the more can be learned from the art which they offer us. For here too there is such a thing as corruption, when children begin to absorb developed works of art or even to imitate them" (quoted in Andreas Hünecke, *Der Blaue Reiter*, Leipzig, 1991, p. 170). Almost all modern artists have thought in the same way. Kandinsky, for example, wrote: "A child knows nothing of practical, utilitarian considerations, because it looks at everything with unaccustomed eyes and still possesses the undimmed faculty of perceiving the thing as it is" (ibid, p. 135). The belief in the innocence of a child's view of the world, which can be heard in these words, was not new. It goes back originally to the Romantics, who, in opposition to the Enlightenment, put their trust in the individual's intuitive faculties. As far back as the Romantic painter Philipp Otto Runge there was talk of the need to become a child again in order to achieve one's best.

Klee's first pictures with childlike elements were produced in 1905. They show children with dolls, who, unlike the later ones, show a tendency toward parody. It was not until after 1912 that Klee developed the children's drawing style that was to become typical of his work, under the influence of French Cubism. This movement, associated above all with the names of Picasso and Braque, put art on a completely new foundation; it also made children's drawings appear in a fresh light. For Cubism liberated art from the obligation toward its subject. It broke down the principle of illustrative organization that had determined artistic creativity over the centuries. Quite different compositions now became conceivable, such as Paul Klee's strange creatures, line-landscapes and ghostly spatial constructions. His pictures are of course not really childlike. Unlike children's drawings, his scribblings and inconsistencies are consciously calculated. However, only a few of his contemporaries perceived this difference. The teachers at the Stuttgart academy were not among them. In 1919, after conferring over whether or not to appoint Klee as a professor, they concluded that Klee's work "showed too playful a character, instead of the strong structural determination demanded particularly by the most recent movements" (Oskar Schlemmer, *Briefe und Tagebücher* [Letters and Diaries], Munich, 1958, p. 85). At the Bauhaus the innovative quality of his compositions was appreciated. Feininger, for example, thought them "quite splendid, tingling and exciting, with an amazing expressiveness and novelty of form ... as I feel it, there is the power in them that is sometimes hidden in children's drawings" (quoted in Hans Hess, *Lyonel Feininger*, Stuttgart, 1959, p. 68).

# Wassily Kandinsky

Norbert M. Schmitz

The fact that Kandinsky retained his significant weight as "primus inter pares" in the council of masters, even at a time when the Bauhaus was becoming increasingly geared to functional demands, contrasts strangely with the romantic individualism with which the pioneer of abstract painting throughout his life proclaimed the autonomy of the individual modern artist. But this very paradox is significant as a conceptual contradiction which, throughout all its changes, the school was never entirely able to resolve. For this reason the following account – necessarily a very limited one, given the complexity of Kandinsky's creative output – will take this contradiction as its starting point.

Kandinsky was born in Moscow in 1866. It was not until a relatively late stage, after having trained as a lawyer, that he decided to go to Germany to study art. After achieving considerable renown within the German avant-garde as the leader of the Munich group of artists, Der Blaue Reiter, he acquired educational experience at the artistic-technical

**Wassily Kandinsky, Spannung im Rot (Tension in Red).** 1926, oil on painter's cardboard, 66.0 x 53.7 cm, The Solomon R. Guggenheim Museum, NYC. • Kandinsky's abstraction is distinguished in particular by extremely open form and coloring. His sole criterion was the subjective one of "inner necessity." He was a mystic, who saw his dramatic compositions as signs of a cosmic world: a utopian alternative to the dominant materialism of the age.

**Oskar Schlemmer, punkt – linie – fläche (point, line, plane).** 1928, Indian ink pen, gold-bronze, collage with silver foil, toner paper, photographic montage and cut-out words (of the title) on whitish card, 20.1 x 20.1 cm, private collection, Oskar Schlemmer Archive and family estate. • Schlemmer's collage illustrates Kandinsky's position at the Bauhaus. The painter, who was preceded by an enormous reputation as a regenerator of art, was also regarded as one of the most important programmatic exponents of modernism.

3

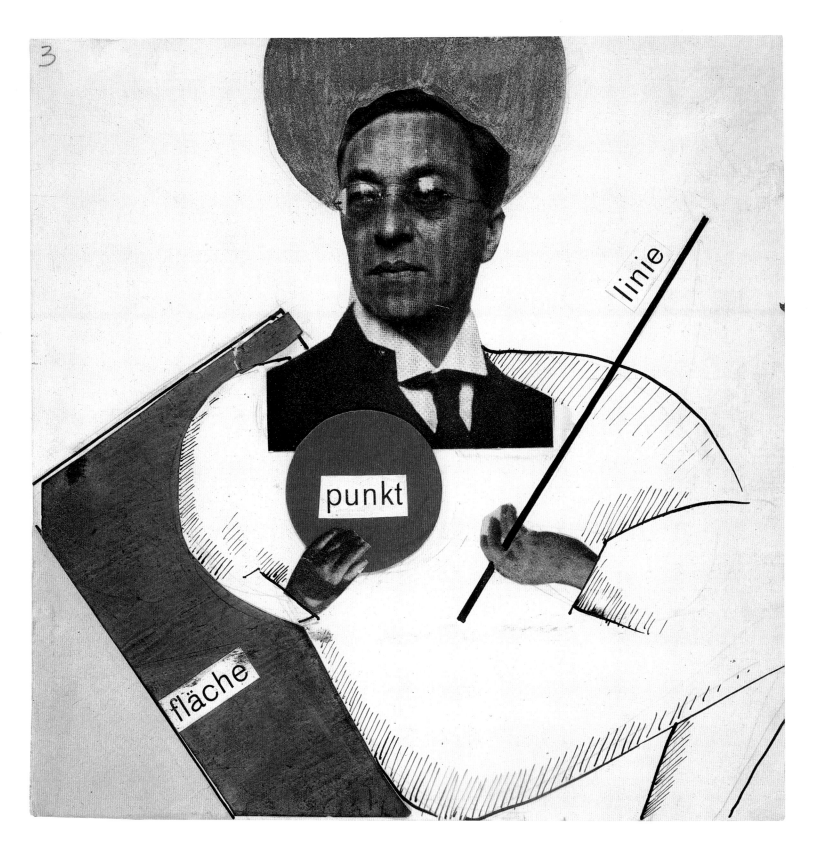

colleges of revolutionary Russia, the WchUTEMAS. As a mystic, whose political thinking ran more in a conservative direction, Kandinsky was scarcely able to share the revolutionary self-image of the Russian avant-garde. He therefore returned to Germany in 1921 and accepted the offer of a post at the Bauhaus in 1922. A champion of pure paint-ing, he also directed the murals workshop until 1925, but his main interest was in the courses in "analytical drawing" and "abstract elements of form." In 1927 he succeeded, together with Klee, in setting up the long-requested class in "free painting." It was a de facto reintroduction of a traditional painting class, but now in abstract art. Despite an increasing lack of rapport with the school, he remained associated with the Bauhaus until its closure by the National Socialists in 1933. He spent the last years of his life in Neuilly-sur-Seine near Paris, where he died in 1944.

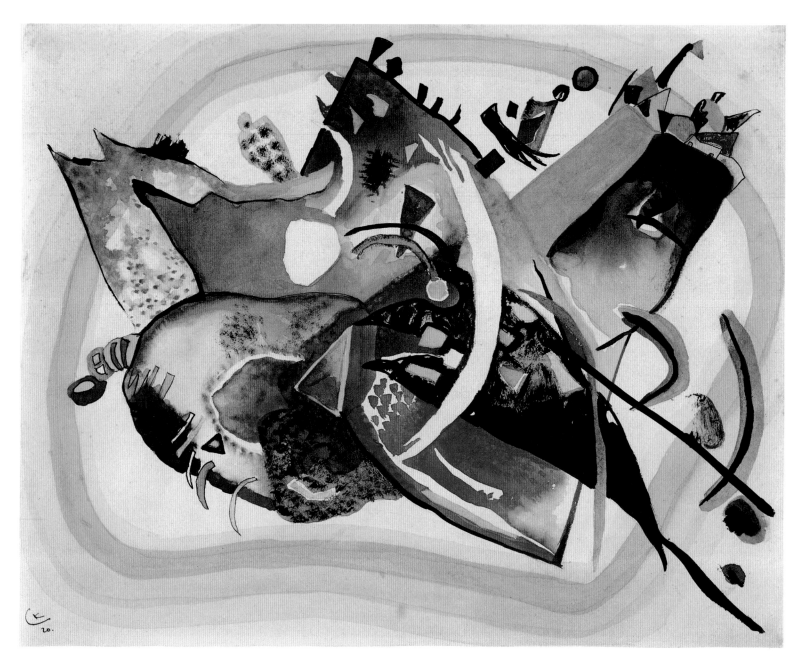

**Wassily Kandinsky, Untitled.** 1920, watercolor, Indian ink and pencil on paper, 22.9 x 29.0 cm, The Solomon R. Guggenheim Museum, NYC. • Kandinsky, who had developed his particular form of nonrepresentational painting around 1910, took this step in a moderate fashion, having first carefully considered its theoretical aspects. Parallel to abstract works, he continued to produce works with recognizable motifs, but without a truly illustrative character. Forms, and objects with a content that can often only be ascertained associatively, are equally intended to evoke inner sound worlds.

When Kandinsky was appointed at the Bauhaus, he was regarded as a leading theoretician of the avant-garde, not only as a painter but also as the author of the programmatic writings "Concerning the Spiritual in Art" (1910–1912) and the Blaue Reiter almanac which he edited with Franz Marc (1912). His first really independent works were decorative fairytale pictures in the then fashionable spirit of Jugendstil and Symbolism. Their lavishly colorful folksiness revealed a naive yearning for an intact world and authenticity. From 1910 he developed, from the increasing independence of

forms and colors, his legendary romantic abstraction which gained him the reputation of a founder of non-representational painting. He justified this radical step through an unconventional model of history compromized of theosophy, anthroposophy and cultural critique, in which a prominent role was allotted to his new art. According to this vitalistic model, the despised positivism, materialism and utilitarianism of the 19th century were to be replaced by an "era of the great intellectual." He considered his own abstraction as an expression of the new spirituality which this necessitated:

"First period, *origins*: practical desire to hold onto the transient *physical*.

Second period, *development*: the gradual elimination of this practical purpose and the gradual *preponderance of the intellectual* element.

Third period, *goal*: the achievement of the higher stage of *pure art*. In it, what was left of the practical desire has been completely eliminated. It speaks from one spirit to another in the language of art, and it is the realm of artistic-spiritual beings (subjects)" (Wassily Kandinsky, *Malerei als reine Kunst* [Painting

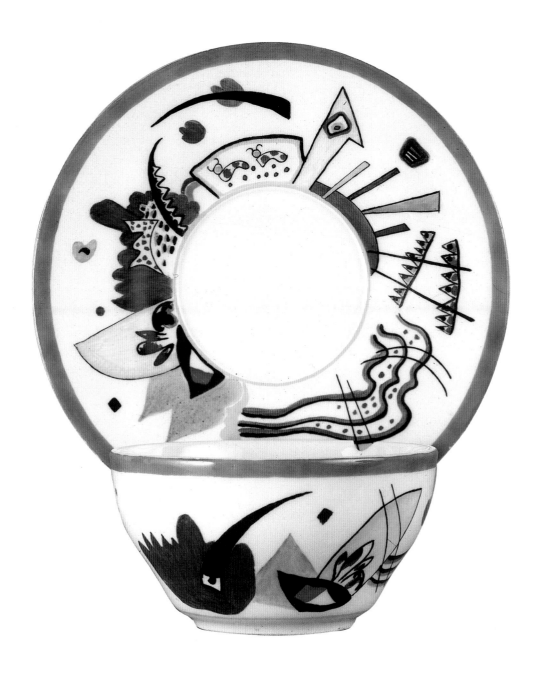

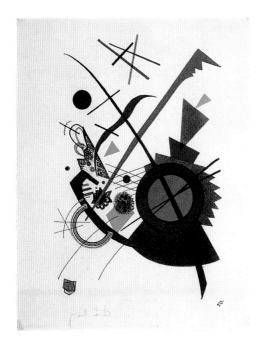

**Wassily Kandinsky, Violett (Violet).** 1923, specimen print, colored lithograph on machine-made deckle-edged paper, 34.0 x 27.0 cm, BHA. • The print shows what is special about Kandinsky's use of form. Breaking all the rules, both classical and modern, he creates relationships between the most disparate pictorial forms: line and plane elements, round and sharp-edged forms, closed and open forms. This counterpoint generates the peculiar subjective emphasis of even his simplest woodcuts.

**Wassily Kandinsky, Teetasse mit Untertasse (Teacup and Saucer).** Designed about 1922, painting on Meissen porcelain, diameter of cup 10.3 cm, saucer 16.0 cm, Musée National d'Art Moderne, Centre Pompidou, Paris. • Kandinsky's applied art designs – here in the traditional genre of painted china – were often no more than a matter of application. The cup and saucer are basically conceived by the artist as an extension of canvas.

as Pure Art], Berlin, 1918). Such speculations were common coin at the time, philosophy for the man on the street. However, Kandinsky did not simply remain an illustrator of theosophical doctrines of salvation and no more. To begin with, like Itten, he illustrated (naturalistically, as it were), the spirit beings from Charles W. Leadbeater's "Thought Forms" and Rudolf Steiner's "Astral Bodies" in pictures such as *Lady in Moscow*. But his painting itself soon became the only place where mystical salvation could occur. Hence his originality consisted in developing, against

this intellectual background, a unique artistic strategy. He did this by dispensing not only with any representation of traditional subjects, but increasingly also with the mimetic representation of the neoreligious conceptions of his faith. For him a spiritual picture grows solely out of an "inner sound" and can be understood by the public only if they spontaneously experience it also. For the "choice of form is thus determined by the *inner necessity* which is in essence the only immutable law page of art" (ibid). Kandinsky did not, however, understand this as subjective

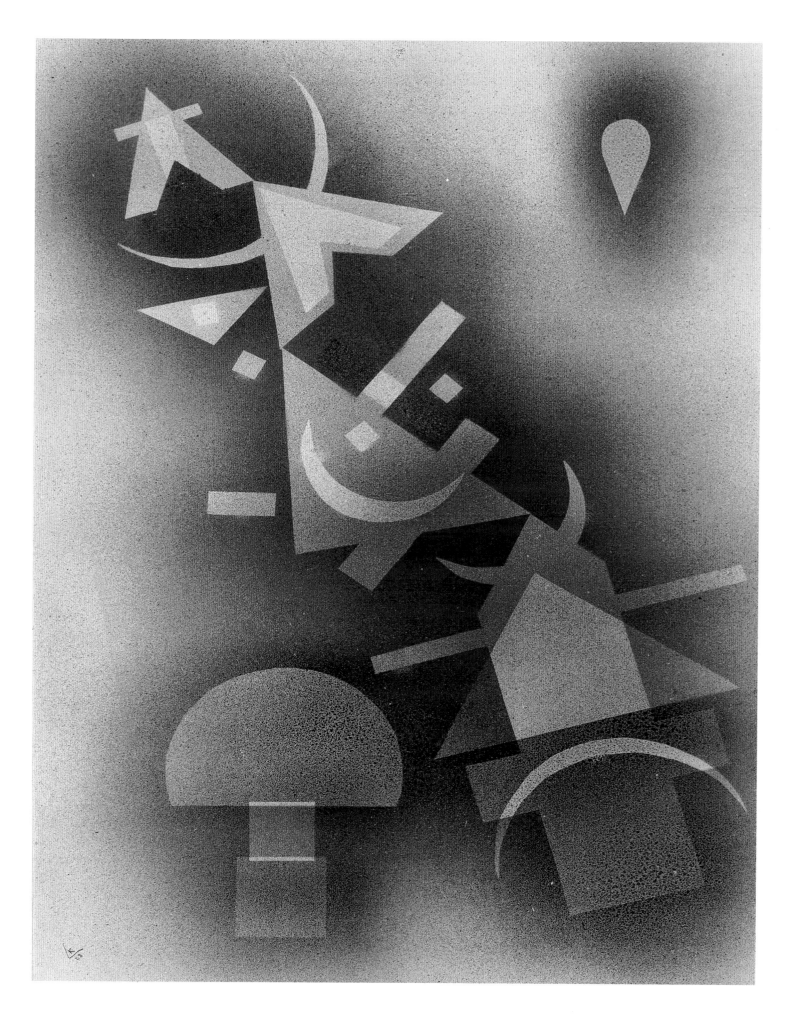

**Wassily Kandinsky, Aus kühlen Tiefen (No. 272) (From the Cold Depths).** 1928, watercolor and Indian ink on paper, mounted on card, sheet 48.6 x 32.4 cm, card 62.5 x 46.5 cm, Norton Simon Museum, Pasadena, CA, The Blue Four Galka Scheyer Collection. • In the Bauhaus years a change in the "atmospheric values" of Kandinsky's compositions began to be discernible. The dramatic tensions of the early work gave way to a light, carefree gentleness of floating forms.

arbitrariness, in the way that the expressive gestures of someone like Jackson Pollock are, so to speak, a record of individual gestures, but rather as an objective necessity. The romantic "genius" Kandinsky is referring instead to a kind of mystical intuition, which must not be restricted either by the external rules of the world of appearances, or the mere individual psyche of the artist, nor by a formal artistic canon. This claim determines the highly personal "handwriting" of Kandinsky's abstract painting, in which very disparate stylistic levels and forms meet within one and the same picture.

In order to understand the special nature of his painting, one should call to mind once again the basic rules of traditional compositional technique. In classical art, over and above all stylistic change, every picture was always

required to be a unified whole. Hence if the artist chose a particular painting technique – for example a flaky impasto – then this was obligatory for the entire work, regardless of its subject or content. This applies to a Madonna by Raphael no less than a nude odalisque from a Paris salon, but at the same time also – and this is the crucial point here – to large areas of early abstract painting. Thus the suprematist figurations of Kazimir Malevich are inherently reproducible variations of quite specific geometric forms, just as the semi-abstract forms of Jugendstil ornamentation, with which Kandinsky's early works have often been compared, were determined by a fixed organic rhythm. Kandinsky, on the other hand, found his own appropriate expression of his "new spirituality" in the radical destruction of all traditional rules of readability, that is to say,

**Paul Klee, Pictorial Letter for Kandinsky's 60th Birthday on December 5, 1927.** 1926, work index no. L3 (=23), watercolor and Indian ink on paper, 29 x 34 cm, Musée National d'Art Moderne, Centre Georges Pompidou, Paris. • The many letters with greetings reflect the close relationship between the two "princes among painters," Klee and Kandinsky, throughout all the years of change and conflict at the Bauhaus.

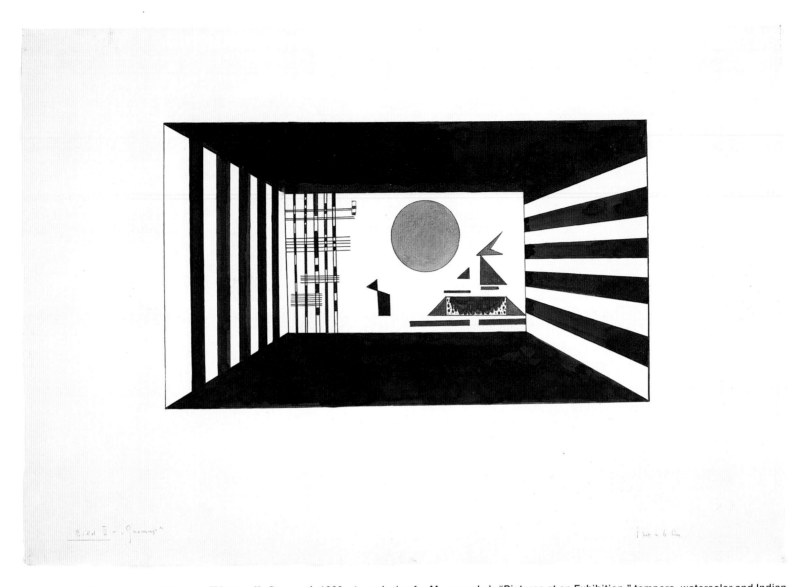

**Wassily Kandinsky, Bild II, Gnomus (Picture II, Gnomus).** 1930, stage design for Mussorgsky's "Pictures at an Exhibition," tempera, watercolor and Indian ink on paper, 20.5 x 35.8 cm, Cologne University, Theaterwissenschaftliche Sammlung. • Kandinsky's legendary stage design for a performance of Mussorgsky's "Pictures at an Exhibition" illustrates his synaesthetic concept of a universal correspondence of forms, colors and musical sounds. In his memoirs he spoke of the visual impressions made on him by Wagner's music.

in an art "out of the negative" – the complete opposite of the abhorred rationalism of the dying materialistic era. A look at his improvisations, constructions and compositions from the romantic "years of genius" in Munich clearly shows the means by which he moved away from any rational, logical form. There we see linear elements opposite plane elements, contrasting round and angular forms. Remnants of representation are to be found alongside almost abstract forms and pictorial elements that oscillate between the two poles. Color sometimes appears sharply outlined, at other times it flows out over the forms. Egon von Rüden uses a woodcut from the Blaue Reiter almanac to describe this rejection of any rational approach: "The

eye, which demands a natural, orderly progression, immediately loses all sense of direction. Whether it penetrates the white formal zone at the bottom right or follows the triple-staggered black planes, with each plane leaping directly into the eye: each of the pictorial values can only be experienced in a single detail.... No form follows logically from another. Each one demands, if its own 'inner sound' is to be perceived, the willingness to make a fresh visual start at every point. But the formal expectations to which the viewer is traditionally accustomed are repeatedly disappointed. Every obvious harmony, with its conciliatory resolution of all contradictions, is negated. Thus whereas all subject-related visual experiences, that is those that

promote visual empathy with the subject, are rejected, it becomes possible to experience objectivity as an elementary discord" (*Van de Velde – Kandinsky – Hölzel. Typologische Studien zur Entwicklung der gegenstandslosen Malerei* [Van de Velde – Kandinsky – Hölzel. Typological Studies in the Development of Nonrepresentational Painting], Wuppertal-Ratingen- Kastellaun, 1971, p. 19).
From 1920 Kandinsky did change his style, replacing such free figurations, with their expressive effect, with increasingly more geometrical forms that appear to show the influence of the constructivism and functionalism of the 1920s. But this change was hardly a guarantee of an inner transformation from a romantic to a rationalist, for it

continued to be a matter of endless variations on individual formal ideas, the inspiration of the artist as free agent, not experimental analysis of form-color effects such as interested Josef Albers, for example. However, in contrast to his own works, which were for the most part highly individual, his educational and theoretical work during the Bauhaus years was marked almost exclusively by the search for the "counterpoint of painting" as a universally valid grammar of forms and colors. It was a systematic attempt to investigate the effects and interrelationships of forms, taking their basic elements as a starting point. One should, however, be careful not to take this teaching – which he himself liked to describe as "regenerated art scholarship" – as a full-blown rational aesthetic. On the contrary, for him it was merely a preliminary stage on the path to a higher, spiritual art: "Only by way of this microscopic analysis will the study of art lead to a comprehensive synthesis, which will eventually extend far beyond the boundaries of art into the realm of the 'unity' of the 'human' and the 'divine.' It is the ultimate goal of the foreseeable future, but is still far removed from 'today'" (Wassily Kandinsky, *Punkt und Linie zu Fläche* [Point and Line to Plane], Munich, 1926, p. 15). His reflections on the contemporary upheavals in the natural sciences are also to be understood in this sense, when, for example, he makes a connection between his abstraction and the breakdown of the old concept of matter by modern astrophysics. Ultimately, what he does is merely to implant the new picture of the world given by the exact sciences in his own aesthetic-spiritual

**Wassily Kandinsky, Figurinen zu Bild XVI, Das große Tor von Kiew (Figurines for Picture XVI, The Great Gate of Kiev).** 1928, parts of the stage scenery for Mussorgsky's "Pictures at an Exhibition," tempera, watercolor and Indian ink on paper, 20.8 x 34.5 cm, Cologne University, Theaterwissenschaftliche Sammlung. • The figurines still suggest an element of representation. But they must be understood as "animated entities of color and form" for the stage – an abstract-concrete theater.

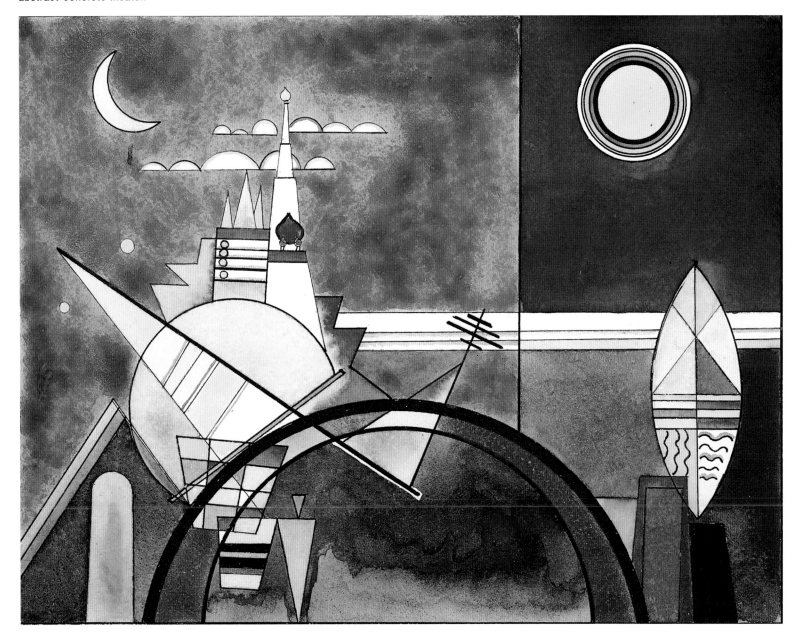

system. For the avant-garde, as Beat Wyss notes, "esoterics and exact science were not mutually exclusive" (*Mythologie der Aufklärung* [Mythology of the Enlightenment], Munich, 1993, p. 20). The more crucial point for Kandinsky was that he regarded such bodies of rules exclusively as an abstract craft and never equated them with true artistry. Behind this contrast was the question that was central for the entire Bauhaus: whether art could be taught at all. For if this was not the case, then his claim, described above, to create from subjective intuition, that is to say, the inspiration of genius, would begin to crumble. Thus even at an early stage he relativized his own life-long search for "counterpoint": "These supposed rules, which will soon lead to a 'figured

**Wassily Kandinsky, Gespannt im Winkel (Tension in the Angle).** February 1930, oil on card, 48.5 x 53.5 cm, Kunstmuseum, Bern, Stiftung Othmar Huber. • Again and again Kandinsky varies the artistic laws of color and form which he developed in his systematic reflections. Here he creates extreme tension between a medium-sized floating circle and an acute angle; a contrast which is harmoniously balanced out by the "valency" of the sickle-shaped lower arm of the angle.

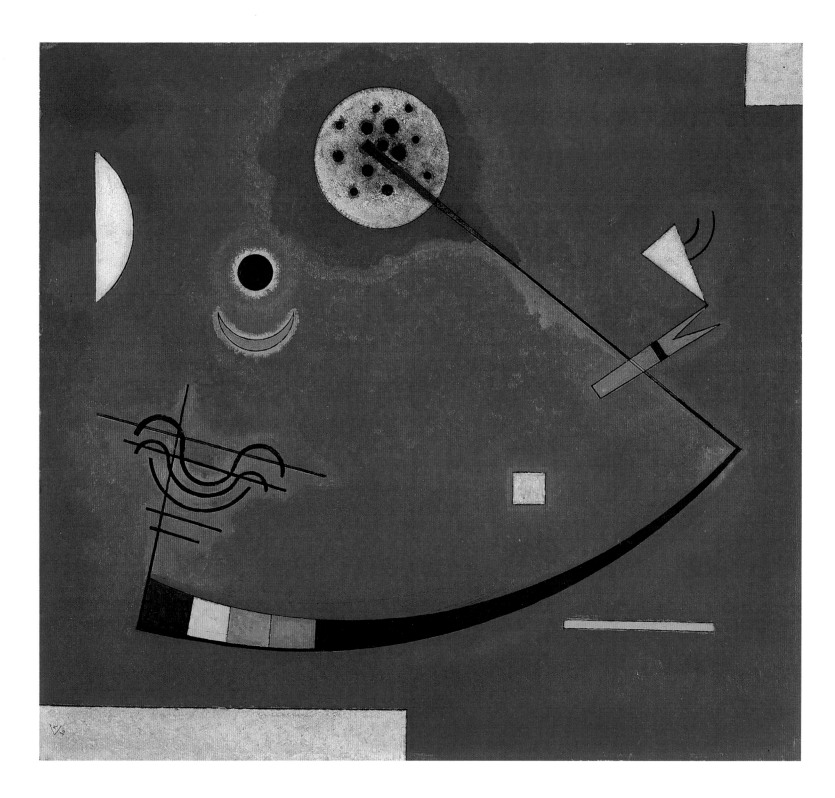

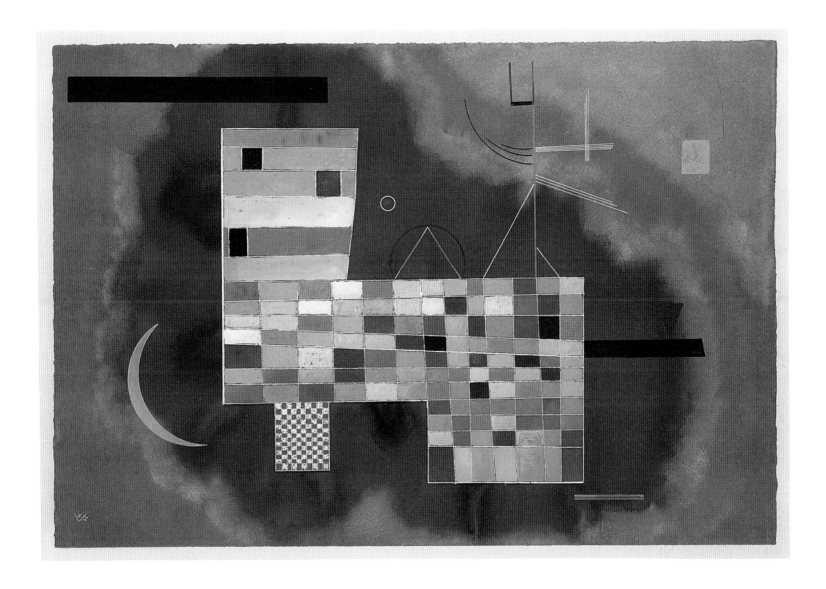

**Wassily Kandinsky, Massiver Bau (Massive Building).** 1932, gouache on paper, mounted on card, sheet 33.0 x 48.8 cm, card 46.8 x 33.0 cm, Öffentliche Kunstsammlung, Kupferstichkabinett, Basel. • The attempt to resolve the tensions which dominate the picture into a harmonious balance was typical of Kandinsky's style during the Bauhaus years. One is struck by the artistic proximity of this picture to the style of Klee, whose ambition was likewise the harmonious balance of opposites.

bass' in painting, are merely the knowledge of the inner effect of individual artistic elements and their combination. But there will never be such a thing as rules which would make it possible to determine, in any particular case, the necessary application of formal effects and the combination of individual elements" (Wassily Kandinsky, "Über die Formfrage" [On the Question of Form] in his *Almanac 1912*, Munich, 1912). Hence the intuitive ability to find the right thing here was a sign of genius after all, and there was scarcely any place for this in everyday design work in the service of industry. The paradox

is hardly resolved by the artist's repeatedly cited synaesthetic ability, the ability to establish necessary connections between colors, forms, sounds or other sensory impressions – for example, to relate, as a matter of rule, a musical note to a particular color. For correspondences such as these apply only to the individual world of his imagination. Thus Kandinsky's legendary lectures and exercises on form and color are ultimately a matter of squaring the circle. He seeks an objective formal law, but only in order to relate art once again entirely to his own subjectivity. It was for this reason that his efforts to comply, at

last, with Goethe's old demand for a "figured bass" for painting, were bound to fail. As the exponent of a radical late 19th-century aesthetic of autonomy, he was unable to go along with what was probably the most fruitful idea to come out of the Bauhaus: that there is no real contradiction between law and individuality, function and form, but both go together as one.

# The Paradoxical Fame of a Bauhaus Master – a Prince among Painters as an Artist of Theory

Norbert M. Schmitz

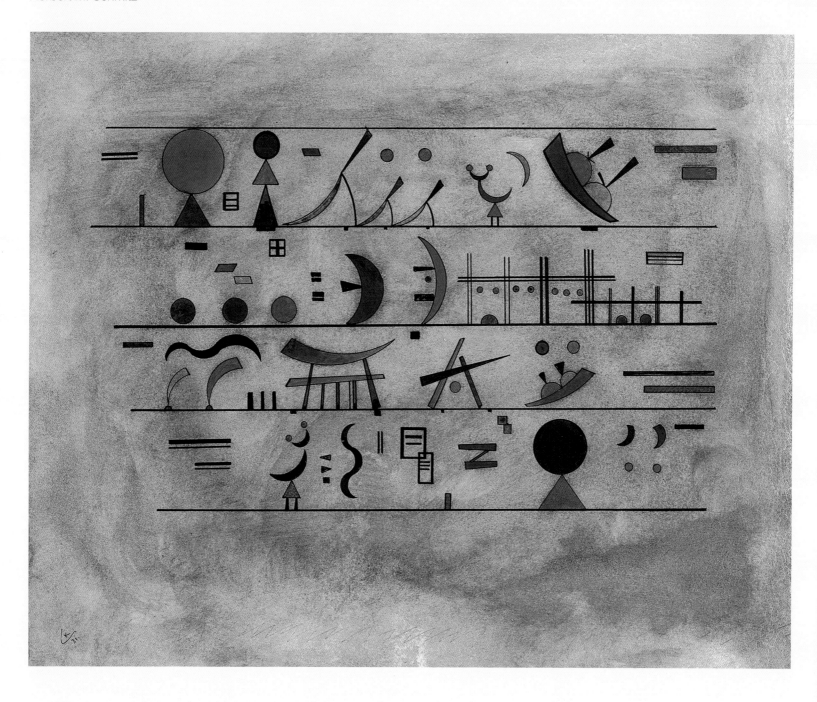

The question still arises: why did Gropius back an irrationalist like Kandinsky? Despite some ambitions as an Expressionist cultural critic, Gropius was to become the driving force behind the Bauhaus's change to a pragmatically oriented training institution geared to the demands of industry. The reason was neither to be found solely in Kandinsky's famous oeuvre, nor in his teaching, which was somewhat marginal compared with other Bauhaus teachers, but rather in the artist's own contradictory nature. On the one hand he claimed the freedom of autonomous art for himself, but at the same time he wished to lay the foundations of an aesthetic that was oriented toward life.

Kandinsky's ambivalent stance between law and intuition, the establishment of what was after all an artistic canon of a very academic kind, and, simultaneously, the expressive rhetoric with which this body of rules was repeatedly jettisoned: all this was in line with the contradictory nature of the entire Bauhaus, and indeed of a considerable part of the international avant-garde in general. This made him the ideal figure to be identified with and to integrate such a heterogeneous reform-minded school. Moreover, his general popularity as a founder of abstract art went far beyond the narrow confines of the institution and was a highly effective advertisement for the entire school.

But there was something else that pointed more clearly to the future: Arnold Gehlen has rightly described Kandinsky as one of the most important artists of classical modernism, precisely because his theoretical reflections compensated for the radical openness of his art: "The unarmed mind of some viewer or other takes from them only some incidental mood or formal charm, a state of mind, and it is simply crude to imagine that this means that one has grasped the thing itself. This latter was much more subtle and eccentric than anyone would suspect without their own 'literature'" (Arnold Gehlen, *Zeit-Bilder* [Images of the Age], Frankfurt am Main, 3rd impression, 1986, p. 119).

Art historians are fond of distinguishing between the artist's romantic spirituality and the liking for strict analysis which can be seen in his theoretical writings. Yet it was precisely the radical irrationalism of his art which necessitated such comprehensive reflection by the man who was the first real artist of theory. Precisely because the images in Kandinsky's pictures have no firm meaning that can be intersubjectively verified – because they leave it open to the public to interpret them however they see fit, or else can simply be perceived as decorative wallpaper – he tried to make his art more intelligible by means of his voluminous theoretical reflections. Hence the paradox lies in the fact that it was this radical irrationalism, of all things, that elicited such painstaking theoretical reflection on every artistic action, however slight. In the end his theoretical reflections became more significant than his actual works. At the Bauhaus, this meant that it was no longer the master's artistic ability but the usefulness of his thinking that was his really significant contribution. It was, however, others who continued radically along this path and cleansed it of the spiritualistic elements depicted there, while Kandinsky escaped into the past in his master class.

**Wassily Kandinsky, Zu grün (On Green).** 1928, watercolor, sprayed, framed with strips of watercolored paper, on card, 50.0 x 24.6 cm, Kunstmuseum, Bern, Klee Museum. • Such floating forms on the theme of "green" can hardly be treated as obligatory models for application in practical design. But as a mannerism of the grand master of the avant-garde, they became part of the cliché of the "Bauhaus style."

**Wassily Kandinsky, Zeichenreihen (Series of Signs).** 1931, Indian ink and tempera on paper, 41.5 x 50.5 cm, Öffentliche Kunstsammlung, Kupferstich-kabinett, Basel (illustration on the left). • Kandinsky was interested, both theoretically and practically, in the nature of the letters of the alphabet. Thus in *Series of Signs* he looks back at the mystical interpretation of Egyptian hieroglyphics as magical signs: word, image, letter and form are parts of a new metaphysical language.

**Wassily Kandinsky, Einige Kreise (Some Circles).** January–February, 1926, oil on canvas, 140.3 x 140.7 cm, Solomon R.Guggenheim Museum, NYC. • The title of the picture – traditionally either an explanation of content or a simple means of locating a work within an artist's output – was for Kandinsky an integral part of the artistic expression: one of the picture's many "inner sounds."

# Lyonel Feininger

Martin Faass

On May 20, 1919 the Weimar regional newspaper the *Landeszeitung* reported: "The Berlin painter Lyonel Feininger, one of the most convinced champions of Futuristic notions ... has just been engaged as a teacher by Walter Gropius, the new director of the Weimar Art School" (*Das frühe Bauhaus und Johannes Itten* [The Early Bauhaus and Johannes Itten], exhibition catalogue, Ostfildern, 1994, p. 387). The new teacher had arrived in Weimar the day before and, almost as soon as he arrived, had been taken by Gropius on a tour of the Bauhaus school. He was enthusiastic about the premises. "But, you know," he wrote to his wife after being shown around, "the most splendid thing of all is the new studio! Well – a room, on the top floor ... a straight window and then in the top third a slanting window ... with central heating of course, and then the view! You can see as far as the Ettersberg, over the gardens, the roofs and the town – indescribable! And that's just the studio.... He (Gropius) took me all over the school, and I saw the copper-plate printing room too! Ah, splendid! You know, it will be like being in a painter's heaven for us!" (letter to Julia Feininger, Weimar, May 19, 1919).

Feininger was the first of a series of renowned artists appointed by Gropius as masters at the Bauhaus. The two men had known each other in Berlin, where they had been members of the Arbeitsrat für Kunst (Working Council on Art) – an association of artists which had been set up in November of 1919 in parallel to the workers' and soldiers' councils, to

**Portrait of Lyonel Feininger.** About 1929, photograph by Andreas Feininger, BHA. • The budding master photographer takes a portrait photograph of his father, the Bauhaus master. The closely cropped face appears serious, almost austere, and does not at all suggest a "Papileo," as Lyonel Feininger was affectionately called by his family and his host of followers at the Bauhaus.

**Lyonel Feininger, Toys.** 1922–1923, wood, colored, varying dimensions, BHA. • Feininger was fascinated by modern machinery: he caricatured it in early stories about cars in comics, took it up in romantic watercolor studies of steam locomotives, and transferred it to childhood dreams of the railroad.

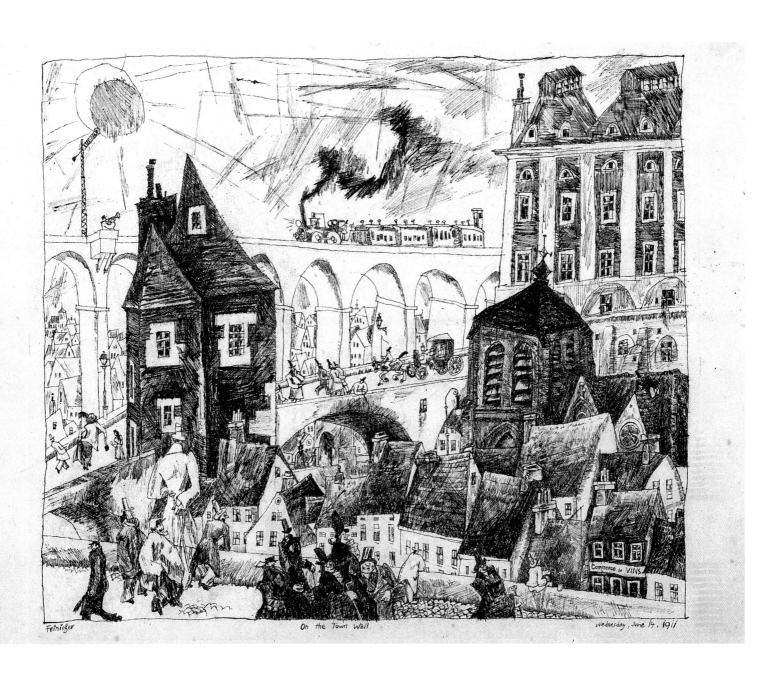

Feininger       On the Town Wall       Wednesday, June 14, 1911

take advantage of the postwar political upheavals to bring about a radical reordering of cultural life. Like almost all Bauhaus masters in the early days, Feininger had emerged from the germ cell and meeting point of Expressionism, Herwarth Walden's Sturm Gallery in Berlin. He exhibited his early Cubist paintings there, at the first German fall salon in 1913, and also had his first big one-man show there in 1917.

Lyonel Feininger, an American of German extraction, was well known as a cartoonist. He moved to Germany in 1887. After studying for only a few semesters at the Allgemeine Gewerbeschule in Hamburg and at the Berlin Academy, he was supplying cartoons for all the big humorous papers. Despite his success

he soon grew tired of playing the clown with his drawings, and therefore opted, in 1908, for free art. Feininger was decisively influenced by the French Cubists. It was through them that he discovered his own particular type of picture in 1911: the architectural portrait, analyzed, crystallized and abstractly distorted. Whereas his early work was a continuation of his output as a cartoonist, and was still marked by grotesque figures, the compositions that followed were devoted above all to simple village churches. It is to these that Feininger owes his reputation as a German Cubist.

Feininger's appointment was closely followed by the opponents of the Bauhaus, the old-established professors at the School of Fine

**Lyonel Feininger, On the Town Wall.** June 14, 1911, Indian ink, 24.0 x 31.2 cm, Graphische Sammlung Albertina, Vienna. • Although Feininger was to banish any reminder of present time and place in the timelessness of his "modern panoramas," here one looks from the town wall directly into a scene from the good old days: a steam locomotive on a viaduct, a stage-coach, trumpeters, anglers, and the dandy as man-about-town – these become the sentimental insignia of the 19th century.

Lyonel Feininger

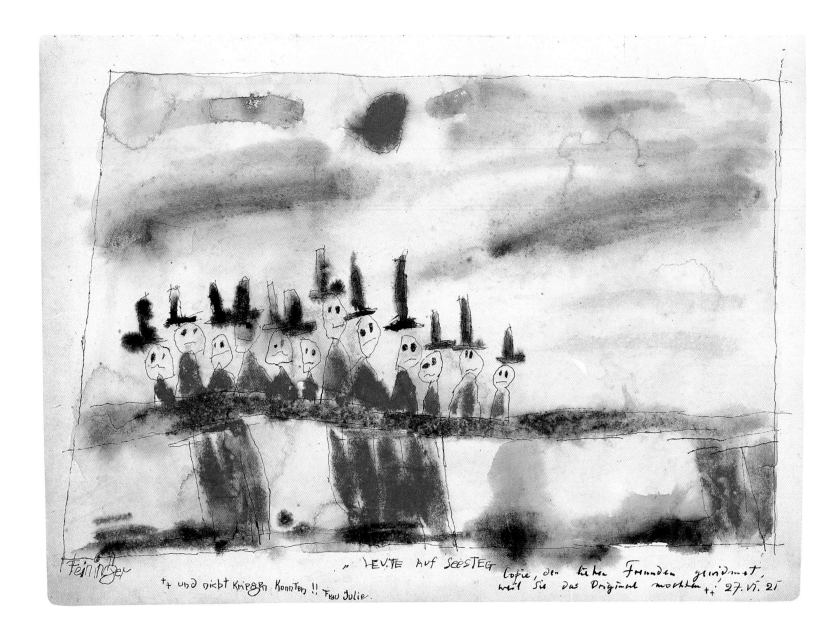

"LEVTE AUF SEESTEG

Art, the members of the art association and conservative local politicians. Being the first, it caused a much louder outcry than all subsequent appointments. Now the cultural dilapidation, which was feared from the new school, had a name at last: Lyonel Feininger. The absurdest accusations were to be heard: people said that he was an agent of subversion and a corrupter of young people. "I am regarded here as a kind of werewolf, about to pounce on the young ..." an amused Feininger wrote to his wife after a week in Weimar, "and even some of the students themselves are quite frightened" (letter to Julia Feininger, Weimar, May 26, 1919).

His first task was to enlighten people, make peace and mediate, and Feininger managed to do this without great difficulty. For there was too obvious a disparity between the new teacher, with his charm and his artistic moderation, and the Cubist thug that had been expected. Some of the former professors at the School of Fine Art, such as Klemm and Engelmann, soon became friendly toward him, and even hoped to use his influence to curb Gropius, who was energetically pushing for modernization. In this way Feininger played an important part in the integration of the early Weimar Bauhaus.

Feininger was appointed form master of the printing and graphics workshop – with good reason, for since 1917 he had been intensively studying woodcut technique. This made him one of the few Bauhaus masters who really knew something about the craft aspect of their workshops. One of the first works produced at

**Lyonel Feininger, Leute auf Seesteg (People on the Sea Path).** June 27, 1921, sheet from the visitors' book of Alfred and Tekla Hess, watercolor and pen on paper, 19.6 x 27.0 cm, BHA. • In Georg Hermann's study published in 1901, *Caricature in the 19th century,* Feininger is lauded as being better at drawing than anyone else in Berlin: "... he has the ability to cover a sheet with comic little figures, weird ideas that spring from his playful way of drawing; and equally he has within him a fairytale imagination that is all his own and is irresistibly comical."

**Lyonel Feininger, Gespensterchen, gutartige (Little Ghosts, good-natured ones).** December 21, 1922, sheet from the visitors' book of Alfred and Tekla Hess, watercolor and pen in paper, 27.8 x 21.2 cm, BHA. • Hess, a shoe manufacturer in Erfurt, was a collector and patron of modern art. His visitors included not only the Bauhaus masters but also Germany's musical and literary avant-garde. Feininger, who has four entries in the visitors' books, reminds us with these wintry goblins of his work as a cartoonist between 1890 and 1910.

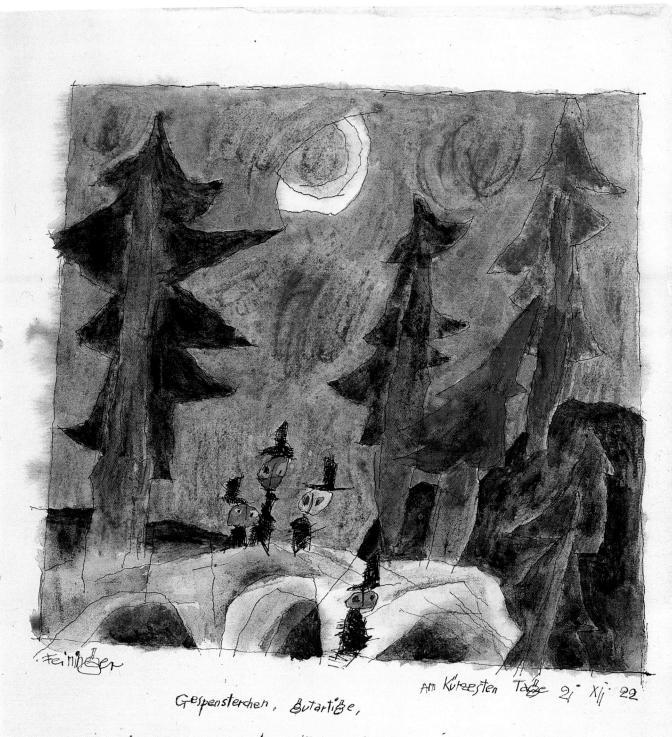

Gespensterchen, Gutartige,

den lieben Freunden ins schöne neue Stammbuch

von ihrem getreuen Maler

Lyonel Feininger

Am Kürzesten Tage 21· Xⁱⁱ 22

Lyonel Feininger

the Bauhaus was Feininger's *Cathedral* woodcut which was reproduced on the title page of the Bauhaus manifesto. The print shows a church crowned with stars, an allusion to the romantic idea of the unity of arts and crafts in the Middle Ages.

In October 1921 the council of masters decided to produce the so-called Bauhaus Portfolios, five portfolios of modern graphic works. The portfolios were printed in-house and distributed partly via external publishing houses and partly by the Bauhaus itself. For Feininger, the master responsible for form, this was of course an extremely attractive project, but it also entailed a good deal of extra work. The graphic design of the portfolios had to be developed, the title pages and tables of contents had to be designed, the question of what kind of paper to use had to be decided, and printing had to be supervised. At times the task was too much for Feininger: "I have a really dreadful amount to do," he complained in a letter to his wife, "... all those things for the portfolios, up to my ears in writing ... but I have taken it on and must see it through, for the Bauhaus masters' portfolio is in my hands, entirely, and is after all being created in honor of our cause" (letter to Julia Feininger, Weimar, November 14, 1921).

Feininger had no teaching experience when he joined the Bauhaus, and in his own estimation he had no aptitude at all as a teacher. A few years earlier he had still been fundamentally skeptical about the usefulness of artistic training. He had reacted to Herwarth Walden's plan to open a Sturm art school with the comment: "I am filled with horror when I think of the number of people who will be 'trained' in this way.... The only thing that can keep Expressionist art alive is for everybody to find out how to become artists by themselves" (letter to Julia Feininger, Berlin, July 15, 1916). Now that he was a teacher himself his view was no longer so radical. But even now he did not think that it was meaningful to offer anything more than help to students wanting to find themselves as artists.

The "evening performance," which he took turns to do like all the masters, was the only event at which he stood in front of a class as a lecturer. He never did any systematic teaching,

**Lyonel Feininger, Fischerboote (Fishing Boats).** 1927, Indian ink and watercolor on paper, 23.8 x 38.0 cm, G. and A. Jenny, CH-Dornach, Courtesy of Galerie Thomas, Munich. • Summers in Deep, a village on the Baltic, were part of the family tradition. Feininger's sons photographed their father drawing in his "cubbyhole" on the veranda of the holiday house. With the cool, flashing blue of the sails, this study of Deep evokes, almost in the manner of a woodcut, a change of weather at sea, with the Cubist "inwardly reshaping and crystallizing" what he observes.

**Lyonel Feininger, Untitled (red sea and yellow ships).** 1933, Indian ink and watercolor, 28.3 x 37.3 cm, private collection. • Feininger's earliest childhood impressions were of frigates and yachts. The painter, who was born in New York, grew up by the East River and devoted a large part of his artistic work to seascapes and nautical motifs.

as Kandinsky and Klee did. He wanted neither to impart anything to his students nor to demand anything from them, but rather "to be of use to them and set them on the right road, by freely interacting with them, exchanging ideas and establishing a rapport with them" (letter to Julia Feininger, Weimar, June 29, 1919). He was thus more of a friendly uncle than a teacher, affectionately called "Papileo" by everyone.

He had great difficulty in evaluating students' achievements. For example, in 1919 he was vehemently opposed to deciding after only a single semester whether students were to be

definitely accepted or not. "... many hopes are shattered there, if the council comes to a negative decision," he pointed out (letter to Julia Feininger, Weimar, July 8, 1919). Of course he always had his own tangled artistic development at the back of his mind: "What would have become of me, without time, without torment, without struggle? I am really not a genius; it was just that painting was perhaps the most difficult thing of all and I did not mature until I was 45" (ibid). Feininger's impact on the Bauhaus came not from his teaching but from his personality and his art. It was through these that he conveyed much of

what mattered to him as an artist: respect for the forms of nature, critical detachment from one's own work and understanding of the need for hard work. Over the years a trend made itself increasingly felt at the Bauhaus: teaching and workshop practice should be geared to the needs of industry. This resulted in particular in changes to the teaching staff. In 1923 the Hungarian Constructivist Moholy-Nagy was appointed to replace the departing Expressionist Itten. Moholy-Nagy "dressed like an industrial worker and did not spend much time on metaphysics" (Frank Whitford, *Das Bauhaus*, Munich, 1994, p. 35). The Bauhaus then

increasingly became a production site, "with its center of gravity in the design and manufacture of industrial prototypes" (Rainer K. Wick, *Bauhaus-Pädagogik* [Teaching at the Bauhaus], Cologne, 1982, p. 36). Teaching was now planned above all to further the versatile application and development of technology, whereas artistic training receded more and more into the background. Feininger observed this development with great anxiety. Highly though he esteemed Moholy personally, he could not agree with his teaching and the change of direction that went hand in hand with it at the Bauhaus.

"The direction taken by the Bauhaus is becoming more precise," he wrote in connection with a lecture by Moholy-Nagy in 1925, "this article causes me great distress! Only optics, mechanics, no further use for the *old* static painting, that you have to *look into* first. Again and again the talk is of the cinema, optics,

**Lyonel Feininger, Night photograph of the south side of the studio block of the Dessau Bauhaus building.** 1929, photograph, gelatin process, 17.9 x 14.3 cm, BHA. • A number of atmospheric nighttime photographs of the Bauhaus building by Lyonel Feininger have been preserved. Like other modern painters, used photographs as aide-mémoires and sources when working on a painting.

**Lyonel Feininger, Heiligenhafen (Sacred Harbor).** Inscribed "Mont. d. 20 Feb. 1922," watercolor and pen, 29.6 x 37.5 cm, Ludwig Museum, Cologne, Stiftung Haubrich. • Landscape views, especially the mock-Gothic village church in Gelmeroda, were among Feininger's favorite motifs: "There are church steeples in godforsaken little places which for me are the most mystical thing that I know, coming from the so-called cultured people."

mechanics, projection and locomotion, and even of mechanically manufactured diapositive slides, in the most beautiful colors of the spectrum, which can be kept like gramophone records and inserted as required in front of a projection lamp in order to project the pictures onto the wall. We may tell ourselves that it is dreadful, the end of all art, but this approach is acknowledged by Gropius as the correct one.... Is that an atmosphere in which *painters* like Klee and some of us can continue? Klee was very apprehensive when he was talking about Moholy yesterday. He thinks he is terrible, with his stereotyped intellectuality" (letter to Julia Feininger, Weimar, March 9, 1925).

Nevertheless the new trends did have some influence on Feininger's artistic output. The strongly expressive puzzle pictures with cubic forms and the free scrawling reminiscent of Klee, as we find them before 1920, were increasingly ousted by a compositional technique marked by a stratification of geometric forms in planes, and by ruled lines.

Feininger had for some time been dissatisfied with his activity at the "box of bricks," as he now called the school with increasing frequency. This was not only because of the triumph of functionalism and mechanics. The demands made on him by the printing workshop, and the institutional commitments such

**Lyonel Feininger, Manhatten IV B.** 1937, watercolor, 31.4 x 24.1 cm, Marlborough International Fine Art, Est. • Forced into exile in the land of his birth, Feininger took possession of the monumental façades of Manhattan as he had previously taken the picturesque aspects of German landscapes and towns. Architectural volumes become transparent, but they are dominated here by a two-dimensionality in the representation of grid-like skyscraper surfaces.

as the council of masters, which kept him away from his painting, had contributed to his discontent. He therefore considered very carefully, just as Klee had, whether or not he should follow the Bauhaus to Dessau. He wanted to, but only on one condition: that he would be completely free to work on his own artworks. This condition was granted unhesitatingly, and so on July 30, 1926 he moved with his family into one of the masters' duplex houses in the Burgkühnauer Allee. As a master without teaching commitments he was now able to devote himself entirely to his artistic work. In 1929 he had the time to accept a commission from the municipality of Halle for a portrait of the town. His intensive study of motifs of the town eventually led to a whole series of paintings.

Feininger continued to be a member of the Bauhaus until 1932, when, under the pressure of political circumstances, the school moved to Berlin. The same pressure led him to return to New York five years later. He spent the last years of his life there. In these surroundings, both excitingly new and at the same time old and familiar, he discovered a whole new world of motifs: the high-rise architecture of Manhattan. It occupied his attention again and again in the relaxed line drawings of his late works, though without being, by itself, sufficient for him. Until his death in 1956, he found it painful to be separated from his beloved motifs, the village churches of Thuringia and the Baltic landscapes. There was some compensation in the sketches that he had taken with him, which enabled him to give new form to these motifs and were an important part of his last creative phase.

**Lyonel and Julia Feininger in the studio of the master's duplex house, Dessau,** 1927, photographer unknown, BHA. • The Feiningers shared a master's duplex house with the Moholy-Nagy family. While the latter provided the interior of Gropius's architecture with "lucid, spare and simple forms," Feininger, Klee and Kandinsky (the "princes among painters") preferred an exciting décor for their houses which offset austerity with "old-fashioned" elements such as a Thonet chair or a Persian carpet.

**Lyonel Feininger, Der rote Geiger (The Red Violinist).** 1921, Indian ink and watercolor, 30.8 x 24.0 cm, private collection. • The fact that his father was a violinist and that he himself passionately loved to make music may have been the source of numerous musical motifs in Feininger's works. Like a "Golem" with a roguish expression, the musician walks through a medieval scene such as the designers Röhrig and Herlth were creating at the same time for German silent films.

Feininger

Der rote Geiger

Feb. 1921

P. L. F.

# Feininger's Fugues – the Domestic Music of the Masters as an Expression of Conservative Sentiments?

Christoph Metzger

Of all the Bauhaus masters, only Feininger and Klee had had a musical training extending over a number of years, acquired in their parental homes. Klee's diaries give evidence of numerous visits to concerts during his Munich period. Unlike Klee, Kandinsky and Itten, however, Feininger was not interested in transferring the laws of music to drawing and painting. He saw music and painting as different forms of artistic expression, each subject to their own laws and of equal importance to him. In his youth he was taught the violin by his father, who had worked as a violinist at the New York Metropolitan Opera. Later he taught himself to play the piano. He particularly admired Bach's *Well-tempered Clavier* as arranged by Busoni in the style of the time.

Feininger's concern with music culminated in the composition of pieces for piano and organ in the early 1920s. In contrast to the arrangements of scores and the musical sketches of other artists at the Bauhaus, that were intended to create a synaesthetic experience of sound and color, or the improvised jazz of the Bauhaus Band, the 12 completed fugues by Feininger must be considered as the ambitious compositions of a musician. Feininger composed a total of three fugues for piano and nine for organ. These 12 completed compositions were published by Laurence Feininger in 1971, in a special edition which for the first time made it possible to view Feininger's musical output in its entirety. With the exception of the Fugues Nos. 1 and 3, the works were composed in Weimar between 1921 and 1927. Feininger was amending his scores until well into the 1930s. He even perfected the process of writing the music down by using zinc templates for the note heads, clefs and rests.

By 1921–1922 seven fugues had been written, notwithstanding some doubts on Feininger's part – at the end of the first fugue, for example, he noted, "Tut, tut, tut – it's all wrong." Julia Feininger, his second wife, submitted that first fugue to Erich Moritz von Hornbostel, the famous Berlin musicologist, asking for his opinion of it. He spoke kindly of the work. In a letter dating from late 1922 Feininger explained the difficulties of the composition, using concepts such as "counterpoint," "part-writing," "pedal point," etc. The flow of the handwriting in the letter creates the impression that a committed composer is speaking here.

Feininger really did live in and with Bach's piano works. His skill as a pianist was not highly developed, but an excellent memory enabled him to play works by Bach from memory at an early stage. He never performed his compositions himself in public, nor even among his students. He is reported to have frequently improvised on his harmonium, which he had in his studio. He also had his own fugues performed for him on the harmonium by an organist by the name of Hansen while he worked on his pictures.

If one looks more closely at the fugues for piano Nos. 1–3 (Fugue No. 3 is a gigue), the pieces do in essence comply with the techniques of fugal writing. Using quaver and semiquaver figures which are in constant motion, a compact flow of energy is achieved that is reminiscent of baroque compositions. But the subjects of the early piano and late organ fugues lack the necessary concentration. There is not a single subject with the unmistakable, terse shape required by a fugue if the subject is to be recognized in the denser textures of the part writing. Moreover, the treatment of harmonic progressions raises questions that can only be answered in terms of Feininger's relatively slight knowledge of strict formal fugue technique. Nevertheless the two- to five-part fugues are technically ambitious compositions. Feininger's choice of different keys showed clearly that his intention was to follow his great model, Bach: *The Well-tempered Clavier* contains 24 fugues in all major and minor keys.

Feininger's fugues have only rarely been performed since 1926. However, the layout and choice of compositional procedures make it clear that Feininger deserves to be named along with Ferruccio Busoni, Paul Hindemith and Max Reger as an important contributor to the reception of Bach in the 1920s, even though his output as a composer can only to a limited extent bear a

LEO studies Bach. Fugues.

**Feininger's music room in the master's house in Dessau.** Undated, photograph by Andreas Feininger (?), BHA. • Clearly recognizable: the music of Bach, the master of the fugue. The Feiningers' house was probably the only one of all the masters' houses in Dessau to have a music room.

**Lyonel Feininger, Leo studies Bach fugues, marginal drawing (much enlarged) from a letter to Fred Werner.** 1890–1891, Art Gallery of New South Wales, Sydney. • With its self-irony, this sketch gives a humorous view of the musician's daily bread: practice, even when it costs sweat and tears. In the same year, having moved from New York to Berlin, Feininger published his first cartoons, 14 of them, in the *Humoristische Blätter* (Humorous Pages).

qualitative comparison with these composers. His son, Laurence Feininger, who was himself a musicologist, expressed the view that "my father's fugues, notwithstanding their modest quantity, constitute a wholly valid creative achievement and are of equal importance, at least within his total output, with any other area of his creativity ... it is a total oeuvre, which is incomplete without the music" (*Das musikalische Werk Lyonel Feiningers* [The Musical Work of Lyonel Feininger], Tutzing, 1971). Against the background of the upgrading of the craft element at the Bauhaus, the fugue, as the most highly developed system of musical logic, underwent a

notable revival in the compositions of the time. In the fugue an intellectual principle was recognized, which at times even took on a national coloring. Feininger's fugues shared with his pictures their interest in history as a thematic source. His works as a painter combined these subjects with the most recent techniques in the handling of color planes; in this respect they are close to Cubism. The spiritual in art, as expounded by Kandinsky and Klee, was appropriated by Feininger by way of his historical understanding of musical form. The composer Feininger is therefore to be regarded as a master with conservative sentiments.

# Oskar Schlemmer

Kay Kirchmann

Oskar Schlemmer was born in Stuttgart in 1888. During his years at the Bauhaus, from December 1920 to 1929, when he finally moved to the Academy in Breslau, he was undoubedly a mediator between the conceptual and aesthetic extremes at the Bauhaus. In the advertising flier of 1923, "The first Bauhaus Exhibition in Weimar," he himself had interpreted the controversies which he encountered there between the late-Romantic desire of a man like Johannes Itten to renew the world, and the Constructivism of people such as László Moholy-Nagy, as a mirror image of the turmoil of the contemporary world: "A school like this, a force for change, changing itself, involuntarily becomes a barometer of the upheavals in the political and intellectual life of the times, and the history of the Bauhaus becomes the history of present-day art" (The State Bauhaus in Weimar. Manifesto from the exhibition flier: "Die erste Bauhaus-ausstellung in Weimar" [The first Bauhaus exhibition in Weimar], 1923).

Taken as a whole, Schlemmer's work at the Bauhaus was an attempt to balance these tensions and contradictions. From his appointment to the Bauhaus until 1922 he was the master in charge of the murals workshop, from 1921 he directed the stone sculpture workshop, and from 1922–1926 the wood sculpture workshop. In 1923 he also took over the Bauhaus Theater Group. It is difficult to reconstruct a consistent account of his workshop teaching, but it probably tended to be more a matter of dealing with specific questions as they arose, while encouraging the students' individuality. In addition he taught a life class from 1921, and later figure drawing, and finally in 1928 took over teaching "The Human Being," a subject with a predominantly theoretical orientation.

Throughout all these years, Schlemmer's attitude toward the evolution of the Bauhaus remained ambivalent. Thus in the early phase he was one of the critics of the craft cult and consistently demanded a rapprochement with industry. But at the same time he saw himself as an artist, and such demands were precisely what an artist cannot achieve. Then, in 1922, he demanded a "reflection on the nature of art.... I cannot wish to do anything that is already being done better by industry, and nothing that engineers do better. What is left is the metaphysical: art" (*Briefe und Tagebücher* [Letters and Diaries], Stuttgart, 1977, p. 63). Incidentally, it was to be precisely that industry which later, in the shape of Herbert's paint factory in Wupperthal, gave the artist, who had in the meantime been vilified as "degenerate," employment and the opportunity of working, until his death in 1943.

**Portrait of Oskar Schlemmer.** 1928, sheet from the portfolio "9 jahre bauhaus. eine chronik" (9 years of bauhaus. a chronicle), photograph, gelatin process mounted on card behind a pink-colored passe-partout, 41.8 x 59.5 cm, BHA. • It was probably the student who had the greatest admiration for him who posed the master beneath the bell jar. Whether T. Lux Feininger was indeed the creator of this comically stylized portrait, set against a "shocking pink" background, is probable but cannot be proved.

Oskar Schlemmer, Das Triadische Ballett. Der Abstrakte (The Triadic Ballet. The Abstract). 1912–1922, sheet No. 13b from the sketch book of "Dance Figurines," watercolor on paper, 28.1 x 21.5 cm, Bühnen Archiv Oskar Schlemmer, Sammlung UJS. • Schlemmer's large-scale conception of the stage aimed at the reintegration of the human figure into an abstract total artwork – a harmonious intertwining of the human figure and pure form.

Along with his theater work, Schlemmer's most original contribution to the Bauhaus was his class on "The Human Being." Precisely because the radical spiritualism of a man like Itten, and the technological utopianism of the Constructivists, seemed to him to be equally problematic, he finally found in the human form a benchmark which amid the general turmoil of the time was the only thing left to hold fast to: "It remains to say that in today's world without gods an art of the great themes, such as monumental painting and sculpture, is left particularly forlorn. The foundations which

formerly supported it are either severely damaged or have vanished altogether: national consciousness, ethics, religion. The birth pangs of the New – controversial – unacknowledged" (Oskar Schlemmer, "Gestaltungsprinzipien bei der malerisch-plastischen Ausgestaltung des Werkstattgebäudes des Staatlichen Bauhauses Weimar" [Visual Design Principles for the Bauhaus Workshop Building in Weimar] in: Das Kunstblatt (Potsdam) 7, 1923, p. 340). Seen like this, the utopia of the early Bauhaus, as a communal enterprise for the creation of meaning under the primacy of architecture, as

Feininger represented it in 1919 in the famous Cathedral woodcut, seemed to Schlemmer to be a hopeless undertaking. Schlemmer's reinstatement of the human figure as the central point of reference for his entire creative output (even including architecture) superficially appears backward-looking. But it can only be understood at all in the context of his disillusionment with this ultimately romantic utopia: "Nevertheless one great theme remains, ancient, ever new, the subject of pictures in all ages: man, the human figure. It has been said of him that he is the measure of all things. So be it!

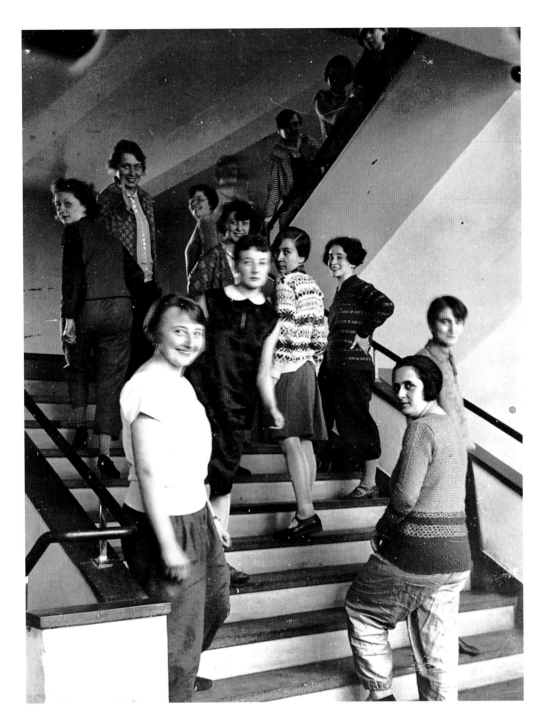

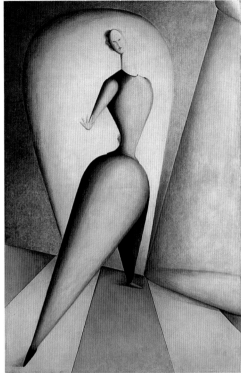

**Women weavers at the Bauhaus.** 1927, photograph by T. Lux Feininger, BHA. • Schlemmer developed the idea of the *Bauhaus Stairs* from this photograph. A comparison with the painting shows how he attempts to portray the individual figures as monumental types, but without abandoning the dignity of the human form.

Architecture is the noblest art of measurement. Ally yourselves!" (ibid). This is at first sight reminiscent of the classical doctrine of proportion, according to which even the dimensions of columns were derived from the human figure. But Schlemmer's stance is more than merely something left over from the 19th century. Rather, he developed his style against the background of an already developed avant-garde. Schlemmer had been perfectly familiar with avant-garde aesthetics since his period at the Stuttgart Academy, where he had attended the course on abstract art and Adolf Hölzel's

classes from 1906, being later promoted to the latter's master student. In those years, at the Sturm Gallery during a stay in Berlin, he also got to know the French avant-garde, especially Cézanne, and the reduction and formal analysis of the Cubists.

His characteristic style emerged in the period up to 1924. It was characterized at that time by the combination of a sober (but never strictly Constructivist) formal language and the constant recourse to the human figure. Despite occasionally approaching actual abstraction, Schlemmer remained essentially

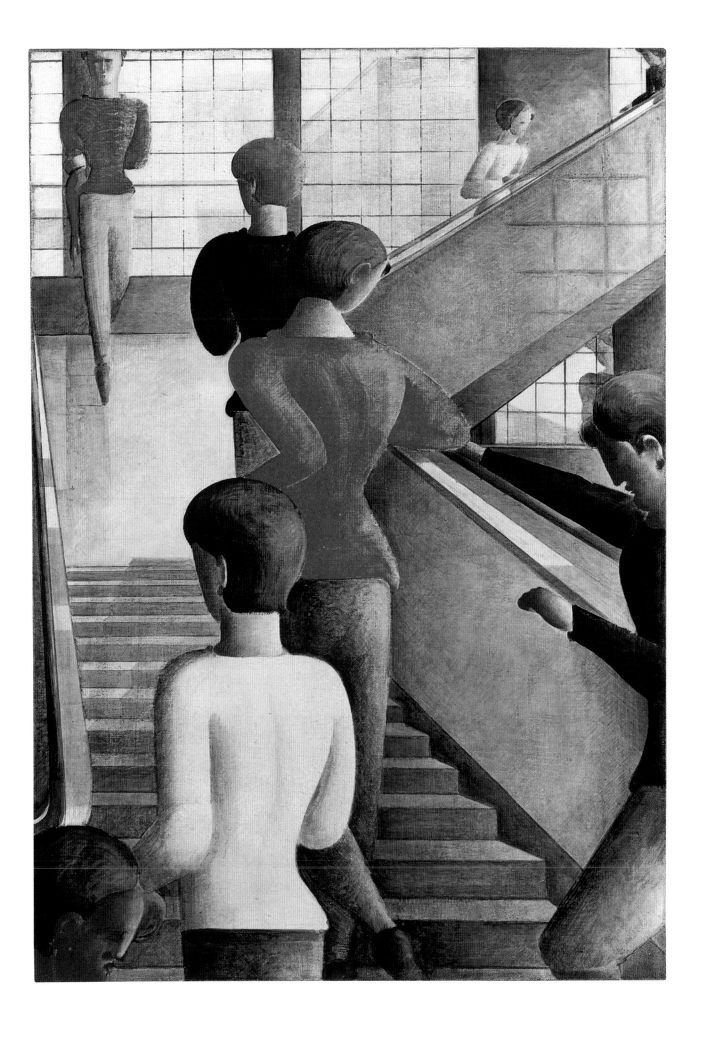

Oskar Schlemmer

**Oskar Schlemmer, Fensterbild XII, Raum mit sitzender Figur in violettem Schatten (Window Picture XII, Room with Seated Figure in Violet Shadow).** 1942, oil over pencil on laminated card, 30.6 x 20.7 cm, Oskar Schlemmer Archive and family estate. • Never was Schlemmer so certain that he was close to the synthesis "in which reality and abstraction, the truth of nature and the truth of art, are effortlessly united" as in the Wuppertal window paintings which he sketched from his flat in Döppersberg. The somber coloring and strict abstraction are in striking contrast to the quiet ideal of the apotheosis of the human figure.

**Oskar Schlemmer, Groteske (Grotesque Figure).** 1923, walnut, ivory and metal rod, 56.0 x 23.5 x 10.0 cm, Staatsgalerie Stuttgart, Oskar Schlemmer Archive and family estate. • For all its high degree of abstraction, this sculpture still shows some anthropomorphic features. For the artist, the question of how far he was able and willing to push nonrepresentationalism was much more than a purely formal, decorative matter. Experimenting in the area of tension between abstract, geometrical forms and the human figure became an obsession in his work, a conflict he was tragically unable to resolve.

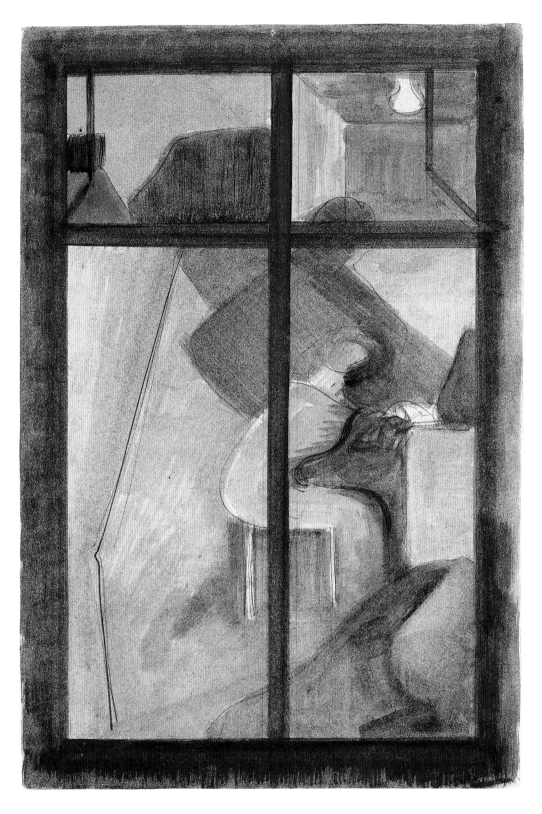

oriented toward representational art, though without ever aligning himself with the "verismo" of the New Functionalism. The more formal investigation of artistic resources remained no less remote to him: whereas, for example, the nudes of classical Cubism had primarily been pure vehicles for an analysis of aesthetic perception, Schlemmer's peculiarly faceless, de-individualized types, a characteristic feature of the large gallery pictures of the Bauhaus years, are always more than a mere pretext for artistic experiment. Rather, the type as a particular image of man is the real essence of his aesthetic. It is not possible here to set out in detail the often complicated and thoroughly contradictory utterances by the artist on this topic. But the question of this image of man is central, and became a programmatic issue for the Bauhaus teacher and master. It is revealing that the obvious transition to the complete autonomy of pure form – even where, as in the case of Kandinsky, it carried a metaphysical charge – ultimately remained just as alien to him as the absolute utilitarianism of a pure

Bauhaus functionalism. The significance of Schlemmer's abstracted figurines can be well illustrated by a comparison with Adolf Hölzel. Even though Hölzel, a cautious avant-gardist, rarely abandoned representation entirely, classical subjects such as the "Adoration of the Magi" were for him really only an object revealing the purely formal treatment of planes. Schlemmer, on the other hand, ultimately rejected such abstract aestheticism, above all because the empty space, mentioned above, in the view of the world of this "utopian without illusions" could not be filled in this way: "Then, knowledge of the means. One day we shall

stand there with our hands full of means ... we have everything, but nothing to say. Nothing to express. There is no idea" (Oskar Schlemmer, *Briefe und Tagebücher*. 1915 [Letters and Diaries], Stuttgart, 1977, p. 111). Schlemmer fully acknowledged, particularly as a teacher, the usefulness of such formal considerations, but for him the means had ultimately to find their justification in the human figure. For the equation of basic geometric forms and the human figure seemed to him part of nature itself. Consequently Schlemmer derived the formal canon of modernism directly from nature. As early as 1915 he formulated the matter thus:

"The square of the chest,
the circle of the belly,
cylinder of the neck,
cylinders of arms and thighs,
sphere of the joints at elbow, knee, armpit and knuckle,
sphere of the head, the eyes,
triangle of the nose.
The line that links heart and brain,
the line that links sight with what is seen,
the ornament formed between body and outside world,
its relationship to it symbolized."
(ibid, p. 22)

**Oskar Schlemmer, Der Mensch im Ideenkreis (Man in the Circle of Ideas).** 1928, Indian ink, pencil and colored pencils on paper, mounted on card 53.0 x 41.0 cm, Oskar Schlemmer Archive and family estate. • Schlemmer's presentation of the figure aimed to be more than a pure illustration of external anatomy. He saw the human figure rather as various interlocking circles of ideas "with graphic means of representation and scientific structure" on the road to a "transcendent world of ideas."

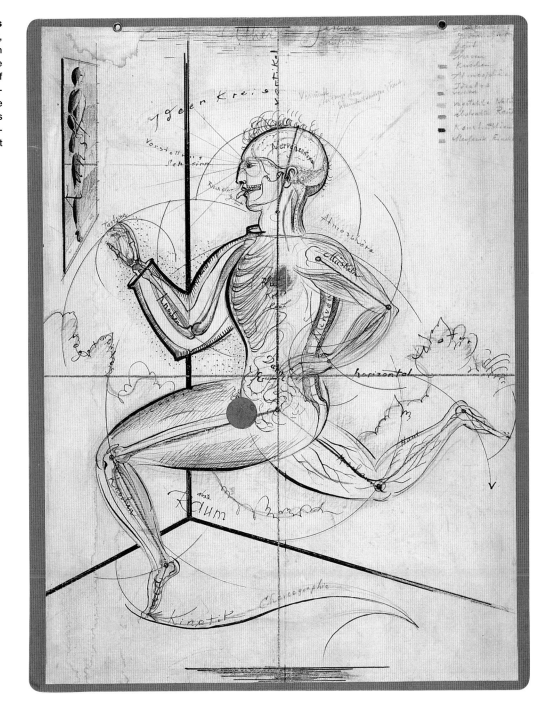

In his own work as a painter, as in his theater work and his teaching, Schlemmer was never concerned with either naturalism (which to him was irrelevant) or subjectivistic distortion in the representation of man, but always with shaping a type with the aim of general validity. "The elementary in the figurative is the type. To create it is the ultimate, supreme task.... The variation of the figurative subject is carried out sculpturally (in relief), and by color and line. The dimensions of the abstract figures are exaggerated: they are shown as very much larger and very much smaller than physical man, who should remain the measure and the center." (Oskar Schlemmer, *Gestaltungsprinzipien* [Principles of Design], p. 340). The range of variation in the degree of figuration formulated here is reflected in the works of painting and sculpture. Whereas in the abstract figure between 1921 and 1923 anthropomorphic features do ultimately appear, in the famous *Bauhaus Stairs* of 1932 the typifying element – notwithstanding all the individualistic, realistic factors – proves decisive. These antipodes are then radically formulated in the late works. The *Stadium Entrance* of 1930–1936 is clearly reminiscent of the heroically enhanced image of man in

the international Neo-Classicism of those years. But in the *Paint Cabinet* from 1941 an anthropological foundation can scarcely be discerned.

Even more unequivocally than his own works, Schlemmer's teaching was characterized by a concern with the human figure that was unique at the Bauhaus, nor did he shrink from life drawing which was regarded as academic and hence suspect. Quite the contrary: objective knowledge of the body was in his view the fundamental prerequisite of artistic work: "to conceive the nude as supreme nature, so to speak, the most delicate articulation and organization, as an edifice of flesh, muscles, bones" (Oskar Schlemmer, *Der Mensch* [Man], Mainz-Berlin, 1969, p. 41). Building on this, an appreciation can be developed of what is essential, the functional coherence of the body. Regardless of this somewhat sober exercise, Schlemmer tried to avoid any academic dryness by heightening the atmosphere (playing gramophone music or transferring the lesson to the stage) and unusual lighting. Even though one might argue about the extent to which some of Schlemmer's own nudes show highly academic features, his central concern was to integrate such study of the body into a comprehensive teaching course that was philosophical, scientific and speculative. This concern was later given an institutional framework in the course on "The Human Being." This course consisted of a practical and a theoretical part: the former included theories of proportion from Polyclitus to Carus, the study of structures and types of head and, as an essential component, analysis of human movement in space. Entirely in the spirit of former academic teaching, Schlemmer took as his starting point schematic basic forms such as simple skeletal lines and cubes. By using these, an understanding of both the body and its movements and relationship to space was developed. Here too Schlemmer was not concerned with the study of physiological functions, for example the workings of muscles, in isolation. However, he considered that such a foundation of art was indispensable, because it alone made it possible to put "intellectualized knowledge of the body at the service of intentions that lie beyond correctness" (ibid). Accordingly, in the theoretical part analysis should, along with some consideration of physiology and hygiene, be complemented above all by a philosophical anthropology culminating in "metaphysical insights ... in order to clarify questions of aesthetics and ethics" (Oskar Schlemmer, "Unterrichtsgebiete" [Areas of Teaching] in *bauhaus*, No. 2–3, 1928, p. 23). Schlemmer expounded his complex didactic and philosophical program in the famous sketch of 1928 – "Man in the Circle of Ideas" – in which he summarized the wide range of aspects that have been touched on here under a concept of totality which, despite its recourse to academic traditions, was ultimately romantic. Wick rightly emphasizes the specific mediation between Romanticism and Classicism in Schlemmer's work (Rainer K. Wick, *Bauhauspädagogik* [Teaching at the Bauhaus], Cologne, 1982, p. 261). In Schlemmer's own words, the artist was always concerned to present the "most romantic idea in the most serene form" (*Briefe und Tagebücher* [Letters and Diaries], Stuttgart, 1977, p. 21).

In this striving for synthesis, the central motif of Schlemmer's figurative art, the human being in space, is also given its characteristic superstructure of ideas. Thus his program for seeking balance made Schlemmer, unlike Kandinsky or Itten, recoil from the threat of the arbitrariness of purely abstract forms just as much as from the dogmatic establishment of an esoteric formal canon. This, then, is the quintessence of Schlemmer's pictures of human beings: the contradiction between law as dogmatic rigidity and subjective arbitrariness was to be resolved in the objectivity of the human form itself, and nature, soul and form were to become as one.

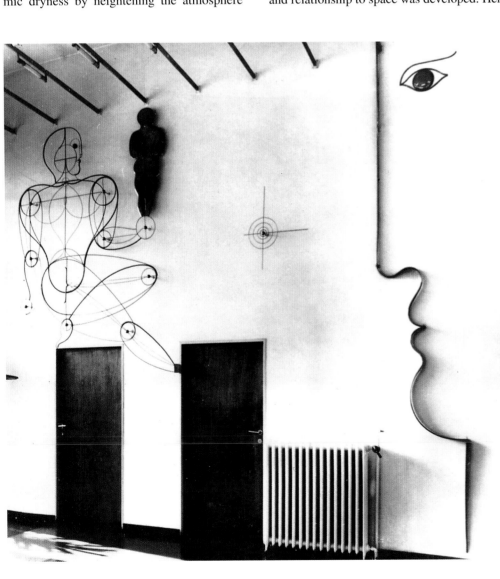

# Oskar Schlemmer's Anthropological Design

Norbert M. Schmitz

Even though it may at first sound disconcerting, with its negative phrasing, the title of Hans Sedlmayer's conservative polemic, attacking modernism – "Verlust der Mitte" (Loss of the Middleground) – describes in the negative sense Oskar Schlemmer's artistic stance particularly well. The Bauhaus at the time reflected the contradictions of modernism as a whole, which must be understood not so much as a process of steady progress but as a disintegration of those elements in the art of recent times which until then had been mediated within the superstructure of a relatively coherent view of the

world. In works of art over the centuries, elements of idealism and realism had again and again been harmoniously presented anew.

In modernism, on the other hand, the extremes of pure abstraction and unmitigated realism confronted each other directly, without any mediation. For Schlemmer both positions were basically extremes as regards both form and content. He countered them with "synthesis, summary, intensification and concentration of everything that is positive into a strong middleground."

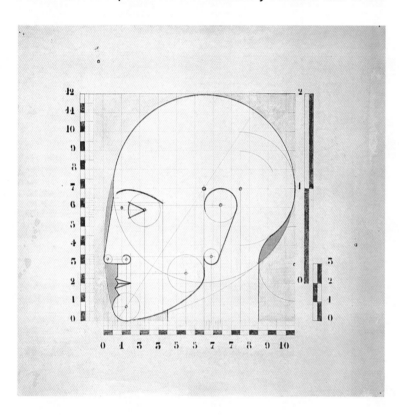

**Hajo Rose, Diagram showing the proportions of the human head.** 1932, colored Indian ink on paper 31.6 x 32.5 cm, BHA. • As in the case of Schlemmer, Joost Schmidt's life class at the Bauhaus was concerned with "inner, imaginary structure" and not the "scientific accuracy of a sawbones."

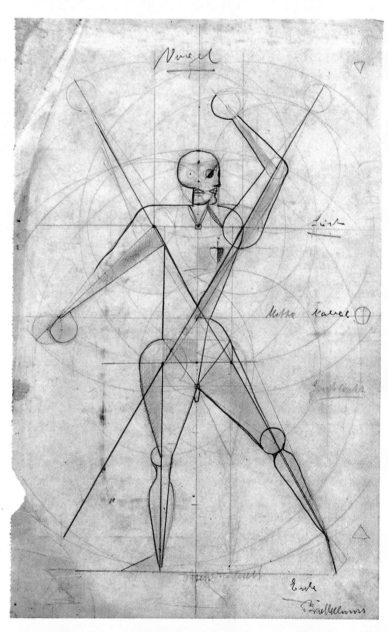

**Oskar Schlemmer, Einfachste Kopfkonstruktion (Profil), (O.S.) (Highly simplified head (profile)).** About 1928, pencil, colored pencils and Indian ink on squared paper, 30.0 x 21.0 cm, BHA, Depositum Bühnen Archiv Oskar Schlemmer (illustration opposite). • With pure geometrical head constructions such as this Schlemmer looked back to the Renaissance doctrine of proportions, which sought ideal measurements in the human body.

**Claus R. Barthelmess, Proportionsstudie.** About 1922, pencil on drawing paper, 40.0 x 25.2 cm, BHA. • The ideal proportions of the human figure had always been a leitmotif of classical art. The basic geometric form, which an artist like Albrecht Dürer concealed in the finished work beneath the cloak of empirical appearances, here becomes itself a worthy artistic subject.

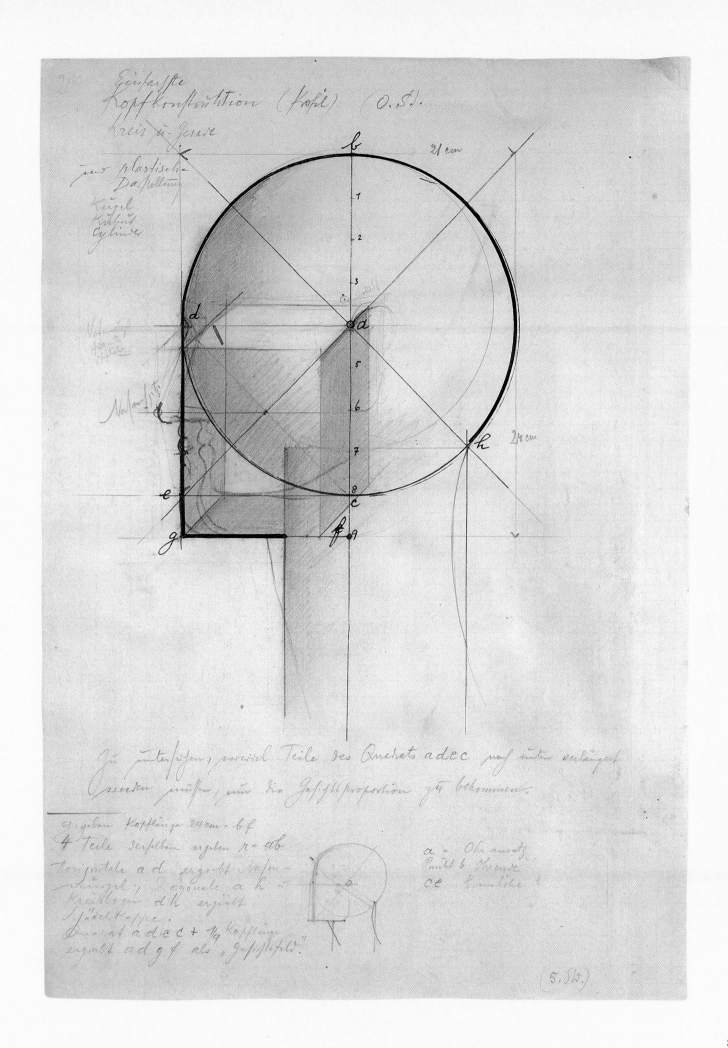

He found this "strong middleground" by making his subject the human figure, to which for him all art had ultimately to relate. His desire was to link the formal and thematic innovations of the avant-garde, which he entirely welcomed, back to this anthropological center. Schlemmer's apotheosis of the human figure points to the body as the ultimate frontier of all creative work. He thus appears, on the face of it, to be repudiating the outcome of 200 years of struggle for autonomous form in modern art, by taking art back again to that point where, at the beginning of the Renaissance, it once began: the representation of man. Schlemmer's development of the figure in space is indeed reminiscent of the emergence of central perspective in the work of Giotto, as a little theatrical stage on which is acted out the story of man's redemption, enlivened by fully shaped figures. The artist's supposed traditionalism continued in his pivotal teaching subject, "The Human Being," in which he went back to the sources of the Academy in modern humanism. His teaching, with its philosophical superstructure, must therefore be regarded not as a negation, but rather as a renewal of this humanist tradition in a form appropriate to the times, that is to say, enriched by the formal vocabulary of modernism. Rainer K. Wick is therefore right to call him a "classic" (*Bauhauspädagogik* [Teaching at the Bauhaus], Cologne, 1982, p. 260 ff.).

Compared with the rhetoric of heroic modernism, this position does appear to be a compromise. But the question at this point is whether this aesthetic anthropology is not far more appropriate to the requirements entailed by the contemporary technological change from an industrial society to a communications society – especially in the field of new digital technology – than the cult of functional objects, the eternal search for an objective and definitive design. Back in the 1970s, François Burckhardt and Bazon Brock were concerned that the true purpose of all design should lie not in the things themselves but in their perception and use by human beings: "The reason for this

extension lies in the fact that relationships between people, the principles by which life is organized and the particularities of linguistic communication, are not as separate from the objective real world as has been supposed hitherto. It may be said that objects, such as industrial products, are used to create such abstract and non-objective conditions of life" (Bazon Brock, "Objektwelt und die Möglichkeit subjektiven Lebens" [Object World and the Possibility of Subjective Life] in his *Ästhetik als Vermittlung* [Aesthetics as Mediation], Cologne, 1977, p. 446).

Certainly, discussion of design in Germany since the war has often enough lacked any reference to its anthropological preconditions. For it is not enough to isolate these preconditions by reducing them to utilitarian functionalism. Instead, man, who is the fundamental condition of design, and for whom it is produced, must be understood as a biological and social organism with a much more complex structure. If today, in an age of increasing digitalization, we are losing the direct contact of traditional design with its materials, if the job of the designer disappears into computers, or, on the other hand, if everything now appears possible, then the claim that "form follows function" must be re-thought.

Be that as it may, "good form" can hardly any longer be derived solely from any qualities of the object concerned, such as appropriateness to the materials used, nor from the optimalization of specific ergonomic functions or the psychology of perception. This makes modernity de facto ossify into the stylistic quotation of neomodern niches or postmodern exaggeration. The human being as an anthropological constant remains as ever the ultimate frontier of all design activity. Design will continue to be tested against his complex physical and psychological structures. Thus of all the members of the Bauhaus it is perhaps Schlemmer, the supposed compromiser, whom we see today as having been truly in accord with the times, because he put man, not forms and things, at the center of theory and teaching, making him the central point of reference of all art. It is most assuredly not the intention here to acclaim Schlemmer's course on "The Human Being" as a complete answer to present-day design problems. The late Romantic aspects of his teaching are, without a doubt, scarcely adequate for the problems of our time, but an anthropological renewal of the foundations of design training, which is on the agenda, can derive support from Oskar Schlemmer.

**Drawing class using a movable model.** About 1932, illustration from the illustrated supplement "Zeitlupe" of the newspaper *Die neue Leipziger,* photograph by Alfred Eisenstaedt, BHA. • Schlemmer frequently made his students draw nude studies from a movable model, so that they were compelled from the outset to pay close attention to the dynamic functional structure of the body, instead of wasting their energy on trivial details and external aspects.

**Joost Schmidt, Figurenstudie.** About 1930 (lost), photograph by J. Schmidt (?), BHA. • In his life classes Schmidt also did not wish to train the skills of naturalistic illustration for their own sake. Nevertheless, study of the human body was intended to be "objectively" oriented in the first place, prior to any expressiveness.

# László Moholy-Nagy

Norbert M. Schmitz

"Of the fourteen years of its existence, László Moholy-Nagy spent only five as a teacher at the Bauhaus, and yet it is perhaps his personality that is most closely bound up with the Bauhaus idea, by virtue of his wide range of interests, his theoretical pronouncements and his artistic practice." This was the verdict of Wulf Herzogenrath in 1974 ("László Moholy-Nagy als Bauhauslehrer" in *László Moholy-Nagy*, exhibition catalog, Stuttgart, 1974, p. 115). His accurate assessment raises the question of what actually constituted the original, pioneering position of the Bauhaus, which makes it appear today as a mythical place where functionalist modernism was founded. The force field within which the school took up its position extended after all from the "Lebensreform" movement on Monte Verità, with its metaphysical orientation, to the radical Constructivist Productivism of the Soviet art schools. Moholy is commonly regarded as a decided champion of the latter faction, but we must be careful not to reduce his work to a one-sided functionalism. For during his years at the Bauhaus he increasingly dissociated himself from the radical Constructivism of his own beginnings. He now countered it with the concept of a synthesis between the demands of the industrial world of machinery and human nature, a kind of technological humanism, the genesis of which is at the center of the following account.

Moholy was born in Bácsborsód in Hungary in 1895. Following his first attempts to draw while on active service during the war, he came into contact from around 1918 with the communist avant-garde group of Actionists associated with the radical socialist magazine *MA*. While still a dilettante as a painter, he soon became quite well known, through assiduous journalistic activity in international avant-garde publications, and in 1922 he had a

**László Moholy-Nagy, Fotogramm.** 1922, photographic copying paper, 17.5 x 12.5 cm, Arnold H. Crane Collection, NYC. • Moholy sought to make the reality of the machine age a subject for art, without abandoning the old mimetic techniques. In the photogram technique, which he rediscovered along with Man Ray and Christian Schad, the artist arranged objects directly on the light-sensitive plate so that, as it were, they photographed themselves.

**László Moholy-Nagy, Selbstporträt.** 1926, photogram and collage, gelatin process, 30.2 x 23.6 cm, BHA. • A program picture. In this self-portrait of collage and photogram elements Moholy's head becomes a part of the technological apparatus, in line with his radical concept of Constructivism.

László Moholy-Nagy

successful one-man exhibition of Constructivist works at Herwarth Walden's Sturm Gallery (he was in Berlin by then). In April 1923, Gropius brought the promising young man to the Bauhaus, hoping, after the bickering over Itten, to find in him a comrade-in-arms for his new concept of the "unity of art and technology." As well as becoming head of the metal workshop, Moholy took over the "study of materials" that was part of the preliminary course, and he was also responsible, together with the director, for the conception, editing and in part also the design of the legendary series of Bauhaus Books. When the Gropius era came to an end Moholy left the school, in 1928, to become director of a graphic design studio in Berlin. At the same time he was also active abroad as a stage designer, film maker and exhibition designer. In 1934 he went into exile in London via Amsterdam. By 1937 he was in the United States and with Gropius's support he became the head of the new Bauhaus in Chicago, which attempted to continue in America the idea of a reformist school that was outlawed in Moholy's homeland. After initial difficulties and a brief closure, it was re-established as the School of Design and soon became the elite school of new American design. Moholy died in 1946, shortly after completing the résumé of his life's work, the book *Vision in Motion*. The starting point for the early Moholy's understanding of art was the reality of the industrial world: "And this reality of our century is technology: the invention, construction and maintenance of machines. To use machinery is to act in the spirit of our century.... It is the art of Constructivism.... In it the pure form of nature finds expression – unbroken color, the rhythm of space, the balance of form.... It is independent of picture frame and pedestal. It extends to industry and architecture, objects and relationships. Constructivism is the socialism of seeing" (quoted in Sibyl Moholy-Nagy, *László Moholy-Nagy, Ein Total-experiment* [László Moholy-Nagy, A Total Experiment], Mainz-Berlin, 1972, pp. 30 ff.). Moholy-Nagy illustrated the new conditions of industrial production programmatically in his legendary "telephone pictures": "In 1922 I commissioned five pictures in porcelain enamel by telephone from an old sign factory. I had the color specimens of the firm in front

of me and sketched my pictures on graph paper ruled in millimeter squares. At the other end of the line the departmental manager of the firm had the same paper in front of him, divided into squares. One of the pictures was supplied in three different sizes, so that I was able to study the subtle differences in the color relationships brought about by enlargement and reduction. It is my conviction that mathematically harmonious forms, precisely executed, are full of emotional quality and that they create a perfect balance between emotion and intellect" (*The New Vision and Abstract of an Artist*, New York, 1949). Whether or not this is merely an artistic legend must remain an open question. But in thought at least, a digital media design practice that today is taken for granted is anticipated here. At any rate, possibilities of this kind demanded a radical break with the classical conception of art, not to say its total abolition. The artist Moholy therefore took the changes in the perceptual world of the big cities, under the "rule of mechanization," into account by studying the new world of industrial media in a way that transcended the separate genres. At the time this was a new kind of theory and practice; its impressive breadth can only be touched on here. Thus he developed his photosculptures from the world of press illustrations – the consciousness-determining reality of the mass media. In them he combines fragments of everyday visual culture with abstract elements of his Constructivist painting, and occasionally mordantly satirical titles. If these playful montages still reveal his early affinity with the Dadaism of a Raoul Hausmann, the layout and in particular the typography of the Bauhaus Books which he designed seem themselves like a Constructivist manifesto. But for all the subtlety of design, the limits of a purely rhetorical Constructivism can also be clearly seen here. The fonts used are derived from an abstract mechanical geometry and hardly take any account of the effective conditions for optimal legibility.

It is true that the typefaces developed by Moholy breathe the same rhetorical spirit as Tatlin's "Tower of the Third Internationale," but, looked at from the point of view of the psychology of perception, they are difficult to read. In this respect they resemble Tatlin's design, for this too could

**László Moholy-Nagy, Telefonbild Em 2 (Telephone Picture).** 1922, enamel and steel, 47.5 x 30.1 cm, MOMA, NY, Gift of Philip Johnson in Memory of Sibyl Moholy-Nagy. • Industrial creativity without a brush: Moholy commissioned these pictures from an enamel firm – at least, that is the legend – by communicating the coordinates of a drawing on graph paper by telephone. The result is the prototype of technologically produced pictures.

**László Moholy-Nagy, funkturm berlin (berlin radio tower).** 1926, photograph, gelatin process, gloss, 23.5 x 17.5 cm, BHA. • Moholy wanted to replace traditional "natural" perception by the industrial eye of photography. The world reveals itself from perspectives that had been almost unknown till then, the objects photographed arrange themselves in abstract rhythms under the neutral eye of the camera.

scarcely have been realized, given the engineering and technology involved. Moholy's typography – the weakness of which he was later to concede himself – thus owes more to the desire for a symbolic, functionalist style than to actual functionality. His relatively arbitrary, individual design is thus ultimately art in the traditional sense after all. This skeptical verdict is not refuted by the fact that such "corporate design" had some point as an advertising strategy for a design school like the Bauhaus. For precisely this practical application of the lofty formal ideal takes no account of the artist's high ethical ambitions. The fact is that selling things was not the artist's sole concern, he also wished to enhance the quality of life.

The conceptual reorientation touched on above – which often seems like an anticipation of advertising design that is a matter of course today – showed itself early on more in Moholy's practice as a painter and sculptor than in his applied design. There, however, the break with the past, with its concept of autonomous art, appeared far less spectacular. The artist's central themes were light, movement and the tension and relationships arising from them. But these only appeared to be traditional subjects, for they only became interesting to Moholy in the context of the changes in life in the industrial world: "It is quite possible that painting, being an exclusively manual creative activity (craft) will survive for decades yet, on the one hand for teaching purposes, on the other as a preparation for a new culture of color or light design. But all that is needed is to ask the right questions – and then, arising from this, to have the new visual organizer (in place of the artist), to shorten this preparatory stage" ("probleme des films" [the problems of film] in *telehor*, special number on Moholy-Nagy, 1936). Even in the field of traditional free painting, Moholy experimented again and again with painting on industrially manufactured surfaces – for

**László Moholy-Nagy, lichter der stadt (lights of the city).** 1926, photosculpture, mounted magazine photographs, tempera on card, 61.5 x 49.5 cm, BHA. • In his photosculptures Moholy takes the omnipresence of photography on board. The realistic photographic picture becomes a sign on an equal footing with others in modern everyday mass communication.

**László Moholy-Nagy, Title page of "Foto-QUALITÄT."** 1931, printed book, A4 size, BHA. • Nowhere else is Moholy's "pragmatic constructivism" so clearly to be seen as in his applied work in graphic design. He finds design solutions which, with the meteoric evolution of the modern mass press, become memorable pictorial formulae.

FOTO-QUALITÄT

ZEITSCHRIFT FÜR WARE UND WERBUNG

HERAUSGEGEBEN VON C. DUNNHAUPT · GMBH · DESSAU

SCHRIFTLEITUNG UND
KÜNSTLERISCHE LEITUNG:
CARL ERNST HINKEFUSZ
BERLIN

IX.
1·2

moholy-nagy

László Moholy-Nagy

**László Moholy-Nagy, Komposition A XXI.**
1925, oil and mixed media on canvas, 96.0 x 77.0 cm, Westfälisches Landesmuseum für Kunst und Kulturgeschichte, Münster. • Moholy's early oil paintings already hint at the future conception of the "light and movement artist." The dynamic and clearly constructed forms seem to go beyond the limits of old-style free painting. On the way to dematerialized light phenomena, the pigment changed from being a bearer of color to being a bearer of light.

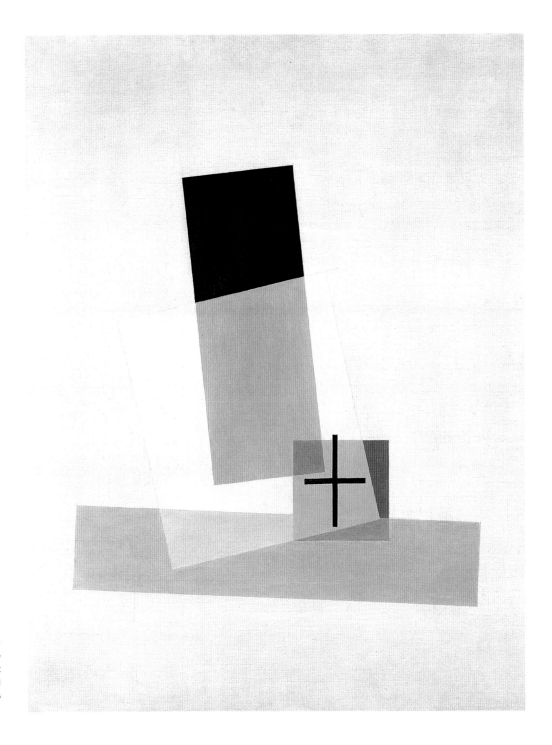

**László Moholy-Nagy, Komposition Q VIII.**
1922, oil on canvas, 95.5. x 76.3 cm, Museum Moderner Kunst, Stiftung Ludwig, Vienna. • The pure forms of Moholy's compositions breathe, it is true, the spirit of Constructivism. But as oil paintings they could at the same time be read as autonomous works of nonrepresentational art.

example plastics or aluminum – in order to create light effects of a new kind. Pigment became for him purely a "place for storing light." But here too it was ultimately a matter of symbolic representation, not the actual shaping of real light: "Until yesterday 'painting' denoted the highest kind of visual creativity. Its point was it worked with the variable reflective capacity of different paints. To the extent that paint was capable of reflecting or swallowing light, it was used to achieve a desired visual effect, which was basically

intended to reproduce the world in the mirror of light. There is no doubt that in comparison with this procedure, a direct beam of light could create a very much more intense effect if it could be controlled to the same degree as painting with pigment. And that is indeed the future problem for the visual arts: the creative use of direct light" ("Fotogramm und Grenzgebiete" [Photogram and Related Areas] in *Die Form*, 1929–IV). Consequently the "light painter" (as Moholy sometimes described himself) turned to direct forms of working

creatively with light. His work in the new media of photography and film, and his plans for reflected light shows, are described elsewhere. Apart from these, it was above all the light-space-modulator, displayed for the first time at the Paris Werkbund exhibition in 1930, which was the real product of these reflections during the Bauhaus years. This machine was a four-part mechanism consisting of various materials, mainly metals, on a rotating round plate. The individual sectors of the construction became visible one after the other through

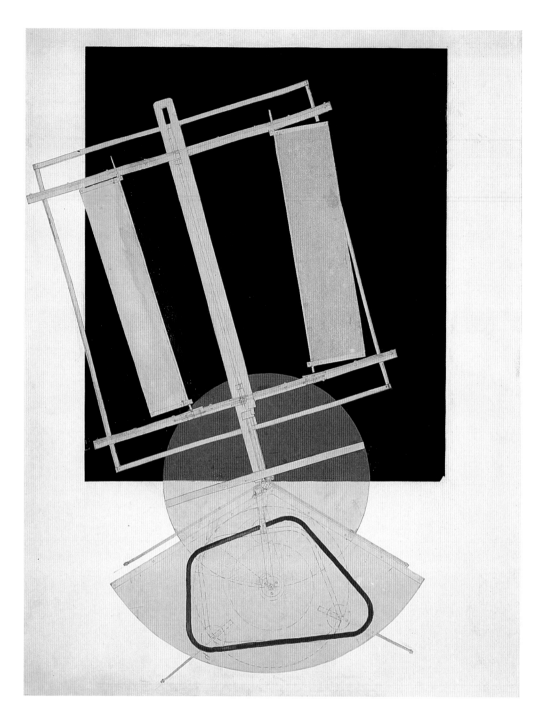

**László Moholy-Nagy, lichtrequisit einer elektrischen bühne (lighting equipment for an electric theater).** 1922–30, representation of a play of movement on the first sector, working drawing, construction by Stefan Seböck, engineer, collage over photostat, watercolor, opaque white and colored paper on card, 60.0 x 60.0 cm, Cologne University, Theaterwissenschaftliche Sammlung. • "lighting equipment" is concerned with the abstract interplay of electric light and various material structures in motion. Here the "light artist" Moholy broke free once and for all from his close ties with traditional painting.

an aperture in the box containing them, in order to reflect the light in different ways according to their surface structure, and also to project a dynamic play of shadows onto the rear wall. It was "an apparatus to demonstrate phenomena of light and movement" (László Moholy-Nagy, "lichtrequisit einer elektrischen bühne" [lighting equipment for an electric theater] in: *Die Form*, 1930–V, pp. 11 ff.). It may seem to anticipate the postwar "light art" of people from Adolf Luther to James Turrell, but the modulator, while formalistically effective, was meant to be understood

primarily as a laboratory for the practical use of light in industry. It could be "utilized for numerous optical purposes, and it seems right to me to continue these experiments sytematically as a move toward light and movement design" (ibid, p. 12). A practical result of such investigations was that, in his teaching role in the metal workshop, Moholy succeeded in stimulating his students to produce lamp models for serial production in the factories of the lighting industry. Their suitability for serial production thus fulfilled the theoretical ambitions of Gropius in the area of industrial design. The director could not but be pleased to have appointed Moholy, for the license fees at last brought income into the Bauhaus, which was still economically insecure.

This practical success may have been the real reason for Moholy's increasing coolness toward his own radical beginnings: "The Constructivists revelled in industrial forms. They were in the grip of a technological monomania" (László Moholy-Nagy, *von malerei zu architectur* [from painting to architecture], Munich, 1929, p. 132). The human being was now the center of artistic creation for him, not as an abstract species in Schlemmer's manner, but rather as part of a collective organism. The task was to compensate for the deprivations of the machine age – in particular the disfigurement of man by reductivist specialization. Such humanism was decidedly different from a contemporary machine aesthetics whose most radical exponents celebrated the transformation of the human body into a functioning cog in the great machine of industry. In contrast to them Moholy wanted, free of all romantic illusions, to reconcile industrial reality with the biological basis of human existence. This was to be achieved neither symbolically, through a separate sphere of art, nor through compensation by the decorative embellishment of life, as Jugendstil had once attempted to do, but through the systematic scientific appropriation of the visual world that we live in and a resulting reshaping of that world. This attitude culminated in the monumental picture atlas of his last work, *Vision in Motion*, which he wrote in exile in America as the quintessence of the visual culture of the present. The promise of a new world created from the spirit of design is formulated here in words and pictures. For

all Moholy's criticisms of its social conditions, this was also an act of homage to American culture. Seen in this light, it is no surprise that the one-time communist left the Bauhaus with Gropius instead of aligning himself with the socialist Utopia of artists like Hannes Meyer. To return to our starting point: that is the Bauhaus of postwar modernism in Western democracy.

**László Moholy-Nagy, lichtspiel schwarz-weiss-grau (film in black-white-gray).** 1930, frames from the experimental film, BHA. • Moholy's aim was to elevate light to the status of an independent creative medium. Whereas the light equipment was a physical object and hence still marked by the weight of its metal materials, the new "material" of light in film projection was almost autonomous.

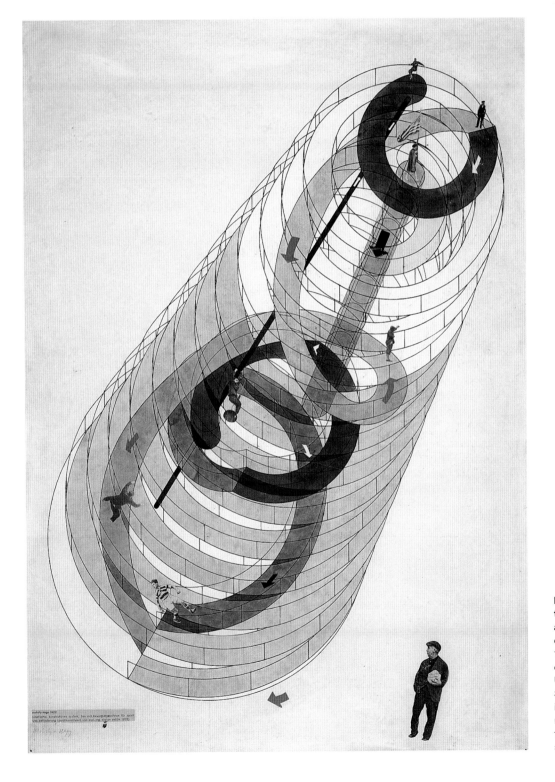

**László Moholy-Nagy, kinetisches, konstruktives system.** Construction with tracks for play and movement. Constructed by Stefan Sebök, engineer, in 1928 from Moholy's first version of 1922, collage over photostat, Indian ink, watercolor and photomontage on card, 76.0 x 54.5 cm, University of Cologne, Theaterwissenschaftliche Sammlung. • Moholy's designs became increasingly spatial and mobile. This "construction" does not signify any concrete architectural concept – the subject is the altered perception of time and space brought about by modernism.

# Synthesis and Total Artwork

Norbert M. Schmitz

Following his disappointment at the outcome of the 1848 revolution, Richard Wagner wished to regenerate his German fatherland at his Bayreuth Festival by means of an aesthetic myth which combined words, music and architecture in an artistic synthesis. Though he was from then on the target of mordant criticism by Friedrich Nietzsche because of his incipient sanctimoniousness, Wagner's total artwork became a paradigm for modernism in general. The most diverse tendencies within the avant-garde were united, aesthetically, philosophically and politically, by the desire to spearhead a social, national and political regeneration with a new image of the whole of society as a unified total work of art. The early Bauhaus was also marked by this idea, and the reversion to the inspiration of the medieval church masons' guilds, the *Bauhütten*, was more than anything else the invocation of a romantically transfigured holistic synthesis of artistic production and social life. It thereby took its place in a long series of social utopias that have dominated the history of modern design. Whether in the Arts and Crafts movement in England, or international Art Nouveau-Jugendstil, the reformers from William Morris to Henry van de Velde were concerned with more than pure form. The new style implied a new life, and the integration of all the arts combined with the universal ambition to bring about a comprehensive reform of life.

Moholy's "total artwork" cannot, however, by any means be simply equated with Wagner's *Gesamtkunstwerk*, the ultimate implications of which led to the total aestheticization of politics, as described by Walter Benjamin. On the contrary, Moholy wished to dissociate himself from such illusions of universal regeneration: "What we need is not the 'total artwork' with life flowing along separately beside it [if only it had always done so! – author] but rather a self-constructed synthesis of all aspects of life in an all-embracing total work (life) that transcends all isolation, because every individual achievement grows out of biological necessity and flows into a universal necessity" (*Malerei, Fotografie, Film* [Painting, Photography, Film], Munich, 1927, p. 15). Thus the combination of all social, aesthetic and biological aspects, rather than the specialization of the present, which he considered tragic, was also the aim of his synthesis. His trust in this utopia became increasingly great, so that, in contrast to his original Marxist views, he even saw aesthetics as the source of the solution to the social problem. Thus Moholy was not concerned, as Walter Benjamin was, to counter the aestheticization of politics with the politicization of art, but rather to resolve social contradictions by a universal creative shaping of all areas of life.

This links him with the beginnings of modern design history. William Morris, who was politically closely associated with the English working-class movement, also wanted above all to remove the alienation of labor brought about by the machine and to restore its meaningfulness by way of manufacturing processes that would as far as possible be centered on the product as a whole and would thus have a sensuous reality for the worker producing it. Thus William Morris, with his social utopia, shared with Marx the notion that man only really creates himself through his labor. But unlike the author of *Das Kapital*, he wanted the actual methods of industrial production to be abandoned. This is the entire history of design in a nutshell: the reversion to pre-industrial forms of production ultimately took the social aspirations of these reformers ad absurdum. In the end it was the radical socialists, of all people, who, because of the high costs of traditional manufacturing methods, produced the most famous luxury articles for the English upper class. In Germany, this issue led to the dispute in the Werkbund between Hermann Muthesius and Henry van de Velde. This controversy is the background to Moholy's real originality: he did not see the humanization of labor as being in fundamental opposition to industrial technology; what he demanded was rather that, by building on that technology, the two should be combined on a new level, but without reducing man – as did some of the technoid Constructivists and Productivists – to a mere adjunct of a personified machine. For Moholy, the overall goal was "the whole man, the man who, from his biological center, can once again face up to all the things of life with instinctive certainty, who today will not allow himself to be outfaced by industry, by hustle and bustle, and the externals of an often misunderstood 'machine culture'" (*von material zu architektur*, Munich, 1929, p.18). His aesthetics of the machine can only be understood when seen in this light. But Moholy's dynamism also too easily overlooked the extreme constancy of human nature, especially its sensory functions. And so the "industrial eye" of his photographs paid no heed to the functionality and constancy – the products of evolutionary biology – of the human organs of perception, and hence his alphabets became illegible.

Despite this obvious dependence on the formalistic stylings of modernism, the attempt to find an increasingly nonideological balance between technology and man, as it emerged above all in the course of the artist's theoretical work, remains the decisive challenge for the present day posed by this design humanist. From our present-day point of view he did indeed too often overlook the fact that it is precisely that biology that he so emphatically adduced which also regards what is fragmentary and incomplete as essential for the physical, psychological and social nature of man. In his design work there is for the most part little to be seen of "man, the being that is open to the world" (Gehlen). Whether we can see, behind Moholy's biological determinism, the old desire in a latent form for totality and unification, the inability to tolerate differences – albeit purged, as a "total design work," of ideological disavowals – this remains open to discussion. The reality of postwar international design would support such a view. Be that as it may, beyond all utopian visions it was the uniformity of the unideological society of pragmatic American capitalism to which the former revolutionary artist Moholy-Nagy gave a fitting symbolic form. An involuntary total artwork.

**László Moholy-Nagy, Fotoplastik (Photosculpture).** 1925, photocollage, drawing and opaque white, 25.5 x 21.0 cm, Collection Arnold H. Crane, NYC. • Moholy was fascinated by the phenomenon of mass culture. He did not wish to replace it with a stylish, aesthetic alternative world; on the contrary, he made it the center of his apotheosis of modern life. But the dream factories of UFA (the German film production company) and Hollywood did not open their doors to the avant-gardist Moholy.

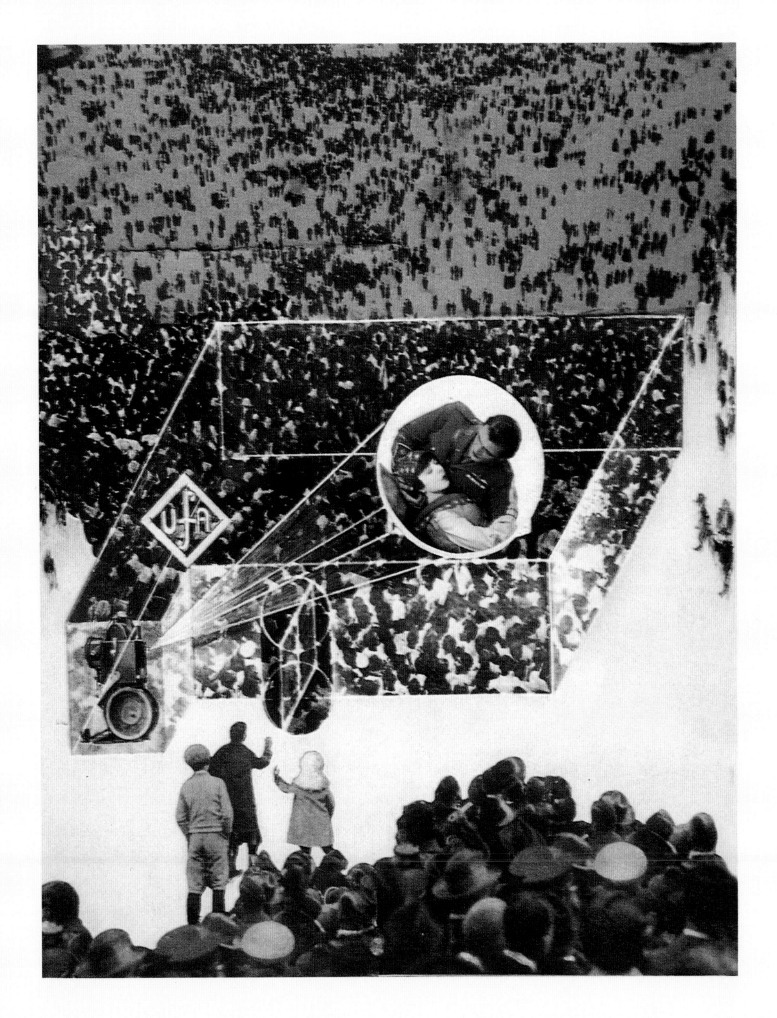

# Moholy's Art of Film or Why the Bauhaus Stayed Away from the Cinema

Norbert M. Schmitz

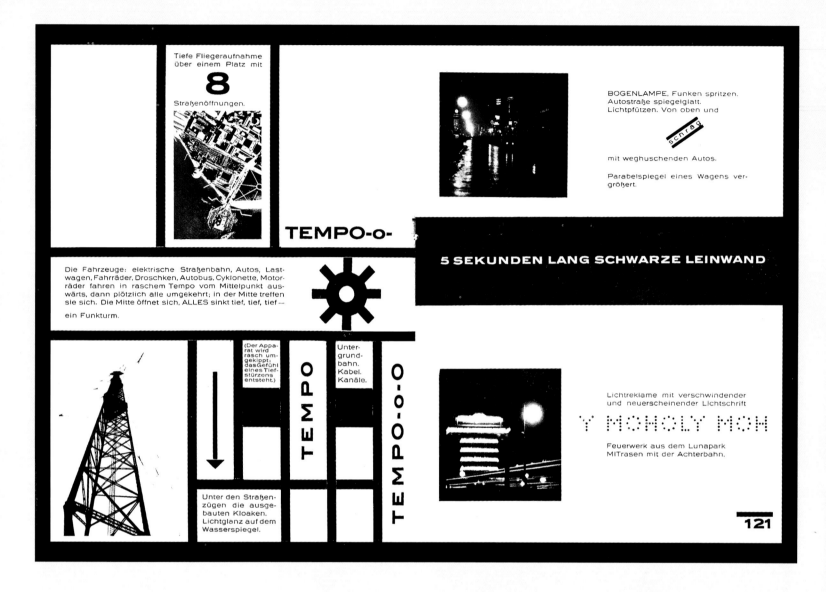

It is a striking fact that for all its emphasis on the "unity of art and technology" and on the needs of the broad mass of the people, little attention was paid at the Bauhaus to the 20th-century medium of film. There were, it is true, contacts with the exponents of early abstract film in Germany, Hans Richter and Walter Ruttmann. But at the Bauhaus the "Musical Score from the Life of an Arrow" by Kurt Kranz remained a draft on paper, just as did Werner Graeff's dynamic development of rectangles. It was a different matter, however, with the "reflected light presentations" of the Bauhaus students Kurt Schwerdtfeger and Ludwig Hirschfeld-Mack. Using moving lamps and a variety of templates, swathes of color, staggered in time and space, were projected onto screens in order to illustrate the inner dynamics of pictures from the school of Klee and Kandinsky. "One element can be developed from another, from point to linear movement, to plane movement, with the form of the plane taking on any form at will. By using dimmer switches on the lamps and by inserting rheostats we can slowly intensify individual and larger color-form

complexes from the black ground to the highest degree of brightness and radiant color, while at the same time other complexes slowly disappear and are absorbed by the black ground.... Using precise knowledge of these elementary resources, with which an endless wealth of variations is possible, we aim for a fugue-like, strictly structured play of colors, starting in each case from a particular color-form theme" (Ludwig Hirschfeld-Mack, score of the "reflected light presentations" in László Moholy-Nagy, *Malerei, Fotografie, Film* [Painting, Photography, Film], Munich 1927, p. 79). Such color music in turn gave Klee the stimulus to paint a picture with the title *Fugue in Red* in 1921.

It was primarily Moholy who, in the spirit of a Constructivism that aimed to give a new shape to life, wanted to replace this abstract romanticism with an art that would shape consciousness. Celluloid, as a modern carrier of light (in comparison with traditional pigment), the possibilities of a technologically created illusion of movement,

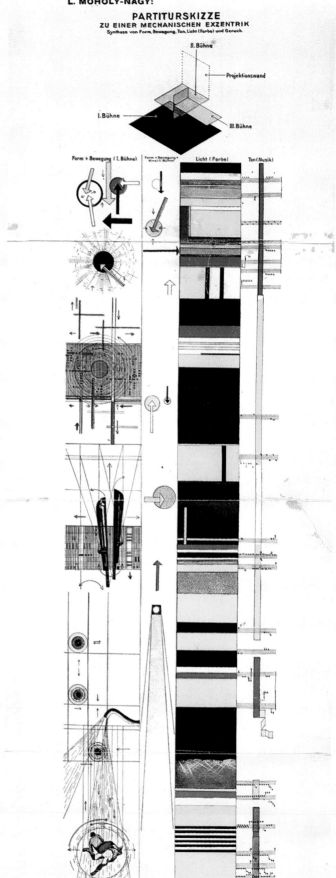

L. MOHOLY-NAGY:

PARTITURSKIZZE
ZU EINER MECHANISCHEN EXZENTRIK
Synthese von Form, Bewegung, Ton, Licht (Farbe) und Geruch.

**László Moholy-Nagy, Partiturskizze zu einer mechanischen Ekzentrik (Score Sketch for a Mechanical Eccentric).** 1925, foldout page from Oskar Schlemmer, László Moholy-Nagy and Farkas Molnár,"Die Bühne am Bauhaus" (Theater at the Bauhaus), Munich, 1925, Bauhaus Book 4, BHA. • Images are no longer thought of merely as static by the "movement artist" Moholy-Nagy. As a logical consequence, the forms strive toward movement. But the artist did not see his score only as an abstract play of forms: the "mechanical eccentric" was meant to symbolize the spirit of the machine age.

**László Moholy-Nagy, Dynamik der Großstadt (The Dynamics of the Big City)/sketch for a film/at the same time a typophotograph.** 1924, double page from László Moholy-Nagy, *Painting, Photography, Film,* Munich, 1925, Bauhaus Book 8, BHA. • "The Dynamics of the Big City" is seen as a montage of different, simultaneous, very rapid impressions. The subject of this "storyboard" is montage, the principle of both filmic and urban perception – a montage of sensory impressions.

but above all the changed narrative modes of montage seemed to him to be the appropriate response both to the technologization of the "work of art in the age of its reproducibility" and to the dynamism of perception in "la vie moderne." Moholy's program reads like the implementation of Walter Benjamin's materialist theory of art. Like him, Moholy was concerned not only with questions of content or style but also with the artistic appropriation of the means themselves: "Since production (productive shaping) serves above all the making of man, we must try to extend the use of techniques beyond the reproductive purposes that they have hitherto exclusively served, and use them also for productive purposes" (ibid, p. 38).

In purely external respects, Moholy's own films scarcely differ from the contemporary film experiments of the international avant-garde. Works in which the function of photographic and projection apparatus becomes the subject, contrast with works concerned with the realism of the new reality. While the former are in line with the almost abstract experiments of Henri Chomette's *cinq minutes de cinéma pure* or Fernand Léger's *Ballet mécanique*, the latter are reminiscent of the socialist manipulation of consciousness in Dziga Vertov's *Man with a Movie Camera*.

In any case, neither of these two groups of Moholy's works must ever be misunderstood as purely formal investigations into the artistic effects of the modern media. On the contrary, like Moholy's parallel photographic experiments between photogram and New Vision, they are strategies for giving artistic form to the perceived world of present-day technology. He did not wish to be a film artist, but a producer of pictures. However, in terms of his constructivist aesthetic, it was precisely in the area of mass communications using contemporary technological media that he failed to achieve that very utopia which he came close to making a reality in industrial design, namely to close the yawning gap between his avant-garde materialism and the real world in which the general public lived. As Tilman Osterwold shows, Moholy revolutionized "the media as regards content by laying bare their potential content ... but did not change the function of the mass medium" ("Moholy-Nagy: Produktion – Reproduktion – Integration" in *László Moholy-Nagy*, Stuttgart, 1974, p. 27). Cinematographic narrative reflected the desires, dreams and anxieties of the broad general public, a compensatory function which was very remote from the aesthetics of modernism, which is characterized by the thematicization by the media of their own qualities. For such counter-images to everyday life (which were in fact themselves not free of contradictions) there was no place in the thoroughgoing rational functionalism of a man like Moholy, his illusion of a social "total artwork" without gaps. He shared with the revolutionary Russian film makers Eisenstein and Vertov the idea that it was purely a matter of "dumbing down" by commercial interests. It is true that in theory at least he was also always concerned with the economic aspect of all creative activity – as the success of his lamps demonstrates – but the peculiar economy of symbolic forms remained alien to him. It was, surprisingly, Erwin Panofsky, the art historian and lover of Hollywood, with his extreme reserve toward modern artists, who in 1936 brought this fundamental dilemma to a point: "Certainly, commercial art is always in danger of ending up by prostituting itself, but equally certainly noncommercial art is in danger of ending up as an old maid" (*Stil und Medium im Film und die ideologischen Vorläufer des Rolls-Royce-Kühlers* [Style and Medium in Film and the Ideological Precursors of the Rolls-Royce Radiator], Frankfurt am Main, 1999, p. 52). Moholy's problems with the cinema are symptomatic of the Bauhaus, which has its secure place in any history of modernist art, but whose influence on the visual mass culture of the 20th century has always been overshadowed by the industrial production of the truly successful entertainment factories. But to change this would have required a very much more far-reaching break with concepts of modern autonomous art than was possible for aesthetes such as Gropius and Moholy.

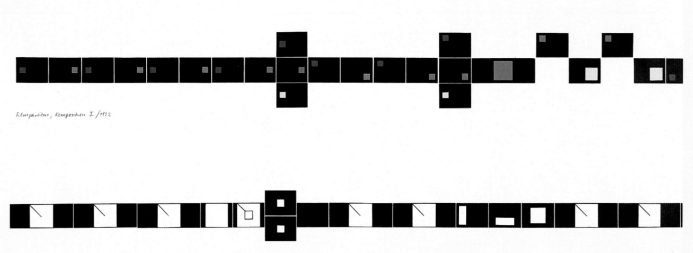

Filmpartitur, Komposition I /1922

Filmpartitur, Komposition II /1922

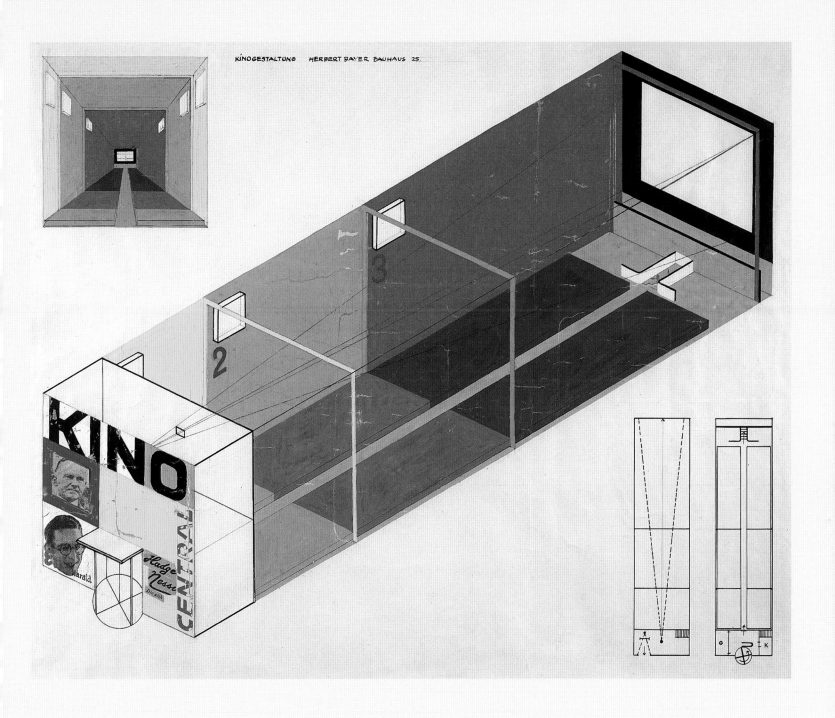

KINOGESTALTUNG HERBERT BAYER BAUHAUS 25.

**Werner Graeff, Filmpartitur, Komposition I und II.** 1922, section of a printed score roll, screen print on cotton, BHA. • Even as a student at the Bauhaus Graeff had designed film scores. Whereas the pioneers Walter Ruttmann and Hans Richter were able to realize their abstract films, the technical and economic conditions for this did not exist at the Bauhaus, nor was there any serious interest in it there.

**Herbert Bayer, Design for a cinema.** About 1925, collage elements, tempera and Indian ink over pencil, 45.7 x 61.0 cm, c ourtesy of the Busch-Reisinger Museum, Harvard University Art Museums, Gift of Herbert Bayer. • The Constructivist idea, to which Herbert Bayer was close for a time, was directed not only at films but at the same time at the places where they were performed. Here the cinema became a total artwork.

# Josef Albers

Friederike Kitschen

The teacher who wanted to be a student, and the student who became a teacher – that is how the story of Josef Albers's life and artistic career begins. He was born in Bottrop in 1888, the son of the petit-bourgeois general handyman Lorenz Albers and his wife Magdalena. Josef Albers was one of the most important teachers and influential personalities at the Bauhaus, from the Weimar period through to the last days of the school in Berlin. Albers the artist was often hidden behind the figure of the teacher, who was as brilliant as he was strict and who became increasingly dominant during the development of the Bauhaus and also in its later reception. Yet it was the urge to become a good painter which over and again drove the young primary school teacher, once he had achieved a secure position, to give it up and to continue, with disciplined persistence, to learn and to seek. It was this same willingness to put a radical question mark over what

of brushwork and color, who had taken his bearings from well-known avant-garde models such as Henri Matisse, James Ensor and the Cubists. But his numerous drawings with their spareness of line already display the severe paring down of his later works. Having returned to Bottrop, Albers still did not wish to bring his years of apprenticeship to an end. In addition to working as a teacher, he attended the School of Applied Arts in Essen as a pupil of the glass painter Jan Thorn-Prikker until 1919, and designed stained glass windows himself for a church in Bottrop (now destroyed). Finally, in 1919, he was able to exhibit his lithographs and woodcuts in Hans Goltz's renowned Munich gallery of contemporary art. This success may perhaps have inspired him to make yet another change: from 1919 to 1920 he resumed his studies, this time at the Royal Bavarian Academy of Fine Art in Munich, and attended – profitably, as he later

**Josef Albers, Three designs for a Bauhaus flag.** 1923, opaque white, watercolors and pencil on packing paper, 23.1 x 15.1 cm, BHA. • For the Bauhaus exhibition, Schlemmer had suggested using symbols instead of names to identify the exhibits of students and journeymen. Albers allocated a right angle to the entire Bauhaus community, which he wanted to be represented by a flag.

he had learned, known and achieved hitherto and to embark on the experiment of seeing for himself and thinking for himself, that in later years he demanded from his own students with rigorous consistency.

Albers trained as a primary school teacher at the school of education in Büren from 1905–1908 and taught at various schools in Westphalia until 1913. But he found subjects such as reading, writing, arithmetic and physical training as uncongenial as the small-town atmosphere. In 1913 he began to study at the Royal School of Art in Berlin, and completed his course by qualifying as an art educator in 1915, having been exempted from military service as a teacher. A few representational oil paintings from these years show Albers as an artist without any particular originality but with a secure grasp

stated – Max Doerner's courses in painting technique, and – with critical reservations – the drawing class of the "prince among painters," Franz von Stuck. A career as a free-lance artist was probably never so close as during that year in Munich. Its threatening corollary, the humble return to the modest but materially secure haven of the Bottrop primary school, was perhaps equally close. A leaflet and Albers's continuing determination to improve and to "compete" with himself, decided otherwise.

Walter Gropius's Bauhaus manifesto of 1919 promised a new kind of art school, with standards and courses that were to be quite different from the traditional kinds of training that Albers by then had had quite enough of, and which he was later to reject emphatically as "knowledge schools."

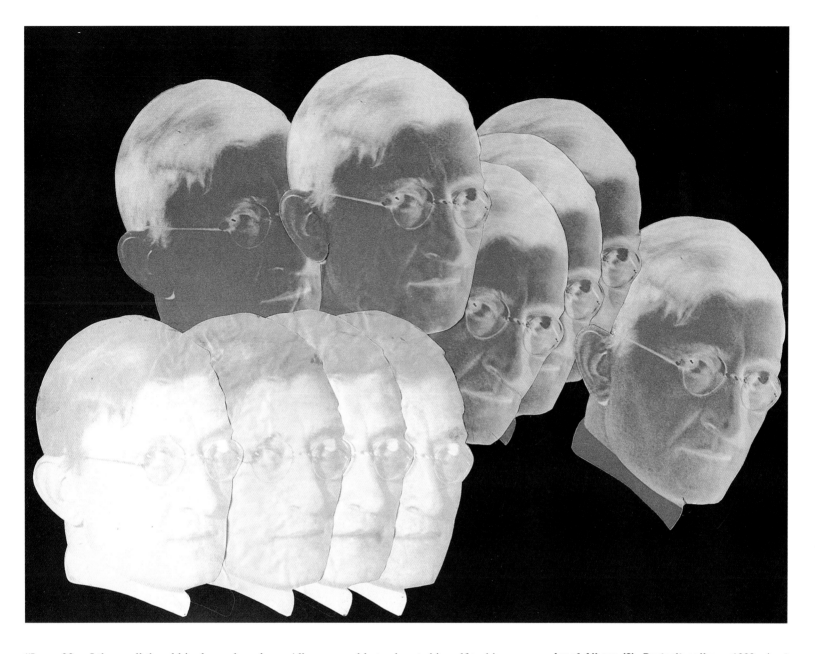

"I was 32.... I threw all the old junk overboard and went right back to the beginning again. It was the best thing that I ever did in my life" (Neil Welliver, "Albers on Albers," in *Art News* 64, 1966, p. 48). When, in 1920, Josef Albers destroyed a large number of his academic studies and enrolled as a student at the Weimar Bauhaus, younger artists such as Gerhard Marcks and Georg Muche were already masters with permanent appointments. Johannes Itten, who was the same age as Albers and had likewise trained as a primary school teacher, had gained a biographical lead by virtue of early theoretical and ideological education. He was by then a master, head of the preliminary course and, at least nominally, of the majority of the workshops, and profoundy revered by many students. As a student

Albers was able to devote himself to his own artistic work, apart from Itten's obligatory preliminary course, which took place only on two half-days. Strengthened by the example of the Bauhaus artists, most of whom worked in an abstract vein, and stimulated by Itten's teaching on the laws underlying the effects of colors and forms, he completely abandoned representational painting and drawing. From then on his entire output was determined by abstract, often geometric forms. But Albers did not jettison everything. Against the recommendation of the council of masters, who wanted to place him in the murals workshop, he returned to working with glass as a material. From the simplest materials, waste glass and wire, he created gleaming, colorful assemblages. He was so persistent and achieved such

**Josef Albers (?), Portrait collage.** 1928, sheet from the portfolio "9 jahre bauhaus. eine chronik" (9 years of bauhaus. a chronicle), brown portraits positive (ozalid), blue portraits negative (cyanotype), cut out and mounted on black card, staggered, 41.6 x 59.2 cm, BHA. • Albers was one of those teachers who made use of their opportunities at the Bauhaus for trying out several materials and techniques for themselves.

**Josef Albers, Untitled.** About 1921, glass assemblage, 39.8 x 37.5 cm, Collection The Josef Albers Foundation (illustration on the right). • Found pieces of glass and bottle fragments are cut and attached to a wire frame. Intentional breaks in the pattern and strong contrasts in size, form and color create a rhythmical work.

**Josef Albers, Gitterbild (Grid Picture).** 1922, glass assemblage, 32.4 x 28.9 cm, Collection The Josef Albers Foundation. • Influenced by the "material studies" in Johannes Itten's preliminary course, Albers began to experiment with waste glass. His intensive study of glass as a material not only led to his promotion to journeyman and head of glass painting, it also brought the Bauhaus many important commissions for stained-glass windows.

high quality that in 1921 the council of masters not only aprroved of his continuing study but furthermore commissioned him to reorganize the glass painting workshop and made him a journeyman in 1922.

In Gropius's diagrammatic outline of the course of study at the Bauhaus, this workshop was on an equal footing with wood, metal, weaving, stone, etc., but in fact lay fallow to a large extent due to the lack of a competent craft master and the casual leadership of the form master (initially Johannes Itten, later Paul Klee): "Thus at one fell stroke I was given my own glass workshop and it was not long before the first orders for stained glass

windows began to come in," Albers later noted with satisfaction. Several stained glass windows that were made but destroyed in the war – for the Sommerfeld and Otte houses in Berlin and the Grassi museum in Leipzig, along with Josef Albers's free artistic glass pictures – show the same development from the assemblage of asymmetrical forms to strict geometrical compositions based on serial structures. From 1925 Albers developed his well-known pictures in multiple layers of colored top-layered glass, in which regular and precisely contoured patterns were worked out using templates and sandblasting. These abstract glass pictures could be made from

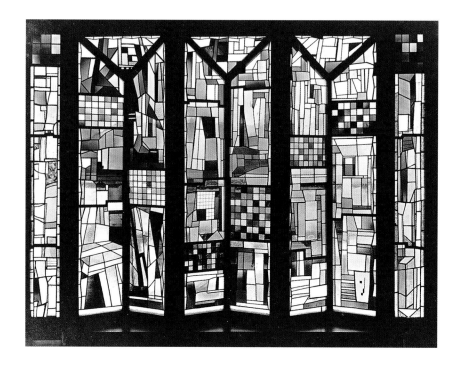

**Josef Albers, Stained glass windows for the staircase in the Sommerfeld house.** 1922 (destroyed), photographer unknown, BHA. • Albers was already familiar with glass as a material before his training at the Bauhaus. At the school both his free artistic work and his applied work developed from assemblages of asymmetrical forms to strict geometrical compositions.

**Josef Albers, Stained glass windows in the outer office of Gropius's director's room at the Bauhaus in Weimar.** 1922 (destroyed), illustration from *Staatliches Bauhaus Weimar 1919–1923*, Weimar, 1923, BHA. • From 1922 Albers was both the only student in the glass painting workshop at the Bauhaus and also his own journeyman and workshop master.

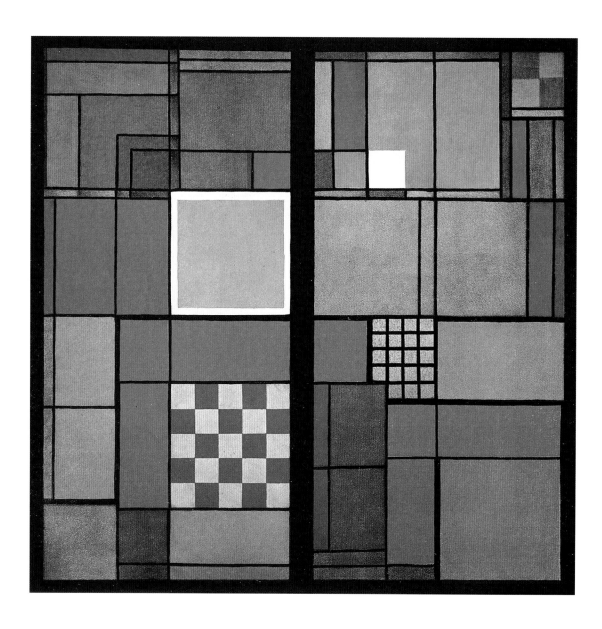

**Josef Albers, Fruit bowl.** 1923, glass and wood, painted black, chromium-plated brass, height 7.5 cm, diameter 36.5 cm, BHA. • From elementary forms – circle and ring, rod and sphere – and using the most current combination of materials, Albers fashioned a composition which might possibly be less effective if it were actually used.

Albers's designs by other people and using purely mechanical means. They were thus entirely in accord with the ambition of the Dessau Bauhaus to cut back on craftwork in favor of industrial methods of production. Austere and purist, they vary simple geometrical motifs – regular grid patterns, staggered slender rectangles and lines – often suggesting the calibrations on measuring equipment, which gained for these works the name of "thermometer pictures." They are Josef Albers's most independent and important artistic work from the Bauhaus years and, with their rational structure and consistent visual logic, are among the significant early works of Concrete Art in Germany.

But it was not as an artist, nor as a designer (for example of furniture, text or tea glasses), nor as a workshop leader (from 1928 to 1930 he was, among other things, head of the cabinetmaking workshop) that Albers exerted a decisive influence at the Bauhaus, but as a teacher and later as head of the preliminary course. By early 1923 discontent had already increased among the teaching staff at the lack of student discipline, caused not least by the small number of classes offered by Itten. At the end of the year the preliminary course was fundamentally restructured. In addition to the

classes in form and theory given by Kandinsky and Klee, there was now on five mornings a week a so-called "work assignment." It prepared the students for work in the workshops by means of practical material exercises, the manufacture of the simplest utensils using elementary craft techniques, and visits to manufacturing works. It also accustomed them to a tighter organization of work. As a student and a journeyman Albers, who "possesses adequate technical and pedagogic ability" (Gropius in the minutes of the meeting on May 26, 1923) was entrusted by Gropius with overall supervision in this area. Although at first almost reluctant, because he had wanted to give up schoolmastering and did not think he had the necessary craft training, from 1923 to 1933 Albers turned this work assignment into the core of the preliminary course and thus a constant and characteristic element of Bauhaus teaching. Following Itten's departure in 1923, "journeyman Albers" took over the main part of the preliminary course, with 18 (later 12) hours a week in the first semester. The newly appointed official head of the preliminary course, László Moholy-Nagy, taught for six hours a week (later reduced to four) in the second semester. After the move to Dessau in 1925, Albers became one of the first "young

**Josef Albers, Easy chair.** 1926–1927, walnut veneer and maple, flat and sprung upholstery, 74.0 x 61.5 x 67.5 cm, BHA. • Two arm rests rounded to form quadrangles form the optical scaffolding of this chair. The desire to combine the comfort of an easy chair with lightness seems to fulfill the idea of quadratic forms, and in this perspective reminds one of "Homage to the Square."

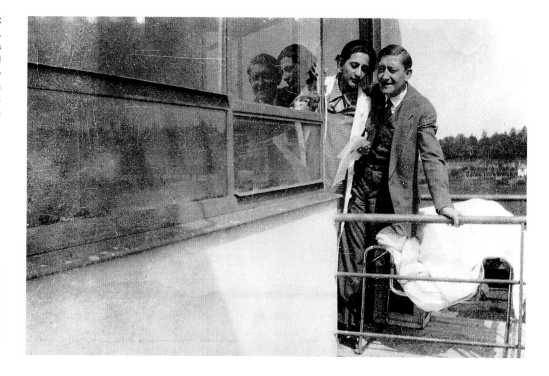

**Anni and Josef Albers on a balcony of the studio block of the Dessau Bauhaus.** 1927–1928, photograph by Marianne Brandt, BHA. • Albers went into exile in the USA with his wife Anni, the weaver, in 1933. There they both continued their teaching activity at Black Mountain College in North Carolina.

**Josef Albers, Combination letters made of glass.** Around 1928, made in 1931, three items from a series of 10, opaque glass about 2 mm thick, rectangle 6.0 x 2.0 cm, diameter of circle 2 cm, diameter of semicircle 4 cm, BHA. • The recurrent motif of "economy" runs through Albers's teaching and likewise through his model designs for industrial production. He also justified the elementary forms that can be combined to produce letters of the alphabet using arguments such as standardization and saving of time and material. It was not so much the model itself as the aesthetic quality of the module construction that was successful.

masters" at the Bauhaus, with the obligation to continue to provide the greater part of the basic teaching. This permanent appointment allowed him to marry Anneliese Fleischmann, a student of weaving. Finally, following Moholy-Nagy's departure in 1928, Albers became head of the preliminary course until 1933. No other master taught at the Bauhaus for longer than Josef Albers.

Craft work in Weimar was initially influenced by existing craft traditions. But after only one semester Albers, as he later recorded, shifted the center of gravity from the "foundations of craft" to the "foundations of design." In 1924 and 1928, although he had previously been reticent about making theoretical and ideological statements, he set out his artistic and pedagogic position for the first time in essays: in 1924 in "Historic or present-day?" and in 1928 in "Form teaching in craft work." In principle he remained committed to Gropius's conception of harmonizing art education, which had hitherto been carried out in isolation, with the craft forms of present-day life. Albers took over the basic features of his practical approach to teaching from Johannes Itten's preliminary course, which he had himself initially attended. But the course was extended, more tightly structured and dispensed entirely with Itten's spiritual content, the physical limbering up exercises and, most importantly, the "arrogant individualism" that Itten had encouraged. In both men's conceptions, however, the creative powers of the learner were to be set free by their own unprejudiced, playful experimentation and discovery, instead of being treated like children in conventional teaching. Students were to be given an overview of materials to discover their inclinations and aptitude for particular materials and areas of work. Albers's motto was "try it out before studying it." His teaching was based on experiencing things for oneself and learning for oneself by way of precisely defined tasks. The main theme of his preliminary course in Dessau was the development of a feeling for materials through "exercises in matter," in which the external appearance of materials was investigated, and "exercises in materials" in which their inner constructional qualities such as durability and statics were tested. Artistic aesthetics or the practical usefulness of the tasks were not what mattered, but Albers paid close and rigorous attention to absolute economy with regard to materials and work, and demanded systematic, constructive thinking and procedures appropriate to the materials in question. Rationality was the supreme slogan. The preliminary course's concept of experimental and "non-utilitarian" material studies was for many students one of the most important experiences of their period at the Bauhaus. But after Hannes Meyer became director in 1928 it was vehemently criticized,

guest professorships and lectures at almost all the important universities and art schools in the United States, and later at the Design School in Ulm (1953 and 1954–1955), Albers was honored in 1949 with the appointment of director of the department of design at the elite Yale University. He was awarded numerous titles, art prizes and honorary doctorates, and made an honorary citizen of various cities. His legendary teaching, his series of works *Homage to the Square*, his essay "Interaction of Color" and innumerable exhibitions and works in the public sector made him one of the best known artists and teachers. He died in New Haven, Connecticut, in 1976. The practitioner and pedagog, the student and young master, who for a long time had been obliged to take second place to renowned artists and weighty theoreticians, in both the public eye and in the internal hierarchy of the Bauhaus, had emerged from his shadowy existence to become an international star.

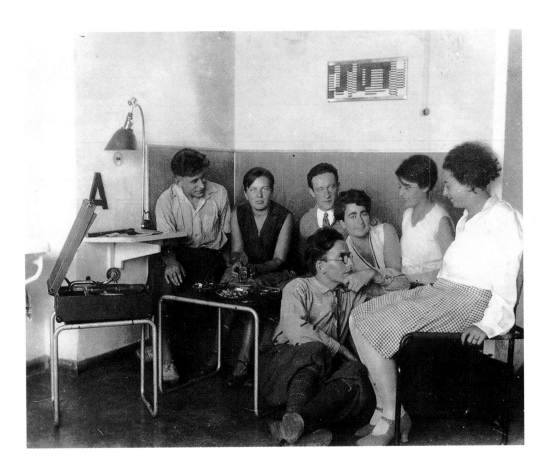

**Socializing in a studio of the Prellerhaus, Bauhaus Dessau.** Around 1929, photograph by Etel Fodor (?), BHA. • The glass picture from the series of "thermometer pictures" is an ideal complement to the modern materials of metal and fabrics and so fits into the décor and furnishing of the studios of the Bauhaus members in the Prellerhaus in Dessau.

**Josef Albers, Kathedrale.** 1930, sandblasted opaque glass, 34.3 x 48.3 cm, Collection The Josef Albers Foundation. • A layer of colored glass was melted onto the pane of white frosted glass. The color, which only remained at the places which were covered over during the sandblasting, was complemented by a further layer added by hand. By precise planning and using a technique developed by Albers, the glass pictures acquire extreme geometric precision and color effects that can only be achieved with this material.

by communist students in particular, as "training in Formalism." They demanded a more scientific approach and concrete preparation for the practical demands of industrially oriented workshop activity. But after Meyer was dismissed and Mies van der Rohe was appointed, the situation was stabilized: instead of being suspended, as had been possible, Josef Albers, the former student, was promoted to the rank of deputy director in 1930. After being accused of "cultural bolshevism," Albers went into exile in the United States in 1933. He was the first Bauhaus master to do so. He went to teach at the newly established Black Mountain College in North Carolina, where he was later director (until 1949), a school which soon became famous for its unconventional teaching methods. In addition to numerous

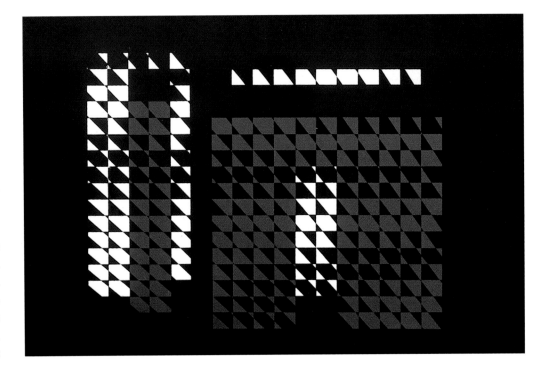

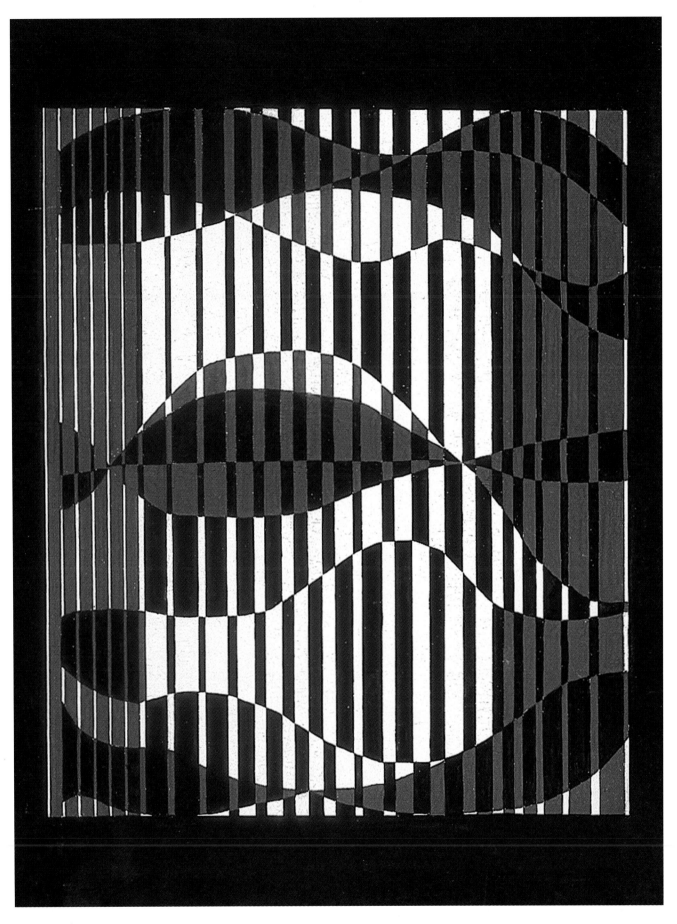

**Josef Albers, Im Wasser (In the Water).** 1927–1928, design for a glass picture, gouache on paper, 53.0 x 40.5 cm, 1927–1928, BHA.
• Evoking the texture of the surface of the water and reflected light, this design, with its amorphous lines, cuts through and overlays the graded lines of geometric glass pictures.

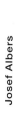

Josef Albers

# Perceptive Painting instead of Op-Art
Friederike Kitschen

The strictly rational art of Joseph Albers, with its often purist limitation to only a few essential elements – the line or the square, its infinitely disciplined and numerous variations and nuances within a single scheme or theme might at first sight appear as a completely self-sufficient artistic tendency, as a hermetic universe. However, the exact opposite is the case – Albers always combined an effective didactic challenge with his art, and the artistic genesis of not one but several developments has been attributed to him during his career. With his constructive glass "thermometer pictures," created in 1925 at the Dessau Bauhaus, Josef Albers was regarded by the second generation of concrete artists, together with Piet Mondrian and Theo van Doesburg, as one of the founding fathers of Concrete Art (Eberhard Roters). From 1933 to 1936 he was a member of one the most important early groups of abstract and concrete artists, "Abstraction – Création," the international association founded in Paris in 1931. As Albers was already working as a lecturer at the Black Mountain College in North Carolina, he became the respected mentor of and ambassador for concrete, geometric-rational art in the United States.

His famous series of pictures, begun in 1949, *Homage to the Square,* varies the theme of four squares set within each other, differing in size and color, in more than 1000 works. With industrially produced colors and strictly laid-down composition schemes, Albers here tests out and demonstrates the reciprocal influences of different colors and their spatial effect. In his 1963 book *Interaction of Color,* he gathers together his experiences with color, which for him is the most relevant medium in art. Albers's psychologically perceptive teaching of the effects of color and line and the strict geometric clarity of his works had a great influence on young American painters, who became aware of it either from a distance, through his writings and exhibitions, or more closely as his pupils and students. In particular he was a role model for those artists who in the early 1950s turned against the all-pervasive abstract expressionism in the United States, countering it with painting based on objectivity and conceptual strictness of design. These artists included Elsworth Kelly and Kenneth Noland, the latter a well-known pupil of Albers at Black Mountain College. Other pupils, such as Robert Rauschenberg, Robert Mangold and Eva Hesse recognized Albers's influence at the beginning of their artistic careers but more critically, saw him as dogmatic, moralistic, disciplined, and strict.

Artists who concerned themselves with the psychology of perception could not ignore Josef Albers, whose whole artistic work is devoted to the theme of "Seeing." However, he vehemently declined the title of "Father of Op Art." For him, art was always visual, but art that exhausted itself in purely optical illusion and immediate visual effects was superfluous. He himself spoke of his art as "perceptive painting." As early as 1931, while still at the Bauhaus, Albers had produced geometric abstract works such as *Falsch gerollt* (Wrongly rolled) which created optical confusion. Around 1936 he

**Josef Albers, Homage to the Square.** 1951, oil on hardboard, 61.0 x 61.0 cm, Collection The Josef and Anni Albers foundation. • Albers devoted many years of his work in America to his theme "The interaction of color." By reducing the form to the minimum he aimed to explore the effects which arise from various combinations and constellations of color.

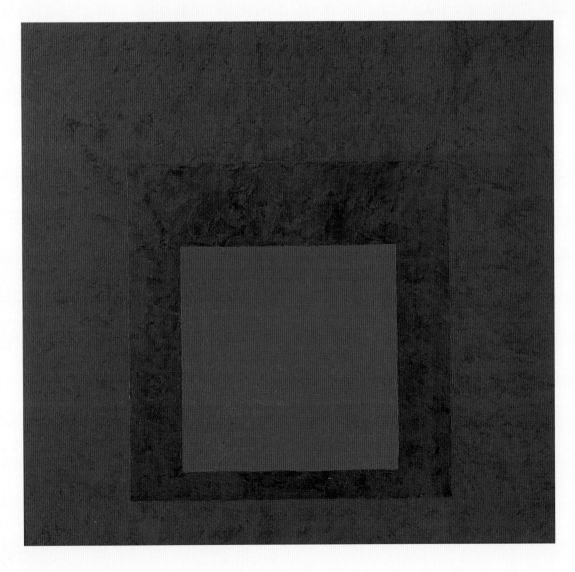

famous (*Interaction of Color,* 1963) he differentiated between "factual facts," that is those facts really in the picture, and "actual facts" which had an effect on the viewer's eye. By disturbing perception with the interplay between picture and eye, and at the same time rendering these seeing experiences transparent, he wanted to make looking at art as much a creative as a rational act. "To open eyes" was his motto, with its dual meaning. Albers hoped that an understanding of seeing would influence the mental processes to the extent that order and meaning, pleasure and reason would increase, and *angst* disappear. He saw the strict icons of his *Homage to the Square* not as didactic showboards, but as "Meditation pictures for the twentieth century."

**Josef Albers, Circles.** 1933, sheet 7 from a collection of "14 Woodcuts," woodcut on paper, 35.5 x 49.5 cm, BHA. • There is an ambiguous relationship between figure and background – compositions such as these from his Bauhaus years, in which the concepts of "positive" and "negative," "space and surface" are challenged, continued to occupy Albers in America where he developed them further.

systematically developed the theme of perceptual irritation in whole series of drawings, leading to the famous series of the 1950s and 1960s, *Graphic Tectonics* and *Structural Constellations* and his 1961 book *Despite Straight Lines*. In these series Albers created complicated puzzle pictures restricted aesthetically to black and white ruled lines. The way the lines cross gives rise to surface relationships and the impression of spatial unfolding which, however, through the trigger of contradictory pictorial representations or conscious re-direction of the gaze, can visually flip from a two-dimensional surface into three-dimensionality, into different spatial directions, into changing relationships between perceived plastic figures and background.

Seeing is challenged, pushed into action, destabilized; the ability to retrieve or produce visual impressions from the picture is stimulated. At the same time Albers's pictures show the impossibility of a final visual perception. The single picture no longer suffices. Instead of one picture, whole series of visual and aesthetic solutions are offered. Albers's aim in this was in no way to produce only a fleeting optical phenomenon on the retina, but rather to encourage the ensuing psychological reaction, so that the painter allows the observer to see more than is physically presented, and "gives him a vision which surpasses the simple optical facts" (Josef Albers, "Op Art and/or Perceptual Effects" in *Yale Scientific Magazine*, November, 1965, p. 1 ff.). In a definition which has become

**Bridget Riley, Fragment 5.** 1965, screen print on plexiglass, Bridget Riley, London. • With his exploration of the optical effects of contrasts, in his foundation course and in his own works, Albers was the forerunner of the Op Art of the '60s and of Bridget Riley, one of its most prominent exponents. The visual effects of this trend were later taken up by future designers of company logos and imprints (e.g. "Pure Wool").

# Marcel Breuer

Andrea Gleiniger

When in 1920 Marcel Lajos Breuer heard from Fred Forbát, five years his senior, and who like him was born in Pécs in Hungary, about the unusual opportunities for study at an exciting new school in Germany, he was 18 years old and had just finished a short but frustrating scholarship at the Vienna Academy of Arts. The new school, called the State Bauhaus, was barely a year old, but its reputation as a futuristic institution had already reached all those who were seeking for a dialog of free and applied arts under the synaesthetic roof of a radical modern vision of architecture. The eight years, with interruptions, which Breuer spent at the Bauhaus were remarkable and decisive both for himself and the Bauhaus. He was a student in Weimar until 1924, then after

**László Moholy-Nagy, Transformation/Angsttraum (Transformation/Anxiety Dream).** 1925, photograph of the original photosculpture by László Moholy-Nagy, gelatin process, 25.0 x 18.5 cm, The J. Paul Getty Museum, Los Angeles. • Breuer, like Moholy-Nagy, saw an opportunity in the richness of ideas offered by constructivism to make new combinations of utilitarian and aesthetic tasks.

**Marcel Breuer, Romantic (African) chair.** 1921 (lost), photographer unknown, BUW Bildarchiv. • The throne-type apprentice's piece with "gothic" contours already showed a feature that was to become characteristic in Breuer's chairs: the woven backrest. The weaver Gunta Stölzl worked it directly onto the wood.

a short period in Paris he was a young master from 1925 to 1928 in Dessau and the leader of the furniture workshop. During this time Breuer became friends with the much older Walter Gropius, and built up a close and long-lasting working relationship with him, the latter acting as a mentor, a fatherly friend and partner until the years of exile in America. In the Bauhaus workshops Breuer also developed those prototypes of his "metal furniture," which together with Mies van der Rohe's and Mart Stam's tubular and cantilever chairs became both incunabula of the design history of the 20th century and the quintessence of the functional and practical aesthetics for modern design represented by the Bauhaus.

Not much is known of Marcel Breuer's childhood and youth in his native city of Pécs, where he was born on May 22, 1902 to a middle-class Jewish family. The idea of becoming an artist and trying out his talent in painting and sculpture drew him to Vienna. However, the spirit of rebellion which had flourished at the turn of the century, giving rise to Secession and Jugendstil, had since become bogged down in academic discourses on aesthetics: architects such as Josef Hoffmann, Otto Wagner and Adolf Loos, who had earlier been the propagators of the provocative outburst, had become incorporated into the artistic establishment. But now the reputation of the Bauhaus for unconventionality and innovation was preceding it.

When Breuer came to the Bauhaus in 1920, improvisation and shortages were omnipresent and a major part of everyday life, however these were transcended by the inspiration and vision of the teachers and masters gathered together and motivated by the euphoric program of new concepts. The furniture workshop, which Breuer joined as an apprentice, was no exception to this. At first the equipment was rather modest, and could only be built up slowly. There was great controversy among the masters about the external contracts that Gropius wished to promote. These were intended to combine theory with practice and promote an opening for industrial manufacturing processes, and also to ensure future resources for the workshops to enable them to develop, and the students to live. Above all Josef

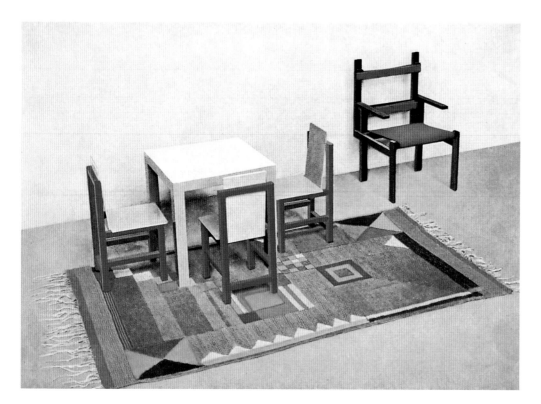

Itten, who at the beginning was also in charge of the furniture workshop, fought against this, and it was over the Weimar furniture workshop that the first argument over principles flared up between Itten and Gropius, when the latter wanted to proceed with the fitting out of the State Theater in Jena which he had built in 1922. When after further disagreements Itten's departure from the Bauhaus became inevitable, Gropius took over the leadership of the workshop himself, before handing it on to Marcel Breuer in 1925.

During Breuer's own years of study at the Weimar Bauhaus, pieces of furniture were made of solid wood and plywood or laminate, which visually exemplified the development of the Bauhaus, and already anticipated a range of those motifs which were to characterize all the design and architectonic features of his work. The first chairs, cabinets, writing desks, etc., are strongly imprinted by the De Stijl movement, introduced to the Weimar students by Theo van Doesburg, who during his brief period as a tutor there agitated against the early expressionism of the Bauhaus. The combination of constructivist logic and cubist spatial organization gave rise to pieces of furniture where the functions can be treated

separately. The stand-alone wood frame bears the weight, and the superimposed plywood defines the areas so that, supported by the different coloring of the individual elements, "this allows the various functioning parts to be separately identified, emphasizing the clarity of the piece" (Marcel Breuer, "Die Möbelwerkstatt des Staatlichen Bauhauses zu Weimar" [The Furniture Workshop of the State Bauhaus in Weimar] in *Fachblatt für Holzarbeiter* [Journal for Skilled Woodworkers], No. 20., 1925, p. 17 ff.).

A high point in his work during the time of his apprenticeship was the first Bauhaus presentation in 1923, which displayed the ideas and aims of the Bauhaus to a wider public through the experimental House on the Horn in Weimar, conceived and designed by Georg Muche and others. This ground plan and interior layout, with decoration by Gropius, Albers, Brendel, Buscher, Dieckmann, and Breuer, was intended to show reformed living and a new futuristic "economy of living" in "the perfectly planned and executed vision of a house, the furnishing, design qualities and technical modernity of which were quite new for their time" (Magdalena Droste, "Die Möbelwerkstatt" [The Furniture Workshop] in *Experiment Bauhaus,* exhibition catalog, BHA, 1988,

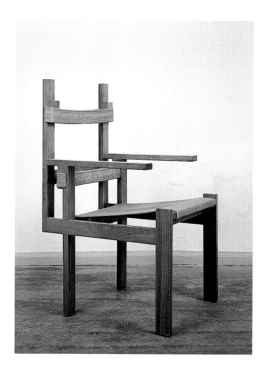

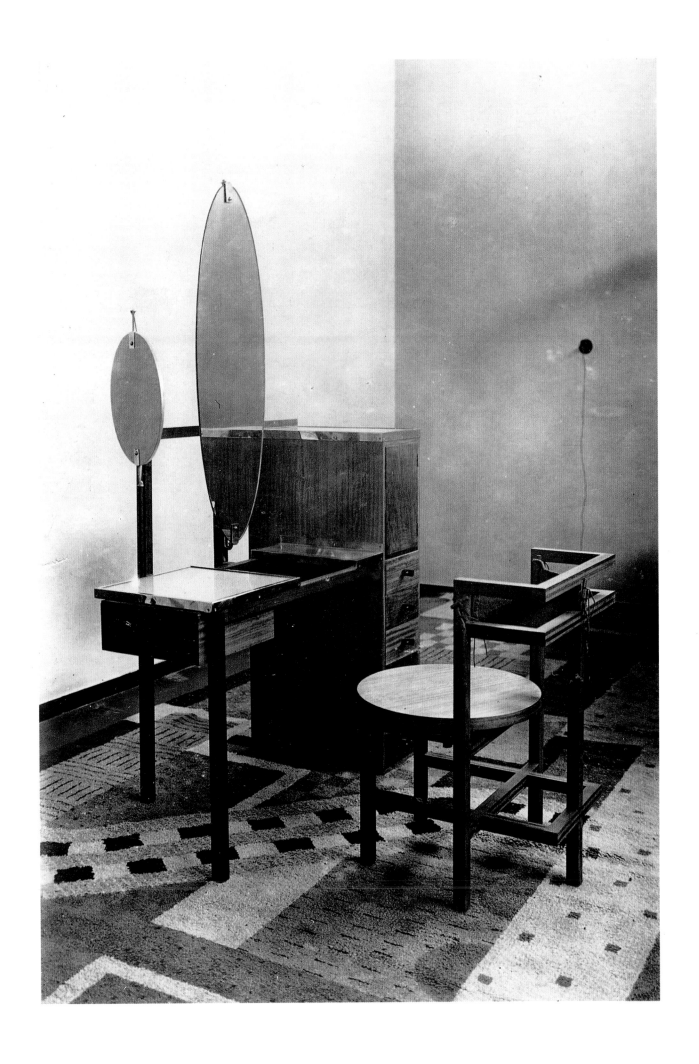

masseinheit 33 cm

vorderansicht

**Marcel Breuer, Module scheme for type furniture.** 1925, BHA. • From 1925 onward Breuer concentrated on the standardization of furniture according to a modular system.

**Marcel Breuer, Lady's wardrobe TI113.** 1927, cabinet panels in cherrywood (exterior) and maple (interior), veneered, 175.4 x 60.0 cm, Design Collection Ludewig, Berlin. • Breuer made a distinction between wardrobes for women and for men. For the lady and her needs a mirror is fitted to the inside of the left-hand door, there is also a small closable compartment for hats at the top, and two ventilated containers for shoes at the bottom.

p. 98 ff.). The furniture designed by Breuer for the lady's bedroom and the living room outlined functionally determined geometric shapes, showing not only the constructivist influence but with strongly accentuated materials and colors. One component of his suggestions for the furniture was the

*Lattenstuhl* (stick chair) conceived in 1922 under the influence of Gerrit Rietveld, who encouraged Breuer to re-evaluate thoroughly the subjects of chairs and sitting. This wooden chair, developed in many versions according to the analysis of function demanded by Gropius, became the best

known example, always quoted and much argued over, of the new form and design. With it Breuer formulated the maxims of pure design arising from the dialog between function and construction, which did away totally with an artistically designed basis, and was conceived in both its constructive logic and its relationship with the material as an item suitable for industrial production. However, none of the pieces of furniture developed by Breuer during this period, in his experimental quest for feasible types, found its way into serial production. The attempts of the Bauhaus to put into effect a program for factory production of the new type furniture were unsuccessful.

The situation of the Bauhaus in Weimar was already precarious in 1924 when Breuer was one of the first students to be completing his course. Armed with recommendations he went to Paris, where he worked in an architect's office, the name of which has been lost. However, in March of 1925, when it was decided to move the Bauhaus to Dessau, Gropius invited him to return to take charge of the furniture workshop, and he immediately accepted. In Marcel Breuer, Gropius had found a congenial student and co-fighter, who rapidly advanced to being the leading figure in the affairs of the furniture workshop, which adopted a "laboratory profile" under his leadership. For Breuer the need to penetrate the furniture industry was not only obvious, he described it as a challenge for those training in the Bauhaus workshops: "The furniture section of the Bauhaus has a double aim, through experimental work in its carpentry and joinery sections to arrive at clear solutions to the problems which are at the base of various furniture types, working out types and systems which make advanced production possible, and furthermore, the training of

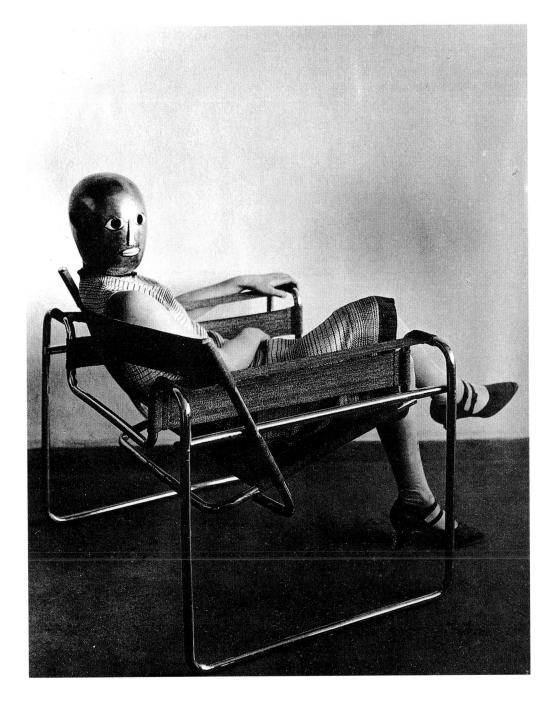

**Marcel Breuer, Club armchair ("Wassily" armchair).** 1926, nickel-plated tubular steel, seat, back and armrests in gray fabric, 73.0 x 77.0 x 68.5 cm, Lis Beyer or Ise Gropius with a stage mask by Oskar Schlemmer, photograph by Erich Consemüller, Bauhaus Stage, 1926, private collection, Bremen. • In his analysis Sigfried Giedion said: "It wasn't just bicycle handlebars and the bentwood chair which led to the new styles, but a new optical attitude. The emphasis on structure and the desire for transparency are manifestations that were first revealed in painting. The Russian painters and plastic artists around 1920, the Suprematists and the Constructivists, may have given a certain aesthetic stimulation. The plastic airy wire creations of the Constructivists, their lightness and transparency correspond exactly to the description which Marcel Breuer gives to his tubular steel chairs: "Their mass will not overwhelm any room."

Marcel Breuer

pupils who by their artistic and technical competence are in a position to exercise a sound and progressive influence on the furniture industry" (Marcel Breuer in *Fachblatt für Holzarbeiter* [Journal for Skilled Woodworkers], No. 20. 1925, p. 17 ff.).

The Dessau Bauhaus began its work in a provisional situation. While the new building, designed by Gropius in the building workshop, was taking shape on a greenfield site, Breuer set up his workshop in the Dessau hall of art. The temporary working conditions appeared in no way to hold back the spirit of experimentation and creativity. It was probably in these first few months that Breuer developed his first tubular steel chair. Breuer had always understood the construction of his prototype furniture pieces as a first step and elemental particle of architecture, as an essential element for the linking, structuring and designing of spatial relationships. The considerations on which his furniture designs were based became the starting point of his architectonic design principles, they offered reciprocal illumination and in varying degrees succeeded in the tasks set: "Thus we come to fixtures and fittings, to rooms, to buildings which in as many of their parts as possible are variable and combinable in different ways. The furniture and even the walls of the room are no longer solid, monumental, apparently rooted or in fact immovable. On the contrary, their outline should sit lightly in the room, as if materializing from the air" (Marcel Breuer, "metallmöbel und moderne räumlichkeit" [metal furniture and modern spaciousness] in *Das Neue Frankfurt*, No. 2, Vol. 1, 1928, p. 11). Hardly anyone could have

**Marcel Breuer, Living room arrangement for Erwin Piscator, Berlin.** 1927, photograph by Lotte Jacobi, Ullstein picture service. • The coolness, emanating from the steel and glass, was envisaged as a domestic ambience by Berlin creative artists, but softened with textile wall hangings and handwoven fabrics.

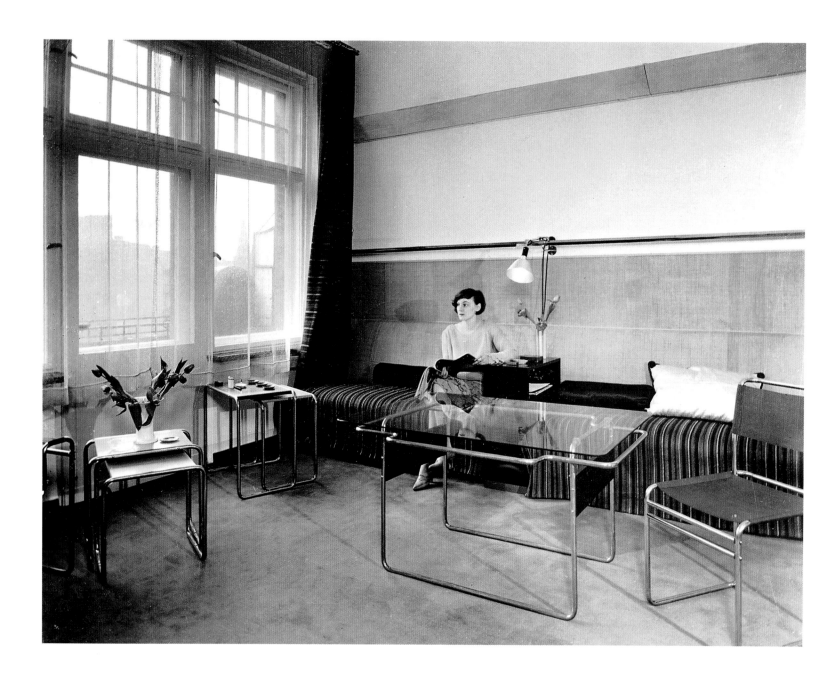

**Karl Hubbuch, Hilde with hair dryer, bicycle and Breuer chair.** 1928–1929, lithographic crayon and watercolor on card, 57.0 x 74.0 cm, Huber collection, Offenbach. • The wind of technology was blowing when the "Wassily" chair gained entry into women's rooms. It was said to be inspired by bicycle handlebars.

more vividly described the effect of those furniture constructions, which in concept and development represented Breuer's second phase at the Bauhaus as a young master and teacher. This was the "metal furniture" phase, which started in the Dessau workshop in 1925. From then on these pieces were to furnish the experimental houses, designed for the modern person, which went on exhibition. Described by Breuer as "the necessary apparatus of modern living" ("metallmöbel und moderne räumlichkeit" [metal furniture and modern spaciousness], 1928), these same pieces would, forty years later, be regarded as exemplars of design history and symbols of a discriminating and uncluttered style of living. Breuer, who originally had only modest success as an architect, but far more as a furniture designer, was represented during this period at all the building and lifestyle exhibitions, such as Stuttgart in 1927, Karlsruhe in 1929, Paris in 1930 and Berlin in 1931, which were propagating the new ideals. In addition, he fitted out a series of apartments and houses for the educated and moneyed classes who set the cultural and business tone in Berlin, financiers,

intellectuals, art collectors and artists. Together with the interior fittings there were also some early architectural design experiments, such as the model for a seven-story house of panels, with duplex apartment dwellings inspired by Le Corbusier, and the design for a multistory block of apartments in 1923, the façade of which is totally delineated by a formal geometry of graphically composed window motifs. Formal architectural training was not envisaged at the Bauhaus, and so Breuer's architectural career only took off after his Bauhaus period, and chiefly in the United States. He and other colleagues at the Bauhaus pressed Gropius without avail to consider the need for a basic and pragmatic training course for architects like those provided in the other areas of the Bauhaus. Although Gropius had formulated the notion of architecture as the ultimate aim of joint artistic effort, he apparently saw concrete architectonic activities as being exclusively reserved to his own building workshop. Before going into exile in America, where his career as an architect really began, Breuer was able to bring to fruition two house projects in Europe of considerable importance, the Villa

Harnischmacher in Wiesbaden in 1932, and the Dolder Valley houses for Sigfried Giedion in Zürich, planned together with Alfred and Emil Roth between 1932 and 1936. Once in the United States, he still had close links with Gropius, maintaining a partnership with him until 1941, before he set up independently in 1946 with offices in Cambridge, Massachusetts, and later in New York. With his detached houses, university and administration buildings which he erected in America and later again in Europe, Breuer found renewed international recognition. With Richard Neutra he became one of the most important exponents of the modern neo-Bauhaus style, filtered through the experiences of his American exile and re-imported into Europe in the 1950s.

Marcel Breuer

# "openwork outlines sit lightly in the room" – the Tubular Steel Furniture of Marcel Breuer

Andrea Gleiniger

In the three years before Marcel Breuer left the Bauhaus in 1928, the same year as Walter Gropius, he had developed a particular typology of steel furniture, or "metal furniture" as he called it, which was to become the embodiment of a new, matter-of-fact, functional living style, rather than merely elements in a modern room. Just as, 70 years previously, specially prepared curved wood was used by Michael Thonet in mass production, now tubular steel came to be seen as the epitome of flexibility and functionality, of lightness, suppleness and economic use of materials.

Breuer made good use of his years as young master in the furniture workshop – he was 23 years old when he took over the responsibility for it. We do not know very much about his teaching methods or his reputation as a teacher and workshop master, but above all else his experiments with chairs can be said to have provided an exemplary set of tangible samples. Although he was the originator of a vast range of domestic furniture, from modular cabinets and shelving systems to tea trolleys, it is the chairs which have made their mark in the history of modern design, representing for Breuer and others an

area of experimentation with advanced furniture technology, and which found their ultimate expression in the almost "collective" creation of the unique cantilever chair with no back legs (Werner Möller and Ottokar Mácel, *Ein Stuhl macht Geschichte* [A Chair Makes History], Munich, 1992, p. 79).

The trend started with the "Wassily" chair of 1925, a club armchair in tubular steel, resting on slides instead of legs. The openwork effect of the complex construction in polished metal, enhanced by firm straps made of stiffened, waxed cotton material, was intended to replace the comfortable traditional upholstery of existing furniture with the optical transparency and physical lightness of airy space. The understanding of seating technology already gained with the earlier exercise in geometric angular construction of the "stick chairs" was a basis for the formal logic, which Breuer translated into the polished nickel-plated steel of the "Wassily" chair. Although wood was then undoubtedly the cheaper material for the mass production envisaged by Breuer, this was no consideration in the face of the symbolic strength which radiated from the shining and sweeping

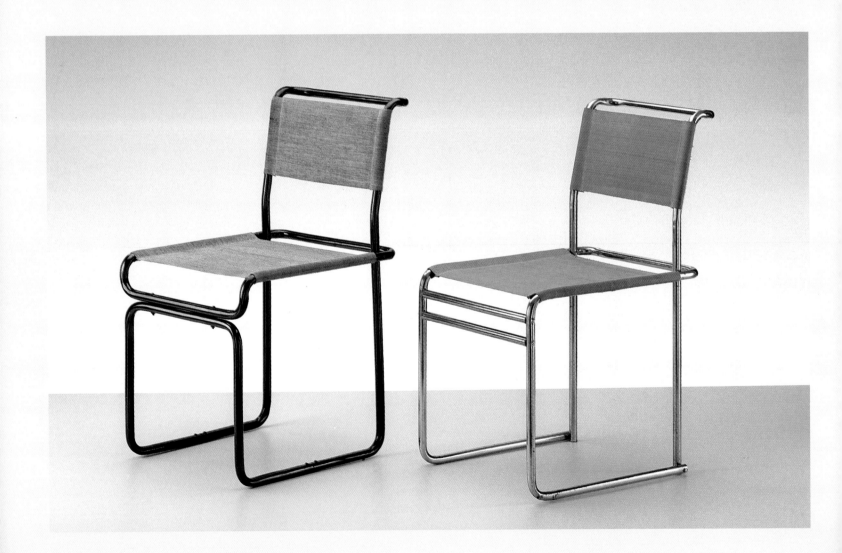

**Marcel Breuer, Chair (prototype B5) and chair B5.** 1926 and 1926–1927, prototype in tubular steel, brown-black finish, fabric seating and backrest, 84.9 x 48.0 x 60.5 cm, B5 in nickel-plated tubular steel, fabric 83.8 x 45.0 x 59.7 cm, BHA. • The disadvantages of this self-contained linear design are clear, the screws on transverses could injure the user's legs. The improved "B5" chair was included in the "Standard furniture" program.

**Visitors in the Bauhaus canteen, Dessau.** About 1929, chairs designed by Marcel Breuer with the B9 stool, 1925–1926, tables from the Bauhaus joinery workshop, photograph by Johann Jacobus van der Linden, BHA. • The stools, created in 1925–1926, and the whole building, furnished and fitted out with the members' prototypes, called forth not only amazement from visitors but occasionally protests.

lines of the curved steel, the embodiment of technological styling. Thanks to Lucia Moholy's photographs there is a record of the variations of design in the development of the "Wassily" armchair, showing how Breuer worked out the economy of technical construction of the parts and the functional form of the complete model. From the start Breuer had always envisaged serial production for his "Wassily" chair, and he bore this out in the design and composition of the parts. He particularly emphasized how the chair could be dismantled into nine parts for economical transportation.

The new Bauhaus building offered him the first opportunity to turn his ideas for furniture into reality. For the dining room he created tubular steel stools, which were later produced in four sizes, doubling where required as occasional tables. For the main hall Breuer created tip-up metal seats with no front legs, which he varied with individual chairs. Another chance to present his range of furniture design came when he designed the interior fittings for Kandinsky's master's house, and above all for Gropius's house. This was a showcase for the concept of freedom from stylized design, stressing neutral combinability and the flexible application potential of types (or targeted types) for interior fittings and furniture modules.

Fitting out the Gropius houses on the Weissenhof estate in 1927 brought his work to a wider public, as did furnishing Mart Stam's apartments and terraced houses from his ever-growing catalog. However, the first cantilever chair which really could claim to be at the heart of the movement toward new chair shapes, and was on show at the exhibition, was Stam's. The chair became the subject of a test case in which the recognition of the inventor was hotly disputed, and detracted from Breuer's claims for innovation when his chair was exhibited a year later, raising a suspicion of plagiarism. Nonetheless, it is his model which is still being produced today by the Thonet company and has become a classic, in contrast to Stam's irregularly angular chair without legs, with its rather rigid design. In 1926 Stam had already designed the prototype of his cantilever chair out of gas pipes, to have it ready for production. However, while recognizing the importance of Mies van der Rohe's even more elegant and sweeping chair which was also exhibited at

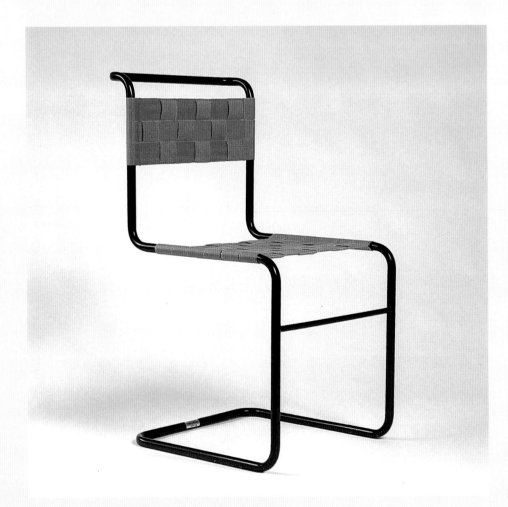

B 32
Thonet

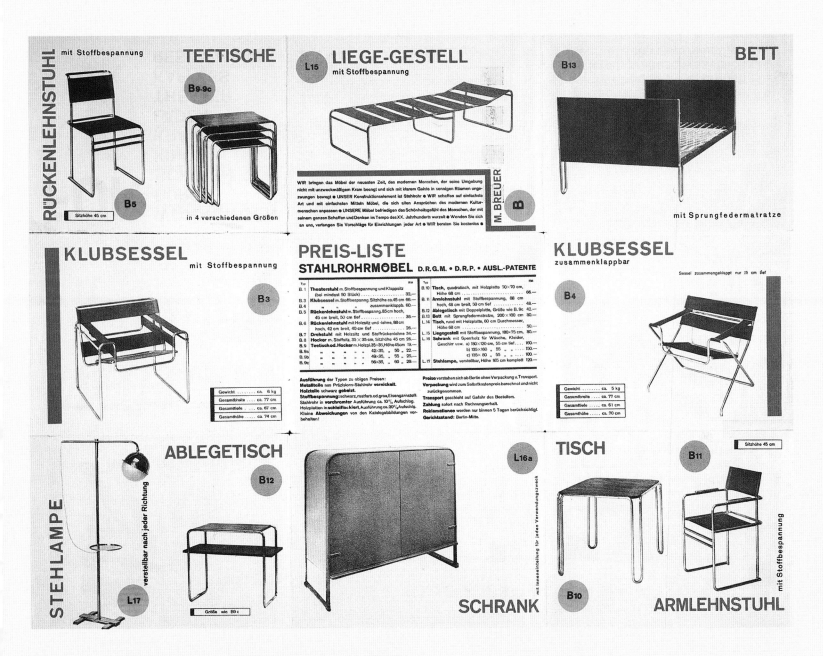

**Kalman Lengyel, Folding leaflet advertising standard furniture.** 1928, extract, BHA. • Breuer's attempts to market his tubular steel furniture by himself soon proved unsuccessful, and he sought to cooperate with production and marketing partners.

Stuttgart, it was above all Breuer's cantilever chair, which appeared to offer a vision of a seat suspended on a column of air, that promoted this development.

As no effective cooperation deal to produce furniture had ever been negotiated between the Bauhaus and industry, Breuer grasped the initiative himself and became a part owner in the Standard Möbel company which Kalman Lengyel had founded in Berlin, and which now took on the production and marketing of Breuer furniture. However, in 1928 Breuer was already selling designs to the Thonet company, which a year later took over Standard after they had run into difficulties. The original Breuer tubular steel furniture never

became a cheap mass production item. From the 1920s, when the pieces were sought after for exclusive Berlin interiors by artists and the medical profession, and the early 1930s, when they appeared in upmarket furniture showrooms set up in Zürich and Basel to promote the new style (inspired by Sigfried Giedion, secretary of CIAM, in conjunction with Breuer) and through to the present day, they have always been the badge of a high standard of living, quality versatile pieces which have outlasted the more conventional kinds of design which they challenged. The real mass production of cantilever chairs exists, ironically, in the many cheap copies and plagiarisms available today, offered by the malls and furniture chains in colorful abundance and questionable workmanship.

# Herbert Bayer

Ute Brüning

The starting point for Bayer's swift career progress to become one of the first "graphic designers," sought after in Germany in the 1930s and subsequently in the United States, was his teaching post at the Bauhaus. Even so, years after his death, the details of this period of his work are in many ways unclear. What he taught in the time between 1925 and 1928, we can on the whole only learn from his own work. There are hardly any traces of pupils and their creations. We are dealing with an output which was being continuously revised and honed by Bayer himself. During his lifetime he monitored who wrote about him and what was written. Gwen Chanzit, who in 1985, shortly after his death, investigated his role as an "early purveyor of modernist design in America," remarked on his striving for exclusivity and control. At the Dessau Bauhaus, Bayer took over the leadership of the newly founded workshop for print and publicity. There followed three years in which he must be considered chiefly as a typographer. Without any prior training in typesetting and printing his name became quite respected in the trade. However, in the picture of himself which Bayer has left behind for us, he made little of such details. Immediately after his departure from the Bauhaus, painting played a central role in Bayer's creative work, but there are scant sources of information available on his earlier work. As a photographer he also first came into the limelight after his Bauhaus period. His famous still life cover for the 1928 Bauhaus journal points, however, to previous considerable if unsubstantiated practice in photography. When Bayer started to come to grips with the experiments on lettering, he had already encountered the first attempts of Doesburg,

**Herbert Bayer, Mit Kopf, Herz und Hand (With Head, Heart and Hand).** 1923, watercolor, tempera, Indian ink drawing and collage, 55.0 x 39.5 cm, private collection, Switzerland. • The heart and hand of the future young master at the Bauhaus were to continue to function rationally as seen in this composition, reminiscent of Schlemmer. His love of integrating several techniques also continued.

**Herbert Bayer, Self portrait.** 1932, photograph of the original photomontage, around 1937, gelatin process, semi-matt, 39.8 x 29.8 cm, BHA. • As a young artist Bayer turned to classic surrealist motifs in his paintings and photography, which he would also frequently use in advertising graphics.

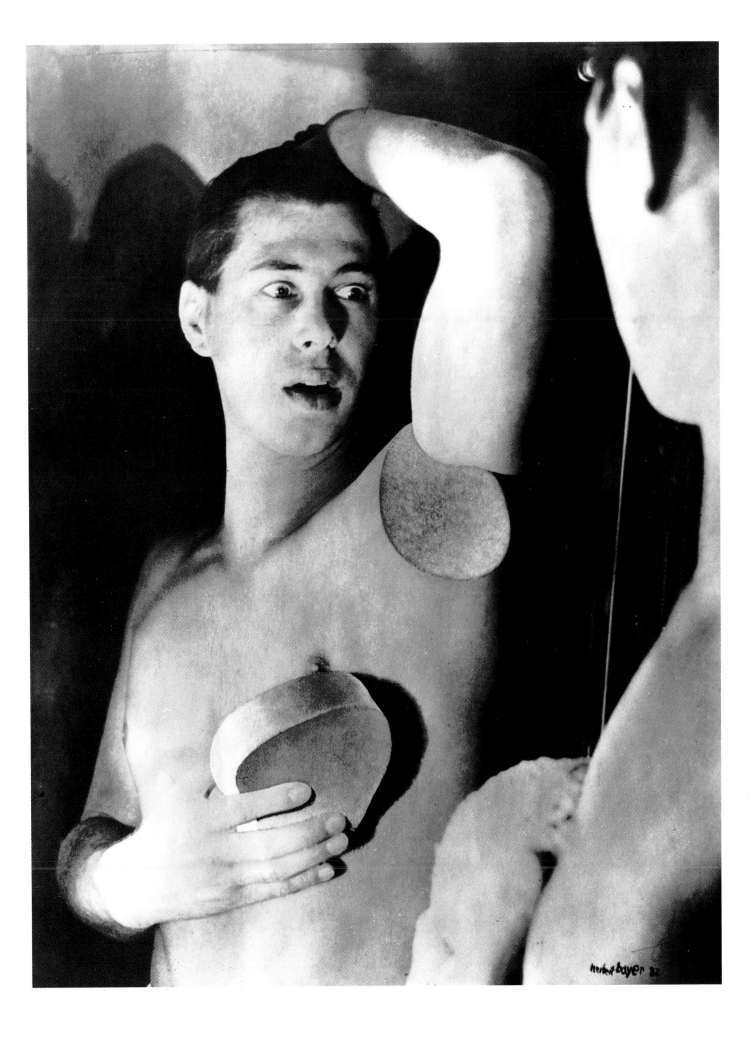

Herbert Bayer

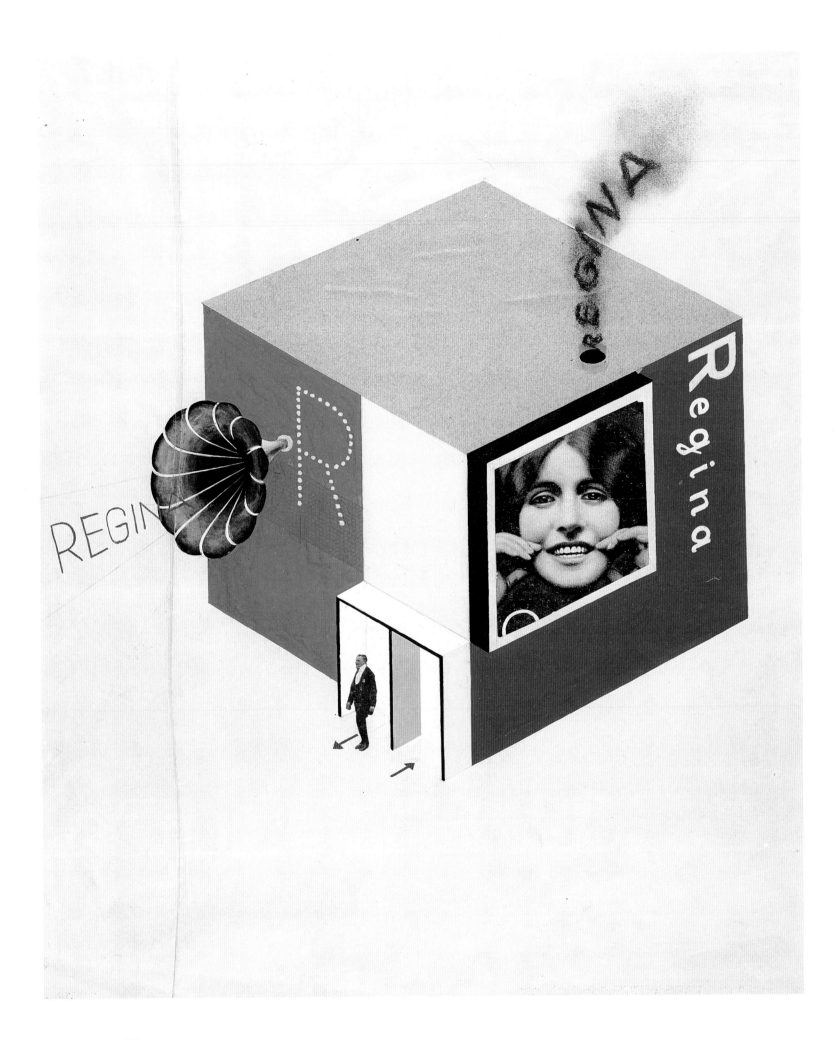

**Lázló Moholy-Nagy, Letterhead for the Bauhaus publishing house.** 1923. letterpress printing, 28.4 x 22.3 cm, BHA. • Moholy-Nagy in contrast used technical typography to achieve an essentially more radical and striking visual effect.

**Herbert Bayer, Standard letterhead.** 1925, letterpress printing, DIN A 4, BHA. • At the Bauhaus Bayer was a protagonist of the Taylorian approach to communication and technical typography, as was László Moholy-Nagy before him.

**Herbert Bayer, Design rough for a multimedia stand at a trade fair.** 1924, collage, charcoal and colored ink over pencil, 54.6 x 46.8 cm, Courtesy of the Busch-Reisinger Museum, Harvard University Art Museum, Gift of Herbert Bayer. • As advertising was not taught at the Bauhaus before 1925, Bayer went to the mural workshop. He combined his experience from studies of wall painting with his training in advertising in the design of many advertisements. He considered the combination of these two disciplines so important that as a young master he incorporated them into the timetable.

Lissitsky, Schwitter, and Moholy to revolutionize life by measuring it against art. In Weimar he had tested the effects of their "new typography" against the models of the Dutch De Stijl movement. But Bayer's own first designs in Dessau spoke a completely different language. There were new-style layouts for the Bauhaus letterheads. The printed version included footnotes, in which Bayer felt he had to explain his design which did not use capital letters, stating that lower-case letters were more economical for legibility, for learning and printing. At the same time Bayer revealed the theoretical program which provided the basis. It was the concept of Walter Porstmann, who envisaged that lower-case characters would facilitate understanding in an economic way. Two other factors are relevant in this context: the new "DIN" standardization of paper sizes according to the Deutscher Normenausschuß (German Standards Committee) and also the layout of text in business correspondence. In order to be able to organize news and its processing more rapidly and thoroughly, printed type, perforations and folding should always be done uniformly. Porstmann had brought these ideas to the Bauhaus. It is amusing to see to what extent

Bayer experimented with the position where the two constructivist lines should cross, until this marked the prescribed edge for typing, whereas Moholy had placed it at the edge of the Bauhaus notepaper. He also stretched Moholy's dynamic typography, with its rich contrasts, until sender and address fitted into DIN 676 size. Porstmann's vision embraced more than mere standardization. He envisaged the creation of an accord to bond peoples together by replacing national languages with a synthetic, rational, newly created world language and script. This also provided a whole edifice of new thinking, more comprehensive than Esperanto, bringing compulsive rationality into quite dissimilar specialist areas. If one remembers that Bayer, in his journeyman examination in wall painting, offered as his test subject the color standards of Wilhelm Ostwald, then it becomes clear how close he already was to the idea of standardization as a universal bond.

It might be thought that Bayer had begun working toward this standardization in the printing and publicity workshop. This is partly true. From this time on, standardization of format and type in lower-case characterized the official publications and internal communications of the

**Herbert Bayer, Invitation.** 1926, lithograph, 20.9 x 28.8 cm, BHA. • Division of the surface area, color and typography illustrate graphically the theme for the "White Party" costumes: "two-thirds white, one-third color, dotted, cubed and striped."

**Herbert Bayer, Experiment with new typeface.** 1926, illustration from *Offset, Buch und Werbekunst* (Offset, Book and Advertising Art), No. 7, 1926, BHA. • Bayer's designs for Universal attempted to create a world alphabet which could be read, written and printed internationally. This design for an imaginary collective scheme was the starting point for a typeface with a wide range of applications.

Bauhaus and its members. However, Walter Gropius, who had also propounded these controversial innovations in his lectures, now sought to attribute only a relative value to them: the "eradication of upper-case characters" was promoted by "extremist proponents of standardization," was "not asked for" by him, and the "battle against upper-case letters" was a "hobby horse of the students" (*Papierzeitung* of July 10, 1926). But why had he given permission for the new type of letterhead, which aroused a great deal of indignation? By doing so, he wished to resolve the rift which had opened up between enthusiasm for rational development methods and newly accessible design innovations, by deciding in favor of the latter.

The intended route toward universal communication also included the development of internationally uniform signs, such as traffic signals and road signs. An essential step in this direction was Bayer's idea for his Universal typeface. As a direct sequel to Walter Porstmann's ideas, the first studies took place in December of 1925. He had in mind one single "world style," usable worldwide for printed, handwritten and typewritten work. This involved a series of symbols which were isolated from each other, in other words the very opposite of a running script, which would be unified into lower-case characters with a continuous line, similar to Breuer's cantilever chair. They are based on an analysis of the Roman Capitalis, the original form of antique typeface. If they are stripped of their "flesh," the distinctive geometric skeleton of a simplified grotesque remains. It was an imaginative concept, and echoed the lettering experts Rudolf von Larisch and Fritz Helmut Ehmcke who had already recommended the beauty and geometry of the Capitalis in their textbooks of 1902 and 1911 as an example for new experiments in type. Bayer humorously demonstrated grotesque in a different way in his 1930 article, written for the Uhu publishing firm: "Undress – and you are Greek." For many of the new typographers, existing skeleton or grotesque types were too incomplete. For Bayer, therefore, the next step was a new synthetic, geometric structure. The experimental sketches show a glimmer of Kandinsky's "analytical drawing." In the specialist journal *Klimsch's Druckereianzeiger* (Klimsch's Printers Gazette), No. 56 of 1927, the head of the Bauer hot metal foundry

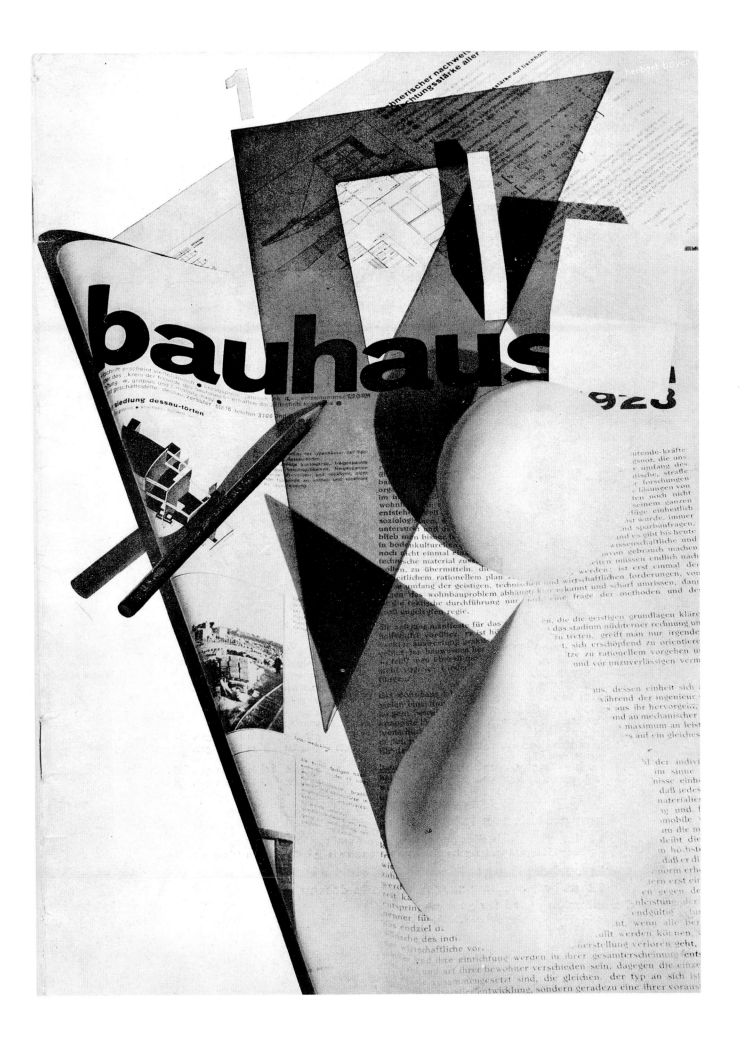

Herbert Bayer

**Herbert Bayer, Facing Profiles.** 1929, photograph of the original photomontage, gelatin process, 35.4 x 27.8 cm, BHA. • After his Bauhaus period, Bayer took the idea from Willi Baumeister of combining photographic and manual techniques to explore perspective space and surface, and developed it further. He arrived at a method of presentation which confidently guides the viewer's eye and stimulates the ability to make associations – a prime factor for effectiveness in advertising.

described the invasion of abstract form in advertising type as "pointless, self-important and superficial." Although the typeface did not appear on the market at that time, designers such as Karel Teige, Sandor Bortnyk, Jan Tschichold, Joost Schmidt and the Bauhaus, Bodo and Heinz Rasch, Raoul Hausmann, the Burg Giebichenstein group and others used it as a basis for further design experiments. (The Universal typeface released in 1975 by the International Typeface Company as "ITC-bauhaus" bears no genuine relationship.) Bayer, however, felt he had been violently attacked (letter of March 4, 1976 to H. M. Wingler, correspondence in the Bauhaus Archive, Berlin). Did he see Universal as a Bauhaus typeface? More recently the London designer group The Foundry have made it available as a digital typeface "faithful to the original" in their "architype" series, although there is not yet a final version.

The very success of this typeface concept makes it so regrettable that there is no documentary proof either of its origin or of Bayer's dating of 1925. In 1924 his colleague in Weimar, Moholy-Nagy, was advocating "a unified typeface without upper- or lower-case characters, only letters unified by their form, not their size." In 1924 the painter Burchartz conceived a similar typeface, probably as the house style for his company, "werbe-bau." With

**Herbert Bayer, "the mouth" card.** 1926, collage, mixed media, newspaper cuttings mounted on cardboard, 59.0 x 125.5 cm, BHA. • An oversized greetings card from the Bauhaus members for Gropius's 44th birthday. The people offering their congratulatory kisses are identified by their signature, and the rest of the surface is strewn with cryptic messages: "The irresistible ones," "Hair in unwanted places," etc.

its rounded letters and no base line it already includes the concept of the unbroken circle, to be taken up by Bayer. The first publication by Bayer of his ideas on a unified typeface did not appear until July of 1926. His contribution in the Bauhaus publication *Offset, Buch und Werbekunst* (Offset, Book and Advertising Art), which he called "Versuch einer neuen Schrift" (New Typeface Experiment) at this stage showed only the first indications of the later designs for Universal. If more letters of the alphabet had been completed, Bayer would surely have presented them here. Similarly, in February of 1927 in Zwickau, at the first exhibition of Elemental Typographers, when Bayer devoted a whole wall panel to his "New Typeface Experiment," there is still nothing that can be recognized as characteristic of the Universal face. Also in 1927, Karel Teige tried to revise the typeface in the offset version, published in Vol. 8, 1929 of the journal *RED*. Not until October, 1927, in the poster for the "2. werbeunterrichtliche woche bauhaus dessau" (2nd advertising classes week at the dessau bauhaus) do letterforms appear for a complete alphabet. These were quite like the Viennese Albertina, and much later were named by Bayer as the

"Universal type 1928." This did not prevent him from continuing until 1938 to do more work on individual letters. It is clear from this how far Bayer had moved away in the intervening years from the theme of a "world typeface" and toward perfecting the letterforms. The fate of Universal shows how quickly a marketable product should evolve from experimentation, and how the radical idea for an imaginary "collective scheme" ended in a design with wide spheres of application.

Under pressure at the Bauhaus to exploit products, Bayer developed his avant-garde publicity and advertising. This owes a debt to another version of world communication, propounded by the advertising and publicity theorist Hans Weidenmüller. His communications model for advertising proposed the shortest route between sender and receiver, and lined up various publicity items in the concept "Nachricht über ein Angebot" (News about an Offer). Bayer avoided individual artistic handwriting, therefore, and with a "neutrally technical" presentation went straight for the essentials in typesetting and printing, continuously perfecting the innovations of others such as Buchartz, Moholy-Nagy and Baumeister. Moholy's

revolutionary typophoto experiments apparently left him cold, however. Of course, he incorporated photography, which he saw as an "objective" new form of illustration. He did not, however, succumb to the fascinating themes of transparency and dematerialization which attracted his colleagues. Why? Bayer quickly realized that he was an "advertising and publicity enthusiast," in the Weidenmüller sense, for whom these experiments were a means to an end, free of artistic value. At the end of 1927, the innovative value of "rational" design methods also seemed to have lost its attraction for him. He transferred his attention to montage, which for him opened up perspectives in design of an "apparently organic super-realism." This idea, drawn from the visions of his colleague Moholy, encouraged him to turn not only toward information but also toward the wish for a predetermined target. In his article "Photographie in der Reklame" (Photography in Advertising) of September 1927, Moholy still called for the creative integration of all imaginable media and techniques, whereas in Bayer's hands (see following pages) this from now on became the way to achieve imperceptible, fascinating seductions.

Zwei große Prinzipien, die wir als Grundgesetze des Lebens ansprechen können, verwirklicht die Natur, wenn sie Lebewesen, die zu höheren Aufgaben berufen und befähigt sein sollen, hervorbringt: Das *Prinzip der Arbeitsteilung* und das dadurch bedingte *Führerprinzip*, d. h. die Möglichkeit, die Träger der geteilten Arbeit zwecks Wiederzusammenfassung der Einzelleistungen zu einer Gesamtwirkung zu steuern. Je umfangreicher die Aufgaben sind, um so vielgestaltiger schafft die Natur den Organismus, um so mehr Organe und Systeme werden herausgebildet und um so wunderbarer die Zusammenfassung aller erhaltenden Teile, jene Zusammenfassung, die den Gesamtorganismus lebens-, also arbeitsfähig erhält. So gestaltet die Natur immer *ein organisches Ganzes*, das in seinem Lebenslauf, in seiner bewußten Willensbildung von einer Stelle aus letztlich bestimmt wird. Mag ein Organ noch so hochentwickelt sein, mag ihm eine Sonderaufgabe von noch so hoher Lebenswichtigkeit aufgetragen sein, hinsichtlich der bewußten Lebensführung trifft die Zentralstelle alle letzten Entscheidungen. Der bewußte Einsatz des menschlichen Körpers, die Steuerung gewollter Handlungen und bewußter Lebensführung beruht im Gehirn. Sei es nun, daß Arm und Hand den Befehl zum Ergreifen des Spatens, mit dem die Scholle umbrochen wird, erhält, oder sei es, daß zu neuer Kräftebildung die Nahrungsaufnahme gefordert wird.

Je tiefer wir eindringen in die Erkenntnis der Naturgesetze, die im höchsten Organismus, den die Natur schuf, im Menschen walten, um so stärker drängt sich uns der Vergleich von Mensch und Volk auf.

*Das große Prinzip von Arbeitsteilung* zwecks Höchstleistung einerseits, und Führerautorität zwecks steuernder *Leistungszusammenfassung* andererseits, wird gezeigt. Und neben diese Darstellung wird eine zweite gestellt, die des naturgesetzlichen, völkischen Staates. Sie läßt erkennen, daß der Aufbau eines solchen Staates nichts anderes ist, als die höchste Organisationsform eines Volkes, in der notwendig die gleichen Gesetze der Arbeitsteilung und ihrer Wiederzusammenfassung durch das Führerprinzip zur Anwendung gelangen.

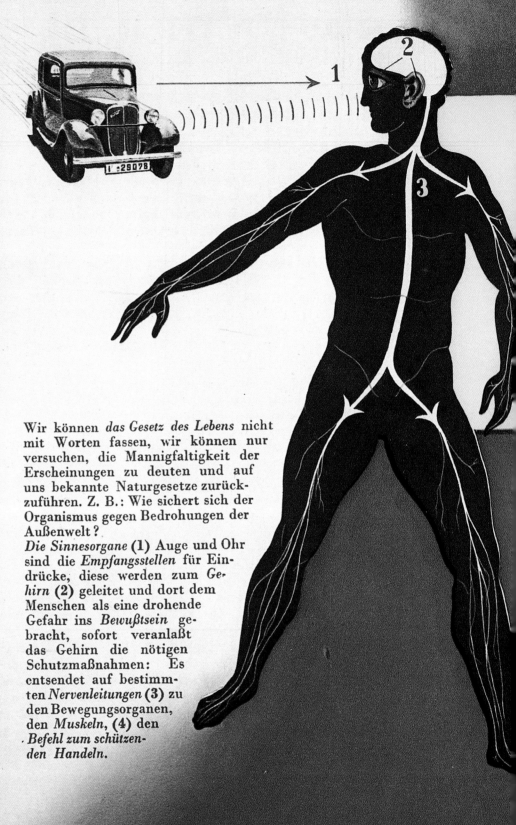

Wir können *das Gesetz des Lebens* nicht mit Worten fassen, wir können nur versuchen, die Mannigfaltigkeit der Erscheinungen zu deuten und auf uns bekannte Naturgesetze zurückzuführen. Z. B.: Wie sichert sich der Organismus gegen Bedrohungen der Außenwelt?

*Die Sinnesorgane* (1) Auge und Ohr sind die *Empfangsstellen* für Eindrücke; diese werden zum *Gehirn* (2) geleitet und dort dem Menschen als eine drohende Gefahr ins *Bewußtsein* gebracht, sofort veranlaßt das Gehirn die nötigen Schutzmaßnahmen: Es entsendet auf bestimmten *Nervenleitungen* (3) zu den Bewegungsorganen, den *Muskeln,* (4) den *Befehl zum schützenden Handeln.*

**Herbert Bayer, double-page spread from the catalog "Wunder des Lebens" (The Wonder of Life).** 1935, letterpress printing, enlarged illustration, size of original 20.9 x 20.9 cm, BHA. • Bayer specialized on his own and on behalf of the Dorland Studio in the architecture of spatial associations. By using a technique of photomontage and spray painting it was possible to evoke thought and picture worlds with many interpretations, which merged into one clear meaning for that particular period of history.

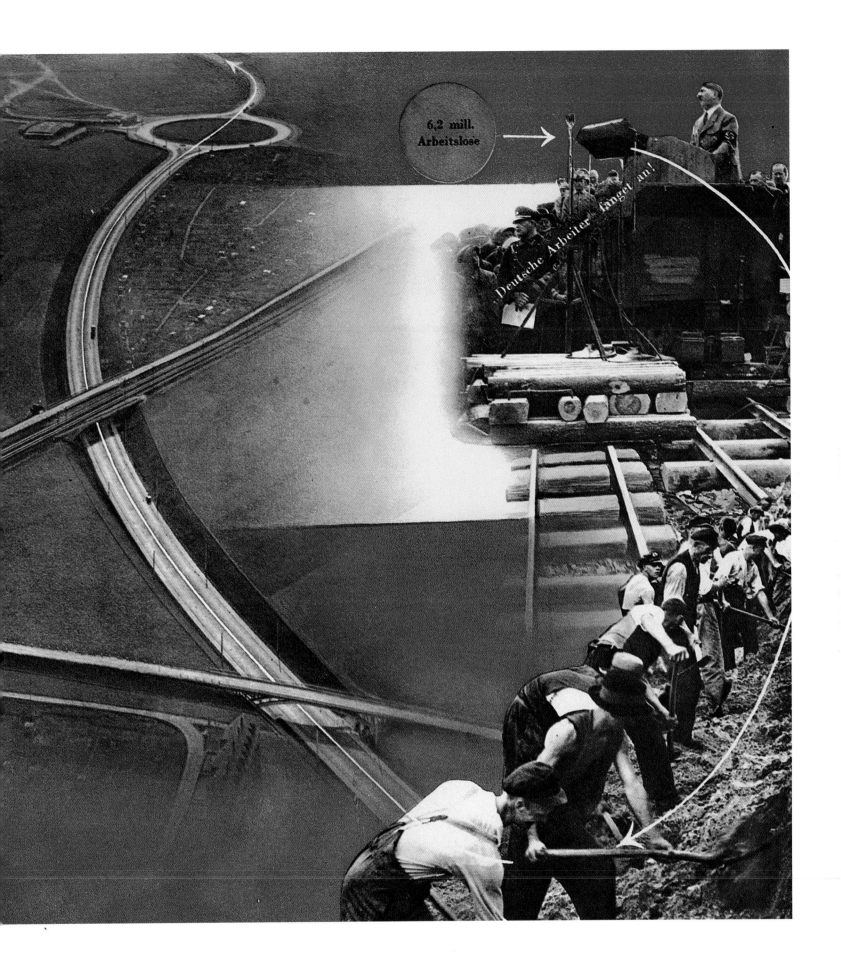

6,2 mill.
Arbeitslose →

Deutsche Arbeiter fanget an!

# Universal Design for the National Socialist Economy and State
Ute Brüning

VENUS IMMER KLASSISCH

*Venus*

VENUS-WERKE · WIRKEREI UND STRICKEREI A.G. CHEMNITZ/SA.

**Herbert Bayer, front cover of "Gebrauchsgraphik" (Practical Graphics).** 1938, letterpress printing, DIN A4, BHA. • Eye and hand, favorite Bauhaus motifs, were presented in this journal cover as mechanical-biological models of artistic activity.

**Designer unknown, "Venus," small poster by the Dorland company.** About 1937, offset printing, 34.5 x 23.5 cm, Dorland Advertising Agency, Berlin. • Classical references combined with infinite space offer customers the opportunity to see themselves reflected in the Venus ideal of Antiquity.

Once he was free of his teaching duties at the Bauhaus, Herbert Bayer took up painting, drawing and photography again, and set up exhibitions. According to wife Irene, in 1931 he "was dealing with the psychic subconscious experiences of the dream world," and he saw himself as "neither intellectual nor political" but "purely creative."

Statements in the catalog for his second individual exhibition in Linz were to remain as his mottos for almost ten years until 1938, a period in which he headed the Dorland advertising agency in Berlin, and employed some of his former Bauhaus colleagues there. The mixture of dream and a technique based in art was important for the aims of

# GEBRAUCHSGRAPHIK
## INTERNATIONAL ADVERTISING ART

OKTOBER 1938

FRENZEL & ENGELBRECHER „GEBRAUCHS-
GRAPHIK" VERLAG BERLIN SW 68,
WILHELMSTR. 148. ALLEINVERTRETER FÜR
U. S. A. UND KANADA: THE BOOK SER-
VICE COMPANY, 15 EAST 40TH STREET,
NEW YORK CITY, SOLE REPRESEN-
TATIVES FOR THE U.S.A. AND CANADA

advertising, and the impact of this new departure was striking. At the beginning of the Third Reich, Bayer's career was set for vertical take-off when he was approached, as an expert in his field, to work on National Socialist state propaganda. His career might then have taken an equally rapid downward path, but it clearly did not. The success curve can be followed in close detail through German trade journals, which all reportedly served National Socialist ideals. *Gebrauchsgraphik* (Practical Graphics) devoted a lot of "unpolitical" pages to Bayer. *Deutsche Werbung* (German Advertising) traced the aims of the Nazi leadership with him. *Seidels Reklame* (Seidel's Advertising) repeatedly displayed his advertising techniques. *Die Anzeige* (The Advertisement) expressed its fascination with the Dorland Studio and its technical and advertising strategies. Surprisingly, the important English trade journal *Commercial Art and Industry* publicized his artistic work quite frequently, thus reinforcing Bayer's image of himself.

What was the focus of the trade press? Initially, it was exhibition posters, in parallel with announcements of the three big Berlin state propaganda exhibitions: 1934, 1935 and 1936. By 1937 the spotlight was on brochures, and then advertisements came to the fore. The

commissions received by Bayer and the Dorland Studio reflect this progression very accurately. It also corresponded to a shift in the official political line of the German Business Advertising and Publicity Council, which laid down the law for advertising. For state propaganda, first the exhibition should be the predominant means of publicity, then the systematic promotion of advertising. The aim was to use this mass medium to achieve an even wider economic education of the public, in other words to direct the consumer. In pursuit of this aim individual advertising should become "communal advertising." The campaigns of firms promoting brand names often served as models for this change in direction. The Dorland Studio, with its proven experience in brand name advertising, worked on this theme in a "purely creative" manner, and thus stayed within the official state line on advertising.

The brochure for the 1935 exhibition "The Wonder of Life" was featured prominently in all the journals named above. Bayer himself regarded it as highly significant, and thus these colorful pages, which at that time called for the purity of the German race, were still being reproduced in many Bayer catalogs (in black and white, with neutral descriptions) into the 1970s. The article "Modern Art gets down to

Business," which appeared in *Commercial Art and Industry* in 1935, glossed over this estimation by explaining that Bayer's technique, with its spatial-logical juxtaposition of completely alien motifs, could bring about "intense, comprehensive thought training." In 1935, however, training German consumers in the powers of association was not without purpose. Bayer's idea, to mark out "association spaces" in an "apparently organic super-realism" (Moholy's words) and to leave the interpretation to the viewer within certain limits, was not perfected at that stage. *Commercial Art* was of the opinion that these methods could also be usefully employed for other kinds of publicity and advertising campaigns. The design of association spaces became Bayer's speciality. Some motifs help this process, for example unending plains with a sky scattered with small clouds, frames the viewer can look through and see something else, amorphous holes and shadows, used to bring depth to an advertisement. One could claim, in explaining Bauer's past, that these techniques were "universal" and served all kinds of purposes, but does that mean approving the method?

The *Archiv für Markenartikelpropaganda* (Archive for Brand Name Propaganda), published by F.O. Doebbelin between 1935 and 1938, confirms that Bayer's way was highly contemporary but also as short-lived as the journal itself. People have no liking for prescriptive doctrinaire directions in advertising – thus ran the argument in 1935 against the often preferred advertising strategy of "hammering it in." "It is much better to leave a keyhole, allowing room for the reader's fantasy to develop, simply supplying him with a point of interest, so that he can then reach his own conclusion" (Karl Heinz Hein, *Eine Quelle neuer Argumente* [A Source of New Arguments], 1st edition, Berlin, 1935, p. 31). In the same publication (p. 72) Hans Domitzlaff gave further support to the argument: "The consumer, once he has unraveled the chain of thought presented to him by the practiced advertiser, believes he has convinced himself."

With the subtle techniques of "apparently organic super-realism" Bayer and his colleagues from the Bauhaus contributed to a discovery which was influential, despite competing with the official Nazi line on advertising, and which, though irrelevant on the brink of war, became all the more important afterward: that desire must be created in the customer by the advertiser, and can then go to work within the customer's subconscious. Rolf Sachsse criticized Bauer for "over-hasty obedience" (*Camera Austria*, 1994, Vol. 46). Bayer was partly responsible for this kind of one-sided assessment in that he allowed himself to be presented exclusively, even dangerously so, as the "universal" artist with a "total concept."

**Kurt Kranz, back of jacket for "Steel Bridges" brochure.** 1936, special edition of the journal *Stahl überall* (Steel Everywhere), copper photogravure on paper, DIN A4 landscape, BHA. • The overlaying of two media, type and documentary photography, here intensifies the publicity effect. In the new ways of relating type and pictures in offset technology, Bauhaus members also made a decisive contribution to changing general perceptions.

**Kurt Kranz, Advertisement for "A.G.B. Fabrics, Tauentzien 17."** 1936, letterpress on fine art paper, 28.8 x 10.5 cm, BHA. • A procession of former Bauhaus members such as Kurt Kranz and Hannes Neuner were to follow Bayer to the Dorland Studio. In the studio's work, advertising and presentation techniques were strongly influenced by Bayer's prescriptive and aesthetic notions.

# Gunta Stölzl

Anja Baumhoff

Gunta Stölzl was one of the most successful women in the Bauhaus movement and outstanding for her creativity, stubbornness and talent for organization. She identified herself fully with the school and became involved not only in the workshop, but also in the kitchen and the garden of the Bauhaus and in the often quite demanding task of organizing the parties. Before she transferred to the State Bauhaus, Gunta Stölzl had studied for eight semesters at the School of Applied Arts in Munich, under the well-known director Richard Riemerschmidt. Entering the Bauhaus after this represented a sideways step for her, but it was perhaps the most important step she ever took. This period of study, combined with her own talent, was the basis for her success in Weimar and Dessau. Although her career as the only female young master in the school is unusual, she was in many respects a typical Bauhaus woman. So who was Gunta Stölzl?

Adelgunde Stölzl was born in Munich in 1897. Her father was a teacher who gave his children a reformed and liberal education. As part of this she studied at a high school for the daughters of professionals and finished successfully with her senior school certificate in 1913, following which she enrolled in the School of Applied Arts. She interrupted her studies and volunteered for war service as a Red Cross nursing assistant when she was only 17. After she had returned to her alma mater she became a member of the students' reform commission and became acquainted with Walter Gropius's Bauhaus manifesto, the front cover of which was illustrated by Lyonel Feininger's famous woodcut: "The motif of the Cathedral of Socialism." This prospectus inspired Gunta Stölzl to visit Weimar. The reforming ideas and the charisma of the director influenced her so strongly that for a second time she enrolled as a student, this time at the Bauhaus. Her

**Gunta Stölzl, Wall hanging No. 539.** 1926, openwork weave and binding, artificial silk, wool, 227.5 x 89.5 cm, Die Neue Sammlung, Staatliches Museum für angewandte Kunst, Munich. • Experiments with warp stitches, dyed according to the weft, giving asymmetric rectangular patterns. Where different-colored warp and weft cross each other, mixed tones occur which have a transparent effect. By also changing the binding Stölzl creates different surface effects.

diaries reveal early spiritual interests. Life-reforming ideas, such as those from the Wandervogel movement, made their mark on Gunta Stölzl and many other Bauhaus members, and formed the basis for both Bauhaus ideas and the special feeling of comradeship which colored their relations with each other. In contrast to most of the other students, who only stayed on average for three semesters, Gunta Stölzl stayed for 12 years at the Bauhaus, six of these as a student.

Apart from her own personality, there were however other reasons relating to the structure of the otherwise male-dominated school which enabled Gunta Stölzl to pursue her career there. The women's class offered the only area of work where a woman could legitimately aspire to a senior position. Without this gender divide it would have been almost impossible for Gunta Stölzl to advance her claim for a high-ranking position. The existence of this dedicated women's section appeared to legitimize the fact that all the other areas such as cabinetmaking, wall painting, ceramics and metalwork were male preserves. There women were only tolerated as an exception.

In spite of her talent and her own dynamism, she did not always have an easy time, as she was not the protegée of any master. She did have allies amongst them, but no one to take up her cause directly. She was the only person in the Bauhaus to acquire her position by a vote in the group. Attitudes, opinions and the

**Gunta Stölzl, W (Weaving workshop).** About 1928, page from the portfolio "9 jahre bauhaus. eine chronik" (9 years of Bauhaus. a chronicle), 1928, collage of cut-up photographs, discs, plastic foil, fabric and watercolored Japan paper on white card, 29.5 x 21.0 cm, mounted on orange-red card, 41.6 x 59.5 cm, BHA. • In spite of Gropius's hesitancy, Gunta Stölzl with her artistic and craft skills finally obtained a leading position in the Bauhaus.

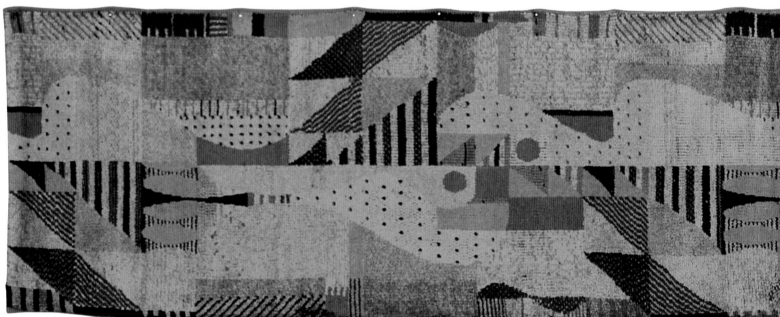

**Gunta Stölzl, Sketch for a runner.** 1923, gouache on paper, 12.0 x 42.0 cm, BHA. • There is hardly any difference between the sketch and the actual form of the runner. In the sketch, just as in the gallery, shapes and colors are arranged with approximately the same weighting around the central axis.

**Gunta Stölzl, Runner.** 1923, Smyrna knotting, warp of hemp, weft of wool, 505 x 100 cm, BHA. • The heightened contrast between the closely positioned delicate surfaces and those with strong colors probably first came about when the sketch was transferred to wool. Anyone who had attended Itten's early courses brought away a sensitivity for the effects and contrasts of materials.

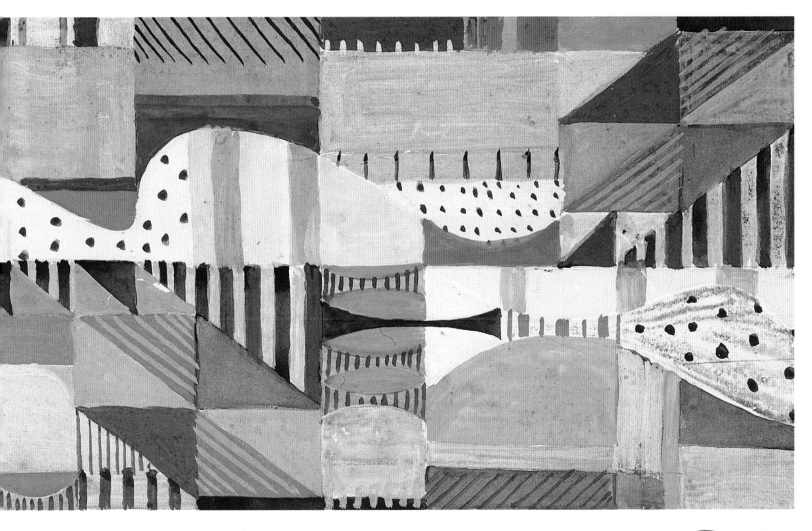

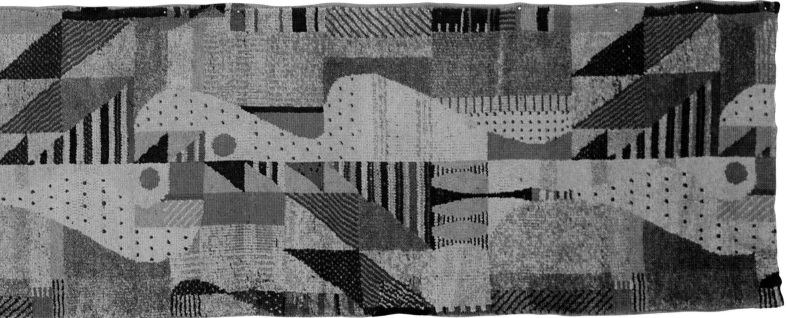

general climate were always of great importance in the small school. As a member of the Bauhaus from its earliest days, Gunta Stölzl attracted plenty of wellwishers who valued her hard work and ready helpfulness. In the 1925–1926 winter semester she was elevated to a senior position by the women students after a tenacious struggle. Ironically, to a certain extent and without wishing it, by becoming a token woman in a senior position she showed that women could make their way in the Bauhaus.

Gunta Stölzl was not solely a weaver, however, now her activities also turned her toward teaching. When she was officially given the responsibility for running the complete weaving section, in June of 1927, she had no real experience of teaching. Although she had some success at this new activity, it soon became apparent that the Bauhaus concept of bringing together theoretical and practical work did not work out for a young master who was female. Paul Klee's teaching was irreplaceable, and Gunta Stölzl limited herself

to practical activities in the workshop with the assistance of Kurt Wanke. There was plenty to be done there. Work in the workshop had to be restructured, and this was her strong point. In 1924 Johannes Itten had called her to Zürich to set up the Ontos workshops there. At the Bauhaus, Stölzl separated the work into teaching and production sections. Experiments were then carried out with new materials, looking for hardwearing but reasonably priced fabrics for the wider market. In addition, pattern books for industry were created, so that the whole output of the workshop was made professional and cost-effective. Gunta Stölzl strove to implement the Bauhaus program in her workshop, although this was not always entirely successful. As the Dessau Bauhaus was more concerned with architecture, the fabrics had to complement the modern building styles and create a harmonious presence in the room. Individual handmade pieces were less common at this period.

Later Gunta Stölzl lost her position in the same way that she had acquired it. A small group of dissatisfied students, supported by masters with right-wing sympathies, made life unbearable. She pre-empted dismissal by handing in her notice and resigned herself to leaving the school in 1931. This was followed by a difficult period. Two years previously she had married Bauhaus member Arieh Sharon, a left-wing Jewish architect, losing her German citizenship as a result. According to her passport she was now a Palestinian. In 1931 she moved to Switzerland, as none of her Bauhaus contacts had led to a new post in Germany. In Zürich she opened a small handweaving workshop with the former Bauhaus members Gertrud Preiswerk and Heinrich-Otto Hurlimann, S-P-H Stoffe (S-P-H Fabrics), but after a short time financial difficulties forced them to give up. The economic and political situation throughout Europe at this time was very difficult, and the possibilities of making a

**Gunta Stölzl, Wall covering for the Swiss Cantonal exhibition.** 1939, rep, warp of raffia, weft of cotton, 77.0 x 60.0 cm, BHA. • Among the products presented at the Swiss Cantonal exhibition there were several from former members of the Bauhaus, including Gunta Stölzl.

**Designer unknown, (Gunta Stölzl?), Polytex fabric.** About 1929, sample piece, Panama binding, artificial silk, BHA. • The Bauhaus licensed the Polytextil GmbH company in Berlin to produce its fabrics for sale, thus freeing the workshop from this burden.

**Gunta Stölzl, Cellophane curtain material for a studio.** 1993, waffle-effect binding, warp of raffia, weft of crepe cotton, photograph by Hanz Entzeroth, BHA. • "Weaving is building up, constructing ordered pictures from unordered threads." Despite having a view of weaving that was clearly inspired by architecture, Gunta Stölzl was compelled to leave the Bauhaus and continued her work in Switzerland.

living out of arts and crafts were few. In spite of this Stölzl continued to run a small workshop called S+H Fabrics until 1937, with Hürlimann as her only partner. When this partnership also came to an end she moved to Florastrasse in Zürich and opened the handweaving shop Flora. She worked alone there for 36 years, until she gave up her workshop in 1967.

The years in Switzerland were not trouble-free but she was finally able to become established. Probably her most successful year professionally was 1937, when the Diplôme Commémoratif was bestowed on her at the Paris International Exhibition. In her new homeland she became a member of the Society of Swiss Painters, Sculptors and Commercial Artists and of a Swiss business association. She took part regularly in exhibitions and fairs, supplied various firms with upholstery material and wall hangings and also worked for individual architects, such as Hans Fischli, for whose buildings she made coverings for walls and other surfaces, as well as for the National Germanic Museum in Nuremberg. Overall however she did not obtain as much as she would have liked of this close work with architects, which she particularly treasured. Her work inspired by Gobelins tapestries counts among the most important of her handcrafted works, although she supported herself predominantly with textiles for everyday living, such as upholstery or clothing fabrics. In the 1970s she devoted herself totally to the Gobelins work and through this gained increasing international recognition. With the rise of the feminist art history movement she became even more widely known and appreciated in the 1990s, not only for her unusual career pattern but also for her textiles.

Gunta Stölzl's woven pieces are distinguished by steady, well-crafted work, and a rich variety of bindings. Her carpets breathe rhythm, carry you away with their many patterns, and cannot be pinned down to a horizontal or vertical Bauhaus scheme. On occasion there are motifs such as cows in a landscape, or as in her later work an ecclesiastical theme. The influence of Johannes Itten's teachings on color contrast is particularly noticeable in her Bauhaus works. The vibrant, joyful colors in some of her early weaving is witness to the vital dynamism and energetic lifestyle of the Bauhaus members. The carpets evoke an atmosphere of jazz and expressive dancing and provide us with just a slight taste of how lively life may once have been at the Bauhaus.

**Gunta Stölzl, Sketch for a wall hanging.** 1923, watercolor, Indian ink and pencil on squared paper, 39.4 x 31.5 cm, BHA. • The sketch has the quality of an abstract picture and is similar to some works of Paul Klee in the color gradation and dynamic build-up.

**Gunta Stölzl, Wall hanging, rug.** 1923, flat weaving with the occasional use of shuttles on a 12-section loom, with a linen binding run in at intervals, warp of cotton, weft of wool, viscose and cotton, 260.0 x 122.0 cm, KW. • In the finished version, the visually attractive changes in the binding and the contrasting material features, such as from shiny to matt, silky to rough, and thick to thin, alter the composition completely from the sketch. The dominating themes are now "interruption," "reflection" and "contrast."

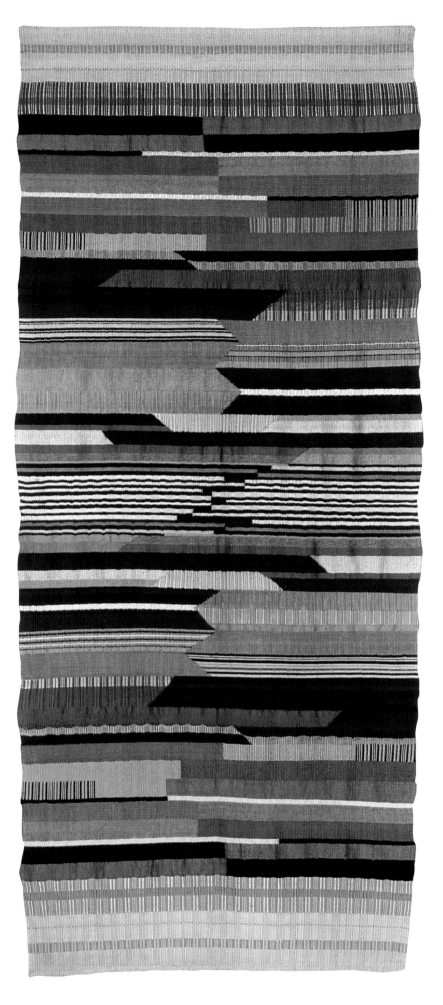

**Gunta Stölzl, "5 Chöre" (5 chords) jacquard hanging.** 1928, jacquard, cotton, wool, silk, 143.0 x 229.0 cm, Museum für Kunst und Kulturgeschichte der Hansastadt Lübeck. • The title of Stölzl's most important piece of jacquard work refers to the way the loom was set up. "The harness is divided into chords. Chord is used to describe a repetition of the thread drawings in the base" (Hermann Oelsner, *Die Deutsche Webschule* (The German School of Weaving), 1902.

**Gunta Stölzl, Sketch for the "5 Chöre" (5 chords) jacquard hanging.** 1928, watercolor and pencil on squared paper, 61.0 x 47.0 cm, BHA. • Such complex patterns can only be carried out on a jacquard loom, where the use of a punched card program enables repetition. The rich variations in form, contrast and color require strict organization in the sketch. As it is almost impossible to intervene in the weaving process once it has begun, this complicated kind of weaving demands not only comprehensive technical knowledge and experience, but also precise sketches.

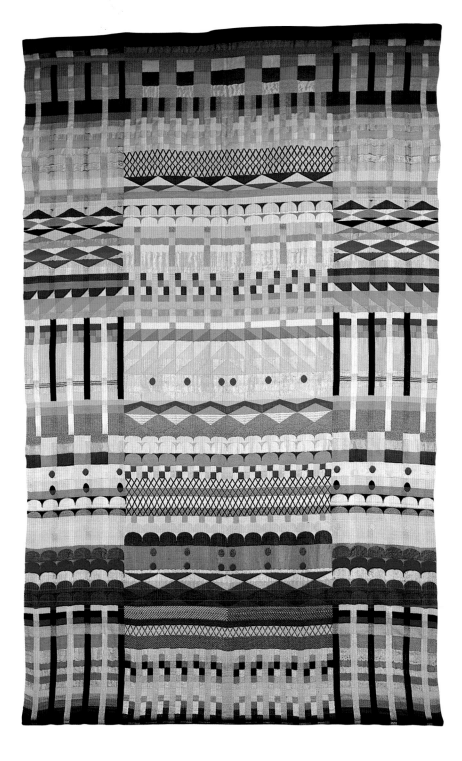

Gunta Stölzl

# The Token Woman Master
Anja Baumhoff

The names of Bauhaus masters such as Klee, Kandinsky, Feininger, Gropius and Mies van der Rohe have lost none of their renown over the years, and continue to reflect this fame on the school itself. The names of famous women, however, are scarcely to be found. After examining the policies of the school toward its students, the question arises how the Bauhaus treated its female staff, and whether the school was able to attract not only the leading men of their time but also the most talented women. As we know, contemporary artists such as Sonia Delaunay, Sophie Täuber-Arp, Eileen Gray, Ljubov Popova, Maria Likarz and Hannah Höch did not teach at the Bauhaus, and on taking a closer look at the situation it must be admitted that the Bauhaus was astonishingly conventional in its attitudes to the sexes.

Let us remember that the Bauhaus did not have professors but masters – form masters, work masters and lastly young masters. The most talented Bauhaus students, who were expected to be able to combine theory and practice in a new style and manner, were nominated young masters, and were supported by the school, and embodied it. Out of all the young masters there was only one woman, and this was Gunta Stölzl. Weaving had been designated as a woman's area, and only for this reason did it appear legitimate for a woman to be in charge. But even this was not a foregone conclusion.

Gunta Stölzl had been with the Bauhaus in its earliest days, and had made herself indispensable in many different areas of the school's operation. However, she was not nominated or selected by the

council of masters. The Bauhaus had never planned to entrust the leadership of a workshop to the hands of a woman. Some six years, or 12 semesters after she entered the school, she was accorded the position of work master. She performed a really demanding job managing the workshop's move from Weimar to Dessau. The form master of the workshop, the painter Georg Muche, was theoretically responsible, but Gunta Stölzl complained to a friend: "When I took on my teaching post in 1925, the first task to confront me was to completely organize the equipment for the weaving workshop.... Herr Muche took little interest in this practical side of the weaving workshop" (letter to Frau Aichele, March 29, 1971). The women weavers reproached Muche for his lack of interest in the weaving workshop, and with the move to Dessau they began to demand that a different person should hold the post. Ise Gropius noted in her diary (entry for June 16, 1925): "The weaving workshop is demanding that Gunta Stölzl functions as its head and is recognized as such. Another storm of protest against the masters." A year later, in June of 1926, Georg Muche decided to give in his notice. However, he remained at the school on full salary until July of 1927. This generosity is all the more surprising, since many women weavers in the workshop were either unpaid, or poorly paid and on short-term contracts. Gunta Stölzl herself only had a three-month contract initially, until her position improved as a young master.

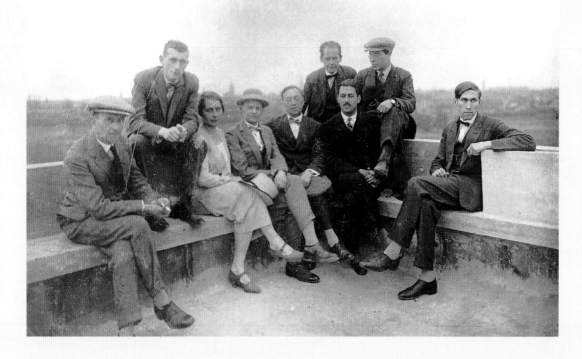

**The Bauhaus masters on the roof of the studio house in Dessau.** About 1927, photograph by Lucia Moholy, BHA. • As the first woman among the young masters, Stölzl had always needed to stand her ground against doubts about the artistic validity of textile design. She addressed the question in an article on weaving at the Bauhaus, published in 1926, which opened with the words "Can weaving claim a place among those arts which offer a challenge to the human creative urge?"

**Gunta Stölzl, Decorative flowers for Bauhaus party.** About 1927, photograph by Lucia Moholy, BHA. • The preparations for the parties, the costumes and decorative arrangements counted amongst the favorite and least burdensome tasks in the weaving workshop.

**Celebration of the first Bauhaus diplomas in the weaving class.** 1930, photographer unknown, BHA. • Whereas it was previously only possible to sit the journeyman's examination in Dessau, the introduction of diplomas indicated a move to set the textile workshop on the same footing as the other creative areas.

Even then her new contract offered no rights to a studio, nor to child allowance or pension. Muche's exceptionally cushioned departure from the Bauhaus stands out in contrast.

Obtaining the master's post demonstrated the power of the women weavers, and to have given in to them was certainly a clever move. The existence of just one female form master showed that women were not barred from chances of promotion at the Bauhaus. Gunta Stölzl was the token, to show other women that it could happen, and this headed off any further dissatisfaction. The women weavers competed among themselves for sought-after positions in the weaving workshop, as there were few other opportunities available at the Bauhaus at that time for gifted women students.

Another woman master was Lily Reich, though she was active at the Bauhaus for such a short time that she had little influence. An experienced machine embroiderer, she took over the running of the workshop on January 5, 1932 from Otti Berger, another woman member of the Bauhaus, who had been acting head until then. Even if it might be thought that Reich gained this position because she was the personal partner of Mies van der Rohe, in fact her qualifications fully justified her in her own right, with a reputation in decoration, interior design and fashion. She was also the first woman member of the board of the German Werkbund. It is, however, difficult to see the appointment of Lily Reich as a really practical decision.

| bezeichnung des materials | art des materials | nummer | art der numerierung |
|---|---|---|---|

*Nordische Wolle* — *1fach*

*Nordische Wolle* — *2fach*

*Nordische Wolle* — *4fach*

*Nordische Wolle* — *8fach*

*Nordische Wolle* — *12fach*

**Gunta Stölzl, Red-green Gobelin.** 1927–1928, Gobelin, cotton, wool, silk and linen, 150.0 x 110.0 cm, BHA. • Rectangular and circular characters, often overlapping and with graded colors, align to form a mosaic which could continue in any direction. As is shown here, there are no color or design limits to what an experienced Gobelin specialist can achieve. The warp stitches are filled in by hand, which means that as many different colored pieces can be patched in as wished.

**Materials card (by Katja Rose) from Gunta Stölzl's class.** About 1931, card with ink and typewritten text, knotted wool and linen threads, DIN A4, BHA. • Knowledge of materials, together with fabric evaluation and an understanding of binding were basic essentials in Stölzl's teaching. The wider content ranged over individual wall hangings, general suitability of fabrics for a task, and the development of special fabric features.

As head of the new "Extension" department, into which the weaving workshop had to be integrated, there was hardly time for her to have any great effect. In the winter semester of the same year the Bauhaus moved to Berlin, where the school attempted in vain to establish itself in an old telephone factory in Steglitz.

In retrospect, Gunta Stölzl remains the only woman young master in the history of the Bauhaus, although her deputies could all in principle have filled a leading post. Both Otti Berger and Grete Reichardt set up workshops independently later on; Anni Albers and Margarete Leischner began to teach after emigrating. Many of the other women weavers found it difficult to find a suitable business outlet. If the Bauhaus had openly promoted its discriminatory policy, perhaps frank discussions could have been held on the board's attitude. Instead of this, each woman's career experience in the school was completely individual, as the institution's policy aims and a subtle dissembling rendered any discrimination against women almost invisible.

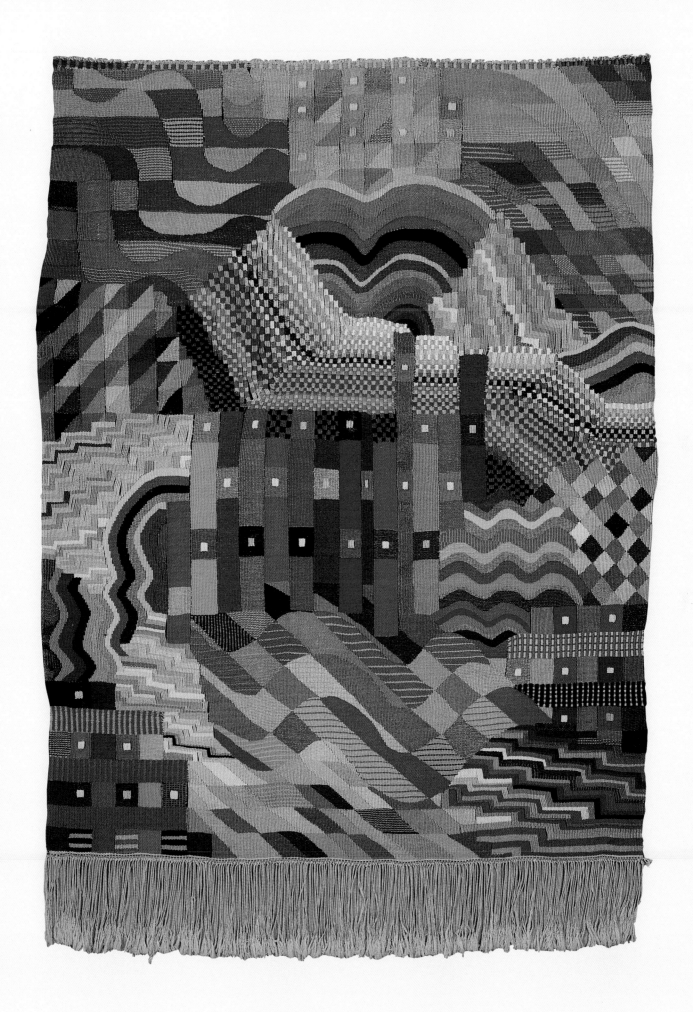

WORK

# Preparatory
# Teaching

# The Preliminary Course under Johannes Itten –
# Human Education

Norbert M. Schmitz

**Gyula Pap, Federnelken (Feather-Carnations), Nature study in light-dark contrast.** 1923, charcoal and colored chalk on tissue paper, 14.0 x 16.6 cm, BHA. • The tracing of contrast effects and their graphic representation were part of the elementary assignments in Itten's preliminary course. In his nature study, Pap explored the light-dark contrast by letting delicate blossom stars explode out of deepest black; the red blossom lends an additional accent of color to the study.

The establishment of a preliminary course, scheduled for the first time in the summer of 1920 and becoming obligatory for every student once, then twice a semester, proved to be one of the most original and successful phenomena at the Bauhaus. In its development almost every curricular change at the school can be traced.

As its first leader, Johannes Itten shaped the preliminary course into one of the most impressive elements of the whole Bauhaus. He was not concerned solely with the technical preparation of new students for the individual workshops, or the purging of students from the educational ballast they brought with them. His aim was the formation of integrated personalities. The traditional instruction at the contemporary art schools, despite some reforms, had remained essentially a

specialized professional training in technical competence, above all in sketching and copying from plaster nudes and pictures by precursors from history. In contrast, Itten, who could look back on his many years of teaching experience at his private art school in Vienna, wanted first of all to stimulate the creative capabilities of his students in the direction of contemporary cultural criticism. Only once they had acquired a foundation in this could the students then specialize in further study through work in the individual workshops.

Much of the time his teaching can be classified in the customary terminology of the day as reform teaching. In particular, he adopted numerous elements of the renowned Hölzel-method, drawn from the teaching experiences of one of the founder-fathers

of abstract art, whom he knew from his Stuttgart teaching years. While Hölzel, the "cautious avant-gardist" (Wolfgang Venzmer, "Adolf Hölzel. Leben und Werk" in *Der Pelikan* No. 65, 1963, p. 14) developed his abstract-oriented aesthetics from a purely inward point of view, Itten was always concerned with an ideologically intensified form of human education. This reinterpretation is characteristic of the expressionist Sturm und Drang, which contributed to the social utopia of unity between art and life at the early Bauhaus.

From Hölzel, Itten adopted two principal elements: firstly the establishment of instruction at the opposite poles of "rules and perception," that is, with objectifiable rules of design and subjective intuition. Hidden behind this was the question of the relationship

**Max Peiffer Watenphul, Nudes (Movements in Rhythm).** About 1920, charcoal on paper, 24.2 x 34.8 cm, BHA. • Rhythmic exercises were used as a preparation for "the more intellectual" tasks. By limbering up and liberating the "body motor," people could physically experience what Rainer K. Wick in his *Bauhaus-Pädagogik* (Teaching at the Bauhaus) called "movement and rhythm as the fundamental and vital principle for organizing basic artistic activity." The sketching of nude figures was also accompanied frequently by music to promote a feeling for rhythm.

**Instruction at the private Itten School in Berlin.** 1930, title photograph from *Die Form*, No. 5, 1930, photographer unknown, BHA. • Sketching with both hands was supposed to contribute to harmonizing the flow of movement, as Itten would first of all demonstrate. "... then he ordered it to be done in time, then he had the same exercise done standing up. There seems to have been an element of body massage intended here, to train the machine (the body) to function instinctively," noted Paul Klee after observing the master Itten.

Preliminary Course of Johannes Itten

between what was teachable and what was learnable. Hölzel had felt that artistry could only be developed on the basis of a strict system of precepts – the "counterpoint of painting." However, it never becomes at one with such a system, but remains an expression of the individual personality. This problem was central to the Bauhaus's teaching as a whole, and the educational and aesthetic differences between the individual teachers can perhaps best be portrayed by their partly contradictory answers to these questions.

At first Itten refined Hölzel's precepts of contrast. He was not able, however, systematically to formulate the universal application of the aesthetic of form which had developed out of it, not least because of the dramatic circumstances surrounding his departure from the Bauhaus. His later accounts from the years 1930 and 1963 give only a partial picture in which, while not wholly suppressing the expressive and spiritual elements of the Weimar preliminary course, he does almost fraudulently understate them. Using this shortened version, purged of many of its provocative elements, Itten then became probably the most important

inspiration of West German art teaching after 1945.

The students' integrated training – including the physical part – continued with gymnastic exercises at the beginning of every hour. They were intended not only to loosen up the body, but above all to lead the students from "chaos" into "harmony" and prepare them appropriately for the rhythm studies to follow. As Klee rather reservedly described the latter: "After he has walked about a bit, he directs us toward a stage where there is a drawing-board with a supply of rough paper. He takes hold of a piece of charcoal, his body gathers itself, as if he is summoning his energies, and then suddenly he makes two rapid actions. You see the form of two powerful strokes, vertical and parallel ... on the top page of the rough paper, and the students are encouraged to follow this example" (*Briefe an die Familie* [Letters to his Family], Cologne, 1979, Vol. 2, p. 970). Thus in the face of the biased rationalism of others, which he reproached as being static and numb, Itten attempted to put into action the life-reforming movement philosophy of the then popular Ludwig Klages, for whom opposition to "rational spirit" and "living soul" could be

**Artist unknown, Study of the character of circles.** About 1920, charcoal and colored chalk over pencil on paper, 40.5 x 29.5 cm, BHA. • The teaching of abstract forms helped to train analytical and design skills, the exercises being resolved by means of "free perception and fantasy."

**Werner Graeff, Rhythm study.** 1920, black bodycolor on yellowish paper, 56.0 x 73.5 cm, BHA (illustration on the left). • Gymnastics and breathing techniques were preliminary, pre-class activities, though equally part of Itten's integrated concept, by which body, soul and senses were purged and reunited in a higher striving for harmony. The possibilities for experience and expression released in these exercises burst out in an "unchained" rhythmic flow.

**Friedl Dicker (?), Color composition (paraphrase of the Hymn of Creation from the Rigveda).** About 1929, collage with colored papers and shiny foils, partly painted over, 55.0 x 36.5 cm, BHA. • Using avant-garde design techniques, the collage is a pictorial paraphrase of the oldest body of Indian writings in Sanskrit. The songs of the "Veda," divided in the year 1054 into "Mandala" (circles), are represented here in the main circular-shaped motif.

Preliminary Course of Johannes Itten

overpowered through the rhythmic development of a harmonic "movement-figure." Rhythm is here more than a formal means of creation; it is the expression of a vitally understood unity of body and soul beyond intellectualized collective bias (Ludwig Klages, *Einführung in die Psychologie der Handschrift* (Introduction to the Psychology of Handwriting), Stuttgart-Heilbronn, 1924). Itten used this rhythm to explore the Old Masters through spontaneous copying. Feeling

had to resonate "above all in the creative self. Arm, hand, finger and not least the whole body should be energized by this sensation.... An externally fixed vision and fluctuating action must yield to an 'inner vision.' With this comes the readiness to allow oneself to be led by feelings" (Johannes Itten, *Mein Vorkurs am Bauhaus* (My Preliminary Course at the Bauhaus), Ravensburg, 1963, p. 111). No less important than such analyses was the contact with materials,

**Moses Mirkin, Contrast study with different materials.** Rough model 1922, reconstruction 1967, metal parts, saw blade, leather and glass mounted on wooden board, 88.0 x 30.0 x 22.0 cm, BHA. • The playful or "intuitive" contact with the materials had a practical side as well as a didactic aim. The student used the exercise to test his talents and interests and to see which workshop he would opt for after the end of the preliminary course.

whose particular characteristics were analyzed under the criteria of contrast and order, first of all independently of their practical exploitation – as materials in themselves: "As an introduction, long lists of different materials such as wood, glass, textiles, bark, pelts, metal and stone were recorded. Then I had the optical and tactile qualities of these materials assessed. It was not enough simply to recognize the qualities, the characteristics of the materials had to be experienced and described. Contrasts such as smooth-rough, hard-soft and light-heavy not only had to be seen, but also had to be felt" (ibid, p. 47). Developing on this, they systematized the qualities of differing textures in ranges of materials. "So that the various textures could be distinguished," Itten then had "long chromatic series of real materials manufactured. The students had to feel these textures with their fingertips, keeping their eyes closed" (ibid, p. 47). This was the basis for the free collages using materials. Many of these are reminiscent as almost independent art objects of the *papiers collés* of the Cubists, or of one of Schwitters's Merz pictures. As with those, the traditional material hierarchies were broken down through the use of apparently worthless waste products. The next stage was to render the resulting contrast effects in drawings. Itten combined such experiments with, first of all, apparently quite conventional nature studies. But this kind of drawing was not only aimed at graphic perfection or at sharpening observational powers, but once more was intended to facilitate the inner experience of the objects and their characteristics: "I gave a still life as a first assignment. To a white plate with two yellow lemons I added a book with a green cover. The class members were almost insulted at having to draw something so simple. With a few hurriedly dashed-off strokes, the outlines were sketched, then everyone watched me questioningly, doubtless waiting for an introduction from me into the geometric problems of form. Without a word, I took up the lemons, cut them and presented everyone with a segment to eat, with the remark 'Have you portrayed the substance of the lemon in your sketch?' A bitter-sweet laugh was the answer" (ibid, p. 47). Itten accompanied such exercises, demanding powers of intuition and expression, with others in the general rules of design. These lessons in the "counterpoint of painting," along with the color analyses of light-dark contrasts, were at the center of Itten's teaching, the

legitimacy of which was established through scales of differing tone-values between black and white.

In addition to this, there was one lesson on form, studying the basic geometric forms of the circle, the triangle and the square. With this vocabulary, the students were supposed to develop abstract compositions, first on a surface and then in space.

Although it may have seemed very modern, this method nevertheless had definite academic precursors. Itten himself was familiar – from the lessons of his Geneva teacher, Eugène Gillard – with the geometric-rational design teaching of Eugène Grasset, based on the traditions of French classicism (*Méthode de Composition Ornamentale* [Method of Ornamental Composition], Librairie Centrale des Beaux Arts, Paris) as well as Hölzel's teaching methods. Already at the turn of the century Grasset was instructing his students to develop complex ornamentation from the basic abstract forms of the square, circle and triangle, the results of which owed a great deal to the Jugendstil movement.

The main characteristic distinction between Itten and his teachers is the spiritual vision with which he charged his rules of form: "Square: calm, death, black, dark, red; Triangle: intensity, life, white, bright, yellow; Circle: infinite symmetry, peaceful, always blue" (Johannes Itten, diary entry for October 20, 1916 in *Werke und Schriften* [Works and

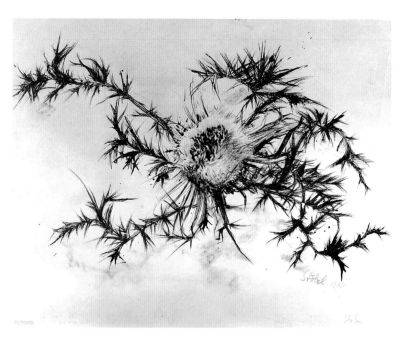

**Gunta Stölzl, Design for a knot-carpet.** 1920–1922, watercolor on paper, 28.5 x 25.0 cm, BHA. • Stölzl's sheet is a rhythm exercise, at once a two-dimensional montage of texture and a study of abstract shapes and their characters. At the same time it is significant for the rich vocabulary of form and movement which Klee's lessons on color gave the students, among them this future weaver.

**Gunta Stölzl, Thistle, material study.** 1920, Indian ink, black chalk and graphite on transparent paper, 30.7 x 38.7 cm, BHA. • The instinctive recording of material and form was intensified by natural and physical studies, in which the physical perception of pain, caused by the thistle's thorns, preceded the representation of its essential nature. This, however, Itten required to be presented as a photographically accurate anatomical study.

Writings], published by Willy Rotzler, Zürich, 1972, p. 51). Also the basic geometric forms – a popular epitome of Bauhaus rationalism – from which Itten started in his own work as well as in the design of his lessons, were principally symbols of a metaphysical philosophy. As with the rhythm-studies, here again reproductions of works of art of very varied origins and type were analyzed with regard to their abstract construction – whether for divisions into light-dark areas, compositional outlines or basic geometrical forms. At the same time, Itten was never concerned purely with isolating examples of formal creative conformity, but also with their transcendental expressive value. Precisely because Itten demanded an integrated form of education, he was quite unable to ignore the spiritualist background to his art which came from his practice as a teacher at a state high-school. His saturnine temperament allowed him little restraint, as we can infer from Schlemmer's account of an

hour's analysis: "Itten gives 'analyses' in Weimar. He shows slides, from which the students have to draw this or that essential quality, mostly to do with movement, outlines, curves. Then he refers them to a gothic figure. Then he shows the weeping Maria Magdalena from the Grünewald-Altar; the students attempt to discover some essence in its complexities. Itten sees their attempts and thunders: 'If you had any artistic sensibility at all, you would not be drawing in front of this most moving representation of weeping, which portrays the weeping of the world, you would be sitting there dissolving into tears.' He says this and shuts the door" (Oskar Schlemmer, *Briefe und Tagebücher* [Letters and Diaries], Stuttgart, 1977, p. 50). Although Gropius had very little patience left for such eccentricity, many of Itten's concrete ideas for teaching and the extension of creativity and observation into metaphysical regions remained central to both Bauhaus teaching and the Bauhaus aesthetic.

**Rudolf Lutz, Plastic study with different form characteristics.** 1920–1921, plaster relief, 23.0 x 20.0 cm, BHA. • As an "intellectual construct for resolving an exercise" Lutz's plaster relief reveals a multitude of contrasts: plane to line, plane to body, horizontal-vertical, high-low, etc., and yet is also an independent artistic expression.

**Ima Breusing, Study sheet with animals and zeppelin.** 1921–1922, pastel and gold color on paper, 24.0 x 31.3 cm, BHA. • A playful study-paper, 0distancing itself from the lost-in-thought approach of "peinture automatique," a long way from the usual strict appearance of preliminary course works.

Preliminary Course of Johannes Itten

# The Preliminary Course under László Moholy-Nagy – Sensory Competence

Norbert M. Schmitz

After the spectacular exit of Itten from the Bauhaus, the council of masters agreed that the preliminary course should be officially taken over by Moholy-Nagy, assisted by young master Josef Albers who would look after the so-called work instruction. From the fall of 1923, while still in Weimar, the preliminary course was extended to two semesters, with Albers teaching 18 hours in the first and Moholy eight hours in the second. Later the required time was reduced to 12 and four hours respectively until 1928, when after Moholy's departure Albers took over the whole of the preliminary course. Gropius had great hopes of Moholy's appointment producing a course which would unreservedly affirm the real world of industry. In fact the Hungarian, in contrast to the artists Kandinsky and Klee, saw no fundamental problem between the world of mechanical production and the training of individual creativity. The concerns of his basic teaching were formulated accordingly. There "everyone applying will be accepted as long as they show some talent and pass a test.... The course will equip them with the basic elements of a diverse knowledge. Their attitude to their surroundings will be clarified, their often numbed sensitivity wakened and sharpened, and their usefulness will be placed under the control of their own personality. Lessons will be given in observing the nature of color, surfaces and shapes in materials, in function, proportion and space. Through exercises in manual skills, the study of materials and designs the student will become familiar with the basis of Bauhaus work...." (Laszlo Moholy-Nagy, "The Bauhaus in Dessau" in *bauhaus*, Book 3, 1927).

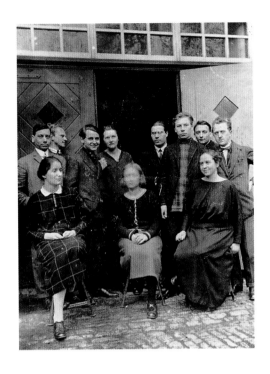

**László Moholy-Nagy (fourth from right) and students of his preliminary course in Weimar.** 1924–1925, photograph by Leo Grewenig, BHA. • Moholy's appointment by Gropius was the signal for a reorientation of the Bauhaus from a New Romantic reform school into a design college for mass-production. He soon forged his preliminary course in the image of modern design.

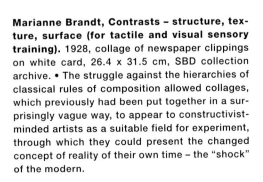

**Marianne Brandt, Contrasts – structure, texture, surface (for tactile and visual sensory training).** 1928, collage of newspaper clippings on white card, 26.4 x 31.5 cm, SBD collection archive. • The struggle against the hierarchies of classical rules of composition allowed collages, which previously had been put together in a surprisingly vague way, to appear to constructivist-minded artists as a suitable field for experiment, through which they could present the changed concept of reality of their own time – the "shock" of the modern.

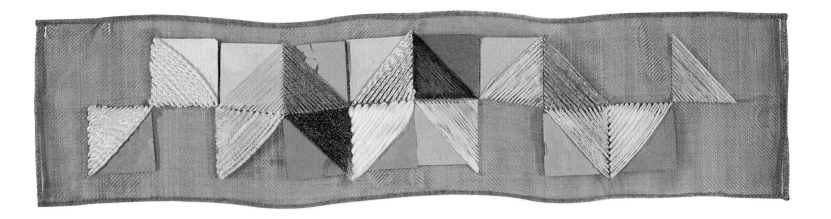

**Otti Berger, Tasttafel aus Fäden (Tactile panel made of threads).** 1927–1928, different textile threads fixed to a wire backing, on which multicolored squares of card are loosely positioned, 14.0 x 57.0 cm, BHA. • The characteristics of the material – and its tactile qualities – should be experienced not just intuitively but, if panels like this were set up systematically, a more practical grasp of them would be revealed.

True to his general aesthetic outlook, the cause was for Moholy the axiomatic starting point for all teaching, and by it he meant something quite different from making up complete training structures from basic geometric forms like the metaphysically organized design teaching of Itten, Klee and Kandinsky.

By 1921, together with Hausmann, Arp and Puni, he had explained: "We advocate elemental art. Art is elemental because it is not philosophized, because it is constructed from its own particular elements. To yield to the elements of design is to be an artist. The elements of art can only be found by an artist. They originate not from his own arbitrary acts; the individual is not isolated, and the artist is only an exponent of the powers which give shape to the world's elements" ("Aufruf zur elementaren Kunst" [Appeal for Elemental Art] in *De Stijl*, IV/10, p. 136 ff.). In 1978, Andreas Haus in his work on Moholy's photographic achievement distinguished between his elementalism and the empirical criticism of Richard Avenarius and Ernst Mach. This philosophy superseded positivist beliefs about world objectivity through its use of imagination; every reality is composed only of subjective perception – the concrete or perceived data. Recognizing this means being able to control the complex interplay of visual, acoustic, tactile and other perceptions with which an essentially nontransparent reality can be managed.

Design is therefore not an area set apart from the rest of life and also certainly not an artistic counterworld, but a particularly complex and distinctive way of seeing things. In his formative Marxist years in the Soviet Proletariat cult led by Alexander Bogdanov, artistic activity was seen as enjoying equal status alongside political and social life as a contribution to the construction of a socialist society. Rainer K. Wick rightly emphasized that this in no way meant for Moholy "that aesthetic production was now reduced to utilitarian concerns such as the 'design' of commodities, but rather that another kind of utilitarianism was implied, namely the systematic organization of human consciousness in relation to socialist production and social relationships. This aesthetic production would come about by 'changing the material elements of industrial culture in terms of volume, surface, space and light,' in other words by *pictorializing the new social content of material production*" (Rainer K. Wick, *Bauhaus-Pädagogik* [Teaching at the Bauhaus], Cologne, 1982, p.125).

Moholy's design for the preliminary course was connected with Itten's experiments in many respects, though the characteristics of his approach are apparent more in the way he varied his treatment of superficially similar exercises. Moholy was more concerned – in the context of his materialistic philosophy – with the training not only of visual but also

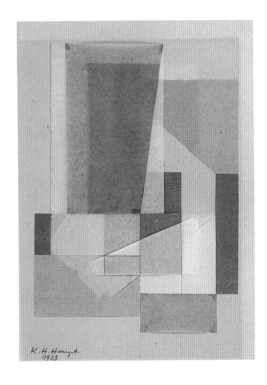

**Karl Hermann Haupt, Collage.** 1923, colored paper mounted on card, 25.5 x 19.0 cm, SBD, collection archive. • Practical knowledge of materials was intended to make the finest differences perceptible both visually and sensorially. Moholy strove to create a "New Man" who would develop an appropriate sensory competence in accordance with the requirements of the age.

tactile sensory competence. Like Itten, he had the students combine contrasting materials with one another according to their superficial composition, not so much to develop their individual ranges of experience as to establish rational and system-atic charts with which such qualities should be cataloged. Otti Berger's two-part tactile panel shows how these "scientific" analyses were supposed to lead to unequivocal data. In his 1929 compendium of work in the preliminary course, called "from material to architecture," Moholy himself developed a system that was not wholly free of contradictions. In this system, *structure* meant "the unchangeable way the material structure was built;" *texture* meant "the organically developed final exterior surfaces of every structure," and *facture* meant "the way it appears, the sensorily perceptible impact (impression) of the work process which shows itself in every aspect of the material's handling, in other words the surface of

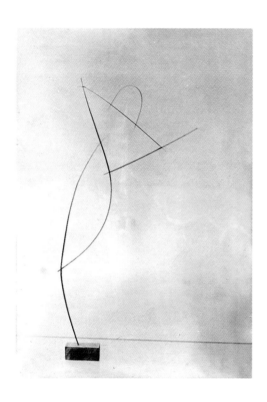

**Leo Grewenig, Exercise in tension.** 1924 (lost), sculpture made of veneer wood, photograph by Lucia Moholy, BHA. • The constructivist Moholy was interested above all in the tensions within the material, which he firstly got the students to analyze independently of practical considerations. This was how students were trained for innovative work in the workshops.

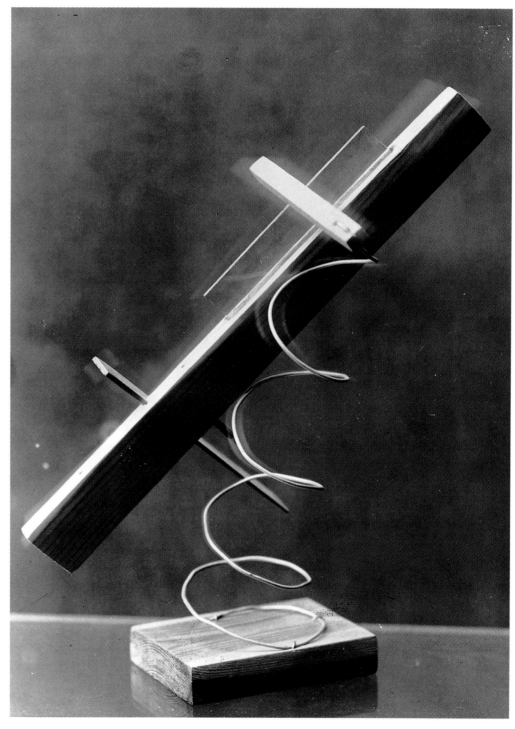

**Corona Krause, Hovering sculpture, study in equilibrium.** 1924 (lost), wood and wire, photograph by Lucia Moholy, BHA. • The desire for a new technical world could also be regarded as an attempt to conquer the force of gravity of the old. Material is no longer understood as a solid substance, but as something to be explored to the limits of its load-bearing capacity so that its inner and outer characteristics, its various strengths and tensions, can be determined.

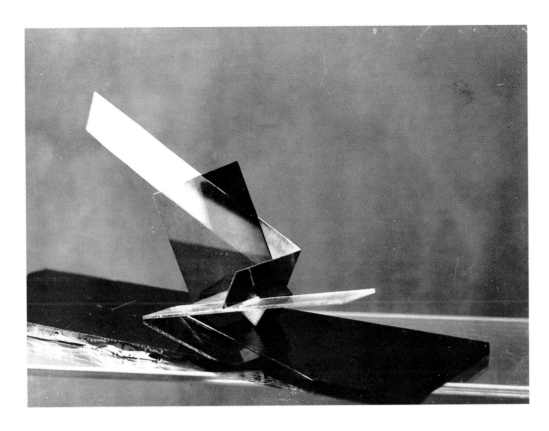

**Anni Wildberg, Study in equilibrium.** 1924 (lost), metal and glass, photograph by Lucia Moholy, BHA. • Moholy's modernism was also reflected in the results of his teaching. The extreme diagonal nature of Anni Wildberg's study seems to symbolize the teacher's optimistic view of progress. Its emotional evocation of the future is reminiscent of the works of artists of the Russian revolution, even if their political ambitions have no real significance here.

**Artist unknown, Construction and material exercise.** About 1927 (lost), sheet metal pieces, incised and folded, photograph by Erich Consemuller, private collection, Bremen. • Moholy came from that body of Constructivists who wanted to broaden the "precious" attitudes of the academic canon toward materials into an emphatic celebration of industrial culture. To construct meant principally the conscious co-designing of an independent piece of living reality that was stamped by its industrial character. Construction studies should therefore not be misinterpreted as "style exercises" using abstract forms. They are models for a utopian technical reality.

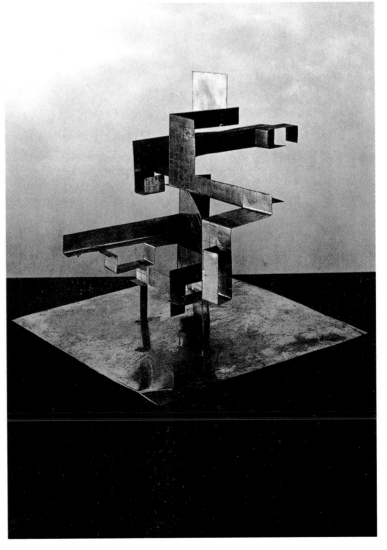

**Konrad Püschel, Photograms: plants and buttons.** 1926–1927, photograms, 9.0 x 12.0 cm, SBD, collection archive. • New media changed the concept of art. Automatic photographic equipment and its technical characteristics were considered by Moholy to be the embodiment of an industrial medium. The elimination of the subjective view in photograms, as the object automatically duplicates itself on light-sensitive paper, was in accordance with his view of industrial picture production.

the externally altered material (its artificial epidermis)." Moholy therefore distinguished between the internal construction of material (structure), its natural surface (texture) and its artificially prepared surface (facture). For the design-process, the third aspect is perhaps the most significant, for which Moholy tried to stimulate awareness among his students with elementary exercises:

"1. Production of paper factures by means of freely selected tools (needle, tongs, sieve) in preferred method of working (piercing, pressing, rubbing, filing, boring, etc.).

2. Production of paper factures with a single tool (needle, knife, forceps, etc.; or through folding or similar).

3. Production of factures using color on different types of material.

4. Production of factures on paper with different tools (paintbrush, spraying machine, etc.).

5. Production of factures with color and brush on different materials.

6. Production of free-choice factures (using graphite, sand, wood-grain, saw-shavings, plane chippings, etc., scattered on adhesive).

7. Production of factures from the materials of various workshops (wool, metal, wood, etc.).

8. Visual presentation (translation) of structure-, texture- and facture-values from the optical illusion through to complete abstraction (drawing, painting, photography). And continuing with:

9. Practical exploitation (toy or similar). The values experienced, transformed into a precise optical form, will thus be understood in a quite new way" (László Moholy-Nagy, *von material zu architektur*, Munich, 1929, p. 59).

While these exercises still predominantly concentrated on the purely external appearance of the materials, the so-called sculptural exercises in equilibrium aimed at the constructive tensions and the balance of their spatial design. These spatial collages of materials aimed to achieve the most complex possible and at the same time the most economically efficient exploitation of the qualities of specific materials, as used for traditional and modern industrial-synthetic work. "In the Bauhaus one also learned to respect these materials, and every gram saved – with no loss of effect – was often seen as a

small victory for inventiveness" (ibid, p. 134). With this training in sensory competence the student was now ready to apply himself to really practical work "so that at the end of the basic training he is in a position to choose which workshop he would like to join on a trial basis, provided that he passes the final examination of the basic training" (László Moholy-Nagy, "Das Bauhaus in Dessau" in *bauhaus*, Book 3, 1927).

Because of the rapid changes in industry at the time, the appropriate organization of these sensory experiences had become unpredictable, but this was at the same time the essence of Moholy's art and teaching method. He was never concerned solely with the development of future designers, for him design itself was a comprehensive means of education in sharpening sensory skills as a basis for humanizing life in general. Shortly before his death, he formulated this idea as follows: "The remedy is consciously to draw upon a generation of producers, consumers and designers who are themselves aware of the importance of the fundamental coherence of "form and function." In the education of its students, the Institute of Design in Chicago endeavors to start with basic knowledge and from it to construct new materials for technical and social conclusions in design. The designer generation raised on these precepts will be armed against the follies of fashion – that easy refuge in the face of economic and social responsibility" (László Moholy-Nagy, *Design Potentialities. New Architecture and City Planning, Symposium*, edited by Paul Zucker, New York, 1944). If for Moholy the conventional autonomous artistic practice became more marginalized, that was not only the fault of practical constraints but the consequence of an aesthetic, for art – if this concept is at all relevant here – is itself a communicative pedagogic act. Despite his occasionally hard constructivist vocabulary, he used it as a theorist and designer to continue an old project of the Enlightenment: Friedrich Schiller's model of an aesthetic education as the reconciliation of necessity and freedom.

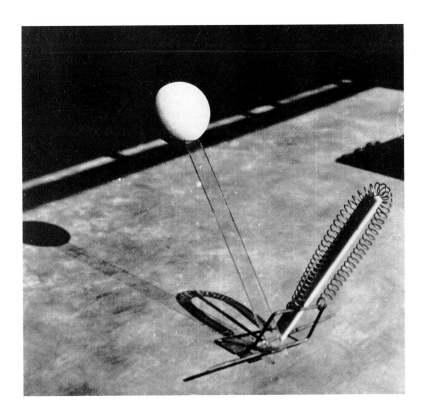

**Max Bill, Exercise in equilibrium.** 1927 (lost), steel pole, wire spring, frosted glass and rubber ball, photograph by Lotte Gerson, BHA. • Moholy set tasks to examine tensions with shapes and materials. Achieving equilibrium does not in fact symbolize metaphysical world harmony any more than it did with Itten, but reflects the functionality of industrial materials.

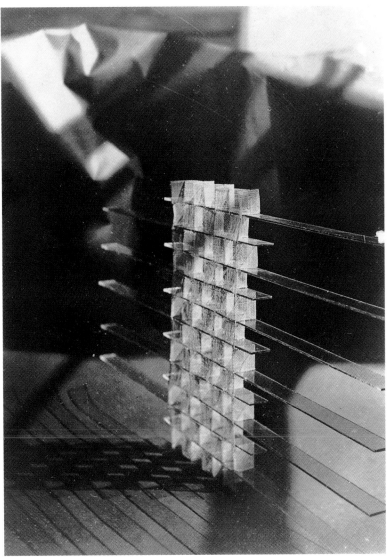

**Otti Berger, Material exercise.** About 1926 (now lost), small strips of glass and fabric, photograph by Lotte Gerson, Getty Research Center, Research Library. • Analysis of work materials offered an insight into industrial design practice. The exercises were meant to sensitize the students to specific structures, textures and factures.

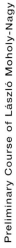

Preliminary Course of László Moholy-Nagy

# The Preliminary Course under Josef Albers – Creativity School
Norbert M. Schmitz

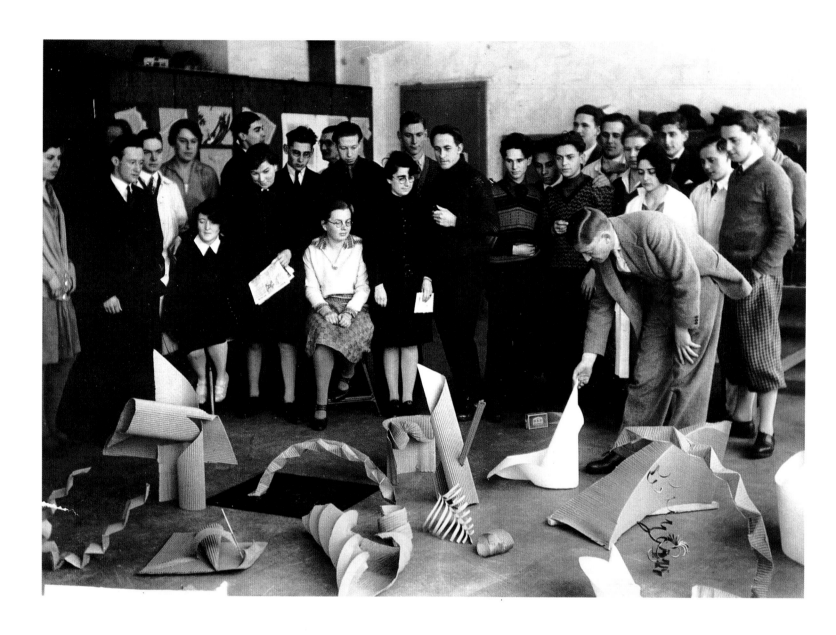

**Assessment of work on Albers's preliminary course.** 1928–1929, photograph by Umbo (Otto Umbehr), Courtesy Collection The Josef Albers Foundation. • Whereas many of the older-generation Bauhaus masters regarded teaching as a burden Albers – who had been trained as a teacher – set it at the center of his art.

Compared with the ideological split between Itten and Moholy, which also showed in their way of teaching, the differences between Moholy's and Josef Albers's ideas were much smaller. Albers had formerly been a student of Itten, and Bauhaus student Hannes Beckmann has a vivid memory of Albers's teaching and personal style.

He "strode into the room with a bundle of newspapers under his arm, which he gave out to the students.... 'Ladies and gentlemen, we are poor, not rich. We cannot afford to waste time and material. We must make the best we can out of what little we have. Every work of art has a particular source material, so we must first investigate how this material is obtained. In order to do this, firstly we are going to experiment, without actually producing anything. At the moment we are going to focus on beauty as skilfullness. How we apply this depends on the material we are working with. Remember that you often achieve more by doing less. Our study should stimulate us to think constructively. Do you understand me?

Now, I want you to pick up the newspaper you have been given and make it into something more than it is at the moment. I also want you to respect the material, make it into something meaningful, taking account of its particular properties. If you can do this without using any aids, such as knives, scissors or glue, so much the better. So have fun!' Hours later he came back and spread out the results of our labors on the floor in front of him. People had created masks, boats, castles, airplanes, animals and various niftily contrived figures. He called all these nursery school junk and said that in many cases they could have been made better from different materials. Then he pointed to a shape that looked extremely simple: a young Hungarian architect had created it. All he had done was fold the newspaper lengthwise, so that it stood upright like two wings. Josef Albers now explained to us how well the material had been understood, how well it had been used and how naturally suited the folding process was to paper, because it made such a pliable material stiff, stiff enough to be able to stand up where it was narrowest – on its edge. He further explained that a newspaper lying on a table had only one visually active side, the rest of it was invisible. But after the paper had been stood upright, it became visually active on both sides. Thus the paper had lost its boring exterior, its boring appearance. The preliminary course was like a group therapy. By looking at and comparing all the solutions that other students had found, we quickly learned to find the most promising solution to a problem. And we learned to criticize ourselves; this was regarded as more important than criticism by others. There is no doubt that this kind of 'brainwashing' we were put through in the preliminary course led to clear thinking" (Hannes Beckman, "Die Gründerjahre" [The Foundation Years] in *Bauhaus und Bauhäusler* [Bauhaus and Bauhaus Members], Eckhard Neumann [ed.], Bern, 1971, p. 159 ff.)

The lesson described above followed methods familiar from Itten's teaching, but used them in a different way. As in the change from Itten to Moholy, the frequently asked question about continuity and change can best be answered by saying that, as quite often happened at the Bauhaus, here too we have an ideological reinterpretation of outwardly the same or similar procedures. For, like Itten,

**Klaus Meumann, Hin Bredendieck and Elisabeth Henneberger, Construction studies.** 1928, photograph by Erich Consemüller, private collection, Bremen. • Albers taught his students to study the particular character of each material with its specific surface stimuli and tensions, and to use these to make a meaningful structure that was as simple as possible.

**Assessment of work on Albers's preliminary course.** 1928–1929, photograph by Umbo (Otto Umbehr), Courtesy Collection The Josef Albers Foundation. • Albers's preliminary course was a kind of laboratory in which students, using general design laws as a foundation, were made familiar with work that was appropriate to the requirements of modern industrial production.

Preliminary Course of Joseph Albers

Albers was a teacher trained in the Reformed Pedagogy, but his criticism of "antiquarian" educational science – to use Nietzsche's expression – and of the training provided in traditional schooling had little to do with Itten's philosophical pragmatism. In the tradition of John Dewey's "learning by doing" – which was propagated in Germany by Georg Kerschensteiner with the Arbeitsschule (Work School) – Albers was more concerned with a disciplined demand for creativity, and working and thinking skills. For example, experimenting with materials was not aimed at simplicity of emphasis but was rather a strictly analytical training in awareness and creativity, intended to lead to individual originality in professional practice with the most economical use of resources.

Through "exercises with materials," in which Albers resorted to the experiments of Moholy and Itten, that shift can be well demonstrated. They were matter-of-fact comparisons of the most varied materials, in which, as with Moholy, not only classical but also modern industrial materials were investigated for their different effects. Albers also took from Moholy the "keyboard scales from hard to soft, smooth to rough, warm to cold, or firm-edged to amorphous, smooth-polished to sticky-absorbent. For example, optical material scales ran from tight to loose-knit; transparent to translucent to opaque; clear to cloudy to dense" (Joseph Albers, "Werklicher Formunterricht" [The Practical Teaching of Form] in *bauhaus*, 1928, Vol. 2–3, p. 7). By contrast with Itten, these collages of material no longer offered any metaphysical experience of things and the charm of dadaistic art objects has completely evaporated. Albers was exclusively concerned with the ordering of sensory experience, its refinement and differentiation as the foundation for an economical and creative contact with the potential of a contemporary material. In this the criterion of economic efficiency was not seen as being in conflict with artistic merit. Moholy thought similarly, but the universalistic design concept of the Hungarian was still backed by a far-reaching utopian claim, whereas Albers essentially confined himself to the practical reform of artistic education. Left-wing Bauhaus students, in particular, criticized his doctrine and suggested that the preliminary course ought to be abolished in favour of training in practical tasks, but there were problems with this and

**Heinrich Siegfried Bormann, Lighting study.** 1931, cyanotypes cut out and mounted on card, 48.0 x 36.4 cm, BHA. • The preliminary course gave rise to some experiments with the technique of cyanotypes, which Albers or one of his students expanded through trials with ozalids and applied to the Albers portrait for the portfolio "9 jahre bauhaus. eine chronik" (9 years of bauhaus. a chronicle), 1928.

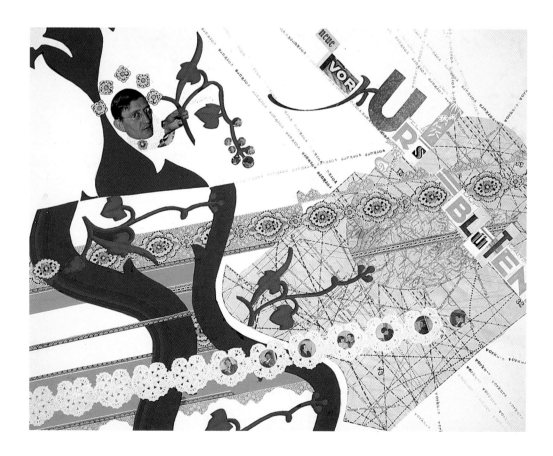

**Josef Albers, neue Vorkursblüten (New Preliminary Course Blossoms).** 1928, sheet from the portfolio "9 jahre bauhaus. eine chronik." 1928, collage of photographs, pattern charts, maps, cake doilies, newspaper lettering, Indian ink and typewriting, 41.6 x 59.2 cm, BHA. • As with Itten, the core of Albers's teaching was practice in using different materials. However, Albers was less concerned with developing the experience of potential individual artists than with a pragmatic education in design for the future.

**Ursula Schneider, Study in materials.** 1928 (lost), tinplate and red cellophane, photograph by Erich Consemüller, BHA. • As well as conventional craft materials, which were used in the early Bauhaus years, new materials were imported from industry – cellophane in this case – whose potential shapes were first of all researched independently of their possible practical uses.

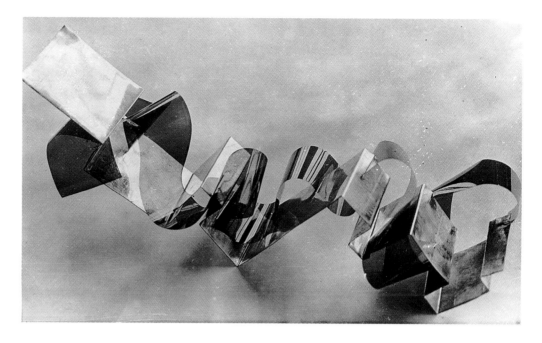

Albers's objection that it might lead to dilettantism could not be denied. Apart from the question whether this could have been put into practice, given the Bauhaus's difficult economic situation and the reservations of the appropriate craft businesses and industry, Albers – who enriched classroom teaching with occasional visits to craft businesses and factories – was chiefly concerned with training students to produce designs suitable for practical tasks. From today's viewpoint, we can argue that the concrete context of industrial production can hardly be simulated directly in a training program, because the demands of this are too complex and subject to constant change. Instead, Albers wanted students to develop the right attitude and adequate creative potential as well as the necessary flexibility. For him a very general creative competence provided the best preparation for overcoming these problems. Thus his pragmatic and inductive method was clearly distinct from the systematically structured teaching of Kandinsky, Klee and Schlemmer.

**Takehito Mizutani, Practical-dynamic materials exercise from Albers's preliminary course.** 1926–1927 (now lost), tin shapes cut and spiraled, freestanding, photograph by Erich Consemüller, private collection, Bremen. • Mizutani constructed an elegant and dynamic design, balanced on a precisely determined center of gravity. Characteristically for work done in Albers's preliminary course, this work concentrates on the original properties of the material; a way of working which evidently suits this piece.

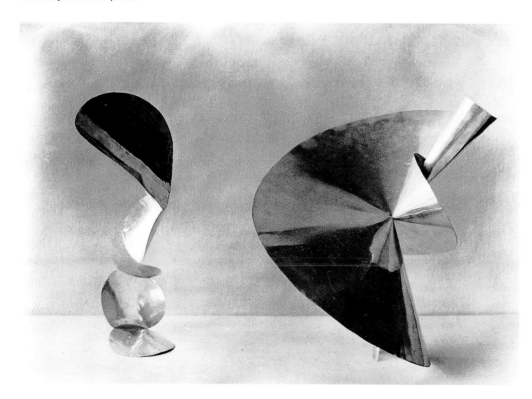

Preliminary Course of Joseph Albers

In his work, Rainer K. Wick has explained the difference between Albers's teaching and the official teaching methodology of the older Bauhaus masters. In doing so he pointed out one of the decisive breaks in Bauhaus pedagogy from a modernized doctrine of art to an aesthetic education in applied design. According to Albers's view, "art could not be 'directly taught' [an argument by which Kandinsky and Klee attempted to safeguard the primacy of their subjective artistic genius – Editor], nevertheless it could be 'learned.' This linguistic nuance expresses the principal difference between Albers's concept of aesthetic education and the one that preceded it" (Rainer K. Wick, *Bauhaus Pädagogik* [Teaching at the Bauhaus], Cologne, 1982, p. 160). This difference is also shown in the relationship between painting and pedagogic practice. Albers's artistic ideas, which reached their high point in *Homage to the Square* – that is those inexhaustible variations on the color and spatial effects of square fields set out in

**Bella Ullmann-Broner, Contrast study.** 1929–1930, pencil drawing enhanced with bodycolor and applied scrap of fabric on soft gray paper, mounted on card, study 29.1 x 21.0 cm, card 30.0 x 24.7 cm, BHA. • Unlike Itten's preliminary course, the purpose of combining traditional processes – in this case pencil drawing – with unconventional materials was not to generate poetic effects but to bring the tensions into balance.

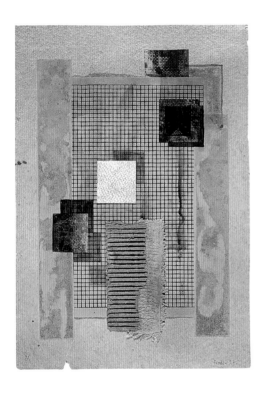

**Alfredo Bortoluzzi, Study in materials.** 1927, collage of different papers, corrugated cardboard and fabric, watercolor, 41.8 x 29.5 cm, BHA.• Whereas for the Dadaists collage was an attempt to overcome the boundaries between triviality and art, Albers encouraged his students in the more down-to-earth practice of studying materials.

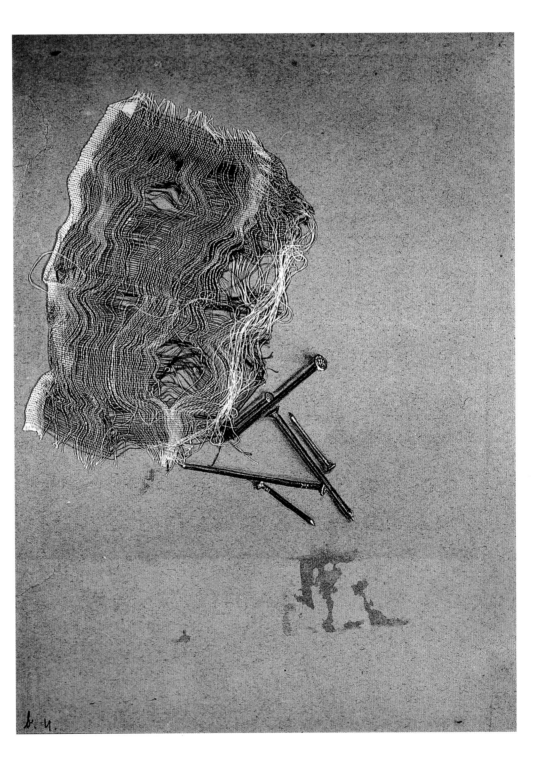

Preparatory Teaching

**Erich Krause, Material composition.** 1928, collage of solder, cellulose, paper, metal shavings on black card, 10.3 x 17.5 cm, SBD, archive collection. • The object of the exercises was not so much a preparation for autonomous artistic activity as the development of a highly sophisticated feeling for materials. Albers the teacher, influenced by the idea of the Kerschenstein Arbeitsschule (Work School), strove for a general training in human creativity.

a scientifically conducted experiment, and which are the basis of his artistic reputation even today – can also be seen as the essence of his pedagogical work. Werner Hofmann has shown the extent to which Albers's Op Art paintings converge with the pages of a Gestalt psychology teaching manual. However, this should not be understood as a criticism of Albers's own works. Indeed their equation is itself the aesthetic strategy. Thus the calculation of objective laws of shape, color, material and perception as the essence of the artistic tends to do away with the distinction between autonomous artistic creation and experimental research in teaching. In concrete terms, many of his works could equally well be individual artistic creations as products of teaching.

Whereas other Bauhaus artists felt teaching was a burdensome duty, Albers was a teacher through and through, not just because of his previous training as a teacher, but also because he was a strict rationalist in the way he produced his artistic work. Perhaps this is what marks the decisive break with nineteenth-century academicism. When artistic creation is based upon a rational foundation – such as the work being done in those years by Gestalt psychology – then a work of art in the traditional sense is still only the differentiated continuation of fundamental aesthetic research, which begins for students in the preliminary course. It was precisely those down-to-earth second generation masters – in other words Albers, Breuer, Bayer, and Schmidt – and not the shimmering artistic personalities Kandinsky and Klee, who were actually the most important protagonists of the new type of rationally and democratically oriented art schools with which the Bauhaus is still identified today.

In any case, Albers himself did not fully realize how much he was harking back to an academic concept belonging to the French classicism of the seventeenth and eighteenth centuries, which concerned mastery of the balance between rule and *variété*. For a French classical artist, genius was simply the art of mastering a strict rule and then ingeniously varying it, without breaking it. It was only with the period of Romanticism that the notion gained its emphatic sense, by which Kandinsky later legitimized the extraordinary in his individually unique art. Paradoxically in this context, reaching back to an old tradition is a sign of radical modernity. In other words, the avant-garde Bauhaus cannot simply be reduced to a style favoring right-angles and white walls. In Albers's preliminary course it is classical in a particular sense, as many supporters and opponents were well aware.

**Georg Hartmann, Bent wire figures, preliminary course work.** 1927–1928, photographer unknown, Getty Research Center, Research Library. With simple means, often precisely prescribed by Albers, the students had to try for an optimal relationship between expenditure and effect – an economic principle that prepared the students for their later professional practice as designers in industry.

**Artist unknown, Study in movement.** 1928–1930, photograph of a collage of newspaper photographs, BHA. • Collages like this attempted to explore the effect of materials ordered in different ways. The task here: to bring movement to the two-dimensional surface, to generate a new optical quality through the dynamic fanning out of the photographic material.

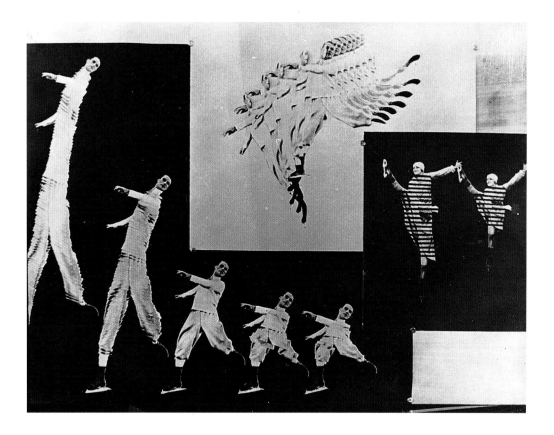

**Ernst Kallai, Caricature of Josef Albers.**
About 1930 (original collage lost), BHA. • In this caricature Albers the "nanny" is giving the baby Preliminary Course the "milk of sound doctrine" – the basic creative principles for the talented offspring of the Bauhaus.

**Joke photograph with preliminary course works.** 1928–1929, from left Xanti Schawinsky, Werner Jackson, Georg Hartmann and others, photograph by T. Lux Feininger, The Paul Getty Museum, Los Angeles. • The disrespectful treatment of serious material. Albers, the Bauhaus nanny, was very probably standing nearby.

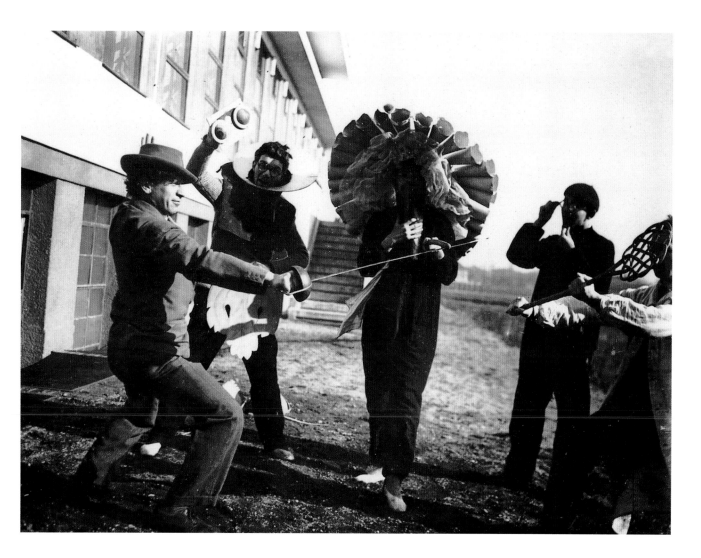

# Teaching by Wassily Kandinsky and Paul Klee

Norbert M. Schmitz

In addition to the preliminary course, students also received teaching on subjects such as form and color from Klee and Kandinsky. These were essentially more or less traditional lectures, complemented by practical exercises. As well as these, there was Kandinsky's course on "analytical drawing," alternating with nude drawing instruction from Klee. In his *Bauhaus-Pädagogik* (Teaching at the Bauhaus), Wick stresses the didactic character of these courses in comparison with the experimental bias of the preliminary course. The teaching of both artists corresponded to their ideas on design. Thus an adequate description of Kandinsky and Klee's teaching essentially means grasping their ideas. The fact that they both disliked the routine pressure to prepare lectures contributed to the two artists' ideas being systematically combined.

The establishment in 1927 of free painting classes, which both Kandinsky and Klee had been demanding for a long time, was a sign of the inner alienation of the two old masters within an increasingly function-oriented Bauhaus. Kandinsky published his "Grammatik der Formen" (Grammar of Forms) in 1926 in the volume *Punkt und Linie zu Fläche* (Point and Line to Plane). Two years later, he summarized his theories again in the essay "Analyse der primären Elemente der Malerei" (Analysis of the Primary Elements of Painting) in *bauhaus* (Vol. 2–3, 1928, pp. 8–10). Here we quote from it at length because its almost pedantic tone gives a good impression of a form of teaching that clearly distanced itself from the open atmosphere of the preliminary course. Kandinsky developed a theory of composition as a grammar of abstract painting:

"1. Through the exact determination of the primary elements and the naming of those elements that derive from them and are already more differentiated and complicated (analytical part).

**August Agatz, Construct in red and blue.** About 1927, tempera and Indian ink on card, 35.2 x 21.5 cm, SBD collection archive. • The relationship between individual creativity and execution in accordance with a strict canon of rules marks many student works from Kandinsky's course. Kandinsky took it for granted that some things were teachable and learnable, but never the essence of the artistic. In contrast to the ideas of Moholy and Albers, Kandinsky regarded teaching as much less important than the individual artistic act.

**August Agatz, Two red circles.** About 1927, watercolor and Indian ink over pencil, 24.0 x 17.0 cm, SBD collection archive. • Kandinsky often regarded teaching as a tiresome duty but it gave him the opportunity systematically to develop his theories of color and design. The works by the students are products of clearly defined set tasks, following particular aspects of Kandinsky's doctrine of design, as developed in his lectures.

**Erich Krause, Composition.** 1929, collage, body-color, pastel, sequins, 50.7 x 30.0 cm, SBD collection archive. • After analyzing the properties of shape, color and their spatial relationships, students had to use these findings in the creation of their own compositions.

2. Through the establishment of possible laws for ordering these elements in a work (synthetic part). The primary element of the drawn shape is the *point*, which is indivisible. *All* lines are derived organically from the point:

A. Lines:

I. Straight: a) horizontal, b) vertical, c) diagonal, d) straight

II. Angled and right-angled lines: a) geometrical, b) free – in horizontal, vertical and other directions

III. Curves: a) geometrical, b) free – as under number II. above.

B. Planes:

1. Triangle / 2. rectangle / 3. circle / 4. shapes which are freer than these three fundamental shapes / 5. free planes that are not derived from geometry.

... The elements of drawing and the plastic elements stand in a constant relationship to each other. This relationship is recognized in the tensions which are simply the

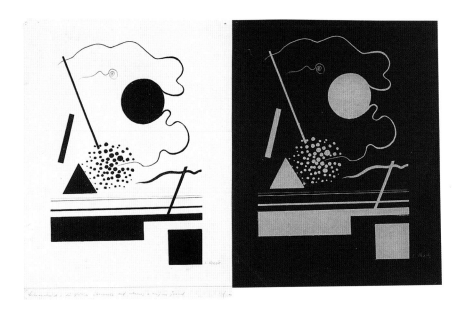

**Ludwig Hirschfeld-Mack, The same elements: black on white and white on black.** 1922–1923, lithograph on white and black paper, mounted on card, white sheet 32.1 x 24.8 cm, black sheet 30.5 x 24.4 cm, BHA. • The different brightness values, graded between white, gray and black, were also investigated for their spatial effects; Hirschfeld-Mack tested the effect of brightness contrast in this reversed image of light-dark: white is seen as aggressive and coming toward the spectator, black as passive, retreating, static.

**Reinhold Rossig. The lines black, blue, red, yellow and white seen in tension.** 1929, Indian ink and pencil on card, 29.2 x 20.7 cm, SBD collection archive. • Kandinsky's teaching, which he systematized during his Bauhaus years in the volume *Punkt und Linie zu Fläche* (Point and Line to Plane), started from the proper relationships between colors and forms. Student works, like that of Reinhold Rossig, were mainly variations on this "counterpoint of painting."

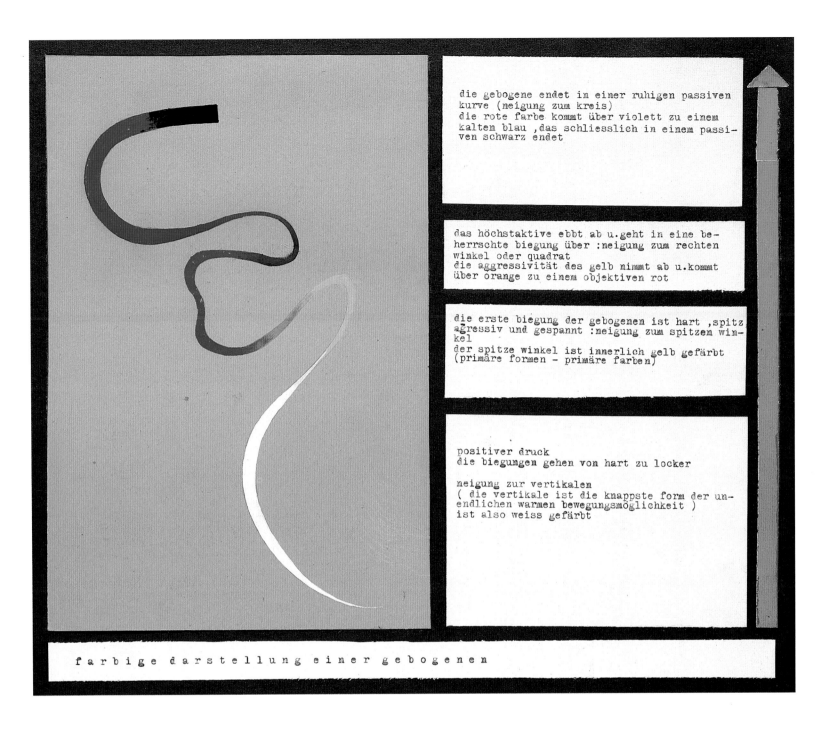

*inner* forces of the elements. These inner forces, which I call *tensions* are exclusively active forces, both in theory and in practice. In an element that has been isolated as far as possible, the tension must be regarded as absolute. In combinations of two or more elements the absolute tensions continue to exist, but they acquire a moderated value. These relative values belong to the individual means of expression of the composition, that is, they serve the object as a single medium and it expresses itself through them."

Taking as his starting point the analysis of the point, Kandinsky declared the line to be the point's "trail of movement." Their position on the surface – horizontal, vertical or diagonal – determines their cold, warm or lukewarm character. Their combinations are also characterized by particular qualities: the acute angle is warm-yellow and the obtuse angle is cold-blue. These correspondences are again referred back to the geometrical base forms of triangle, circle and square. This results in a strict, synaesthetically based system claiming to order the properties and effects of all formal

**Hans Thiemann, Colored representation of a curved figure.** About 1930, tempera over pencil on colored card and paper, typewritten explanations, mounted on black card, 34.9 x 49.3 cm, BHA. • This sketch, complete with comprehensive marginalia, shows how pedantically all the elements of form and color were analyzed and conceptually systematized in terms of their properties and relationships. Besides purely formal explanations, the "psychic" properties of colors and forms (the "aggressive yellow") were systematically recorded.

**Charlotte Voepel, color compositions after analytical drawing.** 1927–1928, above left, colored pencil and lead pencil on transparent paper, 27.9 x 19.2 cm; left, Indian ink and tempera over pencil on watercolor card, 31.5 x 22.9 cm; above, tempera over pencil on watercolor card, 34.0 x 23.5 cm, BHA. • As well as lecturing, Kandinsky gave his own course in "analytical drawing." Here students, at first using still life arrangements, had to analyze the essential constructive tensions between objects, and then draw them. Starting from this analysis, independent compositions were developed. Thus theoretically acquired knowledge became the basis of independent artistic synthesis.

elements – a rule book on whose inherent dogmatism Schlemmer ironically remarked: "It was decided that yellow stood for triangle, blue for circle and red for square, as it were, for all time" (*Briefe und Tagebücher* [Letters and Diaries], Stuttgart, 1977, p. 70). In order to counter this criticism Kandinsky relativized the universal applicability of his rule system: "Looked at theoretically, the triangle is always yellow. In practice however, there is this connection:

1 (absolute value of the triangle) + 1 (absolute value of yellow) = 2.

A blue triangle will produce

1 (triangle) + 1 (yellow) + 1 (additional value of the "harmonic") = 3.

The first combination is, as it were, colored by "lyricism," the second by "dynamism." In practice both are possible, but because they produce different results, they must be used with precise knowledge of the nature of their content. The content is no other than the sum of organized tensions."

As well as this more theoretical teaching, Kandinsky also gave a course in "analytical drawing." This abstract nature study was intended as "training in observation, precise seeing and precise observation, not of the outward appearance of an object but of the constructive elements, the tensions of forces in accordance with the rules which are to be discerned in given objects, and the construction of these in accordance with the rules – training in clear observation and clear reproduction of the connections through which the appearances of planes are an empathetic step toward the three dimensional" ("Analytisches Zeichnen" [Analytical Drawing] in *bauhaus*, 1928, Vol. 2–3, p. 11). In the first stage of these strictly ordered studies, the tension lines and dynamic force fields were still directly derived from objects constructed in front of the students. In the next stage the connection with the object was loosened, to be replaced by the abstract constructional network in isolation. Finally the lines of force became the basis – partly through the use of tracing paper – for independent variations on individual segments. "Because of their high level of abstraction," as Clark W. Poling remarks, "the third stage analytical drawings could serve as the basis of pictorial compositions" (*Kandinsky-*

*Unterricht am Bauhaus* [Kandinsky's Teaching at the Bauhaus], Weingarten, 1982, p. 46 ff.). In this way, as Magadalena Droste says, analytical drawing repeats the step-by-step emancipation of abstract design "from object to composition" in Kandinsky's own art (*Bauhaus 1919–1933*, Cologne, 1990, p. 67).

Kandinsky's "Analyses of Old Masters" should be understood in the same way. Even more than Itten, whose treatment of historical predecessors could be much more spontaneous and emphatic, in his teaching on paintings by Bouts, Rembrandt and Poussin, Kandinsky demonstrated the universal validity of his doctrine of design. The same constructive tensions that he investigated both in his elementary teaching and in his "analytical drawing" course now appear as the aesthetic essence of the whole history of art, a knowledge that was only shaken by the materialism of the nineteenth century: "It can be accepted as certain that painting in this respect was not always as helpless as it is today; that a certain amount of theoretical knowledge existed not just in relation to purely technical questions, that a certain doctrine of composition could be and was applied by the early masters and that, in particular, knowledge of certain facts about elementary forms, their nature and application was common among artists" (Wassily Kandinsky, *Punkt und Linie zu Fläche* [Point and Line to Plane], Munich, 1926, p. 12).

Klee's considerations were similar in many respects to his friend Kandinsky's. Whereas the latter developed his doctrine of design in a mainly systematic way, Klee connected it closely with the genesis of design, and the comparison between the creation of artistic design and the cosmos. He "demanded the study of natural growth and movement processes, in order to apply the insights gained to a deeper understanding of the world's coherence" (Christian Geelhaar, *Paul Klee und das Bauhaus*, Cologne, 1972, p. 23). Klee's "Natural History of Art" – which he partly published in 1925 as his "Pedagogical Sketch Book" in the Bauhaus Books series – also begins with the analysis of elementary principles in order to progress in clearly defined lesson-units to the complex.

**Karl Hermann Haupt, Action drawing arising out of the teaching of Paul Klee.** 1923, pencil on paper, 27.5 x 22.0 cm, Getty Research Center, Research Library. • As an extension to his normal duties, Klee occasionally also taught the course in action drawing. The results of this originally classical-academic exercise show the interest taken in the laws of individual design beyond a conventional imitation of nature.

3 FORMEN IN EINER FORM

S.9 LOGISCH / TEILKONSTRUKTIV BERÜHREND

9 S.10. INEINANDER EINDRINGEND VOLLKONSTRUKTIV

9 SICH NAHE STEHEND

Arndt

**Gertrud Arndt, Three forms in one form/ logically and part-constructively touching/ penetrating fully-constructively/standing near each other.** 1923–1924, watercolor and Indian ink over pencil on card, card 33.0 x 22.0 cm, BHA. • In his lectures Klee developed a systematic doctrine of design, in which colors and shapes were investigated with special emphasis on the dynamics of their relationships. The development of artistic design became a metaphor for "creative becoming."

11 S.11 LOGISCH/ÜBEREINANDER

**Gertrud Arndt, Logically/over each other.** 1923–1924, watercolor and pencil on card, card 44.0 x 31.5 cm, BHA. • For Klee, forms/shapes have a life of their own, with qualities of mood, as his student Gertrud Arndt established by her "visual notations" – "touching each other or penetrating each other, standing near each other" – seeming to bring themselves to life.

He begins with the movement of the point, from which lines are produced. He is less concerned with finished compositions than with the process of producing the picture. The moment of time is more than a mere formal element: the process is a mirror of the dynamic structure of the cosmos. So the point continues as a line, straight or curved, in order eventually to enclose a plane. We can follow the further steps in detail in the comprehensive, later partly published lecture scripts. As an example, we may mention here the doctrine of equilibrium, for every "energy demands a complement in order to attain a

condition of resting in itself, settled above the play of forces" (Paul Klee, essay in the anthology *Schöpferische Konfession* [Creative Confession], 1920, in Paul Klee, *Schriften, Rezensionen, Aufsätze* [Writings, Reviews, Essays], Christian Geelhaar [ed.], Cologne, 1976, p. 121). From the working of active and passive energies in the pictorial medium, Klee developed the symbolism of scales. In contrast to Moholy's exercises calculating equilibrium, Klee's was a romantic symbolism of nature and art, in which all contradictions come into harmonious balance.

Although all these elements marked Klee's work, the canon of rules did not represent a direct key to his own art. Instead, he stressed the intuitive moment. Although for him, as for Kandinsky, the doctrine of design, knowledge of counterpoint and the comparison with the creation of the cosmos were both an artistic program and the essence of any art education, nevertheless the relationship between this systematic doctrine and the artistic practice of each in his own work, remains a cardinal problem. Critics have often underestimated this, reducing the conflict merely to the integration of emotional and rational aspects, for even the coolly analytical Moholy and Albers tried to bring psychic dimensions into their pedagogical practice. But for the Late Romantics Kandinsky and Klee there was a more fundamental danger to their understanding of themselves as artists. Because they thought of themselves as individual artists in the nineteenth-century sense, a universally applicable rational doctrine of design threatened them with the loss of their intuitive artistic creative power. For this reason, in his *Beiträgen zu bildnerischen Formenlehre* [Contributions to the Teaching of Artistic Forms], Klee relativizes the demand for a binding doctrine of design: "Such misunderstandings lead to constructions for their

**Margaret Leischner, Divisions of shapes, sheet from portfolio with notes and colored plates from the teaching of Paul Klee.** 1928, watercolor over pencil on paper, 20.0 x 30.0 cm, BHA. • As in Kandinsky's teaching, with Klee too the individual steps in his doctrine of design were taken, memorized and tested with the help of textual and graphic notations.

DURCHDRINGUNG DER KÖRPER
DEM WESEN U. DEM SCHEINE NACH.

**Grete Reinhardt, Penetration of bodies according to essence and appearance.** About 1928, tempera over pencil, 29.7 x 21.0 cm, SBD, archive collection. • The tender poetry of this student's work recalls the works of her teacher: not so much an exercise, more an autonomous work.

**Peter Keler, Concentration, design for a glass picture.** 2nd version 1922, oil on hardboard panel, 70.8 x 51.0 cm, SBD collection archive. • The study dates from the time when Klee was also running the workshop for glass painting (1922–1924). This student's work shows clearly that the basic aesthetic teaching was aimed less at applied design than at the development of a whole artistic personality.

**Franz Singer, Color penetration of yellow and violet, section from a sheet from Paul Klee's color classes.** About 1922–1923, four sheets mounted on cardboard, watercolor and graphite on paper, whole sheet 63.7 x 49.7 cm, BHA. • As a musician, Klee regarded such charts as "ideal color boxes" which, with their step-by-step changes in brightness value, were a kind of "visuelle Tonleiter" (visual scale). This "optical musicality" was in the tradition of the romantic search for a "universal basis of painting."

own sake. They haunt the heads of narrow-chested asthmatics, giving rules instead of works. Such people have not enough breath in them to grasp that laws should only be a ground in which something can bloom... that laws are only the common basis for nature and art (*Beiträge zur bildnerischen Formenlehre 1921–1922*, Jürgen Glaesemer [ed.], Basel-Stuttgart, 1979, p. 184). This argument corresponded to the contemporary value placed on Kandinsky and Klee's teaching at the Dessau Bauhaus. Even their supporters hardly expected them to give students a concrete preparation for later work in the workshops, but at most to acquire greater sensitivity in general aesthetic matters. It was only with difficulty that such compromise formulae bridged the growing gap between the romantic founding fathers and the educational innovators in an art school like the Bauhaus, in which the classical and genial inspiration of artists was becoming increasingly obsolete. Klee's acceptance of a post at the Düsseldorf Academy of Art was a natural consequence, for this academy, rich in tradition, still offered a secure home to the romantic idea of the artist.

# Teaching Color at the Bauhaus

Britta Kaiser-Schuster

In the early years after the foundation of the Bauhaus, between 1919 and 1922, color was not systematically taught. Even in 1921 it only appeared in the regulations under "Complementary Subjects." It only became obligatory for all students in 1922. Itten actually called himself "Master of the Art of Color" and treated color as part of his foundation course from 1920 until 1921–1922. However, a systematic course on color only began from November of 1922 with Klee's lectures, which were called "Contributions to the Teaching of Visual Design." The students asked the teaching body for a course in color from Itten and weekly lectures from Klee. At the same time Ludwig Hirschfeld-Mack held a color seminar (1922–1923). The principal foundations for Itten, Klee and Kandinsky's work on color theory were drawn from the ideas of Goethe, Runge and Hölzel. On the other hand, Hinnerk Scheper and Joost Schmidt based what they did in the wall-painting and advertising workshops on the strictly schematic color ordering of a Nobel prize-winner, the chemist Wilhelm Ostwald. In the Weimar days there had been protests about him, but in 1927 he was invited to lecture. Soon his 22-part color circle hung in the wall-painting workshop. Even Kandinksy examined his ordering of colors. Klee always rejected it as mere "colors for industry" and "chemical coloring," because in his teaching on harmony Ostwald took no account of the subjective effects of color, which formed the basis of the doctrine of contrast. In 1916–1917 he had set out the color harmonies in his color primer. His aim was to make colors measurable, so that they could be ordered like tones in music. Ostwald distinguished between bright and unbright colors, starting from four basic colors – yellow, u-blue (ultramarine blue), red and sea green. He arranged the eight principal colors in a color-tone circle, dividing each color into three grades, thus creating a 24-part color-tone circle. Scheper's teaching on color (from 1925 to 1929 and 1931 to 1932) was firmly directed toward practice and taught basic craft skills, such as the composition of the painting base, the production of plaster and fresco work from plastering to painting. The work he set included the creation of a comprehensive color-tone scale for oil painting and knowledge of the various techniques in the representation of color tones, such as color-spraying or scanning. Color was a component of all Joost Schmidt's courses. Of his 52-part set of exercises for teaching advertising (1931–1932), 11 were dedicated to color. For the more advanced semesters Schmidt planned to transpose Ostwald's ideas into poster design.

Johannes Itten had already developed crucial parts of his teaching during his study under

**Ludwig Hirschfeld-Mack, Untitled.** About 1923, tempera on canvas, 35.0 x 45.0 cm, private collection. • Additive color mixing: a child plays with color spheres. When they spin they optically mix the basic colors yellow, blue and red into further colors, as the two big discs systematically show. The division and intensity of the colors alter according to the rate at which the spheres spin.

**Johannes Itten, Farbkugel bandräumlich (color sphere with bands in space).** 1919–1920, graphite and colored pencil on paper, 22.6 x 22.0 cm, Itten Archive, Zürich. • Itten employed the visual aid of the color sphere to students teach three-dimensional thinking and feeling. You could travel along color meridians: from warm to cold, from the white pole through the gray inside of the sphere to black, or you could also break through surface segments of the same brightness to complementary areas.

Adolf Hölzel in Stuttgart (1913 to 1916) as well as in his private art school in Vienna (1916 to 1918). There are no known records of his teaching on color at the Bauhaus, which was a component of his introductory semester, called the "preliminary course" from 1920 onward. It is only in his diary for the year 1930, where he gives an account of his teaching at the Itten School in Berlin, that he explicitly formulates a doctrine on color, which essentially anticipates his *Kunst der Farbe* (Art of Color), published in 1961. However, in his diaries for 1913 to 1919 there are numerous entries. He shows interest in the color doctrines of Wilhelm von Bezold, Ogden Rood, Arthur Schopenhauer and Paul Cézanne, as well as in Hölzel's doctrine of contrast (1914). There are notes on the deep effects of colors and the relationship between color and form. Itten classifies red with square, yellow with triangle and blue with the circle (1915–1916). There is an "attempt to construct a color circle, in which the same brightnesses occur at the same meridians" (1917), a two-dimensional attempt to correspond to Runge's projection of the color sphere. Itten himself also constructs a color sphere with meridian, equator and diameter at the same stages of brightness, inspired by the 12-tone musician Josef Matthias Hauer (1919–1920). Then there are reflections on Goethe's "plus-minus polarity" related to the polarities of man-woman, earth-heaven, matter-spirit (1918). Itten formulated no new color theory, but combined different theories in a doctrine of color that united subjective experiences of color with knowledge of objective fundamental rules. He particularly pursued Hölzel's distinctions between seven different color contrasts in a systematic order (simultaneous contrasts of color in itself, light-dark color, cold-warm and complementary, and colors studied for intensity, quality and quantity), which go back to Chevreul (1839) His teaching on color at the Bauhaus can be reconstructed from some of his students' works. The crucial witness, however, is his "Color Star," a supplement to *Utopia. Dokumente der Wirklichkeit* (Utopia. Documents of Reality), published in 1921: a two-dimensional figure, directly taken from Runge's spherical ordering of colors.

Man nennt diese Reihen die Schattenreihen, weil sie die Farben enthalten, welche aus einander durch Beschattung oder Aufhellung entstehen. Sie sind von besonderer Wichtigkeit, weil man ihnen entnehmen kann, wie ein Körper von gegebener Farbe zu schattieren ist.

Die Schattenreihen enthalten daher Farben gleicher Reinheit und heißen deshalb auch Reingleichen. Die unbunte Reihe

in der Achse hat natürlich die Reinheit Null; für die folgenden senkrechten Reihen werden die Reinheiten mit IV, VIII und XII bezeichnet. Die Zahlen springen um je vier Stufen, weil nur jeder vierte Buchstabe der vollständigen Tafel a b c d.... aufgenommen ist, die zwischenliegenden Reingleichen also übersprungen sind.

**Wertgleiche Kreise.** Ebenso, wie die reinsten Farben unseres Farbkörpers, die in der Kante des Doppelkegels liegen, dort einen Farbtonkreis wie S. 19 bilden, findet dies für jedes andere Feld des farb-

**Wilhelm Ostwald, ea-circle from the "Color Primer."** 1916–1917, taken from Wilhelm Ostwald, *Farbenfibel* (Color Primer), Leipzig, 1917. BHA. • Eight color tones with white, brought to the same measurable stage of brightness, form a ring of "bright-clear" colors in the conical Ostwald Spectrum of 680 colors. They are set opposite the "dark-clear" tones, mixed with black.

**Benita Koch-Otte, Color fans.** About 1925, tempera and Indian ink over pencil on drawing card, 31.2 x 31.4 cm, Historical Collection of the Bodelschwing Bethel Institutes. • The late date of the color fan indicates that Otte, a weaver who had attended Itten and Klee's foundation course in color at the Weimar Bauhaus, used the fan as a color thermometer and aid in weaving compositions.

with its teachings about contrast and temperaments, also had a place in Itten's work on color theory.

There are no written records of the extracurricular color seminar for students and masters held by Itten's student Ludwig Hirschfeld-Mack. However, there are numerous color tables arranged in order, light-dark studies with color and gray scales and studies of the relationship between color and shape, which represent either elementary color systems or individual aspects of color. Hirschfeld-Mack illustrated the sorting of colors through the color triangle and the color circle. To Goethe's elementary contrast between white and black, yellow and blue, he added a gray scale, whose middle gray corresponds to the light value of the color red, which according to Goethe arises out of the increase in intensity of the two original colors. Hirschfeld-Mack represented the 12-part color circle with concentric stages of brightness. In Hölzel's doctrine of contrast it was particularly the quality contrast, reproduced in

**Ludwig Hirschfeld-Mack, Twelve-part color circle (120 colors), study in color intensity.** 1922–1923, gouache and collage on Neuruppin art paper, 51.5 x 63.5 cm, BHA. • This shows that even with equal grading of all 12 colors toward black or white, the same intensity and brightness of tone are not always to be found on the same ring.

Starting from the 12-part color circle, which forms the equator line of the sphere, Runge developed his color scale toward a white and a black pole, with the darker colors nearer the center of the sphere. Itten also gave the circle a light-dark and cold-warm alignment. Runge was also the connection for Itten's doctrine of harmony, according to which colors exist in a harmonious balance if the eye can either expand them to a "totality," or attain harmony if the mixture of two or more colors gives a neutral gray. The central importance of Itten's color doctrine is shown in his *Kinderbildnis* (Portrait of a Child) of 1921–1922, in which his son Matthias is represented surrounded by symbols that were full of meaning for Itten: the color sphere beside the Mazdaznan star in the foreground, on the dice to the right in the square, the colors of the 12-part color circle, in the middle of which are the three basic colors plus white as a color-in-itself contrast. Mazdaznan doctrine,

**Paul Klee, Scheidung, abends (Parting, evening).** 1922, work index no. 79, watercolor on Ingres paper, 33.4 x 23.2 cm, Klee Family Collection. • Klee's teaching on color and his work as a form master gave students, especially weaving students, "deeply considered clarifications to problems of design, relationships and color values."

Schopenhauer's quantitative color circle, that stimulated Hirschfeld-Mack toward optical color mixing. This "color gyroscope" relied on the principle of optical mixing through the movement of colored surfaces. The removable color discs represent an attempt to create an order – of quantity and intensity contrast – to deal with problems of gray and color mixing.

Color only became part of Paul Klee's formal teaching in 1922–1923, probably in the summer semester of 1923, the winter semester of 1923–1924 and finally in the Dessau Bauhaus period. In Klee's graphic representation of the idea and structure of the Bauhaus, teaching on color already had a firm place. In his *Beiträge zur bildnerischen Formlehre* (Contributions to the Teaching of Pictorial Form), detailed

**Lena Meyer Bergner, Radiation – the center that wandered off, study from the teaching of Paul Klee.** 1927, watercolor on drawing card, 23.3 x 32.7 cm, BHA. • The "wander" trails begin in blue, run in both directions in a similarly additive mixture toward yellow, and from there in different ways make their way via blue to black. The repetition of the tones in "path" and "goal" makes the movement appear reversible and the stars pulsate.

preparations for his own doctrine of color are documented. Numerous lecture notes of his students give details of tasks set. As he himself stressed at the beginning of his exposition of his color theory, Klee took over "without reservation, ideas of experts in the field and others. To name just a few names, I may mention Goethe, Philipp Otto Runge, whose color sphere was published in 1810, Delacroix and Kandinsky ("Über das Geistige in der Kunst" [On the Spiritual in Art] from Paul Klee, *Beiträge zur bildnerischen Formenlehre* [Contributions to the Teaching of Artistic Forms], Weimar, 1921–1922, p. 153). However, Klee developed his own theory, whose particularity lies in the component of color's moment of movement. In contrast to Kandinsky or Hirschfeld-Mack, Klee did not research colors in isolation, but recorded their range on the edge of the color circle. Klee's starting point is nature study, looking at the rainbow, which he enclosed in the six-part color circle. "The first part of my task is to create a kind of ideal color box for you, in which the colors are set in a well-founded order, a kind of toolbox, if you like" (ibid). Klee called the diametrically opposite pairs red – green, yellow – violet and orange – blue the most important complementary colors. By rotating the diameter, he got three further pairs: red/violet – yellow/green, yellow/ orange – blue/violet, red/orange – blue/green. Because these consist of already existing colors and each when mixed with its complement also gives gray, Klee regarded them as genuine color pairs, like the original pairs, and unlike non-genuine color pairs, which do not arise from a diametrical opposite. Klee understood the process from a row of colors to a circle of colors as a pendulum movement, which becomes a moving circle. This element of movement is Klee's leitmotiv. He described the color movement along the boundary line of the circle as peripheral movement; here the processes continually followed each other in sequence, to a warm and a cold end and also to a peak. Klee defined the range of color through the color-free streak, which lies opposite the colored streak on the circle. He called the movement toward the circle's diameters "diametrical color movement." There were three principal diameters in the six-part color circle. The complementary colors connected by the diameter destroyed themselves as colors when they mixed in a diametrically opposite direction and became gray. Klee called the whole diagram the "Canon of Totality" (compare to Goethe and Runge). Klee transposed this two-dimensional representation into the three-dimensional color sphere (compare to Runge) with three different directions of movement: the peripheral toward warm or cold, the diametrical toward the complementary color and the polar movement toward white and black.

As well as analytical drawing, Wassily Kandinsky lectured on color, concentrating on key areas. His teaching was based on his work *Über das Geistige in der Kunst* (On the Spiritual in Art) (1911), which from 1925 onward he extended into a phenomenology of color-form relationships. He divided the "effects of color" into physical and psychic effects. He

analyzed color and shape as follows: "First one concentrates on isolated color, which immediately divides into two parts: 1. warmth and cold of the color tone and 2. its lightness or darkness. Hence we get four main tones: 1. warm-light, 2. warm-dark, 3. cold-light, 4. cold-dark. The warmth or coldness of a color is generally a tendency toward yellow or blue," which for Kandinsky was the "first great contrast in inner value." Yellow moved toward the spectator, toward the bodily; blue withdrew itself from the spectator toward the spiritual. "The second great contrast is the difference between white and black ... the color's tendency toward light or dark." He called these tendencies movements "in solidified form" (Wassily Kandinsky, *Über das Geistige in der Kunst* [On the Spiritual in Art], Bern, 1952, p. 59 ff. and p. 87 ff.).

At the Bauhaus, Kandinsky expanded this characterization of contrasting pairs with components of smell, taste and music. According to him, in all diametrically opposed colors, green was the ideal balance in the mixture of the two: the movements destroyed themselves and rest ensued. Against green he set red. Both together were motionless – giving rise to the third great contrast. Orange – violet formed the fourth contrast. For both colors the same movements applied as for yellow and blue, but in weakened form.

Thus we have three complementary color pairs, which Kandinsky set against each other in the color circle in such a way that, as Rainer K. Wick noted in his *Bauhaus Pädagogik* (Teaching at the Bauhaus), it gave the wrong results for the color mixing of actual pigments: yellow – green – violet – blue – red – orange. Also problematic was the fact that the poles were outside the circle. "Like a great circle, like a snake biting its tail (the symbol of the everlasting and eternity) the six colors stand before us, which in pairs create three great contrasts. And to the right and left lie the great possibilities of silence; that of death and that of birth" (Wassily Kandinsky, *Über das Geistige in der Kunst* [On the Spiritual in Art], 1911).

In contrast to this theorizing, at the Bauhaus Kandinsky increasingly took as his starting point the material substance of colors, the pigments, from the primary colors yellow – blue – red, as well as the secondary and tertiary colors. Another new aspect was research into color harmonies. The introduction of polar opposites (compare to Goethe's plus-minus polarity), which was expressed particularly in the yellow-blue contrast, was expanded with contrasting pairs such as presence-absence, light-shadow, bright-dark, strength-weakness, warmth-coldness, nearness-distance, repel-attract, active-passive.

**Eugen Batz, Correspondence between colors and forms.** 1929–1930, tempera over pencil on black paper, 42.3 x 32.9 cm, BHA. • Finding analogies between colors and shapes was a focal point of Kandinsky's teaching. From the temperature balance in the angles in their relationship to color, students were led on to the color affinities of closed forms.

**Lothar Lang, Color scale.** 1926–1927, tempera over pencil on white card, picture cut out and stuck on black card, 19.8 x 44.5 cm, BHA. • Kandinsky taught students different color systems. Here three scales are arranged in parallel, with red at the base of the figure, green above it and mid-gray on top. The stable order thus established shows the hierarchy of the effects of basic and non-colors and demonstrates their relationships.

**Joost Schmidt, dust jacket for "Offset: Buch and Werbekunst" (Offset: Book and Advertising Art).** Vol. 7, 1926, offset printing, 31.0 x 23.0 cm, BHA. • Color, explained in measurable quantities by Wilhelm Ostwald, was very important especially in the printing industry. The basic colors used here only need the addition of measured parts of white, black and gray to form a standardized color scale.

Kandinsky's color seminar was one of the compulsory courses in the "Elementary Teaching of Form." In addition he taught "isolated color, the systematization of color, connections, rules of tensions, relationships, effects and appropriateness" as well as "relationships of color and shape, with their shifts in tension and effect" (1928). With the exception of red, which he regarded in isolation, he presented the colors in pairs: yellow – blue; white – black; yellow – blue with white and black; green – gray and orange – violet. He researched the spatial effect of the color in relation to simultaneous contrast. Kandinsky studied the properties of colors in rows (or sequences) of colors and in color circles. He treated green and

gray as correspondences with red, as they also mediated between the light and dark pole on the tonal value scale. For Kandinsky, polar color relationships were important elements in picture composition. At the end of the first seminar he set the students the task of creating balance in a composition, using the primary and secondary colors and white, black and gray with a grid made up of nine squares divided into 18 rectangles. Complementarity was regarded as the basis of harmony. Kandinsky derived the correspondences from studies of basic shapes, angle relationships and basic colors. He himself had set out the connection between color and angle relationships in his 1926 work *Punkt und Linie zu Fläche* (Point and Line to Plane):

the acute angle corresponds to the color yellow, the right angle to the color red and the obtuse angle to the color blue.

The Bauhaus did not have a single coherent doctrine on color. Each lecturer had his own individual emphasis. The painters Itten, Klee and Kandinksy mainly drew from nineteenth-century historical theories of art and color. On the other hand, Scheper and Schmidt relied more on the non-artistic but scientifically exact color ordering of Ostwald, in keeping with the drive toward standardization in the Dessau period.

WORK

# Workshops

# The Joinery and Fitting Workshop
Eva von Seckendorf

## Art and craft

In his 1919 manifesto for the first program of the State Bauhaus, Walter Gropius passionately called upon artists to free themselves from self-regard and devote themselves to the design of everyday things. "There is no such thing as an artistic calling. The aim of all artistic activity is building! ... Architects, sculptors, painters, we must all get back to craft." Gropius did not look to restore a medieval order of handworkers. He wanted to establish a new professional image. By tying artistic crafts to handicraft, Gropius laid the foundation for the development of the modern designer. Following the demands of the industrial art movement, he developed his teaching through the idea of the workshop-school. "Every student must learn a craft!" was a pragmatic rule of the foundation phase. The achievement of the Bauhaus's founder was to adapt the often cited "unity of art and craft" into a program to meet social and economic needs. It was his prag-matic and diplomatic skill that enabled him to fulfill this vision.

First of all Gropius devoted himself to equipping and staffing the workshops. Because there had been no joinery workshop in the school of his predecessor, Henry van de Velde, it had to be newly set up and technically equipped. It was only during the course of 1921 that joinery work could begin in the former sculpture studio of the School of Fine Arts. The search for a suitable joinery workshop leader proved to be difficult. The individualistic character of the Bauhaus required an open-minded personality. Despite all the declarations about equality, the craft masters had hardly any say in the running of the school and no seat or voice on the council of masters. Three craft masters followed one another in the joinery workshop in the first three years. The Bauhaus students also showed interest mainly in the art classes. In a speech at the yearly exhibition in the summer of 1919, Gropius complained about slack discipline and that the students were lacking

**Joinery workshop in the sphere,** 1921, photograph by Georg Muche, BHA. • Only individual pieces of furniture have survived from the time of Johannes Itten, who in the beginning led nearly all the workshops. The focus was mainly on the production of material studies. Themes such as material properties, their changes when curved in a sphere and contrasts in size, form and light could have provided Muche with the occasion for a number of photographic studies.

a sense of craft: "Apprentices, journeymen, novice-masters ... at present these terms are a joke." In 1921 Walter Gropius organized the workshop training into the first official teaching curriculum. After passing a probationary semester, the students could enter the Bauhaus joinery workshop and after three years' study, in accordance with the regulations of the Chamber of Crafts, take their journeyman's examination. The artistic education ran parallel with the craft education. It was examined in accordance with the regulations laid down by the Bauhaus's artistic design teaching council.

### Johannes Itten – creative handicraft

From 1920 the apprentices were taught by an artist, who was the form master, as well as by the craft master. Johannes Itten took on this function in the joinery workshop, and in the other workshops. He urged the students to apply what they had learned about design and materials in his preliminary course on wood as a material. His apprentices "were categorically not to work with strange designs, or the designs of Bauhaus teachers" (Exhibition of works by journeymen and apprentices in the Weimar State Bauhaus, April to May 1922). Itten completely refused to take on commissioned work. For him traditional workshop procedures were unimportant. He wanted creative individual works beyond commercial pressures, allowed the apprentices individual working times and used meta-physical criticism to deal with conflicts. For him the master-joiner Josef Zachmann was too "cramped" and "rigid in himself" so that "his inner rhythm does not swing with his plane"

**Pause for breakfast in the workshop, students in the fitting workshop.** About 1928, from left Gustav Hassenpflug, August Agatz standing, unknown girl in front of him, Wera Meyer-Waldeck, Franz Ehrlich, Hermann Bunzel, Albert Busk standing, photograph by Lotte Gersib-Collein, BHA. • The joinery developed into a furniture workshop, especially under Gropius's leadership. This direction was maintained when it later merged with other workshops to form the fitting department.

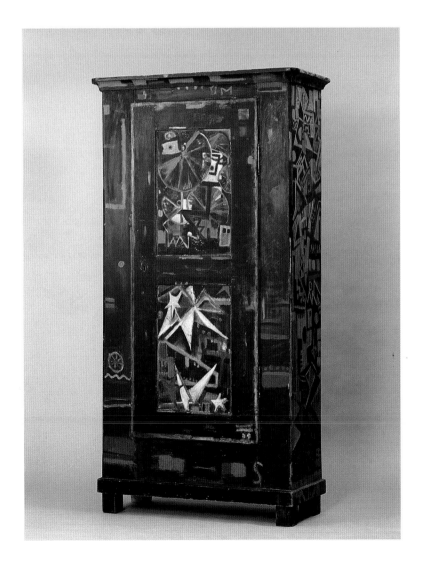

**Rudolf Lutz, Painted cabinet.** 1919–1920, oil paint on wood, 192.0 x 102.0 x 45 cm, SBD, archive collection. • Oskar Schlemmer is meant to have said mockingly that the joinery workshop barely had a single carpenter's bench. Probably the student Lutz used a finished cabinet as a background upon which to paint.

Joinery and Fitting Workshop

**Peter Keier, Furniture designs for a man's bed, woman's bed and baby's cradle.** 1923, collage 37.5 x 48.7 cm, KW. • The symbolic connection between primary geometry and colors and gender has its spaces in the mystical rationalism of Johannes Itten's teaching. It was not only countered by Kandinsky's theories but coincided with it as well.

**Peter Keier, Baby's cradle.** 1922, wood, colored and lacquered, rope webbing, 91.7 x 91.7 x 98.0 cm, KW, Bauhaus Museum. • Itten's students, as well as Kandinsky's, had to deal with the triangle, rectangle and circle and their relations to the primary colors. Combining them as constructive elements of a utilitarian object would not have been conceivable without the influence of De Stijl.

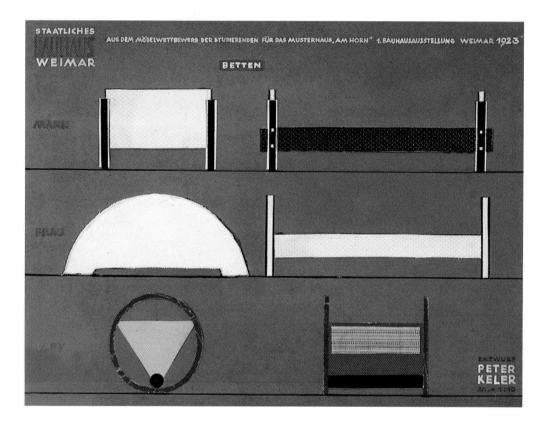

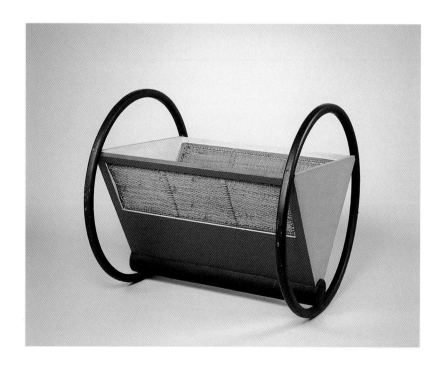

Workshops

(Klaus Weber, "Kunstwerk-Geistwerk-Hand-werk" [Artwork, Spiritual Work, Craftwork] in *Das frühe Bauhaus und Johannes Itten* [The Early Bauhaus and Johannes Itten], Weimar, 1994, p. 223). Under Itten's leadership few individual pieces were made in the wood-carving workshop. Among them was the master's cradle for his son, born in 1920, a decorative composition constructed of circles, triangles, spheres and slats. The "African chair" of the joinery apprentice Marcel Breuer, with a back woven by Gunta Stölzl (which only survives in photographs) alludes to Breuer's homeland in Hungary with folksy ornamentation and coarse woodwork.

### Art and Technique – a new unity

In December of 1921 Gropius stood out against Itten's teaching manifesto. He referred to the financial needs of the school and demanded that the workshops should earn money to consolidate the school financially. "The Bauhaus in its present form stands or falls by the acceptance or rejection of the need for commission work" (Notes of December 9, 1921 for a discussion in the council of masters, Bauhaus Archive, Berlin). In February of the following year, by creating prototypes, Gropius undertook a decisive step toward resolving the opposition between industrial production and artistic work. "How the gap, which is still wide, between what we do in our workshops and the present state of industry and handicrafts will finally be closed, that is the unknown X.... It is conceivable that work in the Bauhaus workshops might lead more and more to the creation of typical individual pieces" ("Die Tragfähigkeit der Bauhaus-Idee, Notizen zu einem Rundschrieben an die Bauhausmeister" [The Load-bearing Capacity of the Bauhaus Idea, Notes for a circular to the Bauhaus masters], February 3, 1922, Bauhaus Archive, Berlin). The quarrel between Itten and Gropius came to a climax when Gropius decided to pass on a private commission of his own to the joinery workshop, namely the seating for the Jena City Theater, which he had built. Itten gave up his job as leader of the wood workshop and in October of 1922 left the Bauhaus altogether.

### Constructivist aesthetics

During 1921, work in the joinery workshop moved away from expressionistic design

**Marcel Breuer, "Slat-chair" TI1a.** 1924 version, maple wood, stained, horsehair webbing, BHA. • The Bauhaus parole "industrial serial production" gave Breuer occasion to regard the economical use of materials and time as an aesthetic stimulus. His renunciation of massive planes on the seat and arms in favor of a structured angular construction was intended to show a new direction in furniture design.

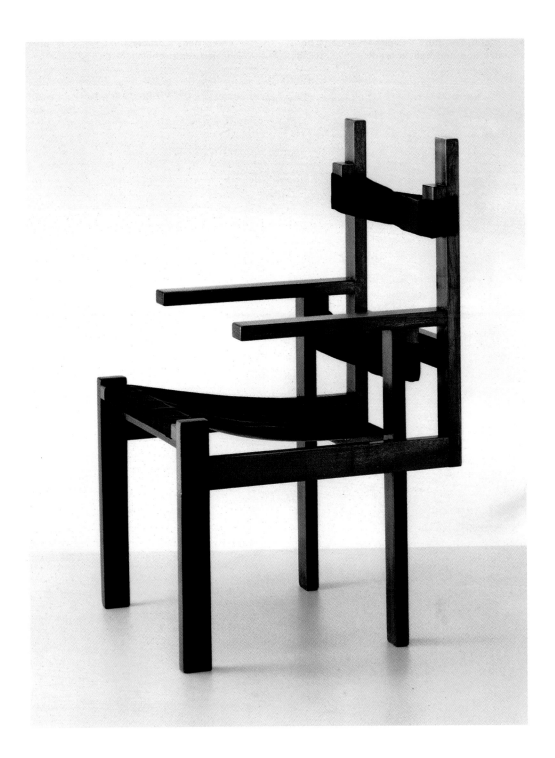

toward constructivist aesthetics. In 1921 this new ideal can be seen in Marcel Breuer's seating for the house of the Berlin building entrepreneur Adolf Sommer. The impulse for the new direction came from outside. Theo van Doesburg, head of the artistic group De Stijl, attracted a great deal of attention when he arrived in Weimar in 1921. His friend Gerrit Rietveld's furniture was carefully studied at the Bauhaus. Rietveld, a furniture maker and later architect, had moved a long way from traditional cabinet-making and joinery, both in

terms of construction and design. He built furniture from simple wooden boards and slats, harmonious constructions with load-bearing and supporting parts. In 1922 Marcel Breuer made a so-called "slat-chair" as an apprentice work. For the frame he chose wood, for the seating and leaning surfaces he used an elastic horsehair material. Breuer's chair was the first product with the puritanical and function-oriented design that characterized the Bauhaus products in the years to come. The "slat-chair" points clearly to its earlier model, Gerrit

Rietveld's red-blue chair from 1917. This influence can also be seen in the furniture designs of Walter Gropius, Erich Dieckmann and Josef Albers. Together with these new designs went a function-oriented description of design method. Marcel Breuer described his "slat-chair" as the result of reflections about function: "The starting point for the chair was the problem of sitting comfortably, together with the simplest construction. After that we were able to list the following requirements:

- Elastic seat and back rest, but no upholstery, which is heavy, expensive and traps dust
- The sitting surface slopes, so that the whole length of the upper thigh is supported, without being pressed, as it is on a horizontal sitting surface
- Sloping position for the upper body
- Freedom for the spine, because any pressure on the spinal column is uncomfortable and also unhealthy.

This can be achieved by the introduction of an elastic back rest. Thus the bone structure and shoulder blades are supported elastically...." (Marcel Breuer, "Die Möbelabteilung des Staatlichen Bauhauses zu Weimar" [the Furniture Department of the State Bauhaus in Weimar] in *Fachblatt für Holzarbeiter* [Journal for Skilled Woodworkers], No. 20, 1925, p. 18).

### Exhibition – The experimental "House on the Horn"

Although he deplored the "failure of co-operation between the workshops" and the small number of usable finished products coming from some of them, Gropius decided to fulfill the conditions of the Thuringian local government and to present the latest Bauhaus works in a big joint exhibition from the middle of August to the end of September,

**Josef Hartwig, Bauhaus chess.** 1924, photograph by Lucia Moholy, BHA. • Based on an idea of the De Stijl artist, Vilmos Huszar, Josef Hartwig created a fundamentally functional game set. Whereas Huszar abstracted the shapes of existing chessmen, Hartwig's chessmen indicated the way they were allowed to move across the board by their shapes.

**Walter Gropius, Director's room in the Weimar Bauhaus.** 1924, furniture and ceiling lighting by Walter Gropius, wall carpet by Else Mögelin, floor carpet by Gertrud Arndt, photograph by Lucia Moholy, hand-colored in the printing process, BHA. • Cubic furniture divides the room, positioned so that an asymmetrical orthogonal network of lines floats through the space, its tension literally underlined by the lighting system. An assemblage of pieces from the workshops – in the service of an architectonic total work of art.

**Alma Busche, Spherical toys.** 1924, wood, colored and lacquered, nine pieces, photographer unknown, BHA. • In 1922 the Bauhaus member Eberhard Schrammen set up a wood-turning shop next to the joinery workshop. Here boxes and bowls were made and also – at the instigation of Itten – series of toys.

1923 (Walter Gropius, *Rundbrief an die Werkstätten* [Circular to the Workshops], March 25, 1922). The fully fitted-out experimental house "Am Horn" also displayed interior joinery work. It was proclaimed as "the first completed example of a new way of living in Germany" (Magdalena Droste, *Bauhaus 1919–1933*, Cologne, 1990, p. 105). Benita Otte and Ernst Gebhardt's "cooking-kitchen" centered on functional worktops, space-saving solutions, easy-care surfaces and the newest technical equipment. In his furniture for the living room and ladies' room, Marcel Breuer dispensed with the impression of cosiness in favor of emphatically constructed forms. Using colored frames and different kinds of wood, he stressed the way the furniture was built.

Workshops

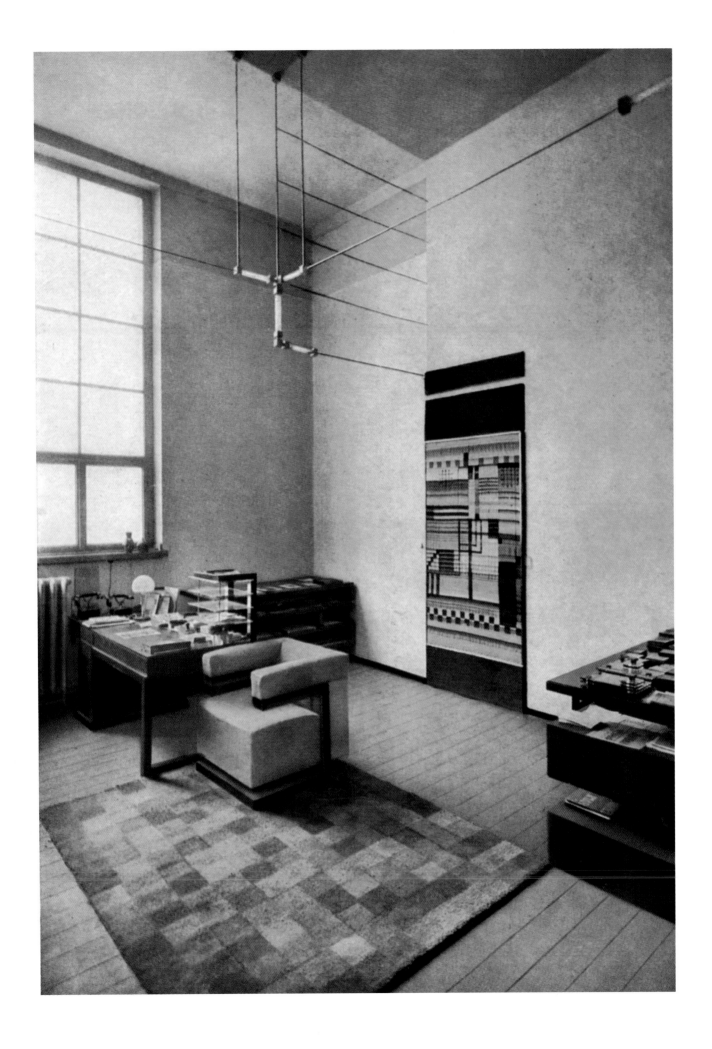

Joinery and Fitting Workshop

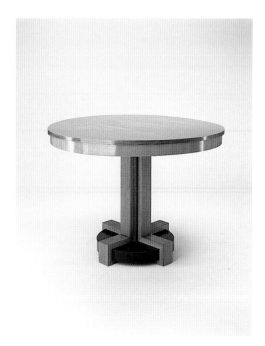

**Erich Dieckmann, Table.** 1923–1924, mahogany, cherry and pear wood, black area polished. Height 73.5 cm, diameter 104.0 cm, BHA. • The cherrywood circle forming the table top is repeated in the small black circle at the base. The lighter uprights, set closely round the cherrywood central pillar, link the color of the recessed underlayer of the tabletop to the floor as they branch out horizontally over the table foot and clasp it. A piece of furniture that uses color to point to its function but at the same time recalls Itten's doctrine of contrasts.

**Moholy-Nagy's dining room in the masters' duplex in Dessau** 1927, photograph by Lucia Moholy, BHA. • Moholy combined Breuer chairs with a table that was made in accordance with Kandinsky's ideas.

Alma Buscher's children's room reflects the discoveries of the new ideas in teaching. The room had no miniature grown-up furniture, but a kind of "container system," which allowed the child's creative imagination free play and also adapted to his or her different stages of development. "If you tip over the ladder chair so that its back is on the floor, it is on wheels, so the chair becomes a car or cart or fireman's ladder to play on.... When the child grows a bit older, the wheels and the footstool can easily be removed and the toy cart can become a chair with a normal sitting height" (Cornelia Will, Alma Buscher-Siedhoff, *Entwürfe für Kinder am Bauhau*s [Designs for Children at the Bauhaus], Velbert, 1997). Contemporary reactions to the exhibition were very varied. In 1923 Paul Westheim, a friend and biographer of Expressionist painters, wrote ironically in the Berlin paper *Das Kunstblatt*: "Three days of Weimar and you can't see a square for the rest of your life." But in the same year the architect Bruno Taut wrote in *Die Bauwelt* praising the innovative strength of the house furnishing and prophesied that its "effects would be felt on wider architectonic work."

### Dessau – Furniture Workshop

After the Bauhaus moved to Dessau in March-April of 1925, Gropius continued the program of the Weimar workshops: "The Bauhaus workshops are essentially laboratories, to develop carefully and constantly improve on models for objects typical of today that can easily be reproduced. In

these laboratories the Bauhaus wants to create a new, previously non-existent way of cooperating with industry and craft, one that masters both technique and design" ("Grundsätze der Bauhausproduktion" [Principles of Bauhaus Production] in *Neue Arbeiten der Bauhaus-Werkstätten* [New Works from the Bauhaus Workshops], Bauhaus Book 7, 1925, p. 7). He gave the overall direction of the joinery workshop to the novice-master Marcel Breuer. Breuer had system-atically worked on the idea of the "slat-chair" to develop it further. At the opening of the new Bauhaus building in 1926 he presented a "steel club armchair," which he had had produced in the apprentice workshops of the airplane company Junkers. With the development of this first representative chair, made of bent seamless Mannesmann tubular steel that could be industrially produced and assembled, Breuer had taken a decisive step forward in the development

**Gropius's living room in the master's house, Dessau.** 1927, Walter and Ise Gropius, photograph by Lucia Moholy, BHA. • The qualities of transparency and variability distinguish the modern home – Breuer's adjustable shelving that "grows with you" fulfills this demand, as do his tubular steel chairs.

**Living room fittings for the housing estate of Dessau-Törten.** 1926, exhibited at the Grassi-Fair in Leipzig, 1929, photograph by Erich Consemüller, private owner, Bremen. • For the confined spaces of the town houses in Dessau-Törten, adjustable, stackable cabinet modules were developed. The light, stretched canvas-covered chairs suited the restricted space.

of design for modern living. The transition from traditional joinery to the furniture workshop was complete. Starting from this first tubular steel model, Breuer developed other furniture: theater seats, tables, stools. Work in the year 1926 included the seating for the assembly hall and the canteen in the new Dessau teaching building, as well as furniture for the students' studios and the staff houses.

The presentation of Breuer's tubular steel furniture at the Werkbund Exhibition in Stuttgart in 1927 led to a break-through for the new furniture. Both material and workmanship suited the social and cultural ideals of an enlightened avant-garde, who were against nostalgic bourgeois comfortable cosiness. Modern people regarded living at home as a purely functional process. Marcel Breuer defended his furniture

**Hannes Meyer, The Room Co-op.** 1926, photograph by Hoffmann, Basel, BHA. • While he was still in Switzerland Hannes Meyer, the future Bauhaus director, conceived his radically modern monk's cell, a private "think tank" for architects and designers.

**Designer unknown, folding chair TI206.** About 1928, illustration for "Chairs" prospectus, October, 1928, BHA. • Hannes Meyer's slogan was "The needs of the people instead of the needs of luxury" – and so it also was in the furniture workshop. This meant furniture that was practical and affordable and suitable for poorer homes.

against the accusation that it was "cold and hospital-like" and "reminiscent of an operating chair" by stressing its functionality: "... a seat constructed of high-grade tubular steel, furnished with stretched material at the necessary places, provides a light, fully self-sprung sitting opportunity, which has the comfort of the upholstered armchair, but with the difference that it is much lighter, handier, more hygienic, and therefore much more practical in use" (Marcel Breuer, "Metallmöbel" [Metal Furniture] in "Zwischen Kunst und Industrie" [Between Art and Industry], exhibition catalog for Die Neue Sammlung [The New Collection], Munich, 1975, p. 236).

In 1932 the architecture critic Julius Posener wrote in the *Vossische Zeitung* against the idea of "a chair as a sitting machine": "Sitting is not produced by the chair but by the human body and, as we have said, there are even some people who have the gift of impressing the way they sit on the most unlikely furniture, even the practical sort!" Breuer praised his own furniture for being collapsible, economical to transport, well thought out commercially and technically, and available "to the widest masses at an affordable price." But despite all his functionalistic protestations to the contrary, wood was cheaper and the chair was too expensive. The liberal art historian Georg Schmidt summed this up in 1932 in the journal of the Swiss Work Federation *Das Werk*: "Today the stress on functionalism is a mark of distinction for the upper classes. The industry must make tubular steel furniture cheaper, so that it can really be for the masses." The furniture workshop also experimented further with wood. The standardized types of furniture by Max Bayer, Peer Dücker and Gustav Hassenpflug were perhaps less spectacular, but they offered usable prototypes for series production.

## Hannes Meyer – Demand economy as leitmotiv

For Gropius the development of prototypes for industry had been the decisive perspective for the workshops. Hannes Meyer, who directed the Bauhaus from 1928 to 1930, prioritized the linking of Bauhaus production to social purposes. In the joinery workshop, reasonably priced furniture now began to be made for popular housing, furniture was

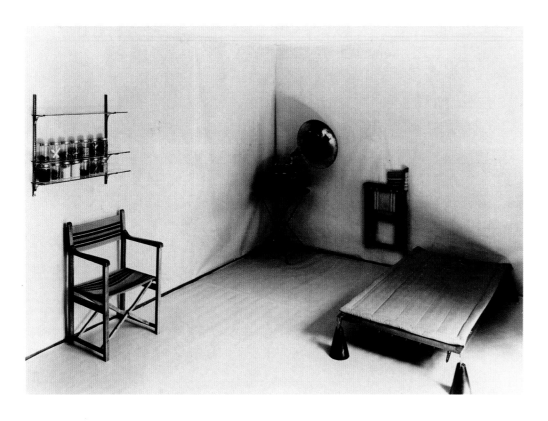

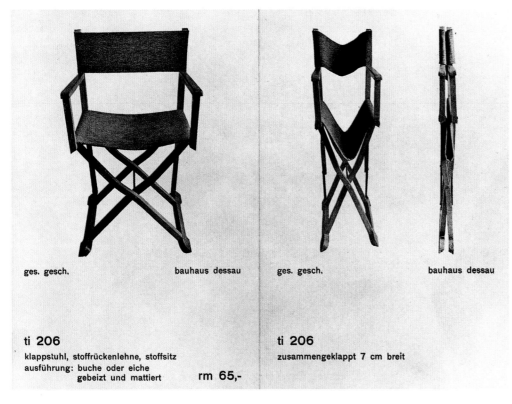

ges. gesch.          bauhaus dessau

**ti 206**
klappstuhl, stoffrückenlehne, stoffsitz
ausführung: buche oder eiche
          gebeizt und mattiert          **rm 65,–**

ges. gesch.          bauhaus dessau

**ti 206**
zusammengeklappt 7 cm breit

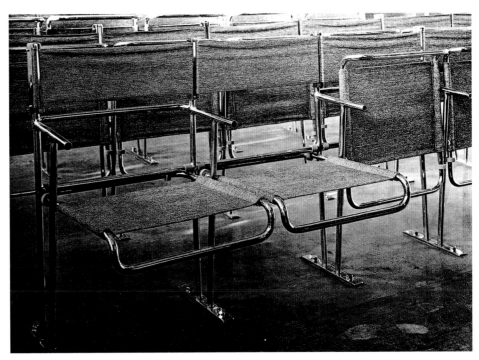

**Hin Bredendieck and Hermann Gautel, Stool ME1002.** 1930, chromium-plated tubular steel, varnished plywood, 60.5 x 39.0 x 48.5 cm, BHA. • Three curved steel tubes rework the principle of the three-legged stool in a new way. Screwed together to form a runner at the back, they create a prismatic space, upon which the saddle-like seat appears to hover. In front the tubes run together for support. Just above the floor they spread out to form the working front feet of the chair.

**Marcel Breuer, Seating for the assembly hall in the Dessau Bauhaus building.** 1927, photograph by Erich Consemüller, private owner, Bremen. • This fold-away sitting machine was noiseless thanks to its rubber buffers. The covering, developed in the weaving workshop using gray fabric to make it hard-wearing and elastic, was meant to stretch tight and could be tightened. This model shows a clear contrast between the rounded seat frames and the jutting out tubular steel armrests.

**Classroom of the technical teaching block.** December, 1926, photograph taken with old color diapositive, photograph by AGFA (?), 1926–1927, BHA. • Research has disproved the former idea that the Bauhaus building and masters' houses were restrained in their color design. This rare, contemporary colored document shows a clear play of color between the space and the furniture, emphasized by structural elements in the reinforced concrete roof beams and the great conference table.

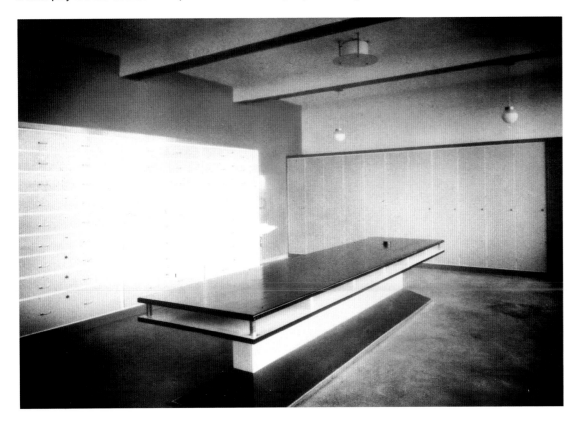

Joinery and Fitting Workshop

**Front cover for "die neue linie" (the new line).** May, 1931, design by László Moholy-Nagy, SMBPK, art library. • For women readers of the "new line," tubular steel furniture was already identified with "modern living."

designed for old people and children, no longer was there "individually crafted furniture for some enthusiastically 'modern' snob." Meyer accorded priority to scientific advance in the design process. The products should correspond as precisely as possible to actual requirements. Students began with "the study of popular customs, social standardization, physiological and psychological functions, the production process and the most careful economic calculation."

In 1929 the architect and former Bauhaus student Alfred Arndt took over the direction of the workshops. (In 1928 Josef Albers had taken over the direction of the furniture workshop from Marcel Breuer, but could not adapt to Meyer's program.) In the summer of 1929 Meyer merged the joinery with the metal workshop and the painting and decorating workshop into one house-fitting workshop. In order to link these fields even more closely to the new Bauhaus aim of "building and fitting out popular housing," the workshops were organized as independent working communities, which made the students "deal with all materials that the completion of a project in their field required, from the ordering of the materials required to the revision of the final account" (Hannes Meyer, *Bauen und Gesellschaft*

[Building and Society], Dresden, 1980, p. 81 ff.). In the workshops students could earn a wage as co-workers rather than paying for their studies. Workshops and co-workers had a share in the sales and license fees. This meant that the less well off could also study at the Bauhaus. The joinery workshop aimed to make furniture cheaper through skilfull construction and the use of economical materials. "Light furniture" and "fold-away furniture" was created from plywood and blockboard, often in combination with metal. Narrow and small homes were catered for with folding and tip-up furniture, which could easily be put away. The School of the General German Trade Union Federation (ADGB) was fitted out with a set of furniture types that had been made as models by the Bauhaus joinery workshop and produced by a Bremen joinery co-operative. The fitting workshop designed the interior fittings for 90 workers' dwellings in the Dessau-Törten housing estate. The furniture units were made to standard measurements, so that each individual unit could be combined with others as required. In Meyer's era the Bauhaus became clearly independent of constructivist design ideas. The joinery workshop met a social demand and created social standard models with a series of innovative furniture.

## Mies van der Rohe – constructive design

The goals of the joinery workshop were changed again after 1930 by the last Bauhaus director, Mies van der Rohe. His attention turned to architecture. Social questions retreated into the background. Mies made the joinery, metal and decorating workshops part of the department of architecture. He himself was the overall director of the department of "Building and Fitting." Under the leadership of Alfred Arndt, the house-fitting department continued at first to work with unit furniture. In 1931 they participated successfully in a program of prototype furniture in a competition set up by the Werkbund for standardized house fittings. At the end of 1931, Arndt had to give up the leadership of the workshop because he was regarded as too left-wing. Following this, Mies van der Rohe brought his long-time Berlin collaborator, Lily Reich, to the Bauhaus. She now became the leader of the weaving workshop and the house-fitting seminar. The production business was curtailed. In the planning of the Junkers housing development, the building and fitting department provided avant-garde designs for houses. Nevertheless this was a long way from the idea of unity between art and craft. Now priority was given to questions of construction and draftmanship.

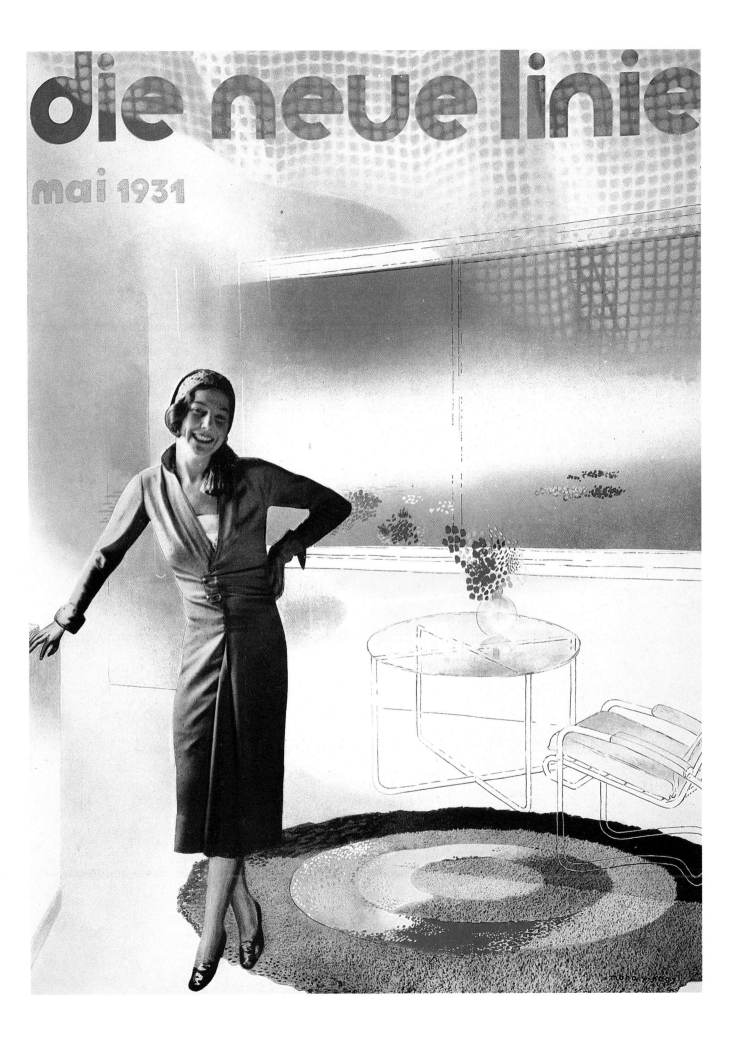

die neue linie

mai 1931

moholy-nagy

# Bauhaus Licenses and Business

Eva von Seckendorff

Two years after the foundation of the Bauhaus, in December of 1921, Gropius demanded that the workshops should show more commercial sense: "The Bauhaus in its present form stands or falls by whether it accepts or rejects the need for commissions. I would regard it as an error if the Bauhaus failed to come to terms with the real world...." This programmatic declaration had a prosaic background. The financial predicament of the school and students made the continued existence of the Bauhaus dependent on additional sources of money. Whereas, for example, the printing press and pottery had been economically productive from the beginning, it was only possible to establish such a way of working in the joinery workshop with the departure of Johannes Itten. After the great publicity success of the first big Bauhaus exhibition and the joinery products in the experimental house "Am Horn," in 1923 the workshops began producing standard goods aimed at exhibitions and trade fairs. In the Stuttgart Werkbund exhibition "Design without Ornament" (1924), the Bauhaus workshops were represented, and their presence at the Leipzig trade fair resulted in numerous commissions. The publication *Neue Arbeiten der Bauhauswerkstätten* (New Creations from the Bauhaus Workshops), which appeared in 1925, introduced 28 products from the joinery workshop. From summer of 1924 until March, 1925 at the Weimar Bauhaus, 26 specimens of the "slat-chair," 262 children's chairs and 32 of Breuer's tables were made. Those giving the commissions were open-minded private individuals and institutions such as nurseries, who ordered Alma Buscher's and Marcel Breuer's children's furniture. But the actual financial results remained far below expectations. However, in October of 1924 Gropius warned

the Thuringian Finance Office against overhasty condemnation in his *Bericht über die wirtschaftlichen Aussichten des Bauhauses* (Report on the Economic Prospects of the Bauhaus): "It is not just a question of one or a few articles, but the vision of whole branches of production have to be changed. The fact that this required a large number of experimental works and a long period of trials has been enlightening. The experimental works became more expensive because many individual parts were made up outside the Bauhaus, as it lacked important machines and tools which are even more important in an experimental workshop than in others. Additionally, raw materials could only be bought in small, uneconomic quantities.... The products were bound to increase sharply in price through this nonrational buying in small quantities, losing the opportunity to profit from favorable economic deals. These price rises had the effect of further decreasing the market for the goods."

In order to prevent the threatened closure of the Bauhaus at the end of 1924, Gropius suggested setting up a limited company to match its public funding. Capital was available. The largest shareholders were the General German Trades Union Federation and the Berlin businessman Adolf Sommerfeld. To Gropius the economic prospects seemed secure. "We have a marketing strategy in place, that is, we now have a series of representatives and we have forged links with industry as well as with business, which will guarantee a secure and constant market and will not leave the Bauhaus with only occasional outlets" (Walter Gropius, Dr. Necker, *Bericht über die wirtschaftlichen Aussichten des Bauhauses* [Report on the Economic Prospects of the

**Tischlerei**

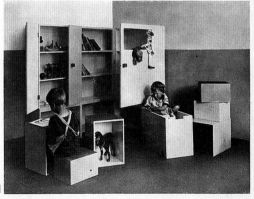

TI 24

KINDERSPIELSCHRANK

im Gebrauch

gesch.
Länge 155 cm und 90 cm
Höhe 150 cm
AUSFÜHRUNG
farbig lackiert
mit bunten herausnehmbaren Kästen
für Spielzeug und Bücher
zum Spielen, Sitzen und Fahren
mit Türausschnitt für Puppentheater

**Alma Buscher, Children's toy cabinet TI24.** 1923, page from commercial catalog, 1925, designed by Herbert Bayer, BHA. • A Bauhaus commercial company was set up and a commercial catalog produced – not entirely successfully as far as furniture and metal objects were concerned – in order to sell Bauhaus products professionally.

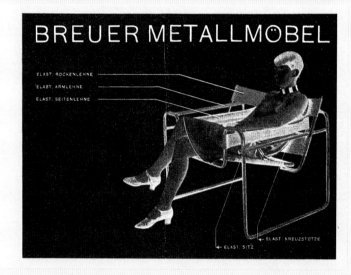

Bauhaus], October, 1924). Now the state only had to pay for the teaching program and the teachers' salaries. However, although he had planned it in Weimar, Gropius only managed to set up the limited company (Bauhaus GmbH) in Dessau in November of 1925 with a startup capital of 20,000 marks. The purpose of the company was to establish sole rights to the models developed in the Bauhaus, which were to be mass-produced by industry.

Gropius was able to secure retrospective ownership rights to about 80 works created in the Weimar joinery workshop by Marcel Breuer, Erich Dieckmann, Erich Brendel, Alma Buscher and others. However, in one crucially decisive case the Bauhaus lost the license rights. Because Breuer had made his first tubular steel chair privately, he claimed sole ownership of the licenses for the chair and the tubular steel furniture developed from it. Without consulting the Bauhaus, in 1926 he had set up the firm Standard-Möbel together with Kalman Lengyel. This firm then developed the first mass-produced modern tubular steel furniture. Nevertheless, Marcel Breuer, Kalman Lengyel, and Anton Lorenz who joined later, could not consolidate the firm economically. On June 18, 1929 the company management sold the Standard-Möbel licenses to the furniture maker Thonet, who were thus able to take a leading position in the future market for tubular steel furniture. "The history of the Bauhaus could have been quite different," wrote Magdalena Droste in her book about the Bauhaus published in 1990, "if Breuer had sold his licenses to the Bauhaus."

In the 1960s domestic tubular steel furniture had a renaissance. In 1962 the Italian furniture producer Dino Gavina put Breuer's furniture back on the market under new names: The "steel club armchair," as Breuer had called his first tubular steel chair, was now marketed as the "Wassily chair," stools and occasional tables were marketed as "Laccio" and Breuer's free-swinging chair as "Cesca." The commercial rights had belonged to the firm of Thonet since 1932, and they also held Mart Stam's copyright in the first tubular steel chair with no back legs. In 1968 Gavina sold his firm to Knoll International, who still make Breuer's furniture on license to this day. Many mass-produced cheap copies, and also many forgeries, prove the continued popularity of furniture that owes much to the spirit of the Bauhaus.

# Wood Carving and Stone Sculpture – the Plastic Arts Workshop

Frauke Mankartz

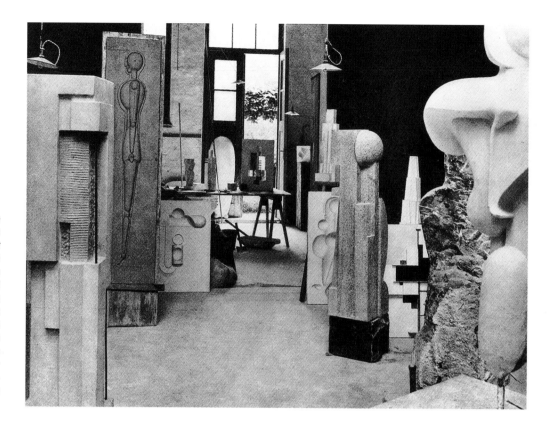

**View of the Weimar Bauhaus stone sculpture room.** 1923, reproduced from *Staatliches Bauhaus Weimar 1919–1923*, Weimar, 1923, photographer unknown, BHA. • For this photograph, which appeared in the catalog for the great Bauhaus exhibition of 1923, the sculptures and reliefs of the design master, Oskar Schlemmer, and his journeyman assistant Joost Schmidt have been prominently arranged as representative works. To left and right of the open door at the back stand parts of the wall relief with which the walls of the Bauhaus were later decorated. On the far left stands a work by the student Kurt Schwerdtfeger with the programmatic title *Bauplastik* (Architectural Sculpture).

Following the Bauhaus program's aim that basic craft training was to be regarded as the "indispensable foundation for all artistic creation," two sculpture workshops were set up, to teach stone masonry, sculpture and plasterwork. These traditional crafts, directed toward the "ultimate aim of building," were intended to equip students to develop forms of decoration that were linked to architecture. First, however, the main concern was to ensure that the wood carving and sculpture workshop was capable of performing the function intended for it. Joost Schmidt describes how at the beginning "everything was jumbled up in a murky chaos, in which it was not yet possible to see what kind of 'Bauhaus reality' would come out of it" ("My experience of the Bauhaus," typescript, 1947, p. 4). A regular teaching program was made more difficult because the workshop leaders responsible for craft training kept changing, and there were not yet any set teaching plans. At the beginning, the artistic tutors could still be freely chosen by the students. Only in the case of the wood carving workshop was Richard Engelmann officially appointed as the form master. The sculptor belonged to the teaching staff taken over from the School of Fine Art, who were to leave the Bauhaus in 1920. Because of his academic bent, he did not seem to be the man to guarantee a new way of teaching following the tenets of the Bauhaus. At the beginning practical sessions to expand the teaching were rare. Because of the lack of "testing" and work places, as envisioned in the program, Walter Gropius and Adolf Meyer's private building studio gave individual students commissions, such as for the Sommerfeld house, from 1920 to 1922. Joost Schmidt was taken out of the wood carving workshop to fit out the interior of the log house. Because he already had a wide artistic training, he was seen as capable of fulfilling this task. Schmidt

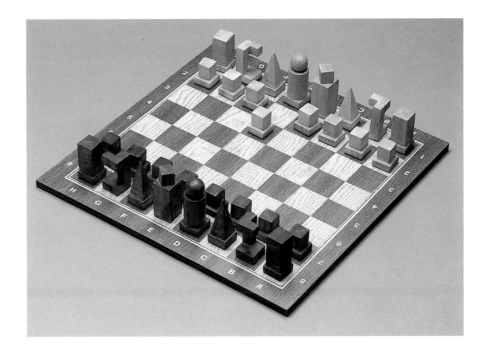

**Josef Hartwig, Handmade preliminary stage for the Bauhaus chess set.** 1922, stained lime wood, height of tallest figure 7.0 cm, SBD, archive collection. • The work master of the sculpture workshop developed a chess set from elementary forms and even produced it as a series, for which Joost Schmidt designed the publicity material.

directed the carving of the doors, wall reliefs and stair-case cladding, which developed in close coordination with the building director, in order to achieve a harmonious interplay of archi-tecture and ornamentation. Individual performances of this kind continued even when the teaching program became more systematic as staff stayed for longer.

In 1921 Josef Hartwig was appointed as leader of the wood carving and sculpture workshop. He openly opposed the arts-and-crafts training approach because, as well as being trained in sculpture, Hartwig had also pursued academic studies. In order to link the artistic form master more closely to particular workshops, in the summer of 1921 Oskar Schlemmer was

appointed to the sculpture workshop and in the following year to the wood carving workshop. His work with reliefs, which were particularly suited for use in an architectonic context, probably contributed to his appointment. He was involved in experiments for the 1923 Bauhaus exhibition, when the school's own building was fitted out with painting and

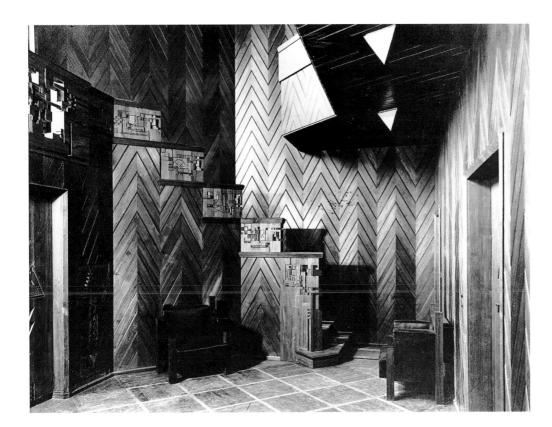

**Joost Schmidt, design for the staircase in the Sommerfeld house.** 1921 (destroyed), photographer unknown, BHA. • The commission of the Berlin businessman Adolf Sommerfeld gave Bauhaus students their first opportunity to do work for a set purpose. All the workshops cooperated in the project. The wood carving workshop did the carving on both the inside and outside of the house, following designs by Joost Schmidt. The figured motifs also reflected Sommerfeld's wishes. Because of the hardness of the teak wood, notching was a technique frequently used. This contributed quite substantially to the expressionistic charm of the interior.

Wood Carving and Stone Sculpture

**417**

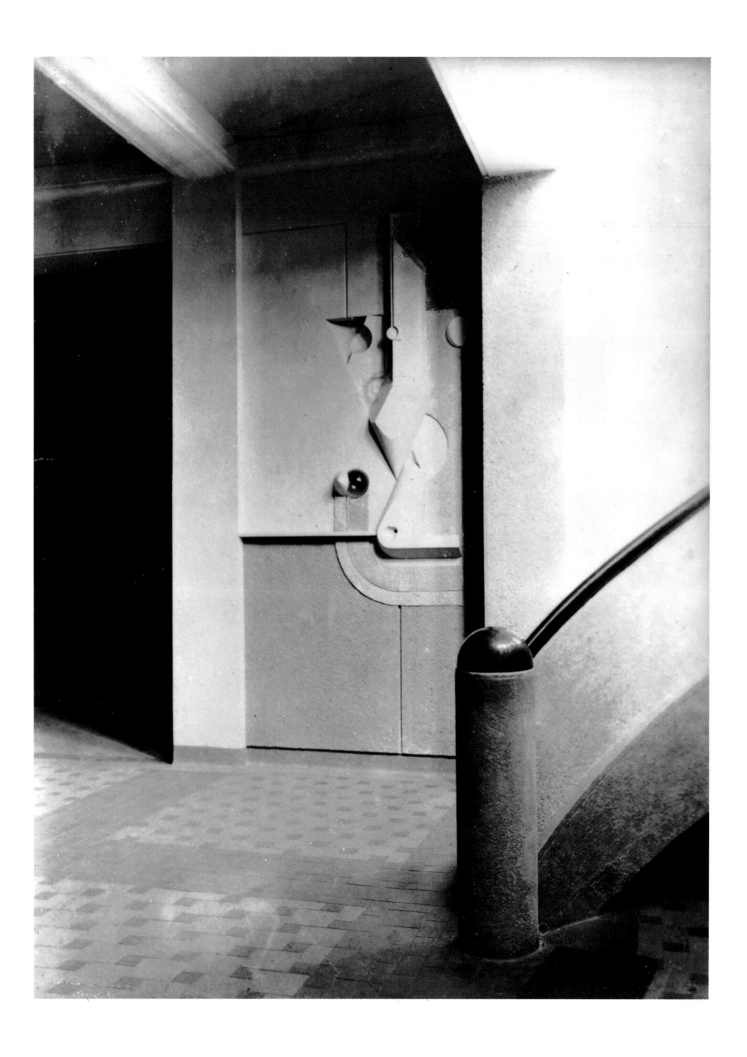

**Johannes Itten, Cubic sculpture.** 1919 (lost), plaster, photographer unknown, Itten Archive, Zürich. • Plaster also played an important part in the workshop, both in free works and in the reproduction of works by Itten and Schlemmer. In addition, the workshop later also produced molds for serial production in the ceramic workshop.

sculpture. The vestibule of Henry van de Velde's building was decorated with three abstract stucco and glass reliefs, made by Joost Schmidt together with Hartwig and a group of students. Oskar Schlemmer created the design for the entry area to the workshop building, which included sculpture and wall painting. The contribution of the students – with the exception of Joost Schmidt – was confined to the practical execution of the Schlemmer drawings. The teacher saw his task primarily as the creation of artistic models, which corresponded to a traditional idea of art education. However, this was not consistent with the Bauhaus program, which ideally required students to work both on design and execution. It was also unsatisfactory that the compositions already in existence did not need to be adapted. This made the desired coordination of sculpture, painting and architecture more difficult. But Schlemmer was delighted at every opportunity offered for this kind of work. "That is why wall painting and particularly sculpture are the problematic workshops at the Bauhaus. Until they have greater effect, the temple of the future, the dome of democracy, the cathedral of socialism will keep us waiting a while longer. Today for the moment we have the

simple house and we must take that as representative, where we find it" (diary entry for November of 1922, *Briefe und Tagebücher* [Letters and Diaries], Munich, 1958, p. 139). In his hope for "greater effect" in a still to be planned representative building, Schlemmer did not realize that the foregoing of building decoration in the interior or on the façades of "simple houses" was not merely an economic "shortage phenomenon." It was increasingly for aesthetic reasons. This was why the sculpture workshops were not involved in designs such as that for the experimental house "Am Horn" or in later plans. The workshops only participated in minor supplementary works, for example the creation of plaster casts for the ceramic workshop or constructing architectural models.

With the transfer of the Bauhaus to Dessau, a new phase began for sculpture. A sculpture workshop was built at Dessau, and, as had already happened in Weimar, it was jointly led by Schlemmer and Hartwig as form and work masters of the two departments. The new name, "Plastic Arts Workshop," indicated that the restriction to the traditional materials of stone and wood during the expressionistic early phase of the Bauhaus, was to cease. Now new materials were regarded as suitable for

**Oskar Schlemmer, Wall design in the workshop buildings of the Weimar State Bauhaus.** 1923, photographer unknown, Oskar Schlemmer Archive and Family Estate. • Schlemmer wrote this in his diary about the difficulty of securing commissions: "The illusory world of the theater can serve here as a valve for these phantasms. We must be content with surrogates, and make from wood and cardboard what we cannot build in stone and steel" (June 14, 1921).

**Joost Schmidt, Relief in the vestibule of the Weimar State Bauhaus.** 1923, photographer unknown, BHA. • Schmidt's abstract positive-negative composition made of plaster and glass is based on ideas of his teacher Schlemmer, which are known from Schlemmer's diary: "white plaster sheets as background, these hollowed out, raised and pierced – inside, glass, glass tubes, mirror glass, colored glass...."

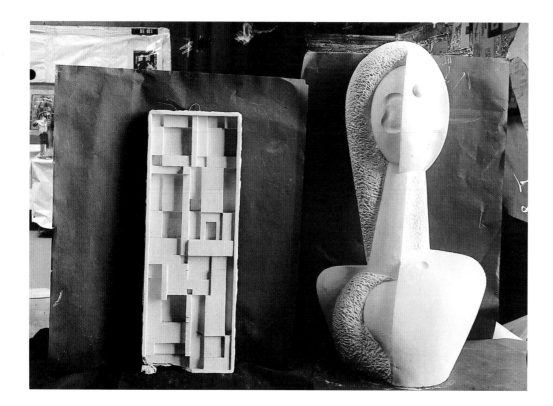

**Artist unknown, Light-dark proportions.** 1922–1923, sculptural works, photograph by Louis Held, SBD, archive collection. • The students took their orientation from the masters but also from international currents of the time. The relief shows strong De Stijl influences. The modern bust recalls the formal language of Brancusi or Archipenko.

design. As in other workshops, the technical and artistic direction was put jointly in the hands of a novice master trained at the Bauhaus. "Although Joost Schmidt was already appointed as leader of the plastic workshop in 1925," the former student Heinz Loew recalled, "at that time there was neither a budget nor a suitable room for it – to be precise, just an empty space" (*Lehre und Arbeit am Bauhaus* [Teaching and Work at the Bauhaus], Düsseldorf, 1984, p. 8). Even in the newly built Bauhaus building, in whose design the plastic workshop had done no more than fit out the masters' houses, the room assigned to sculpture at first remained empty. Equipping it – an activity in which students like Franz Ehrlich and Heinz Loew were involved – was only begun in 1927, when it was designated as the area for "free visual and plastic design." The teaching focused on general studies to expound the spatial and design elements of the plastic arts. Besides this, the workshop members were involved in the building of three-dimensional stage sets and architectural models. In the following year, under the leadership of Hannes Meyer, a close connection was formed with the publicity

department, whose directorship Joost Schmidt also undertook in 1928. Describing the plastic workshop as an "experimental class for commercial and free plastic arts," the teacher defined the poles between which this Bauhaus department moved. Schmidt saw it as an "experimental workshop in which I and my students can test flexible plastic materials." These were photographically documented and their "practical results were put to use in exhibition buildings" ("My experience of the Bauhaus," typescript, 1947, p. 11). For example, Heinz Loew's design for a rotating light advertisement was presented at the "Berlin in Light" show. The stand of Junkers and Co., Dessau, was set up at the "Gas and Water" exhibition in Berlin in 1929 in conjunction with the Bauhaus printing, joinery and metal workshops.

Although the link with the publicity department resulted in more practical work, this did not lead to the hoped-for self-financing. So the sculpture department, as Helene Schmidt-Nonné put it in retrospect, with some exaggeration, became a "workshop that did not deserve the name, but at best could be called a 'small produce stall' – all the while this

**Karl Peter Röhl, Totem-like sculpture.** About 1920, wood, colored, height 89.0 cm, KW. • By notching and digging out Röhl transformed a turned pole into a circular relief. Brilliant red is repeatedly used in the depressions, which counteracts the sculptural design and recalls Itten's themes.

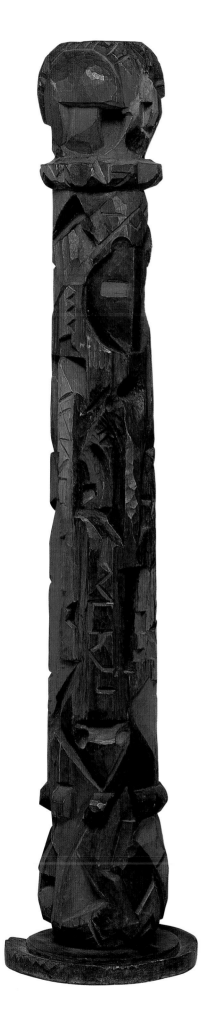

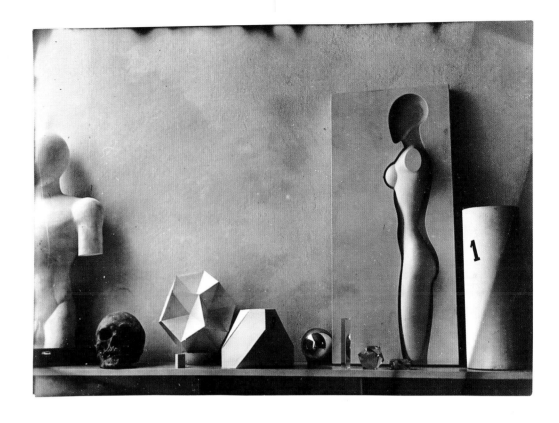

'institute' at the bauhaus had no budget and its eager disciples went through the house swiping the necessary tools and materials, which put paid to their popularity" (letter to Walter Gropius of May 18, 1963). It seems likely that the plastic workshop's ineffectiveness can be explained by the personality of its director. Heinz Loew confirmed that "Joost Schmidt's restraint and modesty often made it necessary for the students to take the fight with the administration and directorate of the Bauhaus into their own hands, in order to maintain their place among the other workshops" (*Lehre und Arbeit am Bauhaus* [Teaching and Work at the Bauhaus], Düsseldorf, 1984, p. 8). However, this lack of assertiveness in Joost Schmidt, the "unknown Bauhaus member" (Rainer K. Wick), does not fully explain why the plastic workshop became the Bauhaus's "stepdaughter." There was also an increasing unwillingness to include the workshop in the Bauhaus program. In the manifesto of 1919, sculpture had been listed as one of the three arts, which together with architecture and painting should contribute to the "single aim of building." This appeared to give it an important place within the Bauhaus, which was reflected in the setting up of two workshops. In reality, even in Weimar there was perplexity about the

contemporary possibilities for using "art for building." That was why, in Dessau, sculpture ceased to belong to the architecture department as part of house-fitting. Even after it had combined with publicity, the plastic workshop was very far from being able to develop its own perspectives. Consequently, in the fall of 1930, Mies van der Rohe classified it as belonging exclusively to the field of "fine arts," as a result of which the department was finally isolated from the business of the other workshops. When Joost Schmidt was not appointed as a teacher at the Berlin Bauhaus, the plastic workshop was doomed.

# The Bauhaus and the Ideas of the Cathedral Guilds

Frauke Mankartz

When the Bauhaus was founded, Walter Gropius demanded that the architect should "once again gather spiritually like-minded workers round him in close personal intimacy – as the masters who built the Gothic cathedrals had done in the Middle Ages. Thus in new living and working communities all artists together could prepare the Freedom Cathedral of the future ...." (*Deutscher Revolutionsalmanach* [German Revolution Almanac], Berlin, 1919, p. 136). The fellowship that stone masons enjoyed in the masons' lodge (named for the site hut or provisional workshop and assembly place on the building site) had already been used as a model, in the 19th century. Proposals were made for founding an association of architects that would "imitate the old masons' lodges, but with changes appropriate to the times," in order to build similar works of art. The Middle Ages were romantically seen as an epoch "in which the lowliest worker was trained in glorious schools" and all the members of the workshop "were imbued with one and the same spirit" (Karl Heideloff, *Die Bauhütte des Mittelalters in Deutschland* [The Church Masons' Guilds in Germany], Nuremberg, 1844, p.IX/26). This ideal picture also informed the ideas of Walter Gropius and his circle. With the Bauhaus, which in its very name already suggested a relationship with the masons' guilds, he attempted a modern version of this form of organization. The Bauhaus logo was copied from the medieval masons' signs and

**Karl Peter Röhl, Logo of the Weimar State Bauhaus.** 1919, BHA. • The logos were produced by internal Bauhaus competitions. In 1919 the theme was "building," expressed here by means of Egyptian-medieval-romantic symbolism.

**Oskar Schlemmer, Logo of the Weimar State Bauhaus.** 1922, Oskar Schlemmer Archive and Family Estate. • Master Schlemmer gave the school a symbol of the spiritual "New Man" who was to be educated. This logo was used from 1922 until the Bauhaus closed in 1933.

became a symbol of the "working community of leading and future working artists." According to the Bauhaus school program for 1919 this "new guild of handworkers" was to build "buildings as a single whole – structure, fitting out, decoration and equipment – all in the same spirit." The idea of the masons' guild, which had originally been restricted to the fellowship of stone masons, was thus expanded to the organization of all the areas of building. The apprentice workshops were set up in the usual professional groups, according to materials, in order to provide a project-based training. The technical workshop leaders were given the title "work master" in conscious allusion to the similarly named directors of medieval masons' guilds. These architects, responsible for both the planning and detailed execution of the building, were following in the educational tradition of the guilds and stood for the union between designer and builder, handworker and artist in a single person.

However, the guilds were not only professional organizations that controlled how education and work were run; they also determined the entire social life of their members, from charitable regulations to drinking customs. The ideal of this communal life also determined the principles of the Bauhaus. At public functions the masons' ceremonies were imitated and guild robes were prescribed for particular occasions like topping-out

ceremonies. The Bauhaus costume or food regulations of the Mazdaznan disciples corresponded to this concept. Such "customs" were intended to strengthen both feelings of belonging and exclusivity. The plans for the school to have its own "territory," a communal dwelling place for Bauhaus members and friends, also took into account the need for social security after the war. At the same time this strong framework of rules fostered the illusion that the school was independent of political and social forces, as the self-governing masons' lodges of the Middle Ages really had been, even having their own legal jurisdiction.

Through the communal creation of the "cathedrals of the future" a self-contained group like the Bauhaus was to bring about a return to communal living. The building of the Gothic churches, in which all the individual arts were united to produce a single work, stood as a symbol for the social unity of this future society. With his faith in the educational function of architecture, Gropius embraced this romantic idea, which Karl Friedrich Schinkel had already conjured up in 1814–1815 in his project for a "Freedom Cathedral." These utopian fantasies were not shared by all the Bauhaus members. "I do not believe," Oskar Schlemmer sceptically said, "that craftwork, as we practice it at the Bauhaus, can go beyond the aesthetic to fulfill a deeper social role" (diary entry for November, 1922, *Briefe und Tagebücher* [Letters and Diaries], Munich, 1958, p. 142). The model of the masons' lodge, bound up with the ideal of craftwork, and the image of the cathedral which decorated the Bauhaus manifesto of 1919 were no longer in tune with the time. Modern developments had made them out of date. This led to an alienation of the artistic disciplines from industrially standardized objects in use in daily life. In particular, the sculptors complained that sculptures were no longer "indispensable components of great building art." With the motto "Art and technology – a new unity" the phase inspired by the medieval ideal drew toward its end. The Bauhaus exhibition of 1923 contained a mixture of "products from the age of expressionistic lodge romanticism as well as from the age of constructivist technical romanticism" (Joost Schmidt, "My Experience of the Bauhaus," typescript, 1947, p. 7).

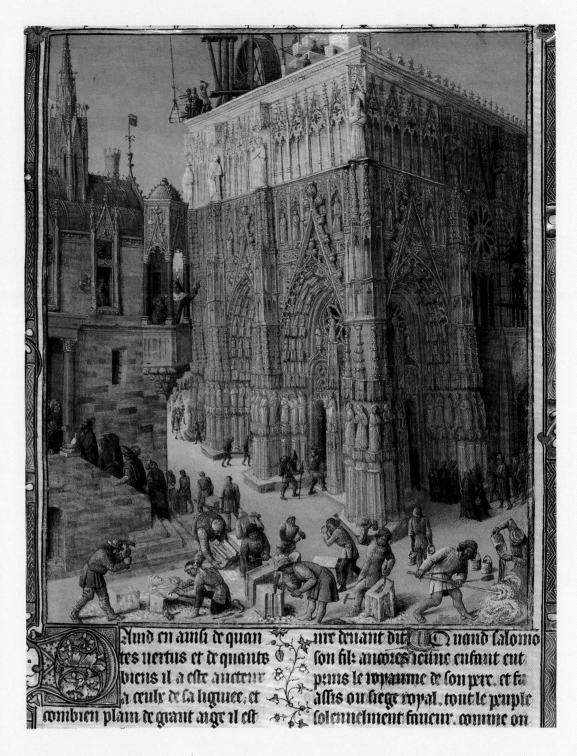

**Jean Fouquet, Antiquités et Guerres des Juifs (Antique Buildings and the Jewish Wars).** End of 15th century, ms. fr. 247, fol. 163, Bibliothèque Nationale de France, Paris. • In the beginning the workshops were intended to function like the old masons' lodges. But in 1922 Schlemmer remarked perspicaciously: "The thought of the cathedral has retreated into the background for the moment.... Today the best we can think of is a house...." And in the sculpture workshop he diagnosed: "The trouble is that we lack great tasks."

# "Plastic Art ... what, at the Bauhaus!?!?" On Sculpture at the Bauhaus

Frauke Mankartz

**Edmund Collein and Heinz Loew, Light sculpture studies.** 1928, photograph by Edmund Collein or Heinz Loew(?), BHA. • These studies were made with a rod or ring, mounted diagonally on a plate and mechanically set in motion. When the speed of rotation was increased, the eye no longer saw the movement of the original shapes, but just their shining orbit, which for a few moments formed a paraboloid or sphere. An elementary work, but at the same time a kinetic and "dematerialized" sculpture.

Much has been said and written about free painting in the Bauhaus, but much less about sculpture. This was the reason for Joost Schmidt's rhetorical question: "Plastic art ... what, at the Bauhaus!?!?" at the beginning of an article on the work of the plastic workshop, which he answered immediately but ambiguously: "at last, again ... well, yes ... still" (*bauhaus*, Vol. 2–3, 1928, p. 21). By defining this position, Schmidt particularly stressed the independence of sculpture from the other arts: "We do not intend to regroup architecture, sculpture and painting into a new unity. What has once been put asunder into three should not be made one again!" Thus in the concept of "art for building" he clearly denied a role for sculpture in serving the work as a whole. However, Schmidt did not thereby want to lay himself open to the suspicion of creating works for no purpose. "Everyone thinks of the word 'sculpture' in connection with the word 'art.' But because we each have our own concept of 'art,' we abolish the word together with the various ideas of 'art.' We can do without it."

As they saw it, the workshop members did not produce "art" but fundamentally important "elementary studies," which were created in "series of experiments." This seemed to correspond to Hannes Meyer's demand for a scientific design process. However, the artistic character of many of the works was undeniable. In particular, photographic experiments acquired artistic independence. Through the rotation of linear elements they created the optical impression of three-dimensional bodies. These "illusionistic plastic works" existed only in photography. The concern to represent the works not as ends in themselves, but as important for the design process, was a reaction to the constant pressure to justify itself felt by free-art sculpture at the Bauhaus.

As director of the wood carving and stone sculpture workshop, Schlemmer had already stressed that artistic exercises that were not related to possible applications were to be avoided "because our

conscience forbids us." For the goal of the Bauhaus was not the creation of free artists. The fact that free-artistic, often three-dimensional sculptures were nevertheless created was "because the students were naturally driven to them in the absence of work" (letter to the council of masters, November 22, 1922). In addition, "free work" in the materials available at the time was given first place in the teaching plan for the workshops set out for 1921. The distinction between practice exercises and free artistic production was generally difficult to maintain, because the studies also had an aesthetic form, which was not "accidental," as Fritz Kuhr commented on his designs for the preliminary course of 1924: "Then came the big, important experience. With my second wood sculpture I had achieved a balance, with the main stress, however, laid on its aesthetic appeal.... Meaningless play with the material was no longer meaningless" (*bauhaus*, Vol. 2–3, 1928, p. 28).

The students were stimulated by teachers who did sculptural work – people such as Itten, Schlemmer, Moholy-Nagy and Schmidt – to produce their own artistic works. The works were produced, not just as a balance to practical workshop routines, but from the "need for spiritual relaxation and equilibrium," as Ernst Kallai put it, playing down their importance ("Das Bauhaus Dessau," exhibition catalog, Trade Museum, Basel, 1929). There was an earnestness, particularly in the students who were already practicing as sculptors before they came to the Bauhaus, or who saw themselves as budding artists. The desire for an artistic education was acknowledged in 1927 with the establishment of the subject of "free painting and plastic design," which taught sculpture within the framework of the plastic workshop.

The artists who worked at the Bauhaus at no time issued rules of style, even when Moholy-Nagy attempted in his study *von material zu architektur* (from material to architecture), published in 1929, to

**László Moholy-Nagy, Untitled.** 1925–1928, photogram, silver bromide matt, 23.9 x 17.8 cm, Folkwang Museum, Essen. • With his photograms Moholy-Nagy encouraged "dematerialized" design, among other things. Instead of pigments he let light leave marks on light-sensitive paper and thus create spaces. His Bauhaus book *von material zur architektur* [from material to architecture] contains an example of "virtual" volume, which is similar to the rotating sculpture from the plastic workshop.

**Work in the plastic workshop.** 1930, photographer unknown, BHA. • Solid handwork was the order of the day in the plastic workshop.

formulate their new ways of designing. He categorized numerous works by students and teachers in his history of the development of the plastic arts. Moholy-Nagy regarded the floating-kinetic plastic works as the highest stage. However, the works produced in this group still showed a strong dependence on constructivist sculpture. The artists took their direction from the general artistic currents outside the Bauhaus. In the beginning works were produced under the influence of "primitive" art from Africa or the Cyclades. Some sculptors held fast to the traditional style of figurative or portrait sculpture, often following Rodin or Lehmbruck. Graduates of the sculpture course did not publicly form a self-contained group, either in Weimar or in Dessau, unlike the "Young Bauhaus Painters" who organized a traveling exhibition in 1928. Because of this, less notice was taken of the sculptors both by the public and the critics. In this context the question "Plastic art ... what, at the Bauhaus!?!?" still makes sense today.

# The Metal Workshop

Olaf Arndt

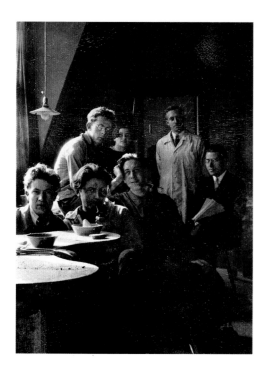

## Laboratory

In the beginning everything was alchemy. Anyone who knew how to deal with metal possessed secret knowledge. To transform solid matter into a different condition (with immense heat), give it a new form (by the power in its indwelling spirit), was the same as creation. If today we go into a museum in which the typesetting shop of the earliest printers has been reconstructed, or if we stand in front of the legendary Zuse, the mother computer with its silver teeth, that makes us think of an urban project, the model town of a metal designer gone mad – there we feel the breath of advance thinking. We hear the smith at work on the future, feel the beauty of the new, see Prometheus and the fire. Here designs become reality. The laboratory, involuntarily associated with working in iron, lead and precious metals, needs to be described, because today at the end of the era of heavy machinery, in the hour of death of the factory, every memory is slowly fading of the long-gone ancestors of production, the manufactories, the work places of handworkers. You could taste the work places of these disappearing professions. The smell of a district told you whether it belonged to founders or tanners. The thickness of the air, oil, dust, shavings and remnants of the milky coolant on the surfaces of the objects being produced, the shuddering of the floor when the machines were running, molding, boring, pressing and turning machines, carpenter's bench and saws, many kinds of saws, circling, scraping, howling as they bit into the material, and – not to be forgotten – the grinding machines, rotating on thick plates made of Greek sand baked

**László Moholy-Nagy and students of the Weimar metal workshop.** 1924–1925, front from left, Josef Knau, Wilhelm Wagenfeld, Otto Rittweger; back from left, Max Krajewski, Marianne Brandt, Christian Dell, László Moholy-Nagy, photographer unknown, BHA. • In László Moholy-Nagy, Gropius appointed a form master who was enthusiastic about Gropius's aim of producing experimental and model workshops for industry. Workshop members had to adopt new tasks and techniques, geared toward industrial mass production.

**View of the metal workshop of the Weimar Bauhaus.** 1923, photographer unknown, BHA. • Under Itten as form master, students still worked on individual pieces, reflecting Itten's interest in linking elementary forms and symbolic design in rational construction. On the left at the back for example, Gyula Pap's menorah is made from circular shapes. Pap's companion piece on the table in front – a pot made from a copper sphere with a bronze cone set on top of it, contrasted with a narrow hooped handle – recalls tasks set by Itten to combine different kinds of shape with each other.

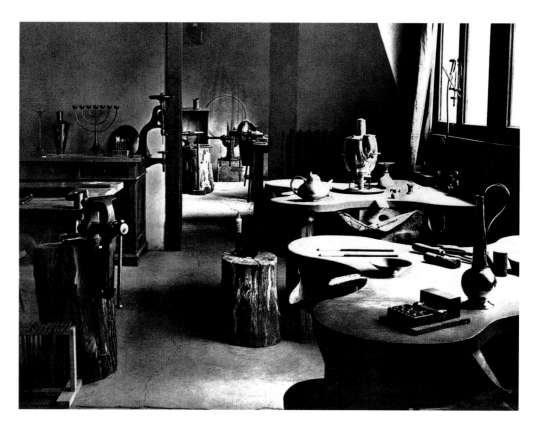

**Marianne Brandt, me.** 1927–1928, sheet from portfolio "9 jahre bauhaus. eine chronik" (9 years of bauhaus. a chronicle), 1928, collage 50.0 x 41.0 cm, BHA. • Marianne Brandt made 28 lamps at the Bauhaus and led the experiments in lighting technology. The collage demonstrates how strongly she identified her workshop with the production of such readily salable products – aluminum reflectors dominate the picture. Technically effective metals had replaced the non-ferrous metals preferred in Itten's time, and smooth surfaces replaced hand-crafted creations. To the left in the collage Marianne Brandt is reclining; the man in the suit is her form master, László Moholy-Nagy.

**Man with mask at coffee table.** About 1927, kettle by Wolfgang Tümpel, bowl by Marianne Brandt, photographer unknown, The J. Paul Getty Museum, Los Angeles. • As well as prototypes for mass production, the workshop also produced luxury goods like those presented here with the unknown metal worker.

stone-hard. Finally, the light, the glow, the soldering iron, electrodes, welding wire, glowing, melting, hardening – all of this is the art of the metal worker, this is the climate in his universe, his "Met-all."

### Experimental work

When in 1919 Walter Gropius founded the Bauhaus and installed a series of workshops, he wanted to establish a "new, previously unknown way of working together for industry and craftwork." These "experimental workers"

were to develop prototypes for mass production. The models were to have a genuineness and beauty derived from the peculiarities of the machine, and be doubly conscious of quality: this was the Bauhaus idea of spearheading the fight against cheap substitutes from the conveyor belt. In the Bauhaus models there was to be no place either for "inferior work" or "applied art dilettantism," which derived from ignorance of materials. In Gropius's "Principles," the "building factor" for industry means visible performance in all departments.

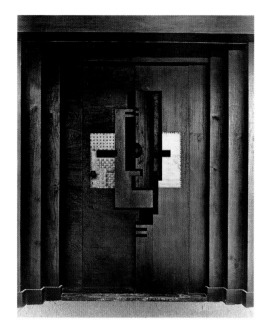

**Designer unknown (Joost Schmidt?), fittings for the front door of the Sommerfeld house.** 1921–1922 (destroyed), photographer unknown, BHA. • The metal worship clearly worked well with Joost Schmidt and the wood carving workshop. The door fittings relief frames the carving and continues its motifs in another medium.

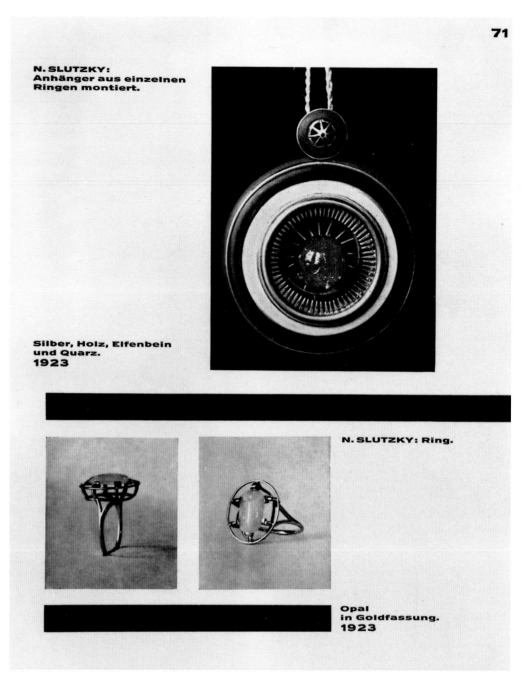

N. SLUTZKY:
Anhänger aus einzelnen Ringen montiert.

Silber, Holz, Elfenbein und Quarz.
1923

N. SLUTZKY: Ring.

Opal in Goldfassung.
1923

**Naum Slutsky, jewelry.** 1923, page from "New Works from the Bauhaus Workshops," Munich, 1925, Bauhaus Book 7, designed by László Moholy-Nagy, BHA. • For a time Slutzky independently led a goldsmith's workshop at the Bauhaus. The imaginative combination of materials with contrasting effects can be traced back to his training by Itten in Vienna and at the Bauhaus.

Creatively gifted people were taught to think that they were not competing with industrial firms but projecting for them. The school thought of itself as producing types, not special editions or unique specimens.

This was a pious wish if we remember that in the first five years the workshop was equipped with few of the necessary electromechanical tools. Before the Bauhaus moved from Weimar to Dessau, it had only a few contacts with production firms who might have been interested in its designs. As well as this, there was an unending conflict over the question of the right way to work, which continually blocked activity. The school directors and workshop masters in the early years were almost without exception goldsmiths or jewelers, and for years they disagreed about what forms corresponded to the technical and economic order of late capitalism, and whether making objects for self-adornment was a superfluous bourgeois nonsense. Starting quite early on, the motto of the originators of the Bauhaus idea was that the workshops should come to terms with "design changes for heating and lighting," that is, with questions of house-building, instead of confining themselves to the creation of luxury objects

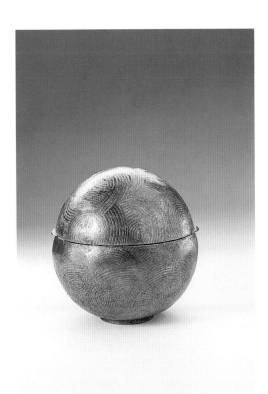

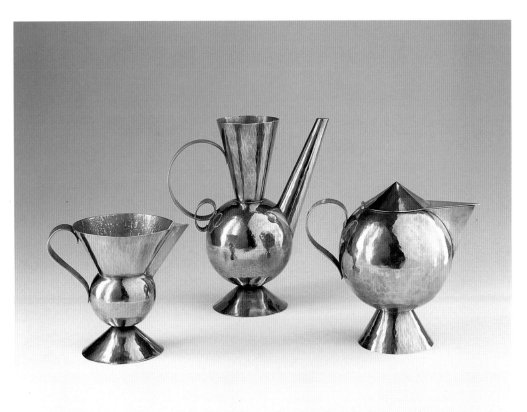

**Naum Slutzky, box.** 1920, chased copper, galvanized inside, height 16.0 cm, diameter 16.0 cm, BHA. • Two spherical sections of slightly different height fit together as "container" and "lid." Whereas the spheres and the chased segments of concentric circles harmonize with each other through their related shapes, their spatial effects contradict each other: set against the larger convex shape of the whole are the changing depths of the delicate graphic pattern woven into it. Contrast, rhythm and texture were central themes of Itten's preliminary course.

**Designer unknown, pots.** About 1921, sheet brass, hammered, galvanized inside, height of the tallest jug 25.6 cm, lidded jug 25.6 cm, small jug 15.2 cm, BHA. • As apprentice works, probably from the early Weimar period, these pots show a clear separation of base, body and neck. The handles look like linear accompanying shapes. In contrast to Dessau products, here the functional role of the articles is still in the background.

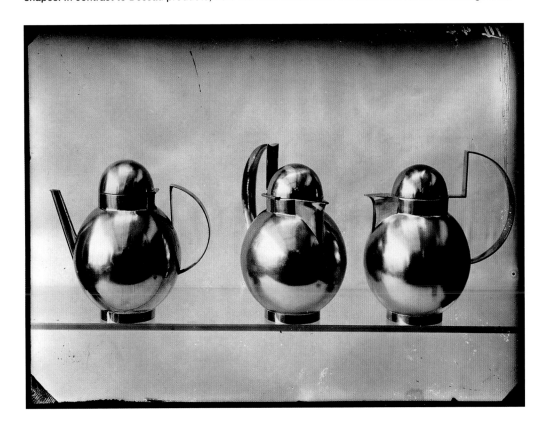

**Wilhelm Wagenfeld (design) and Josef Knau (execution?), pots.** 1924, silver-plated brass, lids and hinges German silver, photograph by Lucia Moholy, BHA. • Lucia Moholy's characteristic arrangement of objects for a photograph at the Weimar Bauhaus – the objects "hover," arranged on glazed shelf with a paper back-ground – gives these jugs a figurative, almost animalistic grace. Variations in material and design are worked out perfectly.

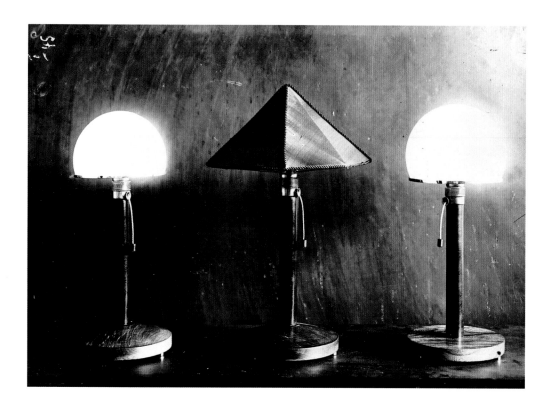

such as brooches and piano lamps. These were not suitable objects for pattern-making and only served an elite set of connoisseurs as items to collect. Ideologists like Gropius and Mies van der Rohe thought of "organic design" in terms of radical reduction and of "living environment" in terms of motor cars and other progressive technology, which they wanted to unite with everyday objects in their architecture.

Anyone who has carefully looked at a house by one of these Bauhaus masters and absorbed its laws, knows how difficult this proposed perspective is. One reason is that people who live in a glass high-rise block often chafe against its unadorned bare skeleton, from which upholstered cosiness has been excluded. Drastic remedies were applied. Tom Wolfe writes ironically in *From Bauhaus to our House* that in Mies's high-rise towers in the United States the architectural taste-police went round each week tearing down the tenants' embroidered pelmets and ruthlessly disposing of other unsuitable furnishings. This was precisely the way in which the Bauhaus members wanted to look truth in the whites of its eyes, change the whole of life and, with the help of more than just a slenderer fork or a practical lamp, finally drag the "dwelling house" into its own time.

## Cutlery

"The living requirements of the majority of people are mainly the same." A dictum that stands like a rock. An idea that can be taken seriously, even in 1925, after Lenin's death, after the failed German revolution and Stalinized Russian revolution, with signs of the approaching first global economic crisis and in a Weimar democracy that would soon break up. Gropius was saying that it was possible to guarantee, with the means available at the time, that the needs of the masses could be rationally met and the "violation of the individual" through the necessary standardization of machine-made goods was as little to be feared as the "uniformity of clothing through the dictates of fashion." The age of enlightenment makes its entry into the cutlery box.

Together with Marianne Brandt, Wilhelm Wagenfeld was one of the members of the metal workshop who did the most far-reaching work. After the end of World War II he wrote, still fully in the spirit of the Bauhaus and the Werkbund: "Metal dishes and plates now belong to a different world, they are its symbolic forms.... What is decisive is always the spirit in which we work: through it we shape things and not from the material, which always remains just a means to an end" (This

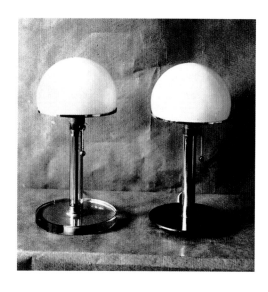

and the following quotations are from Wilhelm Wagenfeld, *Wesen and Gestalt der Dinge um uns, Essays aus den Jahren 1938–1948* [Nature and Form of the Things Around Us, Essays from the Years 1938–1948], Worpswede, 1990). Wagenfeld's words are clear and simple. His forks and knives, unfortunately damaged by sharpening but generally unchanged, are still sold today by the firm WMF. They fulfill their purpose so perfectly that they can never be regarded as an extravagance. Of course, the whole debate about transgressive ornaments and the praise of geometry sounds like a purely formalistic break with tradition. However, statements such as "The best quality of the things around us should be their unassertiveness" contain a new view of history. A further aspect is "old household goods ... simple and unambiguous, but precise and belonging to us." Whereas before people used to knock up styles at will and the petty bourgeois middle class played havoc with design, now interest is being directed again at the reason for a design: "Our ideas on food and drink, what we put them in or on, how we give and take them, have become so closely bound up with the vessels we normally use for them that these forms ... often remind us of ritualistic uses. Was a creatively used hand not

the original form of the bowl? And did hands cupped together to catch liquid not give us the first cup? Add to these the plate, created from one hand laid on top of the other. Bowls, cups and plates are the basic shapes of the open receptacles. None of them is arbitrary. Each has its own definition."

The accusation of "metallization" often made against the Bauhaus is completely unfounded. Although indeed the first appearance of the new was greeted with horror, because the familiar decoration, the superfluous and inappropriate ornamentation was missing, nevertheless today it has become an insult to call something a "designer-plate." It means: the thing is unpractical and does not look good. In 1941 Wagenfeld wrote about this change of attitude: "The refrigerator ... is ... absolutely clearly developed. Its various systems only differ from each other because of their different cooling processes. Its feet and supports are influenced by engineering and reflect an economic use of the material, completely in accordance with our ideas about a well-designed form. On the other hand, the casing of the wireless has remained a happy hunting ground for a jumble of tastes, like the force behind the hoods of pompous automobiles and similarly fantastic architectural creations

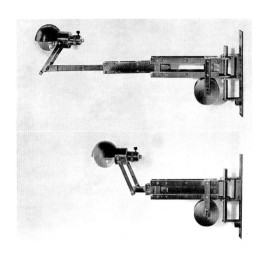

**Carl Jakob Jucker, pull-out electric wall lamp.** 1923 (lost), nickel-plated iron and brass illustration from *Staatliches Bauhaus Weimar 1919–1923*, Weimar, 1923, photographer unknown, BHA. • "more like a dinosaur than a domestic appliance," was Moholy-Nagy's judgment. However, by inquiring into the function of a light source, inventions of this kind steered designers in new directions.

**Christian Dell, Wilhelm Wagenfeld and Josef Knau, "tea-egg" infuser, tea-ball holder and tea-ball.** 1924, tea-egg, silver-plated brass, length 13.1 cm; tea-ball holder, silver-plated brass, length 14.2 cm; tea-ball, silver-plated brass, length 15.0 cm, SBD, archive collection. • The ball-shaped infuser for an individually prepared cup of tea was one of the first inventions to be created in the metal workshop and mass-produced as a "Bauhaus product."

**Wolfgang Tümpel, Tea machine.** 1927, nickel-plated brass, wood, height 28.3 cm, BHA. • In Halle, where Tümpel completed his training at Burg Giebichstein, he developed elegant, Bauhaus-type appliances.

**Marianne Brandt, Coffee and tea service MT50-55a.** Silver, ebony handles, glass lid to sugar bowl, hot water jug height 23.0 cm, coffee pot height 23.5 cm, teapot height 19.0 cm, sugar bowl height 6.0 cm, spirit burner, photograph by Lucia Moholy-Nagy, BHA. • This silver service was the most expensive work ever produced by the metal workshop.

**Gyula Pap, Design for an electric tea machine of glass and metal.** 1922, colored ink on transparent paper, 30.3 x 37.8 cm, SBD, archive collection. The heatable water container was designed to hang on a metal ring, which rested on four glass tubes and a glass plate underneath. The three-quarter ball, which here only has one lid, was later expanded to include a tea-extract container.

**Marianne Brandt, Inkpot stand with pen holder.** 1924, copper sheeting, German silver, 3.0 x 11.7 x 6.5 cm, BHA. • Themes from Moholy-Nagy's preliminary course, such as the daring asymmetrically balanced constructions made from technically effective materials, particularly influenced the student Marianne Brandt. Here she transfers them to an object of practical use.

of the film industry." The purpose of the requirement that technicians should give the apparatus they make an unambiguous shape appears particularly enlightening with regard to the then "new structures," such as the telephone, incandescent lamp and light switch. Nowhere does fashionable embellishment make less sense, because it makes it difficult to see at a glance what the object is for and grasp its function.

## Lights

World War I completely altered the complex social relationships in existence at the beginning of the century. According to the Weimar intelligentsia, the collapse of the monarchy and the delusion of playing a leading role in world politics would also bring about the collapse of the constraints of inner colonialism. They were creating the "New Man," whom they could not see as living in a petty bourgeois, claustrophobic small-town atmosphere. Living rooms had been de-Biedermeiered, now the arsonists were at work. In order not to sacrifice every kind of beauty to Prussian taste, the Thuringian avant-garde tore into it with manifesto speeches. Oskar Schlemmer

became form master of the metal workshop (following Itten and later Paul Klee, whose work has left no trace). In his time Schlemmer drained the bourgeois swamp: "I am against luxury, against the aimless." "I see no point at all in decoration." "I do not believe in craftwork." "Industry produces utensils with such first-rate precision and shape that I prefer these to the handmade. For example, I do not like patina or hammered work, I prefer things that are smooth, shiny, precise...." (diary of Oskar Schlemmer for 1922, transcript in the Berlin Bauhaus Archive). In 1928 László Moholy-Nagy seconded him: "We have only been minimally concerned with decorative objects, because they cannot be counted among elementary needs" (*Deutsche Gold-schmiedzeitung* [Journal of German Goldsmiths], 1928, No. 13, p. 124). But no-one was prevented from engraving a little box if they wanted to. We can read the numerous written complaints and accusations of lack of independence in the metal workshop under the aegis of the silversmiths. Endless bickering and an almost unbelievable turnover of staff mark the early years until at last, with Wilhelm Wagenfeld and Marianne Brandt, there

were two experts who moved on from creating individual free pieces of jewelry. It was no accident that lighting became the workshop's most important area of work. This not only satisfied the demands of their historic mission, to find a way out of self-inflicted darkness, but also by using glass and metal they were uniting two material exponents of the modern, through electricity. Fascination with the phenomenon of light finally led Moholy to a career pinnacle, from where he channeled his own experiments with the "light-space modulator" and so forced the pace of the design engineers. His experiments, his own painting and the examples they gave served to dematerialize the construction of the appliance and free it from the burden of superfluous decoration. An additional stroke of luck came from the link with Osram in Berlin and, even more important, that with Körting and Mathiesen in Leipzig, famous under the company name of "Kandem." This co-venture was mainly due to the personal activities of Marianne Brandt. Products were in circulation from 1927, many of them were desk, wall and standard lamps that have become the classics of today or are still obtainable in new versions. It was only

now that the transformation caused by mass production and the conceptual demands that went with it made this radicalization possible. In a very short time the challenge of making a simple, modular, durable lamp put an end to the teething troubles of the workshop's first ten years. At the beginning in Weimar, candelabra and branching lamps had been regularly produced in small quantities by the workshop. There had been long debates about the mysticism of light and the symbolism of church candles (Gyula Pap). Now rational clarity and transparency became the focus of interest. Marianne Brandt was inspired by legendary predecessors such as the Berlin literary utopian Paul Scheerbart and his architect friend Bruno Taut, whose "glass chain" had started a lively debate about building materials and the spirit of future dwellings. Now she swiftly advanced toward an ontology of the lamp, which rejected dispersion of the light through the addition of a frosted glass shade with a fantasy shape, and put the light source itself, the bulb, in the foreground. There was not long to wait for abuse from the taste-avengers. She was accused of adopting a "culture of nakedness." She over-emphasized technique, her purpose was often questionable because the free-standing glowing light was too blinding.

However, these lights finally corresponded quite unpretentiously to the theory of "concentration, sense of logical structure, grasp of the whole, which today is economically and socially possible." Everything else could be dismissed as initial difficulties. From 1926 the trade press gave isolated and hesitant support, preparing the way for the "popular need" and multiple demand that the new house and its standard equipment met. "Slowly we will manage to accustom ourselves to these objects that seem strange at first. Suddenly a light will go on; how self-evidently clear and beautiful it all is."

## Summary

Between 1914 and 1918 Germany was beset by *Stahlgewitter* (Steel Thunderstorms, novel by Ernst Jünger). On December 8, 1919, out of the amalgamation of Henry van de Velde's School of Applied Art and the School of Fine Art sprang the "All-Workshop" (Wolfgang Tümpel) in Weimar. There is room in it

**Marianne Brandt and Hans Przyrembel, Ceiling light with light pull ME 105a.** 1926, nickel-plated sheet brass, weight filled with granulated lead, reflector diameter 29.0 cm, BHA. • Produced as a series in the workshop for the Dessau Bauhaus buildings, this light was nevertheless designed for universal use. By 1927 it was already possible to buy it with or without the light pull as a "Bauhaus product." It was available in two sizes of reflector, nickel-plated as here, color-sprayed, and also made of brushed aluminum, for which there was little demand.

**Marianne Brandt, Wall lights.** About 1927 (lost), aluminum reflector, swiveling metal rods, photograph by Erich Consemüller, private collection, Bremen. • The idea of making the home and its equipment variable, so that the occupants could adapt them to their needs, was also applied to lighting design. The metal arms and spring hook, cable and shiny nickel lampshade work together as a movable graphic composition.

**Tea-making corner in the living room of Gropius's master's house.** 1926, in the cabinet, top, tea balls by Otto Rittweger and Wolfgang Tümpel, tea caddy by Wilhelm Wagenfeld; bottom, tea glasses by Josef Albers; on shelf below cupboard, ashtray by Marianne Brandt, photo-graph by Lucia Moholy, BHA. • Gropius sparing himself the time to go into the kitchen to make tea. Hence this representative display of products from the metal workshop arranged in his living room cabinet.

**Designer unknown, Ashtray.** About 1927, photo-graph by Erich Consemüller, private collection, Bremen. The mobile ash tray is not just for decoration but is a useful object that moves from the coffee table to the work table.

**Hin Bredendieck and Marianne Brandt, Kandem desk lamp (No. 756).** 1928, sheet steel, steel parts, cast iron base, all parts reddish bronzed, inside of reflector coated with aluminum paint, height about 47.0 cm, BHA. • After intensive work in the workshop on lighting technology and industrial production methods, they were able to produce a table lamp for the Kandem company that combined a movable shade and arm with good light dispersion and reflection.

for working with "Met-All." Its equipment was lamentable, hardly appropriate to its claims to be able to make standard objects for mass production in industry. For example, it was only in 1926 through the sponsorship of the Junkers factory that a lathe was added to the workshop. Then hardly anyone used it through lack of instruction. The first workshop leader was Naum Slutzky, a goldsmith. It was a place where witty samovars and intellectual door knobs were made (Xanti Schawinsky).

On April 1, 1925, under pressure from the conservative regional state government, the Bauhaus moved to Dessau. There they were cut off from the Thuringian craft guilds. Now they were occupied with focusing on the "biologically necessary in things" (László Moholy-Nagy) and were soon swept from their position by a historical storm. Many pieces of Bauhaus furniture crashed about in its whirling blast. Unaffected by all cultural problems, the storm blew Germans back into "steely romanticism" (Joseph Goebbels). The short history of the Bauhaus in Berlin, before it was closed down by the Nazis, records no activities of the metal workshop. The radiant effects of its products were only developed under Ulbricht and Adenauer.

# The Law of Line Production

Olaf Arndt

Time is the best customer of the "Repeat-order" company. Compared with the potential bandwidth of modular ideas that an engineer must develop for mechanical production in order to satisfy all the conceivable needs for a series, history works with a few basic patterns, from which it generates all its products. Thus the production line is not a discovery arising out of the mechanical process of reproduction, but a law of life. When the times require a historical problem to be solved by means appropriate to the conveyor belt, it usually produces a fund of quotable anecdotes.

Every beginning is difficult. It was different with Guillotine: he promised buyers of his invention 100 percent success first time out. (An astonishing guarantee for an 18th-century product, if we consider that today a car firm declares that a no-fault quota at the end of the 20th century can only be achieved by the introduction of "lean production.") In addition, his contraption for the serial uncoupling of torso and skull merely gave the delinquent a small "refreshment of the neck" when the cold steel cut off the head: an almost unnoticeable, even pleasant process.

In mass production, concentration is extremely important. In an environment stamped by the car it is an ever-present experience. At the beginning of the 20th century the presence of this lacquered body was widely criticized. The smart Henry Ford, euphoric at the sensational success of his "Tin Lizzy," answered a journalist who had questioned the somewhat narrow color range of the T-model: "We can sell you a car in any color, so long as it's black."

A further basic law of line production is that the working hand no longer plays an important role. A weapon of mass destruction, a bomb for example, never needs to be touched throughout its manufacture or when it is used, at least not for technical reasons: rolling, punching, casting are all done without human body contact. The same goes for finishing and sealing, which for safety reasons is done by mechanical hands. Loading and dropping are also fully automatic. The first, usually fatal, encounter between body and "instrument" only happens at the end.

## Fittings

One of the few exceptions in the hermetic career of the Bauhaus metal workshop is its cooperation with the Junkers factory. Goethe's remark that art, which decorated the floors of the ancients and vaulted the heavens of Christian churches, had now crumbled into boxes and armbands, can be extended to domestic heating. Quite early on, in 1923, the Bauhaus made contact with Hugo Junkers and the Bauhaus commissioned Junkers and Co., Dessau, to manufacture hot water appliances for a house they were fitting out (Am Horn). Breuer and Gropius used them to manufacture their first tubular steel furniture. It had not been possible in rural Weimar, but when they moved the Bauhaus took advantage of their nearness to industrial production companies – not only Junkers – and profited considerably from their modern manufacturing techniques. In 1925 the close link formed between the aesthetic avant-garde and technical know-how led to the wide circulation of

**Herbert Bayer, Prospectus for Dessau.** 1926, letterpress printing, 20.8 x 52.0 cm, leporello folding, BHA. • By 1923 Gropius had made contact with the firm of Junkers, and maintained it when the Bauhaus moved to Dessau. It is known that Brandt, Przyrembel and Krajewski made use of the Junkers workshops and know-how for their innovations.

several futuristic heaters and kettles. The cooperation with the Junkers factory, who were involved in working with sheet aluminum for airplane manufacture, led to the use of this modern contemporary material in the manufacture of furniture and heating. This access to contemporary production methods and machines made traditional plumbing methods redundant: complex machine tools replaced smithing, with its hones, punches and hammers working on red hot metal, methods which had determined the appearance of household appliances to date. The latest manufacturing techniques replaced copper coating with enameled steel.

The victory of mechanization arose out of a close connection with the military complex. War is the father of nearly all discoveries. The comfort aspect is to some extent a by-product, a civil gain, both in the ergonomic sense and as regards taste. It is a waste of time to consider the formal identity of particular salt pots or tea eggs with ballistic items or weapons. For we cannot prove that a machine formerly used to make missiles was used for the manufacture of kitchen goods. Nevertheless, it seems plausible that, thanks to the shining poetry of the futurists, pragmatism in the design of things which are around us today increasingly has less to do with the beauty of the Nike of Samothracia and ever more to do with warplanes or racing cars. Walter Gropius always wanted to

EIN MODERNES WOHNHAUS
Ja, das ist Hygiene. Ueberall praktische zentrale Warmwasser-Versorgung durch
**J U N K E R S**
Heißwasser-Stromautomat, der Tag und Nacht in allen Wohnungen das ständige Vorhandensein des unentbehrlichen warmen Wassers sichert. Er ist aber auch ein System, das seit Jahrzehnten bewährt und durch ständige Vervollkommnung noch heute unübertroffen ist. Die schöne Zweckform des Apparates entspricht dem Zeitgeschmack, die weiße Emaillierung allen Ansprüchen in Bezug auf moderne Raumgestaltung. Sauber, bequem, wirtschaftlich, automatisch sind die Kennzeichen dieser Anlage, die absolut ohne jede Arbeit, unter genauer Anpassung des Brennstoffverbrauchs an den Warmwasser-Bedarf das warme Wasser liefert. Die Installation ist infolge der geringen Raumbeanspruchung einfach u. leicht.

**JUNKERS & CO.. DESSAU**

**JUNKERS**
**GAS** HEISSWASSER-STROMAUTOMAT  Herr Baumeister, Sie sollten sich orientieren. Auskünfte und Drucksachen kostenlos.

**Advertisement for Junkers gas waterheaters.** 1929, illustration from *Die Form*, No. 23, December, 1929, BHA. • "What attracts the artistic designer to the rational products of technology?" asked Gropius. "The design methods!"

**Show window of the metal workshop in the Bauhaus traveling exhibition, Kunsthalle, Manheim.** 1930, photographer unknown, BHA. • Although Hannes Meyer regarded Gropius's aims and way of working as obsolete in the metal workshop, nevertheless he saw advantages in the Bauhaus moving on from the older products of the metal workers. Therefore he did not leave their exhibit out of the Bauhaus traveling exhibition.

carry some of the "relentless determination" to fly that is found in every airplane, some of the "perfect rationality of technical production" over into design, so that art became a product of technology, the two became one. This was the ideal behind the demand that designers should see design as the result of an ongoing "research into the nature of things." For the fact that a heating grill functions properly means in Dessau logic that it is inevitably beautiful in the above sense of a mutual interpenetration of art, function and history. The resulting aesthetic of technology and construction scarcely overlapped at all with the concept of "art" purported at that time. This is the meaning of Junkers' publicity claim that artists had nothing to do with "the design of our products."

# The Ceramics Workshop

Cornelia von Buol

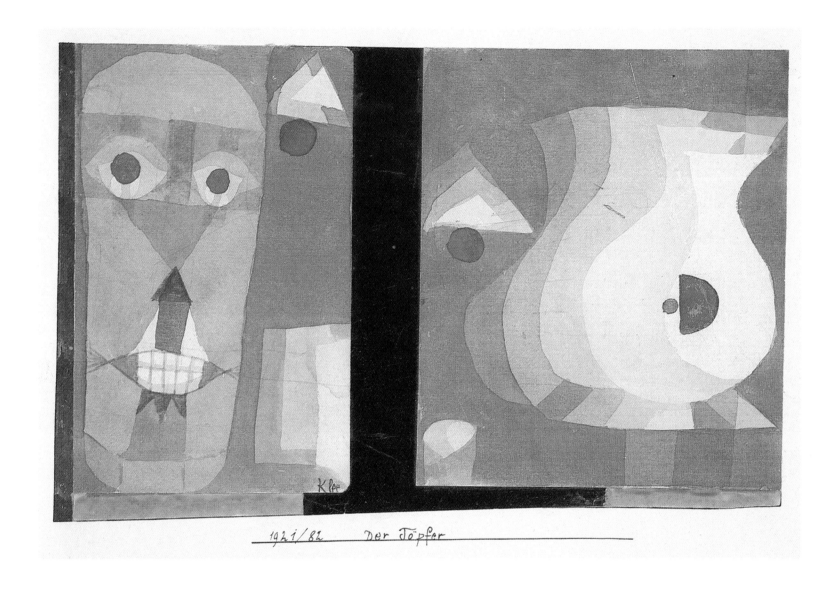

1921/82    Der Töpfer

**Paul Klee, Der Töpfer (The Potter).** 1921, work index no. 82 watercolor and gouache on two pieces of drawing paper, 16.0 x 25.3 cm, Heinz Berggruen Collection, Geneva. • Klee was involved in the Bauhaus from 1921–1931. He was involved in many areas: bookbinding, glassmaking, weaving, teaching design, color and composition, but not in ceramics. In this work he separates the master from his "serial" production by black shiny paper.

"The work of the pottery workshop went almost unnoticed by us in Weimar, for, with Gerhardt Marcks as form master and Max Krehan as work master, it was located in Dornburg, between Jena and Apolda" (Lothar Schreyer, *Erinnerungen an Sturm und Bauhaus* [Memories of Storm (turbulent times) and Bauhaus], Munich, 1956, p. 189 ff.). Lothar Schreyer, head of the theater group workshop, used these words to describe the special situation of the Bauhaus pottery workshop, which was moved to Dornburg on the Saale river. An intense working and living community, which was largely unaffected by the internal conflicts in the other areas of the Bauhaus, grew up here about 30 km away from Weimar. In the six years of its existence in the Dornburg exclave of the Bauhaus it became an extremely important influence on the development of ceramics in the 20th century.

## Gerhard Marcks and the early days of the ceramic workshop

On April 1, 1919, Walter Gropius appointed one of the school's first teachers, the sculptor Gerhardt Marcks (1889–1981), as head of the ceramics workshop at the Bauhaus. Gropius

and Marcks had known each other since childhood. They had worked together as early as 1914 on the Cologne Werkbund exhibition. Marcks had produced some reconstituted stone and terracotta reliefs for buildings by Gropius. After the end of the war they both became members of the Works Council For Art. Marcks had accumulated years of experience with ceramic materials and techniques while producing designs for animal figures for various manufacturers. This training predestined him to manage the ceramics workshop. He was responsible for the artistic education of the students. What was still needed was a craftsman who would run the workshop and be responsible for technical matters.

The pottery, like the other workshops, was originally intended to be located in Weimar as a part of the craft apprenticeship, but as no premises were available in the school buildings and the cost of setting one up was considered too high, an alternative was sought. This was found in the Weimar kiln factory of J. F. Schmidt, and the premises were rented from the fall of 1919. The ceramicist Leibbrand took on the job of leading the workshop on a temporary basis and was soon succeeded by the potter Leo Emmerich. There were only four apprentices in the early months: Marguerite Friedlaender, Lydia Foucar, Gertrud Coja and Johannes Driesch. As the workshop was not sufficiently well equipped for turning ceramic vessels, the students experimented primarily with small sculptures, reliefs and sculpted vessels. But even this temporary solution was under threat.

## Max Krehan and the craft training

The lease with the kiln factory was terminated in March of 1920. Gropius then contacted the pottery master Max Krehan (1875–1925) and in September of the same year appointed him as head of the new workshop. As Krehan did not want to give up his workshop in Dornburg, the Bauhaus ceramics department was moved there. Suitable work rooms, a studio and living accommodation were found for Gerhard Marcks in the stable building and in the "Gentlemen's House" of Dornburg castle. The poorly equipped workshop in the stable building was opened on October 1. In the meantime, the four apprentices had been joined by Ilse Moegelin, followed in November by Theodor Bogler and Otto Lindig, two personalities who were later to play a significant role in the workshop. Like Gerhardt Marcks, they had all committed themselves to working at the Bauhaus pottery for an initial period of two years. Future apprentices would begin their training by attending a six-month foundation course with Johannes Itten in Weimar, followed by a six-month probationary period in Dornburg. The ensuing apprenticeship was concluded with the journeyman examination of the Chamber of Crafts. Small living quarters and a communal kitchen were set up for students on the top floor of the stables building. Each student received a piece of land and an almost self-sufficient working and living community grew up there.

"The external circumstances in Dornburg are promising, its boarding-school-like character corresponds largely to what was intended by the Bauhaus. There is however a danger that the workshop will become separated from the center if care is not taken to prevent this from happening" (minutes of the council of masters, September 20, 1920, Weimar State Archive, quoted from "Keramik und Bauhaus," exhibition catalog, Bauhaus Archive, Berlin, p. 12).

There was an economic crisis in the Thuringian pottery sector caused by a shortage of wood and clay, so the collaboration between the

**View of the Bauhaus pottery workshop, stable building at Dornburg castle.** 1923, illustration from *Staatliches Bauhaus Weimar 1919–1923*, 1923, photographer unknown, BHA. • The ceramics department moved to Dornburg in 1920 where the new work master Max Krehan trained apprentices 'in his own workshop. Gradually the ceramicists built their own Bauhaus workshop and living accommodation in the stable building.

Ceramics Workshop

**Max Krehan (design) and Gerhardt Marcks (decoration), Flask with handle and illustration of oxen plowing team.** 1920–1921, earthenware fired at a high temperature, sand colored pieces with salt-glazing and a hint of cobalt, scratched design in cobalt and white glazing, height 26.5 cm, BHA. • The archaic illustration by Marcks and the traditional design for a water or vinegar bottle by Krehan fit remarkably well together but do not yet show any influence from the Bauhaus experiments.

Krehan family, with its long tradition in pottery, and the Bauhaus was very timely. The Krehan brothers produced respectable craftwork. They turned their vessels on the potter's wheel, decorated them by hand and fired them in the so-called Kassel kiln, which dated from 1770. The clear and simple designs were developed from the use planned for the item, even though they were based on traditional patterns. From the early days Max Krehan's skill at his craft and his pleasure in experimenting molded the teaching course. The training received by the apprentices was both comprehensive and practically oriented. "The apprenticeship with Krehan, the last Thuringian master, was hard and included splitting wood (what a lot the old Kassel kiln needed), digging for clay and emptying the cesspit. Nothing was given away and the food was meager. The form master's suggestions were discussed critically and then translated into the craft. The country life prevented extravagance and dissipation" (Gerhardt Marcks, Otto Lindig in Sigill, *Blätter für Buch und Kunst* [Book and Art Journal], 6/1, Hamburg, 1977). The apprentices spent most of their time working in Krehan's workshop. The financing of this operation was led by the rustic ceramics they produced and put on general sale. This made the pottery the only

**Display case of the ceramic workshop at the "Weimar State Bauhaus 1919–1923" exhibition.** 1923, Weimar, photographer unknown, BUW picture archive. • New models appeared at the Bauhaus exhibition which for the first time accorded with Gropius's concept of mass production.

**Otto Lindig, Ceramic light temple.** 1920–1921 (lost), photographer unknown, BHA. • Many ceramicists working far from the Bauhaus clearly looked for inspiration from Itten.

**Pottery on show at the "Weimar State Bauhaus 1919–1923" exhibition.** 1923, Weimar, photographer unknown, BUW picture archive. • The production of traditional Thuringian utility objects intended for sale was taught in Krehan's workshop. Mostly they were one-off pieces with simple designs and glazes, and do not appear to differ substantially from the Thuringian originals.

Bauhaus workshop in the early years, apart from the weaving workshop, to have its own income. The apprentices were paid for working on purely commercial objects. The early days of the Bauhaus ceramics department in Dornburg were therefore characterized by traditional designs. A friendly and respectful working relationship developed between the form master and the head of the workshop. They worked together closely to create different items. Krehan was primarily responsible for their design and then Marcks, the sculptor, decorated them with etchings or painting. Marcks himself hardly developed any new designs, which caused some criticism in Weimar. "All the Bauhaus members want to see more progress. But we can only achieve this gradually" (letter to Richard Fromme, January 29, 1921 in *Gerhard Marcks. 1889–1981. Briefe und Werke* [Letters and Works], Munich, 1988, p. 38).

At the end of 1921 work started in earnest in the stable workshop, which was now fully equipped with potter's wheels. It was called the Bauhaus workshop to distinguish it from the Krehan Pottery. The work which took place there was of a decidedly experimental nature. It became more and more akin to sculpture and its function took on a secondary role. Marcks was interested in the sculptural possibilities of vessel ceramics and encouraged his students to work freely on different combinations of the individual components: the proportions of the feet, body, neck, handle and spout were constantly changed in a playful fashion, often producing extreme results. It was exactly this pleasure in experimenting which the apprentices and future journeymen and masters retained in their more mature works with their unconventional creations. There was hardly any difference between the technical opportunities in the two workshops. The kilns were fired by wood and reached a temperature of just under 1200°C. They both used the clay from the area around Dornburg. It was only when the casting process was introduced at the beginning of 1923 that more appropriate clays were used. Design was what they were most interested in. Glazing always lagged behind. No experiments were carried out with glazes, as they would not have been able to be put them into practice because the raw materials were expensive and because of limitations with the firing process. Decoration therefore also took on a secondary role. Lindig and Bogler made sparing use of line decorations and gaps in the glazing on the neck, the feet and edges, primarily to accentuate the shape. Decoration still played a more important part in Krehan's workshop with its traditional vessels. Johannes Driesch, Lydia Driesch-Foucar and Marguerite Friedlaender continued to decorate their ceramics with slip painting. But colorful glazing was never allowed to conceal a second-rate piece of pottery or distract from a bad design. "Honesty in the craft" was their slogan, allied to their aim of increasing the quality of the craftwork and the usefulness of ceramic products.

## Otto Lindig, Theodor Bogler and the move to series production

In 1922 a fundamental change took place at the Bauhaus pottery. Internal discussions in the Weimar council of masters about future developments now reached the Dornburg annexe. Gropius believed that there should be no separation between craftwork and industry. He certainly did not deny the importance of a training in craftwork. But he believed that it should be bought closer into line with industrial conditions. Krehan rejected this approach from the standpoint of a traditional craft master, and Marcks viewed it with some

**Theodor Bogler, Nativity figures.** About 1921, photograph by Lois Held, SBD, archive collection. • These little figures were turned in clay like pots.

**Gerhardt Marcks, Stove tile.** 1921, potter's clay, unglazed, 18.7 x 18.6 cm, KW. • At the Dornburg annexe, form master Marcks gave a considerable amount of his time to the few budding ceramicists, one of whom was the apprentice Otto Lindig, whose portrait appears on this tile.

scepticism. Theodor Bogler (1897–1968) and Otto Lindig (1895–1966), on the other hand, who had both sat their journeyman's examination with Marguerite Friedlaender in 1922, were extremely open to this point of view. As early as three years after their arrival there were signs of a generation change at the Bauhaus pottery which manifested itself in the preparations for the Bauhaus exhibition planned for 1923. In October of 1922 Gropius urged the masters to give up the old "romantic way of working" in favor of producing functional everyday objects in a more rational way, based on the slogan "art and technology – a new unity." Contacts were made with the Thuringian porcelain industry in the same year. Lindig and Bogler visited three factories to familiarize themselves with production conditions and the technique of casting in plaster casts. Concrete agreements to produce samples were concluded with a porcelain factory, the Aelteste Volksstedter Porzellanfabrik. Bogler was also able to develop prototypes for his kitchen equipment at the stoneware factories of Velten-Vordamm which were exhibited in the kitchen of the experimental house "Am Horn" at the Bauhaus exhibition in the summer. As a large proportion of

**erhardt Marcks, Portrait of Otto Lindig.** 1922, wood engraving on Japan paper, block 22.2 x 16.0 cm, sheet 30.0 x 19.2 cm, BHA.

Ceramics Workshop

**443**

**Otto Lindig, Large pot.** 1922, earthenware fired at a high temperature, bright sand colored pieces, inside gray, outside dark brown glaze, height 43.0 cm, KW, Bauhaus Museum. Marcks, a sculptor, required his students to look for new plastic qualities in their handling of clay. This unconventional combination of plastic shapes only nominally fulfills its purpose as a pot.

**Theodor Bogler and Gerhardt Marcks, Double pot.** 1922, earthenware fired at a high temperature, sand colored pieces, turned separately and assembled, inside ocher transparent glazing, outside painted with thinly applied black-brown slip, height 31.8 cm, KW, Bauhaus Museum. • The outer cylindrical forms were added to the main symmetrical body, and then the angled spouts which stick out diagonally. The semicircular handles are mounted on a second axis of symmetry. At the top and bottom, conical shapes lead in opposite directions to the pot's horizontal conclusion.

the vessels produced at the Bauhaus pottery continued to be expensive and time-consuming one-off pieces, the need to develop the casting technique and serial production became more pressing. This change of emphasis encouraged Max Krehan to decide to leave his own workshop to the Bauhaus. Bogler then took over the business management of both Dornburg workshops. Individual one-off pieces still dominated the range of Bauhaus pottery. But two of the most important and characteristic model groups of cast vessels were conceived for the 1923 exhibition

and were later produced in series: Bogler's combination teapot and Lindig's baluster-shaped pots and vases. The development of a basic vessel design which could be assembled in different ways with only few variations in handles and spouts was decisive in this process, and gave rise to a number of designs which could be used in a number of different ways.

The Bauhaus's reputation and the demand for its ceramics grew sharply after the first great Bauhaus exhibition and after it had exhibited at the Frankfurt and Leipzig fairs. But as

industry continued to be reticent, the workshop had to increase its production capacity by introducing more rational work processes. However, for financial reasons it was not possible to acquire the necessary technical equipment or to employ the necessary personnel in order to increase serial production. A purely temporary foundry was set up. Krehan and Marcks did not agree with the changes. In January of 1924 Marcks wrote to Weimar: "We must always keep in mind that the Bauhaus is intended to be a place of learning. This means that people with both talent and character should be trained to carry out appropriate tasks, in order to be able to achieve something outstanding in our field. Practical tasks seem to us to be the right way to achieve this. However, these tasks should never be an end in themselves. Otherwise the Bauhaus will become just another factory, i.e. a completely trivial business (letter to the State Bauhaus in Weimar, January 2, 1924 in *Gerhardt Marcks. 1889–1981. Briefe und Werke* [Letters and Works], Munich, 1988, p. 40). As a result of these disagreements Krehan offered to resign, but was persuaded to stay on by Marcks and Friedlaender. At the beginning of February, 1924 a reorganization of the pottery workshops in Dornburg was concluded and the areas of responsibility of both workshops were more clearly defined. Krehan would continue to be responsible for the training of the apprentices in "rustic pottery" and would be solely responsible for production there. The Bauhaus workshop in the stable building would become the experimental and production workshop, supervised by the form master Marcks, while the technical management was transferred to Otto Lindig and the commercial management to Theodor Bogler. Their aim was to create "a production facility working along economic lines, with production processes appropriate to

**Theodor Bogler, Tall pot with lid.** 1923, earthenware fired at a high temperature, yellow clay pieces turned separately and assembled, inside and outside dark brown, in places shiny, metallic glazing with blistering, height 43.5 cm, KW. • There were no lavish experiments with glazing. There was a shortage of raw materials and also limitations on firing imposed by the kilns which they built themselves.

**Marguerite Friedlaender, Jug with handle and slip painting.** 1922–1923, earthenware fired at a high temperature, sand colored pieces turned separately, thin salt glaze over decorations in black-brown slip carried out with a small painting tube, height 34.0 cm, BHA. • Even after she passed her journeyman's examination, the potter was not able to distance herself from the traditional influence of Krehan's teaching workshop. Here she is using a graphic decoration which may have originated with Marcks.

Ceramics Workshop

**Otto Lindig, Squat cocoa pot.** 1923, stoneware, light brown pieces, inside light gray, outside yellow ocher glazing, lid cast in sand-colored pieces, height 14.7 cm, BHA. • This pot has unusual proportions, the long protuberant spout seeming to disturb its balance. Its shape is too comical to be used for mass production and it remains a one-off piece.

**Otto Lindig, Vase, small pot, cocoa pot.** 1923, vase, stoneware, dark red-brown pieces, cast and molded on the wheel, inside black-brown matt glaze, outside a thin application of slip, height 18.2 cm; small pot, stoneware, dark reddish-brown material, cast, assembled and molded on the wheel, inside black-brown matt glazing, outside a thin layer of rust-red slip, height 18.4 cm; cocoa pot, dark reddish brown stoneware pieces, cast, molded on the wheel and assembled, light gray glazing, the reddish brown of the clay shining through in places, height 20.5 cm, BHA. • Gropius wanted to see models for serial production being made in the ceramic workshop as well. Bogler and Lindig worked on clay types and models which were suitable for production using the casting process. Lindig came up with a basic form in plaster of Paris, which could be used to make 16 variants.

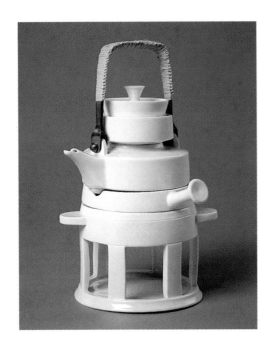

mass production," in which only journeymen and advanced apprentices were to work. A shortage of money, however, led to only a limited extension of the workshop. But Bogler and Lindler concentrated on series production with the result that the development of new patterns and types was almost completely neglected. Once again attempts were made to establish contact with industry. The series production of Bogler's kitchen equipment was taken over by the stoneware factories of Velten-Vordamm. The Voldsstedter porcelain factory now also produced some models, including a coffee machine by Bogler, consisting of several parts, and a cocoa service by Lindig. But as the pieces they produced were of unsatisfactory quality, Bogler and Lindig started negotiations with the Berlin State porcelain factory. These few attempts were the sum of the collaboration with industry. Not even the positive response at the Werkbund exhibition in the summer of 1924 brought any new solutions to the expansion of industrial series production. It must however be mentioned that the workers at the pottery played a pioneering role within the Bauhaus with their contacts with industry. It was not until 1928 that their example was followed in the fields of lighting and textile production.

## The end of the Bauhaus pottery

Under these circumstances, they continued with limited-scale production and tried to satisfy the increasing demand despite both shortages of raw materials for clay and glazing and increasing financial difficulties. At the beginning of 1925, these increasingly difficult circumstances, combined with the uncertainties surrounding the Bauhaus's future, caused Theodor Bogler to transfer the management of the Velten model workshop to the stoneware factories of Velten-Vordamm. On December 26 the council of masters decided to dissolve the Weimar Bauhaus with effect from April 1. This decision had fatal consequences for the Dornburg workshops. The speed of the decision to move to Dessau in effect excluded the ceramics workshop. It is unclear whether any consideration was given to continuing the workshop in Dessau or whether those at Dornburg actually wanted to move there. An additional factor was that Krehan would probably not have wanted to give up his own workshop. Marguerite Friedlaender worked there until Krehan's death in October of 1925. She then followed Gerhardt Marcks to the School of Applied Arts in Halle at Burg Giebichstein, where he had been leading

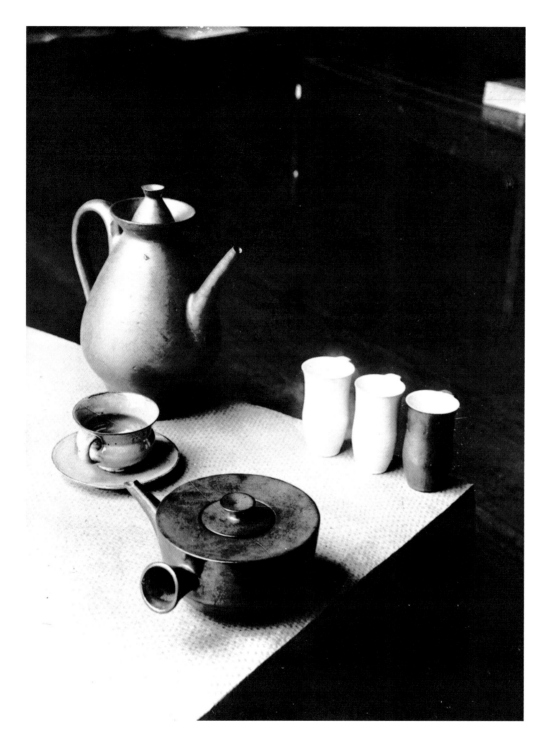

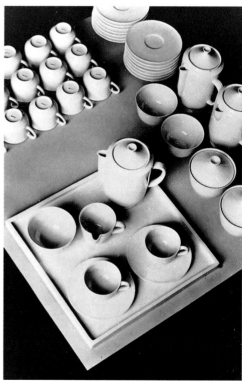

**Marguerite Friedlaender (design)/Berlin State porcelain factory (execution), "Halle Design" coffee service.** 1929–1930, photograph by Hans Fischler, State Gallery of Moritzburg in Halle, Local Art Museum of Sachsen-Anhalt, Photographic Collection, Hans Fischler Estate. • After the Bauhaus closed, Friedlaender moved to the School of Applied Arts at Burg Giebichstein in Halle. Under her leadership, a collaboration grew up between the porcelain workshop and the Berlin State porcelain manufacturers for whom she developed designs for dinner and coffee services.

**Otto Lindig, Theodor Bogler and Marguerite Friedlaender, Coffee pot and cup, teapot, mugs with handles.** 1923, photograph by Lucia Moholy, BHA. • The photographer has emphasized the individuality and proportions of the pieces. The tubular handle of the Bogler teapot is shown to particular advantage.

the sculpture class since the middle of September, 1925. Marcks expressed his dissatisfaction with the work at the Bauhaus in a letter: "I am happy to leave the pottery. It has ceased to interest me and become far too much for me. This is because the young journeymen wanted to have the fame for themselves and showed no respect in their work" (letter to Richard Fromme of

February 8, 1925 in *Gerhardt Marcks. 1889–1981. Briefe und Werke* [Letters and Works], Munich, 1988, p. 4). Friedlaender took up her new job in Halle in November, sat the master's exam in 1926 and then took over the management of the ceramics workshop. Three years later she set up a porcelain workshop at Burg Giebichstein and was thus able to achieve the intensive

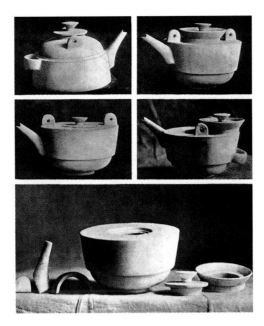

**Theodor Bogler, Plaster model of a teapot.** 1923, illustration from *Weimar State Bauhaus 1919–1923*, Weimar, 1923, BHA. • The architectural principle of prefabricated construction is adopted by ceramics; finished components give rise to four different variations. Initially Bogler had to call on the help of stone sculptors for casting the forms, before the workshop was able to build up its own, extremely modest, plaster works and foundry.

**Otto Lindig (design)/Aelteste Volkstedter porcelain factory (execution), Coffee pot.** 1923–1924, porcelain, cast and assembled, height 18.0 cm, KW. • Lindig's bulbous vessel shapes have here given way to an elegantly varied, rounded cylindrical shape, almost reminiscent of the '50s in the way the short straight spout and inverted double-cone lid make an impudent contrast.

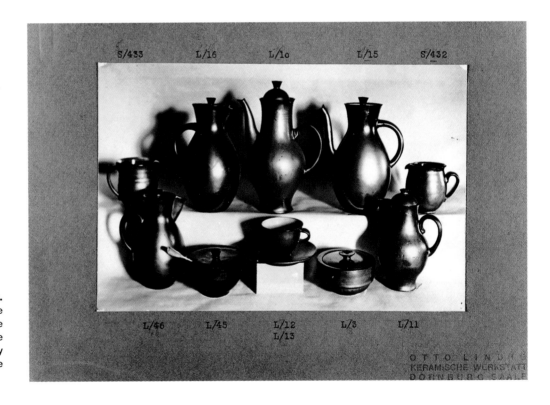

**Sample card from Otto Lindig's workshop.** About 1931, BHA. • Lindig continued to manage the Dornburg workshop as a department of the State Building School in Weimar. Soon afterward the institute was taken over by the Nazis, but as they did not want to integrate the workshop into it, he continued it as an independent concern.

and fruitful collaboration with industry which Bogler and Lindig had been working toward. This served as an artistic experimental laboratory for the Berlin State porcelain factory. Otto Lindig stayed in Dornburg and continued the stable work-shop from April of 1926 as the "Ceramics Department of the State Building School of Weimar." In 1930 he took over the management of the workshop in his own right and ran it until 1947. Ceramics ceased to have any further significance in the development of the Bauhaus in Dessau and Berlin. Although the Bauhaus still owned the right to sell industrially produced porcelain, none of the crockery was produced any longer. However, the ceramicists who had been trained in Dornburg found good opportunities to perfect and realize their pioneering ideas.

# Japan and the Bauhaus Pottery

Cornelia von Buol

After Japan opened up to the West from 1854, a veritable flood of cultural goods and ideas reached Europe from the East. Everything to do with Japan became extremely fashionable, especially in artistic circles. Henry van de Velde was one of the leading experts on Japanese aestheticism. His design activities for, among others, Samuel Bing, the well-known Paris dealer in Japanese goods, had made him extremely knowledgeable about Japanese ceramics. In 1902 van de Velde was appointed artistic advisor for industry and arts and crafts to the Grand Duchy of Weimar-Sachsen. In this role he was determined to pass on the highest technical and artistic standards to the traditional potters. The main lessons to be learned from Japanese ceramics were the clear simple designs, outstanding glazing and sensitive use of clay. Van de Velde founded the "Arts and Crafts Seminar" in Weimar and then the Arts and Crafts School to improve training. Otto Lindig, who was later to have a considerable influence on the Bauhaus pottery, completed his studies at the Arts and Crafts School at the time of van de Velde between 1913 and 1915.

**Theodor Bogler, Small teapot.** 1923, reddish brown stoneware material, cast and assembled, inside glazed in matt black, outside light gray and mainly reddish brown glazing, height 6.7 cm, BHA. • This variant on the combination teapot has a tubular handle to protect the hand from heat, the positioning and form of which appears new and unusual. The separately cast elements could be attached to the body of the pot in different ways. It is very likely that a shape of teapot popular in Japan served as an example.

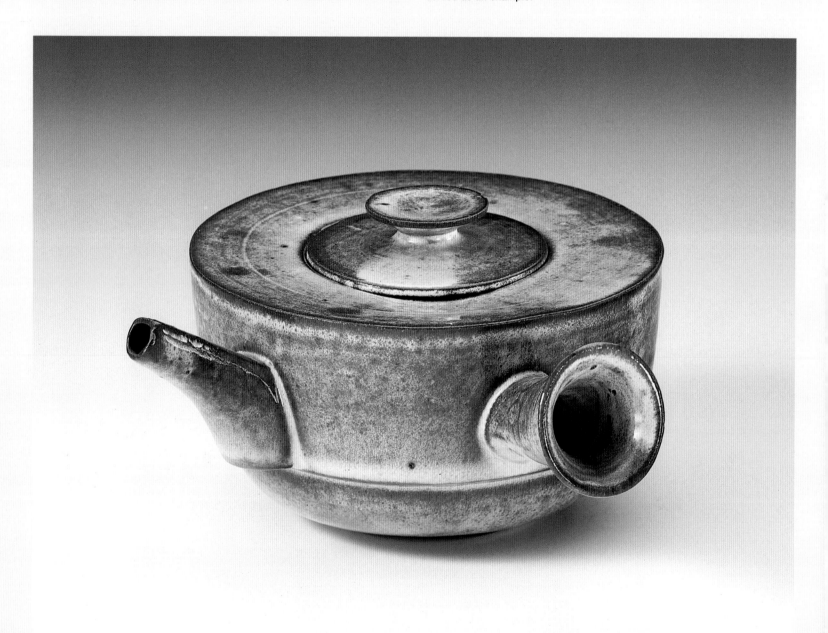

This interest in Japanese designs was thus handed down from van de Velde via Lindig to the Bauhaus pottery.

A connection between the Bauhaus and Japan existed in the person of probably the most unconventional master in Weimar: Johannes Itten. Before teaching at the Bauhaus he had studied Far Eastern art and philosophy intensively and the results had found their way into the Bauhaus preliminary course. Evidence for this can be found both in the analyses of East Asian watercolors and in the study of materials. They were both intended to enable students to discover the qualities of a particular material. Every student was supposed to recognize and make use of their personal talents in the way they used materials. This procedure corresponds to the sensitive ability of Japanese craftworkers to bring out the fundamental characteristics of the raw materials rather then concealing them.

Astonishingly, in Japan the Mingei movement (producing handicrafts by ordinary people for everyday use) developed in parallel with the Bauhaus with the support of an outstanding personality, Soetsu Yanagis, a philosopher and cultural critic. After industrialization had made ever greater progress in Japan, Yanagis became dissatisfied with the quality of the majority of machine-produced goods and looked for new inspiration and designs. In this search he came across traditional handicrafts and began to collect them. For him, beauty was inseparable from both an object's suitability for the purpose for which it was designed and its daily use. He rejected both art for art's sake and purely decorative handicrafts. Sharing the opinions held in the Bauhaus pottery, particularly by the work master Max Krehan, he focused on tradition. New works, however, were not supposed to arise as a result of merely adopting techniques and designs, but as a result of reflection and a kind of exchange with these traditional works. Education also had a role to play in this context. Quality craftwork should connect art and everyday life, art and craft in a way similar to the reformist beginnings of the Arts and Crafts movement in the 19th century up to those of the Bauhaus.

The strength of Japanese Mingei designs lies in their design which concentrates on the bare essentials and is characterized by clarity and austerity. Simplicity is an expression of quality harmonizing with beauty. The balanced and simple design is more important than the eccentric, artistic solution. Mingei ceramics exude a harmony based on the balance between straight and curved elements, between austerity and softness. The creative quality can be seen in the connection between its intended use and the sparse decoration. Superficial glazing is never used to beautify or conceal a balanced design. Rather, the simple, elegant, often monochrome glazes enhance the extraordinarily "simple" creations. In this way they are similar to Bauhaus ceramics, as well as in their choice of colors for the glazing and the textures.

The Japanese influence is most noticeable in one of the most famous Bauhaus ceramics, Theodor Bogler's 1923 teapot. It was finished with different glazes and the individually cast components could be assembled into several different models. One had an unusual side-mounted tubular handle. It slants upward and outward and is mounted almost at right-angles to the spout, so allowing comfortable pouring. The hollow shape of the handle prevents it from becoming too hot. The lid can easily be held with the thumb.

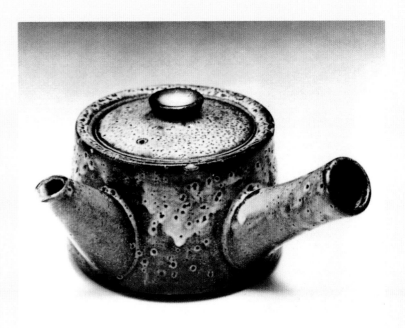

**Designer unknown, "Kyusu."** 20th century, Japan, small stoneware teapot with a side-mounted handle, BHA. • Tea ceremonies which, like the art of Ikebana and Kabuki Theater, are so characteristic of Japanese culture, underwent three transformations in the course of the eight centuries of their existence: one is medico-religious, one is luxurious and one aesthetic. The pottery services used were the only constant element of the rituals and were handed down over the generations as a valuable family inheritance. The observance of a complicated code of etiquette is an important part of the ceremony as well as a respect for the simplicity which is expressed in the noble harmony of the tea implements.

The teapot is captivating in its simplicity and clarity of design and is, above all, a functional object.

Exactly this type of teapot with a handle on the side was and is extremely common in Japan. Just such a small Japanese teapot can be found in the collection of Bauhaus ceramics in the museums of the city of Gera. As a single piece located together with the Bauhaus items, it may well have served as a visual aid for the Dornburg Bauhaus pottery. The Japanese origins can clearly be seen from the characteristic tubular handle.

The search for aesthetically satisfying ways of achieving serial production led both cultural groups, quite independently, to focus anew on traditional methods. Both the members of the Mingei movement and the Bauhaus potters found examples of designs which were determined above all by their function. The Bauhaus apprentices were extremely keen on experimenting and absorbed inspirations other than from Japanese ceramics, and in this way developed new, unconventional items which belonged in the European tradition and yet had a hint of Japan about them.

# The Wall Painting Workshop

Sabine Thümmler

"White, everything must be white" – this much-quoted essay by J. E. Hamman in the magazine *Die Form* of 1930 refocused attention on the colors used in the interior designs of the "New Building" and also those used at the Bauhaus. Both the use of white in the façades of Walter Gropius's buildings and the purist white phase of his French colleague, Le Corbusier, were adopted with such excessive

zeal that colored interior designs of the 1920s were largely ignored. It was for this reason, and also because the interior designs carried out by the Bauhaus have been more or less lost, that in retrospect the wall painting department has received less attention than other workshops, even though they had developed one of the classic products which perfectly fulfilled the later principles of

the school and, additionally, brought in the greatest license revenue: namely, Bauhaus wallpaper.

In contrast to the other famous architects of the time, such as Bruno Taut or Le Corbusier, the teachers of wall painting classes did not write anything theoretical about their work or their approach to color, apart from some short notes. Walter Gropius expressed himself later

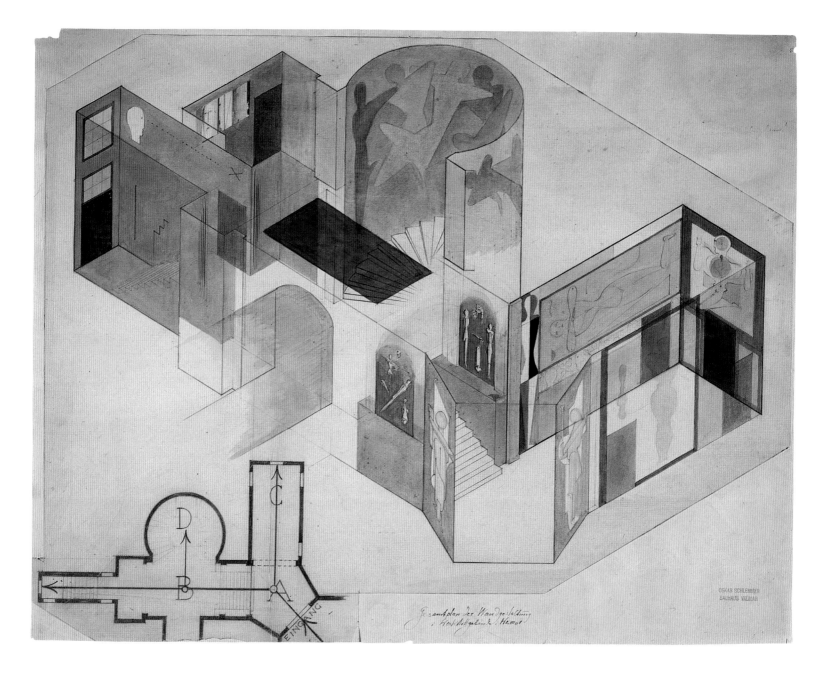

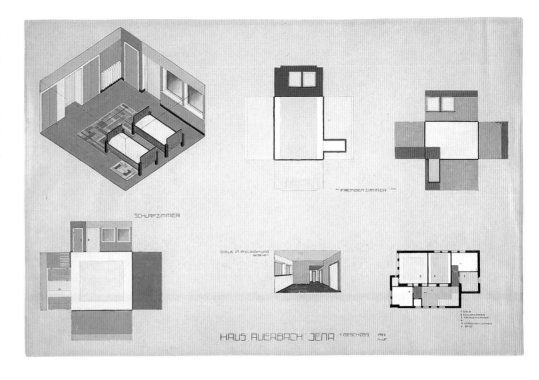

**Alfredt Arndt, Final ground plan and perspective view of the color design for the Auerbach house in Jena.** 1924, tempera and Indian ink on paper, cut out and glued to another sheet of paper, inscribed, 56.5 x 86.0 cm, BHA. • Every architectonic detail of area or line is treated with a contrasting color. The architectural proportions which produce tension are repeated on the floors or the ceiling and focus attention on the quality of the Gropius building. This analytical and inventive plan would not have been possible without the influence of Hinnerk Scheper.

**Peter Keler and Farkas Molnár, Interior design for a passage.** 1923, lithograph from *Weimar State Bauhaus 1919–1923*, Weimar, color plate VI, BHA. • This gateway shows particularly clearly how ideas from De Stijl also influenced students of wall painting. Shining yellow walls and a dark ceiling stand next to each other and act as a painting. The art of painting and the wall painter's color plan have come together.

**Oskar Schlemmer, Overall plan of the wall designs for the workshop building in Weimar.** 1923, pencil and watercolor on handmade paper, mounted on card, 42.5 x 55.0 cm, Oskar Schlemmer Stage Archive. • Due to the lack of contracts the workshop initially set about decorating the Bauhaus and under Schlemmer's leadership created a cycle of wall paintings for the stairwell of the workshop building.

on this subject in a way that almost suggested it was taken for granted: "Everyone knows from experience how much the design of their own four walls or of their working rooms consciously or unconsciously affects their mood. The walls which we put up to protect ourselves, to separate ourselves from nature or from other people can become a prison or a source of wellbeing; they can make us either cheerful or serious, relax us or stimulate us. These effects can only be partly explained by the relationship between the actual, measurable proportions and size of a room; the effects of the optical illusions created by the purely superficial treatment of the walls are often much greater and cannot be ignored. Dark colors make the walls appear to recede, active bright colors have the opposite effect. Identical rooms in an apartment block may in one case appear attractive, in another repellent or neutral depending on whether the designer understands how to add another dimension appropriate to the human psyche by the use of color, texture and design of the wall surfaces. This influence may even go so far as to give the impression of greater warmth in a room if, for example, instead of 'cold' blue or green, 'warm' yellow or red is used on the walls"

("Ausserordentliche Wirkungen erreichen" [Achieving extraordinary effects] in *Die Leistung* [Achievements], 1960, p. 3).

It was painting that provided the spur for a critical examination of the use of color in modern architecture. Le Corbusier was a painter as well as an architect, the Dutch De Stijl movement brought together the painter Theo van Doesburg and the architects J. J. P. Oud and Cornelis van Eesteren, and even Bruno Taut had wavered between painting and architecture at the beginning of his career. It is also no coincidence that the painter Wassily Kandinsky, after initial attempts under the guidance of Itten and Schlemmer, should have worked out the basic principles of wall decoration. The unity of the arts under the leadership of architecture demanded in the founding manifesto of 1919 thus found their logical expression in the founding of a workshop for wall painting. Johannes Itten and Oskar Schlemmer took the class in turn during the first Weimar semester. After attempts to get commissions had failed they initially confined themselves to decorating their own school. According to Lou Scheper's notes this appears to have been carried out in a free, improvised fashion using bright colors in a

also affected the use of color" ("Rückschau" [Retrospective] in *Bauhaus und Bauhäusler* [Bauhaus and Bauhaus Members], Eckhardt Neumann [ed.], 1971, p. 93 ff.).

The influence of Johannes Itten led to a preference for a mixed color scheme, using brown and green, which was still bright but not clear, in order to show off the decorative pieces on the wall. In December of 1920 the Berlin newspaper *Die Tägliche Rundschau*, obviously irritated, wrote about the decoration in the corridors: "they have painted the corridors according to their own taste, every wall and pillar different. A dirty ocher yellow is next to a poisonous yellow-green, Pompeian red next to dirty copper, a door painted with a sad blue oil paint next to a pilaster in a faded blue wash, above the ocher yellow there is a meter-high frieze drawn with red chalk and black. There are many hieroglyphics, arrows, spirals, eyes, parts of steamships, letters of the alphabet...." These were really decorative

**View of Paul Klee's studio.** 1927, photograph by Lucia Moholy, BHA. • The curtained wall closet on the right was used, like the wall shelf above it which extended over the length of the room, to store paintings, frames and portfolios of drawings. Klee had decorated the small corner area opposite the studio window with small paintings.

**Fritz Kuhr, Color plan for Paul Klee's studio in the master's house in Dessau.** 1926, executed early in 1927, tempera, silver bronze and pencil on paper, 24.0 x 34.0 cm, BHA. • The design of this room in calm shades of blue and gray seems to be been based on the effect of the black end wall, which was intended for hanging pictures. Ise Gropius, in contrast, chose a black and yellow studio.

manner influenced by Expressionism. "When we painted the canteen (in May of 1921), the walls and the ceilings, the furthest corners of which could only be reached by throwing sponges dipped in paint, were a veritable playground of lively, very patchy decorations and the most cheerful colors. We worked together at the task of painting and spraying, with both pleasure and a bad conscience, as we knew that our work was completely unfunctional.... Itten, the law giver, demanded that we should alternate between our expressive exuberance and a joyless gray-green as a background for a Far Eastern epigram.... But that was the end of his influence on wall painting at the Bauhaus. It was the end of the view that saw a room as merely housing people rather than as an architectonic creation which drew them inward and separated them from the outside, an almost monastery-like conception, which

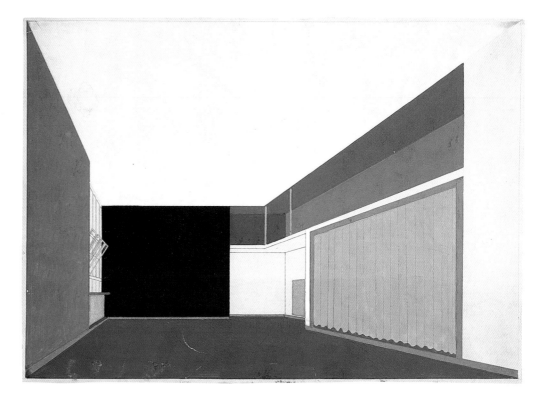

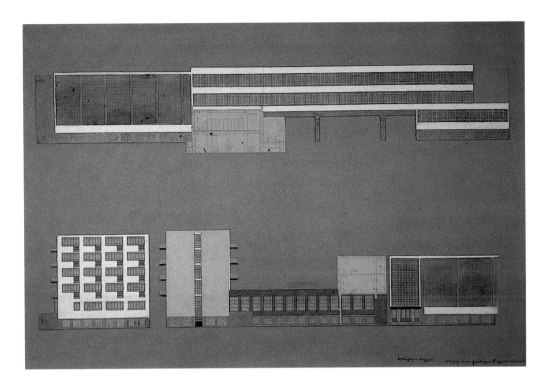

**Hinnerk Scheper, Dessau Bauhaus/rough for painting a colored façade.** September, 1926 tempera and Indian ink applied over blueprint on gray card, 68.5 x 100.0 cm, Scheper Estate, Berlin. • It was never intended to paint the façade of the Bauhaus in color. Scheper's concept was, however, realized in the interior: "Color should not be used as a disguise, but should function as a part of the architecture."

**Hinnerk Scheper, Colored organizational plan for the Dessau Bauhaus.** 1926, tempera and Indian ink on paper, mounted on cardboard, 100.0 x 69.0 cm, BHA. • With highly topical subjects like "organisation" and "orientation" Scheper suggested new areas in which wall painting could become involved. This rough coincides with Herbert Bayer's idea of letting part of the advertising course be devoted to wall painting. Consideration was obviously being given to points of contact between subject areas.

paintings, which were particularly popular at that time as an alternative to rooms with papered walls, but which were much more radical and less pleasing.

Oskar Schlemmer was to provide one of the most important examples of interior design of those days with his design for the fitting out of the entrance hall and the stairwell in the workshop building. Schlemmer and his students covered Henry van de Velde's sober interior design with murals and reliefs for the great Bauhaus exhibition of 1923, which were destroyed as early as 1930 on the orders of the Thuringian Nazi government. However, we are able to gain an impression of the work from historic photographs and a color model by Alfred Arndt, a Bauhaus student of the time, which he constructed in 1955 from old documents. In the center stood a composition of figures, which Schlemmer supported on ethical grounds and which he intended to be the central theme for the wall painting. The entrance hall, the ante-room to the stairs and the curved wall of the stairwell, as well as a corridor and a niche on the top floor, were all decorated with reliefs and huge friezes of figures in an abstract design typical of Schlemmer, while geometric designs appeared on the ceilings. He chose earth colors which could be varnished and metal colors, gold, silver and copper. The large curved wall of the stairwell

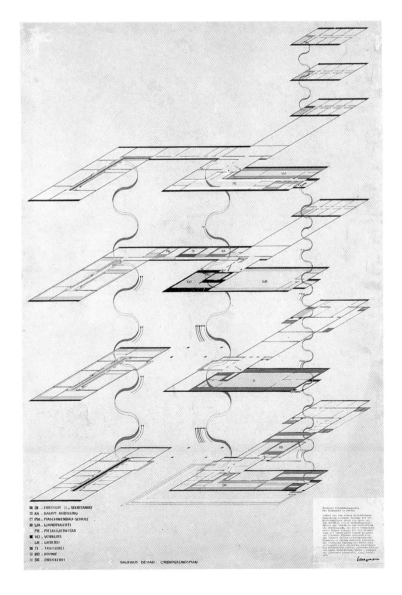

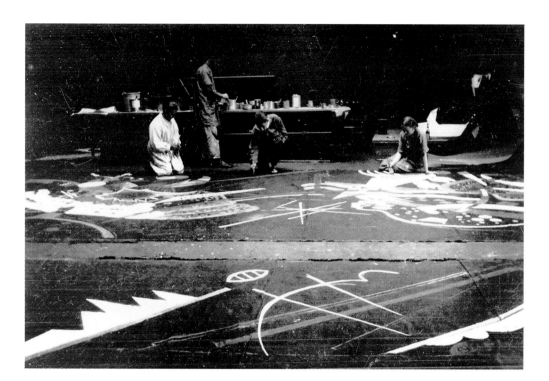

**Bauhaus students producing screens for the wall painting exhibit in the Juryless art show, Berlin.** 1922, photographer unknown, Getty Research Institute, Research Library. • The screens were painted in the main hall of the Bauhaus building under the direction of Wassily Kandinsky.

**Wassily Kandinsky, Design for the B mural at the Juryless art show, Berlin.** 1922, gouache and white chalk on black paper, mounted on card, 34.7 x 60.0 cm, Musée National d'Art Moderne, Centre Georges Pompidou, Paris. • "My dream is to make synthetic work in space, in other words to make it work together with the building," stated Kandinsky in 1924. Creating monumental pictures delighted him. This is one of several murals, many of which had a width of some 8 meters, intended for an octagonal room which was never built.

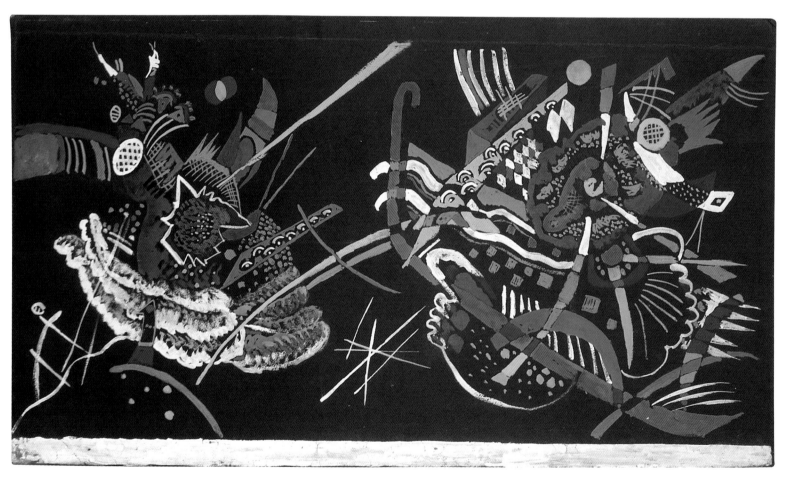

had a pale violet background, against which figures in caput mortuum (a red iron-oxide color), light madder red, light ultramarine, umber, violet and madder red were placed. The windows on the ground floor were painted matt blue and the doors bluish black. The overall effect of Schlemmer's work, with the contrast between the different red and blue tones, must have made for an exceptionally delicate color scheme.

Even under Wassily Kandinsky, who led the wall painting workshop from 1922 to 1925, large murals were created. Kandinsky worked intensively on the phenomenon of color; he introduced a system in which the individual

techniques were taught, starting from the building up of the ground for the painting via the characteristics of the different pigments and binders to the different ways of applying paint. Considerable time was spent on teaching the tools of the craft, for example, applying the ground, painting with distemper and the techniques of fresco and sgraffito. The psychological qualities of color, i.e. the creative effects, were investigated as well their chemical and physical qualities. Here Kandinsky noted, "Among the many powers of color, the most important, for the Bauhaus, is its power to change the original form of something into one that is completely different. This ability of colors to shape a given space in a variety of ways is one of the most important concerns for the Bauhaus" (Hans M. Wingler,

**View of the recess, partly covered with gold leaf, in the living room of Kandinsky's master's house.** About 1928, photographer unknown, Musée National d'Art Moderne, Centre Georges Pompidou, Paris. • Kandinsky used color to design his rooms and give them their atmosphere. The living room had bright pink walls, a color which he associated with softness and insubstantiality. The ceiling was gray, a color which was supposed to reduce the "oppressive" aspect of architecture more effectively than white. In addition contrasts such as reflective gold and black doors emphasized the tensions felt in the existing architecture.

**Wassily Kandinsky, Questionnaire of the wall painting workshop, filled in by an unknown Bauhaus member.** 1923, lithograph, pencil and crayons on paper, 23.3 x 15.1 cm, BHA. • For Kandinsky it was unthinkable that the teaching of color should be seen in isolation. He always saw it in combination with the form in which it appeared. He tried to verify empirically his theory of the correspondence between certain basic geometrical shapes and primary colors by carrying out a survey at the Bauhaus.

**Herbert Bayer, Wall painting at the entrance to the small stairwell of the Bauhaus building in Weimar.** 1923, photograph by Lucia Moholy, BHA. • Beginning with circular motifs on the ground floor, the floors above are decorated with squares and then circles. Following on from Kandinsky's monumental projects, the geometry became huge, the primary colors used are once again reminiscent of Kandinsky's theory of correspondence. But as a budding commercial artist Bayer perhaps saw the series of paintings as an aid to orientation, an early form of the guidance system which is common today.

*Das Bauhaus*, Bramsche, 1962, p. 93). His teaching also involved various speculative experiments and the working out of ranges of color scales. A questionnaire was developed for this and was given to all members of the Bauhaus in order to determine the psychological effects of the interplay of shape and color. Red, yellow and blue had to be assigned to either a triangle, a square or a circle. The majority chose a yellow triangle, a red square and a blue circle. Beside the imaginative pictures carried out under Oskar Schlemmer, mentioned above, other creations of the wall painting workshop, revealing the influence of Kandinsky's teaching, were shown at the famous Bauhaus exhibition of 1923. For example, Herbert Bayer decorated the small stairwell in the main building to show how experiments on the connection between form and color worked out in reality. The first floor therefore received a composition in dark blue with circles, the second floor was painted in bright red with squares and the third floor in bright yellow with triangles. The various painting techniques, fresco, sgraffito and distemper, were displayed in the rooms of the workshop. Herbert Bayer, Rudolf Paris and Walter Menzel, among others, had designed

wall paintings based on constructivism which consisted of overlapping geometric patterns using a strong color scheme. Peter Keler and Farkas Molnár veered away from this kind of decorative wall painting and used color as an architectonic tool, or rather as a means of dividing up space. They had painted the walls of the passage to the Belvedere-Allee with areas of color which were juxtaposed in such a way that they both changed the area and created tension. The influence of the De Stijl movement on the Bauhaus can easily be seen here, particularly in the powerful use of the three base colors supplemented by white, black and gray.

When the Bauhaus moved from Weimar to Dessau, it departed finally from expressionist and arts and crafts tendencies and turned to an industrial design style. This brought about a fundamental change in the work of the wall painting workshop. Figurative decorative painting was given up in favor of designs related to areas. The best example of this is the use of color in the decoration of the masters' houses built by Walter Gropius in 1925–1926. The organization of the space inside the living accommodation was emphasized by the use of contrasting colors for the walls, ceilings,

**Franz Ehrlich, Color plans for a building, study sheet from Joost Schmidt's course.** 1928, tempera on paper, 74.0 x 60.0 cm, SBD, archive collection. • Franz Ehrlich was one of the students who exploited the breadth of the Bauhaus training. He later worked as a graphic designer in advertising, as an exhibition designer and as an interior designer.

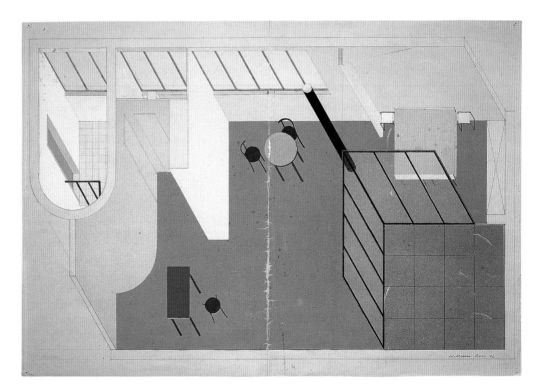

**Wilhelm Jacob Hess, Color plan for an apartment in the Junkers housing development.** 1932, Indian ink, pencil and tempera on drawing paper, 41.5 x 60.2 cm, BHA. • Color is not used in this student's exercise as a dominating element, but rather to clarify the architectonic structures.

corners, doors, etc., in which every space was seen as a unit. Nina Kandinsky remembers her apartment in Dessau in the following way: "The living room was painted with bright pink distemper, and a recess was covered with gold leaf. The bedroom was painted in almond green, the studio and the spare bedroom in bright yellow. The walls of my small private room shone with bright pink ... every space an architectonic unit" (*Kandinsky and I*, Bergisch-Gladbach, 1978, p. 121).

Hinnerk Scheper led the workshop in Dessau, where he had once been a student, from 1925 and later in Berlin. Alfred Arndt, who had been a student with him, stood in for him during his eighteen-month stay in Russia. Hinnerk Scheper was primarily concerned with colorful painting to emphasize the architecture and colorful interior design. Unlike many color designs of the 1920s, Scheper's colors never became the dominant element. Wall painting was subordinated to the architecture, and color was used to emphasize and separate space. In contrast to someone like Bruno Taut, who rigorously rejected mixed or pastel colors, he favored a subtle, very pale color scheme with subdued pastel colors. The teaching in the workshop now included a more diverse training in theory and practice. The timetable covered all the different grounds, such as distemper, plaster of Paris, marble dust or alabaster plasters, repairs to plaster, wood and metal, every known painting technique with different kinds of paint, such as distemper, mineral, wax, gloss, etc. New techniques were developed and tested. The fundamental concepts of color harmony were studied as well as design, erecting scaffolding and book-keeping.

Scheper was entrusted with the color design of the new Bauhaus building in Dessau by Gropius. Scheper incorporated fundamental considerations on color design in his color organizing plan: "In the design a clear distinction is drawn between areas which are load-bearing and those which merely fill space, so that their architectonic significance is clearly expressed. The spatial effect of the color is increased by the use of different materials: smooth, polished, grainy and rough areas of plaster, matt, dull and bright shiny paints, glass, metal, etc." ("Experiment Bauhaus," exhibition catalog, Bauhaus Archive, Berlin, 1988, p. 294). Scheper not only played with

**Hinnerk Scheper and students of the wall painting workshop.** About 1926, photographer unknown, BHA. • The head of the wall painting workshop, Hinnerk Scheper, had studied this subject under the form masters Itten and Schlemmer. In his later career work he developed his view that color design should be used to support the existing architecture.

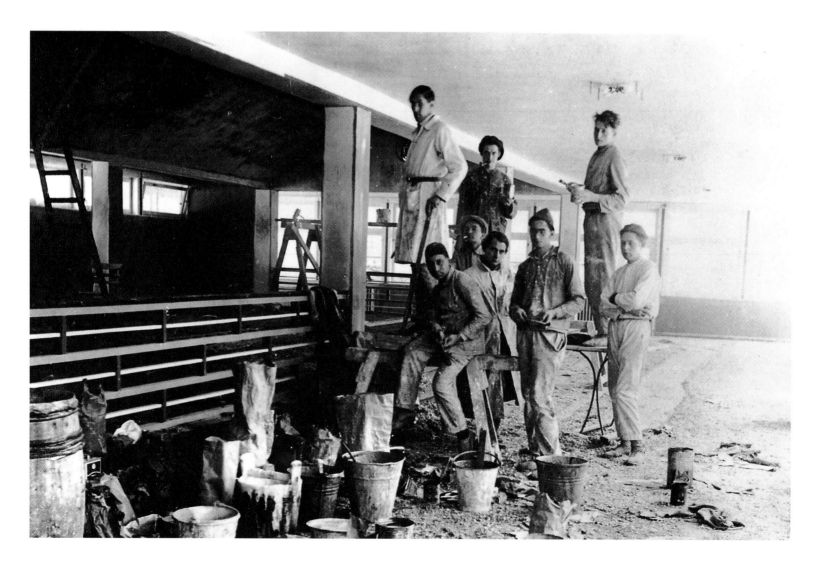

shades, but also with the harmonies of the frequently varied colors and materials used. Old color photographs of the stair area and the teachers' room have survived which show the discreet way in which Scheper used color. Large areas were painted white, while the load-bearing and intervening parts of the ceiling, as well as corners and structural parts, were emphasized in shades of blue, red and yellow. Describing his handling of color, Scheper wrote: "It is less a matter of personal taste, which is aesthetically determined; rather it is linked to laws of design and technique. The principle of color for interior design must therefore be determined by the basic architectonic form. Balance in the color scheme is achieved by the relationship between the quantity and intensity of pure colors to neutral shades. Imbalances disturb the atmosphere, the

right balance creates a new, clear space which feels like a convincing architectonic structure. Color should not disguise but must function as a characteristic of the architecture ... the most important function of color is its psychological effect on people. Color can have an uplifting or depressing effect, it can make spaces larger or smaller, fresh and energizing or sad and tiring" ("Bauhaustapete. Reklame und Erfolg einer Marke" [Bauhaus Wallpaper. Advertising and Success of a Brand], exhibition catalog, Bauhaus Foundation, Dessau, Cologne, 1995, p. 90). Scheper's creative reticence may well be explained by the fact that his color scheme was not designed in conjunction with the architecture, as it was with Le Corbusier. The wall painting workshop went through all the artistic phases. The last ones produced the successful Bauhaus wallpapers.

# The Noble Simplicity of the Roll – the Bauhaus Wallpapers

Sabine Thümmler

From 1926 to 1928, when Gropius built the Dessau-Törten housing development and the extension at the Bauhaus, the wall painting workshop was faced with the task of decorating a considerable number of dwellings. Although the use of wallpaper was discussed at the Bauhaus, a firm decision was made against this despite the rational way it could be used. Wallpaper did not fit in with the Bauhaus's ideas of doing justice to the material and was considered a second-rate product with tasteless patterns. But when the Weimar Republic's big housing schemes were built, wallpaper was reconsidered from the point of view of a building material, as a sort of finished component.

The decisive breakthrough was made by the wallpaper manufacturer Emil Rasch. The son of the chairman had connections with the Bauhaus via his sister who had studied there during the Weimar period under Feininger and Kandinsky and had met Hinnerk Scheper as a fellow student. In 1928 Scheper arranged for Emil Rasch to contact the then head of the Bauhaus, Hannes Meyer, who initially viewed wallpaper with some skepticism, although, from the point of view of socially oriented design work, he did want to produce a limited number of standardized products which would be widely used. It was only when Rasch convinced him that wallpaper did fit in with the Bauhaus concept as an effective and reasonably priced industrial building material, that Hannes Meyer consented. "Bauhaus wallpaper therefore arose out of the Bauhaus's dislike of wallpaper,"

as Hinnerk Scheper put it paradoxically ("Wie die Bauhaustapete entstand" [How the Bauhaus wallpaper started], in *Werk und Zeit* [Work and Times], 1955, special supplement by Rasch). In March of 1929 an exclusive agreement for a range of wallpapers was signed between the Bauhaus and the Hannover wallpaper factory of the Brothers Rasch and Co. Every design and color had to be expressly agreed by the Bauhaus, which also retained the right to design and produce the advertising material and so be able to create a publicity image according to its aesthetic precepts.

The work was given to the wall painting workshop. First of all there was a competition open to all students. This, however, made it obvious that there was no consensus about what a wallpaper created by the Bauhaus should look like: "Believe it or not, there were some with fishes, birds, flowers and geometrical patterns, and little men made of triangles and circles. It was a nightmare because there were so many different attitudes to the wall" (Hans Fischli, quoted in "Die Bauhaus-Tapete" [The Bauhaus Wallpaper] in *Bauhaus-utopien* [Bauhaus Utopias], Wulf Herzogenrath [ed.], Stuttgart, 1988, p. 181). From the many designs submitted, the jury, which consisted of the teachers Josef Albers, Ludwig Hilberseimer, Hinnerk Scheper and Joost Schmidt, only chose those which were based on patterns and which agreed with the basic design principles of wall painting which had been worked out. One of the winners, Hans Fischli, put into practice the methods Josef Albers

**Joke photograph.** Undated, photographer unknown, The J. Paul Getty Museum, Los Angeles. • Masquerade of the roll: At first people at the Bauhaus thought wallpaper was a bad substitute for the effectiveness of surfaces using real materials.

**"Bauhaus Weimar May,"** wallpaper samples from the Rasch company, Bramsche. 1937, proof of a color advertisement, BHA. • The origin of the first range of Bauhaus wallpapers can be traced to the delicately colored plaster patterns, like those that the Scheper workshop enjoyed using. This cheap form of lively color design was industrially produced on paper rolls and had a lasting success. The Bauhaus paper can be seen here next to conventional wallpaper designs of the time, which were also manufactured by Rasch.

taught in the preliminary course on the subject of wallpaper: "Albers taught us ... to create a maximum of images using a minimum of materials" (Hans Fischli, "Bilder, Zeichnungen and Skulpturen" [Pictures, Drawings and Sculptures], introduction to exhibition catalog, Zug, 1986). Fischli experimented with a great variety of paint additives and produced textured paint which he applied on the paper with forks, combs, etc. His intention was to reproduce the surface appearance of different materials. Another winner was Margaret Leiteritz, who came up with restrained, discreet patterns with ruled lines and screen dots. Other designs going in this direction, such as those by Siegfried Bormann, showed fabric patterns and the like rubbed with red crayon. Bauhaus wallpaper was born from this rejection of traditional ways of decoration and its characteristics were fixed by a very few Bauhaus students.

The first Bauhaus pattern book was ready in September of 1929. It showed a total of 14 designs, ranging from blurred crosshatching, vertical and horizontal hatching, through the finest half-tone screening and grid patterns, relieved by different thicknesses and waves created by a comb. Three different tones of a pastel shade formed one pattern which created a blurred effect on the wall and only allowed the overall color to show. Scheper set up these finely graded color schemes and color variations directly on the printing machines with his students. In this way he realized his guiding principle of transferring the Bauhaus concept of color and surface effect from plaster to paper, and created a product which, because of its reasonable price, appealed to wide sectors of the population. As far as the housing developments were concerned, Bauhaus wallpaper was able to compete on price with paint. As a result, slogans such as "modern," "bright" and "practical" for "the people's housing" were used in the advertising.

Bauhaus wallpapers were also produced in the Berlin period. When the Bauhaus closed in 1933, Emil Rasch acquired from Mies van der Rohe the contractual right to continue to manufacture the range under the brand name "Bauhaus Wallpapers." New patterns,

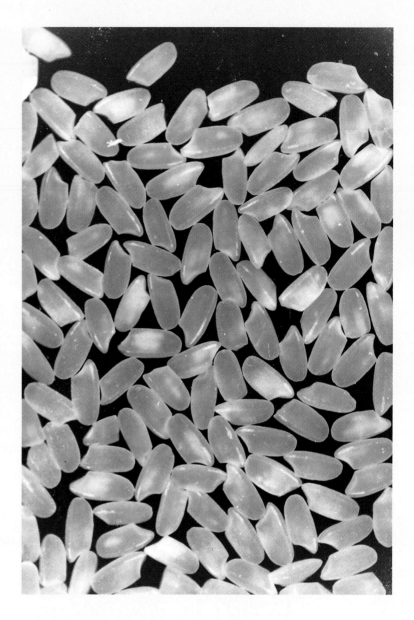

**Hermann Fischer, Photogram.** About 1923, gelatin process, glossy, 12.1 x 8.9 cm, BHA. • As can be seen in this photogram design, small abstract patterns and random designs using tiny particles were particularly favored as an alternative to the usual large flowers or arabesques. This made Bauhaus wallpapers suitable for small rooms too. They helped to smooth out uneven parts of the wall and the almost invisible joins reduced waste.

**Hermann Fischer, Production sample for Bauhaus frosted glass.** 1931–1932, glass etched on one side, approx. 10.5 x 15.0 cm, BHA. • The designer of this retail product had to organize the pattern in such a way as to give an overall impression of opacity.

consistent with Bauhaus ideas, were added to the existing ones up to 1940–1941. Bauhaus wallpapers have continued to be printed from the end of the war up the present day. Scheper was asked to look after the collection and do the design work in 1952–1953 and 1953–1954.

For all that, Bauhaus wallpapers were not particularly outstanding. "Bauhaus wallpaper is certainly nothing exceptionally new for the specialist. We have sample books from different factories with similar wallpapers which appeared two to three years before the Bauhaus wallpaper and are identical to them. These wallpapers had very little success at the time because they did not have the generous advertising supplied by the Bauhaus ...." (*Deutsche Tapetenzeitung* [German Wallpaper Magazine], 1930, p. 100). What was being alluded to were collections, like for example the "housing development plain papers" and the "housing development grids," which Hans Liestikow had been involved in designing for the large Frankfurt housing developments. The success of the Bauhaus wallpapers can be explained through their concept of a standardized collection with a long life, the technical and creative perfection they offered for a low price, the aggressive advertising method used, and most of all through the effect of the Bauhaus name and the reputation of that institute. "Calling them 'Bauhaus' wallpapers worked wonders in the battle against wall painting, and against the basically anti-wallpaper attitude of modern architects" (*Deutsche Tapetenzeitung* [German Wallpaper Magazine], 1932, p. 286).

**Irene Hoffmann, Design for a Rasch poster.** 1930, collage, gouache, 64.8 x 48.3 cm, Misawa Bauhaus Collection, Misawa Homes Co. Ltd, Tokyo. • A contract for collaboration between the wallpaper company Rasch and the Bauhaus released a veritable flood of wallpaper designs. This meant that the advertising for the successful Bauhaus product became an important part of the advertising course.

**Josef Schmidt, der bauhaustapete gehört die zukunft (the future belongs to bauhaus wallpaper), designs for the first catalog of Bauhaus wallpapers.** 1931, photograph, gelatin process, 15.0 x 20.7 cm, BHA. • Bauhaus wallpaper as an accessory of modern living, communicated in up-to-date photographic language. Perhaps too arty, Rasch may well have remarked, too little wallpaper! Instead, the reflecting sphere on the final cover shows how the room could be elegantly transformed by wallpaper.

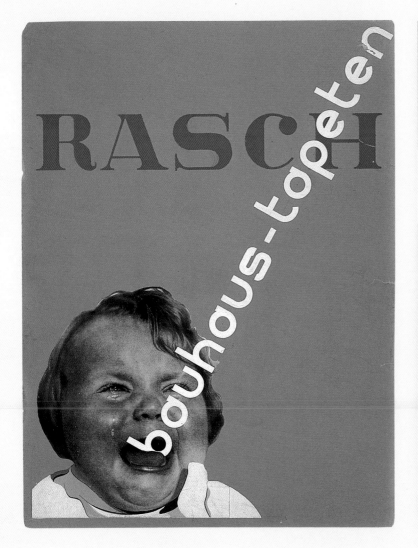

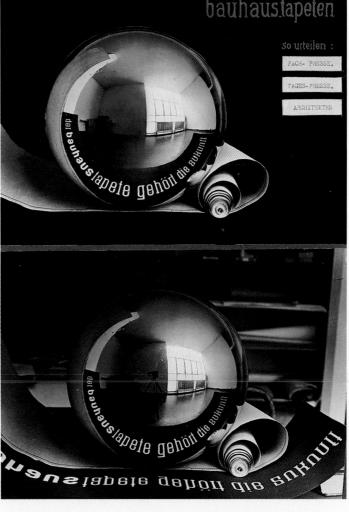

# The Weaving Workshop

Anja Baumhoff

Oskar Schlemmer once joked that "where there's wool, you'll find a woman weaving, even if it's just to pass the time," referring to the weavers of whom he was personally very fond. Nevertheless, his attitude to questions of gender, like that of his male colleagues, was surprisingly conventional. The Bauhaus women themselves were not always aware of this, but some of them noticed the discrepancy. This was particularly true of those who found difficulty in comparing weaving as a feminine pastime with the image of the new woman in the '20s, complete with bobbed hair, cigarettes and personal ambition. At the Bauhaus itself, many female students wanted to develop

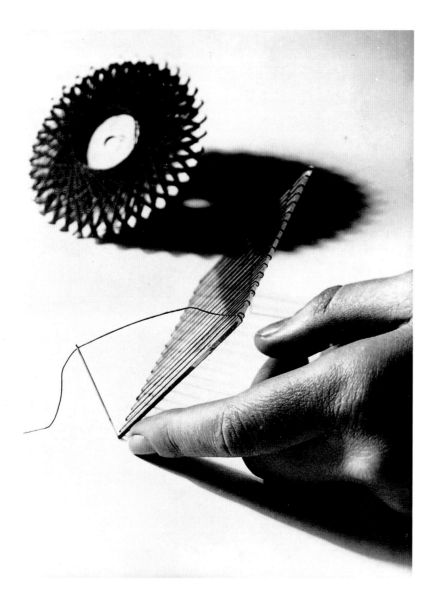

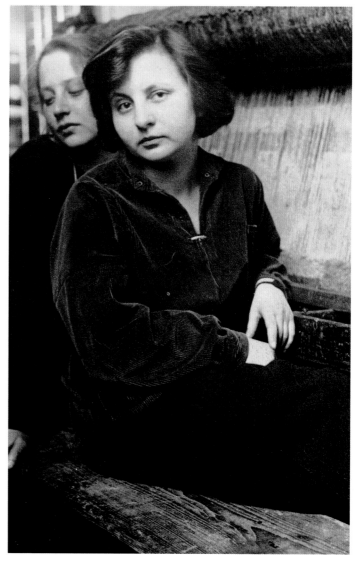

**Photo-composition, Still life for the Bauhaus weavers.** 1922, photograph by Georg Muche, BHA. • In 1921 training in "the craft of textile techniques" included weaving but also knotting, crocheting and sewing. Until 1927 Muche was form master in the workshop, which soon evolved into a workshop devoted solely to weaving.

**Gertrud Arndt and Marianne Gugg at the loom.** 1924, photograph by Walter Hege, BHA. • Some Bauhaus masters found it inconceivable that the women weavers might seriously pursue a professional career.

**Michiko Yamawaki at the loom.** 1931, photograph by Hajo Rose, BHA. • Together with her husband, Iwao, who had also studied at the school, Michiko Yamawaki took the Bauhaus idea over to Japan.

**The weaving class at a loom.** 1928, from the portfolio "9 jahre bauhaus. eine Chronik" (9 years of bauhaus. a chronicle), 1928, collage, artist unknown, photograph by T. Lux Feininger, photomontage with pull-out photographs on tabs, mounted on blue card, 41.7 x 59.3 cm, BHA. • The playful combination of individual facial features and the vertical textured covering of the loom conveys the idea that the creative potential of the Bauhaus women is in their enjoyment of work.

independently, meaning that the choice of workshop did not always work out in the interests of the Bauhaus masters.

Since female students initially constituted the majority, the masters sought to deal with the influx of women by reserving the well-equipped weaving studio as a workshop for the Bauhaus women. This decision represented hardly any loss at all to the male students.

Career prospects in the textile industry were generally poor at that time, as the manufacture of fabric had been automated by industry, whereas working at the loom, as was usual at the Bauhaus, mostly generated expensive one-off articles. Geared as it was to the production of these individual and least profitable

handcrafted items, weaving seemed remote from the future-oriented methods associated with industrial mass production. For men this field held no interest, although there were exceptions. Many women at the Bauhaus carved an independent route for themselves, one which did not necessarily fit with the accepted attributes of their gender at the time. Some of the "ladies," as the director called them, would repeatedly step out of line to try out new opportunities for themselves, be it with the Bauhaus Theater Group, in the joinery or metal workshops. It was a constant struggle to recruit women for weaving.

In 1921 the weaving workshop acquired its first form master in the shape of Georg Muche,

thereby relieving Johannes Itten from his duties as head of the workshop. The new form master had sworn never to pick up a thread, meaning to separate his theoretical teaching from handicraft in the workshop. Neither did he want to be associated with the feminine aura surrounding the activity of weaving, because his real subject was painting. Working alongside him in the weaving workshop was Helene Börner, a member of the Paulinenstiftung für Gewerblichen Hausfleiß (Pauline Foundation for Commercial Homework) in Weimar. Since Henry van de Velde's time she had been head of practical work in the weaving workshop and continued to exert an influence on the reformed Bauhaus.

Along with her, the school acquired the valuable looms which, as private property, had survived the turmoil of the war intact. Helene Börner brought them into the workshop with her when she took up her post. If the workshop had not been equipped in this way, the Bauhaus would presumably not have acquired these looms and would instead have sought to create a more modern character for itself. To the students, Helene Börner was like an ancient relic of German tradition, although in various ways she showed she was committed to working on behalf of the Bauhaus and its needs.

In the spring of 1922 there were 22 students in the workshop. They were unable, though, to acquire the local guild's articles of apprenticeship that the school regulations actually provided for. This was a serious disadvantage which would not be removed until the Bauhaus relocated to Dessau and the local guild in Glauchau issued the weavers with apprenticeship articles. Qualifying as an apprentice was an important step toward the further professionalization of women at the Bauhaus. The ambition and creativity of the weavers was evident in their many different projects. On the occasion of the first major Bauhaus exhibition in 1923, their furnishing fabrics and carpets shaped the interiors of the experimental "Haus am Horn." Even the director's room was

**Ida Kerkovius, Blanket/wall hanging.** About 1921, felt, 206.5 x 164 cm, BHA. • The painter Kerkovius had studied under Adolf Hölzel in Stuttgart and was, at 41, the oldest of the weavers. From her time at the Bauhaus (1920–1923) only four works are known; this appliqué design of folding and mirror symmetries is constructed independently of the color system.

**Dörte Helm, Curtain in the Sommerfeld House.** 1920–1921 (lost), appliqué, photographer unknown, BHA. • The women seem to have derived more pleasure from experimenting than from learning the handicraft techniques taught by the master. This curtain documents their appetite for artistic stimulation, as well as their readiness to turn their hands to the Bauhaus's first joint project. The house's shapes were incorporated into its motifs.

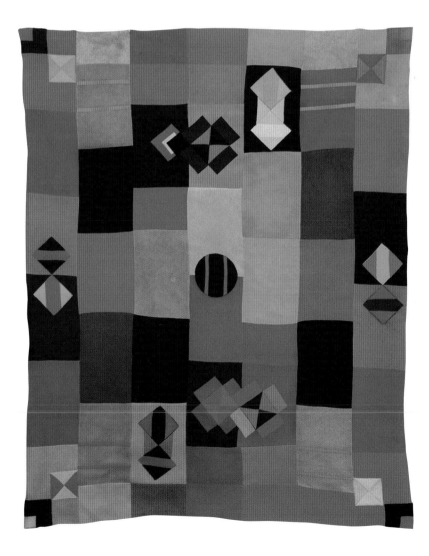

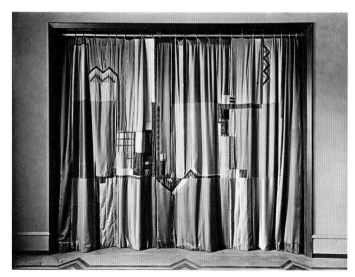

Weaving Workshop

**Designer unknown, Study in light and dark.**
1921, charcoal drawing, pencil and chalk on paper, 42.4 x 31.7 cm, BHA. • One of the set tasks for students in Itten's classes was to produce light and dark effects using different structures and materials (Itten was form master in the weaving workshop for about two years). Many weavers benefited from Itten's contrast exercises in their future careers.

**Felix Kube, Fabric.** 1921, linen weave, sprayed cotton, 38 x 60 cm, BHA. • One of the few male weavers in the workshop, Kube made prompt use of a template spraying technique for applying numbers and letters which would become popular later in the '50s.

**Gunta Stölzl, Wall hanging in black and white.** 1923–1924, half-gobelin, linen weave, spun rayon and wool, 182 x 119 cm, KW. • In a simple linen weave, Gunta Stölzl produced a remarkably large number of half-tones between black and white, made from different textures and composed using a variety of contrasts.

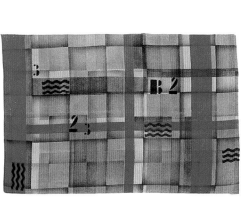

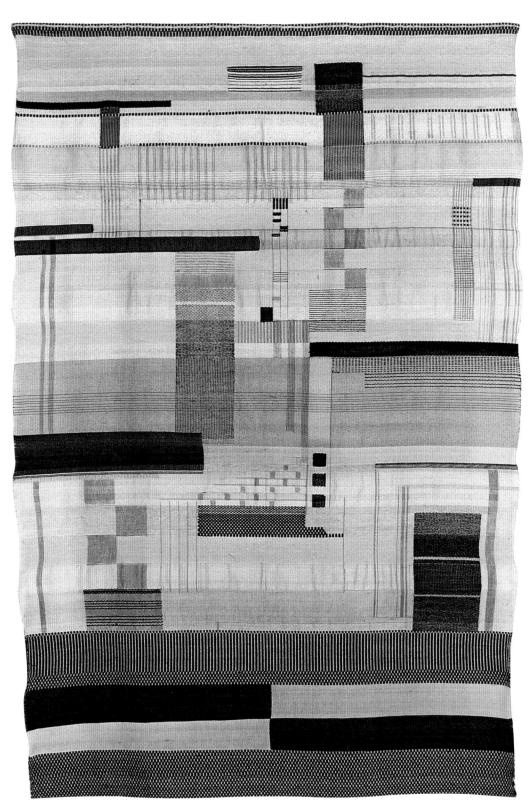

representatively furnished with woven articles. These projects did the workshop some good, and in the winter term of 1923–1924, 20 students worked there out of a total of 114 Bauhaus members. In the autumn of 1924 Walter Gropius complimented the weaving workshop on being the best equipped hand-weaving studio in the whole of Germany.

In the Weimar Bauhaus the usual practice was to sell the articles without naming names, in order to make the Bauhaus brand better known. The concept of the school and the product had to be given priority over the person who made it. The finished articles were the legal property of the Bauhaus that had provided the material for them. Some of the weavers defended themselves against this practice and wanted to be named individually whenever their work appeared in exhibitions or trade fairs. They harbored serious professional intentions, and without their own names it was almost impossible to develop a personal artistic profile. The fact that the women were actually interested in building their careers was underestimated by the male masters who were more inclined to see woman's vocation as marriage and motherhood.

When the Weimar State Bauhaus was disbanded on April 1, 1925, Helene Börner also left the school and stayed on in the successor institution of the Weimar State Bauhaus under the new director, Otto Bartning, as did many other Bauhaus members. Since the furnishings in the workshop had belonged to the original foundation, the Bauhaus had to completely refurbish the weaving workshop in Dessau. Gunta Stölzl took up the post of work master and fundamentally redesigned the workshop while Muche, as form master, devoted himself to art and architecture. When Muche bought several expensive jacquard looms without consultation he was loudly criticized, so much so that he was scarcely able to justify himself. Helene Börner had also come under fire on repeated occasions, and even the weavers were known for their rebelliousness, but hardly to the same extent as Muche. The battle raged during the whole of 1926, with the women refusing to cooperate with Muche. He finally resigned his post and left the Bauhaus in April of 1927. Gunta Stölzl was then able to take up the management of the workshop and in doing so became the school's first and only female

**Hedwig Jungnik, Gobelin with abstract shapes.** 1922, gobelin, linen, cotton, chenille, artificial silk, wool and silver thread, 125 x 90 cm, KW. • Gobelin work is unusually time-consuming and the combination of materials used for this piece is particularly sophisticated. In accordance with Itten's teaching in contrasts, matt areas of wool, camel hair and goat's wool are mixed with dazzling effects created by mercerized yarn and thinly rolled metal threads. Varying weights of material give the composition an additional relief effect.

**Benita Koch-Otte, Rug for a child's room.**
1923, half-gobelin, linen and twill weave, cotton
and viscose, 177 x 101.5 cm, KW, Bauhaus-
museum. • The use of finely graded, almost di-
aphanous shades of green and a transparent gray
are reminiscent of Paul Klee. Klee's color theo-
ries and elementary theory of surface design had
a significant influence on the weaving workshop
– not without having an effect on him in return.
Around 1923–1924 and again in 1927–1928 he
taught form in the weaving workshop.

young master. Stölzl's appointment might be
described as the most unusual in the history of
the Bauhaus. Nevertheless, attempts were made
right up to the end to keep young Muche in
place. Never before or since had a management
post been filled against the wishes of the
director and the masters.

In October of 1926 the Bauhaus moved to its
new building in Dessau, and the weaving work-
shop was put into operation. The Bauhaus now
had its own dye-works too, run by Bauhaus
member Lis Beyer. Kurt Wanke was put in
charge of technical matters and Gunta Stölzl
designed a completely new training program.
She also restructured the workshop's activities
by subdividing the weaving workshop into a
teaching and production workshop.

**Gertrud Arndt, Worksheet, pink fabric and
fabric test.** 1925, card inscribed with ink, top-
left a point paper design, sewn-on wool samples,
design drawing with watercolor, 22.3 x 41.2 cm,
fabric sample with linen weave, cotton, BHA. •
Gunta Stölzl, who had become master in Dessau,
demanded carefully completed worksheets from
the weavers. The rhythm of weft and warp was
recorded on checkered paper, together with the
report, the accompanying fabrics and the calcu-
lation of costs.

**Gunta Stölzl, Colored strap-covering for a
chair by Marcel Breuer.** 1921, woven woolen
straps, interlinked, KW. • The straps seem to have
been "woven on the chair" – an early example of
collaboration between two workshops which was
repeated in other chairs by Breuer and Albers. In
this context it is also worth mentioning the devel-
opment of "glacé yarn" fabrics which, with their
non-stretchable cotton material – smoothed out
additionally with wax or paraffin – were tailored
precisely to the requirements of the tubular
steel chair.

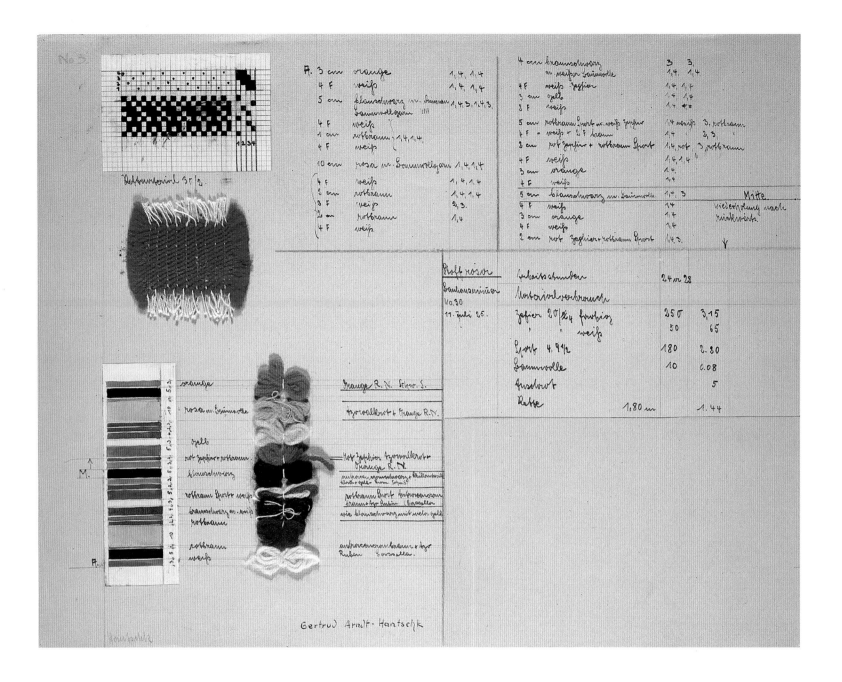

Gertrud Arndt-Hantschk

In the production workshop the trained weavers were able to work on pattern samples for industry and on single pieces with a stronger artistic orientation, while the untrained students were taught in the other workshop. There was an increasing number of experiments with new materials in an attempt to develop durable and inexpensive fabrics for the mass market that were at the same time meant to satisfy sophisticated tastes in design.

While still under Muche's leadership, Walter Gropius designed a plan for the weaving workshop at the Dessau Bauhaus in which he clearly identified the workshop's activities. It was the stated aim of the teaching workshop to train creatively capable people. The equipment was divided into dobby looms and jacquard looms; there was also tapestry weaving, carpet knotting, knitting and dyeing. It was possible for students to sit the apprentice's qualifying examination after one and a half years. If they wished, they could follow this by working in the Bauhaus's experimental and model workshop. This included theoretical and practical training on the mechanical loom and a more advanced and specialized training course in dyeing and textile science. Model articles for industry were developed in this workshop, and interior textile furnishings were designed and implemented. Even self-employment was provided for there. After a further one-and-a-half years there was the second examination, for which the Bauhaus would award a certificate. At this point, Gropius's plan for the weaving workshop took an unusual turn: "After this final examination the work can either be ... continued or, if the aptitude and inclination are there, allow the student to be admitted to a course in architectural theory...." (Bauhaus Masters, "Arbeitsplan der Weberei" [Study Plan for the Weaving Workshop] in Gunta Stölzl, *Weberei am Bauhaus* [The Weaving Workshop at the Bauhaus], exhibition catalog, Bauhaus Archive, Berlin, 1987, p. 124).

However, internally the Bauhaus never strove to integrate women weavers into the teaching of architecture. From the very beginning, Gropius had even come out against training for women

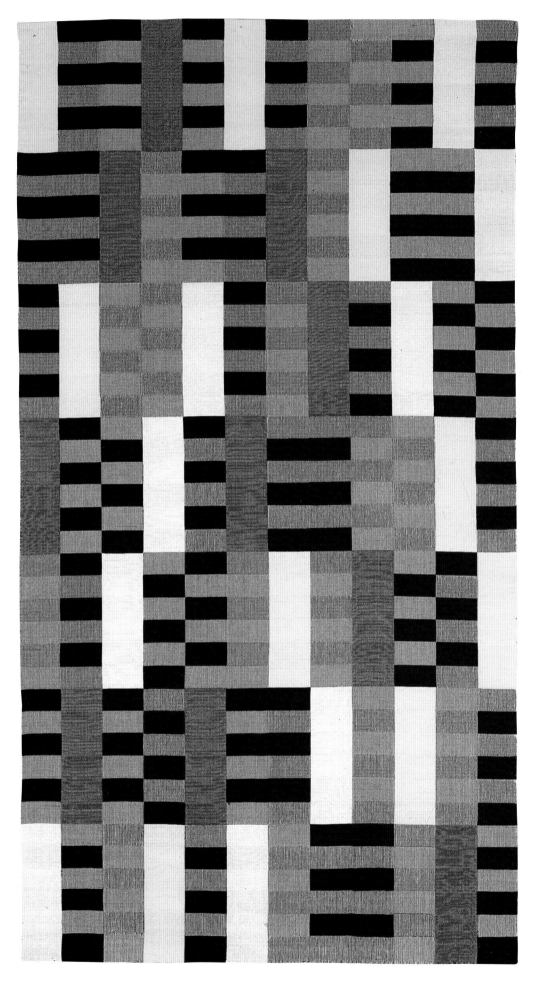

architects. Furthermore, everything to do with textiles was regarded with a certain disdain. In public, however, the Bauhaus wanted to maintain a progressive, egalitarian image. In the newspapers of the '20s, for instance, it was possible to read words such as these written about the Bauhaus: "The relationship between teachers and students is extremely collegial, and of course the women enjoy equal rights in everything" (Fritz Schiff, "Bauhaus-Dessau" in *Die neue Leipziger*, illustrated supplement "Zeitlupe," 1932, p. 9). However, the daily lives of the Bauhaus's female students looked somewhat different.

As far as the outside world was concerned, the "corporate identity" of the Bauhaus, as it would be called today, functioned extremely well. Internally, however, and in spite of Gunta Stölzl's promotion to young master, a variety of inconsistencies still remained. In 1928 there was another major turning-point in the development of the school and the weaving workshop, when Walter Gropius handed over the direction of the Bauhaus to his successor, Hannes Meyer. Meyer was interested in weaving and instituted a fundamental re-organization of the workshop's activities. One of the targets of his criticism was the individual, artistic approach to weaving: "The cube was trumps and its faces were yellow, red, blue, white, gray, black.... The square was red. The circle blue. The triangle yellow. They sat and slept on the colorful geometry of the furniture. They lived in the colored sculptures of the houses. Their floors were carpeted with the psychological complexes of young girls. Everywhere art was strangling life" (Hans Maria Wingler, *Das Bauhaus*, Bramsche, 1975, p. 170).

Meyer was pragmatic and reacted quickly. In future the design class was taught by Paul Klee, but at the same time the new director brought in external lecturers to give academic lectures at the school. The weaving workshop as a whole became more productive and profitable. Furthermore, there was still enough time left for heated discussions about the social relevance of weaving, which resulted in a stronger emphasis on function. Meyer promoted this change of view which led to a preference for textured fabrics, materials that were meant to serve a purpose rather than just be decorative. Probably the best example of this was a fabric developed by Anni Albers for the German Trade Union

**Anni Albers, Blanket/wall hanging WE 493/445.** 1926, triple weave, wool and artificial silk, 223 x 117 cm, BHA. • A series of standardized oblongs in portrait format is put into rows and interrupted or left blank so that they are cottered or separated from one another. The dimensions of the sections are determined by a square that largely remains invisible and which was divided vertically into three and then horizontally into six.

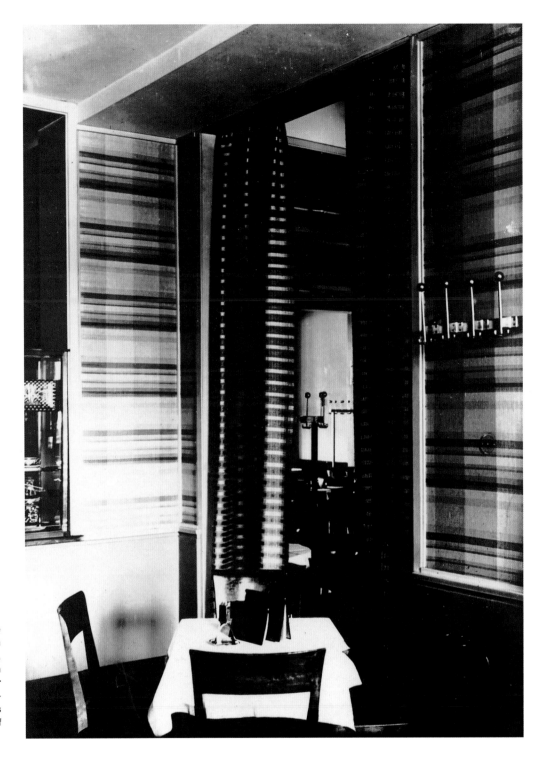

**"Old Theater" Café, Furnishings by the Bauhaus weaving workshop made with Bauhaus fabrics.** 1927, photographer unknown, BHA. • In contrast to other commissions, which required the production of goods by the meter and which were largely unseen as finished articles by the weavers themselves, here the weavers were able to influence the combined effect of their fabrics in the room.

school in Bernau designed by Hannes Meyer, which had both light-reflective and sound-absorbent properties. For a short time during the autumn of 1929, Anni Albers was made deputy head of the workshop. Otherwise, there was a frequent turnover of staff and a good deal of work done free of charge; during the whole of the Bauhaus era, contracts tended to be short-term.

On August 1, 1930, Hannes Meyer was dismissed without notice for political reasons,

and once again the post of director was occupied by an architect. Gropius, who still continued to pull strings, now managed to get his preferred candidate, Ludwig Mies van der Rohe, into the post. Soon afterward the new director brought his partner Lilly Reich to the Bauhaus and entrusted her with the newly established workshops for architecture and interior design, into which the weaving workshop was integrated. Gunta Stölzl had resigned in September, 1931, and the temporary

leadership was once again appointed to Anni Albers, assisted by Margarete Leischner. Then, in the fall, Bauhaus member Otti Berger became head of the workshop, albeit in a temporary capacity. In January of 1932 Lilly Reich took up her post de facto, but from that point on she secured the assistance of experienced and competent weavers such as Otti Berger, who made herself independent in Berlin a short time later. Lilly Reich lacked a formal qualification in weaving, and she enjoyed little popularity in

Berlin exhibition, for which the interior furnishings were also developed by partners Mies and Reich. Interestingly, however, the commission for the carpet did not go to the Bauhaus weaving workshop, but to the Lübeck weaver Alen Müller-Hellwig. The latter also collaborated with the architect Hugo Häring, among others. She had woven for Mies repeatedly since 1929, for instance for the Tugendhat house and the German Pavilion in Barcelona. This makes it appear to us today that the Bauhaus's weaving workshop was particularly modern and progressive, but it is also true that other contemporary weaving workshops have not so far been researched in much detail.

By attending annual exhibitions such as the one at the Grassi Museum in Leipzig, the Bauhaus was soon able to see that in the area of textiles it was hardly leading the way. Other weavers too presented abstract compositions based on square, rectangular and triangular designs or striped patterns. As old woven designs always had an abstract character, not as much progress had been made toward texture-dominated design as it had in painting. The real innovation made by the Bauhaus in relation to weaving lay elsewhere. As a member of the Werkbund, Walter Gropius had adopted many of this group's ideas and stimuli and included them in his program for the Bauhaus. It was thanks to him that the processes involved in the design and execution of a work were brought together at the Bauhaus as a matter of principle. The status of weaving was enhanced enormously by this. The artistic work that went into a design was added to the crafting of designs as

**Gunta Stölzl, Wall-hanging made with cellophane.** About 1931, photograph by Walter Peterhans, BHA. • Like other workshops, the weaving workshop experimented with unusual materials such as cellophane which lends the fabric a sheen but because of its thinness can only be used as a textured material. New properties such as light-reflectivity or even sound absorption were developed by Grete Reichardt.

**Anni Albers, Fabric for the General German Trade Union School in Bernau.** 1929–1930, BHA. • Director Meyer pressed for the production of standard materials instead of artistic or decorative products. In future, materials were produced with simpler patterns and a defined purpose such as curtains, transparent drapes, furniture coverings or wall hangings. Alongside the private production of single items, licenses were also granted for industrial production.

the workshop. Despite her competent but very self-conscious and rather unpedagogical manner, she failed to find acceptance there. However, she did succeed in gaining more status for textile printing. In the one year left to her before the Bauhaus was closed, she had no opportunity fully to apply her considerable knowledge of interior design, furnishings and fashion to her teaching. Despite the comprehensive range of classes offered by the workshop, the number of students was in continuous decline. When the Bauhaus's opponents scored a victory in the Dessau Town Council in August, 1932, the workshop was teaching only three students.

Due to her early death, Lilly Reich's work has for a long time gone almost unnoticed. This undoubtedly has something to do with the fact that her close collaboration with Mies van der Rohe was unknown until a late stage. For instance, the design for the first single-colored carpet stems from an unusually intensive cooperation between architect and textile designer. In 1931, an unpatterned, monochrome carpet constituted a complete novelty. The carpet was a commissioned work for the

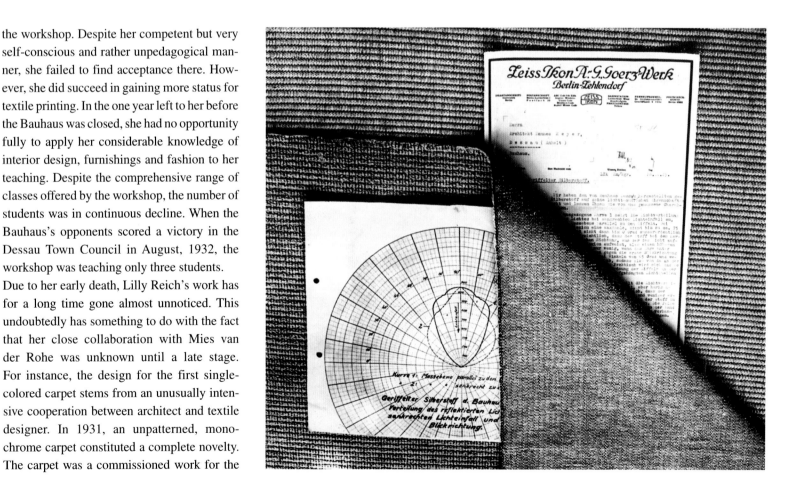

products. This signaled an emancipation of the weaving workshop from the purely technical sphere. Alen Müller-Hellwig, on the other hand, often resorted to using others' designs, and it is therefore fair to assume that the idea of a single-color white carpet can be attributed to Lilly Reich and Ludwig Mies van der Rohe.

Today Gunta Stölzl is perhaps the best known weaver from the Bauhaus. Her fabrics and gobelins were widely praised. If Stölzl's works are nowadays collected by museums the world over, this is not just because of their independent qualities but also because they bear testimony to the Bauhaus's weaving workshop. This period has made her famous, and thanks to academic research on the Bauhaus she has recently become even more well known.

However, due to their different backgrounds, her life's work as a weaver has to be interpreted differently than the work of Anni Albers. The latter emigrated with her husband to America where she was able to develop her career more freely as a weaver, designer and teacher at Black Mountain College. In the USA, Anni Albers reflected greatly on her work and wrote several books which made her additionally well known as an author. Over and above that, she reached out into a new artistic sphere, and from the '70s onward was preoccupied mainly with printing. The quality of her complete works has been frequently acknowledged and praised. From the Bauhaus's perspective, Anni Albers seems to have been the more significant artist, even if Gunta Stölzl embodied the Bauhaus weaver more than anyone else.

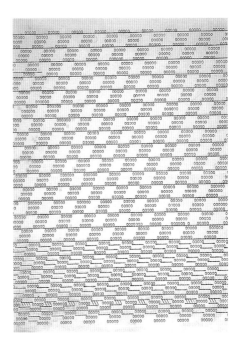

**Hajo Rose, Design for printed pattern.** 1932, typewriter script, DIN A 4, BHA. • Under director Mies van der Rohe competitions were held in all the workshops for the purpose of improving quality. Rose, a graphics student, designed fabric and wallpaper patterns using a typewriter.

**Hajo Rose, Printed fabric.** 1932, based on samples from the second pattern-book of Bauhaus printed fabrics, 1932–1933, cotton and artificial silk, BHA. • Fabric printing had already ceased during the early years of the Weimar Republic. It was revived by Lilly Reich, then master of the weaving workshop, within the combined interior fittings workshop.

**Otti Berger, Fabric for the Bauhaus pattern book in five different colors.** 1932–1933, twill weave, cotton and artificial silk, BUW, picture archive. • Three pattern books presented by the Bauhaus in 1932–1933 contain fabrics of high quality which were industrially manufactured by the firm of C. E. Baumgärtel and Son in the Vogtland. The first album includes printed curtain fabrics, the second "a collection of expensive woven fabrics made from the best materials," the third "ultra-translucent" curtain or latticework tulle.

# The Role of Arts and Crafts at the Bauhaus

Anja Baumhoff

Today we are surrounded by products in unprecedented quantities and they structure both our aspirations and behavioral patterns in equal measure. There has been an explosion in the product culture, and yet we still continue buying. Consumerism has changed through a continuous process, and no one wants to do without its pleasures, no matter how much they already own. However, it would make sense to produce less and to encourage designers to reduce the range of products, as used to happen in the GDR. A similar idea had already led the Bauhaus to declare war against the plush of the *Gründerzeit*, the years of rapid industrial expansion in Germany, and to change interior design fundamentally. Furniture became lighter in weight and consequently more mobile; the wine-red velvet coverings were replaced by plain black leather, and aesthetics were modernized. Their aim was to design inexpensive, attractive furnishings for the mass of the working population. The Bauhaus was unsuccessful in this attempt. The style of classical modernity had always been the trademark of the educated classes. Today, although the aims of *Neue Sachlichkeit* (New Objectivity) and the Bauhaus have influenced the mass market, they have scarcely touched the working classes whose lives they were meant to improve. Only the cantilever chair has conquered both conference halls and canteens in equal measure and is encountered in many different forms everywhere.

**Lilly Reich, The apartment. Trade fair stand with Bauhaus printed fabrics for van Delden in Hall Six.** 1927, Stuttgart, photographer unknown, MOMA, NYC. • The trade fair stand for the van Delden company was the last presentation of Bauhaus products. The design was undertaken by Anni Albers and Lilly Reich.

This reform began not so much with art as with a disapproval of handicrafts. In the popular literature on the Bauhaus it is often overlooked that, while the school liked to disassociate itself from the arts and crafts movement, half of it was nevertheless an arts and crafts school by nature of its origins. This was often intentionally overlooked. Even a Bauhaus supporter such as the art historian Siegfried Gideon regarded the school as a protagonist in the battle to overcome "decorative slime" (Siegfried Gideon, *Bauen in Frankreich, Bauen in Eisen, Bauen in Eisenbeton* [Building in France, Building in Iron, Building in Ferroconcrete], Leipzig/Berlin 1928, p. 49). By forging a close link between the Bauhaus school and commerce, Walter Gropius tried to suppress anything to do with arts and crafts. The Bauhaus set out to counteract the essence of arts and crafts – a term used synonymously with the disparaging word "dilettantism." In contemporary discussions, dilettantism was often overlaid with feminine connotations, deriving from traditional female pursuits such as sewing, embroidery and lacemaking. At the end of the 19th century, an increasing number of women entered the expanding field of arts and crafts, partly to earn a living but also partly because the temples of art were barred to them (Magdalene Droste, "Beruf: Kunstgewerblerin. Frauen im Kunsthandwerk und Design, 1890–1933 in Design Center Stuttgart, *Frauen im Design. Berufsbilder und Lebenswege seit 1900* [Women in Design. Portraits of Professions and Livelihoods since 1900], Stuttgart, 1989, p. 174 ff.). Individual Bauhaus masters also experienced the negative reputation of the art history movement. In their Munich periods prior to the Bauhaus, both Klee and Kandinsky had come under attack from critics who dismissed their abstract paintings as craft. The critics' argument was that the work of these artists was decorative; it was not part of the tradition of the painted canvas, and consequently did not satisfy the requirements of so-called "fine" art. Walter Gropius did not like arts and crafts either, nor its associations with a dilettantist women's school. This fear quickly spread. The reputation of arts and crafts also affected weaving, and at the Bauhaus people in general had an inconsistent attitude toward it. It seemed to be at odds with the innovative efforts of the school, its tubular steel furniture and flat roof designs. Anything to do with textiles was held in low regard, partly due to the material itself. Anni Albers recalled that "I considered weaving too feminine. I was looking for a proper profession. So it was that I began weaving without any particular enthusiasm, because just making a choice of this sort meant causing least offence" (quoted in Wortmann Welgte, *Bauhaus-Textilien*, Schaffhausen, 1993, p. 47). In retrospect Albers realized that her works on paper were categorized as art, but that a similar motif in a

**Lis Beyer, Dress for Dora Fieger.** 1927, Bauhaus material, length 150 cm, skirt width 57 cm, SBD, archive collection. • Articles of clothing constituted a very small percentage of the products made by the weaving workshop, and as they were made to order their expense made them insufficiently profitable for those Bauhaus weavers who were interested in larger commissions.

textile design was suddenly regarded as craft. Along with that went differences in status, prestige and price that, from the viewpoint of the woman producing the work, were unjustified.

Within the hierarchy of art, craft and design, the weaving workshop occupied the lowest position at the Bauhaus. This sexist attitude may not have been systematic, but as a whole it determined the institution's politically realistic treatment of the women weavers. The Bauhaus was not alone in this; the entire modern movement was set against decorative arts and crafts, and ornaments were particularly despised. The architect Adolf Loos declared that "all those objects we call modern are devoid of ornament, apart from those belonging to women" (Adolf Loos, *Sämtliche Schriften*, Vienna, Munich, 1962, p. 162). The feminine, the ornamental, the craft-oriented and the fashionable seemed inevitably interrelated and thus had to be reformed together if modernism was to prevail. The Bauhaus had devoted itself to this campaign by combating dilettantism, by which they tacitly meant the feminine arts and crafts.

# The Weimar Art Print Workshop

Ute Brüning

In the winter semester of 1919–1920, Walter Gropius had four students learning the craft of the graphic printing workshop and gave them a legally binding teaching contract. He did the same for one woman, but she left the workshop soon afterwards (13/282, 42). The fact that women were suited "in the rarest of cases to difficult manual work" was something Gropius knew "from experience," and finally, on March 15, 1921, he succeeded in persuading the council of masters to consider it. Gropius's plan for the school, which promised the renewal of art above a training in handicraft, was illustrated by the appointment of an artistic master in the workshop alongside the technical master. Until 1920 this position was occupied by the graphic artist Walther Klemm. Both the artist and the workshop had been taken over from the Grand Ducal School of Fine Art, the forerunner of the Bauhaus. From October of 1919 the technical leadership was provided by the lithographer Carl Zaubitzer who was appointed as the printshop's "work master."

While other workshops were forced for a long time to continue to fight for their equipment, the art print workshop was fully operational from the start. Further extended in 1920 at Gropius's instigation, there were now a lithographic press, two copperplate printing presses and a manual letterpress machine at the workshop's disposal, on which the classical techniques of flatbed, gravure and intaglio printing were taught (183/14).

After the first year, there was an easing of the fundamental conflict between encouraging creative abilities and yet at the same time earning extra income for the Bauhaus, which was always hard-pressed financially. In October of 1919 Gropius had fixed his sights on securing reproduction commissions from "all Germany's graphic artists" (C 1468/3). It is not clear whether the art print workshop went straightway into carrying out this plan, but on September 20, 1920 the council of masters acknowledged that it was financially the most successful of the workshops. Yet in the same breath they spoke of a mood of crisis: the students "are toying with the idea of switching courses. The reason has something to do with the reproductive nature of this branch of craftwork. Their artistic appetite ... is not whetted nearly enough by mere printing." Gropius drew two conclusions. First, he suggested that masters and students should produce their own works such as "portfolios of graphic prints or illustrated books." Second, the workshop was awarded a special status, although this was not formally established until the teaching timetable was drawn up in July of 1922. The Bauhaus now dispensed with articles of apprenticeship and instead trained Bauhaus members on request. Officially speaking, the teaching workshop was now "predominantly" a production center, in other words the people in it worked for commercial reasons. Although Gropius repeatedly cast doubts on its compatibility with teaching and experimentation, he accepted the situation for financial reasons.

This development was already in the making before 1922. Gropius was still continuing to award commercial design commissions to advanced graphics students rather than printing apprentices, but some students used the art print workshop creatively of their own accord (70 and 183). In 1920 the printing apprentice Ziegfeld embarked on the design, printing and publication of the "Newsletter of the Imperial Federation of German Art School Students" in the workshop itself, as one title page reveals. As early as 1920–1921, students from other workshops worked there, such as Bogler, Gilles, Breuer, Dicker, Molnár and Stefan. In 1920 a student, Röhl, began personally to design and duplicate advertisements for Bauhaus events, and masters and students alike enthusiastically took up this trend, turning it into an established tradition. Students could develop their creative work in the printing workshop even if they did not have an apprenticeship certificate. Consequently the only students who gained their certificate were Hirschfeld-Mack and Baschant, whose appointment as apprentices stretched the State Bauhaus's tight budget. The workforce in the printshop thus ran to four members of staff (including an unskilled worker: C 1468/23; 183/114), which was not necessary for between three and five trainees, but was more compatible with the professional production which evidently had always occupied a place in Gropius's plans.

When the workshops were newly divided among the "form masters" on March 15, 1921, Lyonel Feininger took on this role in the art print workshop, which had been without a head of design since the end of 1920. Before his appointment, in the mood of crisis which hung over the month of September, Feininger had responded to Gropius's production plans and soon afterward, in December, he had advertised his first commercial product. His "12 Woodcuts" were the first works in the substantial series of ten Bauhaus portfolios of graphic prints, the preparation and printing of which made the workshop not "predominantly" but almost completely the service industry for Bauhaus masters and other artists in 1922–1923. The five-part series "New European Prints" was in print in 1921–1922, along with "Small Worlds" by Kandinsky, then in 1923 came Schlemmer's "Game with Heads" and the "Bauhaus Masters' Portfolio" among others, and "The Elder Edda's Lay of Wieland" for Marcks in 1923–1924. However, financial hopes were then shattered by galloping inflation. In Dessau they resorted to advertising, until then a secondary line of activity, in order to seek further chances of earning an income. The growing need for professional propaganda was the decisive factor in the final switch from graphic art to advertising.

(Note: the figures in parentheses refer to the Bauhaus files in the Thuringian State Archive in Weimar; the page reference follows the oblique stroke.)

**Lyonel Feininger, Gelmeroda.** 1920, print from the "Weimar State Bauhaus Masters' Portfolio," 1923, woodcut on Japan paper, sheet 40.3 x 29.8 cm, print 33.1 x 24.5 cm, BHA. • Feininger's print was derived from an older work rather than a new one for this portfolio. The relief plate for the woodcut "Gelmeroda" is dated November 28, 1920. He and his wife discovered the parish church of Gelmeroda, a village near Weimar, in 1913, and from then on it was to remain one of his favorite subjects.

**Lyonel Feininger, Title page for "Bauhaus Prints. New European Graphics," first portfolio of "Weimar State Bauhaus Masters."** 1921, woodcut, 56 x 44.5 cm, BHA. • The first compilation of graphic works by the Bauhaus Masters had a title page by the new form master in the art print workshop. Feininger, who was appointed to this position on March 15, 1921, began it with a cycle of ten printed portfolio works.

**Gerhard Marcks, Am Öfchen (Familie) (At the Stove [Family]).** 1923, print from the "State Bauhaus Masters' Portfolio," 1923, woodcut on handmade paper, sheet 40.3 x 30.6 cm, print 33.1 x 24.5 cm, BHA. • Marcks, a sculptor and the form master in the Bauhaus pottery workshop, wrote of this work: "At the Bauhaus the watchword was abstraction. I only adopted as much of this as I needed to organize the surface, i.e. the board: to put black, gray and white patches in their rightful places, arrange the network of lines in an analagous way, but to do all of this with an illustration in mind, not as an end in itself."

**Lothar Schreyer, Untitled.** 1923, print from the "State Bauhaus Masters' Portfolio," 1923, woodcut on handmade paper, sheet 26.8 x 19.8 cm, print 20 x 12.5 cm, BHA. • The stark white latticework, enunciated in a sharp pattern of bars, interrupts the rectangular space of this dynamic work, which still exudes the spirit of Expressionism.

**László Moholy-Nagy, Composition.** 1923, print from the "State Bauhaus Masters' Portfolio," 1923, color lithograph on vellum, four stones, sheet 39 x 28.8 cm, print 36 x 25.5 cm, BHA. • Light and transparency, movement and balance, together with the tensions inherent in them, were Moholy-Nagy's great themes in his painting, sculpture, photography and (as here) graphic art.

**Wassily Kandinsky, Fröhlicher Aufstieg (Joyful Arising).** 1923, print from the "State Bauhaus Masters' Portfolio," 1923, color lithograph on vellum, sheet 34.2 x 26.7 cm, print 23.8 x 19.3 cm. BHA. • This print seems to hover between the objective world and abstraction: the rising "balloon" is counterbalanced by the earthly trapezoid "launching pad."

**Georg Muche, Auf dem Tisch (On the Table).** 1923, imprint from the "State Bauhaus Masters' Portfolio," 1923, etching on copper print card, sheet 40 x 30.4 cm, print 31.6 x 24 cm, BHA. • This etching constitutes the turning-point from abstract to figurative work in Muche's oeuvre. The shifting planes of the many different spatial areas lend his composition a precarious balance.

**Oskar Schlemmer, Abstrakte Figur nach links (Figur "S") (Abstract figure looking left [figure "S"]).** 1923, print from the "State Bauhaus Masters' Portfolio," 1923, etching on copper print card, sheet 40 x 30.4 cm, print 31.6 x 24 cm, BHA. • This single surviving etching by the artist was developed by Schlemmer from several Indian ink drawings. He valued the hard contrasts formed by their black contours on a white ground. Two strong sweeping lines mark out the figure's torso as the center of dynamism and balance.

# Graphic Editions

Ute Brüning

The high quality of work coming out of the block printing workshop would be put to multiple use. From 1921 onward, the Bauhaus demonstrated some extraordinary artistic, editorial and bibliophilic achievements. In the course of this year, they began to prepare the ambitious series of "Bauhaus prints," bringing together the most important strands of the European avant-garde in the "New European Prints" portfolio published by the Potsdam-based publishing house Müller & Co. In this five-part series the Bauhaus masters presented themselves in one portfolio together with their outstanding contemporaries – German, Italian, French and Russian artists, though their portfolio remained fragmentary. "An international enterprise of this sophistication and scope in the field of graphics has been tackled neither before nor since" (Klaus Weber, "Bauhaus-Künstler" (Bauhaus Artists), exhibition catalog, Kunsthalle, Weimar, 1993). The portfolio was produced with three main aims in mind: It was important for the artists of the Bauhaus, which was in constant political and financial jeopardy, to display evidence of their solidarity by donating a contribution; secondly, they intended to improve their commissioning situation, and finally they wanted to show the school's association with the avant-garde. It was almost as if the printing workshop was outlining the preliminary phase of a Bauhaus that was not to appear until later.

The next masters' portfolio actually went so far as to contradict the Bauhaus's aims. When, on May 26, 1923, the financial safeguarding of the Bauhaus's own publishing house was announced – a necessity for the catalog accompanying the major exhibition – the council of masters came up with the idea of producing a "little portfolio of original works" for this exhibition. Although inflation still prevailed, this masters' portfolio did indeed appear under the Bauhaus imprint. Eight teachers each contributed one work. But was this not just another example of graphic art being excluded from the great synthesis of the arts which the exhibition was supposed to be displaying? On this occasion, was art for the most part not banished to the museum, and did the same thing not happen in the exhibition catalog, which in chapter 3 gave expression to the free arts? In an exemplary way the structure of the catalog reveals the intended unity of the twin tracks of art and "building." The chapters on "The School" and its preliminary course and on "Free Works" appear on either side of the chapter on the workshops entitled "Building." However, if Moholy's dynamic design pervades the whole book, it also balked at trying to unify its components. The original lithographs, with their thicker paper, always broke up the catalog's unity.

There were, nonetheless, productive relationships between art and craftwork, and the masters' portfolio demonstrates how close free art came to the theme of "building." While Feininger's contribution to the portfolio is that of an experienced, accepted master of surfaces, the sculptor Marcks (form master in the ceramics workshop) deals with a rather more interdisciplinary problem, presenting elementary sculptured contrasts in a flat design. The painter Schlemmer, as head of sculpture, presents the geometric and stereometric coordinates of a seated man, and alludes with his torso to a string instrument bending into an S-shape. Muche, another painter, and form master in the weaving workshop, offers a graphic rather than a photographic still-life with a small structural alphabet of simple, elementary shapes interwoven across both space and plane. The master of the Bauhaus Theater Group, Schreyer, who had already renounced the Bauhaus, dispenses with figures and, as in 1922, presents a drama played out between the power of diagonal over perpendicular lines; a succinct solo effort, it is virtually a demonstration against the domination of De Stijl. In a far more complex way, the painter Kandinsky demonstrates the diagonal forces of lines in *Fröhlicher Aufstieg* (Joyful Arising). The head of the wall painting workshop shows how white space can be filled with floating movements, and how lines, whether in the form of a ray or an independent straight line, or thick like a bar, can trim or cut off areas of color, overlap them and set them in motion by giving free rein to artistic effects like color-shading and amorphous shapes. We can see how pure color is unable to resist the graying effect on yellow of a black dotted layer. Even Moholy-Nagy, newly ensconced in his post in the metal workshop, seems able to conjure up color balances from new, transparent materials. The painter Klee, on the other hand, at that time the under-occupied master of the stained glass workshop, uses his lithograph *Der Verliebte* (The Lover) to make color overlayering into a mysteriously ironical haze. He turns the elementary circular form into a vision, inflated like a soap bubble, of arousing events in the lover's mind. The wittiest of all the Bauhaus pictures on the themes of "head," "heart" and "hand," it implies a gentle warning of how, through top-heaviness, other factors risked being forgotten among the bulk of the building work at the Bauhaus.

**Paul Klee, Der Verliebte (The Lover).** 1923, Work index No. 91, color lithograph on vellum, two stones, sheet 34.5 x 27 cm, print 26.4 x 19 cm, BHA. • Eyes sunken deeply inwards, the hands folded in deep reflection, Klee's lover sways soulfully over earthly profanities. Is this a high-pitched song of love, as suggested by the treble clef, or a caricature of something that constantly dominates the man's senses, and would later become famous as Sigmund Freud's comic-style picture puzzle.

1923 91                                      Der Verliebte.

# The Printing and Advertising Workshop

Ute Brüning

For the seven years or so of its existence, from 1925 to 1932, the workshop for printing and advertising fundamentally altered its aims and working methods on three different occasions under its three directors. In the Gropius era, under Herbert Bayer's direction, it became de facto a "production workshop" on a small scale, but in a purer form than ever before. Its main product, advertising, was based on the revolutionary international enthusiasm for "elementary typography" that kindled interest in advertising at the Bauhaus all the more strongly. Under Hannes Meyer's leadership,

the department officially took over as the production facility for the Bauhaus and thereby boosted its status at the school. The head of the workshop, Joost Schmidt, was developing three-dimensional forms of advertising that would make the qualities of both product and company more graphic for the viewer than had been envisioned when the artistic ideas of De Stijl and Constructivism were being assimiliated. No sooner had Schmidt arrived at his dream of creating a major "advertising institute" out of his "advertising workshop," complete with affiliated departments of

photography and plastic arts, than under Mies van der Rohe it fell back once again into the slumber of an arid teaching workshop intended for graphic artists specializing in advertising, and as a result it died before the Bauhaus was closed in 1933.

"Bauhaus typography," as typesetters and printers termed it, sometimes indignantly and sometimes in praise, began life in Dessau before the school had set up its own printing workshop. Bayer probably carried out the first experiments single-handedly, but it is not yet clear where he did so. In general, sources on the

**László Moholy-Nagy, Title page for the publication "Weimar State Bauhaus 1919–1923."** 1923, letterpress, 25 x 25.5 cm, BHA. • "The exploitation of mechanical opportunities is characteristic of the techniques we use in our work today...." observed Moholy-Nagy in 1923. His predilection for discovering forms in the material of the typesetting case which could be applied to compositions using tension and dynamics would have a considerable influence at the Bauhaus. His experiments in composition, print and layout provoked an incessant debate about functional typography.

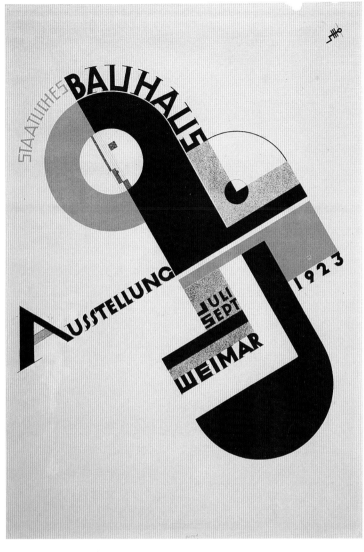

**Joost Schmidt, Title page for the journal "Die Form."** December, 1926, letterpress, DIN A 4, BHA. • The new typographers demanded simplicity, clarity and precision. Joost Schmidt, who was self-educated in these matters, emphasized letterforms whose geometry involved similar forms, achieving a kind of sign language in his compositions.

**Joost Schmidt, Poster.** 1922–1923, lithograph, 60.5 x 48 cm, BHA. • Schmidt, at that time an apprentice in the Bauhaus sculpture workshop, based his award-winning poster on his teacher Schlemmer's use of forms. Alongside the abstract figure, the text and the Bauhaus logo have no independent life.

printing workshop and the advertising workshop from Bayer's time are rare. Vicariously, we have to refer to his own work. The "work plans" of November, 1925 are even now a vivid illustration of the Weimar program. Graphic reproduction was planned, but this was probably not put into practice. The new range of letterpress and manual composition, initially with a grotesque script in all type sizes, was more important for the production work planned. Bayer gave the workshop a new purpose by introducing the subject of "advertising" in place of the advertising department that was merely affiliated to letterpress work. After the printing works had started operating, at least on paper, in August of 1925, and in accordance with "workshop rules," the new teaching timetable of 1926 contained a summary of the content of its classes: the methods and construction of advertising and their effective application were to be investigated and, in future planning, standardization and advertising psychology were to be studied. This indicates a highly up-to-date combination of different sciences which no previous German training school could boast. Bayer would have seen "the construction of advertising" as the

KUNST
TECHNIK } EINE NEUE EINHEIT

AUSSTELLUNG

25. JULI–
30. SEPT.

WEIMAR

STAATLICHES
BAUHAUS

point of contact with the mural-painting department where the class was meant to take place "temporarily," recalling the Weimar Bauhaus's mural designs, the projected light advertisements for the glass painters Kraus and the colored display kiosks.

During the first Dessau period, however, Moholy-Nagy was the unofficial typography teacher, from whom Bayer soon withdrew. Moholy had extended his art-teaching experiments to include printing and advertising and continued to introduce revolutionary innovations into precisely those products that, to the outside world, represented the Bauhaus most clearly: the Bauhaus books and the first year of the *bauhaus* journal of design. The latter went over to Bayer for the first time in 1928, and then to Schmidt in 1929. No students under Bayer's immediate tutelage are known from 1925–1926, but we do know of students from other workshops such as Moholy's metal department. In 1927, for example, Bauhaus students exhibited for the first time at the avant-garde exhibition "Neue Reklame" (New Advertising) in Zwickau, with Jindrich Koch, a wanderer between the workshops for mural painting, metal and finally printing, and Alexander Schawinsky from the Theater Group. Otto Rittweger also worked on professional advertising in the metal workshop in 1926. And when Marianne Brandt explained to visitors the Bauhaus's outwardly hair-raising use of small capital letters, she was threatened with the stocks. Moholy-Nagy, who produced a special issue of *bauhaus* including his influential article "Typofoto" and Bayer's and Albers's experiments with typefaces, publicized them in a printing trade magazine and from then on tried to make the technical world accessible to creatively open eyes. Soon, however, the three "great" Bauhaus typographers – Moholy, Bayer and Schmidt – came up with a stable, though definitely not a completely uncontroversial, division of responsibilities. From then on Moholy concentrated on Bauhaus publications. Bayer looked after the Bauhaus's own productions in the printing workshop. In 1925 Schmidt took over the subject of "type," which was an obligatory part of the preliminary course.

The common interest in advertising became apparent during the "advertising teaching" week in October of 1927. This further education event, affiliated with the Association of German Advertising Experts, had been set up by Weidenmüller, the advertising chief, and brought to the Bauhaus. Gropius, Bayer and Moholy-Nagy took part, as well as the teachers on the preliminary course, Albers and Schmidt (*Die Reklame* [Advertising], 1927, No. 16; *Volksblatt für Anhalt* [Anhalt regional newspaper], October 16, 1927). Bayer's report on this event makes it clear that his goal had not changed. Instead of offering the usual art school training as a graphic artist in advertising, he provided a course of training as an advertising specialist. As early as the first semester of composition theory the students were supposed to undertake practical work. Afterward, too, theory and practice were mixed: students received an overview of the process of advertising, studied the differentiation of advertising media, "elementary"

**Herbert Bayer, Design rough for a poster.** 1923, tempera and Indian ink over pencil on paper, 43.6 x 31.9 cm, Courtesy of the Busch-Reisinger Museum, Harvard University Art Museums, gift of Herbert Bayer. • The first advertising campaign for the Bauhaus exhibition of 1923 was directed by Herbert Bayer. In several route sign posters he balanced colored bands of words against each other like De Stijl pictures. These experiments helped to ensure that henceforth background and text would become design elements of equal value, rendering traditional typographical patterns like symmetry and outline superfluous.

**Charlotte Voepel, Design rough for a poster.** About 1928, collage made from newspaper cuttings, Indian ink and tempera over pencil, 50.3 x 65.3 cm, BHA. • Exercises from Joost Schmidt's "Type and Advertising" preliminary course were aimed at developing skills in lettering and composition. This work shows the strong influence of contemporary artistic prototypes and techniques. It is clearly based on Moholy-Nagy's photo-sculpture and even uses the same newspaper photograph as the master.

**Johan Niegeman, Entrance ticket to the Bauhaus's carnival "Metal Party."** February 9, 1929, letterpress, 14 x 10.7 cm, BHA. • The task of advertising is to provide information about a product or service and it must do so in an objective, factual way. This view was held by several Bauhaus members such as Joost Schmidt, Hannes Meyer and his guest lecturer Niegeman. The architect helped with preparations for the Metal Party, even providing directions on the entrance tickets, engraving a town map on their metallic surface.

**Composition with lead type and ruler.** 1926, photograph by Erich Comeriner, Getty Research Institute, Research Library.

and "eye-catching" design, drawing and, most importantly at that time, "the use of photography and film appropriate to advertising." However, it is not until 1933 that we come across one of Bayer's film productions again (*Commercial Art and Industry*, 1933, No. 89). In the fourth semester, they studied the structure and drafting of advertising plans, as well as commission work which was "tied to a particular purpose and a particular time." In both language and content, Bayer's program was centered on Weidenmüller's advertising theory, tailored to the requirements of the Bauhaus. There were no commissions to help them see the results of making an advertising plan, organized in every area, budget included, down to

the last detail. What remains is Bayer's printed material, which meets the new requirements: the avoidance of subjective forms of expression by use of the technical, "objectivizing" methods of printed type and photograph. The current doctrine of "economization" of communication was made a subject for study, focusing on the DIN (German Industrial Standard) format and arrangement of text, as well as techniques for catching the viewer's eye. The "aim" was to devise a clear, concise "message" behind an "offer." In this way Weidenmüller conveniently neutralized the prevailing ideas about advertising theory and practice. However, Bayer countered them with his particular instinct for walking the tightrope between standardization, mechanization and innovation in advertising.

The practical work and teaching of Joost Schmidt, Bayer's successor in the printing workshop and advertising department, were fundamentally different from Bayer's own work. Schmidt had been active in various fields in the Bauhaus from 1919 to 1925 – in the plastic arts, intaglio printing and graphics – and finally enjoyed a successful period in the advertising department. In 1926 in Dessau he helped with building stage sets and contributed designs for a "mechanical stage." In graphic terms he presented all the elementary combinations of the shifting and rotating movements of geometrical stage levels and backdrops. This brought him into conflict with Schlemmer. In addition to Bayer, a new Bauhaus member had emerged who had distilled his own abstract language of form from many artistic disciplines. From 1925 his principal concern, namely to combine and re-combine elementary figures in many different contrasts of positive and negative, changed into a pedagogical concept that was constantly under renewal. Rather than placing "advertising" as a subject at the center of things, he instead concentrated on developing his "design doctrine," the fourth of its kind at the Bauhaus. Beginning at the simplest level, Schmidt set out to prepare students comprehensively for the requirements of advertising practice. His teaching and practical work were inseparably linked in the Bauhaus manner, and from 1928 became merged together completely in his doctrine. His creations resemble a massive combination exercise, extending still further the Weimar concept of "large-scale building blocks." It is almost impossible to consider one part of Joost Schmidt's teaching separately from his teaching across all the subject areas," said his student Heinz Loew, and he was right (*Joost Schmidt*, Düsseldorf, 1984). As a teacher on the preliminary course and as a subject teacher, Joost Schmidt developed and imparted his universally applicable ideas about the basics of nude drawing, figure drawing and technical drawing, as he also did in his role as head of the workshops for the free plastic arts (1927–1933) and advertising.

**Herbert Bayer, Invitation to the opening of the new Bauhaus building.** December 4–5, 1926, letterpress, 14.9 x 34.6 cm, folded to DIN A6, BHA. • Bayer moderated the excessive contrasts of the new typographers, organizing his work into hierarchically divided items of information. Bayer took Moholy's idea of emphasizing function and developed it into the concept of appropriate function, in this case by employing techniques of photography, text and folding. Whereas the Bauhaus teacher himself soon felt that this kind of mechanized design was unsuitable for the purposes of advertising, this "neutral" form of typography nonetheless continued to be widely used.

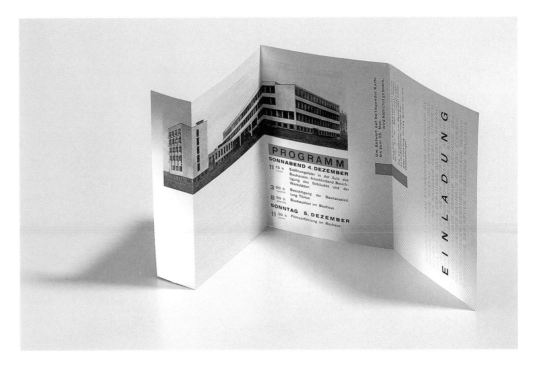

Under his rule, the advertising department worked on visual rules of design which the students, in contrast to the classes of Kandinsky and Klee, had to deduce indirectly and by themselves from the tasks they were set, learning more from discussion than correction. At the beginning students had to experiment with elementary geometric forms and later with more complex elements which were either provided or else prepared in a prescribed way, but only rarely did they work with free forms. They had to produce "contrasts" or "constellations" in series, which from 1931 consisted of 52 parts. The results of advertising theory and advertising psychology were tacitly subsumed in a frenzy of change under the "eternal" visual rules. No matter how suitable this process may have been for advertising, even as late as 1920,

it was ultimately overtaken around 1931. This is exemplified by a task that Schmidt devised for a newly qualified graphic artist Hannes Neuner, from the school of Willi Baumeister. He required Neuner to investigate "how the word 'Bauhausfest' loses out on legibility but gains in exclamatory power as it moves from a horizontal alignment via a diagonal one to a vertical alignment" (letter from Neuner to Helene Nonné-Schmidt of March 6, 1968, Nonné-Schmidt Estate). Avant-gardist advertising had meanwhile distanced itself a great deal from exclamatory power, but nonetheless studies of legibility remained purely marginal in Schmidt's curriculum. Typeface exercises, photographs and collages were also at first considered unsuitable for advertising but were first of all experiments in abstract forms,

**Joost Schmidt, Design for a mechanical stage.** 1925, tempera and Indian ink on card, 64 x 44 cm, Germanisches Nationalmuseum, Nuremberg. • This contribution to the construction of the Bauhaus stage never materialized. But many ideas for mobile exhibition designs resulted from its system of elementary forms and how they basically moved.

**Joost Schmidt, Exercise 8: make contrasts around one given visual element; use the letter P (9 solutions in a square).** 1931, collage with colored Indian inks, partly sprayed, watercolor and newspaper photographs, 42 x 43 cm, BHA. • Schmidt developed set tasks for his students based on his own experiments, beginning with the simplest and becoming progressively more difficult. In this case, it is an exercise for students of advertising.

**Joost Schmidt, Advertisement for the Uher Type (photosetting machine).** 1932, photocopy, DIN A 4, BHA. • The advertisement shows how one of the first photosetting machines produced razor-sharp characters in all sizes, in both postive and negative form, and the tilt effects that could be produced by the accompanying makeup machine.

# 2.

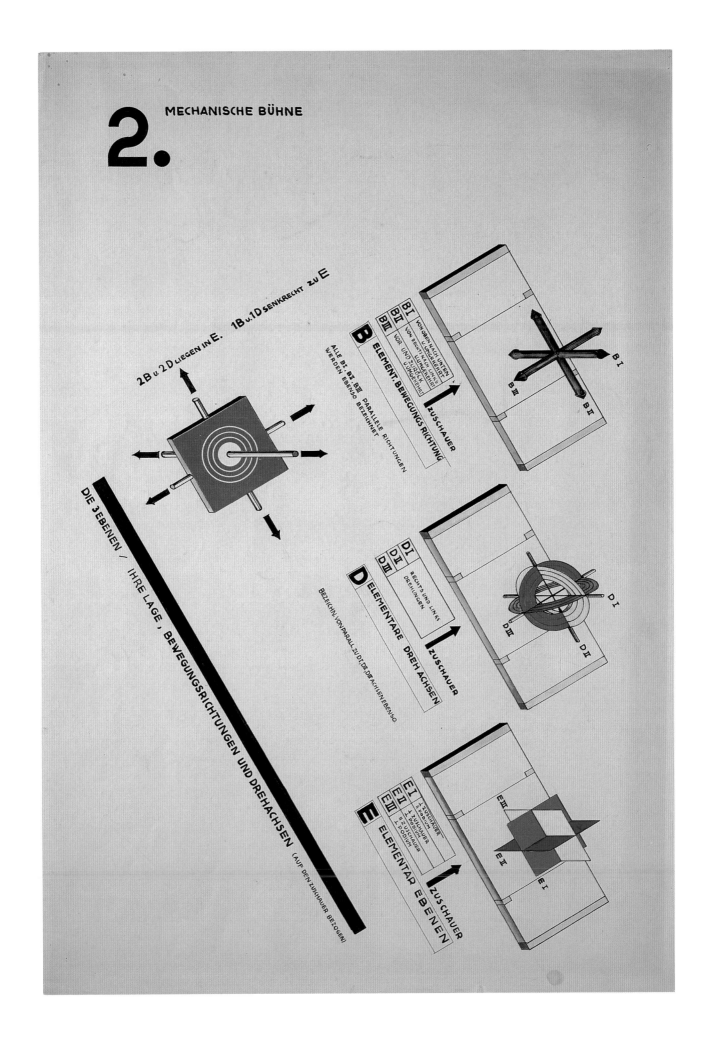

2B u. 2D LIEGEN IN E. 1B u. 1D SENKRECHT ZU E

DIE 3 EBENEN / IHRE LAGE, BEWEGUNGSRICHTUNGEN UND DREHACHSEN (AUF DEN ZUSCHAUER BEZOGEN)

**B** ELEMENT-BEWEGUNGS RICHTUNG

| B I | VON OBEN NACH UNTEN (U. UMGEKEHRT) |
| B II | VON RECHTS NACH LINKS (U. UMGEKEHRT) |
| B III | VOR UND ZURÜCK (U. UMGEKEHRT) |

ALLE B I, B II, B III PARALLELE RICHTUNGEN WERDEN EBENSO BEZEICHNET

ZUSCHAUER

B I
B II
B III

**D** ELEMENTARE DREH ACHSEN

| D I | RECHTS UND LINKS DREHUNGEN |
| D II | |
| D III | |

BEZEICHN. VON PARALL. ZU D I, D II, D III DIE ACHSEN EBENSO

ZUSCHAUER

D I
D II
D III

**E** ELEMENTAR EBENEN

| E I | ↓ ZUSCHAUER ↑ PODIUM |
| E II | ↓ ZUSCHAUER ↑ PODIUM |
| E III | ↓ ZUSCHAUER ↑ PODIUM |

ZUSCHAUER

E I
E II
E III

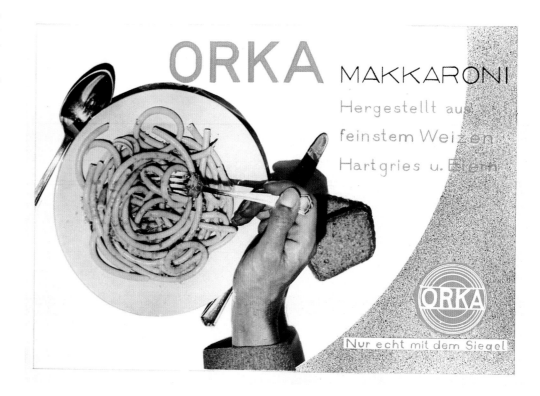

**Herbert Bayer (?), Design for an advertisement.** Undated, photograph by Irene Bayer, collage and gouache, 22.9 x 31.9 cm, Misawa Bauhaus Collection, Misawa Homes Co. Ltd., Tokyo. • The photographic factor: "Truth in Advertising." At that time, a photograph of a prepared pasta dish – still uncommon in Germany – felt superior to any kind of drawn advertisement.

**Irene Hoffmann, Poster designs.** About 1931, collage, gouache, tempera on card, above, 12.9 x 56 cm, below 13.1 x 23.6 cm, Misawa Bauhaus Collection, Misawa Homes Co. Ltd., Tokyo. • Initially the subject of "Relations between lettering and background" dealt with in these posters was given only a little time in Joost Schmidt's classes. Many of his exercises were intended to be more of a general training in composition. Specialization in advertising graphics did not begin until the era of Mies van der Rohe.

subject to the same visual laws as any other two-dimensional form.

In order to explain why this training course seemed suited to producing advertising designers, it is useful to take a look at the workshop for plastic arts. There is an impression that the paths trodden by Bayer and others crossed there most effectively. In 1927 Heinz Loew had translated Schmidt's ideas on the "mechanical stage" into a plastic model for the International Theater exhibition in Magdeburg. The model demonstrated the possible effects of elementary spatial forms and planes in motion.

Investigations like these seemed to be of a general nature and hence could be linked with associations in any area of application. It was quite possible to assign the meanings of "light advertising" and "display window" to them, as happened to the students Loew and Ehrlich in 1928 and 1929 with their "floating vessels of light" for the Berlin event "Night in the Light" (letter from Loew to Nonné-Schmidt of December 14, 1968, Nonné-Schmidt Estate). The systematic exploration of the physical effects of plastic, beginning – and ending – in 1928 with properties of the simplest stereometric forms and their combinations when fused together, could have started with Bayer's progressive photograph for the front cover of

the *bauhaus* journal. A change of material, from plaster of Paris to the popular reflective sphere, also provided the pretext for other cover photographs such as those produced by the student Funkat or the teacher himself in 1931. Schmidt took Moholy's vision of "dematerialization," with its rotating bars, and translated it into virtual bodies and created new types of kinetic models for exhibitions. The Bauhaus utopia of collective work seems to be focused around the figure of the devout Bauhaus member Joost Schmidt. Meanwhile, the acquisition of technical skills was laid down in detail for the advertising students, for instance in typesetting and printing, from 1927 onward by the master Hauswald, and where necessary in-house printing was looked after, characteristically as an associated exercise. Schmidt taught perspective drawing, shadow construction, drawing and painting, including representational art, Ostwald's color theory, and photography under Peterhans was an option from 1929. The exhibition stands that were produced under Hannes Meyer as industrial commissions illustrate very well how the gigantic arsenal of possibilities demonstrated his thinking. Schmidt took over the coordination of the participating Bauhaus workshops, produced some designs himself, and taught the advertising

students. Between 1928 and 1930, in rapid succession, he produced six designs and models. At prominent exhibitions such as the one for "Gas and Water" in Berlin, the stand for Junkers' water-heating machines was designed, and appeared again in the advertising show in Berlin that immediately followed; in Linz, at the "Living and Building" exhibition, they built the stand for the Vienna Museum for Society and Economy. In 1930, at the Dresden Hygiene exhibition, they made the stand for the Economic Union of the Canned Food Industry. It is very likely that, for the Bauhaus's touring exhibition which ran concurrently in 1929 and 1930, the capacity of the workshop was sufficient only for the Breslau presentation, the "Living and Work Space" exhibition. It is even possible that hardly anyone found time to attend the guest events of the foreign advertising designers Piet Zwart (December, 1929) and Karel Teige (February, 1930). In any case, they did not leave behind any visible influences.

The minutes of the Bauhaus council on October 15, 1930 show that the "production department," set up by Hannes Meyer to meet the demands of commissions, was to be outsourced if possible in order to release Schmidt from the advertising department. Yet on December 2 the same year the opposite was the case: they were discussing ways in which this workshop could be "revived." Commissions were needed and the Bauhaus wanted to offer large firms its advertising services. Although the department had just demonstrated its capabilities, an internal competition for advertising designs was meant to produce proof of "suitable strengths." Schmidt interpreted this as a "compromise of his person as the head of the workshop" (December 10, 1930). Mies was critically opposed to Schmidt's way of working. The announcement of further competitions for acquiring methods of advertising Bauhaus products and in particular the use of an "advertising jury" demonstrate how much doubt was being cast upon Schmidt. The council, however, was probably doing the right thing when on December 15, 1932 it handed the advertising designs for Rasch-Bauhaus wallpapers to an advertising jury and in other cases rejected works as "unsatisfactory" and "inadequate"

(May 12 and July 14, 1932). Working conditions were now tighter, not only at the Bauhaus, and the advertising workshop could no longer accommodate specialized requirements like those of Mies van der Rohe. Also Peterhans, who taught photography to advertising students, distanced himself from Schmidt. On July 9, 1930 he made the use of the laboratory subject to his approval, setting out his standards of quality in the process, and, from March 5, 1931 onward, extended his teaching for advertising students – at the expense of Joost Schmidt (minutes of the council). Since the workshop still lacked commissions, Schmidt's plan was to make the best of it in 1931–1932 by limiting his "modular building blocks" to two-dimensional works, and systematizing and tailoring them to fit the job description of "advertising graphic artist." His comprehensive plan, however, collapsed. His aim, to train people to be both artists and technical specialists, able to cope with all the demands of a "practice," was pursued ad absurdum, as was demonstrated by the work of Schmidt and many other Bauhaus members, beginning with National Socialism.

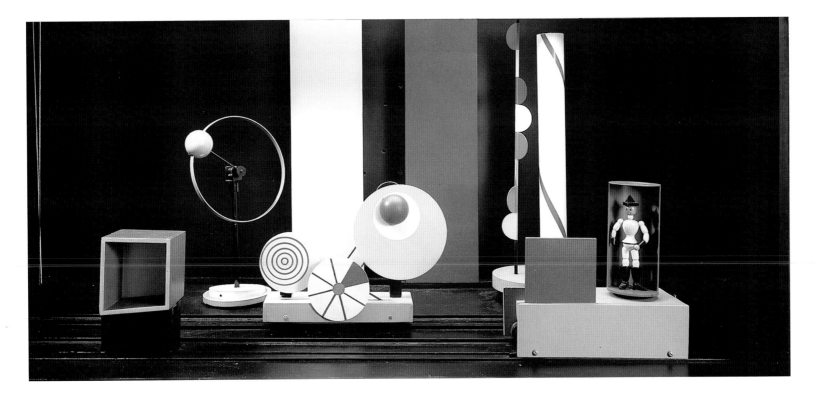

**Heinz Loew, Mechanical stage model.** 1927 (reconstruction, 1968), painted wood and metal parts, 92 x 153 x 76 cm, BHA. • A kinetic demonstration of the range of movements available for basic geometric shapes and colors. The inspiration for this was provided by Joost Schmidt's concept of the mechanical stage.

# Exhibition Design – a Conglomeration of Techniques?

Ute Brüning

Between 1928 and 1931, teams from the Bauhaus developed a whole host of exhibition design techniques, which in some cases continued to be used for decades afterwards. Through their work on advertising commissions, new opportunities arose for orchestrating an exhibition by means of visual direction. If we relate their point of departure – the need for "total design" – to the fundamental principles of the development of advertising strategies then in force, it becomes clear how Bauhaus members had to approach advertising questions in an abstract way, and what the consequences of this were.

Attracting attention was certainly the psychological requirement to which Bauhaus members paid most attention in their exhibitions, and which they achieved by their unconventional use of every material and technique. Around 1930 this factor enjoyed an even greater status than today; eye-catching techniques had to be used in every case where there was a lack of interaction between the capabilities of the product and the means used to advertise it. An example of this is the use of numerous demonstration pieces, whether as an independent statistical gesture or as "lighting equipment." Not surprisingly, Adolf Behne felt the Bauhaus stand at the exhibition of Junkers water heaters was an "oppressive piece of advertising" (*Die Welt am Abend*, August 19, 1929). In his attempt to capture the viewer's attention, Alexander Schawinsky used comic theatrical ideas, presenting giant hot-water characters wearing thickly applied beauty masks and leaping about acrobatically. At the "building and living" exhibition in 1928, Moholy-Nagy and Gropius animated their stand using light, air and sun. Pennants flapped and colored discs span round, one of them bearing the invitation "Come in!" and free-standing letters cast shadow-pictures. The architecture and furnishings attracted curious looks. Exhibition spaces were separated by transparent materials like wire netting, cellophane and, later, glass. Alongside, a passageway was kept ready, finally allowing people to walk down what they had previously only been

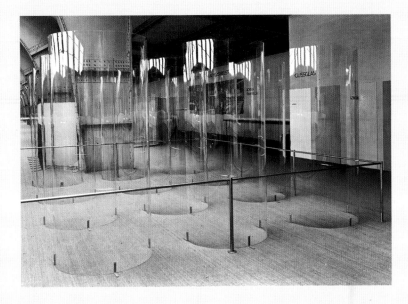

able to view through the display glass. The frequently used "peep-hole" principle appealed to even deeper instincts of curiosity.

The task of arousing interest in the subject of an exhibition was a requirement which Bauhaus members preferred to meet in a more general way. Schawinsky's mechanical "picture clock" of 1929 demonstrated only the daily recurring need for hot water on tap. For many other firms at the "Gas and Water" exhibition that would have been appropriate. Joost Schmidt thought that convincing viewers of the benefits of a product in a practical way, rather than simply persuading them, required general arguments. The necessary "atmosphere" conducive to the "buying decision" thus did not come into play. The required interim stage, the fabrication of a pleasant mood, was created at the Paris Werkbund exhibition of

**Ludwig Mies van der Rohe and Lilly Reich, Design by the glass department at the "German People – German Work" exhibition in Berlin.** 1934, photographer unknown, MOMA, NYC. • At this monumental National Socialist exhibition, Mies and Reich demonstrated the beauty of their material in an open space. State-of-the-art design is employed to promote "community advertising," which the state wanted to use to achieve an identification with the "National Community."

**Walter Gropius and László Moholy-Nagy, Design for the entrance area and restaurant at the "building and living" exhibition in Berlin.** 1928, photograph by Lucia Moholy, BHA. • Moholy used light, air and sun, the parameters of "New Building," as design methods at this exhibition: slatted scaffolding and fences served as message boards, which the sun converted into attractive silhouettes on the ground. Visitors were lured by pennants and colored discs, moving in the wind.

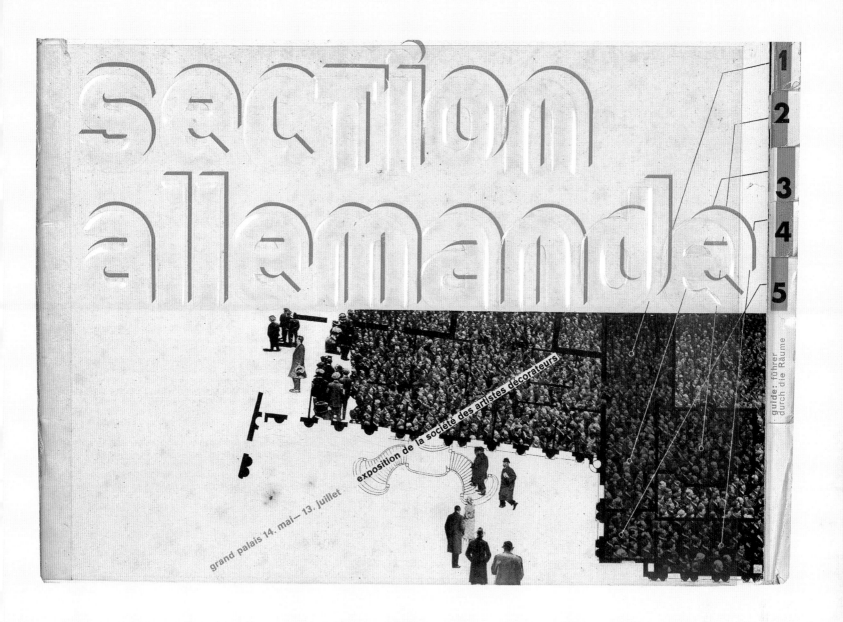

section allemande

exposition de la société des artistes décorateurs

grand palais 14. mai— 13. juillet

guide: führer
durch die Räume

1
2
3
4
5

**Herbert Bayer, Catalog for the "German section" at the International Exhibition of the "Société des artistes décorateurs français" in Paris.** 1930, letterpress, red-brown/black on art paper, embossed cellophane cover, DIN A 5 horizontal, BHA. • Letting your thumb do the walking: you could not only look up products and manufacturers in this catalog index, you could also locate their position in the exhibition. This silent guide accompanied the visitor on a selective tour through Gropius's function room, which was like a miniature museum. The furniture was drawn in to give a three-dimensional view, with pop-up external walls.

**Herbert Bayer, Design for "Room 5" at the International Exhibition of the "Société des artistes décorateurs français" in Paris.** 1930, photograph by Berliner Bilderbericht, BHA. • New strategies of persuasion: now the gentle visitor did not lean in toward the exhibits, but they came to him, positioned as they were in his angle of vision.

1930 using light. Attempts to provoke the viewer into embarking on his or her own voyage of discovery, turning globes, moving surfaces, presumably made it seem more like a work environment than a buying one.

Moholy probably felt inspired by the task of designing routes to the buying decision dramaturgically. In 1928, in his concern as an art teacher to stimulate the viewer into a new and active way of seeing, he introduced abstract themes like exploration, dematerialization and transparency into the exhibition of the Allgemeine Häuserbauge-sellschaft (General House Building Society). He produced a tension-filled path of experience, beginning with an incitement to "Get out of the Sea of Stone!" In 1930, Joost Schmidt pursued this psychological route in an entirely different way, using a graphic construction of a series of arguments which was meant to lead to a decision for or against buying canned goods. At the exit the observer was asked: "This way or that way?" Guiding the viewer's eye along the shortest visual routes was one of the successful outcomes of the Bauhaus's work. Joost Schmidt gave his exhibition visitors essential systems for guiding them along. He introduced mechanical order into advertising using recurring colors and materials in 1929, and light and acoustics in 1934. A comprehensive guide to the form of "objective statistics" indeed became a tool of advertising technique. Joost Schmidt's translation of Otto Neurath's pictorially static methods, importing sociology into advertising skills, contributed to the trend, even today, to present popular statistics pictorially, just like directional guidance systems in the public sphere. Whereas the Werkbund exhibits in Paris (1930) were arranged in favor of a compelling overall effect, the catalog, which could be set up like a three-dimensional miniature museum, pointed the way to the location of the products and allowed names and manufacturers to be found quickly. Techniques of persuasion, also for the purposes of "information," were regarded by Bauhaus members as having multiple uses, particularly in those cases where impressions were supposed to be accepted passively. The discovery that the task of guiding visitors was a designer's task had banished exhibition stands and replaced them with routes, in extreme cases with an "unavoidable pathway," as Heinz Loew described it. Consequently, in 1936, a National Socialist advertising specialist was able to identify "the most ideal method of routing" for transporting visitors on moving walkways, elevators and carousels (Alfred Förster, *Gedanken zur Ausstellungstechnik, Börsenblatt für den deutschen Buchhandel,* [Thoughts on Exhibition Techniques, Marketing Brochure for the German Book Trade], February 4, 1936). Open on all sides, the pure "material show," as Mies van der Rohe and Reich stunningly presented it, offered free movement and suggested freedom in decision-making. However, this alternative proved to be a poor one, like the other Bauhaus exhibition concepts previously mentioned. The idea of developing exhibition design techniques which cut out their political function, seems a dubious avenue today.

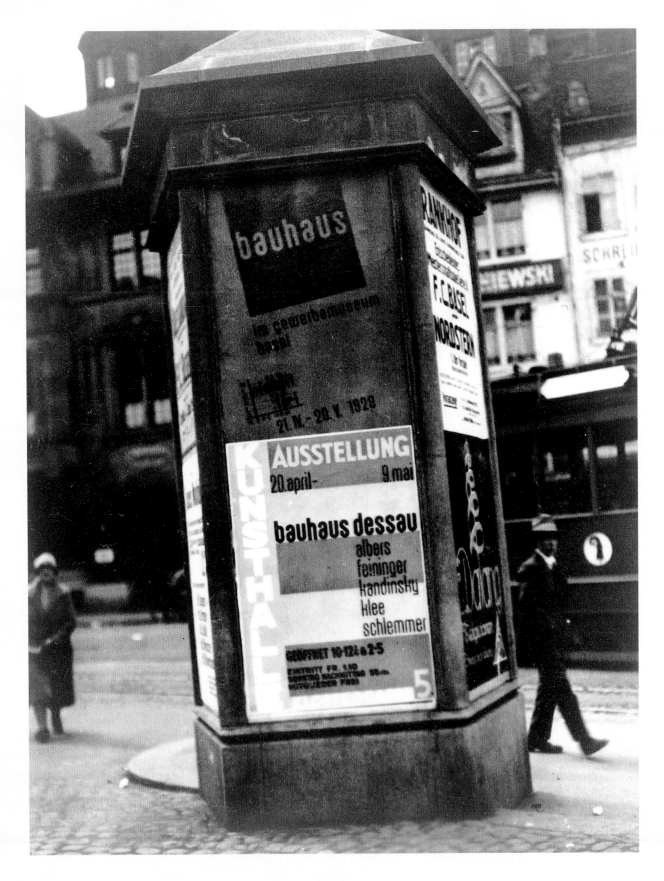

**Herbert Bayer, Walter Gropius and László Moholy-Nagy, Design for an exhibition unit at the department of the German Building Trade Association, German Building Exhibition, view from the gallery, Berlin.** 1931, photographer unknown, BHA. • "Total design": observing the psychological principles involved in guiding visitors, and using ingenious visual directions, the creators tried out a design that remains modern to this day.

**Advertising column with posters announcing two Bauhaus exhibitions, Basel.** • 1929, photographer unknown, Getty Research Institute, Research Library. • The poster at the top, red and black on a yellow background, promised visitors a highly modern Bauhaus exhibition. However, the presentation dispensed with up-to-date advertising elements. Free painting, announced on the poster at the bottom, was exhibited separately

# From reserved gracefulness to the weariness of the rational: propaganda the day before yesterday, commercial publicity yesterday, advertising today, communication tomorrow

F. Karl Kühn

## The day before yesterday

For Germany World War I had been lost. With it, the country took its leave of not only Kaiser Wilhelm II but also of an era that still bears his name today. The political and cultural Germany of the post-Wilhelminian years manifested all the symptoms of breaking out of and away from fixed structures.

Among the many and varied new social beginnings, however, there was a consensus that characterizes the aftermath of every historical epoch – the quest for new truths and their forms. When this quest was set out and implemented, the target groups of the day regarded compromise as a weakness. Their attitude was polarized in an almost Old Testament-like way: anyone who is not for us, is against us. The Weimar Period had not yet learned the rules of democracy. In its political and cultural content it generated a gigantic new wave, but in its social manners it suffered a bitter relapse into Wilhelminian times.

## Yesterday

We know of course where this led politically: to violence applied with an apocalyptic Darwinism. In literary terms there was at the same time, alongside a moderate Thomas Mann, a retreat into the self and the dream of a different, gentler culture, as for example in Hermann Hesse's *Narziss and Goldmund* (Death and the Lover), *Das Glasperlenspiel* (Magister Ludi) and Waldemar Bonsel's *Indienreise* (Indian Journey) and *Biene Maja*. Painting conjured up the dream images of Max Ernst and the nightmares of George Grosz, the Fauves were causing a storm of instinctive passion in France, and both Salvador Dali and Pablo Picasso developed new perspectives analogous to those of the Renaissance: their point of departure was similarly their unadulterated individuality. Their objective was to make an impression on the individual senses of the viewer. In this respect the Bauhaus was different.

## The Bauhaus

Rather like a medieval church-masons' guild, the Bauhaus members probably regarded themselves as a kind of religious order. While the guild would have served the Christian God, the Bauhaus school now created a culture whose aim was to "... discover the design of every object from its natural functions and limitations," and to do so in a lay fashion but with great consistency and with a sense of mission (from Walter Gropius's programmatic essay, "Bauhaus-Produktion," July, 1925). This definition of design included appropriate promotional design, which logically had to be very pared down because each product was meant, literally, to "speak for itself." A "Clementine" from the detergent advertisement, or a "Mister Clean" as a promotional vehicle would have been inconceivable. "The things by themselves," stated Josef Albers in 1926, "arranged in a clear order, have the most compelling effect these days." To see the difference clearly, we need only imagine the catalog page from 1925 pictured opposite with a headline from 1980: "IKEA. WATT IHR VOLT!" ("IKEA. WATTever you want!"). Do that and something remarkable happens to this Bauhaus catalog page. A new dimension is added to the Bauhaus's purely rational and functional approach, namely the quality of the sensual and the integrative. Image and text fit together to make a united message whose character is now involving and inviting rather than projecting. The message to the reader and the observer becomes an integral part of the product! The Bauhaus could not or would not do this. In "tone-of-voice" and content this creative strategy consciously draws the observer into the advertising concept. Until as late as the 1980s the consciously frugal approach of the Bauhaus could be seen in product design and advertising in the totalitarian part of Germany, the GDR. Canned green beans, for example, were sold as "Green beans, 1989 harvest, delicate, class A quality," alongside proof of origin and so on. There was no trace of a developing culture of marketing. Of course, there was no competition either. In the West the very same product was presented as follows: "Bonduelle is the splendid fine vegetable in a can," complete with a friendly jingle and graphics by Tomi Ungerer, and of course the requisite manufacturer's details. This is, in other words, what the American communications guru Marshall McLuhan meant by the phrase "the medium is the message."

## Today

Albers, Gropius and Moholy all believed in the meaning and the value of things in themselves. Today people believe in communicating them. Today no new product is launched for which an awareness level of over 20% in one year cannot be ensured using a fixed budget. This applies to political or intellectual software, from the party program to the TV magazine. It includes any consumer article, from shampoo to holidays. Whereas the Bauhaus confined itself to the meaningfulness of products themselves, today both the product incentive and the creativity of advertising are dominated by the power of the media. It is no longer the message arising from the product, it is the message emerging from the product's positioning in the marketplace which guarantees its success. There is also the synergy of the media. While the Bauhaus had only the resources of the print media, apart from the product presentation itself, today there is an unprecedented mix of media. Furthermore, in a narrow market, marketing strategy is directed less and less often against the competitor's product and more against the competitor's advertising. This is no longer occurring in a projective sense but interactively.

## Tomorrow

Every message is geared to improving contact with the product. Each contact supplied sets up a need for supplementary material and creates a specific world of experience. Each one has to hold its own in the growing oversupply of information given to the target groups. The formula for product advertising is "Make it simple, simple, simple!"

Today's marketing experts demand the same thing for the communication of current products as Albers and Gropius required for theirs. But there is more to it than that: the next stage is no longer a matter of functionally and formally satisfying communicative needs, but far more a matter of developing them afresh and promoting them. Anyone seeing the regular evening preview on television for the programs to be broadcast the day after tomorrow recognizes the fact that

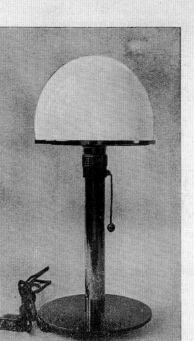

gesch.
Höhe ca. 35 cm
**AUSFÜHRUNG**

Messing vernickelt, Glasschirm, Zugfassung

 ME 2

**TISCHLAMPE AUS METALL**

**VORTEILE**

1 beste Lichtzerstreuung (genau erprobt) mit Jenaer Schottglas
2 sehr stabil
3 einfachste, gefällige Form
4 praktisch für Schreibtisch, Nachttisch usw.
5 Glocke festgeschraubt, bleibt in jeder Lage unbeweglich

**Herbert Bayer, Insert page for the pattern catalog ME 2, ME 1.** 1925, letterpress print on art paper, DIN A 4, BHA.

"advertising for communication" sets this spiral in motion once more. Video-clips for sound storage media demonstrate the synergistic effect in the media mix, and internet grabs on the television screen are similar methods in the same game.

### Retrospectives

The Bauhaus at that time was bad at selling itself because it relied on its own self-image for the strength of its ideas. When Gropius and Mies van der Rohe went to the USA, this immediately changed. Creative supply, American demand, the almost immeasurable financial resources and the communications explosion opened up into an effective international network. In this way the Bauhaus became a leading light in communication; but this was not the case until the New World came into the picture. In architecture it led to a powerful culture of multistory buildings from Dessau to Chicago, the like of which the world had not seen since the pyramids of Egypt. This time, however, the stones were not broken but for the first time remade in similar dimensions in concrete and fashioned into a system by the human mind: "Concrete is whatever we make out of it!" Gropius would have endorsed this advertising slogan of the 1980s.

### Daily work

The great names associated with the Bauhaus would probably never get a job as an art director in an advertising agency today, and certainly not as a copywriter or concept-designer. In today's industry there is no developing of design theories, just results. None of today's TV commercials, posters or "below the line" campaigns bears the names of its creators. Design has become an anonymous activity, and it is faster than ever. Inspiration and leisure are mutually exclusive. However, people using computers at the planning stage still prefer to use the sans serif "Bauhaus scripts" and follow design models that are 70 years old. But they use them without having to know that they are using them. People work in skyscrapers designed like those by Gropius and do not even know it. This knowledge is not necessary to write the headline for Gauloises Blondes. The heritage of the Bauhaus is instrumentalized, it has become a designed set piece. Today no one differentiates between the commercial advertisement, the advertising business and communication – their creators just make them. Everything else is left to the archivists. Walter Gropius would probably have calmly taken note of this, and then with a practiced hand would have straightened his legendary bow-tie.

# Red Bar, Right Angle – a Synonym for the Bauhaus?

Erik Spiekermann

For more than 30 years a red bar has been printed at the top left-hand side of my writing paper. In the era of letterpress printing my name still appeared under it, printed in red. Once this technically ceased to constitute a problem from about 1968, due to photo-composition and offset printing, the name has been printed in white against the red bar. In a period in which almost all functional and geometric-looking objects are attributed to the Bauhaus, even if they originated from Mackintosh, Le Corbusier or Hoffmann, it does not surprise me that the design of my writing paper is associated with the Bauhaus. Perhaps in Germany we should be satisfied with the thought that we at least produced a "style" known and even popular the world over, even if the Italians have the advantage of elegance (and hence of style per se) over us, the Americans have hi-tech, and the British have tradition.

If I am to explain what remains of the Bauhaus and its ideas today, I find it difficult to cite more than this "style" because over the decades too many theories have turned out to be ideologies. However, I will here confine my remarks to the development of typography,

advertising and the design of printed matter at the Bauhaus. In this country one should be able openly to discuss the ideologies associated with it, which however seems scarcely possible. It is evidently sufficient today to formulate a few design truisms with rhetorical authority and to avert possible conflict in advance as stupidity and deviancy. And there are of course whole generations who make such assertions, packaged as pieces of wisdom, into personal conviction and declare all dissenters to be unbelieving blasphemers. Humor and casualness in theoretical debate are plainly not German virtues.

Texts by Bauhaus members and their sympathizers on those subjects that would today be described as typography, graphic design and advertising contain quite a lot of assertions that were presented as philosophies. If, with this in mind, we take a look at the works that go with them, then we see that the noble attempts made by the students only seldom reveal a desire for style. In his standard work *bauhaus. drucksachen typografie reklame* (bauhaus. printed matter typography advertising) (Düsseldorf, 1984), containing Moholy-Nagy's designs for the membership card and the confirmation of membership (for the "bauhaus circle of friends") produced in 1925, Gerd Fleischmann demonstrates that, despite the efforts made toward the creation of "a clear message, delivered in the most vivid form" (László Moholy-Nagy, *Die neue Typographie* [The New Typography], 1923), printed matter is designed in an elementary way, but appears decorative in a new way. On the other hand, a later design, presumably by Herbert Bayer in 1927, is fashioned as a functional form. Willi Baumeister writes of the "New Typography": "If you want to emphasize something, you can content yourself with increasing the size and boldness of the type" (in *Die Form*, 1926). As he then goes on to concede, however, "a bar can no doubt occasionally have a rhythmical compositional value." In his essay "Das Buch und seine Gestaltung" (The Book and its Design) in *Die Form* (1929), Theo van Doesburg remarks on the stylistic methods used, initially in an inflationary way: "It is clear that this abundant use of bars, stripes, rods and points is just as kitschy as the previously common use of little flowers, birds and typographical embellishments." Despite the contradiction of this and many other statements it was nevertheless a question of creating better design. Today, precisely because we make the same mistake of judging designers by what they say, not by what they do, it would be better to stick to the results. If so, we will discover in all the works' practical shortcomings a certain charm in the handmade product, the layman's handling of complicated techniques.

In its 500-year development, lead type has created a mature mechanical system that is nevertheless difficult to understand, even for the well-meaning layman. For any artist who was keen on technique but rarely had the experience to match, it must have been extremely frustrating to know that their imaginative powers were limited by the lead weight of the material. Their sketches were reset by typesetters and printers who regarded the analytical demands of the new typography as merely an affront to their skilled craft. The struggle with the

**Erik Spiekermann, Company writing paper.** 1960s, reconstruction 1999, Spiekermann Archive.

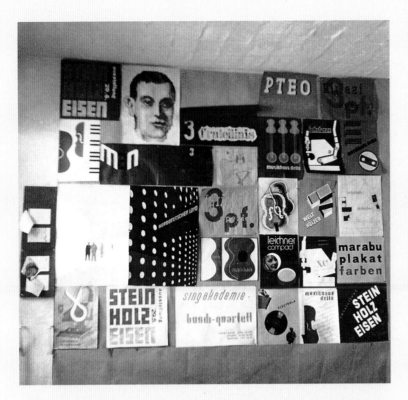

material was expressed in the character of the work. In lead typesetting a great deal of effort is put into organizing the spaces, and although these do not get printed, they have to be constructed from the same material as the letters and pictures. Even if they remain invisible, the spaces define what is visible in print. Just as many of today's printed articles betray the type of software used to produce them, similarly in the case of the Bauhaus's printed matter, the technology has determined its appearance to a greater extent than was provided for in all the passionate theorizing. Herbert Bayer was pretty reasonable about this. In 1928, under the heading "typography and advertisement design" he writes, among other things: "the program of elementary typography that initially came from the constructivists has, without doubt, shown new and fundamental ways of conceiving typographical work. above all, it has given rise to the method of building upon the material's conditions and of developing a compositional form from it ... superficial imitators have however misunderstood or overlooked the real meaning, the functional use of the elements ... all that remained were crude points and thick bars, or even decorations and imitations of nature using typographical material, and that took us back to the beginning. nevertheless, it was valuable for us to experience this development."

If, as early as 1928, the Bauhaus style was a purely external characteristic, then it is scarcely surprising that the sight of a red bar today suffices as an association with this very "style." The requirement to work from the conditions of the material is of little use. Consisting of invisible zeros and ones, this material makes almost every illustration possible, even the unimaginable ones. As far as marketing strategies

are concerned, unambiguity is no longer worth striving for. Wherever worlds of experience are meant to stimulate people to buy and consume, unequivocal information would be downright counterproductive. So what remains? Today the attempt to "combine the areas of functional design, with 'building' as the aim," as Bayer put it, and at the same time to discuss economic, social, formal and ethical questions, is still (or again) doubtless worth striving for, if by "building" we do not just mean houses made of stone but all artifacts. What we today describe as networking, and often only obtain in the form of cabling, is for designers a way out of the mental immaturity, the alienation, which accompanies the boundless opportunities provided by the new technique.

Why, then, does the red bar still appear on my writing paper? What today might be interpreted and is intended to be a quotation was at that time (1964?) a pure necessity. I had no inkling of the Bauhaus, yet without having read Herbert Bayer I had to "build" on the conditions of the material. Anyone describing this type of design as the "Bauhaus style" is not altogether wrong, and by no means diminishes the efforts made at that time. From the conditions of the material I had, albeit without a theoretical background, developed a form of compositional technique. All the elements were deployed functionally and unambiguously. Functional and unambiguous: even if these qualities are not declared at the time, for me they remain the key features of typographical design. And if a red bar suffices to bring these qualities into the conversation, I shall carry on using it in the future.

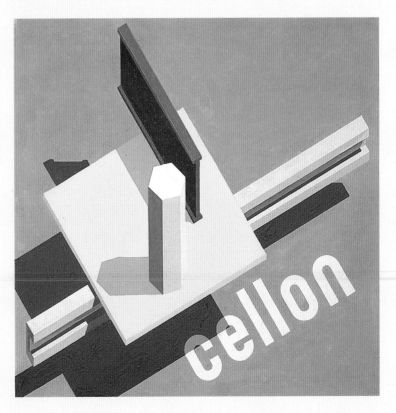

Eugen Batz, Poster design. 1930–1931, tempera on paper, 40 x 40 cm on DIN A 3 diagonal, BHA. • In his advertising classes Joost Schmidt made his students work on didactically prepared series of exercises. They were also taught three-dimensional representation. Here they employed a parallel perspective and shadow construction, using prescribed measurements. Selected constellations of color were also meant to support the three-dimensional effect.

# Photography at the Bauhaus

Katherine C. Ware

It seems surprising that photography, at least initially, played hardly any part as an advanced technical medium at the Bauhaus, a school of art that otherwise strove to reconcile art and the world of industry. Even if it was used on the odd occasion, photography was not introduced as an official subject at the Dessau Bauhaus. This relatively late opening to contemporary media (film was omitted on cost grounds!) was significant for reorienting the school of design under the direction of Hannes Meyer.

This fast-moving time period was characterized by the rapid expansion of previously complex technology. The first user-friendly 35 mm camera, the Leica, launched on to the market in 1925 by Leitz in Wetzlar, enjoyed considerable commercial success and, together with its numerous imitators, became an established part of daily life. Short exposure times, a simple method of operation and easy portability of the camera not only opened up to the photographer an enormous range of subjects and perspectives outside the studio walls, it also meant that the layman took the Leica outside with him, to capture on film the pulsating life of the city, Sunday outings or the ordinary sensations of his private life. The forms of publication for photography similarly changed: magazines such as *Der Querschnitt* (Cross-section), *Die Dame* (The Lady), *Das illustrierte Blatt* (The Illustrated Paper) and other modern weeklies reflected a fresh casualness in dealing with the media and newly discovered realms of images.

The use of photography in a spontaneous way, beyond the norms of the craft-based

**Umbo (Otto Umbehr), Self-portrait at the beach.** About 1930, vintage print, gelatin process, 29.3 x 22 cm, MOMA, NYC. • The dominance of the new seeing apparatus is emblematically stage-managed in Umbo's self-portrait: the silhouette of the camera shades the eyes of the photographer.

**Florence Henri, Parisian window.** 1929, modern print from 1974, gelatin process, glossy, 25.3 x 18.8 cm, Galerie Wilde, Cologne. • By setting up a mirror, the window strips and paneless frames, with the spatial structure "placed behind" them, are thrown completely off-keel. Using the simplest physical methods, the central perspective was canceled out by this diaphanous subject and transformed into a more tension-filled space.

**Marianne Brandt, Reflections.** 1928–1929, modern print from an original negative, gelatin process, high gloss, 22 x 16.7 cm, BHA. • A specialist in metal-processing, Marianne Brandt also experimented with this "effortless" way of combining different materials. The eye of the camera picks out the reflections of light on metal surfaces and forms them into an abstract still-life.

**Florence Henri, La Lune Coquillettes (advertising photography).** 1929, vintage print, gelatin process, 37.2 x 27.2 cm, The J. Paul Getty Museum, Los Angeles. • Analyzing product packaging, taking out the contents and constructing a new image from them which is then dominated by a smiling moon-face: these things were genuinely unusual in the advertising of food products. It is the work of a painter who had learned the craft of analysis and synthesis as a student of Léger and Kandinsky.

tradition that still determined the new medium around the turn of the century, reveals in particular the pulsating feeling of being alive that characterized the Golden Twenties. Machine technology and people's fascination with the rapid pace of life in the big city merged into one, and were uncritically affirmed. The flood of images used at that time also influenced the students at the Bauhaus. Familiar with the possibilities of photography through the print media and

the popular press, the students were eager to use their creative potential for their own work as well. This was similarly true of the younger generation of teachers at the school, including László Moholy-Nagy, Herbert Bayer and Josef Albers: indeed, even a conservative master like Lyonel Feininger began taking photographs at the suggestion of his sons, Andreas and T. Lux. However, the first amateur photography enthusiasts at the Bauhaus either had to

**Herbert Bayer, Legs.** About 1928, vintage print, gelatin process, high gloss, 28.3 x 20.6 cm, BHA. • Cutting off two tanned legs with the viewfinder at the hem of the skirt, which fades away into the light-colored sand, and using a camera-angle from above, the picture that results is of a pair of three-dimensional limbs quite independent of the body.

**Lászlo Moholy-Nagy, Dolls.** 1926–1927, vintage print, gelatin process, 8.1 x 5.5 cm, The J. Paul Getty Museum, Los Angeles. • Moholy's view was that the observer only has to know how to use the sunlight and the "automatically" calculating camera, and new experiences of space will open up to him. In this picture several planes overlap each other and the borders between them are unclear: in the shadow the real fence changes into a patterned surface which becomes transparent on the white blanket but is suspended by the plasticity of the dolls.

**Irene Bayer, New buildings at the Bauhaus, Prellerhaus balconies (seen from below).** 1927, modern print from the original negative, gelatin process, high gloss, 22.2 x 16.2 cm, BHA. • Fixed two-dimensionally from below, and looking up, the viewpoint makes the façade "tilt backward," emphasizing the protrusion of the balcony floors and linking them together in a dark slanting line.

acquire the knowledge on their own, simply learning by doing, or else undertake a course of training at another institution. Rival reformed schools, having made more progress, had long ago abandoned the cult of Expressionism and its archaic forms of illustration (such as woodcuts). Photography, for example, was part of the established program in the teaching curriculum in the Lette-Verein of Berlin, at the Folkwang School in Essen and the School of Arts and Crafts at Burg Giebichenstein in Halle. The Bauhaus, on the other hand, continued throughout its early years to be dominated by the more traditional arts and academic disciplines. The numerous

On top of all this, and despite their personal initiative, the Bauhaus students still had no dark room at their disposal. Prints were produced in converted bathrooms and other make shift premises. It was not until the school moved to Dessau that some of the teachers installed a dark room in their private masters' houses. From 1927 Walter Funkat, a student at the Bauhaus, shared a small photo-lab with his fellow students: the equipment included an old enlarger and a box camera, and there was also a range of lenses for general use. As a rule, the Bauhaus commissioned professional photographers to do its advertising and public relations work. Lucia Moholy and Erich Consemüller were the prominent documentary photographers of the school and its products. However, none of these photographs were central to artistic reform.

Earlier, in 1923, Walter Gropius had demanded a new unity of art and technology,

**Werner David Feist, Detail from a mechanical loom.** 1929, vintage print, gelatin process, gloss, 16.5 x 22.7 cm, BHA. • Since the beginnings and ends of the threads are not visible, their lines cross each other dynamically like pencils of light shooting through the picture.

**Hannes Meyer, Composition.** 1926, vintage print, gelatin process, gloss, mounted on card, photograph 17 x 22.8 cm, mount 29.6 x 42 cm, Kieren Collection, Berlin. • Elementary stereometry and geometry flow into one another in dark tones and are traversed by an amorphous shadow, into which the glinting reflection of light seems to breathe organic life.

surviving photographs from the turbulent Weimar years and, later, from Dessau were for the most part improvised snapshots that captured the daily experiences of studying. Much of what we now know about actual daily life at the Bauhaus stems from the great variety of photographs taken there. Although a camera constituted a substantial financial burden for the students, especially during the period of high inflation, many of them felt it was well worth the effort. Buying the camera, however, did not constitute the only expense. In addition, there were the high costs of equipment, chemicals and paper for the development. Due to the private or experimental character of many of these pictures, a contact print of 10 x 13 cm from the negative was adequate, and furthermore it clearly shows the photo's amateur status as a snapshot and a souvenir, rather than as an exhibitable photographic work of art.

**Gotthardt Itting, Bauhaus building at Dessau, corner of the main stairwell and workshop building.** About 1927, vintage print, gelatin process, glossy, mounted on card, retouched, photograph 14.5 x 9.4 cm, mount 16.3 x 11.1 cm, BHA. • Again a mirror-effect gives this corner of the building the look of a Constructivist composition. Window transoms, wall and radiators appear completely dematerialized and form an abstract construction of contrary diagonal lines.

a program that pushed the basic tendency to change from being a community of artists to a technically oriented design school: the workshops were adapted and equipped for mass production. (As a result of this, images for reproduction and photographic elements of advertising and applied book dessign gained entry into the Bauhaus.) In the same year, and following this ideological development, Gropius invited the artist László Moholy-Nagy to work as head of the metal workshop and as a teacher on the preliminary course at the Weimar Bauhaus. The fact that the Hungarian Constructivist openly rejected the traditional practice of easel painting and artistic handicraft did not exactly make him popular with the long-serving members of the teaching staff such as Paul Klee and Oskar Schlemmer. However, the breath of fresh air that the newcomer brought with him into teaching matched the mood of many of the students. Moholy, an untiring campaigner for change and reform, now became the

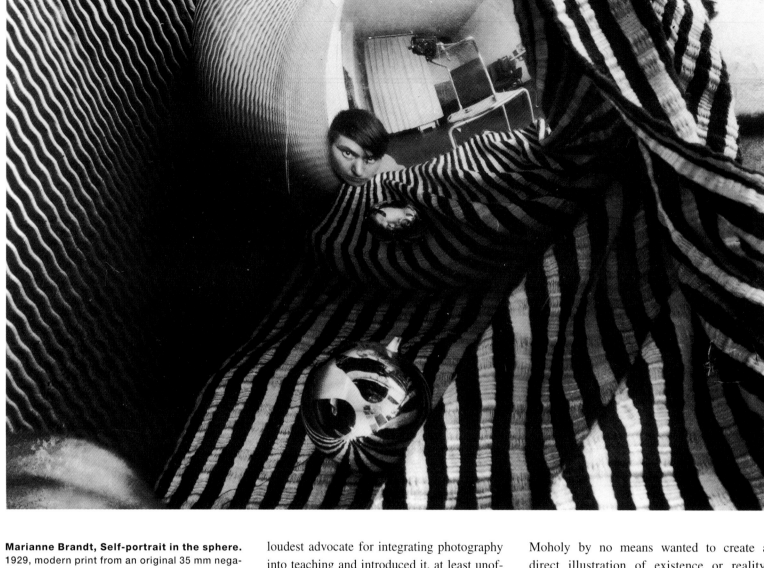

**Marianne Brandt, Self-portrait in the sphere.**
1929, modern print from an original 35 mm nega-
tive, gelatin process, high gloss, 16 x 21 cm, BHA.
• Brandt's self-portraits frequently thematicize
the processes involved in their own production:
camera positioning and automatic shutter release
cable are clearly visible. As in other portraits by
Brandt, the Christmas tree ball becomes the
emblem both of the metalworker and of self-
reflection.

loudest advocate for integrating photography
into teaching and introduced it, at least unof-
ficially, into his preliminary course. The
"technical view" of the camera's eye, the
mechanics of graphic production beyond an
individual artist's trademark, made the
medium seem to him suitable for creating
a graphic language for the present day, a
language in which human perception was
enriched by a new visual dimension. Photo-
grams, a kind of unmediated photog-
raphy in which objects are placed on
light-sensitive paper, and even more so
unconventionally diagonal, often geometric
and almost abstractly constructed forms
from unusual perspectives, were for Moholy
an appropriate expression of visual culture
in the industrial age.

Moholy by no means wanted to create a
direct illustration of existence or reality,
but rather he was interested in designing
a new world from the spirit of technology:
"The secret of their effect lies in the way
the camera reproduces the purely optical
image and shows the optically-true distor-
tions, contortions and foreshortenings, and
so on, while our eye formally and spatially
complements the photographed optical phe-
nomena with our intellectual experience and
turns it, through associative relationships,
into an *imaginative* picture. In the camera
we have the most reliable aid for helping
us toward an objective way of seeing.
Everyone will be obliged to see the optical
truth, the per se interpretable and objective
reality before he can arrive at any subjective

**Marianne Brandt, Railings and steps with shadows.** Undated, modern print from the original negative, gelatin process, 9.5 x 13.8 cm, BHA. • Producing spatial stimuli with the aid of unexpected or inexplicable shadowy phenomena was soon to become a mark of advertising and fashion photographs.

**Karl Hermann Haupt, Road in winter (photo-experiment).** Undated, each picture 2.8 x 5.5 cm, mounted on card, 16.5 x 16.5 cm, BHA. • Using the technique of mechanical duplication, it was possible to transform natural subjects into individual and abstract textures.

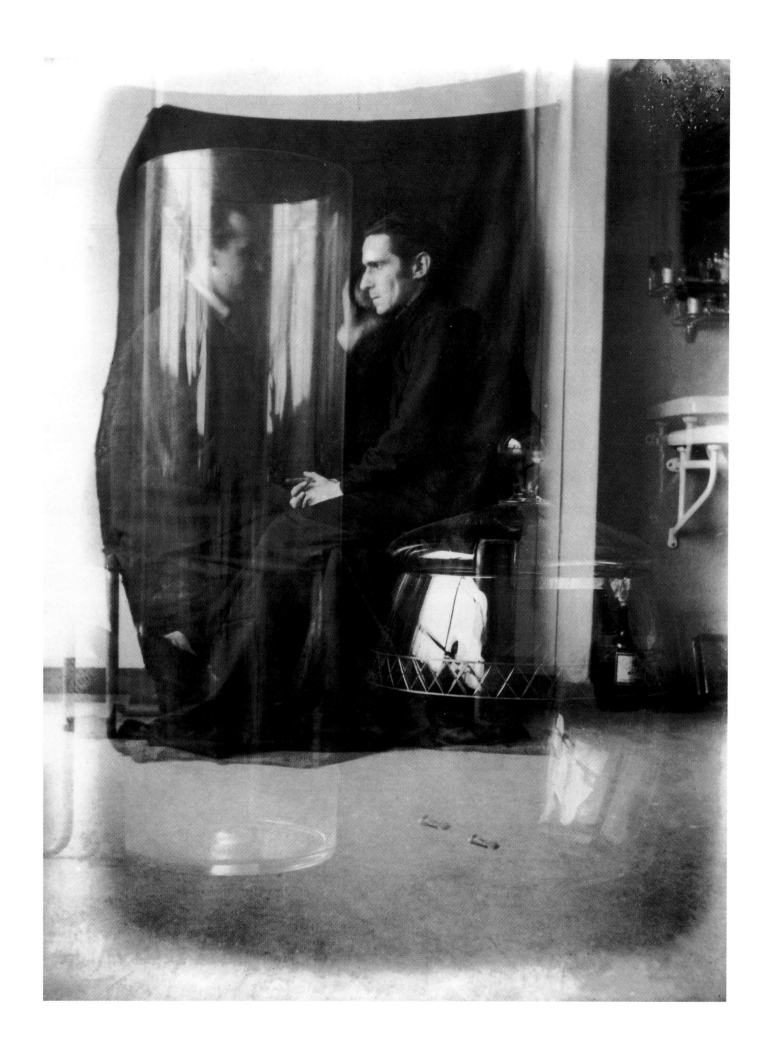

**Heinz Loew and Hermann Trinkaus, Double portrait of Loew and Trinkaus.** 1927, modern print from an original glass negative, multiple exposure, gelatin process, glossy, 21.3 x 15.7 cm, BHA. • This strangely glazed exchange in the dark was carefully arranged before the shot. One of them took the picture while the other posed, and then they switched. So this uncanny situation is only a virtual one.

**Gertrud Arndt, Portrait of Meyer-Waldeckin in negative.** 1930, vintage print, gelatin process, semi-matt, mounted on card, photograph 16.7 x 22.7 cm, mount 24.6 x 32.2 cm, BHA, loaned by Gertrud Arndt. • Reversed into negative, this portrait would not have worked as a photograph because the face would have been under-exposed. The new photographer turned something that was previously regarded as a technical error into an unfamiliar optical attraction.

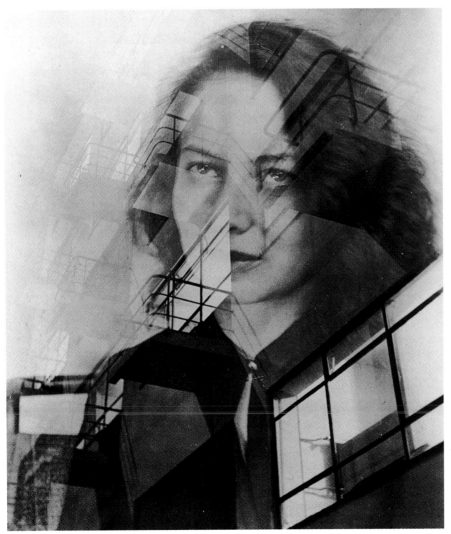

**Photographer unknown (Gertrud Arndt?), Portrait of Otti Berger and studio house.** About 1930, vintage print, gelatin process, glossy, 9.2 x 7.8 cm, BHA, loaned by Gertrud Arndt. • Dream-like, the rails of the balcony are traced through the girl's face. As in a mist, the gray of the face merges with the gray of the wall, and deep reflections of the lamps in her eyes bring the windows, illuminated from the inside, into close association.

T. Lux Feininger, **Girl in the grass.** 1928, vintage print, gelatin process, 19.8 x 23.2 cm, The J. Paul Getty Museum, Los Angeles. • The viewer is allowed to follow the photographer's intimate look at the girl beneath him. He sees, half in light, half in shade, an appealing image of sunlit, tousled hair, lips pinching a stalk of grass, and a body outstretched on a warm blanket.

**Grit Kallin-Fischer, Double portrait of Hilde Rantzsch and Myriam Manuckiam.** 1927, vintage print, gelatin process, glossy, 17.0–20.5 x 16–16.5 cm, BHA. • The heads of two girls, lying close to one another, invite comparison. But since the viewer can assume neither of their opposing points of view, looking down instead of from a side-angle, in such a way that the heads appear one on top of the other in the frame, he/she is preoccupied with searching for a "correct" perspective which is not actually offered.

statement whatsoever.... We are, through a hundred years of photography and two decades of film, enormously enriched in this respect. *One might say that we are seeing the world with completely different eyes.* Nevertheless, the sum total of all this has until today been little more than a visual encyclopedic achievement. But that is inadequate for us. We want systematically to *produce*, as the creation of *new relationships* is important for living" ("Malerei Photographie Film" [Painting Photography Film], Munich, 1925, *Bauhaus Book 8*, p. 26 ff.).

The fact that he was a technical layman in terms of the high standards of traditional professional photography did not trouble him very much because it was to be precisely that automatism of the technical apparatus that made the traditional handicraft skills obsolete. For the student amateur photographers, with their Leicas and other manual cameras, there was ample opportunity to bring their desire for experimentation into their official course of training. At the beginning, whereas they primarily photographed their friends and recorded the colorful cultural and social life at the Bauhaus, the

**Grit Kallin-Fischer, Portrait of Edward E. Fischer.** 1926–1928, vintage print, gelatin process, glossy, 17.2 x 22.3 cm, BHA. • With the hand hovering over the "constructivist cross" and oddly separated from the body, this portrait represents an unusual simultaneity of bust and hand study.

influence of Moholy and his concept of a "New Way of Seeing" was nonetheless reflected in their heavy emphasis on light-dark contrasts, varied lighting and unusual perspectives.

The departure of Gropius, Moholy-Nagy and Herbert Bayer in 1928 heralded another "changing of the guard" at the Bauhaus. In April of 1927, Hannes Meyer, an architect known for his radical, left-leaning political views, became the director of the school. Meyer's particular interests soon became apparent in the supremacy of the architecture and building department, as well as an increased emphasis on social aspects in artistic work. He restructured individual workshops, and in the process began placing the focus on academic and theoretically oriented work. Although Moholy and Meyer both came from the broad background of Constructivism, they interpreted it in very different ways. Moholy's work and theories always led ultimately to an aesthetic utopia. Meyer, on the other hand, set out to realize his aesthetic social vision with both practical and economic efficiency.

Against this background, Meyer commissioned Walter Peterhans, a 32-year-old photographer with a studio in Berlin, to teach the first official course in photography at the Bauhaus. Peterhans, who was gifted with a comprehensive set of technical skills and had practical experience as a professional photographer, mediated between the traditions of photographic handicraft and the aesthetics of the "New Objectivity," which for the medium of photography were new and groundbreaking. The name alone was a program, because such a "sober" course of action stood in extreme contrast to Moholy's technical utopias. In contrast to Moholy's restless gaze, Peterhans fixed his subjects in a higher degree of contemplation, placing value on technical precision and a clean finish. Whereas Moholy stretched the limits of the medium by experimentation, the new Bauhaus master set out to give an adequate, functional depiction of the objective world. Peterhans's readiness to reflect the objective world sharply and precisely – in short, "objectively" – far removed from all subjective artistic frivolity, was for him the basic premise for the meaningful use of technique in the context of its practical commercial application. Furthermore, his course was regarded as an instruction in

the proficient and responsible handling of an important tool in graphic design, namely photography, and not as a place to encourage the subjective creativity of individual artists. Using that as a basis, photography was taught as a part of the workshop for print/advertising/exhibitions under the leadership of Joost Schmidt.

To what extent Peterhans's critique adequately grasped Moholy's theoretical framework is an open question. However, he hit upon a fundamental contradiction in the Hungarian's revolutionary art and practice, even if he only saw Moholy's radical program of technical, applied industrial art as the gesture of a lone artistic genius. Peterhans's own acquaintance with the camera began in his youth, with the support of his father who worked at Zeiss-Ikon. He studied engineering in Dresden and Munich, and graduated in mathematics and philosophy, continuing his studies for a further year at the State Academy for Graphic Art and Printing in Leipzig. After completing his training, Peterhans began his career as a professional photographer; in 1926 he gained his master's diploma for photography in Weimar. The following year he opened a

**Grete Stern, Portrait of Ellen Auerbach.** 1930, modern print, gelatin process, glossy, 27.9 x 21.6 cm, BHA. • Taking a portrait with the model in a reclining position and an extremely relaxed pose was a method used by her teacher, Walter Peterhans. Here, using dark framing and minimal depth of focus, the hand and the face are reversed in the bright, soft area which concentrates the picture solely on the portrayal of the eyes looking into the distance.

**Ellen Auerbach, Glove.** 1929, reprint, silver bromide gelatine, 20.5 x 15.3 cm, Folkwang Museum, Essen. • When a glove is taken off it sometimes gets turned inside out. Here, it looks like an amorphous creature with eyes, changed by a light source positioned "beneath it" from a recumbent position to a floating one.

**Nelly A. Peissachowitz, Fabric.** 1932, vintage print, gelatin process, 20.8 x 17.2 cm, The J. Paul Getty Museum, Los Angeles. • Peterhans's students received a masterful training in portraying (as here, for example) the characteristics of a fabric in such a way that the surface and strength of the material were shown clearly but without exaggeration, and that the weave, pattern and degree of softness were discernible.

studio in Berlin, specializing in portrait photography, and at the same time he also gave private instruction. Knowledge and experience in teaching characterized his didactic approach at the Bauhaus. Peterhans was not only an accomplished technician but also a committed teacher, and he devoted himself to this pedagogical challenge with great vigor and an interest in communicating, which differentiated him clearly from the old masters, many of whom regarded teaching as nothing more than a tiresome duty.

The master's influence is recognizable in his students' work – among them Johannes Auerbach, Eugen Batz, Irene Blühova, Roman Clemens, Werner Feist, Walter Funkat, Kurt Kranz, Herbert Schürmann and Hajo Rose. "Peterhans's photographic theory"

**Students from Peterhans's class, Works from a collected portfolio.** 1929, portfolio in 21 parts with 41 photographs (by Gertrud Arndt, Irene Hoffmann, Fritz Kuhr, Hannes Schmidt), gelatin process, glossy, various dimensions, BHA. • In Peterhans's class students learned to photograph the surfaces of objects in detail. This look at "structure, texture, facture and piled up objects," as Moholy put it, would have had no abstract instrinsic value but was intended as a technical exercise.

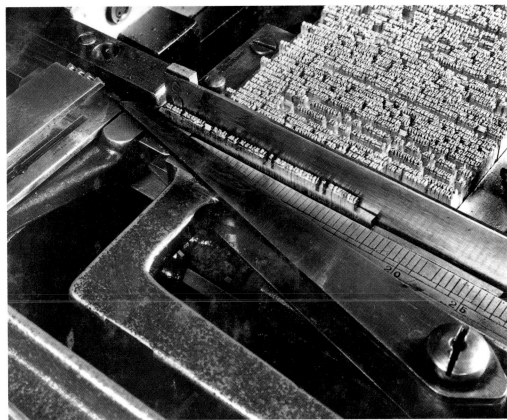

**Theo Ballmer, Series of experiments from Peterhans's class: properties of the emulsion. Relationships between exposure and density of silver precipitate.** About 1929, collage, photographs and typewritten strips mounted on card, 29.7 x 42 cm, The J. Paul Getty Museum, Los Angeles. • In experiments, the greatest attention was devoted to chemical processes in negative and positive developing, and what counted was to produce the most even range of the finest shades of gray. The series was meant to demonstrate the effect of over- and under-exposure upon the granular concentration of the emulsion. The experiments were extended to solarization, i.e. belated exposure in the developing bath.

united the academic requirements of a university with the practical training of a technical school. Ludwig Mies van der Rohe, who took over the management of the Bauhaus in 1930 as Hannes Meyer's successor, later wrote: "I became familiar with his careful work with his students; the great discipline with which he taught them and which he also expected of them" (Walter Peterhans, *Elementarunterricht und Fotografische Arbeiten* [Elementary Teaching and Photographic Works], Ernst-Ludwig-Haus, 1967, p. 5). An aspect of this, its philosophical underpinning so to speak, was

a solid grounding in mathematics and philosophy; a theoretical knowledge that, for Peterhans, constituted the necessary basis for a rational approach to the medium of photography, in spite of all the impetuous experimentation. His classes occasionally resembled a scientific lecture, and his students' notes read like chemistry text books, filled with detailed, pedantic, well-kept notes about chemical reactions and experimental procedures in photography.
Peterhans encouraged his students to begin by observing attentively and plan the subsequent procedure before actually using the

**Theo Ballmer, Lightbulb.** 1929, vintage print, gelatin process, 34.7 x 27.4 cm, The J. Paul Getty Museum, Los Angeles. • Ballmer depicted the lightbulbs with great precision as transparent hollow bodies with a precise, filigree wire construction, and brought out the convex surface which captures the curved reflections in the wide-angle lens. The crumpled paper intensifies the sheen, sleekness and perfection of the technical object.

Theo Ballmer.

camera. The photograph or composition thus became an intellectual undertaking: "You must observe things as if with the eye of the camera," he impressed upon his students. In his view, analysis, preparation and talent were far more important in taking successful shots than mere luck, or the famous "decisive moment" when the shutter is released. However, these methods should be viewed more as a counterpart to Moholy's bold perspectives and the photography of the "New Way of Seeing" because the latter method, according to Peterhans, lacked respect for the genuine quality of the medium, the camera's fascinating ability to reflect the objective world of things. "Photography with a hammer" is what Peterhans disparagingly called Moholy's practice (quoted from a conversation between the author and Peterhans's student Ellen Auerbach). He encouraged his students to aim for the broadest possible palette of gray tones, as opposed to the stark black-and-white contrasts preferred at the time. To do so, they needed not only a first-class negative film, but also had to know how to make optimal use of the dark room in order ultimately to produce a really good photograph. At the same time, the students learned about exposure and pictorial composition as the essential prerequisites for making full use of a negative's potential. In their practical work they experimented with different surface structures and lens filters. They photographed the same subject several times in succession, providing each shot with a different light source and light intensity. Prints were made of all negatives, and these were fixed to a trellis so they could be viewed and compared. The

**Theo Ballmer, Optical exercise 5 from Peterhans's class: photograph from the same viewpoint using various focal lengths.** About 1929, collage, photographs mounted on card, graphic illustration of the exercise, Getty Research Institute, Research Library. • With this set task, Peterhans encouraged the physical comprehension of optical reproduction processes: by reducing the focal length of the lens, as this plan and the photographs show, the subject of the picture is enlarged. In the process, the depth of focus decreases. A kind of resumé of Bauhaus methods for studying nature at that time: the original object and the law of optics, photographic and manual reproduction of the surface.

**Theo Ballmer, Exercise from Peterhans's class, Untitled.** About 1929, collage, piece of wood and photograph mounted on card, graphic illustration of the exercise, Getty Research Institute, Research Library. • A comparison with the original object of the photograph shows best whether the focal length and distance from the subject for his photograph match in their natural size.

conditions under which each of the photographs was produced were neatly written alongside the picture. Other exercises included the appropriate use of different types of photographic plates available in the trade, and presenting the results, as well as studying the the effect of the density of silver particles in photo-emulsion. In order to prepare his students for their practical photographic work, Peterhans required them to draw up lists of commonly used methods, such as those for enlarging or reducing a picture to the right size for a publication. These exercises not only gave students knowledge of the theory, they also provided these future professional photographers with a practical orientation.

The Bauhaus members' carefree individual expression and rush to acquire cameras had been replaced by the professionalization of camera technique for press and advertising work; it was the turning point between the "New Way of Seeing" and an applied objective photography. By the early 1930s the amateur had finally matured into a professional.

# Walter Peterhans – toward a subjective photography

Ulrike Hermann

When one of the most important photographic exhibitions in postwar Germany opened in 1951 under the title "Subjective Photography," it offered a retrospective introduction to the work of László Moholy-Nagy and Herbert Bayer – two former Bauhaus members – as well as photographs by Man Ray. Otto Steinert, who used the exhibition to display the modern artistic trends that were internationally wide-spread in the photography of the time, described the work of the three "classic" photographers as important links with the subjective photographs on show there. The exhibition henceforth lent its name to that particular approach to photography. What kind of influences were exerted on subjective photography by the Bauhaus and in particular by Walter Peterhans, the only photography teacher employed there?

**Walter Peterhans, Untitled (Glasses III).** 1929, vintage print, gelatin process, 23 x 17 cm, The J. Paul Getty Museum, Los Angeles. • Peterhans often depicted the properties of glass objects on two different levels. The transparency of the material is demonstrated by clean contours, its bulbous shape by the tiny points of light, and by the shades of gray at its sides. The thickness of the glass, its massiveness, and its reflective properties are characterized on the level of shadow.

Since subjective photography refers to a framework for a strongly figurative, author-centered and multifarious approach to photography rather than a narrowly defined concept, comparisons are better made using the example of one work than by lumping different works together. Steinert's work is a useful example. He was not only its promoter, he was also its best-known representative. Moreover, he advocated the concept of subjective photography in teaching and was beginning to do so in photographic theory too (Otto Steinert, *Über die Gestaltungsmöglichkeiten der Fotografie* [On the Potential for Design of Photography] in *subjective fotographie* 2, Munich, 1955). There are consequently numerous parallels between him and Peterhans. His work *Strenges Ballett – Hommage à Oskar Schlemmer* (Strict Ballet – Homage to Oskar Schlemmer) constitutes a direct reference to the Bauhaus. With his two wire figures, which evoke virtual volumes, he refers to Schlemmer's costume designs for the *Triadic Ballet*. A combination of photogram, montage and motion photography, Steinert's work at times demonstrates an intensive engagement with the new experimental design methods that had become established during

**Walter Peterhans, Untitled (copper plate with engraved musical notes and accompanying tools).** Undated, vintage print, matt gelatin process, 29·8 x 23·9 cm, BHA. • Peterhans's photographic analysis of material allows him to depict the technical process through a still-life arrangement.

the '20s with avant-garde photography in art. For example, the influence of Man Ray can be seen in his solarizations, and that of Moholy-Nagy in his photograms. The man from Saarbrücken was interested in avant-garde methods, but not in the thematic impetus originally associated with them. He did not share Moholy-Nagy's desire productively to broaden our perception. Philosophical and political themes and references to the real world are seldom seen in the artistically oriented photography of the postwar period in Germany. It was therefore only in outward appearance that Steinert's concept of photography came close to Moholy-Nagy's approach, which referred directly to practical life. In his concentration on photographic composition and high technical standards, his approach can be more readily compared to that of Peterhans, though he rejected experiments as "spurious problems of photography." For, just like Steinert, Peterhans did not want to alter reality or express direct criticism of civilization or art. As well as making full use of the medium's technical potential he was primarily interested in creating photo-specific designs ("by virtue of their unmistakable technical characteristics"), emphasizing the creative, selective and transforming influence of the photographer as the author of the work, and the autonomous expressive character of photography. With their timeless and location-less contexts, in which the individual character of what is depicted retreats behind the pictorial composition, his portraits can be compared to Steinert's portraits of the '50s. Even in those cases the subject of the portrait is first and foremost given a design function by including them in an abstract composition reduced to a black-and-white contrast. The still-life photographs offer yet more parallels. Peterhans's work, with its accentuated objective forms, its almost autonomous structures, its abundance of tones and stylized composition form photo-specific pictorial spaces and materials. Steinert's still-life photographs demonstrate a similar visual presence. In his *Still-life with Pipe*, for instance, the gleam of the porcelain, the dull texture of the

**Walter Peterhans, Still life with pipe.** 1958, vintage print, silver bromide gelatine, 59 x 48 cm, Folkwang Museum, Essen. • After World War II, the retreat into inner positions visible in Peterhans's work is intensified in the philosophies of subjective photography and its main exponent, Otto Steinert.

**Walter Peterhans, Untitled (still life with oyster and matzo).** 1929, modern print, contact print, gelatin process, glossy, 9 x 12 cm, BHA. • In a grid-like arrangement and using the most precise modeling in the widest spectrum of gray tones, Peterhans's composition of material and his depiction of surfaces acquire an immediacy bordering on "airlessness." The viewer is placed in a vacuum of objects.

shells' surfaces and the spots of condensed water on the mirror look as palpable as the pictorial elements used by the Bauhaus members. In addition, the spatial arrangement in Steinert's work is presented in an unclear way which is ultimately intrinsic to the image. With their accentuated orientation around a middle axis and their contrapuntal positioning of objects, his stark compositions bring out the photographer's influence on the design even more strongly.

This concentration on the potential of the medium and its ability to influence was already apparent in Peterhans's work. His approach to photography clearly shows that the atmosphere of a new beginning in art that had dominated the early '20s, had abated by the end of the decade. Modernity no longer wanted to change the world. Traditional, tried-and-tested criteria such as aesthetic autonomy and authorship had long since ceased to appear in art criticism, but were becoming topical again. Ideological standards that went beyond the medium had become questionable as people began to view the previously widely-held belief in progress with skepticism. Since this was similarly the case for the period after World War II, it is not surprising that at that time numerous efforts were made, including those by the subjective movement, to link up with the "late" and more strongly media-intrinsic and design-oriented avant-garde. The fact that it already assumed the status of a "tame classic" as early as 1930, well before the postwar period, is clearly visible in Peterhans's work.

# The Bauhaus Theater Group

Arnd Wesemann

"Aus lieber Dummheit tat's der alte Schlem-
mer, Dem Wein und Bratenduft den Sinn
umnebelt" (Out of fond foolishness old
Schlemmer [= gourmand] did it, His senses
befuddled with wine and the smell of roast
meat), from Heinrich Heine, *Almansor.*

It was not because it lasted for a comparatively
long time that the *Triadic Ballet*, the most
famous choreographic production by the
*Bauhausbühne* (Bauhaus Theater Group),
became well known. It was first performed
at the Württembergisches Landestheater in
Stuttgart on September 30, 1922, and its last
showing was on July 4, 1932 at the inter-
national dance competition in Paris. Ten years
is no great age for a ballet. Furthermore, only
about 1000 people saw the *Triadic Ballet* dur-
ing this period. Also, Oskar Schlemmer, whose
name is so closely associated with this ballet,
derived little pleasure from his pioneering
choreography. Throughout its entire stage life,
the *Triadic Ballet*, despite requiring very few
resources – only three dancers and 18 cos-
tumes – proved a financial, and sometimes also
an artistic, fiasco. In present-day terms it would
be considered a free group production. The
venue need be no more than the stage of a
school hall, but without any subsidy financing
was dependent on a meager paying audience.
Even Schlemmer's status as head of the Bau-
haus Theater Group in Dessau from 1925 had
no positive influence on the fortunes of the
*Triadic Ballet*. There were few festivals at that

**Oskar Schlemmer, Andor Weininger and stu-
dents at a Bauhaus Theater Group rehearsal.**
About 1927, photographer unknown, Oskar
Schlemmer Theater Archive. • The stage depart-
ment at Dessau, though small, was a lively focal
point for all the areas of design studied at the
Bauhaus. Its head, Oskar Schlemmer, with his
infectious enthusiasm, set a stimulating example.

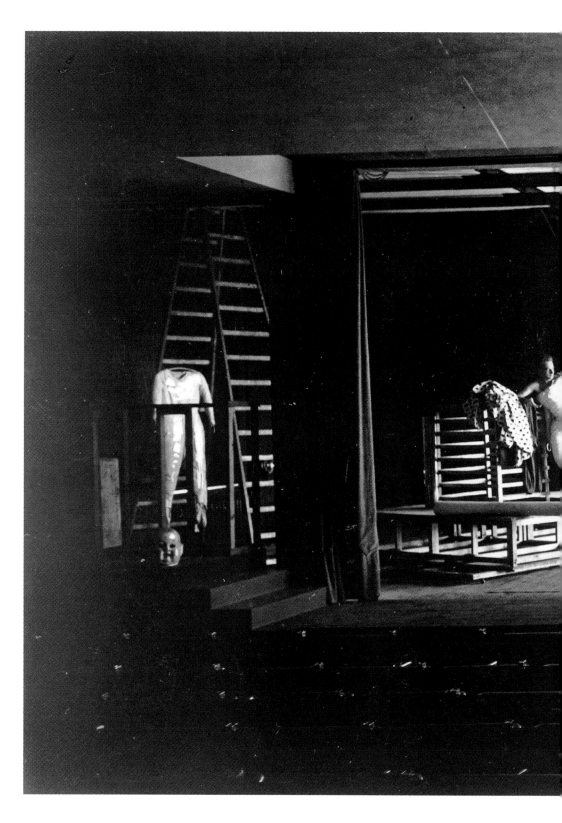

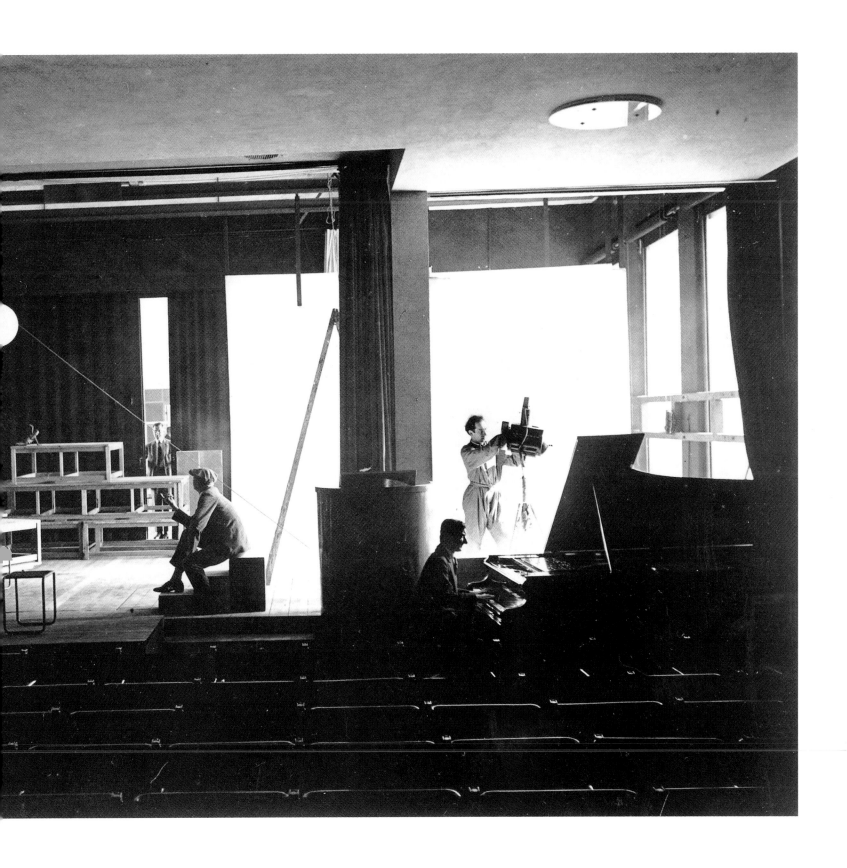

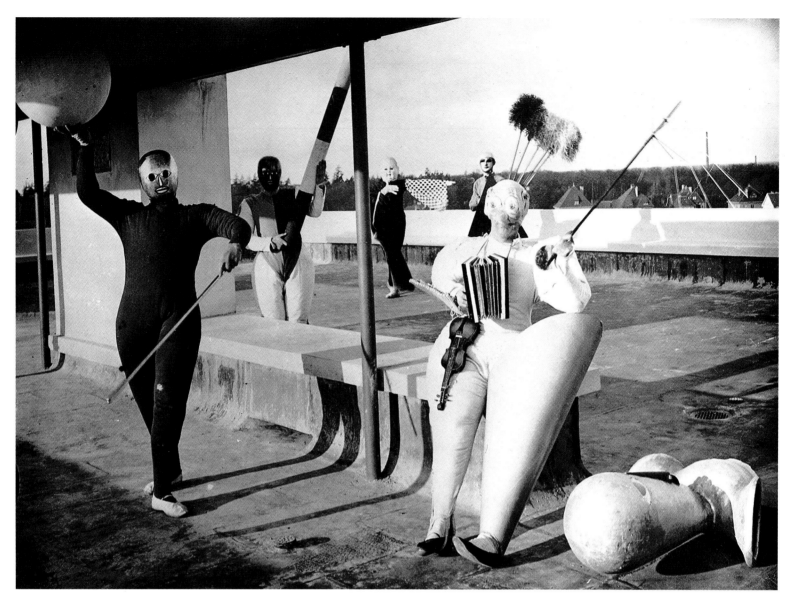

**The theater class.** 1927, photograph by Erich Consemüller, Oskar Schlemmer Theater Archive. • Stage jokers climb onto the roof. Here pantomime came close to its proper function, and made itself felt in the real world.

**Oskar Schlemmer as a musical clown.** About 1927, photograph by T. Lux Feininger, Oskar Schlemmer Theater Archive. • For Schlemmer, the musical clown marked the "frontier zone between music and the grotesque" and enriched the theater with the expressive potential of variety theater and circus. At the stage show during the opening of the Dessau Bauhaus on December 4, 1926, Andor Weininger was the musical clown.

time, and only on one occasion did the Donaueschinger Musiktage (Donaueschingen Festival) offer to play the part of co-producer. The myth that nevertheless attaches to the *Triadic Ballet* began when the painter Oskar Schlemmer, then aged 24, met the dance couple Albert Burger and Elsa Hötzel in Stuttgart. They were both highly enthusiastic about the Jugendstil rhythmic gymnastics of Emile Jaques-Dalcroze in Dresden-Hellerau that was in vogue at the time. The first sketches and drafts for the *Triadic Ballet* date from that time, 1912. They led to a triad for three dancers and

three nudes, the so-called yellow, pink and black series. Ten years later, Burger, Hötzel and Schlemmer danced the *Triadic Ballet* for the first time, without a fee and without rhythmic gymnastics, but incurring considerable debts because of the high cost of producing the costumes, these being riveted, soldered and reinforced with papier mâché. They were brittle, because they were rigid, the saucer-shaped starched skirts looking like tutus, the bell masks reminiscent of divers, along with wire costumes, conical helmets and spherical cuffs. Arguments arose because Burger and Hötzel,

by then a married couple, had difficulty in giving shape to Schlemmer's ideal of abstract dance movements with figurines reminiscent of E.T.A. Hoffmann's automata, a Cubist *Cabinet of Dr Caligari* made of the simplest materials. But above all it was a question of money. The Burgers wanted half of the figurines as security for their expenses. A substantial success in Weimar on August 16, 1923 was followed ten days later by a flop in Dresden. The handful of people who came to see it left shaking their heads. The relationship broke down completely and Schlemmer lost half his figurines.

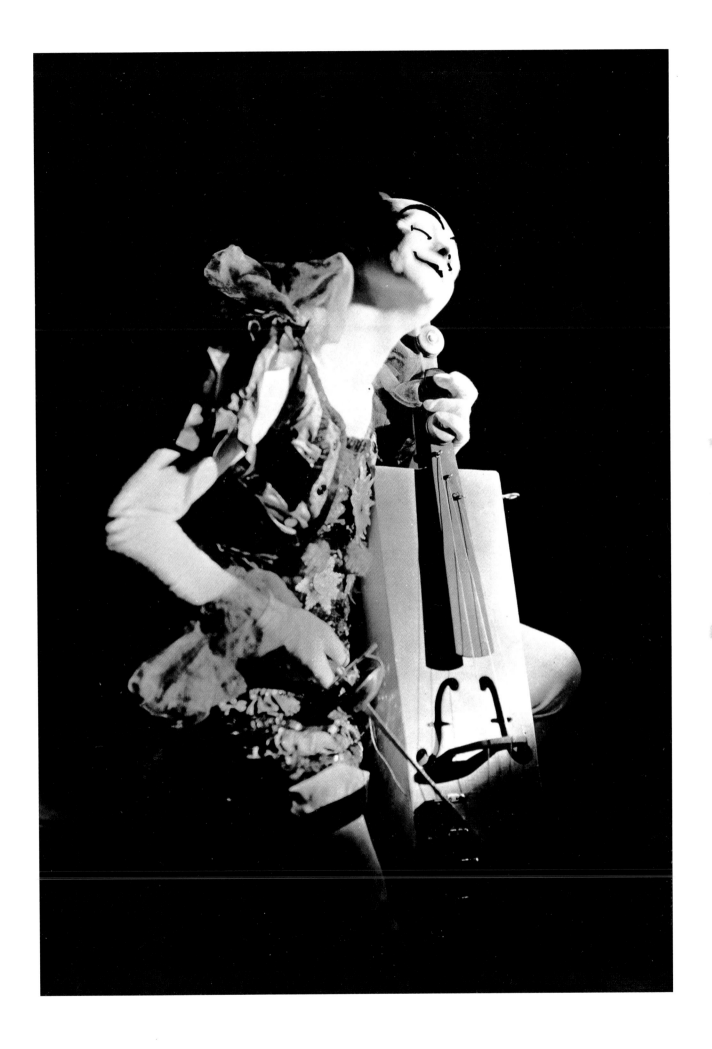

**Joost Schmidt, Study for a mechanical theater.** About 1928, crayon on paper, 43.0 x 31.0 cm, Getty Research Institute, Research Library. • Schlemmer's former student was involved in helping to set up the Bauhaus's first theater of its own in Dessau. In illustrating the basic possibilities of movement in the stage area, he had in mind the installation of machinery for non-human actors, but this could not of course be financed by the Bauhaus.

Three years later Paul Hindemith composed music for the mechanical organ for the Donaueschinger Musiktage on July 25–26, 1926. Schlemmer's *Triadic Ballet*, which has no plot, was juxtaposed to this organ work rather than integrated into it (and was not very well danced either.) Once again it was barely possible to meet the costs of transport and of making the costumes: Schlemmer hired out the figurines – in order to reduce his debts – and his brother Carl, though on hostile terms with the Bauhaus, mounted the production for next to nothing. The Metropol Theater in Berlin borrowed the figurines in September of 1926 for the opening of

its revue. No fee was paid, and Schlemmer even believed that it would be publicity for him. For three months the figurines were battered about, then the revue was taken off. Not until 1932, six years later, was the ballet performed again, after expensive repairs, at the international dance competition in Paris. Enthusiasm was moderate. There was too great a contrast between the marionette-like dances and the perfect dancing demanded in Paris. Even so the ballet came sixth in the competition. But Schlemmer had had enough. This art form was too expensive, too fragile and attracted too little public attention. Contemporaries noticed the curious

**Designer unknown (Eberhard Schrammen?), Stage costumes.** About 1923, photographer unknown, Misawa Bauhaus Collection, Misawa Homes Co. Ltd, Tokyo. • It was probably Eberhard Schrammen himself who resolved to bring his wooden puppets to life and send them onto the stage to dance.

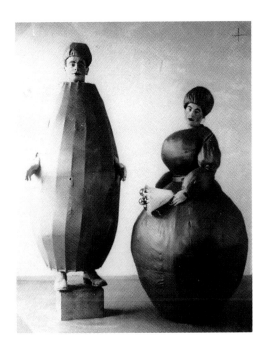

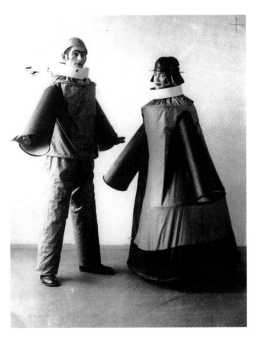

**Designer unknown (Eberhard Schrammen?), Stage costumes.** About 1923, photographer unknown, Misawa Bauhaus Collection, Misawa Homes Co. Ltd, Tokyo. • Dressed in their crinolines as Humpty Dumpties and with limited scope for movement – it was as though Dada were beckoning to the figurines from the other end of the stage.

**Eberhard Schrammen, Glove puppet designs.** About 1923, watercolor and graphite on drawing card, 45.5 x 58.6 cm, BHA. • The puppets, made almost exactly to these designs, reveal costume ideas from the *Triadic Ballet* in the tradition of toy figurines from the Erzgebirge.

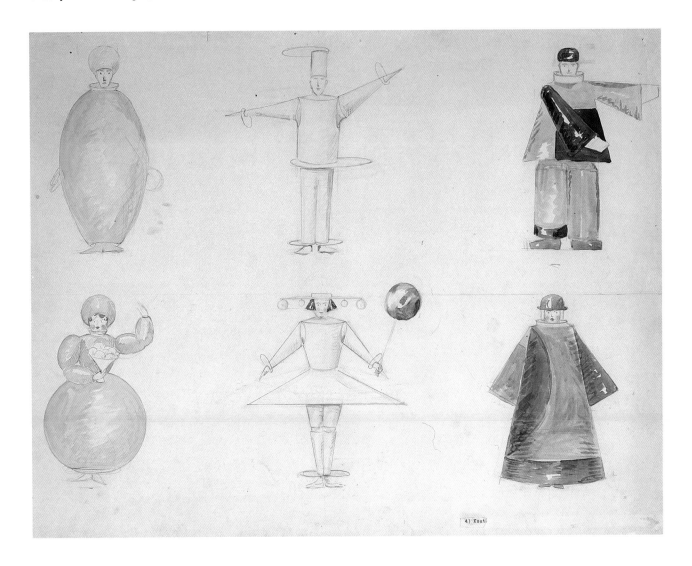

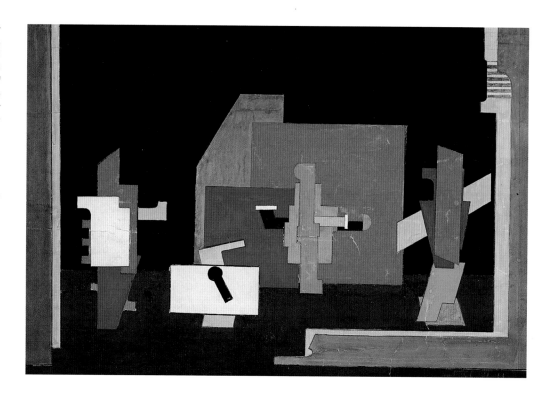

**Kurt Schmidt, Design for the mechanical ballet.** 1923, bodycolor on paper, 33.5 x 48.5 cm, KW, BM. • Actors were comically hidden behind these five abstract figures, and carried them across the stage to the accompaniment of music by Hans Heinz Stuckenschmidt. To many members of the Bauhaus in Weimar it seemed obvious that art could be completely de-individualized by using mechanical energy.

**Lothar Schreyer, "Der lüsterne Mann" (The Lustful Man).** 1918, figurine for the marionette play "Birth," gouache and Indian ink over graphite on paper, 40.0 x 30.5 cm, Schiller-Nationalmuseum, Deutsches Literaturarchiv, Marbach am Neckar. • This project was not carried out. The scope for action of the psychologically conceived figure, for all its apparent mobility, would perhaps not have been greater than at other performances by the Kampfbühne (Theater of Struggle) in Hamburg, which was where Schreyer had come from. There it was primarily words – with a rhythmic, quasi-religious intonation – that played an important part. Schreyer brought these Expressionistic cult productions to the Bauhaus.

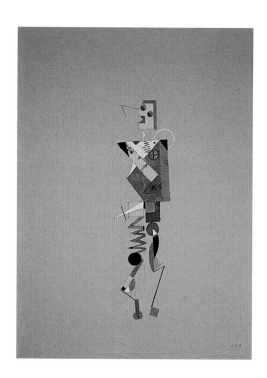

figurines rather than the idea of the choreography, its opposition to the conventions of ballet and the "mathematical" effect of its equation of music, sculpture, painting and dance. In 1938, nine of the 18 figurines found their way to New York City for an exhibition. Colorful papier mâché figures, lifeless yet radiating the spirit of dance. They stood around there, godforsaken – and that is where the real history of the *Triadic Ballet* begins. For now, with nothing moving any more, everybody asked how these sculptures might once have danced. Suddenly the *Triadic Ballet* began to write its own history: the history of its reconstruction. Reconstructed by dancers, it was performed from 1968 by Margarete Hasting in Munich, from 1973 by Gerhard Bohner in Darmstadt, from 1978 by Helfried Foron in Tübingen and from 1982 by Debra McCall in New York.

Looking back in 1935, Oskar Schlemmer wrote: "No, the Triadic Ballet was not a mathematical joke. But it was an attempt to fuse many elements, some of them heterogeneous, in an unusual unity. Not only did the geometry of the dance floor have to be organized, that appealing chessboard with its ever-changing games which needed to be seen from above, that is to say by an audience in the gallery. Not only did the artistically beautiful relief figures, that give the stalls a feast for the eye, have to

be designed. The attempt had been made – and herein lies the problematic nature of this ballet – to pack the dancers in more or less rigid costumes in the belief that the dancers' energy – physical as well as psychological – would be sufficient to overcome the rigidity of the costumes through their intensity of movement. It must be admitted that this struggle with matter did not always end in victory for the dancer. But when the dancers did succeed in imbuing their costumes, the vessels that contained them, with the most lively emotion, and in assimilating, that is to say incorporating them into themselves, then the aim was achieved: to enrich dance as an art form in one of its departments, that of costume dance or, as it used to be called, masquerade, and to provide a reminder of the potential beauty of this genre." There were hardly any precedents at the time for the body costume, at most a few similarities with Fernand Léger's work for the Ballets Suédois. Schlemmer stated, back at the first performance on September 30, 1922, that they had been inspired by the Basel masquerade. On the back of the program note he wrote "Ballet? Ballet! – for of the two manifestations of dance, the cultic dance of the soul and the aesthetic masquerade, it is the latter. The result: in the one case, nakedness; here, the costume, the disguise (in between, the scraps of material

and the ecstatic fluttering of today's female dancers, a middle way that rules out either nakedness or costume.)"

Schlemmer's style of writing is still vintage Expressionism. The "cultic dance of the soul" undoubtedly refers to Emile Jaques-Dalcroze, to those rhythmic gymnastics – the liberation of the body from the discipline to which it had been subjected – from the midst of which German expressive dance had been born. The Weimar Bauhaus constituted a somewhat odd countermovement to this. The euphoria of the liberated body, of which Schlemmer was still an adherent in 1928, in his lectures on the subject of "the human being," joined hands with the "mathematically sublime" as understood by Kant. This contemporary spirit was embodied in particular by Lothar Schreyer, the first head of the Bauhaus Theater Group from 1919–1923, who, in the manner of Expressionism, saw in an almost cultic, "sound-speaking" stage action a "cosmic mirror," albeit of

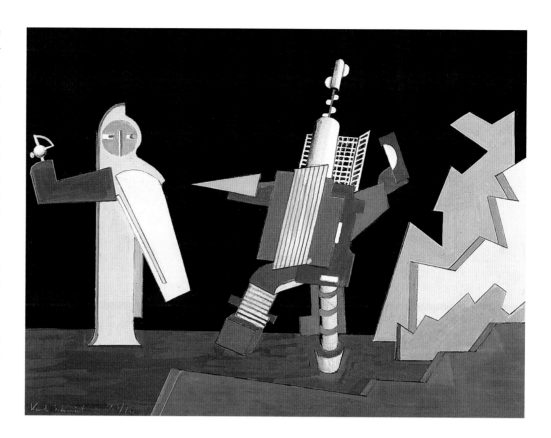

**Kurt Schmidt, "hippopotamus," sheet 2.** 1923, tempera over pencil underdrawing, 35.8 x 47.7. cm, SBD, archive collection. • Schmidt's great success with the piece "The Mechanical Ballet" lay in the simple shifting of geometric stage flats. In this design he worked with the transformation of "organic forms into technologized structures" – as the title in German suggests: *Nilpferd* has become "hippopotamus."

**Xanti Schawinsky, Stage and costume design for the Tamer and Monster scene from "Circus."** 1924, tempera, Indian ink and pencil on paper, 34.2 x 50.1 cm, BHA. • For the opening of the Bauhaus on December 4, 1926, Schawinsky's pantomime *Circus* provided the merry finale on the new studio stage: a girl at a riding school trains her hobbyhorse, an athlete lifts papier mâché weights and a tightrope walker balances on an imaginary rope – a white line drawn on the floor of the stage.

mathematical beauty, because he was similarly impressed with Cubism. In 1916 Schreyer wrote in the periodical *Der Sturm*: "The basic forms (of theater) are mathematical solids and planes. The basic colors are black, blue, green, red, yellow, white ... moving color is moving light or a moving body. Physical movement transforms space." These sentences, with their rudimentary analysis of the individual elements of theater – body, light and space – read like pure Bauhaus, but they are in fact plagiarized. The ideas are to be found in Wassily Kandinsky, the later Bauhaus master, who had written his essay on "Stage Composition" back in 1910. Oskar Schlemmer, soon to become the leading man of the Bauhaus Theater Group, also shared Kandinsky's position. Schlemmer opted for the explanation of the origin of dance in festivities, in masquerades, and not without good cause: the extent to which the Bauhaus

**Walter Gropius, Total Theater project for Erwin Piscator.** 1927, perspective drawing by Stefan Sebök, Indian ink and tempera, sprayed, 69.0 x 95.7 cm, Courtesy of the Busch Reisinger Museum, Harvard University Art Museums, Gift of Walter Gropius. • Efforts to conceive a form of democratic theater in place of the usual absolutist stage conception brought about, externally, the disappearance of the entrance façade and an architectural leveling. The interior could be transformed from a proscenium arch stage into an amphitheater or an arena. This made total involvement of the audience possible – but also implied exposing the auditorium to total manipulation.

**Farkas Molnár, U Theater in use.** 1924, illustration from Oskar Schlemmer, László Moholy-Nagy, Farkas Molnár, "Die Bühne am Bauhaus," Munich, 1925, Bauhaus Book 4, BHA. • Analyses of the stage machinery also include the stage area. The traditionally separate areas of auditorium and acting space were beginning to penetrate each other.

Theater Group (for which, often enough, no funding at all was available) seemed to be subject to a dictatorial anti-Expressionism, can be seen from a letter written by Schlemmer in 1923 to his friend Otto Meyer-Amden: "The literary aspect is avoided almost as a matter of principle; hence formal elements ... mechanisms, light effects. Dance above all."

The Bauhaus Theater Group ventured to present itself to the public for the first time on August 17, 1923. The event was euphemistically described as the *Battle of Jena* (but won by Germany), and the program note included the words: "The mechanical cabaret." In Jena, Kurt Schwerdtfeger's idea of a shadow play as a presentation of reflected light (a precursor of abstract film) was well received, as was the "mechanical ballet" of Kurt Schmidt and Georg Teltscher, which was conceived in the tradition of Kandinsky, and culminated in Kandinsky's *Pictures at an Exhibition* in Dessau in 1928, and Schlemmer's "figural cabinet" of Cubistic cardboard figures. The human body, which before World War I was still the object of an unbridled ideology of liberation, now plays the part of a "mechanical master of ceremonies." The real actors are now canvasses, cardboard flats and rhythm – a sculptural theater which, as in the Japanese

Bunraku puppet play, gives human beings the role of mechanics. The artist appears as an engineer and almost vanishes behind his mechanical creation.

Despite this initial success, funding and public recognition of the "mechanical cabaret" remained precarious. One solution was to open up the stage (which was situated immediately adjacent to the canteen), the "great hall" at the center of the Bauhaus, as a "party space," partly in order to earn money, but also in order to persuade the public to accept the ideas and aims of the Bauhaus. The stage had ambitious visions. But nobody could realize the multi-layered light-sound compositions of László Moholy-Nagy, or the mighty total theater for Erwin Piscator, conceived by Walter Gropius in 1927, Andreas Weininger's spherical theater developed in 1926–1927 or Farkas Molnár's "U Theater" with room for an audience of 1200. These were all architectural visions of theater just at a time of global economic crisis, gigantic alternatives to the traditional proscenium arch stage, but there would never be a Bayreuth for the Bauhaus. In the real world, Schlemmer's Cubist masquerade continued to be performed as a party piece at the Lantern Party to mark the solstice, and at the fall Kite Party. As is today becoming fashionable again,

Workshops

**540**

**Metal dance.** 1929, stage photograph with Karla Grosch by T. Lux Feininger, Oskar Schlemmer Theater Archive. • The metal dance was part of the repertoire of dances which made the material, with its inherent scenic potential, into an active participant. In the dance, which lasted for only a minute and a half, the "dancer" – here the Bauhaus gymnastics teacher Karla Grosch – performed gymnastic rather than dance movements.

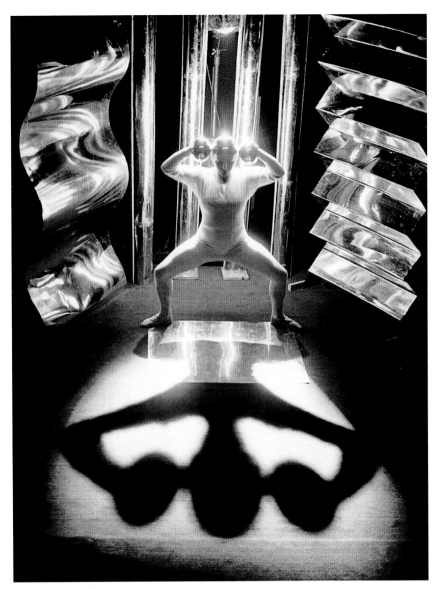

**Lines in space.** 1926, stage photograph (multiple exposure) with Werner Siedhoff, photograph with inscribed framing lines by T. Lux Feininger, Oskar Schlemmer Theater Archive. • Schlemmer's idea of deriving types of movement from the coordinates of the stage space looks like the fitted "Frankfurt kitchen" brought to life. The linear organization of space gives a mechanical quality to the housewife's movements. The actor's physical postures are subordinated to the linear organization of an imaginary architecture.

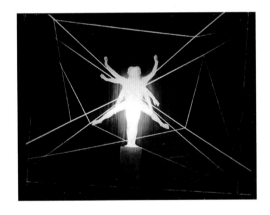

**Stages of dramatic gesture.** 1927, stage photographs (multiple exposure) with Werner Siedhoff, photograph by Erich Consemüller, Oskar Schlemmer Theater Archive. • An eerie multiplication of human outlines and movements with the actor and dancer Werner Siedhoff as a performer of dramatic gesture. He appeared on the Bauhaus stage between 1925 and 1929.

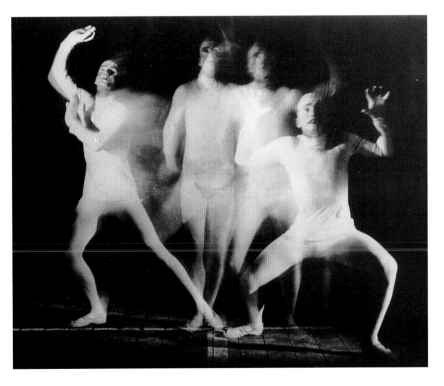

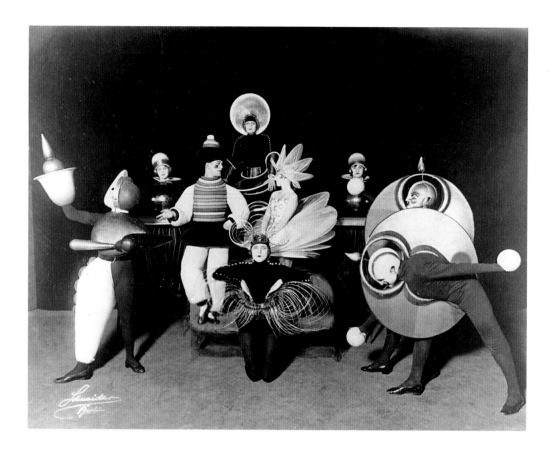

**Costumes for the "Triadic Ballet" in the revue "Metropolis Again" at the Metropol Theater, Berlin.** 1926, overall view (posed photograph) from the director's copy for Hermann Scherchen, 1927, photograph by Ernst Schneider, Oskar Schlemmer Theater Archive. • The transformation of human outlines into material and color, geometry and stereometry does not go so far that the dancers are forgotten. Those very movements that are restricted by costumes create an abstract organic quality.

**Box game – witty afterthought.** 1926, stage photographs (double exposure) with Werner Siedhoff and Wolfgang Hildebrandt, photograph by Ruth Hollós, Oskar Schlemmer Theater Archive. • The box game was not a witty afterthought in avant-garde theater history, but an attempt to explore the nature of the stage prop as the "initiator of artistic pantomimic dancing."

theater was not the only thing on offer, but provided the occasion for the evening. Between a dadaistic stage show, Paul Klee's puppet shows and the fancy dress party (with music provided by "Andor" Weininger's Bauhaus Band) there was eating, drinking and a good deal of laughter, for example at "an interpretation of Morgenstern's 'Fish Song' followed by gargling variations."

Following the enforced move to Dessau, Schlemmer, after initial vacillation, took charge of the stage department. Between 1925 and 1929 (interrupted by engagements as a stage designer, mostly at the Volksbühne in Berlin) he developed the idea of "theater as festivity." The Bauhaus Theater Group retained its function as an experimental theater; today one would call it a rehearsal stage. There were no professional dancers, amateur status was

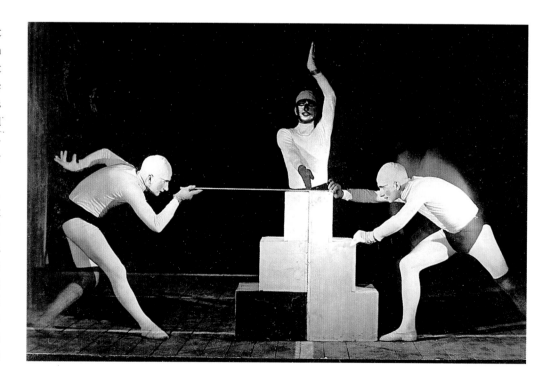

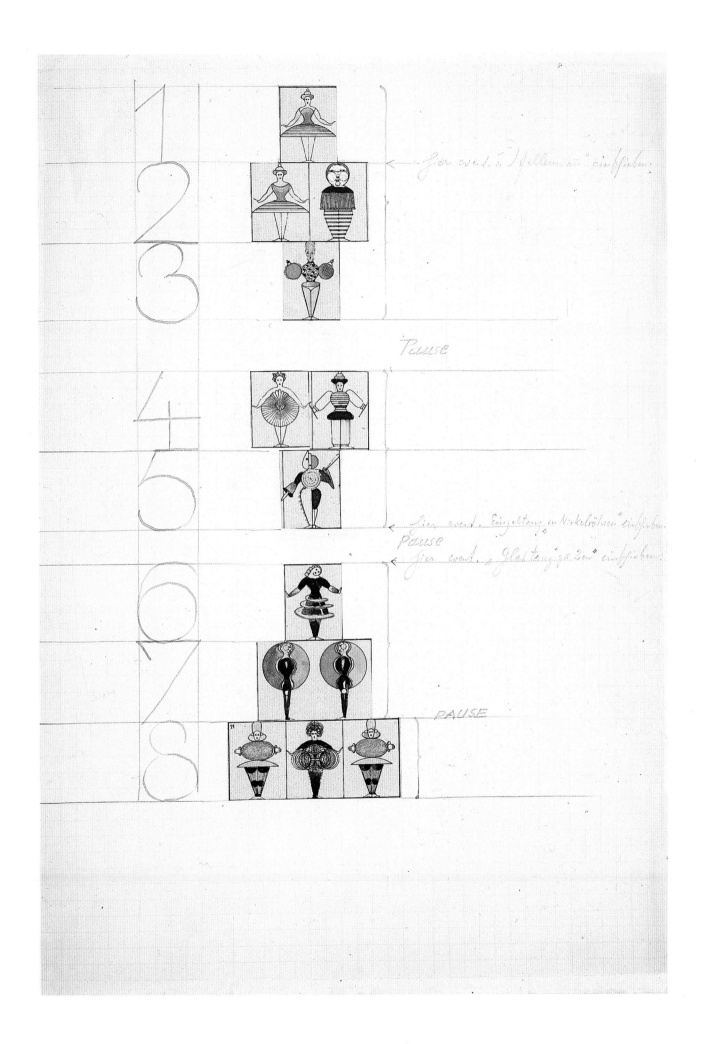

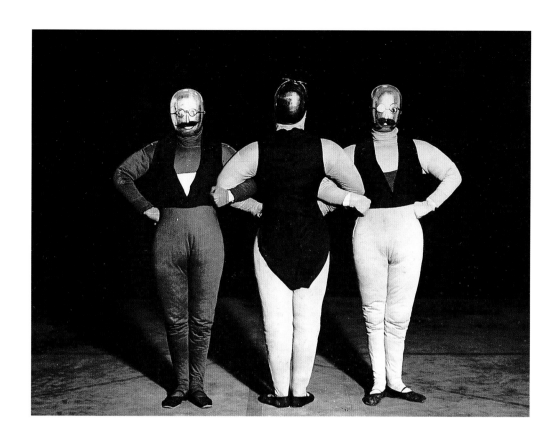

the event: "The takings for the evening will be not far short of 200 marks, which I shall share out between those involved." There were "champagne booths" and the celebrations were generally exuberant. The Madrid art historian Angel Gonzáles bluntly describes these Bauhaus theater parties as a "madhouse," at which the audience danced away the night while the puppets amused themselves on stage, for "only in dancing could the Bauhaus unite and reconcile the opposing forces which threatened to destroy it." When, for example, it was announced that Gropius had been dismissed from Weimar by the right-wing political parties that had been in government since 1924, Schlemmer wrote in his diary after the farewell party: "Gropius was carried and dragged around more than he could bear. Everybody was shouting and screaming. I was worn out and went home, alone, at half-past four."

In the aggressive political atmosphere of the time, the abstract costumes which Schlemmer

**Gesture dance III.** 1927, stage photograph with Oskar Schlemmer, Werner Siedhoff and Walter Kaminsky, photograph by Erich Consemüller, Oskar Schlemmer Theater Archive. • Relationships between eggheaded "master criminals"? Or, more likely, how simple masks with a moustache, tailcoat and spectacles create, as if by magic, a vocabulary of gesture in a dance lasting six minutes.

**Hoop dance.** 1928, stage photograph with Manda von Kreibig, photograph by T. Lux Feininger, Oskar Schlemmer Theater Archive. • Lighting, rotation and overlapping perspectives transform the wooden material into animated graphics.

the rule – which was why it enjoyed so much freedom and was ultimately even able to adopt a revolutionary stance. Indeed, some of the passages in Schlemmer's diary from this period suggest descriptions of present-day disco designs rather than theater. In connection with the Metallic Party on February 9, 1929, he wrote: "A slide lined with white metal, under rows of innumerable silver balls lit up by spotlights, led to the party ... a staircase, each step of which gave out a different musical note ... led to the tombola, where, it is true, there were no folding metal houses or 'machines for living in' to be won, but the preliminaries were there: steel chairs, nickel bowls, aluminum lamps, even nice cakes with a metallic look about them." At these parties, where the main participants wore fancy dress designed by Schlemmer, the "official program" of performances comprised the abstract dances and cabarets, interspersed with tombolas, which made a not inconsiderable contribution to the financing of

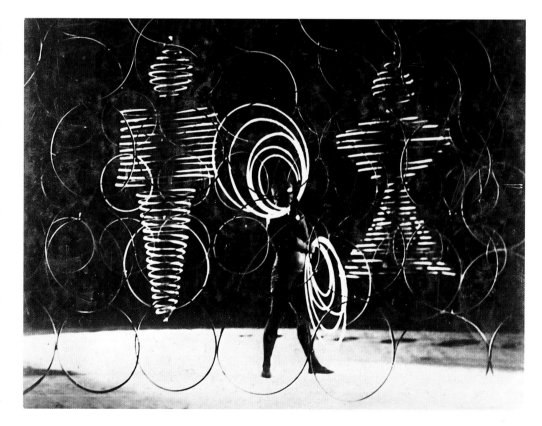

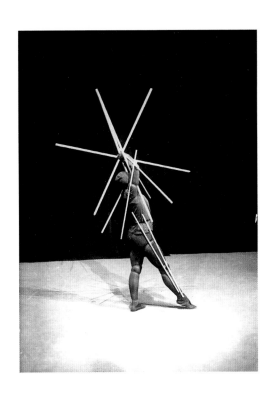

devised for the masquerade increasingly took on the quality of armor. In Schlemmer's famous essay of 1925, "Mensch und Kunstfigur" (Man and Art Figure), he emphasized the fundamental role of "man as dancer, transformed by costume, moving in space": "Magical figures of this kind, personifications of the loftiest ideas and concepts ... will also be able to serve as valuable symbols for a new faith." But senior students such as Kurt Schmidt and Xanti Schawinsky did not take this idea of a social utopia from the grotesque dancer, armed with mask and cothurn, quite so politically (and Schlemmer himself probably did not either). On the contrary, they associated masks with machines, for example in Schawinsky's "tap dancer versus tap-dancing machine" at the White Party in Dessau in 1926, or in Schmidt's "The man at the switchboard" (which did not follow the former to Dessau). But instead, the hope that was born at the Bauhaus of a reconciliation betwen art and industry continued to

**Rod dance.** 1928–1929, stage photograph with Manda von Kreibig, photograph by T. Lux Feininger, Oskar Schlemmer Theater Archive. • A theorem of physical geometry: restricted movement of the limbs entails increased movement of their extensions. Here the "mathematics" of the human body were meant to become visible.

**Oskar Schlemmer, Stilt walkers.** 1927, preliminary study for the "rod dance," watercolor over pencil on chamois-colored watercolor paper, 45.3 x 60.7 cm, Oskar Schlemmer Theater Archive. • Schlemmer was a master at finding the simplest props which confronted human physical forms with a breakdown into their most basic elements.

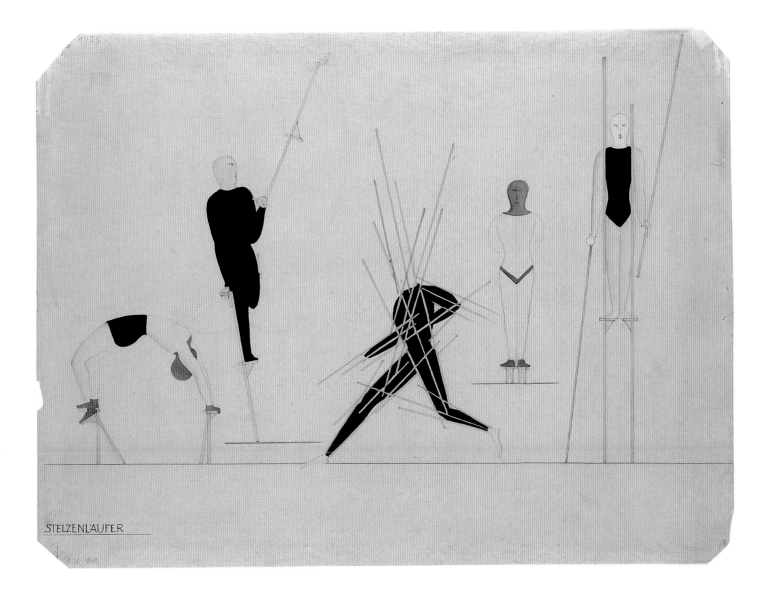

STELZENLÄUFER

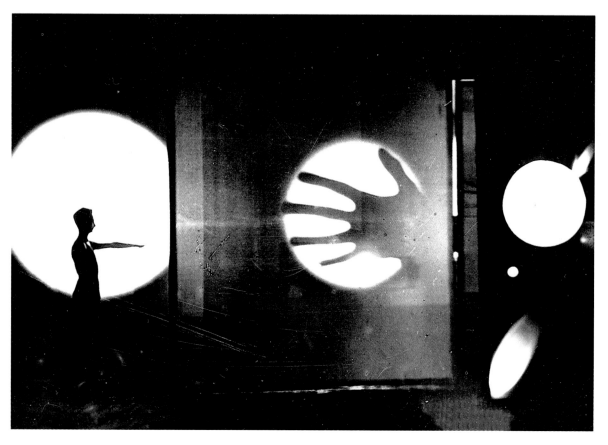

**Light play/experiments with light in various forms.** 1927, photograph by T. Lux Feininger, Oskar Schlemmer Theater Archive. • Moving body plus moving light create new optical spaces for the viewer from four parallel transparencies.

**Roman Clemens, Stage design for a play of form, color, light and sound, 3rd scene: Tango.** 1929, tempera, 31.0 x 49.0 cm, Cologne University, Theaterwissenschaftliche Sammlung. • Roman Clemens was the only member of the Bauhaus Theater Group who later continued its holistic, elementary approach professionally.

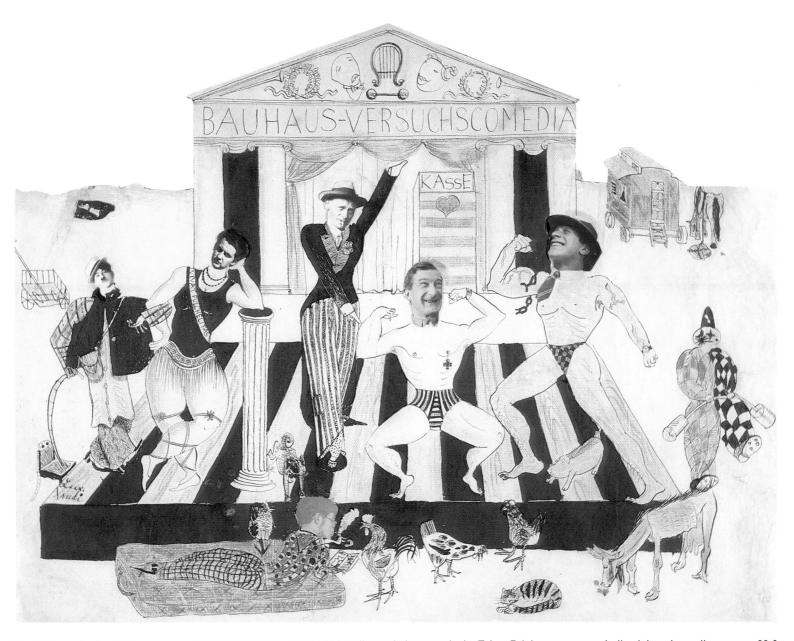

**Xanti Schawinsky, Bauhaus experimental comedy.** About 1928, collage of photographs by T. Lux Feininger, crayons, Indian ink and pencil on paper, 39.6 x 52.6 cm, BHA. • A guest performance by a traveling circus with artistes, comedians and Charlie Chaplin in front of his classical backdrop, with built-in privy. The fact that the show takes place in front of bored domestic animals, while the prompter reads the magazine *Der Uhu*, does not detract from our enjoyment.

decline. The attempt by Hannes Meyer, the Swiss architect who succeeded Gropius, to exploit the mechanization of the theater as a communist propaganda theater co-op and use the masks for Brechtian "alienation effects," failed in the long run.

Schlemmer committed himself – in the face of increasing resistance at the Bauhaus – to a much more consistently introspective policy for the theater. In 1926 he began to design "figure types," following the example of the commedia dell'arte, and in his "Demonstration der Bühnenelemente" (Demonstration of Stage Elements) of 1927 he investigated the effects of

the curtain; the relationship of the human figure to stereometric space, with the aid of a nexus of cords; and the effect of masks, abstract backdrops and projected light. In 1928 Manda von Kreibig, the dancer from Darmstadt, gave a guest performance in Dessau. Among other things she developed the "rod" dances, which had become famous as a result of the guest performance by the Bauhaus at Kurt Jooss's newly established Folkwang school in Essen. Here the spatial effect of the body was demonstrated by using long wooden rods to extend the limbs. On March 3, 1929 the Bauhaus Theater Group gave a guest performance before an audience

of 2000 at a matinée at the Berlin Volksbühne. They presented their repertoire of what by then had become ten such "space analysis" dances. There were further guest performances in Frankfurt am Main, Stuttgart and Basel. The Bauhaus Theater Group became a familiar name, at exactly the same time that it was being politically vilified under Hannes Meyer in Dessau. Schlemmer, who in frustration accepted an appointment in Breslau, invited both Kandinsky and Klee to take over the direction of the theater. Both refused. By 1930 Meyer had led it, as an internal agitprop stage, into complete insignificance.

# Bauhaus masks – a loose liaison of dancers and artists

Arnd Wesemann

The mask obliterates the human being as a person and gives scope to the dancing creature with its artistic urge (Mary Wigman).

The guest appearances in the '20s by the Ballets Russes with their head faun Vaslav Nijinsky attracted a host of painters. Theater inspired the artists. Back in 1918, the Futurist Fortunato Depero constructed never-ending stage variations for his ballet fantasies. In Halle, not far from the Weimar Bauhaus, Katharina Heise modeled the most famous modern dancer of its time and Wigman's first male pupil, Harald Kreutzberg, in clay. No secret was ever made of Ernst Ludwig Kirchner's fascination with Mary Wigman herself, the grande dame of German expressive dancing. Although she did not cultivate direct contact with the Bauhaus to any degree, it was she who gave to expressive dancing, with its roots in Expressionism, features of the

**Gerhard Bohner: "Im (Goldenen) Schnitt" (In the [Golden] Circle).** 1990, stage design by Paul Uwe Dreyer, photograph by Klaus Rabien, "ballet-tanz" Archive. • Body geometry without props: Schlemmer's concept proved capable of even further reduction.

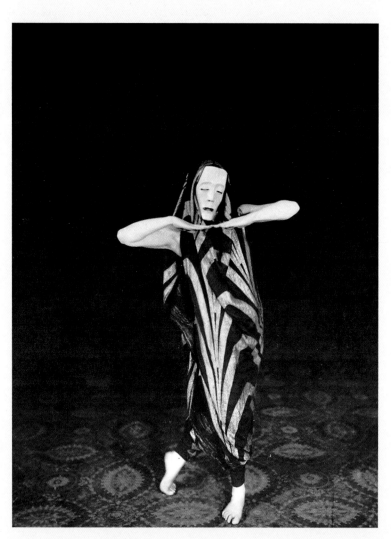

New Functionalism that had evolved at the Bauhaus. Mary Wigman, who worked in Dresden, was very impressed with Wassily Kandinsky, and this had a direct influence on her work. Her choreography for *Circle* (1923) followed Kandinsky's painting *Circles within a Circle* of the same year. With Oskar Schlemmer she was on terms less of friendship than of cool admiration. She helped out with her pianist at the guest performance of the Triadic Ballet in Dresden on August 26, 1923, and three years later wrote him the following letter of recommendation: "You know yourself what a powerful impression the Dresden performances made on me at the time, and how greatly I regretted the fact that these decorative dance works, which are unique in their way, could not be shown more often. It would be welcome in every way if the ballet could be presented to the interested art-loving public to a greater degree than hitherto, and a theater exhibition would probably provide the best context for this. For your creations, apart from their purely artistic value, are stimulating and pioneering works for the entire modern mode of representation." Not only Schlemmer, in his *Triadic Ballet* – first performed in 1922 – but also Mary Wigman used masks. Her *Witch's Dance* of 1926, which she danced with a wooden mask in front of her face, made her world-famous.

One of Wigman's most gifted pupils, Gret Palucca, who opened her own studio in Dresden in 1925 in competition with the Wigman school (which was usually severely overcrowded), cultivated closer contacts with the Bauhaus. Gropius, Mies van der Rohe, Schlemmer, Feininger and Moholy-Nagy from the Bauhaus, along with Lissitzky and Jawlensky, all revered her for the precision of her dancing and for what

**Mary Wigman in "Mask Dance."** 1926, photographer unknown, Ullstein picture service. • What Wigman began as the individual's expression of general human feelings, Schlemmer's masked dances developed into an organic expression of elementary artistic resources.

Kandinsky described as her "principal assets": "1. Simplicity of the whole form, and 2. Construction of the large form." Kandinsky produced four famous "analytical drawings after Charlotte Rudolph's photographs of Palucca dancing." Her dance postures and her body are rendered there in arrow-like lines – the drawings are like flashes of lightning. Ernst Kolbe modeled Palucca's head in 1925–1926. Ernst Ludwig Kirchner, who revered Wigman, painted the *Leaping Dancer Gret Palucca* in 1932, and supplemented the painting with colored woodcuts. Piet Mondrian's *Composition I with Blue and Yellow* of 1925 hung in Palucca's practice hall until 1944. Gret Palucca, although never directly associated with the Bauhaus, was the only member of the Dresden dance circle who now and again, as for example in April of 1927, also appeared on the Bauhaus stage.

The Bauhaus Theater never became as well known as artists like Wigman or Palucca. The Darmstadt ballet leader Manda von Kreibig came to the Bauhaus in 1927–1928 and exerted a decisive influence on Schlemmer's stage work. Her hoop and rod dances, among other works, were created in partnership with the actor Werner Siedhoff. It was thanks to Kreibig that Schlemmer was taken at all seriously as a choreographer by the world of dance, which at the time was becoming polarized between Dresden and the Folkwang School in Essen, and did not always work in an interdisciplinary mode, often isolating itself in solo performances. Schlemmer's official work on dance consisted essentially of commissions for stage designs, for example for Stravinsky's ballet *Les Noces*, which he planned with the conductor Hermann Scherchen until 1928 but was never able to realize. In that same year Tchaikovsky's *Nutcracker Suite*, with stage designs by Schlemmer, was at least moderately successful in Dresden. The choreography was by the now forgotten Ellen von Cleve-Petz.

The fact is that artists were far more impressed by the dance genre than vice versa (with the exception of Gret Palucca). Dance appears to have been a kind of leading art form in the Weimar Republic. Andor Weininger's abstract revue, a dancing geometry of colors entitled the *Electro-mechanical Bauhaus Theater* of 1926, likewise took its cue from rhythmic movement, as did Kandinsky's *Pictures at an Exhibition*. The picture itself was expected to dance. The idea that, vice versa, a dance might become a picture, that dance could ever become a visual, spatial art has always been regarded as purely theoretical in the world of dance. Mary Wigman postulated instead: "Not the tangible, limited and limiting space of concrete reality, but the imaginary, irrational space of expansive dancing which is able to transcend the bounds of physicality and bestows on the fluid gesture an illusion of infinity" – that was considered a worthy aspiration.

In Paris in 1892, before Mary Wigman's *Witch's Dance*, the American Loie Fuller was the first female exponent of these "immaterial" interactive performances using light, color and dance. As a proto-avant-gardist she is regarded as a forerunner of the masked dances of both Wigman and Schlemmer. With the help of gigantic draperies attached to rods and variable lighting, Fuller danced an "architecture like the blowing wind." She paved the way for both Schlemmer's *Metal Dance* and Otto Piene's *Light Ballets* after World War II – attempts to make the materials themselves dance and to conceive of the body more as an engine of this "dancing architecture." Gerhard Bohner was the first artist who, by "reconstructing" the Bauhaus Theater, as he did for *Im (Goldenen) Schnitt* (In the [Golden] Section) in 1990, won back the body from this concept of it being purely mechanical. He succeeded in reinstating the body as the starting point for thinking about the Bauhaus traditions of modern dance and architectural ballet. Through his infectious enthusiasm, masks and materials such as rods became true mediators between humanity and abstraction. Bohner was the first dancer and choreographer who did not reconstruct Schlemmer but on the contrary gave him, at last, his due by seeking in architecture and abstraction precisely that resistance which they exert on the real body.

**Wassily Kandinsky, Dance curves of the dances of Gret Palucca.** 1926, illustration from *Das Kunstblatt*, No. 10, 1926, BHA. • A photograph, in which time seems to stand still, stimulated Kandinsky to make "analytical drawings." The physical tension in the photograph led him to translate it into visual equivalents of that tension.

**Wassily Kandinsky, Dance curves of the dances of Gret Palucca.** 1926, illustration from *Das Kunstblatt*, No. 10, 1926, BHA. • Kandinsky described Palucca's "principal assets" as: "1. Simplicity of the whole form, and 2. Construction of the large form."

PALUCCA
Drei Gebogene, die sich in einem Punkt treffen. Als Gegensatz – zwei Gerade im Winkel. Beispiel für die extreme Biegsamkeit des Körpers – Gebogene als bestes Mittel dazu.

PALUCCA
Zwei große parallellaufende Linien auf einen geraden Winkel gestützt. Energische Entwicklung der Diagonale. Genauer Aufbau der Finger als Beispiel für Exaktheit in jeder Einzelheit.

# The Bauhaus Theater after the Bauhaus Theater

Arnd Wesemann

The real Bauhaus Theater is situated in Dessau. It has the tiny dimensions of a school hall. Today, wherever dancers carry rods or wear heavy masks, wherever the old cabaret form turns up with its mechanical apparatus and witty décor, stages are no longer small but as big as a whole town. Nevertheless, open air parades seem like pure successors to Schlemmer. In spectacle, man and architecture constitute and celebrate a grotesque social re-experiencing of urban space. Schlemmer's own source of inspiration, the masquerade or carnival, erupts nowadays in street parades. A straight line could be drawn from the first Bauhaus stage experiments right down to Christopher Street Day, even if nothing more were to emerge from this than the idea, never risked in Dessau, of realizing on such a popular scale the image of the whole "man," complete with present-day trappings of political correctness.

Of course, these events lack both homogeneity and the "purity" envisioned by Schlemmer's theater. Nor of course do such parties make one think immediately of the Bauhaus. But the decentering of man and the breakdown of the distinction between actor and audience are derived from a stock of ideas which the Bauhaus had already drawn on. On the other hand, a reconstruction of Schlemmer's ballets, or attempts to premiere Kandinsky's dramatic sketches, as was done recently in *Violett*, merely appear backward-looking. In Düsseldorf there is the Theater of Sounds which claims a direct link with the Bauhaus tradition. But ideas and productions which use the Bauhaus as a basis today have scarcely anything to do with the original any more. The emphasis had already shifted in postwar Germany. What came closest to being a further development of the Bauhaus in stage art was the Zero group around Otto Piene, Günther Uecker and Heinz Mack, also based in Düsseldorf.

For them the Bauhaus after 1950 constituted above all a historical vehicle for purification and rationality, a means of "escape from the filth, the rubble, the compulsory drama into a purer, more intact world." The desire of modernism for salvation, searches for "purity of color, purity of light," and for an art that will "forbid contrast, put tragedy to shame, take its leave of drama," as Otto Piene put it. He wanted to dispense with the tragic protagonist. There was also a general distrust of naturalistic stage decoration, as had been the case once before, after World War I, when the ground was being cleared for a stagecraft drawn equally from mathematics and utopia, as it was at the Bauhaus.

While grotesque and absurd theater helped people in Germany to come to terms with the war, or salvation was sought in the (apparently) dialectically resolved world of a Bertolt Brecht, Piene, from 1959, created so-called 'Light Ballets', productions with slowly moving sheets of foil which modified space through their light spectra. These ballets are not only reminiscent of László Moholy-Nagy's "light-space-modulator" of 1922–1930, they are precisely what is valued today as "ambience" in the design work of someone like Nick Schweiger. In their day, the 1960s, they were even respected by the theatrical avant-garde. In the ballets it was no longer the material papier-mâché figurines or the painted wooden wall, as in Kandinsky's *Pictures at an Exhibition*, but light, the immaterial medium itself, which can be regarded as a further development of the Bauhaus stage. Back in 1929, Moholy-Nagy, in his stage design for the *Tales of Hoffmann* at the Kroll Opera in Berlin, had tried to create a stage from light and shade alone, an architecture with a completely immaterial effect. After Alwin Nikolais in the 1970s the best-known successor in light choreography is certainly the American Robert Wilson. By means of lighting effects, his stage not only allows the actor to appear but, much more, shows the human being as a figure fitting into a total picture. His heroines, no longer stamping around the stage as the self-centered focal point of all perspectives, are Schlemmer's disguised offspring.

In some contexts the Bauhaus degenerates into a mere name with pulling power. Where people used it to try and extract the root from the mathematical-symbolic image of the human figure in a world which lighting and electrification had made appear more and more immaterial, an early propagandist for the new technologies, Jürgen Claus, simply describes the use of up-to-date media as "the electronic Bauhaus." Design in the service of man is

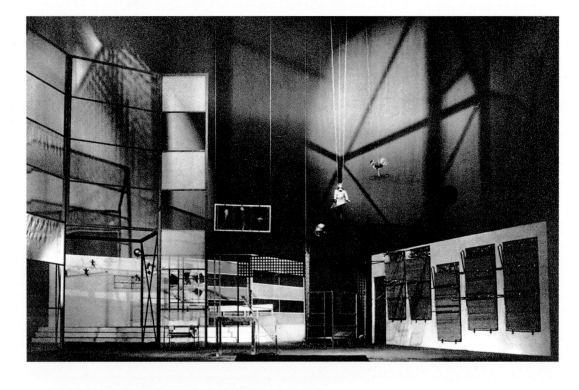

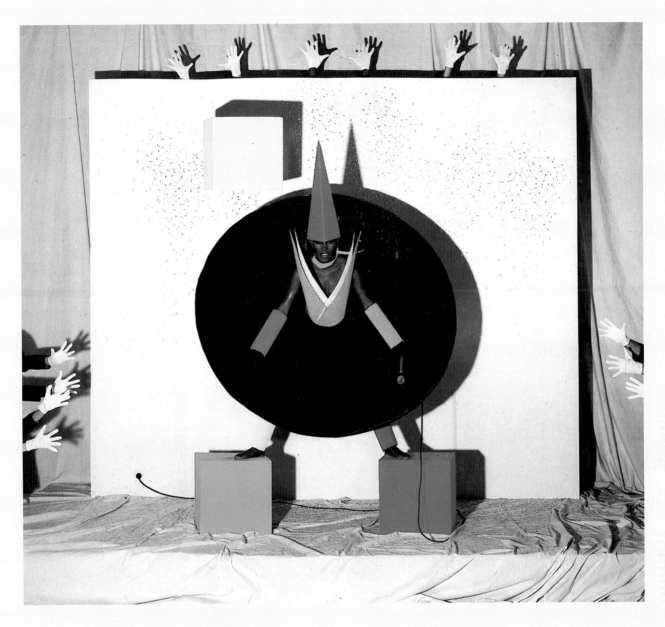

**László Moholy-Nagy, Stage design for Jacques Offenbach's "Tales of Hoffmann."** 1929, photograph by Lucia Moholy, BHA. • The stage as a "light-space-modulator": a few materials, arranged so as to be transparent, gather, disperse and reflect the light. Light and shade extend the setting into uncertain spaces.

**Grace Jones Show, NYC.** 1979, photograph by Jean-Paul Goude, private collection. • Invisible claqueurs applaud the "postmodern" appropriation of Bauhaus staging and costumes by the cult figure Grace Jones.

extended by a dematerialized dimension, the mathematical aspect is taken over by computers. Virtual elements stand in for visual ones. The theater responds, if at all, helplessly to these detours, and scarcely attempts to defend itself against the abolition – plain for all to see – of the human protagonist, as, incidentally, the Bauhaus stage had already tried out with its pure abstraction. The Bauhaus idea that man has been joined on the stage by other images on an equal footing is denounced as inhumane. But, not least through the acceptance of virtuality and genetic engineering, voices such as that of the Australian performer Stelarc, who talks about the "obsolete body," have become almost as popular as, in the 1980s, the pop symbolism of the most famous post-Bauhaus diva of them all: Grace Jones. Her black briquette haircut is a

trademark, her body remains perfectly disguised, and appears as purely biological architecture, which can at any time mutate into a different shape, a different state of being. At the same time a new Bauhaus manifesto takes shape in her video, *Slave to the Rhythm* (1985), a reminiscence of the Bauhaus. Schlemmer's costumes for the *Triadic Ballet* are taken out of the wardrobe. Using computer animation, which was still a novelty in the mid-'80s, it proves possible to make Jones's face, as a mask, into a folding stage, to transform her into an electronically animated cabinet of automata, which has Schlemmer's figurines dancing on Jones's nose. In this video, to greater effect and with greater popularity than in any other attempt to revitalize it, the Bauhaus has been rehabilitated as the mother of the exploratory stage arts.

# From the Bauhaus to Housebuilding – Architecture and the Teaching of Architecture at the Bauhaus

Martin Kieran

In previous evaluations of the Bauhaus, its activities and influences, it has been very frequently noted with surprise that until the Swiss architect Hannes Meyer was appointed as director in 1927 there was no separate building or architectural department there – even though, as early as 1919, the opening sentence of the Bauhaus manifesto, written by Walter Gropius, stated: "The ultimate goal of all artistic activity is building." The reasons for this absence are to be found in the manifesto itself. Even here Gropius declared that the "artistic" element had priority, not, for example, architectural issues such as construction, science, technology or even tectonics. The real dilemma lies precisely in the fact that the discipline of architecture was meant to be subsumed in an art school (and this is how the Bauhaus must be regarded), that is to say a school that had nailed its colors to the mast of this artistic element. It is thus not quite so disconcerting that all architectural work done at the Bauhaus during the years prior to Meyer's

appointment in spring 1927 – and of course some later work also – arose more or less from a visual, artistic impulse, not a well-founded and secure body of architectural theory. From the works produced in Weimar from 1919 to 1925, and in the first Dessau phase, it can be seen that strenuous efforts had initially been directed toward a visual expressiveness for architecture, frequently borrowed from Expressionist painting and scultpture. The foundations of architecture, the potential of space and order, construction and technology, tectonics and assembly, by contrast, were not made part of teaching or design.

But not only the work of the Bauhaus was tainted with the stigma of the formal. It can also be discerned in Walter Gropius's projects: from Expressionism, which aimed to redeem mankind, via the lyricism of abstraction to the neoplasticism which merely gave formal emphasis to building volumes; from there to Cubist Suprematism and beyond, to an

**Students of the building class.** About 1930, from left Wils Ebert, unknown, unknown, Selman Selmanagič, photographer unknown, Kieren Collection, Berlin.

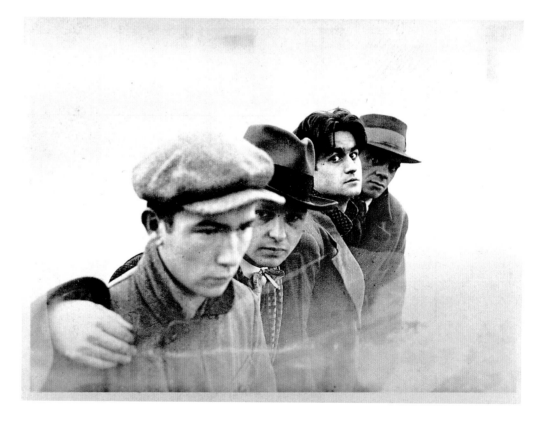

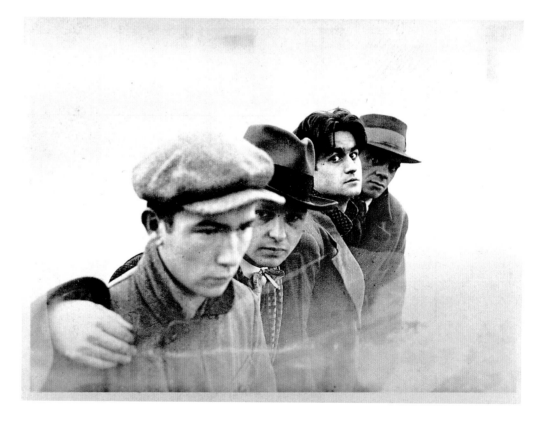Workshops

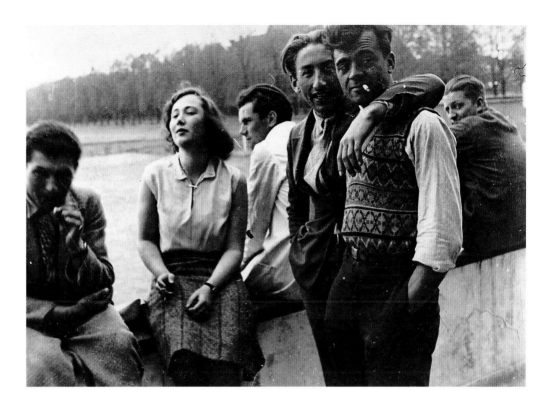

**Students of the building class.** About 1930, from left unknown, Hilde Reiss, unknown, Jean Weinfeld, Selman Selmanagič, unknown. Photographer unknown (Hajo Rose or Irena Blühova?), Kieren Collection, Berlin.

**Bauhaus building development, compiled for the exhibition "Staatliches Bauhaus Weimar 1919–1923," Weimar.** 1923, BHA. • An attempt to take part in the debate about serial production by way of the "building box principle." However, formal aspects (cubic volumes) are foregrounded, along with the idea of a "modern" flat roof. The Bauhaus was always far removed from any tendency to give "passionate emphasis to the dynamic factor," as Adolf Behne said of Soviet architecture in 1923.

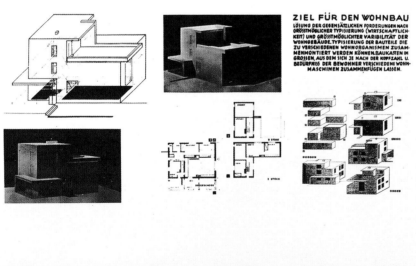

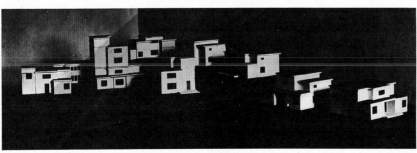

aestheticizing, geometrical Constructivism, right down to the New Functionalism that was to improve the world and suddenly claimed that the fulfillment of the functional would liberate architecture from all its constraints. Gropius's practical and rhetorical achievement lay in attentively following the European architectural scene and its theories, absorbing its results, so to speak, and working them into his own projects – but only "formally." Closer investigation and analysis make it clear that in his striving for expressivity Gropius was always guided by these purely formal principles, and not by the architectural issues with which other architects were grappling, far away from the Weimar idyll of the Bauhaus.

These facts may be explicable in terms of the age, the chaotic social conditions, the disastrous economic fragmentation following World War I: both the symbolism and formalism of the buildings strike us as strange today, as does the often cathedral-like appearance of plans and projects (as can be seen in the mystical rays of light in many architectural drawings, or even in the clerestory in the central room of Georg Muche's House on the Horn) and the "search

**Plan for the Bauhaus housing development in Weimar.** 1920, model by Walter Determann, photographer unknown, KW. • This plan owes much to postwar Expressionism. The idea of a community finds its expression in the central building and the free area for meetings, sports and gymnastics.

**Walter Determann, Plan for the Bauhaus housing development in Weimar.** 1920, body-color on transparent paper, 66.0 x 50.0 cm, KW. • Here once more the formal idea on which this plan is based becomes visible: the strictly symmetrical ground plan of the site is written into the topography as a rhythmic-crystalline ornament. Rational, functional aspects have not been taken into account. A housing development as an emblem of reformist ideas.

for form" as a substitute in a society that offered nothing to hold onto. But the aim of the Bauhaus manifesto quoted at the beginning of this essay remained for a long time a promise that was not kept. All efforts in those years to set up a separate, independent building department at the Bauhaus, with meaningful interrelationships with the other workshops, failed. Only after the move to Dessau and the appointment of Hannes Meyer did the possibility arise of at last securing for architecture a suitable place in the canon of artistic work at the Bauhaus.

### Walter Gropius, Weimar

During the years of the Weimar Bauhaus, architectural achievements were directly linked with the private office run by Walter Gropius and Adolf Meyer. Bauhaus students were, it is true, frequently involved in the plans that were produced in this office, and the buildings that were actually realized, but only as fellow-workers. The projects were not discussed in class. Thus, on the subject of architecture at the Bauhaus during those early years, it can only be said to have amounted to a series of presentations and cathedral visions illustrating the mood of a fresh start and bearing witness to the commitment that Gropius expressed in 1918 vis-à-vis Karl Ernst Osthaus, "to get a *Bauhütte* working." The

Expressionistic features of this phase made themselves felt, for example, in Johannes Itten's *Tower of Fire*, in the "ceramic temple of light," and in the plans for the first Bauhaus housing development by Walter Determann. It is an unchained architectural language that breaks loose here. It bears no relation at all to the building activity of the time, and shows a degree of complacency. In a first joint effort the Bauhaus tried its hand – again in collaboration with Gropius's building office, which had been given the commission – at a real building task: to build the Sommerfeld house in Berlin, in 1920–1921. Almost all the workshops were involved in working out the plans and the interior design for this wooden house. The glass painting workshop designed the stairwell windows, the joinery workshop made a bookcase and a seating group, the metal workshop designed the facing for the radiators and the lighting units, and finally the weaving workshop made three carpets. From 1922, some plans for "type houses" were prepared, in connection with the planning for a Bauhaus housing development that had begun back in 1919. Building units were developed which were to be assembled to create various types and forms of houses. Gropius spoke in this context of a "honeycomb." He was concerned to transfer serial production from other

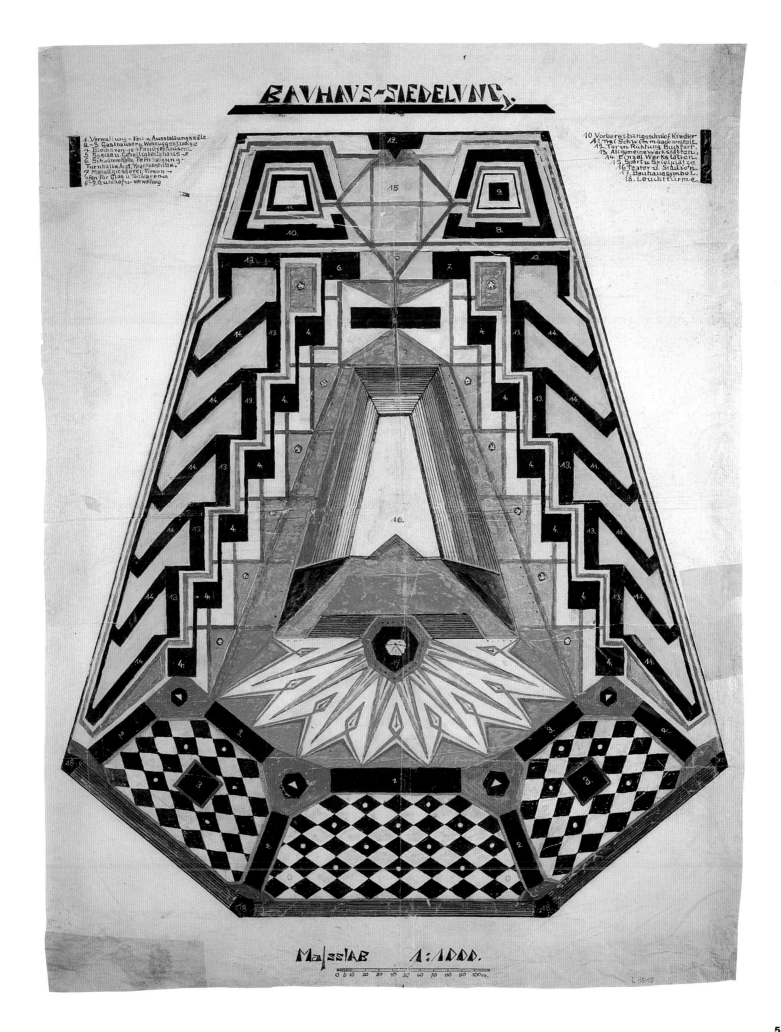

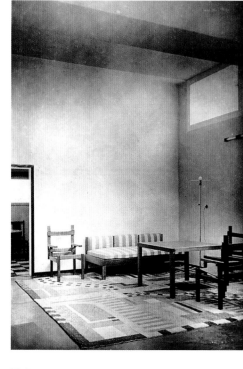

**Living room, model House on the Horn, Weimar.** 1923, interior design by the Bauhaus workshops, photographer unknown, BUW, Bildarchiv. • The clerestory derived from church typology and the high, free interior walls thus created give the inner space a religious and aesthetic quality. This impression is supported by the somewhat sparse appearance of the furniture.

**Living room with working area, model House on the Horn, Weimar.** 1923, interior design by the Bauhaus workshops, photographer unknown, BUW, Bildarchiv. • Here one can see the interpenetration of the various building unit volumes which give a rhythmic shape to the inner organism of the building and create interior spaces.

**Georg Muche (plan) and Gropius's building office, Bauhaus workshops (interior design), German industry and the firm of Adolf Sommerfeld, Berlin (building work), model House on the Horn, Weimar.** 1923, completed for the opening of the Weimar Bauhaus exhibition on August 15, 1923, photographer unknown. BUW, Bildarchiv. • In this building, the model or experimental House on the Horn, Palladian features are to be seen in the central building unit, along with formal echoes of the early phase of the Bauhaus. Above all, the rigid geometry is in contradiction to the advertised functional outfitting of the building's organism.

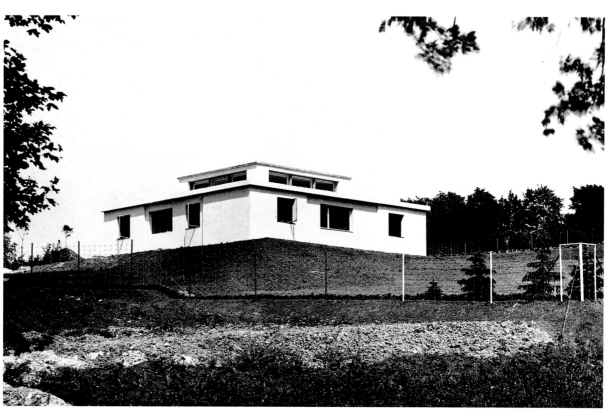

**Georg Muche, Ground plan of a single-family "type house" (model House on the Horn).** 1923, BHA. • The ground plan illustrates the contradiction between the strict geometry and the various dimensions of the spatial figurations, which suggest a different, less strict shape for the building. Apart from the Sommerfeld house in Berlin, the model house is the Bauhaus's only building project carried out during its Weimar phase.

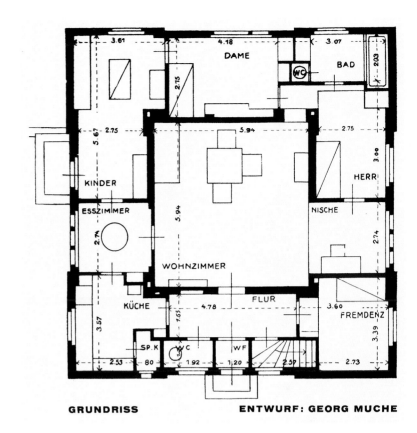

GRUNDRISS        ENTWURF: GEORG MUCHE

**Benita Otte, Isometric presentation of the model House on the Horn.** 1923, single sheet from "Staatliches Bauhaus Weimar 1919–1923," Weimar, 1923, BHA. • The function of the isometric drawing is to present all the parts of the building, walls and spaces in their actual relationships to one another. Otte's delicate wash drawing (she was a weaver) invites one to play with the box of bricks and shift the spatial volumes around.

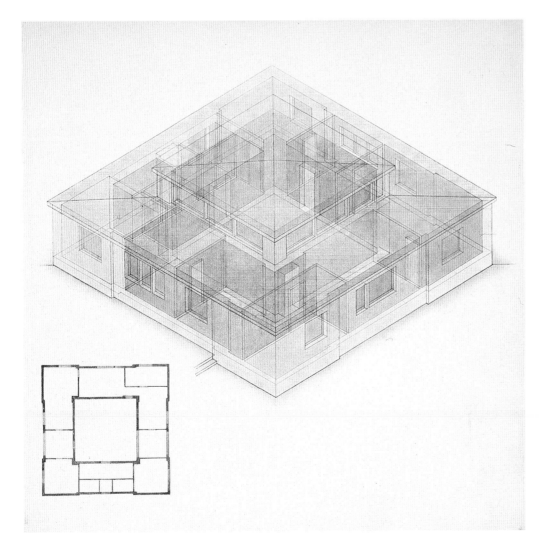

**Gerhard Marcks, Postcard for the Bauhaus exhibition.** 1923, BHA. • In addition to the physiognomy of the model house, one is struck by the contradiction between the rationality of the overall volume of the building and the expressive, painterly gesture of the hands – the latter, like the typography, is indebted to the "Neo-Romantic" early phase of the Bauhaus.

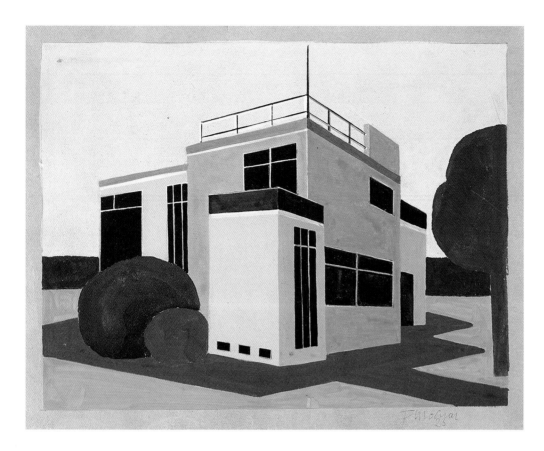

because of the lack of an architectural department at the school he did not succeed in anchoring this idea in systematically developed teaching. Hence all attempts to adapt to the conditions of the building sector and to supply plans accordingly did not, for the time being, go beyond a declaration of intent. Not until 1923 was a Bauhaus building, the House on the Horn, actually built. Georg Muche provided the plans. The house was an integral part of a display of the Bauhaus's achievements that had been demanded by the regional government. With it, the Bauhaus was to document the results of its activity. As a model and show house it was intended to demonstrate the state of the art in building technology, for example: walling in large pieces of waste concrete, and using a two-skinned inner/outer wall with a layer of peat-based torfoleum between them for insulation. The spatial organization in this house follows functional principles; however, the ideal-type arrangement of the central space is a hindrance to this. As in the Sommerfeld house in Berlin,

**Farkas Molnár, Design for a single-family house.** 1923, photograph of a drawing, BHA. • The planes and colors of this drawing point directly to the influence of Theo van Doesburg, who visited Weimar repeatedly between 1921 and 1923, and sometimes taught there.

**Farkas Molnár. The Red Cube, design for a single-family house.** 1922–1923, model, BUW, Bildarchiv. • This plan is the most radical interpretation of parameters whose use has become purely formulaic: colored plane, pure geometry, reduction of the building volume to a figure with façades of equal size.

branches to house building, an idea which had been pursued for some considerable time, both in other countries and elsewhere in Germany. The working out of this project (which was also given the name "large-scale box of bricks") was the responsibility of the student Fréd Forbát, who subsequently also introduced the type of central space, as an element of the ground plan, which was to resurface in 1923 in the above-mentioned House on the Horn. Further projects which came about in connection with this box of bricks, were "The Red Cube" by Farkas Molnár, and a plan for a studio block by Fréd Forbát. They are all games with forms, taking the Bauhaus cube as their subject, but not the house as a constructional and functional organism. During these years Gropius repeatedly pointed out the need to industrialize building work. But

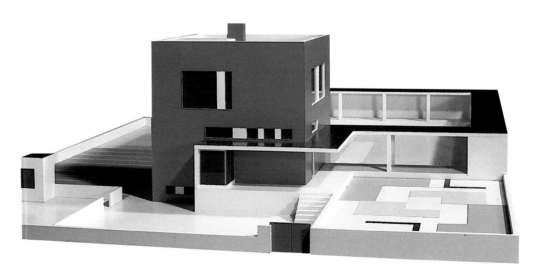

**Carl Fieger (plan), Fieger's house in Dessau.**
1927, view seen from the west, photographer
unknown, about 1944, SBD, archive collection. •
Gropius's colleague gave the house in which he
himself lived many formal aspects of the New
Functionalism: interpenetration of various solids,
arrangement of the windows based on functional
considerations, simple lines, smooth, non-orna-
mented façades and sections of walls.

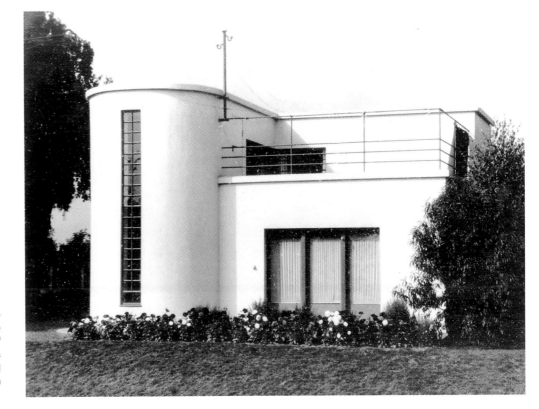

**Carl Fieger (plan), the Kornhaus restaurant,
Dessau.** 1928–1930, view from the southwest,
photograph by W. Moser, 1930, SBD, archive
collection. • Here both the organization of the
ground plan and the constructional features of
the building find expression. Exemplary solutions
have been found for the rhythmic shaping and
arrangement of the inner spatial figures, which
face outward.

**Georg Muche and Richard Paulick (design), Steel house.** 1926–1927, view from the southwest, photographer unknown, SBD, archive collection. • The effect of a "container to live in" – as the press critics put it – makes it clear that in serial production of buildings aesthetic aspects must be taken into account just as much as functional and economic factors.

the interior décor of this house was provided by the Bauhaus workshops. Here there was also one of the first fitted kitchens, a precursor of the standardized kitchen furniture that later became well known under the name of the "Frankfurt kitchen."

In the last phase in Weimar hardly any further architectural plans were drawn up, certainly not systematically as part of any training. There were only attempts by some individuals to pursue individual questions to do with industrialized building. Marcel Breuer, for example, provided variations of the plans for the House on the Horn, and Farkas Molnár explored the possibilities of a reinforced concrete skeleton construction in plans for a terraced apartment

block. It was also Muche, Molnár and Breuer who presented plans at a building exhibition in Stuttgart in 1924, a first step toward making the public aware of the efforts being made by the Bauhaus to take part in progressive architectural developments.

### Hannes Meyer, Dessau

The move to Dessau brought a fundamental change in the position of architecture. Hannes Meyer, the Swiss architect who was appointed head of the newly established building department at the Bauhaus in 1927, had written to Gropius in 1926: "we are in agreement that proper architectural teaching is only feasible if it is directly linked to practical building work,

otherwise the new architectural department would not be any different from that of any technical college, i.e. it would be superfluous. the basic thrust of my teaching will most definitely be functional and constructional. as regards the teaching syllabus i think your idea is right: not to draw one up at all to begin with. the basic questions of architectural organization could be explained by way of practical assignments (carrying out building work or taking part in competitions)." Of great importance for the architectural teaching developed by Hannes Meyer during the following years were, to begin with, the concepts of "harmony" and "balance of forces," which he often used. In addition there were moves toward a markedly

**Georg Muche, Design for a town apartment block with gardens on all floors,** 1924, BUW, Bildarchiv. • The plan is unusual through its very size – it is an early idea for an apartment block. The rationality of the construction in combination with a relatively elastic ground plan is the result of an increasingly exploratory spirit at the Bauhaus.

**Marcel Breuer, Design for an apartment block, model.** 1924, entry for a competition organized by the magazine *Bauwelt,* BUW, Bildarchiv. • This design for a high-rise block was Breuer's response to the debate about concentrating big-city populations which was initiated by Le Corbusier and pursued in Berlin by Ludwig Hilberseimer in particular.

biologistic conception of architecture, which took on an increasingly firm shape and had a direct effect on his teaching (in the form of exact analysis) and on his building plans. Finally a pronounced liking for formulae is to be observed on Meyer's part, for mathematically "calculated" planning parameters with their supposed objective and irrefutable truth. Meyer himself spoke of "scientific thinking."

The year 1927 seems to have been a very difficult one at the Bauhaus both in terms of organizational and economic problems. Close examination of all the evidence leads to the conclusion that there was no regular teaching of building or architecture. Thus it was only after Meyer became director in the spring of 1928 that there was any question of systematic architectural teaching, and even then only with reservations, since with Meyer's visits to his building site in Bernau, his lecture tours and other commitments elsewhere, he was hardly able to provide proper teaching. He began, however, by appointing Hans Wittwer, his colleague from his period in Switzerland, to help with the new building department. Wittwer was made head of the teaching of architectural planning and was for a short time head of the building office that

was established after they had won the competition for the central trade union (ADGB) college in Bernau near Berlin in the spring of 1928. If one looks for evidence to support the thesis of an increasingly "scientific" approach to architectural teaching at the Bauhaus under Hannes Meyer, one must take various aspects into account. There were never more than ten enrolled students per semester in the building department (with widely differing levels of previous knowledge), and some of this small band, moreover, belonged to Gropius's building office. And here the suspicion is confirmed that Gropius often used the Bauhaus for his own purposes. This is also clear from the fact that the first numbers of the *bauhaus* periodical, which appeared from late 1926, document a series of buildings and projects by Gropius (as a private architect), and there is never any question of Bauhaus students being involved, let alone of a building department or of architectural teaching at the school. Investigation of the supposed tendency toward a more scientific approach to teaching, as claimed by Meyer, will therefore be restricted to the years 1928–1930. The evidence is somewhat sparse for a detailed analysis. It comprises the documents relating to the restructuring of teaching, lists of appointments, Meyer's statements of position in the texts which he wrote during this period, a few fragmentary student assignments and – but only to a very limited degree – the actual buildings that were put up during the Meyer era. And these are, if one looks solely at buildings in which students were involved, the ADGB central college and the trellised-walkway houses of the housing development in Dessau-Törten.

It can be seen from the semester plan for 1927 how work and teaching proceeded during the first year. As previously in Weimar there was the preliminary course in the first semester that was obligatory for all students. The second semester was set aside for work in the workshops, as was also the third semester. Within the architecture department there were sections for "building" (plans and technology) and "interior design" (joinery, metal workshop, wall painting and weaving). From the fourth semester through to the diploma, "work in the planning studio followed by practical building" began and there were individual lectures to attend on "building construction, building with reinforced concrete, statics, thermodynamics,

# der grundriß errechnet sich aus folgenden faktoren

## 1. bewegungsfaktoren

der arbeitsplan ergibt die reihenfolge der funktionen

kommen
gehen
anziehen — umziehen
geschütztes wohnen — baden — schlafen
ungeschütztes wohnen

## 3. sonnenberechnung

berechnet für ort:
breitegrad: 47.30
ländegrad: 0.00

frühling und herbst.

winter.

sommer.

## 2. sonne

man braucht morgens sonne im schlafraum
man braucht abends sonne im wohnraum

daher

schlafräume nach osten
wohnräume nach westen

nachdem die wohnzellen aneinander liegen müssen, können sie:
1. vertikal erreichbar sein.
es sind maximal zwei wohnzellen an einer zugang.-

wohnen | schlafen

2. horizontal durch geschlossenem gang, da die wohnzelle nur teil der wohnräume im hause.-

a. schlaf-ankleide-bade-raum durch zugang von wohnraum getrennt.-

forderung der wohneinheit nicht erfüllt.-

b. geschlossener gang an o.seite.

forderung der unmittelbaren besonnung und belüftung nicht erfüllt.

c. gang über schlafraum aufwand zu gross.

1 und 2 gibt 4

2 und 3 gibt 5

| | wohnraum | balkon |
|---|---|---|
| besonnung im winter bis | 16.15 uhr | 16.15 uhr |
| besonnung im frühling und herbst | 16.20 uhr | 18.00 uhr |
| besonnung im sommer bis | 15.10 uhr | 16.30 uhr |

### luftbedarf des schlafzimmers.

1. luftwechselbedarf.
kohlensäureproduktion 0,015 cbm /st.
kohlensäuregehalt in 1 cbm zuluft 0,0004 cbm
zulässiger kohlensäuregehalt in 1 cbm raumluft 0,001 cbm.

$$q = \frac{0,015}{0,01-0,0004} = 25 cbm/st.$$

2. natürliche (selbst)belüftung.
der berechnung liegt nur der natürliche luft-ausgleich zugrunde, der durch die undichtig-keit der geschlossenen fenster verursacht wird.
fensterfläche 1,98 qm. temperaturdiff. 30 .
rauminhalt des schlafzimmers und anschliessen-den ankleideräumen 22,0 cbm.
überdruck der zimmerluft 0,54 kg/qm.
luftdurchlässigkeit des fensters 8,65 cbm/st.

3. fensterlüftung.
frischluftbedarf 16,35 cbm/st.
luftgeschwindigkeit bei 30 temperaturdiff.
v= 2,95 m/sec. ergibt einen luftungsquer-schnitt von 15,5 cm.
wirkungsgrad der lüftungs klappen= 72 %.
ergibt die faktische grösse von 20,60 cm .

### konstruktion

trockenbauweise  eisenskelett  ausfachung

blickbereich beim erwachen

letzter strahl im wohnraum
letzter strahl auf dem balkon

strahl, frühling 6.30 uhr
strahl, sommer 6.30 uhr
ost

**Philipp Tolziner and Tibor Weiner, Plan for a communal apartment block for factory workers in a socialized state,** 1930, No. 2 of 3 sheets, BHA. • With Hannes Meyer as director of the Bauhaus, other central aspects of architecture became more prominent. Here we have an attempt to develop a plan in accordance with scientific and social criteria.

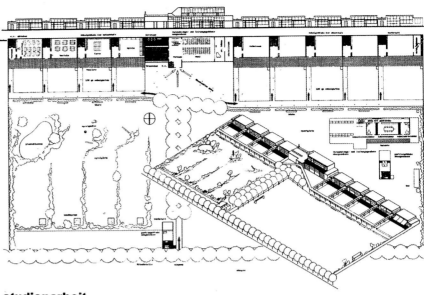

## studienarbeit
### zu einer achtklassigen siedlungsvolksschule.

| | |
|---|---|
| **aufgabe:** | bauliche neugestaltung einer achtklassigen siedlungsvolksschule in großstadtnähe, auf grund neuer pädagogischer erkenntnisse. |
| **vorschlag:** | nach süden geöffnetes flachbausystem mit davorgelagertem gartenland und spielplätzen. |

**beschreibung:**

**das portiergebäude:** blick über eingang und schulgelände. zweizimmerwohnung mit küche, bad und garten. werkstatt mit abstellraum.

**versammlungs- und leitungsgebäude:** im mittelpunkt des schulgeländes. erdgeschoß: vorraum mit w.c., springler und treppenaufgang. rechts: saal mit abstellraum, durch schiebewand vom vorraum trennbar, für spiel, gymnastik, theater, singunterricht, versammlungen. links: brausebad, für 15 mann schichtweise benutzbar. heizraum. obergeschoß: gang mit garderobe, waschgelegenheit, sitzplätzen. schulleiterzimmer mit arbeitsplatz, schrank, ablegetisch, empfangsplätzen. lehrerzimmer mit sitzungstisch, bibliotheks- und sammlungsschrank, ruheplätzen. schularztzimmer mit arbeitsplatz, schrank, metallbett, sitzplätzen. umkleideplätze im gang. terrasse: blick über das schulgelände.

**schulgebäude und werkstätte der oberstufe mit sportplatz:** innige verbindung der schulgebäude mit garten und sportplatz. vorraum mit garderobe, w. c. und waschgelegenheit. schulraum mit schrankwand, schreibflächen ringsum. fensterwand im sommer zu öffnen, markise als sonnenschutz. gepflasterter vorplatz mit 150 qm gartenfläche, geräteschuppen. sportplatz 95×55 m, für freie spiele, fuß-, faust- und handball, barlauf usw. sitzbänke. werkstatt mit materialraum für elementaren werk-, physik-, chemie- und biologieunterricht.

**schulgebäude der unterstufe mit spielplatz:** wie oben. 100 qm gartenland, spielplatz 50×60 m. in kleine spielgelegenheiten unterteilt (vorliebe 6—10jähriger für alles zierliche) reichlich bepflanzt, planschbecken, sandkästen, rundlauf, wippen usw.

**konstruktion und material:** eisenbetongerippe, isolierende ausfachung, schiebefenster, gummifußboden, vitaglas, ölbeheizte pumpen, warmwasserheizung.

**bepflanzung:** linden (schatten, duft, lange belaubt) und immergrüne sträucher.

**anmerkungen:** alle raumgrößen bestimmen sich durch ihre verwendungszwecke. tür, w.c., mobiliarmasse usw. bestimmen sich durch die jeweilige kindesgröße; jede altersstufe verbleibt 4 jahre in „ihrem" schulgebäude.

ernst göhl, bauabteilung, bauhaus

**Ernst Göhl, Study for an eight-class housing estate primary school, from Hannes Meyer's course.** About 1928, page from *bauhaus* 4, 1928, BHA. • The elasticity of the plan and its constructional development are derived from the central college in Bernau designed by Hannes Meyer and Hans Wittwer. With them the development of a new type of school building begins which is still influential down to the present day.

installation, estimates, tenders and norms." In addition there were special courses on urban architecture, traffic and business management. Training was thus essentially based on design and theoretical work on selected, self-chosen assignments. Assignments worked on by students in Gropius's building office were now no longer part of the teaching. The teaching program which Hannes Meyer put forward in the spring of 1928, shortly after his appointment as director, envisioned a more systematic training,

a tightening up of semester assignments, additional scientific subjects and student participation in actual building work. In order to do justice to this self-image and this demanding program, Meyer subsequently appointed a few new teachers in the building department: Hans Wittwer as head of the building office and for the teaching of planning; Ludwig Hilberseimer as head of the building course and for constructional planning and courses in urban building; Mart Stam gave lectures on elementary building

and urban building; Anton Brenner became head of the building studio (building office) and design teaching; Alcar Rudelt taught mathematics, statics, theory of the strength of materials, and steel, concrete and constructional engineering, and Edvard Heiberg took over courses on housing construction and design. Looking at the few extant student assignments from the two years of Hannes Meyer's architectural teaching, one is struck by the fact that some of the plans look like illustrations taken

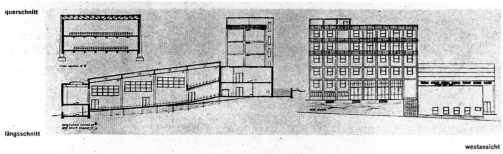

querschnitt

längsschnitt

westansicht

**Siegfried Giesenschlag, Neighbor relations, student assignment from Hannes Meyer's building class.** 1930, BUW, Bildarchiv. • Here functional, social and biological studies are carried out in order to derive planning parameters from them. Meyer's "biologistic" reflections on building can be clearly seen.

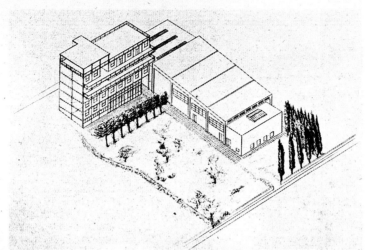

arieh sharon, bauhaus dessau:
entwurf für das haus des
arbeiterrates in jerusalem.

**Arieh Sharon, design for the workers' council building in jerusalem, Hannes Meyer's class.** About 1928, illustration from *bauhaus* 1, 1929, BHA. • The articulation of the building units and the internal functional organization are typical products of the late phase of architectural teaching, in which constructional and technological criteria were foregrounded.

from two texts written by Meyer at the Bauhaus in 1928 and 1929.

They are concerned with investigations into the course of the day, based on calculations of the position of the sun, and focused on the subject of collective living. These subjects also reappear in Meyer's revealing texts "building" and "bauhaus and society." Other studies were evidently carried out in direct connection with the ADGB central college in Bernau and the building of the housing estate at Dessau-Törten, for which the building department under Hannes Meyer drew up a building plan in 1929–1930, the first section of which was realized in the form of five trellised-walkway houses. Again, some student projects reveal the influence of plans for the Petersschule and the League of Nations Palace designed by Meyer/Wittwer from 1926–1927, others show the influence of Mart Stam and Ludwig Hilberseimer, especially as regards urban building strategies and terraced house studies. All these pieces of work by students have in common a markedly analytical "scientific"

approach to architecture, which Hannes Meyer had formulated in the two texts mentioned above, when he wrote, for example: "we investigate the course of daily life for every occupant, which gives us the functional diagram for father, mother, child, baby and other people. we explore the relationships of the house and its occupants to other people: postman, passer-by, visitor, neighbor, burglar, chimney sweep, laundress, policeman. we work out annual variations in ground temperature and use them to calculate the heat loss of the floors and the depth of the foundations. we calculate the angle of sunlight over the year and relative to the latitude of the building site we work out how much sunlight enters by the bedroom window, and we calculate the day-time lighting of interior work areas. the new house is a social artifact, and even more so the new housing estate, an ultimate goal of public welfare, is a consciously organized communal enterprise in which, on an integral, cooperative basis, individual energies and cooperative energies are balanced for the good of the community.

the modernity of this housing development does not lie in flat roofs and vertical-horizontal division of façades – building is simply organization: social, technological, economic and psychological organization."

Here Meyer finds his own voice: "the new study of architecture is a discovery of knowledge about existence. as design teaching it is the song of songs of harmony. as social teaching it is a strategy of balance. this study of building is not a study of style, it is not a constructivist system, nor is it the study of technological miracles. it clarifies equally the concerns of the physical, the psychological, the material and the economic. it explores, demarcates and orders the force fields of the individual, the family and society. finally, all architectural design is subject to fate in the form of the landscape: as designers we fulfill the destiny of the landscape."

If, in addition to the students' work, one also looks at the plan for the ADGB central college, the result is an exact summation of Hannes Meyer's "scientific thinking," his "doctrine of

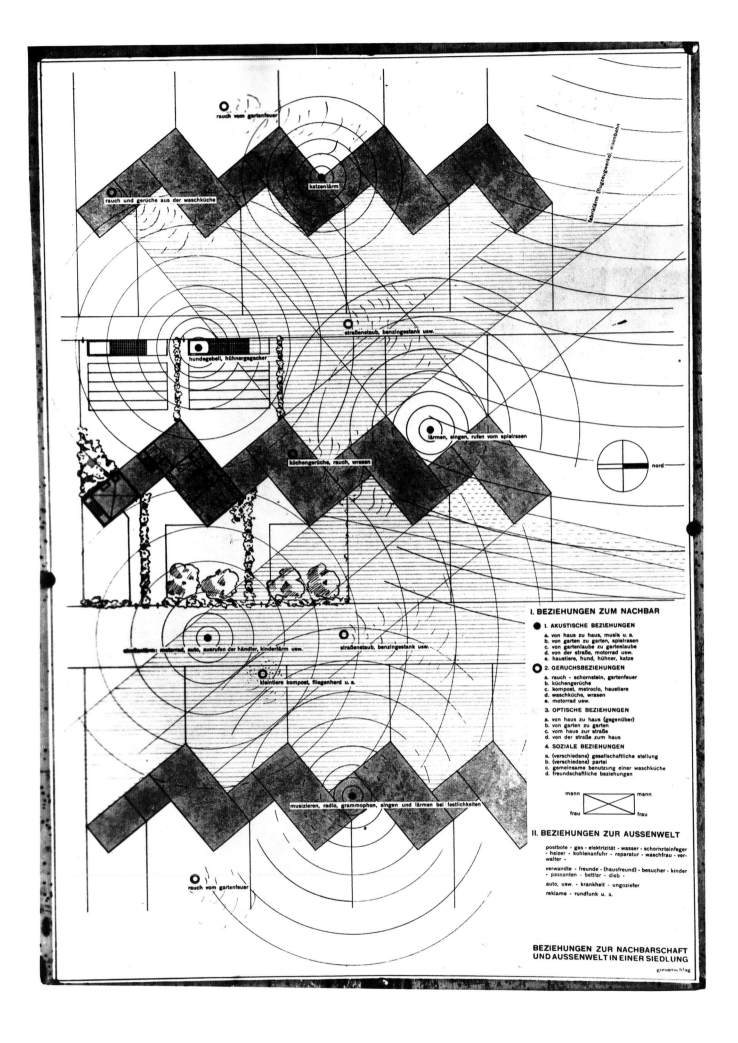

rauch vom gartenfeuer

rauch und gerüche aus der waschküche

katzenlärm

fabriklärm (flugzeugwerke) eisenbahn

straßenstaub, benzingestank usw.

hundegebell, hühnergegacker

lärmen, singen, rufen vom spielrasen

nord

küchengerüche, rauch, wrasen

straßenlärm: motorrad, auto, ausrufen der händler, kinderlärm usw.

straßenstaub, benzingestank usw.

kleintiere kompost, fliegenherd u. a.

musizieren, radio, grammophon, singen und lärmen bei festlichkeiten

rauch vom gartenfeuer

### I. BEZIEHUNGEN ZUM NACHBAR

● **1. AKUSTISCHE BEZIEHUNGEN**

a. von haus zu haus, musik u. a.
b. von garten zu garten, spielrasen
c. von gartenlaube zu gartenlaube
d. von der straße, motorrad usw.
e. haustiere, hund, hühner, katze

○ **2. GERUCHSBEZIEHUNGEN**

a. rauch - schornstein, gartenfeuer
b. küchengerüche
c. kompost, metroclo, haustiere
d. waschküche, wrasen
e. motorrad usw.

**3. OPTISCHE BEZIEHUNGEN**

a. von haus zu haus (gegenüber)
b. von garten zu garten
c. vom haus zur straße
d. von der straße zum haus

**4. SOZIALE BEZIEHUNGEN**

a. (verschiedene) gesellschaftliche stellung
b. (verschiedene) partei
c. gemeinsame benutzung einer waschküche
d. freundschaftliche beziehungen

mann — mann
frau — frau

### II. BEZIEHUNGEN ZUR AUSSENWELT

postbote - gas - elektrizität - wasser - schornsteinfeger - heizer - kohlenanfuhr - reparatur - waschfrau - verwalter -

verwandte - freunde - (hausfreund) - besucher - kinder - passanten - bettler - dieb

auto, usw. - krankheit - ungeziefer

reklame - rundfunk u. a.

**BEZIEHUNGEN ZUR NACHBARSCHAFT
UND AUSSENWELT IN EINER SIEDLUNG**

giesenschlag

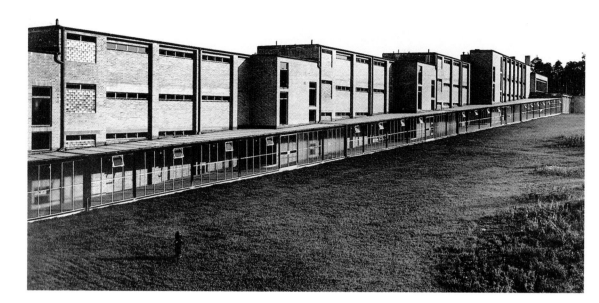

**Hannes Meyer, Hans Wittwer and the building department of the Bauhaus, Dessau, ADGB central college, Bernau.** 1928–1930, teachers' wing with trellised walkway, photograph by Walter Peterhans, BHA. • The ADGB college set new standards in the field of school building. Studies of the topography and internal organization led to an original layout which aroused international interest and furthermore – apart from the trellised-walkway houses of the building development in Dessau-Törten – was the only project by the building department to be carried out while Hannes Meyer was director.

**Hannes Meyer, Hans Wittwer and the building department of the Bauhaus, Dessau, ADGB central college, Bernau.** 1928–1930, interior design for a student room, photograph by Walter Peterhans, BHA. • The "standard room," which Meyer also called a "cell for living," was the starting point for the design. The relationship of these cells to one another is to be explained in terms of Meyer's "system of small circles," which in turn had been developed from one of Pestalozzi's educational ideas.

harmony" and "study of architecture." The sheets of the competition project are covered with ostensibly "scientific" formulae, calculations and analyses of external conditions and functional demands. The site, with its staggered pavilions along a connecting glass walkway, demonstrates features of a harmonious composition, and the individual cell areas in the housing pavilions correspond to the "vertical brigades," into which Meyer organized the study of building. In these units, which he called "brigades," students from the lower semesters were directly involved in building work and learned from students from the higher semesters. Here, in the college in the forest, in the "destiny of the landscape," the "system of small circles," Meyer's favorite way of describing any building assignment, is tied into a composition of spatial sequences adapted to the rhythm of the terrain, growing out of it, so to speak, to form an organic whole.

## Ludwig Mies van der Rohe, Dessau/Berlin

Of the three Bauhaus directors, Ludwig Mies van der Rohe is undoubtedly the best known and also the most gifted architect. It is said that he once remarked of Gropius that his greatest achievement was to have invented the name "Bauhaus"; he considered Gropius's status as an architect to be wildly overrated. Mies's fame is virtually unconnected with the Bauhaus and his work there. It stems rather from his buildings and his teaching at the Illinois Institute of Technology in Chicago. When he was asked about contributing to a Bauhaus exhibition in 1968, he said: "I have nothing to do with the Bauhaus."

As far as teaching is concerned, Mies restructured the Bauhaus as a different kind of educational establishment: "I don't want any old mess, I don't want workshop and school, I want school." Looking back, it can indeed be seen that Mies brought the teaching methods into line with that of other schools. First, the obligatory preliminary course was abolished, then workshop production was questioned – and eventually terminated. In all the changes he initiated, he indicated that for him the business of the Bauhaus – *nomen est omen* – was above all to build, to teach architecture. He did not wish to manage a production works. He was supported in this approach by Ludwig Hilberseimer, who had been appointed by

**8 kl. volksschule**

**Waldemar Hüsing, 8-class primary school.** 1932, perspective drawing, Indian ink and wash, typed explanations and printed labels on drawing paper, 41.9 x 59.4 cm, BHA. • Hüsing's perspective drawing bears witness to his training under Mies, for the presentation is reduced to the bare necessities: rhythmic shaping of the site, physical building volumes, wall planes, window apertures.

**Lothar Land, Boarding school.** March 20, 1931, photograph of a drawing, BHA. • This drawing is one of a series of plans for school buildings which, as public building assignments, were of interest to students in connection with the ADGB central college. Here the development of the walkways is evidently derived from the building in Bernau.

**Pius Pahl, House on Lake Garda.** 1932–1933, bird's-eye view from the northwest, BHA. • This sheet clearly shows the influence of the villas which Le Corbusier planned and built at that time, in particular in the connections between the building units, the "pilotis" (stilts) and the arrangement of the window bands.

**Pius Pahl, House "C."** 1931–1932, perspective view from the garden of the living and sleeping quarters, BHA. • Influences of Mies van der Rohe's designs for villas can be seen, right down to the presentation (cantilever chairs): open, fluid spatial figures, slender steel supports, wide-opening windows, absence of "classical" façades.

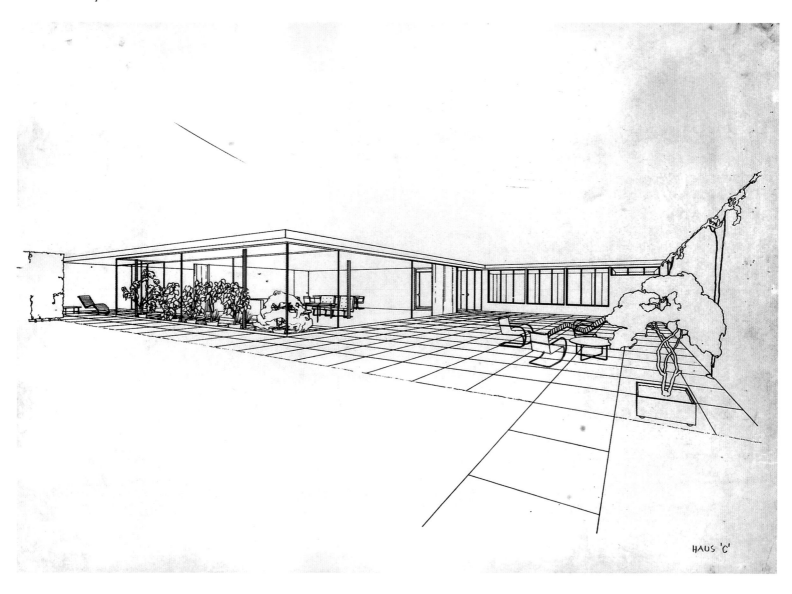

**Howard Dearstyne, Ground plan for a house with courtyard.** 1931, pencil on paper, BHA. • The shape of the ground plan now consists only of wall panels and large-scale windows developed as glass façades; this is the work of a student copying his teacher to the most slavish degree.

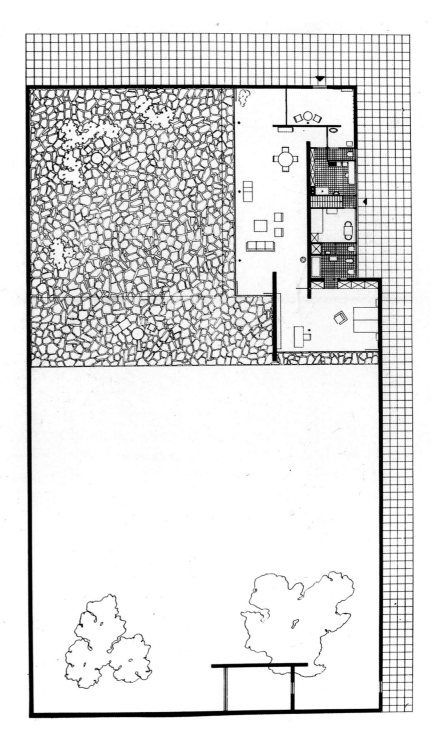

Hannes Meyer. He had been a close friend of Mies for several years and had collaborated with him many times.

Extant student planning projects show two things: some were still very much under the influence of Hannes Meyer's theoretical, "scientific thinking" and his design methods. It was mostly a matter of building units snugly adapted to the terrain, or structures broken down into small spatial modules following the topography of the building site. Or the units were dominated by the spirit of constructivist, functionalist aesthetics that characterized the plans for the Petersschule, the League of Nations Palace and the ADGB central college designed by Hannes Meyer and Hans Wittwer. These assignments were carried out by students who had spent most of their years of study under the direction of Hannes Meyer. The other student assignments were devoted to abstract tasks not arising from practical work. Their preference was for designing detached single-family houses. Mies's role in architectural teaching was limited to correcting the students' plans. Since then people have spoken somewhat derogatorily of the "Mieslings," students who studied under Mies at the Bauhaus, and naturally enough an imitative quality can be seen in many of their assignments.

At the same time, as at other colleges, students were taught a special canon of subjects.

Hilberseimer worked again and again with students on the "house with courtyard" type. Clearly, this type of house can be traced back to the concrete project of the second building section of the housing estate at Dessau-Törten under Hannes Meyer. That was where it was to be applied. On the other hand, the variants of the "house with courtyard" that were worked out are also in keeping with studies in urban building which Hilberseimer had been pursuing since the mid-'20s. Looking back, it can be

seen that the notion of "Bauhaus architecture" is the product of a misunderstanding: the targeted propaganda and the public exhibition activities of the Bauhaus and its founder Walter Gropius have led to the view that the architectural scene in the '20s was to a substantial degree produced and given its special quality by the Bauhaus. But the exact opposite is the case. The Bauhaus received its essential impulses from outside, even though the "institute" liked to lay claim to them for itself.

# From the housing estate house to urban building – the architect, town builder and pedagog Ludwig Hilberseimer

Martin Kieren

**Ludwig Karl Hilberseimer, High-rise city project, north-south street.** 1924, photograph of a drawing, BHA. • This project constitutes one of the most radical formulations of city zoning: apartments of equal status pointing east-west, a pedestrian area, beneath it office and business buildings on traffic-carrying roads. At the same time, however, purist plans such as this became a benchmark for the critique of a "soulless" architecture.

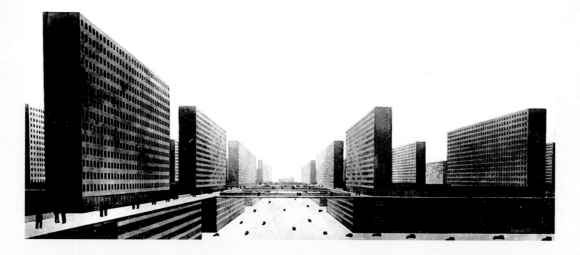

Ludwig Hilberseimer was one of the most interesting teachers at the Bauhaus in its late phase. His influence on the teaching of architecture and on the work of later generations of architects, including some who had no direct contact with the Bauhaus, cannot be over-estimated. In some of his urban building conceptions there are pioneering approaches which were not taken up again and discussed until very much later, and which continue to reappear as so-called innovations in the plans of subsequent generations. His most central interests were housing developments and urban building, along with the phenomenon of Functionalist reinforced concrete constructions, for which he demanded an expression purged of all stylistic features. Appointed head of the building department at the Bauhaus by Hannes Meyer in 1928, he at first kept a low profile in his teaching of architecture, but exerted an influence in the background, and during the period when Mies van der Rohe was director he developed a theory of planning ranging from the small "type house" to a variety of housing development typologies.

Hilberseimer was born in September, 1885 in Karlsruhe, where he studied architecture at the technical college under, among others, Friedrich

Ostendorf. Consequently, his image of the phenomenon of the city was initially marked by the austere baroque layout of his native city. His later work in urban building can be read as an ongoing reflection and lasting critique of this kind of traditional urban layout. From 1911 he worked as a freelance writer and critic in Berlin, where he also met Mies van der Rohe for the first time. Mies had worked from 1905 as a furniture designer for Bruno Paul and from 1908 in Peter Behrens's studio. The two men collaborated closely in Berlin from 1918–1919, i.e. from the time when the "November Group" and the "Working Council for Art"

**Ludwig Karl Hilberseimer, Model made from various kinds of wood as a teaching aid when studying the relationships between building forms and population density.** 1930, BHA. • This study was made in connection with the plan for the second building section of the Dessau-Törten housing development. At this time Hilberseimer was concentrating his work on exploring the advantages and disadvantages of different house types.

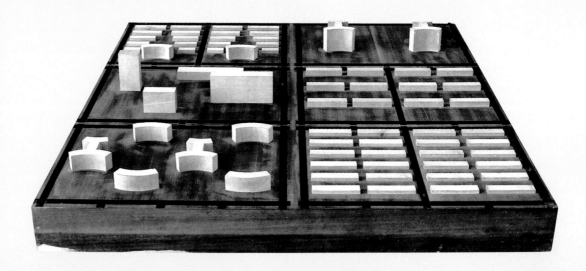

were set up. Mies's and Hilberseimer's interests coincided particularly in the design periodical *G. Material zur elementaren Gestaltung* (Grammar of Elementary Design). Mies was the editor of this periodical for a time and invited Hilberseimer to write for it. Their first international contacts were made by way of this programmatic, short-lived periodical, which was strongly influenced by the Russian periodical *Vesc/Object*, initiated and edited by El Lissitzky, and through the editor, Hans Richter, who maintained good contacts with like-minded people in Switzerland and France. Here they publicized their views on the application of reinforced concrete constructions, on town planning and the industrial manufacture of buildings. In 1923, for example, Hilberseimer wrote, in the second number of G, an article on "Building Craft and Industry," in which once again he castigated architects for not being able to adapt to industrial mass production, which was where the future lay: "The architecture of the last century was backward-looking. An attempt was made to rectify this deficiency by way of all kinds of formal imitations. Even in their best achievements architects did not go beyond overlaying necessity with beauty. Instead of presenting engineers and industry with demands for new constructions and materials for the realization of new formal ideas, architects have used the new constructions and materials quite senselessly, as a substitute for the old ones." He thereby touched on precisely those questions which were occupying Gropius at the time, both in his practice and at the Bauhaus.

# bauhaus zeitschrift für gestaltung

herausgeber: hannes meyer
schriftleitung: ernst kállai

gesamtübersicht

## l. hilberseimer
### kleinstwohnungen
#### größe, grundriß und städtebauliche anordnung.

über nichts herrscht größere unklarheit als über die größe einer wohnung. man ist traditionell gewohnt, durch die übliche zimmerteilung die größe einer wohnung nach der anzahl der zimmer zu bestimmen. so gibt es ein, ein-einhalb, zwei, zweieinhalb, drei, dreieinhalb usw. -zimmer-wohnungen. nichts ist falscher als mit solchen dehnbaren begriffen wie zimmer und ihre anzahl die größe und art einer wohnung festzulegen.

heute bestimmt man die wohnungsgröße nach der größe der wohnfläche. so sollen nach den neuesten bestimmungen der berliner wohnungsfürsorgegesellschaft kleinstwohnungen eine fläche von 48, 54, 62 qm haben, wobei 48 qm einer eineinhalb-zimmer-wohnung, 54 qm einer zwei-zimmer-wohnung, 62 qm einer zweieinhalb-zimmer-wohnung, entspricht. aber auch diese flächenbemessung ist genau

wie die bemessung nach zimmern von traditionellen gewohnheiten abhängig und für eine freiere grundriß-gestaltung, die auf das wirkliche bedürfnis der bewohner eingeht, ist damit noch keine basis geschaffen.

die an sich richtige methode, die größe nach der fläche zu bemessen, scheitert an der willkürlichen annahme dieser fläche, die von der alten zimmerteilung abhängig ist.

bei festlegung der flächengröße für eine wohnung muß die erste überlegung die sein, wieviel personen darin unterzubringen und wie die räume auf der fläche zu verteilen sind. es ist zu ermitteln: die wohnungsgröße für 1, 2, 3, 4, 5, 6 usw. personen, wobei zu berücksichtigen ist, daß jede wohnung, gleichgültig für wieviel personen sie gedacht ist, den nötigen wohn- und schlafraum, bad und küche haben muß.

If one goes sytematically through Hilberseimer's numerous publications during these years, one is struck by the fact that what most fascinated him and occupied his mind was the phenomenon of the (American) high-rise block, in particular the interface of façade and construction, of stylistic cover and inner kernel. Iron and reinforced concrete were the materials which dominated discussions about a contemporary "theory of cladding," with the help of which – according to Mies and Hilberseimer – the "dualism" of supporting structure and façade could be resolved, if one could only free oneself of the pipe-dreams and stylistic features of the last centuries or the last decades.

**Ludwig Karl Hilberseimer, Mini-apartments.** About 1929, title page from *bauhaus* 2, 1929, BHA. • Hilberseimer commented: "These ground plans were an attempt to satisfy everybody's legitimate minimum demand for living space, but the satisfaction of legitimate demands depends on the wealth of a people and the level of technology."

**Pius Pahl, Building plan, ground plans and views for a housing
development of L-shaped, extendable single-family houses.** 1931–1932,
BHA. • The L-type – a house form with which Hilberseimer also frequently
experimented – is here extended; its structure provides privacy from neigh-
bors' eyes, an important consideration in large-scale housing developments.

One of the drawings with which Hilberseimer entered his name
in the book (of sins) of the 20th-century radical functionalists
of urban building, is his "outline for a high-rise city" which he
published for the first time in 1924. In the following years he
repeatedly varied this outline and published it in a variety of
connections, in order to publicize his concern, his demands for
a "vertical separation of urban functions." This eventually culmi-
nated in his "city building proposal" (Berlin) of 1929 which today
appears startlingly naive and romantic at the same time, in which
he had gigantic terraced high-rise blocks resting on continuous
two-story bases, towering over an area comprising several apart-
ment blocks in south Friedrichstadt to the west of Friedrichstraße.
In its radicality this outline is reminiscent of Le Corbusier's vision of

the *Ville contemporaine* (1922) or his *plan voisin* (1925), with simi-
larly gigantic buildings towering over the inner city of Paris.

That "left-wing architectural functionalism" (Winfried Nerdinger) to
which a number of architects of the time subscribed, among them,
for example, Mart Stam, Hannes Meyer and Hans Schmidt, was
based on the notion that everything could be planned if only the will
existed. They did not believe in self-generating and self-regulating
urban energies and space management. For them, the uncontrolled
workings of internal stimuli simply meant city chaos. The obvious
muddle had to be countered with something new. But this had to be
conceived within a general, as it were overriding change, that is to
say a change in society, the revolutionary re-evaluation of everything

that had been thought until then. On this subject, Hilberseimer wrote in the periodical *G*: "But the really new, the really central task of our time that concerns everybody today – is it not to create a new social order and to campaign for the ideas on which it is based?" (No. IV, 1926). This attitude naturally made him, in Hannes Meyer's eyes, a suitable head of the Bauhaus building department. Here he was initially responsible for constructional planning and at the same time gave courses on urban building. In his plans and studies his interest in housing development problems becomes increasingly clear. For example, he investigated with his students the dependence of building density on the appropriate form of housing for the less well-off, and in this connection he developed special types of single-family houses and apartments based on urban building analyses. As regards theory, he consistently held fast to left-wing views. This meant that he always related the search for new solutions to the problems of architecture and urban building back to social conditions, especially the affordability of housing space for the poorer classes.

In this connection Hilberseimer's influence on the building section of the Dessau-Törten urban development, worked out under Meyer in 1930, cannot be overlooked. This has hitherto never been mentioned, not even in passing, and has therefore never been properly appreciated. The reason why Hilberseimer's share in this original housing estate, developed at the Bauhaus is never mentioned – it was the only commission to go directly to the building department! – is probably that Meyer increasingly laid claim to this work for himself and published it under his own name. For the extension of the development which had been built by Walter Gropius between 1926 and 1928, a special mixture of buildings was envisioned, comprising a trellised-walkway type of house and various flat building types. In the '20s there was little or no investigation – except, that is, by Hilberseimer – as to whether such a mixture of buildings, with types of houses combined in various ways, could be used. Other concepts were always more rigid, less flexible and more one-sided. In this sense he refined and transformed the existing approaches to urban building developed by Le Corbusier for the city of Paris, which Hilberseimer himself, even in the mid-'20s, still regarded as exemplary.

Two extant plans that have been published many times – but never under Hilberseimer's name – show his undoubted influence: the analysis and presentation of both the terrain profile and the street profiles, and the bird's-eye views, are typical of Hilberseimer's repertoire. But the development of the individual house types can also be attributed to Hilberseimer: L-shaped house types in a zig-zag arrangement or terraced to produce a kind of open house with a courtyard. In addition, there was another terraced house type with a ground plan layout that is entirely

typical of Hilberseimer. In subsequent years, plans and ground plan studies for all these types of houses are repeatedly to be found, produced by Bauhaus students under Hilberseimer's guidance. He evidently continued to pursue this idea uninterruptedly, probably seeing in these planning projects an opportunity to occupy the students with real building tasks and not, as Mies did, with abstract assignments.

Under Mies van der Rohe as director, Hilberseimer became one of the most important teachers, both in matters of organization and restructuring the teaching, and in the direct development and supervision of student projects. Almost all student assignments from the last years of the Bauhaus reveal their dual origins: the formal borrowings and expressive qualities come from Mies's austere teaching, whilst their conceptual and functional development, on the other hand, accords with the rational typological strictness taught by Hilberseimer. Later, when he was based in the USA, his influence increased still further. In 1938, at Mies's suggestion, he accepted an appointment at the Illinois Institute of Technology, where he taught until his death in 1967 and where he continued to work in very close and amicable collaboration with Mies. From 1955 he was head of the department of city and regional planning. Some of the most important of his many writings date from this period, the most outstanding of them being the book *Development of a Planning Idea* (published in German in 1963), which may be regarded as a kind of legacy from the creative output of this architect, urban builder and teacher.

**Pius Pahl, Ground plans and views for a chain development with extendable L-shaped terraced houses.** 1931–1932, BHA. • Pahl tried here, like Hilberseimer, to develop a terrace from a single type of house with a courtyard, following a rhythmic additive principle.

# The Brave New World – a house building review. A walk through an impossible Bauhaus city

Martin Kieren

**Walter Determann, Bauhaus housing development, main building, two views.** 1920, watercolor and Indian ink over graphite on paper, 62.7 x 79.5 cm, KW. • Expressionistic ideas for a "people's house," religious elements and elements of folk art are to be found in this plan. In this respect the planned center for the Weimar housing development is typical evidence of the early Bauhaus phase.

Every vision wishes to become reality. Once brought into the world, as an image projected onto and given in trust to the future, it aspires to transcend its status as a vision and become material reality. Thought up for many reasons – sometimes very dark ones – but mainly formulated as critique, that is to say as a reflection on the existing state of affairs, every vision, thanks to its inherent energy, seeks a path through the jungle of reality in order to take its place there. No, not just one place among many – it wishes to take up other places, to replace the potential of existing images, the sediment of history, by a vocabulary which it has generated itself. This applies also to the vision, or the envisioned goals, of the Bauhaus. At the time of its foundation, what was in the foreground was not the idea of setting up an arts and crafts school that would be famous at the end of the 20th century, or a snobbish alternative institution for craft training, but – a vision. One which encompassed conditions of living and production as well as a consciousness and way of thinking that differed from tradition, that aimed at enhancing the visible material world, making it a more agreeable

place. Houses and objects in daily use, clothing and furniture, wallpaper and fabrics – everything was to be made different, more beautiful, better. The idea that "the ultimate goal of all artistic activity is building!" did not actually refer to a building as an outer shell to live and work in more agreeably, but the world as a building, liberated from the shackles of tradition, to accommodate a new man.

In addition to spiritual education, one of its goals was to make the world a more beautiful place. Or at least – to begin with – to make our cities, the "built environment," as we say today, more beautiful. Strange as it may seem, design, whether on a small or a large scale, whether applied to objects or buildings, always has to do with *venustas* (beauty), with that extra something that goes beyond what is necessary and preserves something that remains inexplicable, a mystery – otherwise one need not bother but could leave it to the engineers and the machines built by them.

However, only parts of the ideas enshrined in these visions are ever implemented. This can be seen in our cities. While some, the visionaries in particular, deplore this as an overall failure, others welcome this juxtaposition, variety and garishness. Considering what the Bauhaus at the outset conceived and envisioned for making a "brave new world" into a reality, it is futile to ask today whether it would be more advantageous to be one of the welcomers rather than one of those who despair at the fact that once again a totalitarian strategy foundered on its own antagonisms. Even if what confronts us as the visible result cannot always be described as "beautiful" or even the result of an attempt to create beauty.

As in the other workshops and departments of the Bauhaus, but especially in its attitude towards architecture (for a long time there was of course no separate department of architecture), one can discern regular shifts of emphasis over a short time span – above all in this particular *métier* in the context of ideas being discussed elsewhere. This was on the one hand due to the different architects who were directors of the Bauhaus (Gropius, Meyer and Mies) with their different backgrounds, different practical and ideological leanings and very divergent gifts and inclinations. On the other hand, however, this constant change was due to the fact that economic, technological and especially political, social and cultural conditions in Germany during the 14 years of the college's existence were prey to a logic of extremely rapid movement

and change. This left nothing untouched, certainly not the training institution which had itself proclaimed its commitment to such energetic change, almost as an inner structural impulse to change and enhance the world.

If, as an intellectual exercise and in compensation for the failure of the vision(s), we were to imagine a city which had come into being entirely in the spirit of the building department (while allowing for the contributions of elements of decoration and embellishment from the other workshops), the confusion and the working conditions in Weimar, Dessau, and finally in Berlin would become clear. But an abstruse image of urban life and (stylistic) inconsistencies in the elements and buildings of which this city vision consists, would also become visible. If one were for once to compile a typological catalog of the buildings which were designed and built by members of the Bauhaus between 1919 and 1933, one might be surprised to discover that a complete city could in fact be "synthetically" assembled from them. One would also be able to note that this city did not present a unified appearance in accordance with a visual vision but that it was, like reality, assembled from the sediment and manifestations of various visions and ideas.

The typological spectrum encompasses the following (the list is incomplete) arranged by city (Weimar, Dessau, Berlin): factories with modern steel construction; a rebuilt municipal theater and a hyperbolic Symbolistic-Expressionistic monument in the vicinity of a "Palladian temple" as a central building for a family to live in; single- and multiple-family accommodation produced using both craft techniques and mechanical methods governed by Taylor's "scientific management," their "slab" logic visibly part of the mechanized procedures used, which also had damaging effects on the buildings themselves; buildings with an Expressionistic appearance built strictly orthogonally, in the De Stijl manner, which seem to have come out of the world of images and paintings of van Doesburg and Mondrian, to which the later, often-invoked Functionalism is completely alien; mystically flickering temples of light made of various materials such as sheet metal and colored glass, a tower of fire and a log house made completely of wood in the style of American prairie houses; buildings from the realm of utopian prophecy; residential settlements built in an alternative, folksy style with colorful scenic elements and ground plans that look like patchwork rugs from the pop era; and a skyscraper made from a reinforced concrete skeleton faced with shell-limestone for a large newspaper, modern, it is true, but with borrowed building elements; storerooms and administration buildings, smoothly rendered and finished in the New Functionalist style with standard windows, for tactical reasons, and looking like the brutal houses in Georg Grosz's big-city pictures; recklessly constructed graveyards; a philosophical academy conceived as a

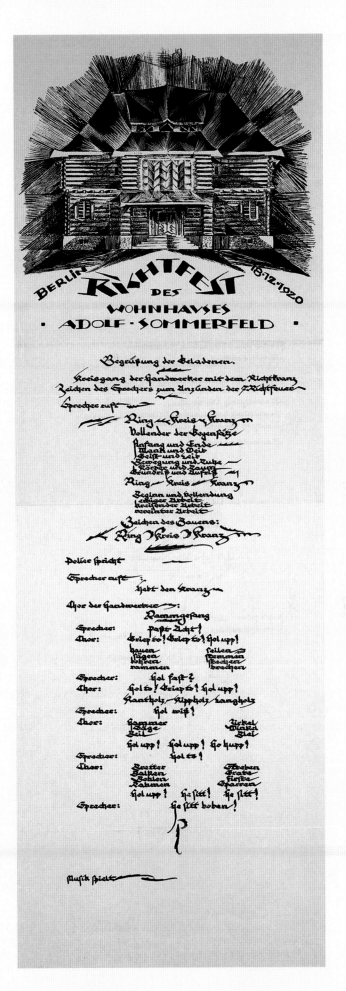

**Program for the topping-out ceremony at the Adolf Sommerfeld house, Berlin.** December 18, 1920, woodcut by Martin Jahn, BHA. • In the first phase of the Bauhaus its members saw forerunners of their own ideas in the mysticism of the Middle Ages, their church-masons' guilds and the crystalline symbolism of rays of light. In Jahn's woodcut, the Sommerfeld house rises up like an epiphany from a garland of rays of light.

**Farkas Molnár, Plan for a half-timbered single-family house (reinforced concrete).** 1923, original reprophotograph of the plan, BUW, Bildarchiv. • In these studies Molnár tried to create a balance between construction, structure and building unit volumes. At this time the Bauhaus was discovering reinforced concrete as a building/construction material.

Attached to the school building is the arts and crafts vocational school (or technical school) building that breathes the same spirit. The school is finished, teaching begins, students and teachers plan and build, the production of pictures for the New City starts. The following are built: to begin with, houses for the professors (the resident "masters"), a composite of interlocking cubic volumes, well-proportioned and of sound workmanship; a building for the Konsum retail cooperative and a labor office, positioned with precision and élan in the city space; a steel house (as an "experimental building site"), more single-family houses and villas in every variation of cubic style, that is to say shaped like cubes and crates, with flat roofs, windows without rhythm; a "house of the people," a house for a doctor: terraced, flat, clean, cool, healthy; a trade union college organized like a monastery which fits snugly into the landscape and the irregular terrain; a working men's bank whose location and appearance are derived from an (ergonomically speaking) correctly illuminated desk; a restaurant by the riverside; trellised-walkway houses for workers in classical brick similar to 19th-century English working men's houses, and new-style houses with courtyards for salaried employees on the outskirts of the city which appear to anticipate the family idyll of present-day suburban housing estates; an airport; schools with varying spatial and architectural features; large estates and further developments of low-built and terraced houses, containing the entire potential of the next 60 years of building; a total theater for experimental performances; and finally the most elegant villas in the style of the "Barcelona Pavilion" designed by Mies for the world exhibition of 1928–1929. These latter were created for the most

strictly rhythmical building that complies with functional criteria; a convalescent home for children, a nursery/crèche and cube-shaped studio blocks which have been unable to shed the appearance of the basic shape, compulsively retained from the preliminary course; and finally an exhibition building designed to exhibit itself, in which all these attempts to plan and build a city and its integral elements are also exhibited. So much for this potpourri of architecture and urban building from Weimar.

Let us remain with this image, this manner of describing a town that has never existed, but which we can nonetheless inspect with our mind's eye. In Dessau the first extensions (to the city) are made. First the school is built to train the architects who think up this city, plan it, design it in detail and extend it on a large scale. It is the austere, cubic, brilliant white "laboratory for new ideas on architecture and the city. Having outgrown "pure doctrine," it transmits its waves, so to speak, onto the New World, neutral, functional and yet also, with its crystalline glass curtain wall, rhetorical.

**Andor Weininger, Stijl Fantasia House.** 1922–1951, Indian ink, graphite and gouache on paper, 30.5 x 42.4 cm, KW. • The motif goes back to the influence of van Doesburg, who was staying in Weimar at the time this drawing was made, agitating against an Expressionist Bauhaus and campaigning for De Stijl, which exerted a powerful influence on Bauhaus students.

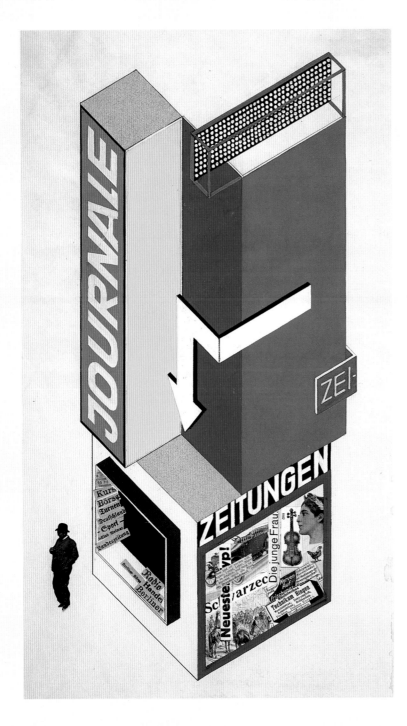

part during the Berlin period – as were a number of other high-quality buildings which form an abstruse contrast to the age and to human needs – before the experiment in planning and building a new city had to come to an end. The components are real, but the complete city is non-existent – and yet, after World War II, the Bauhaus vision was reactivated in various widely differing quarters, specific issues were raised once more which had to do with the building of this visionary city. Particular problems moved into the foreground. The rationalized method of constructing large-scale housing development units reappears in both the capitalist West and the socialist East. The simple cube form was used for almost every type of building until it had been worked to death by the least gifted copiers and was replaced by the kidney shape. But down to the present day the idea of lucid, functional form that was enshrined in those cubes has been repeatedly salvaged, refined, and up-dated. In the building of private villas some of the principles of the "New World" likewise continue to be applied: open spatial sequences with staged vistas, economical pathways and rational arrangement of space; topography is taken into account and there is flat-roofed, terraced interlocking of building masses and volumes.

What has not been fulfilled is the vision of making cities beautiful as a strategy for reconciling the different classes, the contrasts produced by society and visibly reflected in everyday life. There was a desire to build islands of beauty, to inject, as it were, exemplary architecture into the city. The intention was to infect the city, so that in order to survive it would be compelled to absorb this new beauty, to appropriate its criteria. But when one looks back the result is depressing, for in proportion to the goals envisioned the opposite tends to be true. From the fragmentation of our built environment, of the built-up sediment that has come into being since the Bauhaus, compared with how the Brave New World could look, individual witnesses stand out silently, amid the roar of traffic and surrounded by the work of ungifted copiers.

**Herbert Bayer, Design for a newspaper kiosk.** 1924, tempera and collage, 64.5 x 34.5 cm, BHA. • Bayer tried here once again to make planes and typography, building unit volumes and color serve an idea. The models were provided by the propaganda art and Constructivism of the Soviet Russian avant-garde.

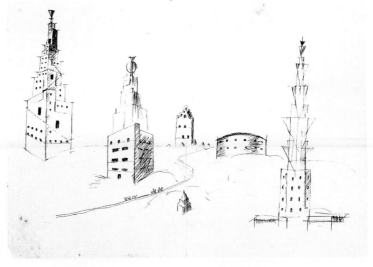

**Gerhard Marcks, Landscape with tower buildings.** About 1919, pen on paper, Archive of the Gerhard Marcks Stiftung, Bremen. • Marcks sketches a strange location, almost in the manner of Klee: towers with an imaginative and postmodern effect rise upward from a kind of mountain landscape, through which a path passes along which two riders and a donkey-cart are moving. The potter Marcks as creator of bizarre romantic architecture.

# Theory

# The Bauhaus as Madeleine – against Retrospective Prophecies

Bazon Brock

Bauhaus? Well, yes. Preliminary course. Basic teaching, cooperation of form masters and work masters, unity of art and technology – that may have been quite attractive at one time, but it's hardly worth mentioning today. Who cares about objectives? And what came out of it was hardly anything more than better-class arts and crafts.

If that is hardly worth mentioning, why the innumerable studies of the history of the Bauhaus in Weimar, Dessau and Berlin, in Tel Aviv, Chicago and Cambridge? And why is it not possible to have any conversation about the future of industrial design, about college curricula or about the self-image of artists and designers in which the mention of the name or the concept of the "Bauhaus" can be avoided?

The broadest answer to this question is: the Bauhaus enterprise was the victim of the rigid and narrow-minded political and cultural strategies of both the National Socialists and the Universal Socialists (Communists). From our own experience of the closely circumscribed scope for self-assertion we tend to identify with the members of the Bauhaus as victims. We perform a kind of restitution on our own behalf when we give an account of what was done to the Bauhaus. And then we are fired with enthusiasm for retrospective prophecy: what might have become of the Bauhaus if it had become what it never was, because it was not allowed to be? How different would our understanding of cultural production be if we too had become members of the Bauhaus as a community of multiple copies of Gropius: with directorial autonomy of decision-making, adept at dealing with businessmen, opinion-shapers and politicians – committed as a matter of course to ecological parameters and equally so to economic welfare and future generations?

Anyone who looks at these elaborate prophecies is in for a surprise. We have become exactly what we never thought we could become as Bauhaus members *manqués*. With

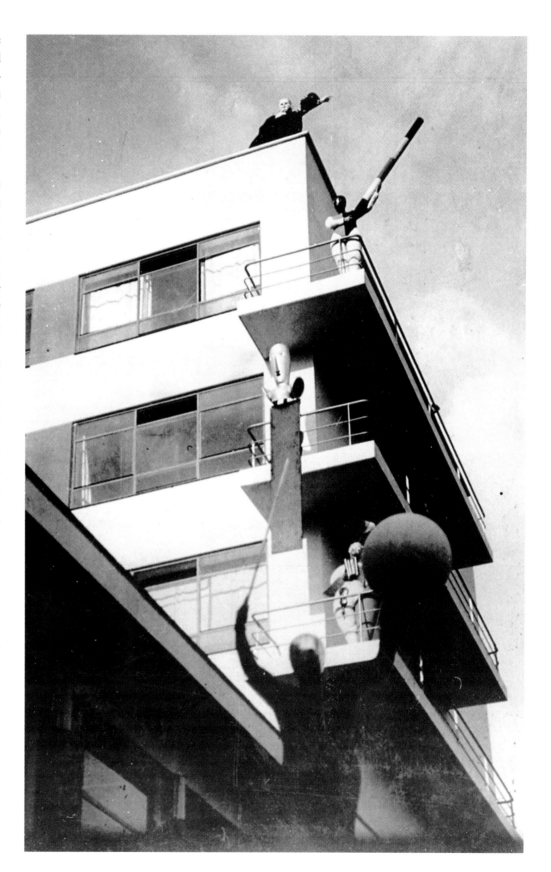

**The building as a stage.** 1927, photograph by Erich Consemüller or T. Lux Feininger, Oskar Schlemmer Theater Archive. • Schlemmer used the "diving-board" design of the studio block as an open-air stage and for the vertical rearrangement of dramatic stage productions. An early form of "art with building."

**High jumper in front of the Prellerhaus.** 1930, photograph by Hajo Rose, BHA. • The grass in front of the studio block in Dessau, also known as the "Prellerhaus," served as a pitch for football and other forms of physical exercise.

**Gingerbread for the White Party.** 1926, decoration for a Bauhaus party by Gunta Stölzl, photograph by Lucia Moholy, BHA. • Even a piece of gingerbread appears to take on a dynamic quality if it was made by a member of the Bauhaus.

us the Bauhaus has triumphed as the most successful enterprise of 20th-century cultural practice. Who today would forgo the use, in his work, of the most advanced technology and experimental methods? Who refuses to countenance the mass distribution of his products? Who does not present his credentials as a good "team worker" precisely because he comes across as a self-confident individual? Who does not as a matter of course strike a balance between economic utility and spiritual self-gratification? Who does not systematically promote his success by joining exclusive communities based on mutual ego-boosting? Put in historical terms, this means: we all accept the production-line character of all work; we acknowledge the primacy of functionalism including aesthetic,

psychological and social functions. We bow to the unity of lifestyles by physical exercise, psychotherapy, healthy eating and life planning. But in particular we are prepared as a matter of course to state that the Bauhaus style is the predominant style of classical modernism, although quantitatively speaking it is in fact of negligible importance for architecture and design, décor and fashion. This discrepancy between, on the one hand, the declared awareness of modernity on the part of the entire population, and, on the other hand, "business as usual" produces a kind of revulsion from statements of allegiance to the Bauhaus and gives rise to historically distanced assessments. It is, to be precise, revulsion from the success of the Bauhaus as an ideology of justification.

**Bauhaus Christmas tree with angel in baby mask.** About 1928, photograph by T. Lux Feininger, BHA. • Mysterious music making and meditation under a Christmas tree which looks as if it is made of components of the "Wassily" tubular steel chair.

We do not wish to justify, or to see justified:

- Hitler on modern furniture. It is intolerable to us that Nazi programs such as "Beauty of Work" and "Strength through Joy" were a genuine expression of that modernity which we would like to keep unsullied as a powerless victim of totalitarianism. We refuse to accept that the programmatic realization of modernity worldwide at least took on, and will continue to take on, totalitarian features.
- That Gropius and Mies were able, while remaining true to their aims, to arrange, and did indeed design, for the Third Reich, exhibitions that remain exemplary to this day.
- That at least until 1936 some young National Socialists paid homage to the Bauhaus as the expression of modernity as they understood it.
- That as regards the architecture of functional buildings Bauhaus modernity remained exemplary throughout the entire Third Reich.
- That the functional logic of modernity has achieved success primarily in 20th-century weaponry design (to this day nobody dares to award the modern designers of these outstanding achievements all the prizes for "good form," the criteria for which they fulfill as does no other group of products).

And, vice versa, we refuse to acknowledge that the modernists, with the Bauhaus at their head, were at least as much esoteric prophets of spiritual salvation as devotees of formalist calculation. Gropius's historical concepts were "magic" and "spirituality." Their forms of community sprang from the same sources as previously expounded "people's communities" or the "orders" of the Nazi activists, along with the concepts of the institutions of education in national politics.

We could not but take note of such attempts at justification in view of Heidegger and Benn, Jünger and Carl Schmitt – without, of course, any implications for our self-image as representatives of modernism. Are we now also to be compelled to subject the Bauhaus heroes Gropius and Mies, to say nothing of others, to such dubious enlightment? We refuse.

Studies such as those of Elaine Hochman on Mies van der Rohe and the Third Reich are not translated into German any more than those of Hannah Arendt are translated into Hebrew. It is even more precarious, notwithstanding Thomas Mann's early notion of "Hitler, our brother," even to begin cautiously to wonder what would become of our self-promotion to the rank of new, modern man if we were to comply with the demand that we should see in Hitler and Stalin the true exponents of absolute modernity. We would do better to stay with the beautiful ceremony of Proust: we share out the Bauhaus as delicious cakes and biscuits made to faith-healing recipes, and at Bauhaus congresses we dip the Bauhaus madeleine together in our healthy herb tea in order to revel in memories of lost modernism. Childlike memories of something that never existed.

We stylize modernism, and especially the Bauhaus as its most glittering representative, in counter-factual statements. But the feedback of such historical stylizations into our awareness of contemporary modernity is much more devastating than would be the case if we were to bid farewell to the innocent purity of modernism. The normative power of the counter-factual is always more powerful that that of the factual. That is why attempts to develop another, second modernism appear so feeble and even hopeless. For these attempts ought of course to reckon with historical facts, that is to say with reality. But it would only be reality if it did not give way before ideas, however humane, and programs for shaping our future, however desirable. If reality does not give way to our desires, we inevitably lose the impetus that comes from being able to have a successful shaping effect on it. But that would be tantamount to admitting our powerlessness. Until now there has been only one attempt in the whole world to base man's relationship to reality on the radical confession of powerlessness – in Christianity, with its founding act of crucifying all bringers of salvation, cultural heroes and leaders. Does that mean that our truly timely concern with the Bauhaus should lead us, as it were, to crucify the historical Bauhaus and its heroes so that the failure of

this enterprise to be absolutely modern might fruitfully reveal its true exemplary quality? What the result of such an attempt would be, remains for the time being an open question.

I suspect that the Bauhaus was able to have such a convincing effect in the USA because the American elites were still of a homogenous Christian stamp. To a large extent the pioneers' associations still followed the patterns of social cooperation which Gropius wished to reactivate when he derived the programmatic name "Bauhaus" from the Christian *Bauhütten* (church-masons' guilds). Americans could accept the roots of modernity in Christian communality more unreservedly than Europeans, who had been overwhelmed by Nietzsche's concept of modernity. Nietzsche acquired his ideas by the simple inversion of suffering into triumph, of the community of the powerless into the icy singularity of mighty heroes. American pioneers were aware of their dependence on the communities that supported them; their thinking was egalitarian. Their civilizing achievements could not be defined in terms of Nietzsche's lunacies. Measured by his ideas, the Americans were working in a positively unmodern Christian and "Old-European" way – a concept which was explicitly used even during World War I in an attempt to clarify whether that war was the result of the consistent demand for modernization or of the rejection of modernity.

The American missionary zeal of Presidents Wilson, Roosevelt, Truman and Kennedy, and the missionary zeal of civilizers such as Ford drew their dynamism not from any break with a communality rooted in Christianity, but rather from its optimization. The success of the Bauhaus concept in the USA could be understood in terms of the Americans' ability not to evaluate Bauhaus modernism as a radical upheaval, as was claimed in Germany in particular. The question remains whether the significance of the Bauhaus is not indeed to be seen – in the sense of Weber versus Nietzsche – in its having preserved the continuity of the Old-European Christian understanding of the world instead of asserting modernism as a radical departure from its European roots.

# Strange Forces – Three Possible Retrospective Takes on a Spatialized Modernism

Michael Erlhoff

Many of those who have now for some time been very fashionably announcing the end of modernism, have, it is certain, let themselves be guided rather by a complete and consistent image of what they take modernism to be. In so doing they have either simply overlooked or else been unable to bear, or have rejected as un-modern, the radical contradictions within modernism which have been expounded many times over since the publication of Horkheimer and Adorno's *Dialectic of the Enlightenment* (Amsterdam, 1947, English edition New York, 1972). But here they join hands with precisely those people who mistook modernism for a jewel box from which they tried royally to help themselves and legitimize their own credentials. They therefore glossed over all its contradictions and merely indulged their love of harmony in gracious simplicity. Neither group is worth any further attention here.

Even so, if one is called on to reflect on the phenomenon of modernism in the '20s one is confronted with these attitudes. One hovers, so to speak, above an area that cannot be seen in its entirety, in order retrospectively somehow to exercise one's powers of judgment. So one spins one's threads to see where they break and where they hold: Baudelaire does not go with Raoul Hausmann, but the latter could be linked with Helmholtz; Faraday stumbles over Robert Houdin, but is horrifically subsumed in Albert Speer; Mallarmé could become involved with Gropius via Lewis Carroll, or better still with Bruno Taut, but then Alfred Hitchcock steps in jointly with Charlie Chaplin, wraps up Piscator and Meyerhold in a roll of newsprint and hits Rodchenko with it, who drops him. In the meantime some people are jumping around on Monte Verità, interpretations of dreams are losing their way on rapid tramways, and above everything there is a menacing black square. If, in this turmoil, one looks at the Bauhaus, it is difficult to avoid the impression of having stepped straight into a room full of pubescent young people, a room where the people who live in it are already trying to make it into a real space, not just playing a game of "now you see it, now you don't." Clearly one can only tentatively extricate oneself from this predicament, but even so it might yield some passing insights.

## Social hygiene

At the very beginning of our century the writer Paul Scheerbart, who was enthusiastic about the New Building of, for example, Bruno Taut and about "glass architecture" as a whole, produced the rhyming couplet: "Das Ungeziefer ist nicht fein/Ins Glashaus kommt es niemals rein" (Vermin is not refined/It will never get into a glass house). If we cautiously assume that this advertising slogan was not phrased without chutzpah, then it reveals – no matter whether simply in a hypochondriacal vein or out of mere malice – the radically contradictory nature of the new glasshouse fortresses. Even a first retrospective look at the "New Building" shows '20s modernism to be in many respects monumental, rhetorical, homely or purely gestic, full of outward appearance and empty social gesture.

The fact is that Paul Scheerbart's couplet, like many of the buildings and interiors, proclaims both openly and surreptitiously the real jungle of the cities. He looks at the rear side of the transparent glass architecture with its walls drenched in light, which present an image of transparency and communication but which in fact are an attempt to cater for, in glassy exclusivity, a certain lifestyle or a late romantic yearning. All of a sudden communication can be seen as something which permanently excludes all who are unable to share its resources. Even at that time, inside and outside had become a mere television program, the windows were screens, and anything looked at had to be greeted with violent enthusiasm, inflated out of all proportion to make an impression at

any cost, so that the viewer would no longer be considered as vermin.

"The landscape streams in," wrote Siegfried Giedion in 1929, looking at a hospital in Waiblingen designed by Döcker. He went on to elaborate this insight entirely in Scheerbart's spirit, but even more drastically: "Light and psychological relief are as vitally necessary to the patient as medication." Bearing in mind the architectural catchwords of the time, Giedion's insight has a certain social right on its side, for tenement blocks, dark living rooms and grubby hospitals do degrade the life of the little man. Even so, Giedion here cunningly disappoints all the hopeful expectations of those who are minded to associate that puberty of modernism (as one is justified in calling it) as expressed in "liberated living" with any utopia other than a purely functionalist one of hard-working industry. Although the book *Befreites Wohnen* (Liberated Living), compiled with commentary by Giedion in 1929, proclaims on its title page "Light, air, opening," what is illustrated on the book's dust jacket is more like the interior of a sanatorium for tuberculosis patients straight out of Thomas Mann's *Magic Mountain* with, furthermore, prefatory quotations first from Jabert: "As with plants and animals, in architecture too a new species only appears after the disappearance of the old," then from Henry Ford: "It has taken a long time, but progress will now be very fast." Not only is progress presented here as some kind of natural function (as was so frequently and typically the case in that period) because it is natural, in accordance with nature, necessary and inevitable. There it joins the eternal enthusiasm for neatness, steely bodies, fitness (Erwin Piscator's bedroom is also illustrated in the book, complete with its gymnastics wall), for the countryside, the heraldry of right angles and the heroism of cleanliness. It is also placed, in a manner that is as relentless as it may be unthinking, in the vicinity of that most complete creative lunacy of history hitherto, the "1000 Year Reich." There too, as is well known, steely bodies and decorative masses were celebrated, there was the lunacy of machines and cathedrals of light, the attempt to write the continuation of history in accordance with natural laws, there was

**On the beach at Mulde.** 1928–1929, photograph by Irene Bayer, BHA. • "Social hygiene" or a summer Bauhaus revue – directed by Xanti Schawinsky as master of the parasol. The swimming masters and beginners included Georg Muche, Hinnerk Scheper and László Moholy-Nagy.

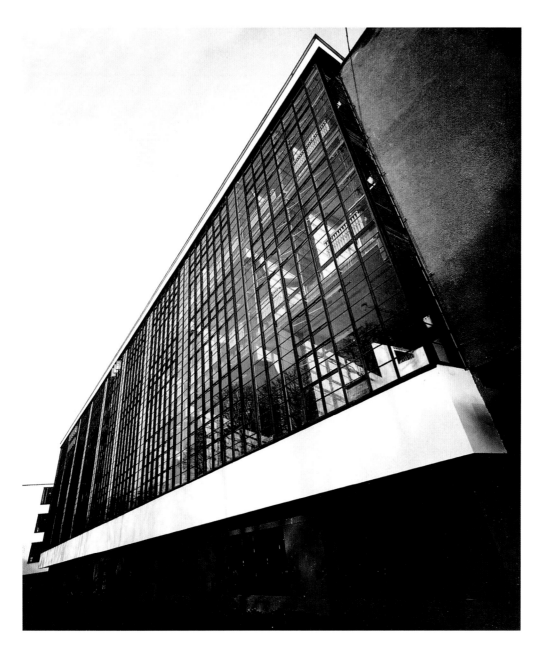

**Bauhaus building, Dessau, workshop façade.**
1926, photograph by Lucia Moholy, BHA. •
Architecture without people, but behind its
famous glass curtain-wall it is easy to imagine
people working industriously to design a new
environment.

## Modern murder

In the second assessment, one is forcefully
struck, given the numerous extant illustrations
of modern architecture, by the fact that, con-
trary to their captions and picture titles, which
continually refer to man and the conditions of
his life, people are only very rarely to be seen
in these photographs.

This could be explained by the fact that the
texts always speak of human beings in gen-
eral, whereas any photograph would necessar-
ily only ever reveal specific human beings.
(Characters who in the early days of 18th-
century domestic tragedy were still conceived
didactically, as types, underwent in the 19th
century a strange partial reindividualization of
their destinies, which in the '20s was lost once
again in a masquerade of animated puppets.
This phenomenon fascinated a number of
photographers at the time, including Umbo.)
On the other hand, however, this absence of
people in the buildings and individual rooms
illustrated, accords precisely with the program
of architectural modernism, in which laws are
more often to be found disporting themselves
than living beings and in which the names of
the creators tended to be more important than
the men and women who occupied the build-
ings and had to live in them day in and day
out. This is indeed totally paradoxical, since,
for example, Bauhaus architecture and interior
design were supposed to convey authoritative
experiences, but were impervious to any ratio-
nal argument or other objections. Hence these
rooms and houses existed not for actual peo-
ple but rather for ideal beings, which was the
reason why the designers had to be regarded
somewhat as geniuses of social awareness.
Incidentally this also marks the limits of
what was at the time, and in part still is today,
the customary scope of functionalist or even
ergonomic deliberations. From Taylor to
Gastev, and down to German Industrial Norms
(DIN), the emphasis has always been on
presenting not people but sample collections
of ideal users as the minimum standard of
behavior and order.

The most plausible objection to the Bauhaus
was broached in the '20s by the Hanover artist
Kurt Schwitters. He pointed out that any
intrinsically harmonious space is from the
outset inhuman, since any human being enter-
ing this space would destroy the harmony.

compulsory order, standardization and clean-
liness, acclaim of serial manufacture and
social integration, the wretched happiness
of standards and rules.

This is truly not merely a matter of super-
ficial associations. On the contrary, the
discipline, the shabby mania for social legiti-
macy, the unlimited belief that everything
and everybody could be put into a proper
shape: these were harshly converted into
the "Triumph of the Will" and a definitive
aestheticization of politics, into a watertight
totality of rhetorical formulae, and hence also
into an aestheticized economy, to the point
where anybody who was vermin, and was
thus not allowed to occupy the glasshouse,
was exterminated.

(Schwitters therefore experimented from an early stage with flexible spaces which were intended to be remeasured by the human beings who entered them.) Modernist spaces do in fact appear exclusive and empty of people, if not indeed as fundamentalist statements or the product of general rights of use. Their artifacts do not show the usual signs of use, they withhold any patina that would show their ageing process. These spaces – and up to the present day this has been, with a few exceptions, the problem with architecture that is greedy for space – represent a special ordering of life, empty contrived statements, along with their own deeply and enthusiastically felt emotion in the face of fictitious economic rules. In the '20s modernism in building took on a form that was still authoritarian and stationary, or at least Prussian, and didactic. It offered utopia as an actual place, accordingly took objective facts ostensibly as premises and principles, and attempted to boil everything down to its lowest common denominator. (At the Bauhaus this applies particularly, for example, to Paul Klee's *Pedagogic Sketchbook* and to Moholy-Nagy's theory of film, which sets out to argue quite differently from, for instance, Viking Eggeling or Hans Richter.)

In this context it comes as no surprise that there was no place at the Bauhaus or in officially sanctioned modernism for the "partners" of Dada, or Schwitters's Merz group of Dadaists, who considered social rules to be chaotic and therefore looked for open systems or even empirical forms of play, and represented rather the ruinous side of modernism as quality. They were driven off by the exponents of modernism (with few exceptions, one being the brief cooperation between Schwitters and Gropius). Part of the problem here is certainly the fact that all those who were once associated with Dada had to leave Germany swiftly after 1933 for an impoverished exile. Only in exceptional cases were they allowed to enter the promised land of the stewards of

**6 people have a car.** About 1924, photographer unknown, BHA. • Freely adapted from Luigi Pirandello's play *Six Characters in Search of an Author*, which was given its first performance in Berlin in 1924, directed by Max Reinhardt. On the far left is Hebestreit, the caretaker at the Prellerhaus, the student accommodation of the Bauhaus in Weimar. In the group are, from left to right, Marcel Breuer, Lotti Hebestreit, Günther Nordmeyer, Walter Herzger, Wolfgang Tümpel, Johannes Driesch, Georg Teltscher (?). On the far right is the chauffeur.

democracy, the USA. Modernist gentlemen, however, such as Gropius and Mies, enjoyed success there, not without first having flirted extensively with the Brownshirts, and eventually, after 1945, washed clean and inwardly purified, were handed back to the Germans as a bright spot in the record of their country, now due for restoration.

## Window on the world

A critique of modernism in building and design in general always entails a critique of general perceptions and, in particular, of the intellectual discourse of recent decades. This may be a cause of frustration in that life does not follow rules quite as much as that order-loving part of modernism would like to deceive us into believing. It is not a matter of apportioning blame here, but even so the problem does arise of how the inner dynamism and affectation (which is still dominant) of that style are to be understood, and how one should deal with these contradictions. It could be a question of understanding that serial production also implies serial murderers, that to this day the artifacts that function best are weapons, that even a garotte or an electric chair is always described by the people who manufacture them, or who merely legitimize them, as functional, humane and ethical (and, it goes without saying, economical.) Transparency also leads to the deification of the display window pane, the ideal undergoes its final reshaping as virtual reality and every harmonious space declares its inwardness.

This could be the moment for a gradual relativization of the idea of "modernism," or at least for distinguishing between different areas of cultural history. Mindful, however, of the need for brevity here, we shall restrict ourselves to examining one single, possibly distinctive moment, that general point of reference in the history of art and literature: Romanticism. As a metaphor for the contradictions and discrepancies of the Enlightenment that had opened up and been recognized, or even given artistic shape, its manifestations in central and eastern Europe are clearly completely different from those to be seen in the

west or the south. Romanticism established itself especially strongly in the rapidly industrializing regions of the Protestant north. Here, thinking had in many respects been shaken and unsettled in the processes of political upheaval and artistic production. Helplessness in the face of new everyday realities and phenomena led artists to resort to the romantic magic box: thus the mining engineer Novalis came up with dwarfs, others invented fairy tales or a complicated Gothic romanticism, and others again escaped into mysticism and religiosity (it took a Baudelaire finally to put a railway train into a poem). This is tragically articulated in particular by all those who in the 19th and early 20th centuries were still looking for criteria on how to treat everyday life and buildings artistically. Like the German poets Tieck and Wackenroder, who had escaped from industrialized Fürth to medieval Nuremberg, John Ruskin and William Morris helped themselves from the wondrous storehouses of the Middle Ages. In them the combination of pre-industrial modes of life and production and the idea of the perfectly shaped life took on its golden form. From it there developed the pioneering program for design (viz. the country house) and the Arts and Crafts movement.

If England, despite or because of such principles, was at least scurrilous enough to go down eccentric byways with Lewis Carroll and Margaret Cameron, the Prussian civil servant Hermann Muthesius, who had been sent by his government to London at the end of the 19th century for the purpose of establishing categories for German products by adopting English guidelines, found that all that was left for him to do was to transfer linear structures to Germany. Even so, this Muthesius was the most important pioneer of the German Werkbund, which had taken on the task of heralding modernism officially. If this does not in itself cause surprise, it could from our present-day point of view appear all the more surprising that even turn-of-the-century liberalism, which thought itself humane, as outstandingly personified by Friedrich Naumann, fell prey to similar patterns, likewise extrapolating

rustic domesticity and artistic craftwork from an imagined Middle Ages and elevating them to the status of contemporary forms of work and life. Gropius too subscribed to the periodical published by Friedrich Naumann, and implanted at the Bauhaus, and thus in the model of creative modernism, firm medieval structures such as the master classes and the general idea of holistic production and expertise.

Strangely enough, it was overlooked that not only scientists but also the late Romantic E.T.A. Hoffmann, who had explored the utmost depths of his romanticizing age, could, with his critical reflections on social and aesthetic conditions, be read as a critic even of the Bauhaus. At an early date Hoffmann pursued and analyzed, for example, the fashion for mirrors and views, for neatness, idyllic sociability and a localized utopia. To list and comment on such possible involvements of creative modernism makes it clear that the myth of a rational, lucid, thoroughly economic-minded modernism is a pure mystification. Basically, modernism adhered to the transfigured idyll and the quest for simplicity. This is tragic – not per se, but because modernism shaped itself as a religion and for too long suppressed its inner contradictions. Only in its works can this inner turmoil sometimes be discerned.

How clever and at the same time how painful it was that, of all people, the artist Kazimir Malevich, whose painting *Black Square* of 1918 was publicized by the modernists in the '20s as a nail in the coffin of traditional painting, should write in a letter to Matyushin that this "black square on a white ground" was a window on the world, i.e. it was to be understood purely symbolically. That sounds like Albrecht Dürer, but let us not deceive ourselves: it was official modernism that changed life and the perception of life (though, it seems, almost against its own will.) It is thus part of the history of modernism's impact, with all its contradictions, which we are only now beginning to understand, as far as we can, while it violently shakes and involves us.

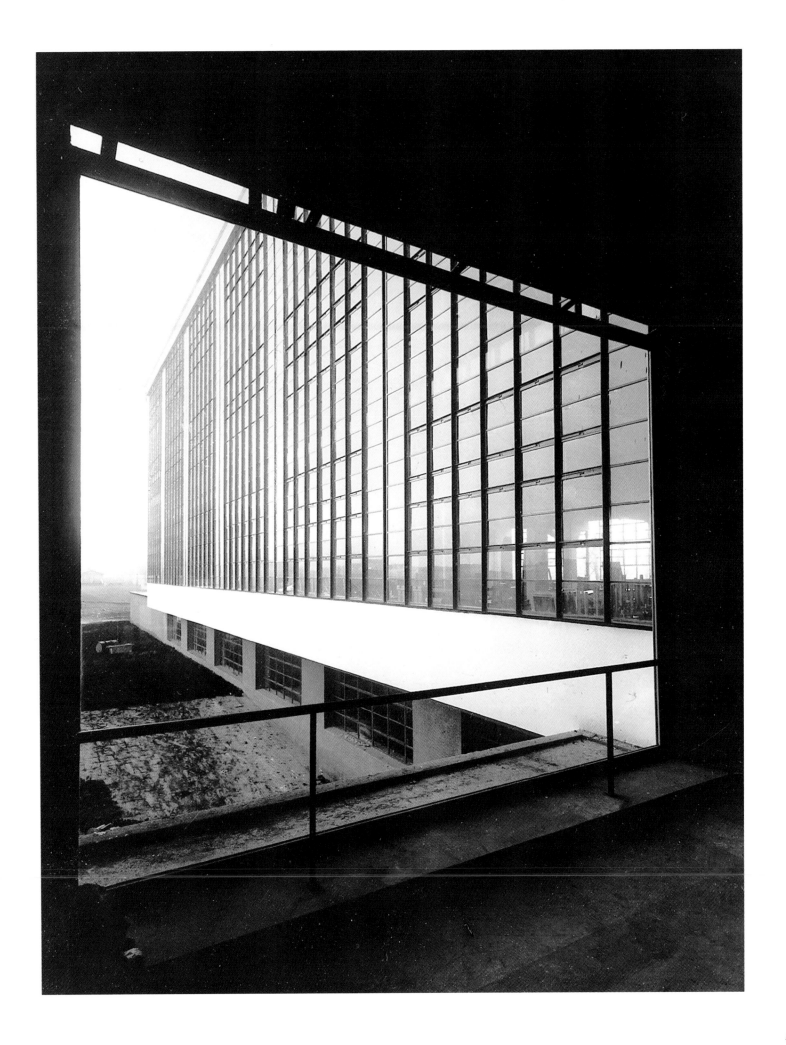

# Chalk and Computers – Principles of Order in Dynamic Image-making

Olaf Arndt

## "Languages of seeing"

Peter Eisenman, a past master and distinguished theoretician among contemporary architects, once said: "The day the appearance of my buildings is determined by a computer will be my last day as an architect." However, his pupil Greg Lynn, who is considered one of the bright lights of the new design and is an enthusiastic advocate of the theory of design without an author, discovered this about his teacher. As he states with disconcerting clarity: "From the appearance of their buildings I can tell with certainty that Peter works with Form-Z and Frank Gehry uses CATIA." He explains the jargon as follows: "All computer software has its own very individual way of describing a particular form. A curve built with Form-Z is something quite different from a curve created using ALIAS, the program which we use."

The end of the architect as author has come. Banal gadgets and their potential increasingly determine the appearance of a building, not, any more, the designer's genius. This means nothing less than that our physical environment will soon be determined by the contingencies of program language. Indeed, it means more than that: it already is! The Guggenheim Museum in Bilbao, acclaimed as the work of the century as soon as it was built, would, according to many experts, never have been built without the special technical benefits of the computer, even though Gehry's initial design was a hand-built model that was later scanned and developed further

It was 50 years ago that György Kepes (who was born in Hungary in 1906), the painter, designer, photographer, teacher and later offspring of the Bauhaus working in North America, began his major work, *Language of Vision*, with this statement of the absolute: "Today we are living through chaos." What for him in 1944 still signified solely a failure of organization, became soon afterward the subject of an extensive investigation into the issue of complexity at the newly established Massachusetts Institute of Technology, today famous under its acronym MIT as the world's leading elite college in the fields of media, robotics and new architecture. The image of breaking something down into its smallest units, denoted by the keyword "fractal," became proverbial when a human form suddenly reappeared in it: the little Apple man.

Before the huge capacity of large-scale calculators, which at the time filled entire rooms, made such insights possible, generations of planners and designers worked on the development of handy "modules," in other

**Greg Lynn and Ed Keller, Model for Cardiff Bay Opera House.** Illustration from *Arch +*, No. 128, 9/1995. • Lynn is the philosophical artist among the champions of the theory that a machine can and should take over creative design work. His thesis is: symmetry means loss of information, asymmetrical forms embody intelligence. Computer algorhythms are the artificial geniuses we seek.

**Frank O. Gehry, Neuer Zollhof, Düsseldorf, Rheinhafen, view from the city side.** Building begun in September, 1996, completion date for blocks B and C December 1998, block A June 1999, photograph by David Artichouk, Arndt Archive.

words design principles geared to the dimensions of the human body and its canonization. Man as "modulor," pressed into concrete by Le Corbusier, gave us the endless corridors of high-rise blocks, 2.26 meters (7'6") high, which today should preferably be looked at with one's head on one side, and rows of box-shaped chairs into which hardly a single German backside will fit.

## Dynamic image-making

Design aesthetics has seen many "zero hours" in this century: the end of painting celebrated by Malevich's *Black Square on a White Ground* at the end of World War I; Yves Klein's end of exhibitable art – an empty shopwindow; and another nightmare of emptiness and emptying – Le Corbusier and his *plan voisin* to pull down the whole of Paris

and rebuild it in the form of a few widely spaced cross-shaped high-rise blocks. Radicalism has been at a premium throughout the entire century. Better to clear the ground and make a fresh start than to be thought of as someone who is prepared to make concessions. Thus it comes at first almost as a surprise that the artists who had been exiled to America before the greatest tribal reorganization of the century – the plan for a total reordering of Greater Germany – were looking, far from Europe's blood-drenched soil, for another way back to natural order.

All of them, including György Kepes, have since then developed a healthy skepticism as regards extremes of purity, and seek to tie their theses, which are in most cases called "revolutionary," into society: "Inherited visual language has fossilized events by means of a

static system of signs. The revolution in the visual arts has restored a dynamic approach to us in the realm of the senses. These structures must, without abandoning the qualities of visual austerity, expand to absorb the images, charged with significance, of concrete social experience ... this goal will only be achieved when art once again lives in indissoluble harmony with human life" (from György Kepes, *Language of Vision*, New York, 1995). His demand will serve us as a benchmark in assessing present tendencies to capture the complexity of life in a process similar to that of creation, with the help of powerful calculating machines.

## Natural systems

Greg Lynn, the inventor, together with Hani Rashid, of the "paperless office" in which

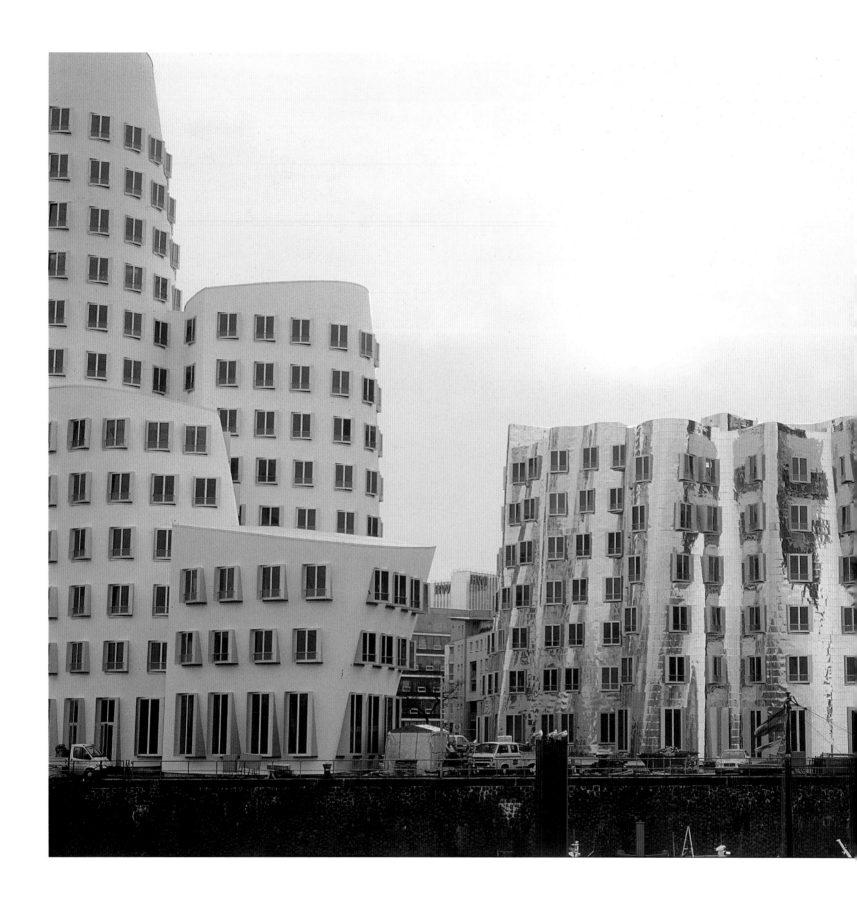

**Frank O. Gehry, Neuer Zollhof, Düsseldorf, Rheinhafen, view from the harbor side.** Building begun in September, 1996, completion date for blocks B and C December 1998, block A June 1999, photograph by David Artichouk, Arndt Archive. • At first sight it is as if one were standing in front of a huge monitor looking at a computer-generated simulation. Each of the buildings is given an individual touch by way of its skin: block C has a facade with chamois-colored rendering, block B, the central element of the ensemble, is in gleaming high-quality steel which reflects the two other clones of the group. Block A is seen by Gehry as referring to the harbor site; it is faced with brick like the walls of the quay.

everything is animated on screens and a good deal is invented by calculators, gives what is probably the most progressive description of his profession: "Today the architect is not so much a provider of form as someone who conducts, as it were, while forms come into being." In his office, the process is as follows: as soon as a site is offered to him for planning, he feeds into his computer a series of data which, in the orthodox way of doing things, are of only marginal importance: wind velocity at the site, traffic flow on a neighboring motorway, possibly also paths used by passersby on the site. Following this, he observes how the computer transforms these data into algorhythmic curves. He activates his animation software and allows these curves to unfold in the virtual space of the program. They interact there with the aim of providing suggestions for a possible design of the building in question. If the configuration looks interesting, Lynn "freezes" the screen, thereby holding fast to an image. The almost cabbalistic belief in the power of numbers allows the architect, as a formal conductor, to create, with the help of the computer's capability, genuinely "surprising" forms for the first time, with chance playing the most prominent part and human imagination, in contrast, lagging far behind it.

## Liquid building

This process of picking out individual sequences from a stream of fluid variations, that is to say, reducing design to a split-second decision, has been taken even further and transferred to the realized building by Marcos Novak of UCLA. To this end he uses interactive media as supplementary building materials, and tries to create a reactive, flexible ambience which will adapt to the occupants' wishes. Novak calls this idea, in highly poetic, utopian language "liquid building." It has become legendary as a result of newspaper reports about the bungalow of Microsoft chief Bill Gates, which cost millions, where the walls speak, colors change as you walk by and the visitor's favorite music begins to play. Screens that fill an entire room, and an army of sensors, ensure that the house "welcomes its occupants with open arms" and protects Gates from undesirable intruders.

## Fabrics

"Weaving was already a multi-media activity," says Sadie Plant in her wonderful book *Zeros and Ones*, which is about the marginal participation of women in the development of communicative tools. With just a few plausible arguments she demonstrates that the mechanical loom, on which a vast number of threads are interwoven in a complex mechanical process, can be regarded as the first image generator, and punched card-controlled weaving as an early example of digital image processing. She illustrates the idea with a reference to the fact that Jacquard, to prove the efficiency of his loom, had a self-portrait woven with a degree of resolution which was not to be surpassed in the following 50 years, not even by the medium of photography. In view of the later takeover of design by computers, it might be worthwhile investigating whether the art of design at the Bauhaus did not progress further in the weaving workshop, somewhat snobbishly dismissed as a female domain, than in the teaching of future architects in the college's building department.

## The cell

"In our researches we must never lose sight of the perfect human 'cell,' the cell which most perfectly accords with our physiological and emotional needs" (Le Corbusier). Today we are once again learning much from biology. At the beginning of our century many things became clearer for the first time through teratology, the study of malformations, and the concept of "emergence," i.e. the sudden appearance of new characteristics in gigantic groups of individuals (so-called mass intelligence). Today, one of the customary philosophical strategies is to remember nature's patterns or to look at them in the new light of complex technology. There is the questionable method of using this principle to explain global markets (cash flows, telecommunications, urban development) and to idealize processes that are actually economically controlled and geared to profit, as if they were organic developments similar to those of natural history, thereby confusing exploitation and evolution. But the tendency to "biologize" our economic arrangements does also produce some intelligent patterns for the determination of deviant developments

which from the very outset resist the rigid work rhythms of Taylor's principle of discipline at the workplace, and are in a position to under-mine traditional (power) structures, if not to abolish them.

The clock, and in particular its evil cousin, the time clock, represents a system of the anti-organic, destructive division of life. The image always associated with it is that of the all-penetrating beam. On the beam of time, life is available at will. Opposed to the clock is the principle of the cell as the ideal smallest unit, from which complexity develops through a process of reproduction, by branching off, splitting up and other tricks and strategems of nature. To think in modules means to be able to distinguish between two fundamentally different kinds of unit: on the one hand, the standardized, inorganic divisions superimposed on one another, whose serial sequences imitate the products of nature and even claim to surpass them in perfection, that is to say in uniformity, and on the other hand the basic bricks of life, particles that resemble themselves and are infinitely combinable.

## Artificial limbs

The technique of optimization in the exploitation of labor is called ergonomics and is regarded today as a field of research which chiefly gave us spine-friendly chairs and half-moon shaped cut-out working plates. They are based on two ideas, both closely connected with their time of origin: to regard the worker as a tool (as an effect of the imminent total mechanization of factory production), and to install even half-men as fully functional cogs in the machine (an effect of World War I). The cradle of ergonomics is to be found in field hospitals filled with the amputees of mechanized warfare. The integration of the mass of war-wounded into the normal process of production was the first great task of the new sciences of labor: to get a one-legged man to stand at a work bench, to enable a man without an arm to use a drill – the replacement of organs by crutches.

To think of the working man as a tool, to see his arms as pincers, his feet as rollers, means to recognize the practical usefulness of the body as a "simple, complicated machine." It means splitting him up into different abilities, ignoring the whole being. To increase his ability to stand, to minimize his emotional life with the aim of increasing the speed of his reactions, to test his physical extensions for their suitability for conveyor belt working: that was the task of ergonomics. The worker suddenly became a medium, not himself any more! It is said that the quality of a culture can be measured by the number of machines that it develops which produce other machines in their turn. This shows the analytical extent to which history is thought of as the history of technology, as the history of success through invention, as a victory of "second nature" over the first, natural nature. People can also be such machines. This notion as presented here is indebted to an anecdote about the relationship between the tool and its consequence: Albert Einstein, in all of his known photos, forms a strange scissor shape with his writing hand, whereby the pointer finger and thumb are separated by only a few centimeters. This is the hand that guides the chalk over the chalkboard; it is the least distance of separation.

## Cut/CAD

From the work of the biologist Gregory Bateson, who worked for a long time on deformed hands, we know that loss of information goes along with increased symmetry. The hand is the most exciting interface between inner and outer in the anthropological development of man and his cultural history. Language and writing are inseparably bound up with the evolution from a four-legged animal to a two-legged animal. Briefly: theoreticians such as André Leroi-Gourhan suppose that it was only when teeth were set free from the task of tearing food into pieces, once the hands became free for this activity (as a consequence of walking upright), that the emergence of communication by means of differentiated codes (language) became possible. Man forfeited the stability of standing on his four extremities and to counter the potential of staggering permanently on two legs, he was given the opportunity of developing complicated forms of transport. He installed a modular principle which provided a higher density of communicable information: language consists of words, syllables, phonemes, a variable combination system with fixed smallest parts, viz. letters, in the printer's type-setting box. Bateson's conclusions concerning structure in nature, derived from the investigation of mutated insects' feet and from the study of deformed human hands, tell us that information prevents symmetry. The breach of symmetry produces an increase in information in an open, flexible, dynamic system. A similar gain-loss balance can be drawn up for the control of complex processes. Today, when computers are connected in parallel in order to overcome certain problems of speed arising from the physical limits of storage space and even of the processors themselves, then the desired higher effectiveness is obtained, but with a loss of ability to influence proceedings. Fish, birds and other creatures that live in flocks or shoals are well aware of this phenomenon. "More is different," contemporary systems philosophy tells us. New, unexpected characteristics appear (emerge), qualities possessed only by the group and not to be found in the individual creature, if it could be isolated from the group and dissected. The analytical approach, the attempt to explain the workings of the entire apparatus in terms of the individual cog, misses the true qualities of the super-organism.

As we know from the endless reproductions of the little Mandelbaum men, which by now have degenerated into the wallpaper of the digital era, uniformity and order exist in patterns which appear to us to be incomprehensibly chaotic. A few years ago researchers investigated a wild, craggy coastline in various scales, and discovered a quasi-geometry, an identity of pattern in descending sizes, from the super-form, i.e. stretches of several kilometers along the line between land and sea, to the shape of an individual bay. Today, computer programs make use of such structures in the organic sphere in order to support the creative process, the design of forms. Like living beings, that is how computer-generated programs should evolve. The designer as author recedes completely into the background, is merely involved in selecting and running a suitable program for his design, the machine and its software. The technical term for this technique is CAD (computer aided design). Even in the

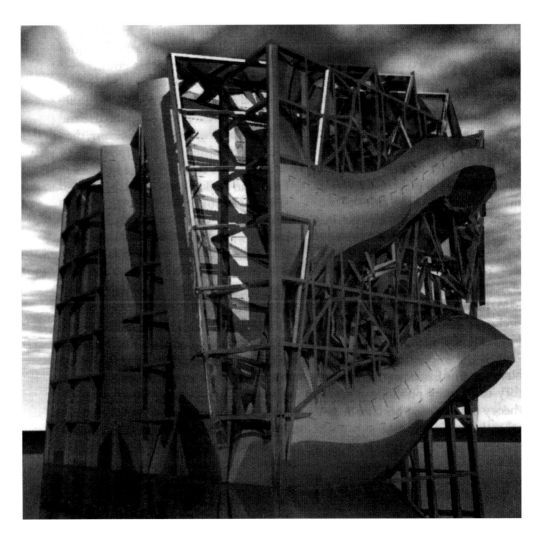

**Marcos Novak, Animation of so-called "liquid architecture."** Illustration from *Lingua Franca. The Review of Academic Life*, 1998. • The future of housing is no longer fixed. For many contemporary architectural pioneers the distinction between real and virtual space, between houses that are thought up and houses that are built, has become blurred. Exploding forms and wildly flickering data fantasies are not the only reason why many of these projects only exist in the world behind the screen: "the unreality of our cities."

studio, the disappearance of matter is striking. The CAD user lives in Lynn's paperless office. Here there is no longer any snipping, only cloning. The guru of CAD, Bill Mitchell, who in the mid-'80s was a total cyber enthusiast who set up a digital workplace for every student of design at Harvard, has now likewise found a new home at MIT.

Such aesthetic experiments with only a slight material substratum and slight user-control are widely known as "Morphing." It has an omnipresent application as an enjoyable video game featuring interchangeable faces – man melts into woman and becomes a virtual mixed being; a dog unites its facial features with those of a politician, and everybody laughs. Even the police use software to create phantom images. Digital post-editing of images increasingly governs the special effects business: pictorial elements are extracted from the film, "painted" and reinserted. They then have a life of their own, fused with the authentic image. Entire sequences with actors who

have died in the meantime are produced by computer. The animal world is also affected. The swarm of bats in *Batman's Return* is entirely animated. The programmer, the "image-maker" Craig Reynolds, has strictly limited the characteristics of his computer mice and has thereby imbued them with a powerful collective intelligence. Each one by himself can only carry out three crude commands, but these are compulsorily and successfully linked: "All advance!" "All stay together!" and "Avoid obstacles!" Nature has thus been simulated with deceptive realism by breaking down complex events into manageable units.

Today more and more artists, and other interdisciplinary nomads, work on their high-speed laptops with these new prosthetic tools. On some days they gather in the south of Germany. Along with the (historical) Bauhaus and the (still highly contemporary) MIT, there is now also the big, powerful laboratory in Karlsruhe, the ZKM (Zentrum für Kunst und Medientechnologie/Center for

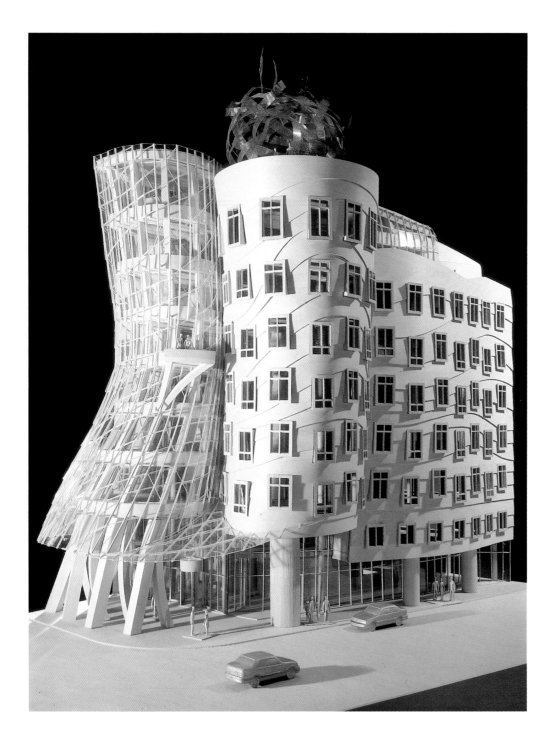

**Frank O. Gehry, Model of a Prague apartment block.** 1995, illustration from *Arch +*, No. 128, 9/1995, designed with Catia software on IBM Risc 6000. • The irruption of the parallel world into everyday life. This model, which was cut with a CAD-controlled cutter, shows a block which has now been built in Prague. A building which fits in with its neighbors in the street as the Golem fitted in with humans, as if it were an act of homage to the writer Gustav Meyrink. Here too one is struck by the perfect transposition of the screen effect into hyper-dimensions.

Art and Media Technology), which even before it was built was described as a "digital Bauhaus." The only thing that is certain after one's first visits is that Baden is a virtual Thuringia, and one can also detect an element of Weimar conservatism. The ZKM multimedia lab is equipped with a number of silicon graphics machines and many even better things. Thanks to support from the wealthy federal region and a number of industrial interests a place has been created here for the horizontal integration of research and aesthetics.

### Thinking in fields

Today, anyone who experiments with digital "artificial limbs" thinks in fields, not in spatially determined forms. If standardization is re-garded as the ancestor of animation, this is only the case inasmuch as numbers feature in both. However, the inherent potential of standardized small parts that can be combined in many ways stands in the same relationship to the proliferation of root-like buds, the non-hierarchical space of digital rhizomes, as cave painting stands to photography. The total stripping bare of all

decoration, the pragmatic beauty of the module in serial manufacture – this is the other side of a development which at the end of our century, again with the help of machines but now using the twisting paths of artificial intelligence, is attempting to conquer the domain of true beauty, and to dispute in the most lively way its exclusive claim to the highest artistic form.

**Photo study for a title page.** 1930, photograph by Grit Kallin-Fischer, BHAS. • "Archetypal" writing materials: the study with pencil and ruler on millimeter squared paper was not used as a title page either for the periodical *Gebrauchsgraphik* or the *Typografische Mitteilungen*.

# Documentation

# Bauhaus Chronology

Ulrich Giersch

## WEIMAR

### 1860

Grand Duke Carl Alexander founds an art school in Weimar (from 1910 an art college). Teachers include Böcklin, Begas and Lenbach.

In the 1880s realistic outdoor painting develops here, with the emphasis on landscape painting. The "Weimar School of Painters" has a place in the history of art.

### 1902

Through the good offices of Count Harry Kessler and Elisabeth Förster-Nietzsche, the leading minds of a small group of reformers whose aim is to renew art and culture, Henry van de Velde is brought to Weimar and commissioned by Grand Duke Wilhelm Ernst to establish an artistic consultancy for arts and crafts in the form of an

applied arts seminar, with the aim of improving taste and stylistic awareness among local manufacturing companies, and so make light industry in Thuringia able to compete with international mass production. In particular, modern product design would strengthen the regional economy.

Between 1904 and 1911 a new building for the Kunsthochschule (Art College) is erected in two sections, according to plans by van de Velde. (From 1919–1925 it is used as a studio and administrative building of the State Bauhaus. From 1921 the west wing serves as a studio building for the Staatliche Hochschule für bildende Kunst [School of Fine Art] which at this point has separated from the Bauhaus.)

Between 1905 and 1906, also to plans by van de Velde, the facing building of the Kunstgewerbeschule (School of Applied Arts) is built, with the sculptors' studio of the Kunsthochschule. (From 1919 it serves as a workshop building of the State Bauhaus.)

In May the first international exhibition of modern decorative art opens in Turin. Exhibits from the most important exponents of European modernism include work by Henry van de Velde.

In the USA, F.W. Taylor develops a method of rationalization known as "scientific management": an attempt to increase productivity and efficiency by means of time and motion studies.

### 1903

In March Count Harry Kessler becomes honorary director of the Museum für Kunst und Kunstgewerbe (Museum of Art and Applied Arts) in Weimar. His desire is to establish an international center of modern art here.

The "Rodin scandal" instigated by conservative groups brings his appointment to an end as early as 1906.

In May the Wiener Werkstätte (Vienna Workshop) is established by Koloman Moser, Josef Hoffmann and Fritz Waerndorfer, a production cooperative of craftsmen who dissociate themselves from mass production and the commercialism of the Sezession style. Their functional, geometrical style is influenced by the Arts and Crafts Movement of the Scotsman Charles Rennie Mackintosh.

On December 15 the inaugural meeting of the Allgemeine Deutsche Künstlerbund (General Union of German Artists) takes place in Weimar; the reactionary cultural policies of the German Empire led modern artists and their advocates to join forces.

### 1905

On June 7, the students Erich Heckel, Ernst Ludwig Kirchner, Karl Schmitt-Rotluff and Fritz Bleyl set up Die Brücke, the Expressionist league of artists, in Leipzig.

### 1907

In the newly established Großherzoglich-Sächsische Kunstgewerbeschule (Grand Duke of Saxony School of Applied Arts), van de Velde gives a prominent position in training to workshop teaching that is geared to

practice. Gradually, workshops for bookbinding, ceramics and enamel painting, metalwork and engraving, weaving, embroidery and macramé, as well as goldwork, are built up.

On October 6, the German Werkbund (Work Union) is established in Munich, bringing together artists, craftsmen and workers in industry to improve the quality of applied artwork.

The era of plastics begins with the production of bakelite. The new material replaces traditional materials in many fields. Cubism is founded by Pablo Picasso and Georges Braque, who take as their starting point Cézanne's reduction of reality to a few basic geometric forms.

### 1908

Adolf Loos publishes his essay "Ornament und Verbrechen" (Ornamentation and Crime) as a manifesto against the sham architecture of historicism. For the sake of honest building he demands that there should be no decoration of façades.

### 1909

On February 20, the Italian writer Filippo Tommaso Marinetti publishes his Futurist Manifesto in a Paris daily paper.

The AEG turbine assembly hall in Berlin is completed: using glass and steel, Peter Behrens – AEG's

artistic consultant from 1907 – develops a functional factory building. In Behrens's office, between 1908 and 1910, the young Walter Gropius becomes familiar with the entire spectrum of modern design for industrial manufacture. On December 1, the first exhibition of the Neue Künstlervereinigung (New Association of Artists) founded by Wassily Kandinsky and Alexej Jawlensky opens at the Thannhäuser Gallery in Munich.

### 1910

At the Brussels international exhibition, applied artwork production from Germany is widely acknowledged, partly as a result of van de Velde's influence. Herwarth Walden establishes the avant-garde magazine *Der Sturm*.

### 1911

Together with Franz Marc, Wassily Kandinsky establishes the Blaue Reiter (Blue Rider) association of artists in Munich. Unlike the Neue Künstlervereinigung, they now demand complete abstraction instead of representational art.

### 1912

Herwarth Walden establishes the Sturm gallery and, starting from this year, organizes the Sturm art exhibitions.

### 1914

More and more frequently exposed to nationalistic hostility, the Belgian van de Velde gives notice, even before the outbreak of World War I, to

---

**Edvard Munch, Count Harry Kessler.** 1906, oil on canvas, 200 x 84 cm, SMBPK, Nationalgalerie. • **Josef Hoffmann, Palais Stoclet.** Brussels, 1905–1911, Bildarchiv Foto Marburg. • **Carlo Mense, Front cover of the magazine "Der Sturm."** No. 5, Vol. 5, 1914, linocut, 19.1 x 24 cm.

leave his post as director of the Kunstgewerbeschule, which is closed down in 1915. (He is not able to leave Germany until 1917.) Van de Velde recommends Walter Gropius, Hermann Obrist and August Endell to the ministry as candidates to succeed him in the post. Gropius visits Weimar in December for personal talks and is granted an audience with the Grand Duke.

On June 28, the Austro-Hungarian heir to the throne Franz Ferdinand is assassinated at Sarajevo. In the German Empire mobilization is announced on August 1; World War I begins.

**1915**

Constructivism in Russia develops out of Cubism and Futurism. Suprematism is founded by Kazimir Malevich. Both influence work at the Bauhaus.

**1916**

In February Hugo Ball opens the Cabaret Voltaire in Zürich, the point of origin for the Europe-wide spread of Dadaism.

**1917**

In June the first number of the periodical *De Stijl* appears in Amsterdam, and at the same time the first number of *Dada* appears in Zürich. On October 1, Theo

van Doesburg and Piet Mondrian establish the Dutch association of artists, De Stijl.
Gerrit Rietveld constructs the "red-blue-chair," a model for the famous slatted chair developed by Marcel Breuer at the Bauhaus from 1922. The Sturm theater group is founded by Herwarth Walden, with Lothar Schreyer.
On November 7, the October Revolution begins in Petrograd (St Petersburg).

**1918**

The first Dada evening in Berlin is staged in the I.B. Neumann Gallery on February 18.
The first De Stijl manifesto is published in November. In the same month, following the example of the workers' and soldiers' councils that were set up in the revolutionary period, the Working Council for Art is created by artists and intellectuals with the aim of creating a new culture. On December 3, artists of a revolutionary cast of mind set up the November Group in Berlin. Most of them are Expressionists; they include Max Pechstein and Erich Mendelsohn. The Armistice is declared on November 5. On November 8, the November Revolution in Germany spreads to the imperial capital. On November 9, the Republic is proclaimed in Berlin: Emperor Wilhelm II abdicates.

**THE WEIMAR BAUHAUS**

**1919**

The new training institution is officially founded on April 1 by Walter Gropius, who has been invited to Thuringia as its director. Its full name is the Staatliches Bauhaus in Weimar – Vereinigte ehemalige Großherzogliche Hochschule für bildende Kunst und ehemalige Großherzogliche Kunstgewerbeschule (State Bauhaus in Weimar – Union of the former

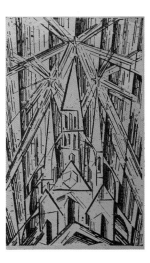

Grand Ducal School of Fine Art and the former Grand Ducal School of Applied Arts). Gropius publishes the Bauhaus manifesto and program as a four-page leaflet with Lyonel Feininger's cathedral woodcut on the front cover. The leaflet contains the programmatic statements: "The ultimate goal of all artistic activity is building!" and "Architects, sculptors, painters, we must all return to craft! ... The artist is a higher form of craftsman."
Gropius transfers his building office to Weimar (his colleagues are Adolf Meyer, Carl Fieger and Ernst Neumann among others). Lyonel Feininger is appointed as head of the graphic printing workshop; at about the same time Gerhard Marcks takes up his post as artistic head of a ceramics workshop that is to be established.
The art teacher Johannes Itten is appointed to teach painting; he is put in charge of the preliminary course and also, from 1920, a number of workshops. The teaching staff also includes four teachers from the old Kunsthochschule. Along with teaching by the masters, workshops exist for bookbinding, weaving and art printing.

By late 1919, the Bauhaus is already faced with hostility from right-wing circles. This conflict is waged at political meetings, in the press and the Thuringian regional parliament. Since the Bauhaus is a *Land* (i.e. state) institution and hence dependent on parliamentary approval for its funding, its existence is made precarious from the outset by bickering of this kind and by changing political majorities. Gropius receives support from friends in the circle of the Werkbund, the Working Council for Art, and the November Group.
In the winter semester of 1919–1920 the college has 101 female and 106 male students, the highest number of any college in Weimar.

The Berlin Working Council for Art demands that artistic training should be made independent from state influence, that it should be geared to society, and that art should be reformed by way of craft. The working council is initially led by Bruno Taut, later by Walter Gropius.
In Paris, the avant-garde magazine *L'esprit nouveau* is founded by Le Corbusier and Amédée Ozenfant. André Breton gathers around him comrades-in-arms for Surrealism.
In September the first Waldorf school is opened by the anthroposophist Rudolf Steiner in Stuttgart. The inclusion of artistic/creative and practical/craft subjects in the curriculum is characteristic of this type of school.
In Berlin the classic Expressionist film *The Cabinet of Dr Caligari* is made by Robert Wiene. Members of the Berlin group of artists Der Sturm are involved in the film's production.
Because of the volatile situation in the imperial capital of Berlin, the national assembly meets in

the Weimar Court Theater (later the German national theater) until the summer. On February 11, the Social Democrat Friedrich Ebert is elected President. The newly elected parliament grapples with the Weimar constitution. On February 18, the Staatenausschuß (representatives of the regions) decides to adopt black, red and gold as the colors of the Weimar Republic.
On January 15, radical right-wing militiamen murder the Socialists Rosa Luxemburg and Karl Liebknecht.
The Paris peace conference opens on January 18.
In early April the Bavarian Räterepublik (socialist republic) is proclaimed in Munich and bloodily suppressed by paramilitary groups a month later.
On June 28, the Peace Treaty of Versailles is signed. It assigns the sole blame for the war to Germany and its allies and declares them responsible for all war damage (reparations demands.)

**1920**

The painter Georg Muche is appointed as master of wood carving and book binding. Like other masters at the Weimar Bauhaus he comes from the Sturm Gallery circle and has been head of the Sturm School. Workshops are also developed for copper and silver work (later the metal workshop), wood and stone sculpture, decorative painting

(then wall painitng), joinery and pottery (in Dornburg/Saale). During this period, training at the Bauhaus is comparable to a craft apprenticeship leading to examination by the Handwerkskammer (Chamber of Crafts). Starting in the winter semester, in line with the concept of combining arts and crafts, each workshop is led by a craftsman (the work master) and an artist (the form master). Feininger takes charge of the printing workshop, Marcks the pottery; all other workshops are led, to begin with, by Itten and Muche.

A compulsory probationary semester under Itten develops into the preliminary course. In this artistic preparatory course, all the basic elements of creativity and design are dealt with: materials, their formal and representational potential, and construction. Itten teaches the preliminary course, which has a lasting influence on the development Bauhaus teaching, until spring 1923. Muche takes over the course that summer. The first series of Bauhaus soirées begins in April. During the winter semester of 1920–1921 the school has 143 students enrolled, 81 of them are male and 62 female.

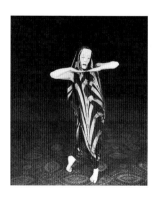

Mary Wigman sets up a school for the new artistic dancing in Dresden.

The Expressionist Einstein Tower is built by Erich Mendelsohn on the Telegrafenberg near Potsdam. In the Soviet Union the WchUTEMAs are established (acronym for "artistic-technological studios," from 1927 "colleges"). Malevich, Kandinsky, Rodzhenko, Tatlin and El Lissitzky work there, among others.

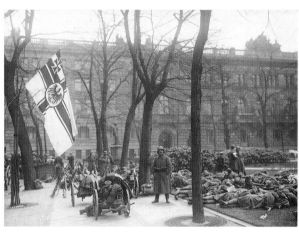

On March 13, the Kapp-Lüttwitz putsch against the German government is carried out by right-wing militants. The coup d'état collapses after a few days when the trade unions call a general strike. In Weimar soldiers are brought in to disperse demonstrators by force. The victims are eight dead and 35 injured, some of them severely.

On March 18, the "March dead" are buried, some Bauhaus members attend the funeral. Gropius, faithful to his maxim of keeping the Bauhaus out of politics, does not join the demonstration.

A general election on June 6 produces the first elected parliament of the Weimar Republic in which, due to substantial gains by the right-wing parties, the democratic center-left coalition no longer has a majority.

## 1921

Paul Klee and Oskar Schlemmer are appointed at the beginning of the year; in the fall Lothar Schreyer becomes the

head of a newly established theater department. Workshop heads are reassigned: Gropius takes over joinery, Schlemmer stone sculpture, Muche wood sculpture and weaving; Paul Klee becomes form designer for the book binding workshop. Gropius's building studio, in collaboration with the Bauhaus workshops, designs and builds the Expressionist log house for the businessman Adolf Sommerfeld in Berlin-Dahlem.

The more traditionally oriented Kunsthochschule, which broke away from the Bauhaus in October of 1920, opens as an independent college in April.

In summer Itten attends the Mazdaznan congress in Leipzig, and subsequently brings the mystical doctrine to Weimar. Through him and Muche, Mazdaznan acquires an influence on some of the students; the Bauhaus canteen serves vegetarian food. This quasi-religious indoctrination adds to internal tensions at the Bauhaus.

Theo van Doesburg, the leading member of the De Stijl group of Dutch artists, stays in Weimar between April 1921 and November 1922. He opposes the expressionistic style and the craft orientation of the Bauhaus and campaigns for his own concept of constructivist

design geared to modern technology.

In October the Bauhaus masters decide to publish the "Bauhaus prints. New European Graphics, published by the State Bauhaus in Weimar." In November/December artists from the Bauhaus exhibit at the Sturm Gallery in Berlin.

During the winter semester of 1921–1922 the school has 108 students, 44 female and 64 male.

## 1922

From the beginning of the year Gropius introduces a process of rethinking and restructuring at the Bauhaus. Gearing work to industrial production leads to fundamental disagreement with Itten, who is committed to free artistic expression as an educational principle. Itten resigns as head of the metal and joinery workshops, but remains in charge of wood sculpture and the preliminary course until the end of the semester.

On May 1, the memorial for the victims of the Kapp putsch, designed by Gropius, is unveiled at the main cemetery in Weimar. Wassily Kandinsky is appointed and succeeds Schlemmer as head of the wall painting workshop. Pottery and weaving are the only workshops which are able to make more than a negligible contribution to the school's finances from the sale of their products.

A Bauhaus housing development association is established and draws up plans for a housing development comprising various types of houses for teachers, students and friends of the Bauhaus and, later, a school building. Because of the difficult financial situation, however, it is only possible to build

a single model house for the 1923 Bauhaus exhibition.

In October Klee takes charge of the glass painting workshop. In the winter semester of 1922–1923 the school has 119 students enrolled, 48 female and 71 male.

From May 29 through 31, the International Congress of Progressive Artists is held in Düsseldorf. The international Constructivist faction breaks away on May 30 and decides to meet again that fall in Weimar. On September 20, the *Triadic Ballet* by Burger/Hötzl/Schlemmer is given its first performance in Stuttgart.

At the end of September, Theo van Doesburg organizes a Constructivist and Dadaist congress in Weimar. Those taking part include László Moholy-Nagy, Kurt Schwitters, Tristan Tzara, Hans Arp, Hans Richter and students from the Bauhaus. A competition is announced for the Chicago Tribune building; more than 30 German plans are submitted.

Wilhelm Köhler, the director of art collections in Weimar, sets aside rooms in the Schloßmuseum for works by some of the Bauhaus masters.

The Treaty of Rapallo between Germany and the Soviet Union, signed on April 16, regulates the consequences of the war and enables normal political relations

to be established between the two countries.

On June 24, the German foreign minister Walther Rathenau is murdered. It is one of numerous political murders in the early years of the Republic.

From August, inflation of the German currency increases. In September Friedrich Ebert declares *Deutschland über alles* to be Germany's national anthem.

The Union of Soviet Socialist Republics (USSR) is established on December 30.

### 1923

When Itten leaves the Bauhaus in March, the Constructivist

László Moholy-Nagy is appointed as head of the metal workshop in Weimar, and from the fall also teaches the preliminary course. Following Schreyer's departure, Schlemmer takes charge of the stage workshop and also succeeds Itten as head of stone and wood sculpture.

The Bauhaus participates for the first time in the Leipzig fall trade fair, with woven goods, ceramics and metalwork.

The Bauhaus exhibition in Weimar from August 15 to September 30 serves as the first major report for the regional government, necessary for obtaining continuing financial support. Exhibits from

teaching, from the workshops and free works of art by the masters are on show, along with an exhibition of international architecture.

Wall designs are created by Herbert Bayer and Joost Schmidt for the main building of the Bauhaus, and by Oskar Schlemmer for the workshop building. Using designs by Gropius, the director's room is furnished and decorated by the Bauhaus joinery, weaving, wall painting and metal workshops.

The building of the model House on the Horn (to plans by Georg Muche) is carried out as a joint assignment with the Bauhaus workshops in an effort to achieve a "total artwork."

In August the "Bauhaus week" takes place, with stage events, recitals and lectures. The exhibition attracts national and international attention to the school.

The main area of work is now design techniques geared to industry and mechanized methods of manufacture. With the slogan "Art and technology – a new unity," Gropius formulates a new, definitive concept for the Bauhaus. The fall sees the publication of *Staatliches Bauhaus Weimar 1919–1923*.

From the winter semester the

preliminary course comprises two semesters: craft work with Josef Albers, Moholy-Nagy's course on "material and space" and courses in form and color with Paul Klee and Wassily Kandinsky.

On November 23, Gropius's house is searched by the army following anonymous political accusations. During the winter semester of 1923–1924 there are 114 students enrolled at the school, 41 female, 73 male.

Arnold Schoenberg composes *Five Piano Pieces* (Op. 13) using the 12-note technique developed by him. Kandinsky suggests appointing Schoenberg as the director of the music school in Weimar. Le Corbusier publishes his programmatic essay "Vers une Architecture," (Toward an Architecture) which is published in Germany in 1926 under the title of "Kommende Baukunst."

At the Great Berlin Art Exhibition, El Lissitzky presents his "Prounen room."

Henry Ford's autobiography, *My Life and Work*, is published, in which he campaigns for new working methods. His ideas on conveyor belt manufacture and mass production are energetically accepted both in industry and in the world of culture.

In January the Ruhr region is occupied by French and Belgian

troops, ostensibly in order to ensure the payment of reparations.

A grand coalition government is formed under Stresemann, comprising SPD (social democrat), Center Party, Democrat and People's Party politicians.

In September-October inflation in Germany reaches its highest point. In November, the leader of the NSDAP, Adolf Hitler, along with others of his persuasion, attempts a coup d'état in Munich, which, however, fails.

### 1924

Elections to the Thuringian regional parliament in February result in a bourgeois-conservative government. In September the contracts of the Bauhaus masters are terminated "as a precautionary measure" with effect from March 31, 1925. Both the financial situation and political hostility make any further cooperation impossible. On December 26, the masters therefore announce the closure of the Bauhaus with effect from April 1, 1925.

The Association of Friends of the Bauhaus is established in October to support the school. Members include, among others, Peter Behrens, Marc Chagall, Albert Einstein, Gerhard Hauptmann and Arnold Schoenberg. In November the

Bauhaus production works are converted to a limited liability company.

Work from the Bauhaus joinery, metalwork and pottery workshops is put on display at the Werkbund exhibition "Die Form" in Stuttgart.

In Utrecht the Schröder house, built by Gerrit Rietveld in accordance with De Stijl design principles, is completed.

André Breton publishes the Surrealist Manifesto in Paris.

At the general election in May, the bourgeois parties and the SPD suffer losses while there are gains for the radical parties. Further elections in December bring gains for the SPD and losses for both the (Nazi) NSDAP and the (Communist) KPD.

In Germany a period of economic boom and relative stability begins, which lasts until the global economic crisis of 1929.

### 1926

After April 1, 1926, teaching continues in Weimar under the "Staatliche Hochschule für Handwerk und Baukunst" (State College for Craftwork and Building) with the architect Otto Bartning in charge. Former Bauhaus students, among them Ernst Neufert, Wilhelm Wagenfeld, Otto Lindig and Erich Dieckmann, stay on as teachers at the successor institute. Here there is now also proper architectural training. Products developed for industry, in particular the "type furniture" program, are marketed by a new distribution organization. In 1930, Paul Schultze-Naumburg is appointed by the national socialist minister Wilhelm Frick to be the new director of the successor institute, the "Staatliche Hochschule für

**Oskar Schlemmer, diagram of figures for the "Triadic Ballet."** 1927, sheet 2 from the director's copy for Hermann Scherchen, pencil and watercolor on diagram of figures printed on squared writing paper, collaged, 30.0 x 21.0 cm, Bühnen Archiv Oskar Schlemmer. • **Walther Rathenau.** Photographer unknown, SVT Bild/Das Fotoarchiv. • **Gunta Stölzl, jacquard hanging "5 Choirs."** 1928, jacquard, cotton, wool, silk, 143.0 x 229.9 cm, Museum für Kunst und Kulturgeschichte der Hansestadt Lübeck.

Baukunst, Bildende Künste und Handwerk" (State College for Building, Fine Art and Craftwork).

## BAUHAUS DESSAU

### 1925

At the beginning of the year negotiations regarding the continued existence of the school are conducted with various municipalities, including Frankfurt am Main and Dessau. In March the Dessau town council, at the prompting of the mayor, Fritz Hesse, decides to take over the Bauhaus.

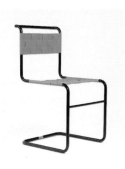

In April, teaching begins at the Dessau Bauhaus. Except for Marcks, all the form masters move to Dessau. Former students take over the workshops as "young masters"; Herbert Bayer takes charge of the typography/advertising workshop (formerly the printing workshop), Marcel Breuer takes over joinery. The metal, weaving, wall painting and general sculpture workshops, and the theater group, continue to exist. The pottery, glass painting, wood and stone sculpture workshops are not reestablished in Dessau.

In his new program Gropius emphasizes the importance of industry and science for design. He declares the central task to be the development of suitable housing for the age, to include everything "from simple utensils to a complete

dwelling." The workshops are described as "laboratories" for the production of models for industry. From this year tubular steel furniture is produced, followed two years later by the legendary "Freischwinger" (cantilever chairs) of Marcel Breuer, Mart Stam and Mies van der Rohe.

From June the series of "Bauhaus books" begins to appear, edited by Walter Gropius and designed by László Moholy-Nagy. Authors include Klee, Kandinsky, Malevich, J. J. P. Oud and Mondrian. For the typographical image of the school, it is decided to use lower-case letters only and to adopt DIN norms for all printed matter from October.

In Dessau a citizens' association is formed to combat the Bauhaus.

In November the Bauhaus is established as a limited liability company for the commercial exploitation of its products. During the winter semester of 1925–1926, only 63 students are enrolled.

In Paris the "Exposition Internationale des Arts Décoratifs et Industriels Modernes" turns into a demonstration of a new style, called Art Déco. Le Corbusier builds the Pavillon de l'Esprit Nouveau in stereometrical forms. The Neue Sachlichkeit (New Functionalism) traveling exhibition opens in Mannheim. With it, Gustav F. Hartlaub coins the concept of a new style of 1920s painting.

In November the first Surrealist group exhibition is shown at the Pierre Gallery in Paris. Sergei M. Eisenstein's film *Battleship Potemkin* has its first showing in Moscow on December 21.

In Germany the first government to include German nationalists is established.

General Field Marshall Paul von Hindenburg is elected President of Germany on April 26.

### 1926

In March the topping-out ceremony of the Bauhaus building takes place. In October its status as a college is recognized by the regional government, its masters are appointed as professors. From now on the Bauhaus is officially known as a "design school (university)."

On December 4, the new Bauhaus is opened in the presence of over 1,000 guests from all over the world.

From now on, training is comparable to a course of academic study. The Bauhaus diploma is awarded on completion. During this period the international reputation of the Bauhaus is consolidated

by its spectacular new buildings: the school building, the masters' houses and the Dessau/Törten housing development.

The first number of the magazine *bauhaus* is published; it continues to appear quarterly until 1929 and again in 1931.

Establishment of the architects' association "Der Ring." Its members include Hugo Häring, Max and Bruno Taut, Mies van der Rohe and Gropius.

### 1927

In April an architecture department is opened with the Swiss architect Hannes Meyer as its head. In addition, the free painting classes of Klee and Kandinsky are set up, so that for the first time purely artistic training is possible. In July, Muche leaves the college as a result of quarrels with the Bauhaus weavers. Thereupon, despite resistance from some of the teaching staff, Gunta Stölzl takes over as head of the weaving workshop. She remains the only female master.

On July 10, Fritz Lang's film *Metropolis* has its first showing in Berlin.

The Weißenhof housing development is built in connection with the Werkbund exhibition "Die Wohnung" (Living) in Stuttgart. Led by Mies van der Rohe, the architects Peter Behrens, Le Corbusier, J. J. P. Oud, Hans Scharoun and Walter Gropius, among others, are involved.

### 1928

Gropius resigns as director with effect from April 1, in order, among other things, to concentrate on his activities in his own building office in Berlin. Bayer, Breuer and Moholy-Nagy go with him.

At Gropius's suggestion, Hannes Meyer becomes the new director. His concept of design is of a scientific procedure, geared to rational requirements. Meyer criticizes the previous work of the Bauhaus as formalistic, and demands as its social basis "the needs of the people instead of the needs of luxury." For the first time Bauhaus designs (for metal lamps) are sold to industry for serial production. The weaving workshop subsequently also produces designs for fabrics to be sold by

the meter. Other workshops go along with this new production policy.

There are 166 students enrolled at the college.

In Budapest the so-called Budapest Bauhaus is opened by Sándor Bortnyik as a private institute under the name of "Mühely." Farkas Molnár is one of the school's teachers.

CIAM (international congress for new building) is founded in La Sarraz (Switzerland). Those involved include Le Corbusier and Hannes Meyer.

The international "Pressa" press exhibition takes place from May to October in Cologne. El Lissitzky designs the Soviet pavilion. On August 31, Brecht's *Threepenny Opera* is given its first performance in Berlin.

### 1929

In April the "Bauhaus traveling show" opens in the Museum of Applied Arts in Basel and is subsequently to be seen in Breslau, Mannheim and Zürich. The exhibition offers a representative survey of work at the Bauhaus under Hannes Meyer. In May the topping-out ceremony of the central trade union (ADGB) college takes place in Bernau near Berlin. All the workshops are involved in this, the most important building project during Hannes Meyer's period as director.

**Mart Stam, Chair.** 1926, TECTA Stuhlmuseum, Burg Beverungen. • **Herbert Bayer, Front cover of the magazime "bauhaus."** No. 1/1928, BHA. • **Fritz Lang during the making of the film "Dr. Mabuse der Spieler."** 1922, photographer unknown, SVT Bild/Das Fotoarchiv.

In July, with Alfred Arndt in charge, the metal, joinery and wall painting workshops are amalgamated to form the "building workshop." The primacy of the building department is thereby made clear. Schlemmer leaves Dessau in November, whereupon the theater group is closed down. When the photographer Walter Peterhans is appointed, a photography workshop is set up for the first time. The architect and town planner Ludwig Hilberseimer is appointed to the building department. The college numbers 170 students, 51 female and 119 male.

In summer the exhibition "Film and Photo" opens in Stuttgart, the most important photographic exhibition of the 1920s. The photographic department of the Bauhaus is represented by 90 exhibits.
This is followed in September by the exhibition of German arts and crafts in the Grassi Museum in Leipzig. One of three modern museum rooms is designed and arranged by the Bauhaus.
The 2nd CIAM congress takes place in Frankfurt. Its subject: housing for those with minimal

steel, green glass and yellow onyx. The Bauhaus workshops are also represented at the exhibition.
On October 25, "Black Friday," the New York stock exchange collapses; the world economic crisis begins.

**1930**
At the beginning of the year Bauhaus wallpaper goes on sale, and is an extraordinary commercial success.
The social ambitions of the syllabus under Hannes Meyer do not fail to influence the students. When some students turn unequivocally to communism and spread its slogans at the Bauhaus itself, Meyer is dismissed by the Dessau municipal government. Meyer goes to Moscow with 12 students.
Gropius mediates once again. As a result, the architect Ludwig Mies van der Rohe is appointed as director in April and takes up his post in the fall. Under Mies, training is organized in five departments: planning and building, advertising, weaving, photography and visual arts.
In addition to concentrating on school-style teaching and shortening the training course

are given prominence, while industrial design work becomes less important.
By remaining neutral, Mies initially succeeds in keeping the school out of the increasingly acrimonious political debates.

In the spring the exhibition of the Société des Artistes Décorateurs Français takes place in Paris. The German section is designed jointly by Gropius and Herbert Bayer, Marcel Breuer and László Moholy-Nagy. Typical interior décor,

lamps and furniture are exhibited. Moholy-Nagy presents his "light-space-modulator." On January 23, the national socialist Wilhelm Frick becomes regional minister of education in Thuringia; he is the first NSDAP minister in a regional government. In October his specialist advisor Paul Schultze-Naumburg has modern painting removed from the Schloßmuseum in Weimar, including pictures by Kandinsky, Klee, Feininger and Schlemmer. In October, as director of the State College for Building, Fine Arts and Craftwork, he orders the wall designs for the 1923 Bauhaus exhibition in the school building to be destroyed.

**1931**
In January and February the first Bauhaus exhibition in the New World takes place, in the John Becker Gallery, New York. Klee accepts an appointment at the Academy in Düsseldorf, in October Gunta Stölzl also leaves the Bauhaus.
At the local elections in Dessau the NSDAP emerges as the

strongest party, having called during the election campaign for subsidies to be withdrawn and the Bauhaus demolished.

**BAUHAUS BERLIN**

**1932**
At the beginning of the year the interior designer and longstanding partner of Mies van der Rohe, Lilly Reich, joins the Bauhaus as head of the building department.
Political conflicts at the school increase. Following a motion by the NSDAP the Dessau town council decides to close the school down with effect from 1 October. Mies wants to continue the school as a private institution in Berlin. License fees, among other things, make this appear a possibility.
In October a vacant telephone factory in Berlin-Steglitz is rented. During the summer semester there are 168 students in Dessau; during the winter semester there are 114 students at the Berlin Bauhaus. The teachers include, as before, Kandinsky, Albers, Hilberseimer, Reich and Peterhans.

In March there is a CIAM congress in Barcelona; Gropius and Le Corbusier are among those taking part.
To mark the exhibition in the New York Museum of Modern Art, John Russell Hitchcock and Philip Johnson publish the book *The International Style. Architecture since 1922* in which the New Building is defined as a style. Aldous Huxley's anti-utopian *Brave New World* is published in London. In Berlin the film by Dudow/Brecht, *Kuhle Wampe, or who does the world belong to?* is given its premiere.
In February the number of unemployed reaches a record 6.1 million. In May the Brüning

government falls and is succeeded by Papen's cabinet. In May the NSDAP make great gains at regional elections in several regions, including Anhalt. There the SPD/Democrat regional government is defeated by an NSDAP/DNVP government. At the general election in June the NSDAP polls 37% of the vote and thereby emerges as the strongest party.

**1933**
After action taken by the Gestapo on April 11, the Berlin Bauhaus is sealed off. On July 20, the teaching staff decide to close the school down, being unwilling to go along with the Gestapo's unacceptable conditions. The NSDAP government has thus accomplished the exodus of the Bauhaus.

On January 30 Adolf Hitler is appointed Reich Chancellor by President Paul von Hindenburg.
In the German Reichstag building a major fire breaks out on February 27–28. The following day Hindenburg signs the emergency decree "for the protection of the people and the state," submitted by the government. Important basic rights are thereby suspended. At the end of March the first concentration camps are set up in the German Reich.
On May 10, the campaign "Against the un-German spirit" reaches its climax in the burning of books.

resources. The German pavilion at the international exhibition in Barcelona, designed by Mies van der Rohe, proves a major attraction: a flat-roofed building made of

to five semesters, architectural training continues to increase in importance under Mies. Problems of building technology in relation to aesthetic questions

**Ludwig Mies van der Rohe, German pavilion at the international exhibition in Barcelona.** 1928–1929, interior view with onyx wall, BHA. • **Wassily Kandinsky, "Gespannt im Winkel" (Tension in the Angle).** February, 1930, oil on card, 48.5 x 53.5 cm, Kunstmuseum Bern, Stiftung Othmar Huber. • **Iwao Yamawaki, "Der Schlag gegen das Bauhaus" (The Blow against the Bauhaus).** 1932, collage, BHA.

# Bibliography

(Selective)

Adler, Bruno. Das Weimarer Bauhaus. Darmstadt: 1963.

Albers, Josef. "Werkstattarbeiten des Staatlichen Bauhauses zu Weimar". Das Badische Handwerk, 21.2.1924.

Josef Albers. At the Metropolitan Museum of Art; an Exhibition of his Paintings and Prints. New York: Metropolitan Museum of Art, 1971.

Josef Albers. A Retrospective. New York: Solomon R. Guggenheim Foundation, 1988.

Allen, James Sloan. The Romance of Commerce and Culture: Capitalism, Modernism, and The Chicago-Aspen Crusade for Cultural Reform. Chicago: University of Chicago Press, 1986.

Arbeiten der Metallwerkstatt des Bauhauses in Dessau. Deutsche Goldschmiede-Zeitung, 31, Nr. 5, 1928, pp. 9–12.

Argan, Giulio Carlo. "Gropius und das Bauhaus". Bauwelt Fundamente 69. Braunschweig/Wiesbaden: 1992.

Alfred Arndt, Gertrud Arndt. Zwei Künstler aus dem Bauhaus. Exhibition catalog. Regensburg: 1991.

Alfred Arndt. Maler und Architekt. Exhibition catalog. Darmstadt: 1968.

Gertrud Arndt. Photographien der Bauhaus-Künstlerin. Exhibition catalog. Berlin: Das Verborgene Museum, 1994.

Ellen Auerbach. Berlin – Tel Aviv – London – New York. Exhibition catalog. Munich/New York: Akademie der Künste Berlin, 1998.

Avant-Garde. Photography in Germany 1919–1939. Exhibition catalog. San Francisco: Museum of Modern Art, 1980.

bauhaus. Katalog der Galerie am Sachsenplatz Leipzig, Catalog 6. Leipzig 1977 (and later editions though the 1990s).

bauhaus. Zeitschrift für Gestaltung, Dessau 1926–1931 (quarterly).

The Bauhaus. Masters and Students. Catalog from Barry Friedman Ltd., New York: 1988.

Bauhaus 1919–1933. Le Bauhaus dans les collections de la République Démocratique Allemande. Exhibition catalog. Brussels: 1988.

Bauhaus 1919–1933. Meister- und Schülerarbeiten Weimar, Dessau, Berlin. Eine Ausst. mit Exponaten von Museen der Deutschen Demokratischen Republik. Exhibition catalog. Zürich: 1988.

Bauhaus-Archiv, Museum für Gestaltung. Architektur, Design, Malerei, Graphik, Kunstpädagogik. Exhibition catalog (selection), 2nd edition, Berlin: 1987 (1st edition: 1981).

Bauhaus Berlin. Auflösung Dessau 1932. Schließung Berlin 1933. Bauhäusler und Drittes Reich. Eine Dokumentation. Edited by Bauhaus-Archiv Berlin, Weingarten 1985.

Bauhaus Dessau. Collection catalog (selection). Dessau: 1990.

Bauhaus Dessau. Dimensionen. 1925–1932. Exhibition catalog. Edited by Bauhaus Dessau, 1993.

Bauhausfotografie. Exhibition catalog. Edited by Wulf Herzogenrath. Stuttgart: Institut für Auslandsbeziehungen, 1983.

bauhaus fotografie. Mappe mit Originalfotos von Bauhäuslern. Text by Lotte Collein. Leipzig: Staatlicher Kunsthandel der DDR, Galerie am Sachsenplatz, 1983.

bauhaus fotografie 2. Mappe mit Originalfotos von Bauhäuslern. Leipzig: Staatlicher Kunsthandel der DDR, Galerie am Sachsenplatz, 1988.

Bauhaus. Photographien. Exhibition catalog. Köln: Galerie Rudolf Kicken, 1982.

Bauhaus Photography. Cambridge, Mass.: MIT Press, 1985.

Bauhaustapete. Reklame & Erfolg einer Marke. Exhibition catalog. Cologne: Tapetenfabrik Gebr. Rasch GmbH & Co. and Stiftung Bauhaus Dessau, 1995.

The Bauhaus Weaving Workshop. Source and Influence for American Textiles. Philadelphia: 1988.

Bauhaus Weimar 1919–1928. Werkstattarbeiten. Kunstsammlungen zu Weimar. Weimar: 1978.

Bauhaus Weimar. Arbeiten der Werkstätten für Holz, Keramik, Metall und Textilien der Weimarer Periode des Bauhauses 1919–1925. Kunstsammlungen zu Weimar, Weimar, 1969.

Herbert Bayer, et al. Bauhaus 1919–1928. Exhibition catalog. New York: Museum of Modern Art, 1938.

Herbert Bayer. Kunst und Design in Amerika 1938–1985. Exhibition catalog. Bauhaus-Archiv Berlin. Berlin: 1986.

Bertonati, Emilio. Das experimentelle Photo in Deutschland 1918–1940. Exhibition catalog. Munich: Galleria de Levante, 1978.

Bogler, Theodor. "Arbeiten des Staatlichen Bauhauses Weimar. Keramische Werkstatt Dornburg/Saale." Keramos 3, (August) 1924, pp. 287–289.

Bogler, Theodor. Soldat und Mönch. Ein Bekenntnisbuch. Cologne: 1936.

Bouqueret, Christian, ed. Bauhaus: Photographie. Paris: 1984.

Brandt, Grete. "Die Keramiken Theodor Bogler". Die Kunst-Keramik 5. Vol. 5, 1926, pp. 1–84.

Brooksbank, Andrew J. Bauhaus: Beneath the Mask. London: Nemo, 1997.

Brevern, Marilies von. Künstlerische Photographie von Hill bis Moholy-Nagy. Berlin: 1971.

Bröhan, Karl H. Metallkunst. Kunst vom Jugendstil zur Moderne (1889–1939). Sammlung Bröhan, Bestandskataloge 4. Berlin: 1990

Brüning, Ute, ed. Das A und O des Bauhauses. Bauhauswerbung: Schriftbilder, Drucksachen, Ausstellungsdesign. Exhibition catalog. Leipzig: Bauhaus-Archiv, 1995.

Brüning, Ute, Angela Dolgner, Walter Funkat. Vom Bauhaus zur Burg Giebichenstein. Bauhausminiaturen 3. Dessau: 1996.

Busch, Günter, ed. Gerhard Marcks. Das plastische Werk. Frankfurt am Main, Berlin, Vienna: 1977.

Chanzit, Gwen, Herbert Bayer. Early Purveyor of Modernist Design in America. Vol. 1/2, University of Iowa: 1985.

Claus, Jürgen. Das elektronische Bauhaus. Gestaltung mit Umwelt. Zürich: 1987.

Claussen, Horst. Walter Gropius. Grundzüge seines Denkens. Studien zur Kunstgeschichte, vol. 39. Hildesheim: 1986.

Cohen, Arthur A. Herbert Bayer. The Complete Work. Cambridge/Mass., London: 1984.

Concepts of the Bauhaus. The Busch-Reisinger Museum Collection. Collection catalog. Cambridge/Mass. 1971

Conrads, Ulrich, Magdalena Droste, Winfried Nerdinger, Hilde Strohl, eds. Die Bauhaus-Debatte 1953. Dokumente einer verdrängten Kontroverse. Bauwelt Fundamente 100. Braunschweig/Wiesbaden: 1994.

Cucciolla, Arturo. Bauhaus. Lo spazio dell'architettura. Bari: 1984.

De Michelis, Marco and Agnes Kohlmeyer, eds. Bauhaus 1919–1933. Da Kandinsky a Klee, da Gropius a Mies van der Rohe. Exhibition catalog. Mailand: Fondazione Antonio Mazzotta, 1996.

Dearstyne, Howard. Inside the Bauhaus. New York: 1986.

Deutscher Werkbund. Exhibition catalog. Cologne: 1929.

Dexel, Walter. Der Bauhausstil – ein Mythos. Texte 1921–1965. Starnberg: 1976.

Die Form ohne Ornament. Werkbundausstellung 1924. Bücher der Form, 1 Stuttgart, Berlin, Leipzig:1924.

Droste, Magdalena. Bauhaus 1919–1933. Trans.: Karen Williams. Cologne: B. Taschen, 1990.

Droste, Magdalena, Manfred Ludewig. Marcel Breuer. Design. Cologne: 1992.

Droste, Magdalena, Manfred Ludewig, eds. Das Bauhaus webt. Die Textilwerkstatt am Bauhaus. Exhibition catalog. Bauhaus-Sammlungen in Weimar, Dessau and Berlin. Berlin: 1998.

Droste, Magdalena, ed. Herbert Bayer. Das künstlerische Werk 1918–1938. Berlin: 1982.

Droste, Magdalena and Jeannine Fiedler, eds. Experiment Bauhaus. Das Bauhaus-Archiv Berlin (West) zu Gast im Bauhaus Dessau. Exhibition catalog, Berlin: 1988.

Duberman, Martin B. Black Mountain: An Exploration in Community. New York: W.W. Norton, 1993.

Ehrlich, Doreen. The Bauhaus. New York: Mallard Press, 1991.

Farblehre und Weberei. Benita Koch-Otte: Bauhaus, Burg Giebichenstein, Weberei Bethel. Exhibition catalog. Berlin: 1976.

Feininger, Andreas. Photographer. New York: 1986.

Lyonel Feininger. Die Zeichnungen und Aquarelle. Exhibition catalog. Hamburger Kunsthalle, Kunsthalle Tübingen. Ulrich Luckhardt u. Martin Faass, eds. Hamburg: 1998.

T. Lux Feininger. Photographs of the Twenties and Thirties. Exhibition catalog. New York: Prakapas Gallery, 1980.

Fiedler, Jeannine, ed. Fotografie am Bauhaus. Exhibition catalog. Bauhaus-Archiv Berlin: 1990.

Fiedler, Jeannine, ed. Social Utopias of the Twenties: Bauhaus, Kibbutz and the Dream of the New Man. Trans: Miriam Nuemann, William H. Boyle. Wuppertal, Germany: Müller + Busman Press, 1995.

Film und Foto. Internationale Ausstellung des Deutschen Werkbunds. Exhibition catalog. Stuttgart: 1929.

Fleischmann, Gerd, ed. Bauhaus. Drucksachen, Typografie, Reklame. Düsseldorf: 1984.

Forgács, Éva. The Bauhaus Idea and Bauhaus Politics. Trans: John Bátki. Budapest, New York: Central European University Press, Distributed by Oxford University Press, 1995.

form + zweck. Fachzeitschrift für industrielle Formgestaltung (Sonderhefte Bauhaus), 8, H. 6, 1976: 50 Jahre Bauhaus Dessau (1. Bauhausheft); 11, H. 3, 1979: Bauhaus Weimar Dessau Berlin 1919–1933 (2. Bauhausheft); 15, H. 2, 1983: Neues Bauen – Neues Gestalten (3. Bauhausheft)

foto-auge/oeil et photo/photoeye. Edited by Franz Roh und Jan Tschichold, Stuttgart: 1929.

Fotomontage. Exhibition catalog. Berlin: Staatliche Museen, Staatliche Kunstbibliothek, 1931.

Frei, Hans. Die Bauten der HfG (Hochschule für Gestaltung) in Ulm 1949–1955. Architekt: Max Bill. Zürich: 1985.

50 Jahre New Bauhaus. Bauhausnachfolge in Chicago. Exhibition catalog. Berlin: Bauhaus-Archiv, 1987.

50 Years Bauhaus. Exhibition catalog. Stuttgart: 1968.

Gaßner, Hubertus, ed. Wechselwirkungen. Ungarische Avantgarde in der Weimarer Republik. Marburg: 1986.

German Art of the 20th Century. Exhibition catalog for Busch-Reisinger Museum, Harvard University, Cambridge, USA. Frankfurt am Main, Berlin, Düsseldorf: 1983.

Gidal, Tim. Modern Photojournalism. Origins and Evolutions. 1910–1933. Trans. Maureen Oberli-Turner. New York: Collier Books, 1973.

Giedion, Sigfried. Space, Time and Architecture: The Growth of a New Tradition. Cambridge: Harvard University Press, 1947.

Sigfried Giedion. 1888–1968. Der Entwurf einer modernen Tradition. Exhibition catalog. Zürich: 1989.

Glaeser, Ludwig. Ludwig Mies van der Rohe. Furniture and Furniture Drawings from the Design Collection and the Mies van der Rohe Archive. New York: 1977.

Graeff, Werner. Jetzt wird Ihre Wohnung eingerichtet. Das Warenbuch für den neuen Wohnbedarf. Potsdam: 1933.

Graeff, Werner. Es kommt der neue Fotograf! Berlin: 1929.

Greenberg, Allan C. Artists and Revolution. Dada and the Bauhaus, 1917–1925. Michigan: 1979.

Grell, Johannes. "Deutsche Kunstkeramik. Wege und Wandlungen." Keramische Rundschau, 38,1930, pp. 200–202.

Gropius, Walter. "Bauhaus-Produktion", Qualität, 4 vol. 7/8, 1925, pp. 127–136.

Gropius, Walter and Günther Freiherr von Pechmann. "Das Bauhaus in Dessau". Velhagen und Klasings Monatshefte 41, vol. 7, 1927, pp. 86–90.

Gropius, Walter. Idee und Aufbau des Staatlichen Bauhauses Weimar. Munich: 1923.

Haenlein, Carl, ed. Dada. Photographie und Photocollage. Exhibition catalog. Hannover: Kestner-Gesellschaft, 1979.

Haenlein, Carl, ed. Photographie und Bauhaus. Exhibition catalog. Hannover: Kestner-Gesellschaft, 1986.

Hahn, Peter. Junge Maler am Bauhaus. Munich: 1979.

Hahn, Peter. Kandinsky. Russische Zeit und Bauhausjahre 1915–1933. Exhibition catalog. Berlin: Bauhaus Archiv, 1984.

Hahn, Peter and Hans M. Wingler, eds. 100 Jahre Walter Gropius. Schließung des Bauhauses 1933. Berlin: 1983.

Hahn, Peter and Hans M. Wingler. Ein Museum für das Bauhaus? Zur Eröffnung des nach Plänen von Walter Gropius errichteten Museumsgebäudes am 1. Dezember 1979. Berlin: 1979.

Harris, Mary Emma. The arts at Black Mountain College. Cambridge/Mass.: 1987.

Haus, Andreas. Moholy-Nagy. Fotos und Fotogramme. Munich: 1978.

Herzogenrath, Wulf, ed. Bauhaus Utopien. Arbeiten auf Papier. Exhibition catalog. Budapest, Cologne, Madrid: 1988.

Herzogenrath, Wulf and Stefan Kraus, eds. Erich Consemüller. Fotografien Bauhaus Dessau. Munich: 1989.

Herzogenrath, Wulf. "Zur Rezeption des Bauhauses". Beiträge zur Rezeption der Kunst des 19. und 20. Jahrhunderts. Vol. 29. Munich: 1975.

Heyden, Thomas. Die Bauhauslampe. Berlin: 1992.

Hochman, Elaine S. Bauhaus: Crucible of Modernism. New York: Fromm International, 1997.

Humblet, Claudine. Le Bauhaus. Lausanne: 1980.

Hundert Jahre Lichtbild. Exhibition catalog. Basel: Gewerbemuseum, 1927.

Hüter, Karl-Heinz. Das Bauhaus in Weimar. Studie zur gesellschaftspolitischen Geschichte einer deutschen Kunstschule. Berlin: 1976.

Isaacs, Reginald R. Walter Gropius. Der Mensch und sein Werk. Bd. 1/2, Berlin: 1983/1984.

Itten, Johannes. Mein Vorkurs am Bauhaus. Gestaltungs- und Formenlehre. Ravensburg: 1963.

Janda, Annegret. "Bauhauskeramik". Kunstmuseen der Deutschen Demokratischen Republik, Mitteilungen und Berichte. Vol. 2, 1959.

Jones, E. Michael. Living Machines: bauhaus Architecture as Sexual Ideology. San Francisco: Ignatius Press, 1995.

Kandinsky, Wassily. Punkt und Linie zu Fläche. Beitrag zur Analyse der malerischen Elemente. Foreword by Max Bill. Bern-Bümpliz: 1973, 7th edition.

Kandinsky, Wassily. Über das Geistige in der Kunst. Foreword by Max Bill. Bern-Bümpliz, 10th edition.

Kandinsky. The Bauhaus Years. Exhibition catalog. New York: Marlborough-Gerson Gallery, 1966.

Kentgens-Craing, Margret, ed. The Dessau Bauhaus Building, 1926–1999. Dessau Bauhaus Foundation. Trans.: Michael Robinson. Basel, Boston: Birkhäuser, 1998.

Klee, Paul. Über die moderne Kunst. Bern: 1979. 2nd Edition.

Paul Klee als Zeichner 1921–1933. Peter Hahn, ed. Berlin: 1985.

Paul Klee. Die Sammlung Berggruen im Metropolitan Museum of Art, New York u. im Musée National d'Art Moderne, Paris. Edit. by Sabine Rewald, Stuttgart: 1989.

Koob, Manfred, et al. Bauhaus, Avant-garde of the Twenties: Visionary Architecture. Heidelberg: Editions Braus, 1994.

Künstler des Bauhauses. Arbeiten von 26 Meistern und Schülern aus der Zeit von 1919 bis 1983. Foreword by Peter Hahn. Weingarten: 1983.

La tessitura del Bauhaus 1919–1933 nelle collezioni della Republica Democratica Tedesca. Venice: 1985.

Leben am Bauhaus. Die Meisterhäuser in Dessau. Dessau: Stiftung Bauhaus, 1993.

Lindinger, Herbert, ed. Die Moral der Gegenstände. Exhibition catalog Berlin: Hochschule für Gestaltung Ulm, 1987.

Lotz, Wilhelm. Wie richte ich meine Wohnung ein. Berlin: 1930.

Luckhardt, Ulrich. Lyonel Feininger. Munich/New York: 1998.

Lupton, Ellen and J. Abbott Miller, eds. The ABCs of [triangle square circle]: The Bauhaus and Design Theory. New York: The Cooper Union for the Advancement of Science and Art, c. 1993.

Manske, Beate and Gudrun Scholz, eds. Täglich in der Hand. Industrieformen von Wilhelm Wagenfeld aus sechs Jahrzehnten. Bremen: 1987.

Gerhard Marcks – Keramik. Exhibition catalog. Düsseldorf: Hetjens-Museum, 1977.

Marcks, Gerhard. Was das (Auge) sah und das (Herz) empfand, zeichnete die (Hand) und nun hast Du's da! Gerhard-Marcks-Stiftung, Bremen: 1985.

Maur, Karin von, ed. Vom Klang der Bilder. Die Musik in der Kunst des 20. Jahrhunderts. Munich: 1985.

Meister- und Schülerarbeiten aus keramischen Lehr- und Versuchswerkstaetten. Berlin: Deutsche Keramische Gesellschaft, 1927.

Mellor, David, ed. Germany. The New Photography 1927–1933. London: 1978.

Hannes Meyer 1889–1954. Architekt, Urbanist, Lehrer. Exhibition catalog. Frankfurt/M., Berlin: Bauhaus-Archiv Berlin and Deutsches Architekturmuseum. 1989

Michaud, Eric. Théâtre au Bauhaus (1919–1929). Nevers: 1978.

misawa homes. Bauhaus Collection. Tokyo: 1991.

Moholy-Nagy, László. The New Bauhaus, School of Design in Chicago: Photographs 1937–1944. Organized by Adam J. Boxer. New York: Banning + Associates, c. 1993.

László Moholy-Nagy. Compositions Lumineuses 1922–1943. Fotogramme aus dem Centre Pompidou Paris und dem Museum Folkwang Essen. Exhibition catalog. Paris: 1995.

László Moholy-Nagy. Exhibition catalog. Ostfildern: Museum Fridericianum Kassel,1991.

Moholy-Nagy, Sibyl. László Moholy-Nagy, ein Totalexperiment. Mainz, Berlin: 1972.

Georg Muche. Das malerische Werk 1928–1982. Exhibition catalog. Berlin: Bauhaus-Archiv, 1983.

Georg Muche. Das künstlerische Werk 1912–1927. Kritisches Verzeichnis der Gemälde, Zeichnungen, Fotos und architektonischen Arbeiten. Magdalena Droste, Christian Wolsdorff, Bauxi Mang, eds. Berlin: 1980.

Nauhaus, Wilhelm. Die Burg Giebichenstein. Geschichte einer deutschen Kunstschule 1915–1933. Leipzig: 1981.

Naylor, Gillian. The Bauhaus Reassessed: Sources and Design Theory. London: 1985.

Nerdinger, Winfried, ed. Bauhaus-Moderne im Nationalsozialismus. Zwischen Anbiederung und Verfolgung. Munich: 1993.

Nerdinger, Winfried, ed. The Walter Gropius Archive. An Illustrated Catalog of the Drawings, Prints and Photographs from Busch-Reisinger Museum, Harvard University Art Museums. New York: Garland Publishers; Cambridge, Mass: Harvard University, 1990–1991.

Neumann, Eckhard, ed. Bauhaus and Bauhaus People: Personal Opinions and Recollections of Former Bauhaus Members and their Contemporaries. Trans.: Richter, Eva and Alba Lorman. New York: Van Nostrand Reinhold, 1993.

Neumann, Eckhard and Roger Schmid, eds. Xanti Schawinsky. Foto. Bern: 1989.

Neusüss, Floris M. Das Fotogramm in der Kunst des 20. Jahrhunderts. Cologne: 1990.

Nicolaisen, Dörte, ed. Das andere Bauhaus. Otto Bartning und die Staatliche Bauhochschule Weimar 1926–1930. Exhibition catalog. Berlin: Bauhaus-Archiv, 1996.

Norberg-Schulz, Christian. Bauhaus Dessau. Roma: 1980.

Opitz, Georg and Arturo Cucciolla, eds. Bauhaus Dessau 1926/1932. Bari: 1985.

Pannaggi, Ivo. Bauhaus. Recanati: 1979.

Passuth, Krisztina. Moholy-Nagy. Corvina: 1982.

Pastor, Suzanne E. Photography and the Bauhaus. Tucson: Center for Creative Photography, University of Arizona, 1985.

Pelka, Otto. Keramik der Neuzeit. Leipzig: 1924.

Walter Peterhans. Fotografien 1927–1938. Exhibition catalog. Foreword by Inka Graeve. Essen: Fotografische Sammlung im Museum Folkwang Essen, 1993.

Poling, Clark V. Kandinsky's Teaching at the Bauhaus: Color Theory and Analytical Drawing. New York: Rizzoli, 1986.

Probst, Hartmut and Christian Schädlich. Walter Gropius. Vol. 1–3. Berlin: 1985–1987.

**Quoika-Stanka,** Wanda. Bauhaus Art and Architecture. Monticello, Ill.: Vance Bibliographies, 1987.

**Read, Herbert.** Kunst und Industrie. Grundsätze industrieller Formgebung. Stuttgart: c. 1958.

**Lilly Reich.** Designer and Architect. Exhibition catalog. New York: Museum of Modern Art, 1996.

**Reichel, Peter.** "Culture and Politics in Nazi Germany," Political Culture in Germany. Dirk Berg-Schlosser and Ralf Rytlewski, eds. New York: St. Martin's Press, 1993.

**Reichel, Peter.** Der schöne Schein des Dritten Reiches: Faszination und Gewalt des Faschismus. München: Hanser, 1992.

**Reineking von Bock, Gisela.** Keramik des 20. Jahrhunderts, Deutschland. Munich: 1979.

**Remsbury, Ann R.** The Teachers of the Bauhaus. A Comparative Study of the Art Pedagogy of Itten, Albers, Moholy-Nagy, Kandinsky and Klee. Dissertation. Essex: 1978.

**Richard, Lionel.** Encyclopédie du Bauhaus. Paris: 1985.

**ringl+pit. Grete Stern, Ellen Auerbach.** Exhibition catalog. Museum Folkwang, Die Fotografische Sammlung, Essen: 1993.

**Rodrigues, Jacinto.** Le Bauhaus, sa signification historique. Paris: 1975.

**Rowland, Anna.** Bauhaus Source Book. London: Grange Books, 1997.

**Rübenach, Bernhard.** Der rechte Winkel von Ulm. Ein Bericht über die Hochschule für Gestaltung 1958/1959. Darmstadt: 1987.

**Sachsse, Rolf.** Lucia Moholy. Düsseldorf: 1985.

**Schädlich, Christian.** Bauhaus Weimar 1919–1925. Weimar: 1979.

**Xanti Schawinsky.** Malerei, Bühne, Grafikdesign, Fotografie. Exhibition catalog. Peter Hahn, ed. Berlin: Bauhaus-Archiv, 1986.

**Scheidig, Walther.** Bauhaus Weimar 1919–1924. Werkstattarbeiten. Leipzig: 1966.

**Scheper, Dirk.** Das Triadische Ballett und die Bauhausbühne. Schriftenreihe der Akademie der Künste, Band 20, Berlin: 1988.

**Schlemmer, Oskar.** The Theater of the Bauhaus: Oskar Schlemmer, Laszlo Moholy-Nagy, Farkas Molnár. Walter Gropius and Arthur S. Wensinger, eds. Trans.: Arthur S. Wensinger. Baltimore: Johns Hopkins University Press, 1996.

**Schmidt, Joost.** Lehre und Arbeit am Bauhaus 1919–1932. Düsseldorf: 1984.

**Schneider, Katja.** Keramik der Kunstgewerbeschule Burg Giebichenstein (1925–1933). Arbeiten von Marguerite Friedlaender, Franz Rudolf Wildenhain und Gerhard Marcks. Keramos, 118, 1987.

**Schulze, Franz,** ed. Mies van der Rohe: A Critical Biography. Chicago, London: 1985.

**von Seckendorff, Eva.** Die Hochschule für Gestaltung in Ulm. Marburg: 1989.

**Sharp, Dennis.** Bauhaus, Dessau: Walter Gropius. London: Phaidon, 1993.

**Naum Slutzky** 1894–1965. Ein Bauhauskünstler in Hamburg. Exhibition catalog. Hamburg: Museum für Kunst und Gewerbe, 1995.

**Spaeth, David,** ed. Mies van der Rohe. Der Architekt der technischen Perfektion. Stuttgart: 1986.

**Staatliche Bauhochschule Weimar.** Aufbau und Ziel. Weimar: 1927.

**Staatliches Bauhaus Weimar 1919–1923.** Weimar, München: 1923; Reprint: Munich, 1980.

**Mart Stam** 1899–1986. Architekt – Visionär – Gestalter. Sein Weg zum Erfolg 1919–1930. Konzeption Werner Möller. Exhibition catalog. Deutsches Architekturmuseum, Frankfurt am Main, Tübingen, Berlin: Deutsches Architekturmuseum, 1997.

**Steckner, Cornelius.** Zur Ästhetik des Bauhauses. Ein Beitrag zur Erforschung synästhetischer Grundsätze und Elementarerziehung am Bauhaus. Stuttgart: 1985.

**Stiftung Bauhaus Dessau.** Die Sammlung. Lutz Schöbe u. Wolfgang Thöner, eds. Ostfildern: 1995.

**Gunta Stölzl.** Weberei am Bauhaus und aus eigener Werkstatt. Exhibition catalog, Bauhaus-Archiv. Magdalena Droste, ed. Berlin: 1987.

**Gunta Stölzl.** Meisterin am Bauhaus Dessau. Textilien, Textilentwürfe und freie Arbeiten 1915–1983. Ostfildern: Stiftung Bauhaus Dessau, 1997.

**Strauss, Konrad.** Deutsche Keramik der Gegenwart. Halle/Saale: 1927.

**Syberberg, Hans Jürgen.** Fotografie der 30er Jahre. Eine Anthologie. Munich: 1977.

**Tavel, Hans Christoph von and Josef Helfenstein.** Johannes Itten. Künstler und Lehrer. Bern: 1984.

**Tower, Beeke Sell.** Klee and Kandinsky in Munich and at the Bauhaus. Ann Arbor, Mich.: UMI Research Press, c. 1981.

**UMBO.** Vom Bauhaus zum Bildjournalismus. Exhibition catalog. Concept by Herbert Molderings. Düsseldorf: Kunstverein für die Rheinlande und Westfalen, 1995.

**Vitale, Elodie.** Lenseignement au Bauhaus de Weimar (1919–1925). Paris: 1985.

**Walsh, George, Colin Naylor, Michael Held,** eds. Contemporary Photographers. London: 1982.

**Wangler, Wolfgang.** Bauhaus – 2. Generation. Cologne: 1980.

**Wangler, Wolfgang.** Bauhaus-Malerei. Cologne: 1988.

**Wangler, Wolfgang.** Schüler des Bauhauses und ihre Malerei von heute. Cologne: 1982.

**Weber, Klaus,** ed. Die Metallwerkstatt am Bauhaus. Exhibition catalog, Bauhaus-Archiv. Berlin: 1992.

**Weltge-Wortmann, Sigrid.** Women's Work: Textile Art from the Bauhaus. San Francisco: Chronicle Books, 1993.

**Westphal, Uwe.** The Bauhaus. Trans.: John Harris. New York: Gallery Books, 1991.

**Whitford, Frank.** Bauhaus. London: 1984.

**Wick, Rainer K.** Bauhaus-Pädagogik. Cologne: 1982.

**Wick, Rainer K.,** ed. Ist die Bauhaus-Pädagogik aktuell? Cologne: 1985.

**Frans Wildenhain.** A Chronology of a Master Potter. Exhibition catalog. Rochester/N.Y.: 1975.

**Marguerite Wildenhain.** A Retrospective Exhibition. New York: 1980.

**Wilhelm, Karin.** Walter Gropius. Industriearchitekt. Braunschweig/Wiesbaden: 1983.

**Wingler, Hans M.,** ed. Kunstschulreform 1900–1933. Dargestellt vom Bauhaus-Archiv Berlin an den Beispielen Bauhaus Weimar Dessau Berlin – Kunstschule Debschitz München – Frankfurter Kunstschule – Akademie für Kunst und Kunstgewerbe Breslau – Reimann-Schule Berlin, Berlin: 1977.

**Wingler, Hans M.** The Bauhaus: Weimar, Dessau, Berlin, Chicago. Trans.: Wolfgang Jabs and Basil Gilbert. Cambridge, Mass.: MIT Press, 1978, c. 1969.

**Wingler, Hans M.** Kleine Bauhaus-Fibel. Geschichte und Wirken des Bauhauses 1919–1933. Mit Beispielen aus der Sammlung des Bauhaus-Archivs, 2nd edition. Berlin: 1979.

**Wolfe, Tom.** From Bauhaus to Our House. London: Picador in association with Jonathan Cape, 1993.

**Wolsdorff, Christian.** Der vorbildliche Architekt. Mies van der Rohes Architekturunterricht 1930–1958 am Bauhaus und in Chicago. Exhibition catalog. Berlin: Bauhaus-Archiv, 1986/1987.

**Farkas Molnár, Cover design Bauhaus Book 1.** 1925, letterpress, 23.5 x 53.9 cm, BHA.

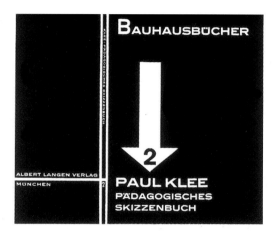

**László Moholy-Nagy, Cover design Bauhaus Book 2.** 1925, letterpress, 23.0 x 53.9 cm, BHA.

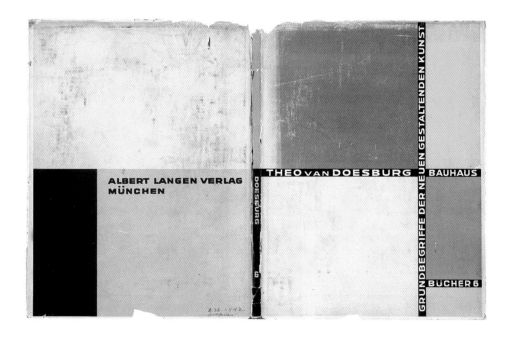

**Theo van Doesburg, Cover design Bauhaus Book 6.** 1924, litho printing, varnished, 23.0 x 52.2 cm, BHA.

**László Moholy-Nagy, Cover design Ba** BHA.

**László Moholy-Nagy, Cover design Ba**

**László Moholy-Nagy, Cover design Ba**

NE ARBEITEN DER HAUSWERKSTÄTTEN

7. 1925, proof, letterpress, 27.3 x 55 cm,

**László Moholy-Nagy, Cover design Bauhaus Book 12.** 1930, letterpress, 23.7 x 54.5 cm, BHA.

8. 1925, letterpress, 23.0 x 53.9 cm, BHA.

**László Moholy-Nagy, Cover design, Bauhaus Book 13.** 1928, letterpress, 23.6 x 52.0 cm, BHA.

0. 1926, letterpress, 23.6 x 50.0 cm, BHA.

**László Moholy-Nagy, Cover design Bauhaus Book 14.** 1929, letterpress, varnished, gloss finish, 23.6 x 56.1 cm, BHA.

# Exhibitions at the Bauhaus

Ute Brüning

The Bauhaus, in its sum total of individual artistic activity, had a breathtaking range of exhibitions to present. This should be considered in the context of the time, if we are to gauge the creative personnel of the Bauhaus and how they worked together. How much, for example, did the painters' individual or group exhibitions contribute to the image of their institute – even if they only sailed for a relatively short time under the flag of the Bauhaus? Wassily Kandinsky did not for instance want to be seen as the supporter of any movement. The printing and advertising department, on the other hand, did not stage any "Bauhaus exhibitions," but in 1927–1928 sent a fixed team to all the relevant shows. Despite this, their products became known by the name "Bauhaus." At other exhibitions, the Bauhaus labeling emerges in a new guise. Walter Dexel was not alone in encountering the "Myth of Bauhaus Style"; Hannes

Meyer had to defend himself against "Style Creation" at his institute. To Walter Gropius and Ludwig Mies van der Rohe, the Bauhaus name was welcome for very different reasons.
Beginning in 1922–1923 with a still legendary Bauhaus exhibition in Calcutta, it is the single, great international events which catch the eye, not because of the number of Bauhaus members concerned but as a result of the sensation that they provoked. Thus, for example, the Werkbund exhibitions "The Apartment" in Stuttgart (1927) and the German section in Paris (1930), and also the touring exhibition "International Architecture" (1928). In 1927, five masters represented the avant-garde when they appeared at the Mannheim Gallery in "Routes and Directions of Abstract Painting in Europe." In the same year though, only the metal workshop contributed to the exhibition "European Applied Arts" in Leipzig. By contrast, in

1929–1930, members of the Bauhaus from all workshops were represented at two touring exhibitions of modern photography, even before the actual Bauhaus department was active: these were the Essen "Contemporary Photography" exhibition and "Fifo" in Stuttgart.

Whether the Bauhaus's participation in the spring, fall and specialist fairs, already well known by 1923–1924, was any more successful than their art exhibitions, is debatable. It is surprising to realize that virtually only the internal exhibitions at the Bauhaus, which they designed themselves, were photographically documented. By 1922 it was already thought necessary to have an exhibition and sales room for visitors, as a result of which the whole of the Dessau building became accessible to swarms of visitors. Information about exhibitions of students' graphic works in Weimar was mainly

**Herbert Bayer, Exhibition Design "Bauhaus 1919–1928," MOMA, NYC.** December 7, 1938 to January 30, 1939, photographer unknown, BHA. • Gropius presented his vision of the Bauhaus to a wide American public with great success, but deliberately excluded his successors Meyer and Mies from this combined show. In this way he was to contribute in a major way to a very one-sided view of the school which lasted for some ten years.

circulated internally. In 1922, architecture and works by journeymen and apprentices were added to these shows. The preliminary-course exhibitions, introduced in 1920 by Johannes Itten as the enrolment examination for beginner students, initiated a first-rate opportunity for people to see what others were doing, though under Mies van der Rohe these became private shows. From about 1929, the Bauhaus also opened its doors to exhibitions by external artists, and it soon became a very selective business deciding what was to be shown there publically and what was reserved for internal consumption.

The way the Bauhaus wanted its work to be judged can be seen from two shows. The first, which took place in Weimar in 1923, was ordered by the regional government, the other was set up at the Bauhaus's own instigation and finally realized in 1929 as a touring show, which appeared in Basel and Dessau, Breslau and Essen and, in 1930, in Mannheim and Zürich. Gropius proclaimed a "state of emergency" at the school almost a year in advance so that every energy could be mobilized in preparation for the exhibition, and Hannes Meyer let these preparations run in parallel with instruction and productive work. The differing Bauhaus concepts stand in harsh contrast to each other: in 1923, the attempt to show the interplay of Bauhaus personnel exclusively to an international public; in 1929–1930, the concern to publicize the school as a place with production workshops geared to the needs of the public. On both occasions, the events were organized without assistance. In Weimar, they set up their own advertising department for this purpose, for the touring exhibition they did without its services, well aware that it would turn out to be too flashy. Gropius sought to demonstrate the vital union of arts and technology through the Bauhaus building and the experimental House on the Horn. Meyer standardized the Bauhaus teaching, turning the empty museum spaces into areas of expertise, the engine-room of the Bauhaus's products; it was all lucidly explained, but won little understanding. In 1923, they organized their own exhibition and hanging committees, created a catalog book and offered an accompanying cultural program, lasting for a week. In 1929, they had only one good and several wretched posters, catalogs for only two departments, and

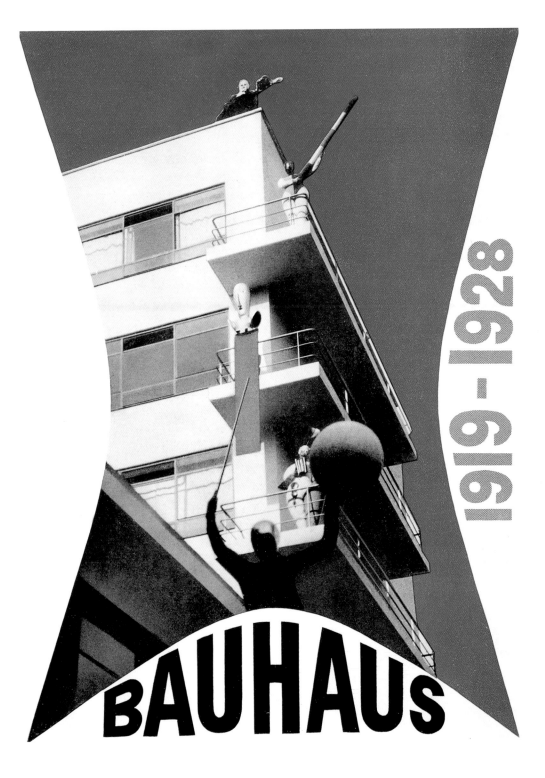

delegated just one master and an assistant to set it all up. The only bright spot was the Breslau exhibit in the Werkbund's 1929 exhibition "Living and Work Space," achieved with the help of the advertising department. Otherwise the touring show presented a sad picture. The material proceeds for both exhibitions were around nil. Although the Gropius production is still effective to this day, Mies van der Rohe refused to let the work of his few departments be turned into a Bauhaus spectacular.

**Herbert Bayer (design) and T Lux Feininger (photography), Dust-cover of catalog "Bauhaus 1919–1928," MOMA, NYC.** 1938, proof on art paper, 26.6 x 19.2 cm, BHA. • Among the Bauhaus members who emigrated to the USA with Gropius were Albers, Breuer, Schawinsky, Moholy-Nagy and Mies van der Rohe, also Herbert Bayer, who in 1938 designed the exhibition and catalog for the Bauhaus show in New York.

# Glossary

Ute Bruning

**Auditorium in the Dessau Bauhaus, lightly raked auditorium with 164 seats, view into the open vestibule** About 1927, photograph by Erich Consemüller, BHA.

## Auditorium seating

The Bauhaus auditorium was not only regarded as an auditorium but also as a viewing space for the adjacent stage. In his seating design Marcel Breuer thus veered toward having rows of folding chairs, as in cinemas and theaters. The use of steel tubing for this purpose was completely new. All Breuer's chair types share the principle of frame construction, with a simple piece of stretched fabric taking the place of the seat and back support. The space-efficient principle of runners was however not employed here, but instead the slender supports were secured firmly to the floor by screws.

## Awegit

Company name for a paste designed to waterproof flat roofs. Applied warm to the roofing felt, the material was relatively economical and was used on the Bauhaus housing development at Dessau-Törten.

## Bauhaus diploma

The diploma, a university degree, could only be awarded after the Bauhaus had attained university status in 1926, and was at first intended only for graduates in building. All other students from 1919 to 1928 were awarded journeyman and master's articles as proof of their craftwork abilities. From 1922, design skills were assessed in Weimar by the council of masters, who appointed members either "Bauhaus journeymen" or "masters." From 1925, the journeyman examination for the intermediate level to the "official certificate" was issued only after successful periods in the experimental and finishing workshops. Not until 1928 could students qualify for a diploma in every department. Today, diploma certificates from 1929 to 1933 are an important source of information, since they list all the events which the student enrolled for by semester, and in many cases also document commissioned and voluntary work.

```
bauhaus dessau    hochschule für gestaltung

auf grund des beigefügten zeugnisses über ausbildung und leistung ist
durch beschluss des meisterrates

de rstudierenden    frau  m a r i a n n e  b r a n d t
geboren  1.X.1893    zu    c h e m n i t z/i.sachsen

als beleg für das abgeschlossene studium
in der              m e t a l l - werkstatt        abteilung

dieses   b a u h a u s - d i p l o m

zuerkannt worden

dessau, den  10.september 1929

die direktion:

die abteilungsleitung:
```

**Marianne Brandt's Bauhaus diploma.** Awarded on September 10, 1929 as proof that she completed her studies in the metal workshop, BHA.

## Bauhaus dog

Dogs were apparently too conventional a companion for most Bauhaus members, who were much more involved in the search for the "New Man." Thus, apart from Gyula Pap's dog, probably the only animal deserving the title of "Bauhaus dog" was the director's.

## Bauhaus-GmbH (Ltd)

By the end of 1923, a contract had been set up to convert the workshop business into a private limited company (GmbH), in order to be able to carry on production and sales independently of the teaching activities and in the process to put the Bauhaus on an economically sound footing. This venture was temporarily set back by the dissolution of the Weimar school, but recovered in Dessau where, on October 7, 1925, the company was recorded in the trade register of Bauhaus as having "exclusive exploitation rights." The "Catalog of Samples" and business stationery of 1925–1926 reveal the company's professional intentions, though customers were obviously lacking. When licensing contracts came into being, the limited company finally became meaningless.

**A Bauhaus dog.** About 1930, photographer unknown, BHA. (Ellen Frank, Ise Gropius and Dachshund)

## Bauhaus publishing house

By May 1922, the idea of founding an internal publishing house was considered as a way of bringing out the ambitious "New European Graphics" series under the Bauhaus's own imprint. The project's fulfillment appeared so certain that, by the end of 1922, the school prospectus already described the publishing project as a fait accompli. Its financing, by contrast, was so precarious that they were at the same time looking for external publishers for the book project *State Bauhaus Weimar 1919–1923*. Meanwhile a private financier was found in Ernst May from Munich, who provided 50 percent of the requisite capital. Thus in May 1923, Bauhaus Publishers Ltd was founded with May as its managing director. As well as the catalog book, other releases included the graphic works *Master Portfolio and Edda's Elegie for Wieland* by Gerhard Marcks. The Bauhaus books on the other hand, did not appear under the Bauhaus publishing imprint, as it was declared bankrupt at the beginning of 1925. After this the books were published by Albert Langen in Munich.

## Bauhaus style

The vast and comprehensive advertising measures initiated by Walter Gropius in order to maintain and promote his institution, led to this catchphrase being used publically during the period of his directorship. It referred and refers, partly in a derogatory and partly in a eulogizing way, to the artistic character of the products, against whose dominance Hannes Meyer in particular campaigned with fluctuat-ing success, though later in vain. Ultimately, this indiscriminate, blinkered view meant that the core aim of design – function – was disregarded.

## Cactus collection

For cactus lover Gropius these exotic organic forms may have offered a welcome counterbalance to the rectilinear nature of his architecture. In the '20s, cacti were part of the decorative style of the enlightened middle-classes, rather like the sumptuous proliferation of palm trees in Jugendstil interiors.

## Canteen

Social meeting-point for Bauhaus members and, especially in Weimar, for many students the only place for a decent meal. In Dessau this dinning hall with its lovely, frequently photographed sun-terrace was still mostly known as the "canteen." The rules of October 21, 1930 prohibited social life there, because

**Man's room in the House on the Horn with an early form of strip lighting, furniture by Marcel Breuer.** Weimar, 1923, photographer unknown, BHA.

the director suspected that cells of political subversives were operating there. From then on, the message was: "the canteen is only open for the taking of meals."

## Cantilever chair

Originally, the idea for a tubular steel chair with no back legs goes back to the ideas of the architect Mart Stam. He inspired Ludwig Mies van der Rohe to make his "Weissenhof" chair. By contrast with the Stam design, made of iron gas-pipes, Mies used the flexible quality of the material for seating comfort, something other designers seized upon. With the "cantilever chair" concept this advantage was emphasized still further.

## Cellophane

This new foil, developed out of cellulose, fascinated Bauhaus members with its visual attractions, such as transparency and sheen, and its special handling quality – flexibility.

## Combination teapot

The attempt to turn the Bauhaus into a design workshop for industrial mass-production even affected the ceramics workshop in 1923. Like Walter Gropius, Theodor Bogler must have had modern assembly processes in mind as he developed prefabricated elements for teapots which could be assembled in line with the box-of-bricks principle to fit different models.

## Constructivism

Constructivism, the engineer's method of using all materials according to principles of organization, is one of the artistic impulses which at about the same time emerged from De Stijl and the Soviet revolutionaries. This leaning toward modern production techniques, though very varied in its individual expression, shared with Expressionism the rejection of individual arbitrariness. Constructivism seemed to be capable of realizing the super-individual design which a collective society apparently needed, whatever its nature. At the Bauhaus, László Moholy-Nagy worked these stimuli into an original concept in which, above all, the production of unknown and highly tensioned relations between techniques and materials was highly productive both in pedagogic and artistic terms.

## Dark room

The student Walter Funkat installed a dark room for the first time at the Bauhaus in 1927 for his fellow students. After 1929, photography became a subject for study and the laboratory

**Metallized yarn piece by an unknown designer at the Dessau Bauhaus.** About 1928, BHA.

was equally used by students of photography and advertising, and from 1931 there was continuous in-fighting between the departments over standards of quality for photographs, since it was those who produced good work for the head of department, Walter Peterhans, who were allocated time to use the laboratory. Director Ludwig Mies van der Rohe planned two dark rooms for the Berlin Bauhaus.

### Electric Laundry

With the establishment of a community, Walter Gropius sought to bring about a change in social life, and to this end he was influenced by the theories of the sociologist Franz Müller-Lyer. The former had diagnosed a social development of man from the "Epoch of the Individual" down to the "Cooperative Epoch," a time when the personal development of a human being could take place outside the family. Dwellings could thus be small, because they would be supplemented by communal spaces with the most modern technical fittings, such as kitchens, fitness installations and even central laundries.

### L'Esprit Nouveau

The architect Le Corbusier, cofounder and publisher of this French cultural magazine from the years 1920 to 1925, received a starring role at the 1923 Bauhaus exhibition in the department of "International Architecture." As an advocate of standardization, Gropius felt himself allied to the creator of the most quoted catchword in New Building, the "living machine." Nevertheless, he received strong criticism from Le Corbusier. It was aimed at Gropius's attempt to typify industrial production with aesthetic geometrical fundamental forms. An art school was, in Le Corbusier's view, incapable of improving industrial production.

### Expressionist Bauhaus

To categorize the early Bauhaus according to features of style and mental attitudes found in Expressionism hardly grasps what the school was specifically about. With their romantic belief in the defining role of the small craft community, modeled on the medieval church mason's guilds, as the way to renew art, they wanted to avoid familiar forms of expression and develop a change in the concept of education. Nor does this concept reflect Gropius's own persistent attempts to direct those titanic ideas, which he himself had conceived, toward a practical ideology.

### Ferro-concrete

This material, today replaced by reinforced concrete using steel was, because of its iron reinforcement, better suited to bearing thrusts and tensions than traditional materials. Walter Gropius and Adolf Meyer in particular anticipated that the use of ferro-concrete would have a similarly revolutionary influence on architectural design as the use of glass and iron. These three building materials, until then known only to structural engineers, had no tradition in the field of high architecture. Using it, people were freed from the design restraints of architectural tradition, and at the same time encouraged to introduce a new plasticity into architecture.

### Filament lighting tubes

Tube-shaped incandescent lights, mounted between two sockets, the use of which was

**View from the roof of the Prellerhaus (studio) over the roofs of the bridge and the technical teaching rooms, Dessau Bauhaus.** 1929, photograph by Mathilde Reindl, BHA.

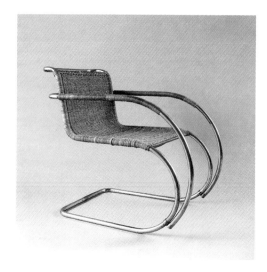

**"Weissenhof" chair by Ludwig Mies van der Rohe.** 1927, tubular steel, chrome-plated, wickerwork, 82.5 x 57.0 x 82.0 cm, BHA.

new in living areas. These naked lighting devices sprang up as individual pieces at the House on the Horn and in Walter Gropius's director's room, while under metalworker Max Krajewski they multiplied in the Dessau Bauhaus foyer and the auditorium as surface-filling ceiling lighting. László Moholy-Nagy also arranged strips in a constructivist style on the living-room ceiling of his master's house in Dessau.

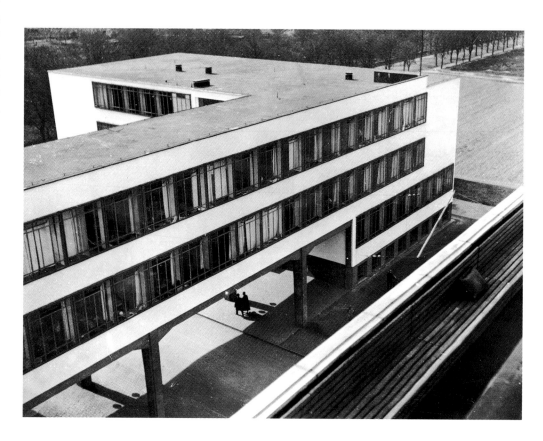

## Flat roof

Flat roofs were as much part of the design repertoire with which the New Building chose to distinguish itself as continuous windows. In cubic constructions, this final plane was often converted into roof gardens or terraces. The emphasis on the flat roof, based on rational grounds, certainly did not fit with the expense needed to secure the buildings permanently against moisture. In the '20s there were already arguments against the aesthetics of flat-roofed buildings. The argument that they were not typically German prevailed in the Nazi period, when new dwellings were restricted to the "native homeland" style with pitched and hipped roofs.

## Functionalism

In the '20s, the reassessment of the point of an object marked a revolutionary departure from a rigid design canon and created room for very diverse methods of design and theory. Walter Gropius called his method for understanding functions "essential research." Functions were supposed to be represented as faithfully and clearly as possible. Aesthetic design discussions were regularly suppressed and reinterpreted as debates about aims. This was typical of the Bauhaus period until 1930. Under

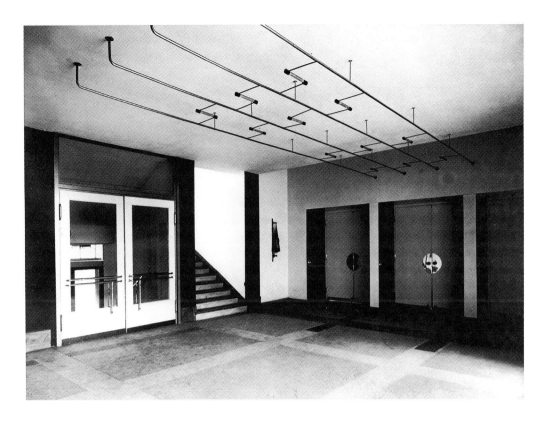

Hannes Meyer students used strictly scientific methods to investigate the catalog of functions to which he had added a fundamental social dimension. Functionalism at the Bauhaus culminated with Meyer under the maxim "Meet all the needs of life" by considering the best methods of organisation and economy, while under Ludwig Mies van der Rohe aesthetic viewpoints finally became meaningful again.

## Glass curtain-wall façade

Façades made of glass were only made possible by moving portable parts of the building to its interior. For the Bauhaus workshop wing, they managed to pre-hang an iron framework with no loadbearing function by means of a ferro-concrete pier system, which bore the floors, and this supported the glazing of two "walls." Thus the famous "glass corner" came into being. However, because they used simple window glass, the insulation of the rooms was so poor that Bauhaus members had to suffer extreme fluctuations of temperature.

## Grotesque type

A typeface family in which the letters dispense with serifs, the small lines, mostly horizontal, which accentuate the terminations of a letter. The new typographers avoided serifs which seemed to them to be superfluous

**Strip lighting construction by Max Krajewski in the hall of the Dessau Bauhaus.** 1927, photograph by Erich Consemüller, BHA.

ornament. Their hopes of designing a new kind of type were based on the "skeleton character" of Grotesque, a type-face quite free of flourishes which seemed to come closest to the geometrical total look which they sought.

## International Style

Alfred H. Barr coined this highly significant term in 1932 on the occasion of the similarly named architecture exhibition at New York's Museum of Modern Art, which was organized by Philip Johnson and Henry Russell Hitchcock. The buildings of the previous decade from 1922 appeared to relate to each other on an international scale in three areas: their walls are surfaces which enclose space and form volumes as opposed to the massive solidity of earlier buildings. The new constructions reveal regularity and symmetry and remain undisturbed by contrived ornamentation.

## Jacquard weaver's loom

Large-dimension, richly patterned fabrics could be produced in complicated weaves on this loom. It worked with perforated cards which directed the rise and fall of the shafts,

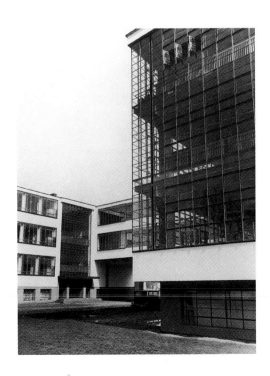

**"The glass corner," view from the south-west of the workshop wing at the Dessau Bauhaus.** 1927, photograph by Lucia Moholy, BHA.

which in contrast with other looms were all individually mobile. For every pattern, the movement of each individual warp thread had to be recorded on perforated card. The installation of the loom took a relatively long time, in other words it was only worth using for the production of large quantities of fabrics.

## Light fittings

Individual lamps for the House on the Horn preceded the design classic by Carl Jakob Jucker and Wilhelm Wagenfeld. The table lamp came into being under the direction of László Moholy-Nagy, who thus brought the metal workshop into Gropius's course for producing designs for industrial manufacture. By 1926, lighting production was elevated in the constitution to the status of a "special work area" of the metal workshop. This was

**Walter Gropius on the veranda of his master's house, Dessau.** About 1927, photograph by Ise Gropius (?), BHA.

followed by collaboration with two firms: in 1928–1930 in the form of licenses to the Berlin lighting company Schwintzer & Gräff, and in 1929–1932 with a contractual arrangement for Bauhaus students to work on and redesign lamp types for the Leipzig firm Korting & Mathiesen, which went on the market under the name of Kandem.

## Lower-case letters

To be economical with time and materials was a standing order and the most important one of all for the Bauhaus, stuck as it was in chronic financial difficulties. This stipulation for design was soon reinterpreted at the Bauhaus as an aesthetic measure – even down to saving on upper-case lettering. The inspiration came from, among others, the circle of advertising chief Weidenmüller, who not only wrote in

lower-case but systematically and expressively introduced the language of economic word-building into the teaching of advertising. The Bauhaus did not take economy that far, however almost everyone wrote in lower-case as a symbol of their progressive attitude.

## Metalized yarn

The concept has no connection with the use of iron, but refers to the particularly hard-wearing quality of the material. Metalized yarn is a stiff, glossy cotton yarn, which is smoothed down with wax and paraffin in a special finishing machine. Metalized yarn material was developed in 1927–1928 at the Bauhaus through the decisive involvement of the weaver Grete Reichardt in making the covers for Breuer's tubular steel chairs. Like other fabrics it is woven from cloth and an additional base-weave to prevent tearing or unraveling. In the '30s it was also used for covering airplane seats.

## Minutes of the council of masters

In the time between October, 1919 and July, 1922, these record the discussions and decisions of the committee of artistic teachers on all matters concerning Bauhaus internal

affairs, insofar as these were not the responsibility of the regional government. According to the constitution of July, 1922, they were largely taken over by the minutes of the "Bauhaus Council," which came into existence at the request of the craftwork masters and gave them voting rights. Since at the same time the division of powers became more complicated, there were additional minutes of separate discussions between the form masters and the work masters. The originals of this important resource can be found partly in the Thuringian State Archive, Weimar, and partly in the Bauhaus Archive, Berlin. Only a few minutes (1931–1932) exist from the "conference" known as the internal "council of masters"; they are owned by the collections of the Bauhaus Foundation, Dessau.

## Monthly workshop reports

The craftwork masters in Weimar were obliged to compose a monthly report on the activity of their workshops, which went to the regional government. These records revealed

**Children's chairs in a rectilinear slatted design by Marcel Breuer.** 1923, photograph by Lucia Moholy, BHA.

the strains suffered by the workshop on a more or less regular basis. For the period between 1921 and 1925 they paint a dire picture of lapses in production, and name the participating students and journeymen. The originals are in the Thuringian State Archive, Weimar.

## Needs of the people
Under Hannes Meyer, work groups were established to research living spaces and habits. Meyer saw the satisfaction of the "collective" needs of the people as the aim of the Bauhaus. Standardized "types" were realized according to economic, technical and psychological criteria. Hannes Meyer refused to design for the luxurious requirements of middle-class snobs, and rejected "Bauhaus style" design products from the Gropius era which were supposedly devised for individuals.

## New Building
This European movement of the '20s liberated itself from rigid aesthetic and technical building traditions, and chiefly applied its fascination with new materials, technologies and ways of living to solving social building questions. Subjects such as housing developments – and city-building as well as transport planning – were at first also the subject of extensive political debates. Le Corbusier's controversial catchword, the "living machine," defined for many the target concept of precise function-fulfilling and typifying. Walter Gropius, in particular, saw industrial building methods using prefabricated standard building parts not only as the way toward economical and justifiable dwellings, but also toward the creation of a style. His theories were only partly confirmed as the new design repertoire was quickly worn out.

## New Seeing
Two "rival" movements in the '20s, opposed to the negative use of cameras in pictorial photography. They were called New Seeing and Objective Photography/New Objectivity (Functionalism). Influenced by Russian constructivism and by the films of Sergei Eisenstein and Dviga Vertov, they developed a new style of camera-photography symbolized by extreme perspectives, dynamic tilts and fragmentation of the objects portrayed. The

constructivists' grab on reality sought to define a new relationship of people to space and how it could be captured by photography. The intention was not passive mechanical reproduction, but an active redesign, which incorporated the observer into the process.

## New Typography
Defined as "new" or "elemental," these were the revolutionary experiments with type that the constructivists adopted with a view to bringing a mechanical precision to content and to provide originality and urgency to statements through the use of abstract geometric materials. The contrasting colors and sizes, daringly balanced against each other, produced hitherto unknown visual relationships between content and form, and rejected ornamentation and familiar symmetrical construction. Composition, printing and photographic illustration emerged as the up-to-date techniques of this new attempt at defining communication. At the Bauhaus, László Moholy-Nagy was responsible for inspiring the New Typography, whose strength of expression was soon devalued by an overly righteous attitude toward aims and by standardization.

## Parties
Party – play – work – this soon became the rhythm of the Bauhaus in Weimar. Walter Gropius knew, as he designed the Bauhaus building in Dessau, that music, fun, dressing-up, scenic ideas, culinary experimentation, dancing, guests, all of these was necessary for the mental relaxation of the Bauhaus members. Thus the auditorium, stage and canteen were situated one behind the other on the ground floor, and could be combined into one large party area where the canteen could open onto the stage and vice-versa.

## Prellerhaus
This was the name of the former studio-building of the painter K. A. Louis Preller in Weimar, which was used by outstanding students of the Bauhaus. In 1923 there were 13 rooms which students applied for to the council of masters, each of whom could allocate rooms to up to three Bauhaus members. In Dessau, they simply transferred the name to the tall new building with studio accommodation which was now integrated into the

Bauhaus. In 1931 the majority of inhabitants had to leave their rooms because Mies van der Rohe joined them together and turned them into teaching rooms.

## Productive enterprise
The term seems socialistic, however the process it defined had little to do with socialism, although it did arouse controversy in Weimar. Because of the all-too-tight teaching budget, among other things, Gropius urged the workshops energetically to produce useful, marketable commodities. Already by 1922 there was a separate account for the proceeds from this "Productive Enterprise." Of course, a constant conflict followed between experiment and reproductive activity, between teaching and a versatile manufacturing-type operation. Through the installation of "productive workshops," Hannes Meyer sought to separate the diversity of Bauhaus products from the teaching side. The allocation of licenses for industrial companies to carry out mechanical production, which was finally set up under Mies van der Rohe, was a relief for the productive enterprise.

## Prototype and mass-production
To create a union of art and technology, Gropius visualized the Bauhaus as a laboratory,

**Prellerhaus, studio-house for students at the Bauhaus in Weimar.** About 1920, photographer unknown, BHA.

in which prototype items of daily use would be developed for industrial mass production by "experimental work." These "types" were to be crafted according to their functional, technical and economical requirements. He expected this integrated creative approach to produce a harmony which would fundamentally differ from arts-and-crafts methods of improving design. Industry was geared to mass-production. A lack of awareness of industrial production techniques was typical of the Gropius era. The workshops took a long time to produce their works, and only the award of a few licenses ultimately redeemed Gropius's program.

## Slatted chair

An apprentice piece by Marcel Breuer, who produced it in 1922 as a result of Walter Gropius's appeal to make useful objects and perfected it as the "Bauhaus chair," ripe for

**Lampshade production in the metal workshop at the Dessau Bauhaus.** About 1927, photographer unknown, BHA.

mass-production. The construction, an economical frame of slats of equal cross-section – thus cheap and rational to manufacture – has, like the reclining chair, only fabric for the seat and back-rest. Breuer arrived at this shape after making a functional analysis of comfortable seating. The influences of the De Stijl movement revealed here were never a subject that he willingly discussed.

## Standardization

To order and organize life rationally meant to abolish the existing technically and economically unnecessary diversity of products and instead to standardize in a planned way. Many of the current standardization initiatives of the time were enthusiastically adopted at the Bauhaus, and applied to the design of functional things that were suitable for industrial manufacture – not only in architecture and furniture, but also in paper sizes and colors, type and correspondence.

## Stijl, De

In Weimar, Theo van Doesburg – that touring propagandist of the Dutch De Stijl movement – taught students about the harmony of pure proportions and colors and their integral tensions as an expression of future collective design-consciousness. In 1921 and 1922, the imported orthogonal compositions and Doesburg's universal theories, calling for environmental design, had a significant influence on a number of Bauhaus members. As a result of these collective ideas, the "Nieuwe Beelding" (New Design) also had a subversive effect at the Bauhaus and changed architecture as well as painting, furniture and advertising design. In 1923, the "quadratic way of thinking," which Doesburg rejoiced in, finally replaced the individualistic era of Itten at the Bauhaus: illustrations from the library's copy of the De Stijl magazine were, much to the annoyance of the Bauhaus director, constantly being cut out.

## Studio accommodation

Gropius used 28 rooms in the Prellerhaus to allow students to withdraw for private creative and recreational activities within the communal residence. "Studio accommodation" therefore offered above all plenty of space and light for work – the bed and washing facilities were set up in niches, and utensils were concealed in built-in closets.

## Tea-kitchen

Every floor of the Dessau studio-house was equipped with a tea-kitchen not far from the studio, providing opportunities for communal housekeeping and convivial breaks. At the same time the rooms could be kept free from the clutter of kitchen utensils.

## Technology

This was a constant mental and practical reference point, as well as a vehicle of hope, for those artists who saw themselves as designers of a coherent future lifestyle. From 1922, courses changed direction at the

**Tea-kitchen in the Prellerhaus, studio-house for students at the Dessau Bauhaus.** About 1927, photographer unknown, BHA.

Bauhaus from craftwork toward technology and industry, the change being deemed complete in 1923. The joining of craft-oriented design practice to the technological demands of industrial mass-production certainly remained a widespread vision. However, particularly under László Moholy-Nagy's influence, stimuli from the technological realm became the creative factor and led in many respects to new functional and aesthetic results.

## Unikat

The study of individual self-awareness, the development of which was standard in the workshops under the directorship of Johannes Itten – was regarded as a one-off. Gropius soon opposed this method of working in favor of a more outwardly directed and effective method of study that at the same time would jettison the design of perfected items in favor of industrial mass-production.

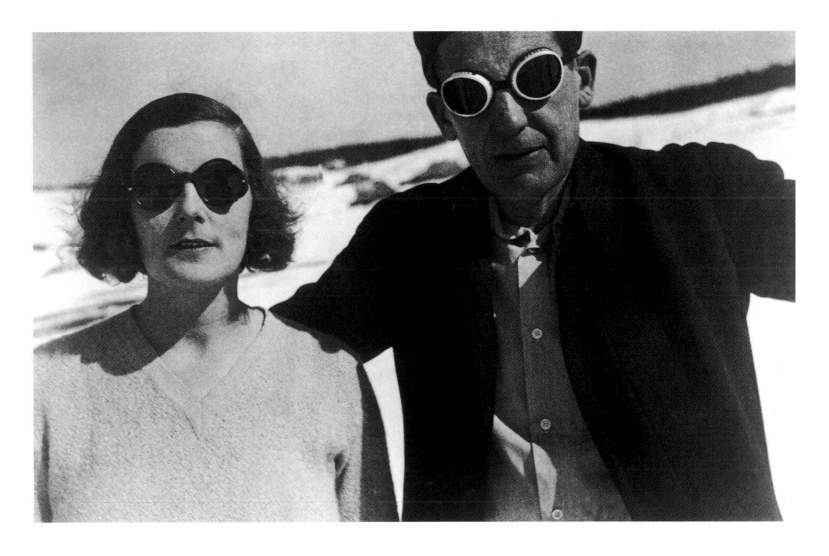

**Ise and Walter Gropius, New Hampshire.** About 1930, photographer unknown, Getty Research Center, Research Library.

# Merchandising Appendix

Karsten Hintz

"It also seems to me somehow a little strange to rehash the chair at this point, it ought to have been pressed in a prayer-book" – that was Marcel Breuer's opinion in 1977 of the plan to reproduce a 50-year-old chair. Relatively few Bauhaus objects are manufactured today, and most derive from three phases of the school. The Bauhaus lights and chess figures are part of the playful-geometric objects from the years 1923 to 1924. A few metal objects, lights and chairs come from the constructivist period 1926 to 1928. The cantilever chair with which the Bauhaus is most commonly identified was only designed by Breuer after he had left the school. Alongside it is Mies Van der Rohe's luxurious furniture which characterizes the later Bauhaus. Our representation of the Bauhaus is characterized by Bauhaus reproductions, among them the cantilever chair and Bauhaus lights. Yet the reproductions both distort and simplify this picture, as much through their variety as through their presentation.

The variety of Bauhaus models being made has to do with our present-day tastes, as have the changes which were effected. Most striking of all is the case of Breuer's tubular-steel chairs which in the '20s were originally covered with material, and never with leather. This was sometimes strongly colored like the

1. Tea table (K 10)
2. Erich Brendel, 1924/1974
3. W 45 cm, D 45 cm, H 60 cm (extended 125 x 125 cm)
4. Stained wood
5. Larger version as dining table
6. Tecta
7. From DM 2310

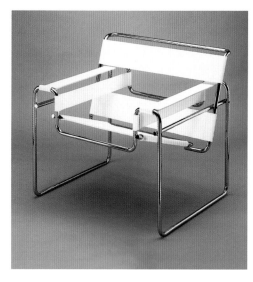

1. "Wassily" armchair (50 L)
2. Marcel Breuer, 1925–1926/1963 (Gavina)
3. W 79 cm, D 70 cm, H 74 cm
4. Tubular steel, chrome-plated. Leather covering
6. Knoll
7. DM 1948
8. Old name: B 3. The covering made of leather rather than fabric is inconsistent with the design.

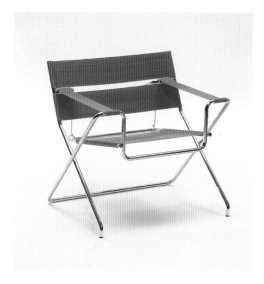

1. Folding armchair (D 4)
2. Marcel Breuer, 1927/1980
3. W 78 cm, D 61 cm, H 71 cm, SH 44 cm
4. Tubular steel, nickel-plated. Covering in colored metallized yarn or leather
6. Tecta
7. From DM 1295
8. Old name: B 4. Reconstructed with an original as model.

1. Name of object (current description of manufacturer) 2. Designer, year/year of reproduction (as far as is known) 3. Dimensions (W = width, D = depth, H = height, SH = Seat height, L = length, Dia = diameter) 4. Materials 5. Further parts and variants 6. Manufacturer 7. Price (1998) for cheapest version and model 8. Comments 9. Other manufacturers

enameled frame; today it would be probably too lively and pretentious for a classic. In the post-war years, the manufacturers adapted to a demand for improved aesthetic qualities and presentation, and a long life: chrome, leather in black or white – typical Bauhaus, really. After the war, the Bauhaus was accused of sterility, mainly caused by the use of a "Bauhaus style" in banks, offices and apartments.

Naturally it has to be like the original, and no Bauhaus product is more exposed to fetishism and genuflection than the Bauhaus glass table lamp. Here, however, "the" original does not in fact exist. Not until the redesign did it become a classic: the much cited proportion of all its parts was developed in 1980, when Wagenfeld reworked the lamp. Previously it was manufactured at the Bauhaus in Weimar, then in Dessau, and later it was taken on by a succession of different lighting factories. Even sample versions made in the same place differed significantly in the proportions of the glass dome, shaft and base. And even Wagenfeld's revised version, which since 1980 has been admired as "the original," was not actually improved in several of its details: the visible thread has moved upward, the bulb sits higher, the metal cylinder in the glass shaft reveals an additional section. Similar changes occurred during remakes in the '20s with many of the objects listed below. The metal wares, which are today so popular and which were manufactured by hand in the Bauhaus workshops, were recommended as models for serial production. Even the silver service which Marianne Brandt has handed down to us was intended for mass production. A creative misunderstanding: the idea was well ahead of the work itself. Some of these articles considerably lose their aesthetic attraction when they are machine-made.

Not until 1926 did designs come into being which are suitable for industrial manufacture, like for instance the two-piece ashtray by Marianne Brandt. There were always changes using industrial production. Then, as today, a success in the market immediately brought variations in material and form. With their door-handle, Gropius and Meyer similarly designed a sculpture from a cylinder and a

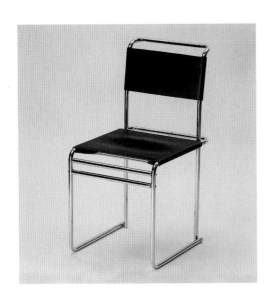

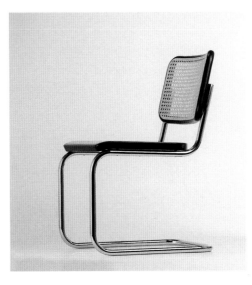

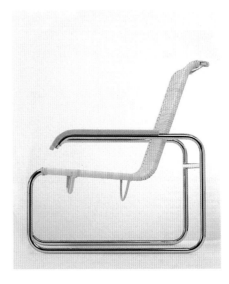

1. Tubular-steel chair (B 40)
2. Marcel Breuer, 1926
3. W 45 cm, D 51 cm, H 82 cm
4. Tubular steel, nickel-plated. Covering in colored metallized yarn or leather
6. Tecta
7. From DM 691
8. Old name: B 5

1. "Cesca" cantilever chair (S 32)
2. Mart Stam/Marcel Breuer, 1928
3. W 45 cm, D 57 cm, H 80 cm, SH 44 cm
4. Tubular steel, chrome-plated. Stained wood, wickerwork
5. Armchair
6. Thonet
7. From DM 820
8. Old name: chair B 32/armchair B 64. The arm-rests were sensibly shortened, the joint-wood frame of the back-rest was replaced with wood.

Photograph by Michael Gerlach

1. Cantilever easy chair with arm-rests (S 35R)
2. Marcel Breuer, 1928-1929
3. W 65 cm, D 83 cm, H 83 cm, SH 36 cm
4. Tubular steel, chrome-plated
5. Matching stool
6. Thonet
7. DM 2236
8. Old name: B35. Two originals have metallized yarn covers; in old photographs, the armchair can be seen in an upholstered version.

Photograph by Thonet

square-section rod, fixed with a screw in each corner to a square plate. In present-day standard doors, this type of handle no longer exists, now most of them are fixed left and right with two screws – definitely less handsome. One of the manufacturers made a further refinement when he placed two screws above and below center which cannot and are not meant to hold anything in place. Hard to say what Gropius would have decided – presumably he would have been influenced by its eventual use.

Whether it was intended as an industrial design, or merely idealized as one, a "new production" refers really to the objects. No terms like replica or copy are used, only "new production." And every new production follows the laws of its time: the type of manufacture, material and price match the market-potential. Which changes are necessary, which are possible and which sensible, all of these have to be decided at the design stage. Equally important is whether the new product is valid in itself. The term "original" means items listed as produced before 1932.

For luxury objects, their use becomes less and less material. The worth of things has to emerge from the objects themselves. Previously, consumers had problems with the simplicity of many objects, with a thin metal or technical material. As Marianne Brandt reported: "At that time, aluminum could be fatal, so we sometimes sprayed the lamp-shades with color." Meanwhile similar aluminum lights are today available in many furniture stores, and an untrained eye would not find the Bauhaus product much different from them. As a result, there is today a trend toward solid, elegant and valuable products, which enhance the object's artistic character. Josef Albers's fruit bowl, which in its original form was nickel- or chrome-plated, is now silver-plated, and there has also been a silver-plated "Weissenhof" chair.

As early as 1930, the steel chairs were considered chic in artistic and cultural avant-garde circles. The chairs can be seen in the apartments of artists and musicians as well as in

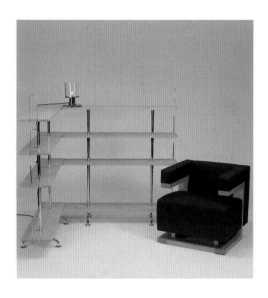

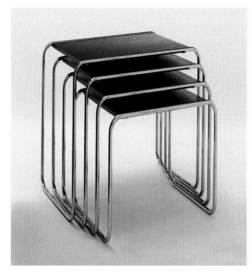

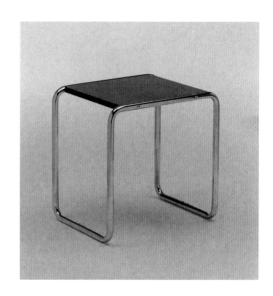

1. Bookshelf (S44)
2. Marcel Breuer, 1932
3. W. 120 cm, D 25 cm, H 12 cm
4. Tubular steel, chrome-plated. Lacquered wood shelving
6. Tecta
7. From DM 1349

1. Armchair (F 51)
2. Walter Gropius, 1920
3. W 43 cm, D 46 cm, H 82 cm, SH 46.7 cm
4. Wooden stand. Upholstery polyurethane. Cover in fabric or leather
5. Three-seater sofa
6. Tecta
7. Armchair from DM 2513
8. Reconstructed using photographs.

1. Nest of tables (B 9a to d)
2. Marcel Breuer, 1925–1926
3. Largest table W 75 cm, H 60 cm. Smallest table W 60 cm, H 45 cm
4. Tubular steel, chrome-plated. Stained wood
6. Thonet
7. Set from DM 2652; also available individually
8. Former name: B9 to 9c. The tables were earlier finished in different colors; an original in the Bauhaus Archive, for example, is red/yellow/ green/blue in palish tones reminiscent of the color-palette of the '50s.
Photograph by Till Leeser/Thonet

1. Stool (László)
2. Marcel Breuer, 1926/1994
3. W 45 cm, D 36 cm, H 45.5 cm, Dia 2.2 cm
4. Tubular steel, chrome-plated or nickel-plated. Wooden top, varnished
6. Stendal
7. DM 303
8. The Bauhaus canteen was fitted out with this forerunner of stool B9. Somewhat crude because of its thicker tube, it is nevertheless clearly and simply designed, with the screws emphasized as constructional details. This stool is one of the most successful "new productions."
9. Tecta: tubular steel, nickel-plated, with wood surfaces or wickerwork (C 4) in the dimensions of later version B9 (W 45 cm, D 39 cm, H 45 cm, Tube Dia 2 cm); from DM 396.

German films around 1940. Even today the new versions are mainly seen as cultural objects. Quite often they are used in décors to represent a supposedly Bauhaus style. The chairs only came into popular circulation in the last 15 years via very cheap replicas. Poor in workmanship and atrocious in detail, not to mention design, such versions are still in many respects useful everyday chairs compared with similar merchandise and at these prices. The tubular-steel chairs were initially nickel-plated and recognizable by their warm light yellowish color tone. In time the nickel plating became matt. Only after 1928 did the chrome-plating of chairs become possible, which with its bluish-white sheen gave a cooler and harder effect. At the same time chairs were lacquered in colors; in a catalog of 1930, 14 color tones were offered, among them lemon yellow, pea green and violet. These were cheaper but less durable. They do not appear so often in old photographs – presumably it was already a matter of taste. Today the steel tubing is chrome-plated, only those made by Tecta are nickel-plated and then only the most basic model; S 43, by Thonet, is available in colored tubular steel (today powder-coated to make it more environmentally friendly). The earlier chairs have various textile coverings; later the metallized yarn developed at the Bauhaus in 1927 was used, which consisted of tightly twisted cotton

1. Display case (S 40)
2. Marcel Breuer, 1923
3. W/D 80 cm, H 165 cm
4. Wood, lacquered in black and white. Glass
5. Smaller version
6. Tecta
7. DM 4323
8. Reconstructed using photographs. Breuer designed only the larger version.

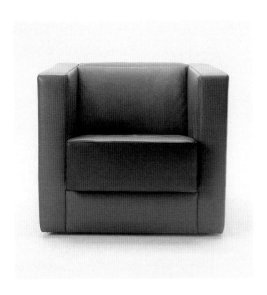

1. "Kubus" armchair (D1)
2. Peter Keler, 1925
3. W 80 cm, D 72 cm, H 66 cm
4. Covered in fabric or leather
5. Matching sofa
6. Tecta
7. From DM 2652

1. Cradle
2. Peter Keler, 1922
3. L 98 cm, dia 91 cm
4. Wood and tubular steel, lacquered. Wickerwork
5. 
6. Tecta
7. DM 3203
8. The only original version in the art collection at Weimar has a flattened hoop, not a round one; the blue color is darker.

yarn coated with paraffin. Leather covers are a discovery of the post-war years. Supposedly they are more durable, though the thicker leather makes the chair optically heavier and improves it artistically. Tecta is the only firm to manufacture this metallized yarn and they sell chairs covered in it as well as in leather. Recently, Knoll brought out Breuer's "Wassily" chair in an expensive limited edition in blue metallized yarn.

Following a legal trial in Germany, the artistic copyright for the cantilever chair in cubic form was awarded to Mart Stam. Since Breuer applied this exact principle for his most famous cantilever chair, his designs are available today in Germany under the name of Mart Stam. This also applies to such

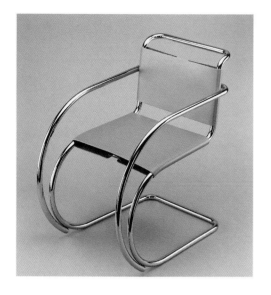

1. "Weissenhof" chair (256 C)
2. Ludwig Mies van der Rohe, 1927/c. 1964
3. W 53.5 cm, D 82.5 cm, H 79 cm, SH 44 cm
4. Tubular steel, chrome-plated. Leather cover
5. Armchair
6. Knoll
7. DM 974 without arms
8. Thonet: tubular steel, chrome-plated, with basketwork (S 533R, from DM 1311). Tecta: tubular steel, nickel-plated, with wickerwork (B 42/D 42, from DM 1045).

1. "Barcelona" armchair (250 L)
2. Ludwig Mies van der Rohe, 1929/1948
3. W 75 cm, D 76 cm, H 77 cm
4. Steel bars, chrome-plated. Leather cover
5. Stool, sofa and occasional table
6. Knoll
7. From DM 6029

1. "Brno" chair (255 A)
2. Ludwig Mies van der Rohe 1930/1960 (steel bars)/1977 (tubular steel)
3. W 58 cm, D 57 cm, H 79 cm, SH 46 cm
4. Steel bars, chrome-plated. Cover in fabric or leather
5. Variant in tubular steel
6. Knoll
7. Steel bars from DM 1678;
   Tubular steel from DM 1157

well-known chairs as the "Cesca" with seat frames and back-rests in cane wickerwork. Of course, "Cesca" or "Wassily," the names under which the chairs became popular, only came into existence after the war, when they were newly produced. Made in Italy, the furniture was given a name – as was the practice there. The "Wassily" appeared earlier in a prospectus under the more factual title "Tubular-steel armchair B 3" (B for Breuer).

Our list is a selection of highlights, although it does not incorporate only Bauhaus designs. If one was to restrict oneself purely to the Bauhaus period, then the famous "Weissenhof" chair by Mies van der Rohe (which came into being before his time at the Bauhaus) and all Breuer's cantilever chairs (which were developed after the Bauhaus era) would be missing. This is not only a problem unique to this list, but one that pervades

Bauhaus literature as a whole. To me it was important that the design concepts are founded on Bauhaus ideas. Breuer's work at the Bauhaus on the cantilever chairs was certainly continued consistently. From Wagenfeld, who was only at the Bauhaus from the fall of 1923 until early 1925, we have taken the Jena tea service of 1931, whereas some of his designs for lights and metal objects from the years 1927 to 1930 are absent. Shown here are the products of just a few firms who, for decades, have been concerned with Bauhaus objects and see them as part of their business culture. They are the "official" manufacturers of such things. Since there is no copyright protection for utility objects in Italy, the chairs are equally available from various Italian firms by mail-order. Their quality should not necessarily be any worse, though each individual item would need to be examined.

The specifications for the models are quoted from the companies' catalogs. As far as possible I have compared the smaller objects with originals and photographs in the Bauhaus Archive, Berlin, which have also served as patterns for a few new productions. Variations referred to are only estimated or slight. All statements concerning current products were made to the best of my knowledge and are based on material available to the author up to the summer of 1998.

1. Fruit bowl (JA 24Si)
2. Josef Albers, 1923–1982
3. H 7.5 cm, Dia 36.5 cm
4. Brass, silver-plated. Glass, synthetic spheres
6. Tecnolumen
7. DM 1300
8. The original in the Bauhaus archive is made of chrome-plated brass, originally thought to have been nickel-plated; it has black lacquered wooden spheres. While the new version was improved through silver-plating, the black lacquered spheres had to be replaced in the course of time by synthetic ones. The stems between the wooden spheres and the metal ring were unnecessarily extended, the distance between the glass disk and the metal ring is around half as much again as in the original.

1. Occasional table (259 T)
2. Ludwig Mies van der Rohe, 1927/c.1964
3. Dia 71.5 cm, H 52, 5 cm, glass 1.2 cm
4. Tubular steel, chrome-plated. Glass
6. Knoll
7. From DM 670

1. Two-piece ashtray (90010)
2. Marianne Brandt, 1926/1985
3. Dia 11 cm
4. Brass
5. High-grade steel
6. Alessi
7. Brass DM 103; high-grade steel DM 95
9. The original in the Bauhaus Archive is brass.

1. Shallow bowl (90041)
2. Marianne Brandt, 1928/1995
3. Dia 29 cm, H 3.2 cm
4. High-grade steel
5. Alessi
7. DM 99
8. Old name: ME 160. There was also a smaller version of the bowl. The originals in the Bauhaus Archive were produced at the Bauhaus (brass, chrome- or nickel-plated) and later in a metal factory (brass, chrome-plated).

1. Glass tea service
2. Wilhelm Wagenfeld, 1931/1997
3. Tea Pot H 13.8 cm, Cup Dia 11 cm
4. Flame-resistant, blown glass
5. Tea Pot, tea cup with saucer, cake plate, sugar bowl/ cream jug
6. Schott Jenaer Glass
7. Tea Pot DM 216; tea cup with saucer DM 36
8. The original Glass Pots were irregular in shape, today they are uniform.

1. Ashtray with round opening (90047)
2. Marianne Brandt, 1924/1995
3. Dia 12.1 cm, H 6.8 cm
4. Bowl brass. Lid high-grade steel
5. Bowl and lid made of high-grade steel
6. Alessi
7. Version in brass/high-grade steel DM 165
8. In the original in the Bauhaus Archive the bowl is of brass, the lid of nickel-plated brass. A perfect remake which can hardly be differentiated from the original.
9. Tecnolumen: variants in triangular opening.

1. Silver tea and coffee service.
2. Marianne Brandt, 1924/1985
3. Tray 51.5 x 32.5 cm
4. 925 silver, handles in ebony
6. Alessi
7. Complete set DM 43,660; single items also available, e.g. Teapot DM 9460
8. The service is an exact hand-produced copy of the original in the Bauhaus-Archive.
9. Tecnolumen: Teapot DM 9950

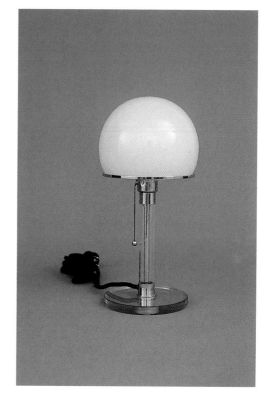

1. Tea-ball stand
2. Otto Rittweger (stand)/Josef Knau (tea ball), 1924/1995
3. Stand Dia 9.7 cm, H 18.5 cm, Tea ball Dia 2.9 cm
4. High-grade steel
6. Alessi
7. Tea-ball holder with 2 tea balls DM 202; individual tea ball DM 59
8. The original tea-ball stands are made of German silver, the tea ball from different materials. About 1924, various solutions for tea balls were developed at the Bauhaus. The tea-ball stands were at the time mostly furnished with another version of tea ball which came from Wolfgang Tumpel. This was also chosen for the new version, refined with a pusher device.

1. Tea caddy
2. Hans Przyrembel, around 1926/1995
3. Dia 6 cm, H 20.7 cm
4. High-grade steel
6. Alessi
7. DM 153
8. The originals are made of German silver. They consist of a cylinder with segments inserted. In the new version, caddy and lid are pressed from one piece. Because of the industrial manufacturing process, the result deviates from the original.

1. Glass table lamp (WG 24)
2. C. J. Jucker/Wilhelm Wagenfeld, 1923–1924/1980
3. H 36 cm, dome Dia 18 cm
4. Metal, nickel-plated. Clear glass, opal glass
5. Metal base and shaft/black enameled metal base and metal shaft/glass base and metal shaft/glass base and glass shaft
6. Tecnolumen
7. DM 695
8. Old name: MEI. Described in a Bauhaus advertising journal as a "table lamp made of glass," it is today popularly known as the "Bauhaus lamp" or "Wagenfeld lamp." It is disputed, both legally and by art historians, whether Jucker and Wagenfeld or Wagenfeld alone should be credited as the originator. The glass base, glass tube with visible electrics and visible thread come from Jucker, while the dome, its support and the metal rod in the glass shaft are by Wagenfeld. This version of the lamp was reworked in 1980 by Wagenfeld. Earlier, before 1967, Jucker had also reworked the lamp. This version (by Imago) differs quite clearly from the old models.

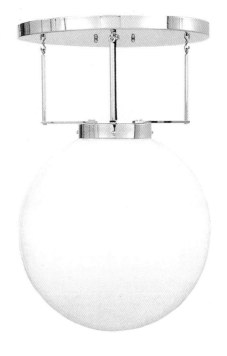

1. Standard lamp
2. Gyula Pap, 1923/1981
3. H 168 cm, bulb Dia 37 cm
4. Iron, black-enameled. Metal, nickel-plated. Glass, etched, matt
6. Tecnolumen
7. DM 2680
9. No original survives, though a height of 160 cm has been recorded. Reconstructed probably with the aid of photographs and drawings of similar lamps. A few details were slightly changed, as a whole the new lamp has a somewhat more modern effect.

1. Hanging light (HMB 25)
2. Marianne Brandt/Hans Przyrembel, 1926/1981
3. Dia 30 cm
4. Aluminum, nickel-plated or white-enameled
5. Dia 30/50 cm, with or without runners and clip
6. Tecnolumen
7. From DM 700
8. Former name: ME 85a, Dia 30 cm, with runners ME 78b. The originals in the Bauhaus Archive are brass, nickel-plated and made of simple aluminum plate; they were also sprayed in colors. The canopy of the old version is wider and thus lower.

1. Ceiling light (DMB 26)
2. Marianne Brandt, c. 1926
3. H 61 cm, Dia 40 cm
4. Brass or brass-plated. Opal glass
5. Variants Dia 25/30/35/40 cm
6. Tecnolumen
7. Dia 40 cm, from DM 1450
8. Old name: ME 27, only in Dia 40 cm. Photographs show a ceiling plate made of dark lacquered wood, which today is produced in a burnished metal. In Moholy-Nagy's studio in Dessau, the three legs of the light were mounted directly on the ceiling, only in the center was there a small plate for the connection.

1. Wallpaper collection "Bauhaus 99"
2. Walter Gropius's office, c. 1930/1988
3. Roll 0.53 x 10.05 m
4. Fleece, relief pattern
5. Currently five patterns, in various color ways
6. Rasch Brothers Wallpaper factory
7. Approx. DM 62 per roll
8. The wallpapers have been produced in constantly changing patterns since 1929. The current designs came from Hermann Fischer and from Walter Gropius's office.

1. Metallized yarn
2. Grete Reichardt, 1927
3. Width 7.5 cm, 13.5 cm, 20 cm, 40 cm
4. Metallized yarn consists of tightly twisted cotton threads, coated with paraffin. Colors blue, rust-red, green, black.
5. Tecta
7. DM 255/m, 40 cm wide
8. Metallized yarn was developed at the Bauhaus for covering the tubular-steel chairs.

1. Door-handle
2. Walter Gropius/Adolf Meyer, 1922
3. Handle L 11 cm, Dia 2 cm
4. Brass, matt or gloss, nickel- or chrome-plated.
5. A great variety of parts depending on producer
6. Dorow
7. Handle with plate, key-plate nickel-plated from DM 233
8. In 1923 a modest production run was undertaken in Berlin. Old versions are relatively different in pattern and measurements.
9. This handle is no longer subject to copyright and is thus available from several firms in various designs:
Bisschop
Tecnolumen (since 1984): from DM 290
Redesign by FSB (since 1986): only in high-grade steel, approx. DM 500 and aluminum approx. DM 250.
The latch is also available from FSB in a redesign by Mendini with a small joint at the end of the cylinder. The handle loses its historical flavor with the modern materials of high-grade steel and aluminum, its look is technical and contemporary; for this reason it can be seen in many public buildings of the past few years. In the brass or nickel-plated versions, the handle makes a "fine piece" in a sophisticated setting.

1. Carpet
2. Gertrud Arndt and others, 1926 until 1930/1993
3. Width of loom 4 m
4. Tufted fine velours made of Polyamide
5. The collection of carpets includes designs by several Bauhaus weavers: Gunta Stölzl (2), Gertrud Arndt (2), Kitty Fischer (2), Monica Bella-Broner (2), Grete Reichardt (3).
6. Vorwerk
7. Approx. DM 118/m2
8. The realization of designs for weaving or carpets as flooring went against the idea of making products at the Bauhaus; however, at least two of the weavers, Gertrude Arndt and Monica Bella-Broner, oversaw the realization of their designs.

1. Bauhaus building game
2. Alma Siedhoff-Buscher, 1924/1977
3. 27 x 6.5 x 4 cm (boxed)
4. Colored lacquered maplewood, 19 pieces
6. Naef
7. DM 145
Photograph by Naef

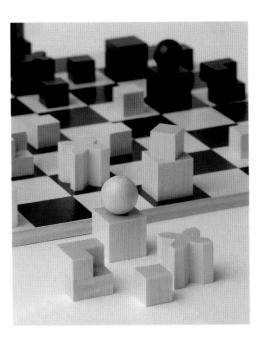

Firms:
Alessi Germany GmbH (Ltd), Tel. 040-3860000
Bisschop GmbH, Tel. 02051-63049
Dorow GmbH, Tel. 0421-321190
FSB, Tel. 05272-60 80
Jado, Tel. 06074-896 01
Knoll International GmbH, Tel. 07144-2010
Naef AG, Switzerland, Tel. 0041-61-851.1844
Schott Jenaer Glass GmbH, Tel. 03641-6810
L. & C. Stendal GmbH, Tel. 03931-6326
Tapetenfabrik Gebr. Rasch (Rasch Brothers Carpet factory), Tel. 05461-81200
Tecnolumen, Tel. 0421-444016
Tecta, Tel. 05273-37890
Gebrüder Thonet GmbH (Thonet Brothers Ltd.), Tel. 06451-5080
Vorwerk & Co, Tel. 05151-1030

1. Optical spinning top
2. Ludwig Hirschfeld-Mack, 1924/1977
3. Dia 10 cm
4. Clear/colorless varnished maple, tip strengthened with metal. Seven colored disks in lacquered cardboard
6. Naef
7. DM 50
9. An original of this top in the Bauhaus-Archive has been slightly adapted in shape and color for functional reasons.
Photograph by Naef

1. Chess figures
2. Josef Hartwig, 1924/1981
3. 44 x 7.5 x 4.5cm (case)
4. Maple, partly black-coated, 32 figures
6. Naef
7. DM 335
8. In the '20s, the chess figures were produced in at least three different versions. The game produced by Naef is probably the latest and most radical. Both board and box, which also existed in several versions, were newly designed.
Photograph by Naef

# The Authors

**Ute Ackermann,** b. 1965 in Leipzig; studied art education and German language and literature in Leipzig; from 1992 exhibition projects on the Bauhaus master Georg Muche; involved in publications on the Bauhaus and journalism; at present scholarly work editing "The Minutes of the Council of Masters at the Weimar Bauhaus, 1919–1925" in the Thuringian main state archive in Weimar; lives in Weimar.

**Olaf Arndt,** author and visual artist, lives in Berlin; founder of the machine group BBM; currently working as art director at the ZKM in Karlsruhe for the Expo 2000 "Knowledge" theme park.

**Christoph Asendorf,** b. 1955, studied art history, history and German in Heidelberg and Berlin; since 1996 professor of art and the theory of art at the Europa University in Frankfurt an der Oder; most recent publication, *Super Constellation – Flugzeug und Raumrevolution* (Aircraft and Space Revolution).

**Eva Badura-Triska,** b. 1954 in Vienna; studied art history and classical archaeology in Vienna and London; since 1979 curator at the Museum of Modern Art in Vienna; numerous publications on 20th-century art, including monographs on Johannes Itten, Rudolf Schwarzkogler and Franz West.

**Anja Baumhoff,** studied German, politics, history, ethnology and anthropology at the Universities of Freiburg and Oxford; doctorate in social history at the Johns Hopkins University in Baltimore, USA, on the connections of gender, art and technology at the Bauhaus; 1992–1993 on the staff of the history department of the Technical University of Berlin; since 1994 assistant at the Bauhaus University in Weimar in the field of design history; co-editor of the periodical *Frauen/Kunst/Geschichte* (Women/Art/History).

**Paul Betts** teaches European history at the University of North Carolina, Charlotte; currently working on *The Pathos of Everyday Objects. A Cultural History of West German Industrial Design, 1945–1965*, to be published by the University of Carolina Press; co-editor of *Pain, Prosperity and the Past: Twentieth-Century German History Reconsidered*, to be published next year by Stanford University Press.

**Bazon Brock,** b. 1936, training and experience as literary and artistic theater director; from 1957 first "didactic action pieces"; from 1968 schools for visitors at "documenta" in Kassel, and at "Art Frankfurt." 1965–1976 taught aesthetics at the HbK Hamburg, 1977–1980 at the School for Applied Arts in Vienna, since 1980 at the BUGH, Wuppertal. Publications include: *Ästhetik als Vermittlung (Aesthetics as Mediation), ed. Karla Fohrbeck, Cologne, 1977;* Ästhetik gegen erzwungene Unmittelbarkeit (Aesthetics against Enforced Immediacy), ed. Nicola von Velsen, Cologne, 1986; *Die Re-Dekade – Kunst und Kultur der 80er Jahre* (The Re-Decade – Art and Culture of the 1980s), ed. Achim Preiß, Munich, 1990; catalog book *Die Macht des Alters* (The Power of Age), Cologne, 1998: *Die Welt zu Deinen Füßen* (The World at your Feet), Cologne, 1998; chairman of the "Malkasten" (Paintbox) association of artists, Düsseldorf; editor of the series *Ästhetik und Naturwissenschaft* (Aesthetics and Science), Springer Verlag, Vienna.

**Ute Brüning,** art educationist and art historian; since 1981 freelance work in Berlin; exhibitions, projects and publications on advertising, typography, the culture of everyday life and design in the GDR.

**Cornelia von Buol,** b. 1968 in Munich; studied art history, communications and psychology in Munich; master's thesis on the Japanese architect Tadao Ando; 1992–1998 work on the New Collection at the State Museum for Applied Arts in Munich, in recent years particularly on the ceramics and porcelain collection; currently working on doctorate on a subject to do with American photorealism.

**Nicole Colin,** b. 1966; studied philosophy, German, history and aesthetics; doctorate in 1993; academic author, translator, artistic theater director, lecturer; designer of historical exhibitions (inter alia for Goethe Institute); publications: *Leiden – im Lichte einer existezialontologischen Kategorialanalyse* (Suffering – in the Light of an Existential/Ontological Categorical Analysis), Amsterdam/Atlanta, 1994; "Bazon Brock. Der Selbstfesselungskünstler. Einführung in eine Ästhetik des Unterlassens" (Bazon Brock. The Artist Who Unchains Himself. Introduction to the Aesthetics of Omission), Weimar, 1995; lives and works in Paris.

**Michael Erlhoff,** scholar in German literary studies; editor-in-chief of an art periodical, freelance author, member of the advisory board for documenta 8, manager of the design council, founding dean of the department of design of Cologne University, president of the Raymond Loewy foundation; consultant to international design colleges and businesses; lives and works in Cologne.

**Martin Faass,** b. 1963 in Karlsruhe, studied art history and German at the Phillips University, Marburg and the Free University, Berlin; master's degree in 1993 with a dissertation on the figurative Constructivism of Rudolf Jahns; doctorate at the Free University, Berlin on the subject of Lyonel Feininger and Cubism; works as academic author and as curator of various exhibition projects; lives in Hamburg.

**Jeannine Fiedler,** b. 1957, studied theater and film, art history and journalism at the Free University, Berlin; publications include *Fotografie am Bauhaus,* (Photography at the Bauhaus), Berlin, 1990; *Paul Outerbridge, Jnr.,* Munich, 1993; *Social Utopias*, Wuppertal, 1995; lives in Berlin.

**Ulrich Giersch,** b. 1954 in Moers on the Rhine; studied art and cultural studies in Marburg, Paris and Berlin; doctorate 1985; exhibition curator and journalist; publications include *Spurensicherung. 40 Jahre Werbung in der DDR* (Securing the Evidence. 40 Years of Advertising in the GDR), Frankfurt am Main, 1990; *Sehsucht – Zur Geschichte der Panoramen* (Addicted to Seeing – on the History of Panoramas), Bonn, 1993; *Gummi – die elastische Faszination* (Rubber, the Elastic Fascination), Dresden/Berlin, 1995; lives in Berlin.

**Andrea Gleiniger,** historian, with doctorate, of art and architecture; 1983–1993 on the staff of the Deutsches Architecturmuseum; since 1994 lecturer and visiting professor at the School of Design, Karlsruhe; author of numerous articles on the history of 20th-century architecture, contemporary art, architecture and new media.

**Andreas Haus,** holder of a chair in art scholarship at the School of Art in Berlin; spokesman there for the postgraduate seminar on "Practice and Theory of Artistic Creativity"; research areas and publications: 17th-century

Italian art and architecture; general art scholarship and aesthetics since the Enlightenment, especially since the Industrial Revolution; K. F. Schinkel; Bauhaus; history and theory of photography; specific features of artistic creativity in its historical context.
(p. 530–531)

**Ulrike Hermann,** b. 1961; studied art history, archaeology and history in Bochum and Berlin; currently submitting doctoral thesis on the photographic work of Otto Steinert at the Ruhr University in Bochum; work on photographic negatives from Otto Steinert's estate at the Folkwang Museum in Essen; teaches the history of photography at the Fachhochschule, Dortmund.
(p. 624–633)

**Karsten Hintz** works for the Bauhaus Archive Ltd in Berlin and is in charge of the "bauhaus shops" program. Post-Bauhaus designs, including reissues of Bauhaus designs, are on sale at the museum and by mail order.
(p. 392–399)

**Britta Kaizer-Schuster,** b. 1957; studied art history and philosophy in Heidelberg and Berlin; numerous publications and exhibitions relating to the Bauhaus, in particular color at the Bauhaus; departmental head at the Kulturstiftung der Länder (Regional Cultural Foundation), Berlin.
(p. 188–215, 552–577)

**Martin Kieren,** b. 1954; studied architecture in Dortmund and Berlin, diploma 1979; 1979–1989 on the staff of the School of Art, Berlin, the Bauhaus Archive, Berlin, and the ERH, Zürich; doctorate 1989; has worked since 1990 as teacher, author, editor, exhibition curator and contributor to various radio stations and architectural periodicals at home and abroad; lives in Berlin.
(p. 280–287)

**Kay Kirchmann,** university lecturer in media studies at the University of Konstanz; studied theater, film and television, German and English in Cologne; doctorate at the University of GH Siegen; publications on the theory, history and aesthetics of film and television, media and contemporary studies, cultural and perceptual history of media, dance and avant-garde theater.
(p. 308–319)

**Friederike Kitschen,** b. 1964; studied art history, literature amd theater studies in Bonn and Munich; 1994 doctorate on "Paul Cézanne. Stilleben" (Paul Cézanne. Still lifes), published 1995; publications on 19th- and 20th-century art; since 1996 head of the Kunstverein (Art Association) in Ulm and project leader of the exhibition group "Architektur und urbaner Raum" (Architecture and Urban Space) at the Stadthaus in Ulm.
(p. 502–503)

**F. Karl Kühn,** b. 1944; for 20 years copywriter and creative director for international top ten agencies, accounts ranging from De Beers and Pepsi Cola to pharmaceuticals

and international banking, all media; currently creative consultant for business-to-business projects in Oberursel near Frankfurt am Main.
(p. 416–425)

**Frauke Mankartz,** b. 1965 in Hamm/Westphalia; studied history of art in Marburg, Vienna and Berlin; master's dissertation on Alberto Giacometti; worked for several years in the field of exhibitions and museums; special interest in sculpture in the first half of the 20th century, currently on the staff of the Georg Kolbe Museum in Berlin.
(p. 140–151, 278–279)

**Christoph Metzger,** b. 1962 in Munich; 1991 MA, Frankfurt am Main; 1997 doctorate in Berlin under Helga de la Motte-Haber and Hermann Danuser, on perspectives on the reception of Gustav Mahler; on teaching staff of Berlin Technical University; since 1996 chairperson of the Berlin Society for New Music; organizer of festivals such as "Music and Light," 1996, "Music in Dialog," 1997/1998, "Minimalisms," 1998, "transmediale," 1999, "Klangkunstforum" (Tonal Art Forum), Potsdamer Platz, 1999; publications on 19th- and 20th-century music, theory of film and "tonal art"; lives in Berlin.
(p. 120–125, 232–243, 256–267, 288–307, 360–391)

**Norbert M. Schmitz,** b. 1960; art and film scholar; 1992 and 1996 assistant at the Combined University in Wuppertal; has taught at the Ruhr University in Bochum and the University of Artistic and Industrial Design in Linz; doctorate on "Art and Science in the Age of Modernism" (Exemplarische Studien zum Verhältnis von Kunstwissenschaft und klassischer Avantgarde um 1910), Alfter, 1993; further publications on the history of style and motif, and aesthetic questions relating to the genres of painting, photography and film; editor of the lectures of Heinrich Wölfflin and Max Dvorák, Alfter, 1993; areas of work: reciprocal relationship of art and film history, aesthetics of modernism, modernism, culture of media and industry, questions of methodology in art scholarship.
(p. 402–415)

**Eva von Seckendorff,** b. 1955; doctorate at the School of Design, Ulm; freelance art historian; works for the Ulm museum and the HfG archive; has organized exhibitions for numerous museums; teaches history of design at the Fachhochschule in Würzburg.
(p. 504–505)

**Erik Spiekermann,** b. 1947; print and typographical designer; after studying art history and spending eight years in England, founded Meta-Design in 1979 with two partners; honorary professor at the HfKM in Bremen; vice-president of the design council and president of the international institute of information design; author of several specialist books on printing and typography; seminars, lectures and teaching activity all over the world.

(p. 452–465)

**Sabine Thümmler,** b. 1956, studied art history, classical archaeology and ethnology in Bonn; doctorate 1987; 1986–1989 costume designer at the Schauspiel in Bonn; since 1990 on the staff, and since 1991 head, of the German wallpaper museum in Kassel; exhibitions and publications on design, commercial art and history of wallpaper.
(p. 26–33, 56–61)

**Justus H. Ulbricht,** b. 1954; married, two sons; studied history, German and education in Tübingen 1974–1980; since then freelance scholar and househusband; from 1995–1998 on the staff of the foundation Weimarer Klassik. Numerous publications on the history of the *völkisch* (folk/race/nation) movement, the bourgeois youth movement, the history of publishing in the 20th century, neoreligious movements in Germany, German intellectual history and the cultural history of Thuringia in the 20th century.
(p. 506–529)

**Katherine C. Ware;** since 1990 assistant in the Department of Photographs of the J. Paul Getty Museum in Los Angeles; most recent publications: *In Focus. Man Ray*; *In Focus. László Moholy-Nagy*; collaboration with photographic collections in the San Francisco Museum of Modern Art and The Oakland Museum; editor at the Smithsonian Institution Traveling Exhibition Service.
(p. 532–551)

**Arnd Wesemann,** b. 1961; studied applied theater studies in Gießen; critic of, inter alia, the *Frankfurter Rundschau*; editor of the magazine *ballet-tanz* in Berlin; publications: *Jan Fabre* (in the series "Regie und Theater" [Directing and Theater], Fischer Verlag) and *Netznomaden & Datendummies* (Verlag Fannei & Walz).
(p. 180–187)

**Karin Wilhelm,** professor of art history at the Technical University in Graz; lives in Berlin and Graz; has taught in Germany, with visiting professorships in Berlin, Kassel, Oldenburg and Bonn; study and research visits to Italy, England and the USA; organizer of several international exhibitions of modern architecture and design (Berlin, London, Stockholm); special interests: architecture and art from the 18th to the 20th century, theory of art and aesthetics; publications include: *Walter Gropius. Industriearchitektur, Porträt Frei Otto, Kunst als Revolte? Von der Fähigkeit der Künste, Nein zu sagen* (Art as Revolt? On the Ability of the Arts to say No), *Sehen – Gehen – Denken. Der Entwurf des Bauhausgebäudes* (Seeing – Walking – Thinking. The Design of the Bauhaus Building), *Zeichen des Körpergefühls. Zur Raum- und Körperwahrnehmung in der Architektur* (Signs of Bodily Awareness. On the Perception of Space and the Body in Architecture), and many others.

# Index

The semibold page numbers indicate illustrations

# Photo Credits

**Annje Urias (Dolores del Bochum).**
1927, Photo by Walter Allner, SBD,
Archive of the Collection

## Acknowledgements

Without the generous help of picture material provided by the many institutions which have maintained the inheritance of the Bauhaus, its history and works, through research and collecting, this book would not have been possible. We owe them considerable thanks. A special acknowledgement goes to those who not only helped in gathering the selected picture material, but also provided important corrections and advice: Sabine Hartmann and Elke Eckert, Bauhaus-Archiv Berlin; Margot Rummler, Stiftung Bauhaus Dessau; Angelika Goder, Kunstsammlungen zu Weimar; Katherine C. Ware, Department of Photographs, J. Paul Getty Museum, Los Angeles; Beth Ann Guynn, Getty Research Center, Research Library, Los Angeles; Kaho Somada, Misawa Bauhaus Collection, Tokyo. We also appreciate the efforts of Kirsten Thietz, Regine Ermert, Susanne Klinkhamels and Thomas Ristow for their correction of the texts, Sylvia Mayer for the through correction of the photo credits, and Sabine Schwarz for her tireless support throughout the duration of the project.